Marks of Distinction

D1500807

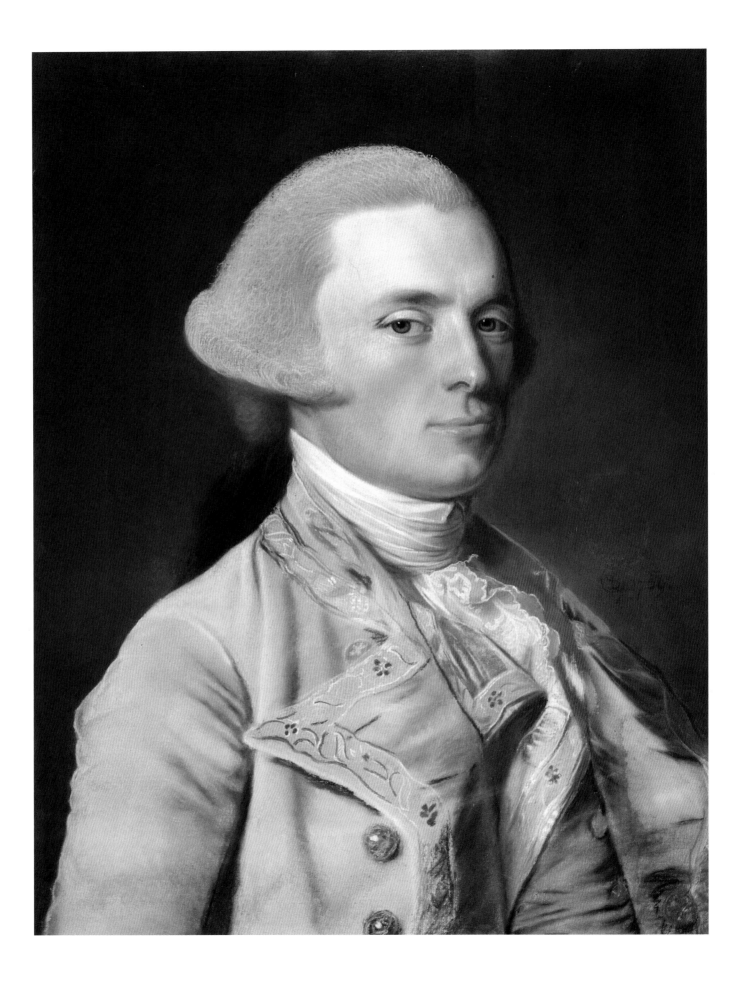

Marks of Distinction

Two Hundred Years of American Drawings and

Watercolors from the Hood Museum of Art

Barbara J. MacAdam

With an essay by JOHN WILMERDING and contributions by MARK D. MITCHELL

Catalogue entries by Derrick R. Cartwright, Katherine W. Hart, Barbara J. MacAdam,

Mark D. Mitchell, and Barbara Thompson

Hood Museum of Art · Dartmouth College
Hanover, New Hampshire

Hudson Hills Press
New York and Manchester

This exhibition and publication project was organized by the Hood Museum of Art, Dartmouth College, and supported in part by a major grant from the Henry R. Luce Foundation. Its presentation at the Hood Museum of Art is generously supported by the Bernard R. Siskind 1955 Fund and the Hansen Family Fund.

Exhibition Itinerary

Hood Museum of Art, Dartmouth College
Hanover, New Hampshire
March 29–May 29, 2005

Grand Rapids Art Museum
Grand Rapids, Michigan
June 24–September 4, 2005

National Academy Museum
New York, New York
October 20–December 31, 2005

Published in the United States by Hudson Hills Press LLC,
74-2 Union Street, Manchester, Vermont 05254.

Distributed in the United States, its territories and possessions, and Canada by National Book Network, Inc. Distributed in the United Kingdom, Eire, and Europe by Windsor Books International.

Co-Directors: Randall Perkins and Leslie van Breen
Founding Publisher: Paul Anbinder
Manuscript editors: Nils Nadeau and Fronia W. Simpson
Designer: Christopher Kuntze
Indexer: Susan DeRenne Coerr
Proofreader: Robert M. Tilendis
Color separation by Pre Tech Color, Wilder, Vermont
Front cover: James McNeill Whistler, *Maud Reading in Bed,* 1883–84 (cat. 29)
Frontispiece: John Singleton Copley, *Governor John Wentworth,* 1769 (cat. 1)
Back cover: Eva Hesse, Untitled, 1964 (cat. 75)

Printed and bound by CS Graphics Pte., Ltd., Singapore

LIBRARY OF CONGRESS CATALOGUING IN PUBLICATION DATA

Hood Museum of Art.
 Marks of distinction : two hundred years of American drawings and watercolors from the Hood Museum of Art / Barbara J. MacAdam ; with an essay by John Wilmerding and contributions by Mark D. Mitchell ; catalogue entries by Derrick R. Cartwright ... [et al.].
 p. cm.
 Catalogue of a traveling exhibition held at the Hood Museum of Art, Dartmouth College, Hanover, N.H., Mar. 29–May 29, 2005, at the Grand Rapids Art Museum, Grand Rapids, Mich., June 24–Sept. 4, 2005, and at the National Academy Museum, New York, Oct. 20–Dec. 31, 2005.
 Includes bibliographical references and index.
 ISBN 1-55595-275-5 hardcover (alk. paper)
 ISBN 1-55595-254-2 softcover (alk. paper)
 1. Art, American—19th century—Exhibitions. 2. Art, American—20th century—Exhibitions. 3. Art—New Hampshire—Hanover—Exhibitions. 4. Hood Museum of Art—Exhibitions. I. MacAdam, Barbara J., 1954– II. Title.
 N6510.H577 2005
 760'.0973'0747423—dc22 2004018481

Contents

Foreword

Marks of Distinction: American Drawings and Watercolors from the Hood Museum of Art is the result of highly focused curatorial effort and inspired philanthropic support. It gives me pleasure to acknowledge the individuals who are most responsible for the success of this scholarly undertaking—the first, but certainly not the last, comprehensive critical catalogue of a singular strength within Dartmouth's historic object holdings. Everyone who reads this catalogue or who visits the handsome exhibition that it accompanies will appreciate the deep debt that is owed to Dartmouth alumni and other generous patrons of the Hood Museum of Art. These men and women, too lengthy a roll call to enumerate here, are the true reason for this project's necessity and ultimate success. The essays in this volume by John Wilmerding and Barbara J. MacAdam identify many of those key supporters. We should all share an interest in the formidable growth of collections that they have fostered at Dartmouth since 1772, the year of the college museum's founding in Hanover, New Hampshire.

I offer first thanks to the Henry Luce Foundation for its large role in launching this project. It is important to recognize the crucial leadership of Henry Luce III, whose genuine interest in the Hood Museum of Art and this exhibition in particular was a source of encouragement at critical junctures. Ellen Holtzman, as always, was a source of advice and sound judgment throughout the research and production of the exhibition and catalogue. On behalf of all students of American art history, I thank these individuals and the foundation they represent for the significant achievements that they have delivered to the field by promoting scholarly projects such as this one. I hope they will take the same great satisfaction in seeing *Marks of Distinction* reach this ultimate useful form as I do.

The presentation of *Marks of Distinction* at the Hood Museum of Art has been generously supported by the Bernard R. Siskind 1955 Fund and the Hansen Family Fund. I count the friendship I have shared with members of both the Siskind and the Hansen families to be among the most gratifying elements of my four years' work at the Hood Museum of Art. This project could not have been completed without their uncommon philanthropy and their impressive vision for building exhibitions of distinction in Hanover. Robert Levinson, longtime member of the Board of Overseers of the Hopkins Center and Hood Museum of Art, also played a decisive role in this project's development, as did

other current and past members of that distinguished group: Maxwell Anderson, Judy Carson, Jon Cohen, Robert Dance, Marc Efron, Hugh Freund, Edward Hansen, Charles Hood, Maggie Fellner Hunt, Jan Seidler Ramirez, James Reibel, Bonnie Reiss, Rick Roesch, Benjamin Schore, George T. M. Shackelford, Connie Spahn, Barbara Dau Southwell, and Bob Wetzel. They know already, I hope, how grateful my colleagues and I are for their wise counsel and enthusiasm.

Colleagues at the National Academy Museum, New York (formerly the National Academy of Design)—most critically the Director, Annette Blaugrund, and Assistant Curator of Nineteenth-Century Art, Mark Mitchell—and at the Grand Rapids Art Museum—where Director Celeste Adams recognized the strong interest that the project would have for her constituents—have ensured that this project is sensitively presented to appreciative audiences in larger metropolitan settings than those of the Upper Valley region of New Hampshire and Vermont. I am grateful for their support and care for these enduring works of art. We could not have wished for stronger or more able collaborators than these. John Wilmerding, one of the most revered scholars of American art history, first contributed to the growth of knowledge in the collections while a young professor at Dartmouth College, and he has continued to serve the institution by writing a thoughtful, summarizing essay here. I thank him for his professionalism and the generous spirit with which he has always performed these services. Marc Simpson, a trusted friend and respected colleague in the American field, gave the volume a deep, critical reading that has surely improved all of its contents, including my own entries. Colleagues at Hudson Hills Press, including Leslie van Breen, Randall Perkins, founder Paul Anbinder, designer Christopher Kuntze, and especially copy editor Fronia W. Simpson, also deserve credit for their keen attention to our text and enthusiasm for this project. I thank them here for their deep investments in this research.

Projects like this one could not be so regularly accomplished without the high intellectual atmosphere of Dartmouth College itself. I seize this opportunity to express my personal gratitude to the administration of the institution: James Wright, President, and Barry Scherr, Provost. Both leaders have articulated a significant vision for a vivid cultural life on the campus, and we all benefit from the high standards they have set. Other colleagues throughout the community have provided essential professional support for

this endeavor. We owe a debt of thanks to the Dartmouth librarians, especially Laura Graveline and Barbara Reed in the Sherman Art Library; Philip Cronenwett, formerly Curator of Manuscripts, Sara Hartwell, Barbara Krieger, and Patricia Cope in Rauner Special Collections Library; and Patricia A. Carter and Ron Chabot at the Baker-Berry Interlibrary Loan Office. Robert B. Donin, General Counsel for the College, and Dartmouth faculty members, especially art historians Robert L. McGrath and Marlene Heck, costume historian Margaret Spicer, and environmental biologist Richard Holmes, all provided valuable assistance. Additionally, a number of Dartmouth undergraduates contributed to *Marks of Distinction*: Amanda Ameer ('04), Amelia Kahl ('02), Brooke Minto ('01), Ann Philippon ('96), Laura Smalligan ('04), and Tim Zeitler ('03) all helped with aspects of research and organization of this catalogue.

At the Hood itself, I have been privileged to work with colleagues of exceptional intelligence and rigor. Everyone on the museum staff has played a role in this project. I would like to recognize in particular the contributions of the following individuals: Juliette Bianco, for overseeing all dimensions of the exhibition's coordination; Patrick Dunfey, whose exhibition designs match the quality of the objects themselves; Richard Gombar and John Nyberg, for their efforts in the preparation, framing, and installation of the objects; Kellen Haak, for coordinating conservation and details of the traveling show; Mary Ann Hankel, for her careful assistance with programming details; Kathy Hart, for contributing numerous entries and for helping with academic programming; Deborah Haynes, for facilitating access to collection documentation; Nancy McLain, for her attention to financial details; Mark Mitchell, for his astute entries and invaluable research assistance while serving as the Luce Assistant for American Art at the museum; Nils Nadeau, for his considerable editorial skills; Kathleen O'Malley, for her attention to the extensive photography of the permanent collection required for this publication; Norman Rawlins and Roberta Shin, for supporting the Director's Office with diligence; Sharon Reed, for her expertise in communications; and Lesley Wellman, Amy Driscoll, and Kris Bergquist, for contributing to the project through innovative educational programming.

Most important of all, this project has depended mightily on one individual: Barbara J. MacAdam, a scholar, connoisseur, and colleague of tremendous breadth and insight. I have only the most profound admiration for Bonnie's talents and always gracious manner. *Marks of Distinction* is in every way a fitting tribute to her selfless commitment and strong work ethic, and it is an enduring demonstration of her contributions to this institution. I congratulate her on this project's final form. As we appreciate this volume and enjoy the exhibition that it so richly complements, we owe her final thanks for providing us with such a gesture of professionalism and lasting wonder in American art history.

Derrick R. Cartwright
Director, 2001–04

Acknowledgments

This long-term research, publication, and exhibition project could not have been accomplished without the generous assistance of many individuals. First, I wish to thank former Hood Museum of Art director Derrick Cartwright, now director of the San Diego Museum of Art, for his wholehearted embrace of this endeavor, which was already under way when he arrived at the Hood in 2001. From the outset, he provided crucial guidance and very tangible support, including the authorship of several entries for this catalogue. I am particularly grateful for his bold commitment to enhancing the museum's collection through the purchase of several major works in advance of our publication deadline. Timothy Rub, director of the museum from 1991 to 1999, also played a key role by helping to shape this project during its inception and to secure critical funding from the Henry Luce Foundation. I deeply admire both directors for devoting such significant institutional resources toward the acquisition, research, publication, and exhibition of the museum's most important asset, its permanent collection.

A primary goal from the outset of this project has been to thoughtfully document and interpret works in the museum's collection that, for the most part, have never received full scholarly attention. The degree to which we succeeded in doing so is due in large measure to the exceptional assistance provided by my colleague Mark D. Mitchell, now Assistant Curator of Nineteenth-Century Art at the National Academy Museum. Such a comprehensive and detailed publication simply could not have been completed on time and with the same degree of thoroughness without his excellent contributions. Throughout his term appointment as a curatorial assistant for this project, Mark demonstrated phenomenal research skills in his persistent and intelligent interrogation of the museum's collection and its history. He also lent his fine analytical and writing talents to this effort, authoring nearly thirty of the publication's entries. With characteristic intelligence, efficiency, and good cheer, he provided vital curatorial and administrative support to me in ways far too numerous to mention. To him I extend my warmest appreciation.

I am also deeply grateful for the generosity and astute contributions of the additional authors here. Derrick R. Cartwright, former director, Katherine W. Hart, Curator of Academic Programming, and Barbara Thompson, Curator of African, Oceanic, and Native American Art, all authored catalogue entries. Their insights and distinctive voices greatly enhanced this publication. I am especially honored that renowned scholar of American art John Wilmerding, a professor at Dartmouth from 1965 to 1977, graciously offered his unique perspective on the collection through his fine introductory essay on American art at Dartmouth. I unreservedly echo Derrick Cartwright's special thanks for his invaluable participation.

Early on in the planning process for this project I benefited from the expertise of two distinguished scholars who have made deep and lasting contributions to our understanding and appreciation of American drawings and watercolors: Carol Troyen, Curator of Paintings, Art of the Americas, at the Museum of Fine Arts, Boston; and Linda S. Ferber, Andrew W. Mellon Curator of American Art and Chair of the Department of American Art at the Brooklyn Museum of Art. Five years ago Carol and Linda spent several days in Hanover reviewing with me hundreds of works from our collection for possible inclusion in this study. Seeing the museum's holdings afresh through their eyes was for me an enormous and lasting privilege. Their keen observations greatly aided the difficult process of creating our final checklist.

At several stages of the project I benefited from the assistance of paper conservator Leslie Paisley of the Williamstown Art Conservation Center. In 2000 she spent several days at the museum, inspecting works to confirm media and evaluate condition. During the intervening years, she and her colleague Rebecca Johnston sensitively treated dozens of works from the collection, often under tight deadlines. The extent to which this project provided the impetus for improving the physical state of works in the collection will remain one of its most enduring legacies.

I would like to echo Derrick Cartwright's warm thanks to our collaborators at Hudson Hills Press and our manuscript readers. All of the authors owe a special debt of thanks to Marc Simpson, who generously reviewed the entire manuscript under short time constraints and offered invaluable suggestions. Copy editor Fronia W. Simpson also provided excellent improvements to the text, as did the museum's own adroit editor, Nils Nadeau.

As Derrick also notes in his foreword, virtually every member of the Hood Museum of Art staff at some point aided in preparing this publication and exhibition. I share his great debt of gratitude for the professionalism, hard work, and steadfast support of each of my colleagues, as well as of

the many Dartmouth students who also offered their research support over the course of this project. Photographer Jeffrey Nintzel expertly produced the vast majority of the photographs for this publication, and I thank him for his talent, perseverance, and good humor throughout this rigorous process.

In our research efforts, we were fortunate to benefit from the expert aid of colleagues at museums, universities, libraries, and archives across the country and beyond. For their assistance with a wide range of inquiries, Mark Mitchell and I wish to thank first and foremost the Dartmouth Library staff enumerated by Derrick Cartwright in the foreword. We also extend thanks to Caroline Welsh, Adirondack Museum; Judy Throm and staff, Archives of American Art, Smithsonian Institution; Larry Lee, formerly with the American Numismatic Association; Nancy Weekly, Burchfield-Penney Art Center, Buffalo State College; Laura Muir, Busch-Reisinger Museum, Harvard University Art Museums; Louise Lippincott and Amber D. Morgan, Carnegie Museum of Art; Dolores Chance and Jean Johnson, Coe College; Eileen McNally, Edith Belle Libby Memorial Library, Old Orchard Beach; Miriam Stewart, Fogg Art Museum, Harvard University Art Museums; Barbara Buhler Lynes, Georgia O'Keeffe Museum; Deanne S. Rathke, Greenlawn-Centerport Historical Association; Ulrich Luckhardt, Hamburger Kunsthalle; Joann Potter, Frances Lehman Loeb Art Center, Vassar College; Judith Johnson, Lincoln Center for the Performing Arts; Ryan Hyman, MacCulloch Hall Historical Museum; J. J. Brody, Maxwell Museum of Anthropology, University of New Mexico; Carrie Rebora Barratt, The Metropolitan Museum of Art; Mary Murray, Munson-Williams-Proctor Arts Institute; Barbara Stern Shapiro, Museum of Fine Arts, Boston; Crystal Polis, Navy Art Collection; Margaret C. Conrads and staff, The Nelson-Atkins Museum of Art; Lucinda H. Gedeon, Neuberger Museum of Art; Elizabeth Wyckoff, New York Public Library; William Aldrich, Norwich (Vt.) Historical Society; William Kimmel, Parsons School of Design; Cheryl Leibold, Pennsylvania Academy of the Fine Arts; Lydia Herring, Portland (Maine) Museum of Art; Amy R. Fitch and Michele Hiltzik, Rockefeller Archive Center; Scott Atkinson, Rachel Evans, and Lili Perry, San Diego Museum of Art; William J. Reid, South Boston Historical Society; Stephen H. Goddard, Spencer Museum of Art, University of Kansas; Robert Bridges, West University Art Collections; Nancy Mowll Mathews, Williams College Museum of Art; and Robin Jaffee Frank, Yale University Art Gallery.

Artists, scholars, and other individuals who have assisted in a variety of ways include Lee Bontecou, Lois Borgenicht, Robert Cozzolino, Jeff Crowell, Hildegard Cummings, Barbara DeSilva, Helen Dickinson, Thomas George, Paula Glick, Wendy Greenhouse, Don Hawthorne, John Henderson, Randall and Tanya Holton, Colleen B. King, Charles Lazzell, Thomas O'Grady, Glenn C. Peck, Peter Rübel (Tuck School Class of 1939), Arthur Serating, Allen Staley, Ellen Wiley Todd, Stephen and Linda Waterhouse, and Paul W. Wilderson.

Many colleagues working with artists' estates and catalogue raisonné projects shared important documentation regarding the provenance and exhibition histories of works in our collection. We are grateful to Ani Boyajian, Stuart Davis Catalogue Raisonné; Nancy Litwin, Adolph and Esther Gottlieb Foundation, Inc.; Kathleen Burnside, Childe Hassam Catalogue Raisonné, Hirschl & Adler Galleries, Inc.; Richard Ormond, John Singer Sargent Catalogue Raisonné; Susan Cooke and Peter Stevens, David Smith Estate; and Karen Baumgartner, Wyeth Collection.

A number of art dealers were similarly generous with their assistance. We thank Peg Alston, Peg Alston Fine Arts; Ed DeLuca, DC Moore Gallery; James N. Goodman, James Goodman Gallery, Inc.; Nicolas H. Ekstrom, Ekstrom & Ekstrom, Inc.; Charlotte Sherman, Heritage Gallery; Katherine Degn and Carole Pesner, Kraushaar Galleries; Nina Nielsen, Nielsen Gallery; M. R. Schweitzer, Schweitzer Gallery; Robert Kashey, Shepherd & Derom Galleries; and the late Vance Jordan, Vance Jordan Fine Art.

On a personal note, I wish to thank my family—my husband, Doug Tifft, and our children, Rosa and Will—for their unfailing support and their forbearance with the demands that this project placed on my time.

And finally, I extend appreciation to all of the donors, museum and library staff, and faculty members who have helped to develop and tend the American collections at Dartmouth College since its founding. In preparing the historical introductory essay for this catalogue, I was particularly reminded of the extraordinary kindness, professionalism, and passionate commitment to art embodied by longtime director of the museum Churchill P. Lathrop (1900–1995). I applaud his role in the expansion and stewardship of these holdings and humbly dedicate this effort to his memory.

Barbara J. MacAdam
Jonathan L. Cohen Curator of American Art

Essays

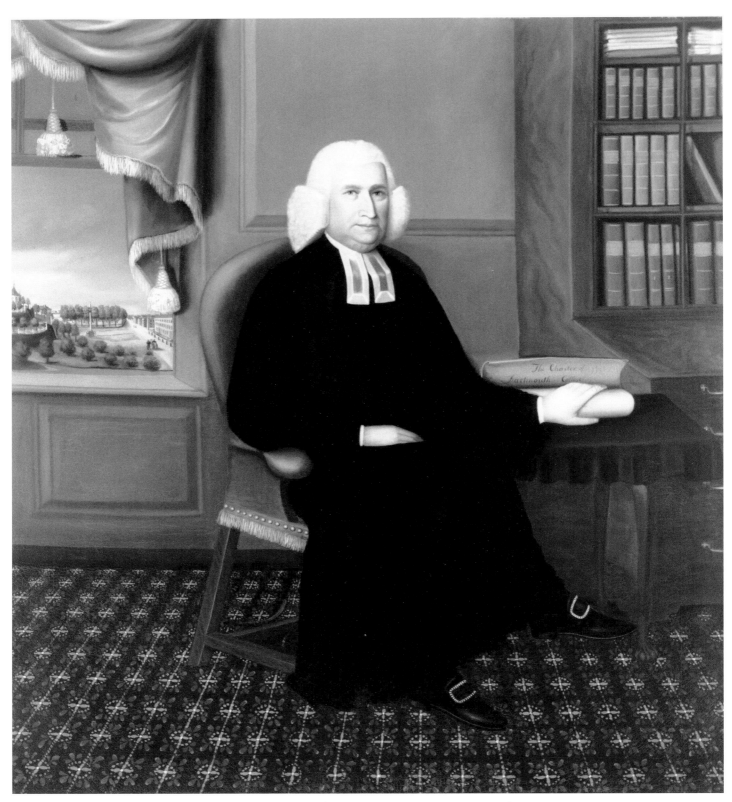

Fig. 2. Joseph Steward, *The Reverend Eleazar Wheelock, First President of Dartmouth College (1769–79)*, 1793–96, oil on canvas, 201.0 x 177.5 cm (79⅛ x 69⅞ in.). Hood Museum of Art, Dartmouth College; commissioned by the Trustees of Dartmouth College; P.793.2

Dartmouth and American Art | John Wilmerding

While Dartmouth College has had a long engagement with American art, both historic and contemporary, one marked by some notable and even famous acquisitions and commissions, it has been a sporadic story until recent years. Unlike many other venerable New England colleges with well-established art museums and substantial collections that include strong holdings of American art—Smith, Mount Holyoke, Williams, Amherst, Bowdoin, and Colby come to mind—Dartmouth came relatively late to building a comprehensive art museum and to collecting and exhibiting American art in any conscientious or passionate manner. The current exhibition changes that uneven course: it culminates a serious and inspired curatorial effort to give fuller shape to the entire American collection and presents much new material that will delight and possibly surprise both College loyalists and the larger public.

The history of Dartmouth's interest in American art intertwines buildings, people, and objects. Perhaps appropriately, the College's first acquisition of American art marked the foundation of the institution itself, the gift in March 1773 of a silver monteith, or bowl, presented by the royal governor of New Hampshire, John Wentworth, to Dartmouth's founder, Eleazar Wheelock (fig. 1). Designed by the Boston silversmith Daniel Henchman and engraved by Nathaniel Hurd, who was also commissioned to design the College's official seal, this work exemplified the beginnings of American sculpture in the colonies, a production of objects that fused practicality and beauty. Almost exactly two centuries later Frank L. Harrington, Class of 1924, and his wife, Louise, built on this foundation object with a complementary gift of Massachusetts silver that eventually comprised some seventy-five pieces and represented such masters as John and Benjamin Burt, Jeremiah Dummer, and Paul Revere.[1]

Within three decades after its founding the first important American paintings came to the College: the portrait commissions in the mid-1790s of Wheelock, founder and first president (fig. 2, essay frontispiece), and John Phillips, a longtime early trustee and himself the founder of Phillips Academy in Exeter, New Hampshire. The painter of these impressive large-scale portraits was Joseph Steward, briefly a student of the Revolutionary War history painter John Trumbull and, as is evident from his style and composition, an admirer of the work of the Connecticut artist Ralph Earl. Like Earl, Steward was a master of the strong, no-nonsense likeness and a lively decorative design, here amplified by the ambitious size and rich coloring of his canvases. Over

succeeding years the trustees, often with the financial assistance of loyal alumni, continued to hire notable contemporary portraitists to capture likenesses of prominent alumni, officers, and friends of the College. After a previous commission by the trustees languished, in the 1830s alumnus George Shattuck arranged for and donated to the college portraits of the four distinguished counsel members who, led by legendary statesman Daniel Webster (Class of 1801, fig. 3), defended the institution's identity as a private college, rather than state university, in the "Dartmouth College Case" of 1817–18. Thomas Sully painted Philadelphia attorney and Congressman Joseph Hopkinson, Chester Harding portrayed former New Hampshire attorney general Jeremiah Mason, and Francis Alexander painted Webster and former New Hampshire chief justice Jeremiah Smith. As it did for many peer institutions, this accumulation of early portraits provided the basis for broader, later collecting of art, while offering a window onto their times, in this case evidence of another practical art from the early period of the republic. In the work of Sully and his successors we see touches of both the new romanticism and the realism that arose during the first third of the nineteenth century.

By 1828 the newly built neoclassical Thornton Hall adjacent to Dartmouth Hall had a gallery of paintings, primarily portraits, and the College also had acquired early on an extensive number of Native American artifacts, in keeping with its founding tradition to educate the Indian as part of its mission. These latter pieces served as the foundation of its sub-

Fig. 1. Daniel Henchman and Nathaniel Hurd, *Monteith*, 1771–73, silver, 15.6 height x 27.3 cm diameter (6⅛ height x 10¾ in. diameter). Hood Museum of Art, Dartmouth College; gift of John Wentworth, Royal Governor of New Hampshire, and Friends; D.977.175

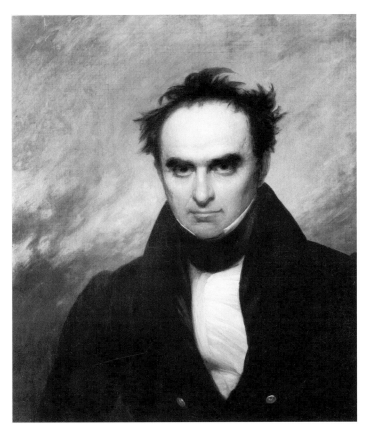

Fig. 3. Francis Alexander, *Daniel Webster, Class of 1801*, 1835, oil on canvas, 76.2 x 63.5 cm (30 x 25 in.). Hood Museum of Art, Dartmouth College; gift of Dr. George C. Shattuck, Class of 1803; P.836.3

Fig. 4. Dartmouth Gallery of Paintings in Wilson Hall, late nineteenth century. Courtesy of Dartmouth College Library

sequent anthropological and ethnographic collections.[2] About 1885 many of the portraits were moved to Wilson Hall (fig. 4) and eventually to Baker Library, on its completion in 1928. A year later a major turning point in the life of the collections and their use came with the construction of Carpenter Hall, which was intended to serve both exhibitions of art and a growing Department of Art within the faculty. The teaching of art history had actually begun in the 1890s, with the modern area covered by a course on the Renaissance to the nineteenth century. George Breed Zug is believed to have been the first professor to introduce American art into the art curriculum, about 1913, and also the first to have organized an exhibition in the field on the art colony in Cornish.[3] This too proved prescient, for later in the century the trustees of the Augustus Saint-Gaudens National Historic Site transferred to Baker Library at Dartmouth all the archives of this leading member of the Cornish group and greatest American sculptor of the nineteenth century.

About the time of Carpenter Hall's construction, other developments took place that would have profound effects on the course of modern art at the College. The young Churchill Lathrop joined the Department of Art and would devote a lifetime to teaching in the modern field as well as building up the permanent collections, especially in the area of works

on paper. He influenced a number of Dartmouth's most prominent collectors, notably Nelson Rockefeller, Class of 1930, Walter P. Chrysler Jr., Class of 1933, and Morton D. May, Class of 1936. Lathrop was also instrumental in advancing the idea of an artist-in-residence program and in particular inviting the controversial Mexican mural painter José Clemente Orozco to Dartmouth, first to come lecture and demonstrate his art form and technique, and later for a two-year residency while he executed his major mural cycle *The Epic of American Civilization* in the lower-level reading room of Baker Library (fig. 5). The story of this historic and provocative work is by now well known. Orozco was given a temporary appointment as professor of art and was later defended at length by the administration when assaulted by alumni offended by his critical visual program. This mural

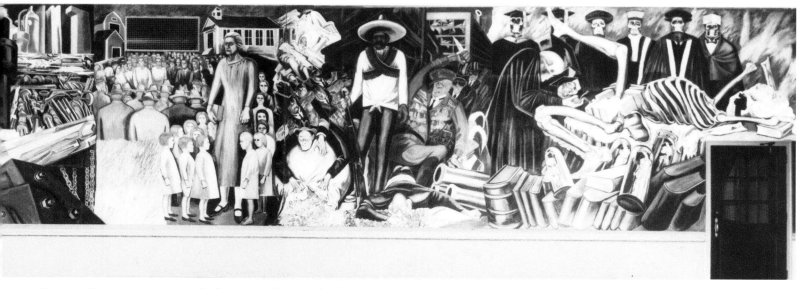

Fig. 5. José Clemente Orozco, *The Epic of American Civilization* (detail), 1932–34, fresco, reserve corridor, Baker Library, Dartmouth College. Courtesy of Dartmouth College Library. © 1934

cycle has of course survived to become one of the major artistic expressions of the 1930s, important for among other things exemplifying a type of art practiced by many American painters, such as Thomas Hart Benton, during the Depression years. We know that it had a significant impact on Jackson Pollock's early career (Pollock actually went to Hanover to study the mural) as he began to take up surrealist motifs and totemic images, and move toward a mural scale in his compositions that would culminate in his radical contributions to abstract expressionism.

With the new spaces available in Carpenter Hall, not just for lecture and seminar courses but also for the display of the permanent collection and the practice of art itself, student interest in accredited studio courses grew. President Ernest Martin Hopkins gave his support to the introduction of a program allowing artists to visit for temporary periods to teach and demonstrate their practice, one already in effect under way with Orozco's formal presence. Among the early invitees were some of the best-known names in modern American art and architecture: Josef Albers, Thomas Hart Benton, Stuart Davis, Reginald Marsh, Buckminster Fuller, Walter Gropius, and Lewis Mumford.[4] The new program was made possible in part by a gift of funds from Mr. and Mrs. John D. Rockefeller Jr., the parents of Nelson Aldrich Rockefeller, who was a senior art history major in 1930. Five years later his mother, Abby Aldrich Rockefeller, would make the first major donation of modern art to the College of some one hundred paintings, sculptures, watercolors, and drawings, highlighted by the moving full-length portrait entitled *The Architect*, of John Joseph Borie III, which was painted in the late 1890s by Thomas Eakins (fig. 6). It is one of a series of paintings the artist executed at the time that were intended to

depict both typologies of profession and unique individuals.

Other American paintings had already begun to enter the collection, including perhaps most unusually Frederic Remington's *Shotgun Hospitality* of 1908 (fig. 7), presented just a year later at about the time of the artist's death. During the following decade the first nineteenth-century landscapes

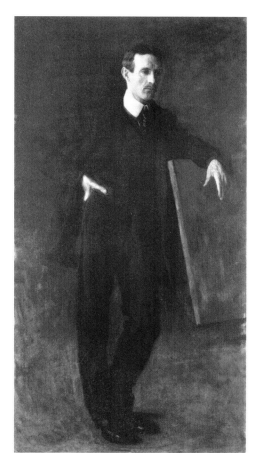

Fig. 6. Thomas Eakins, *The Architect (Portrait of John Joseph Borie III)*, 1896–98, oil on canvas, 201.9 x 105.4 cm (79½ x 41½ in.). Hood Museum of Art, Dartmouth College; gift of Abby Aldrich Rockefeller; P.935.1.19

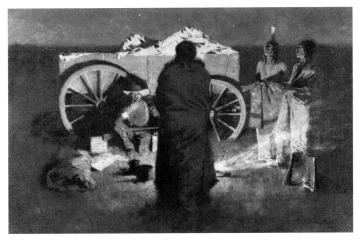

Fig. 7. Frederic Remington, *Shotgun Hospitality*, 1908, oil on canvas, 68.6 x 101.6 cm (27 x 40 in.). Hood Museum of Art, Dartmouth College; gift of Judge Horace Russell, Class of 1865; P.909.2

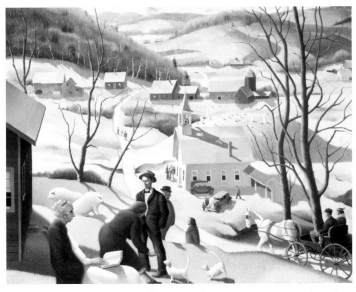

Fig. 8. Paul Sample, *Beaver Meadow*, 1939, oil on canvas, 101.6 x 122.6 cm (40 x 48¼ in.). Hood Museum of Art, Dartmouth College; gift of the artist, Class of 1920, in memory of his brother, Donald M. Sample, Class of 1921; P.943.126.1

arrived in the collection, works by William Sonntag and George Loring Brown, followed by a fine Maurice Prendergast watercolor (cat. 31) and a William Merritt Chase oil.[5] Also in the late 1930s the studio art program gained new stability with the appointment of Paul Sample, Class of 1920, as artist-in-residence with the rank of tenured full professor. Well established as an accomplished realist with regionalist subject matter, Sample guided honors work by art majors for many years while actively painting landscapes of the Upper Valley area. His best work, which includes examples residing in the museum (fig. 8), now ranks high among that of prewar regionalist painters.

After World War II shorter visits by well-known artists resumed, among whom were Ivan Albright (who would later settle in nearby Woodstock), Leonard Baskin, Hans Hofmann, Rockwell Kent, Alice Neel, Ben Shahn, George Tooker, and John Sloan, who was cousin of John Sloan Dickey, president of the College during the 1950s and 1960s, and who resided in Hanover during his last summer. Along with Lathrop, two other professors in the Department of Art contributed greatly to the teaching of American subjects from the 1930s to the 1960s: Ray Nash, who specialized in the graphic arts, including work by modern American artists and calligraphers; and Hugh Morrison, who wrote the first definitive biography of Louis Sullivan and taught modern and American architecture. (The foundations that these individuals provided for the department's curriculum have been built on in more recent decades by the teaching of American and modern art and architecture by such professors as Robert L. McGrath, Jim M. Jordan, and John Jacobus.) Another milestone in the fortunes of art collecting, exhibition, and instruction at Dartmouth came in the early 1960s with the planning and construction of the Hopkins Center (fig. 9), a major complex for the arts on the southern flank of the Dartmouth Green that honored the College president who had for so

long supported the arts and was realized by an equally sympathetic young new president, John Sloan Dickey. More exemplary early American landscapes continued to fill out the American holdings, including works by Thomas Doughty (fig. 10), William Hart, Regis Gignoux, and George Inness. In 1977 the College was given an early American masterwork, John Singleton Copley's pastel portrait entitled *Governor John Wentworth* of 1769 (cat. 1). In chronology it anchors the beginnings of American art; in quality it establishes a level of refinement and strength in the collection worth applauding and following.

Once the Hopkins Center was open, the idea of artists-in-residence visiting for a full term became firmly established, and for the next few decades a parade of distinguished names, often of rising stars at the outset of their careers, went to Hanover, among them Robert Rauschenberg, Frank

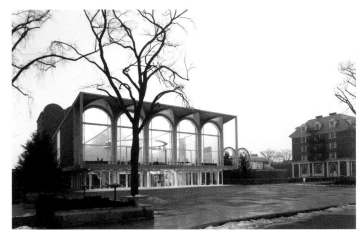

Fig. 9. Hopkins Center, opened 1962, Wallace K. Harrison, architect. Courtesy of Dartmouth College Library

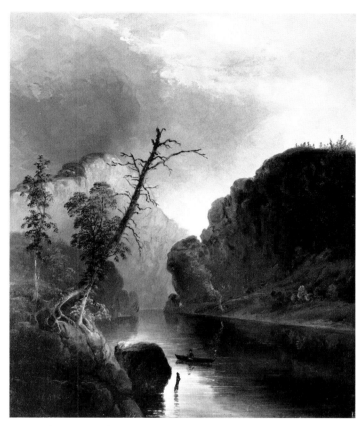

Fig. 10. Thomas Doughty, *Rowing on a Mountain Lake*, c. 1835, oil on canvas, 43.2 x 35.7 cm (17 x 14 in.). Hood Museum of Art, Dartmouth College; purchased through the Julia L. Whittier Fund; P.967.88

Stella, George Rickey, Donald Judd, Richard Anuskiewicz, Varujan Boghosian, Walker Evans, Fritz Scholder, Ashley Bryan, Marie Cosindas, R. B. Kitaj, and Ralph Steiner.[6] These artists would demonstrate their practices for students and exhibit their work in the Hopkins Center galleries, and often the museum would add examples of their art (often prints) to the collections.

Of course, Dartmouth has also had a venerable tradition in the theater arts and film, counting among its alumni the eminent London-based film director Joseph Losey, Class of 1929. It has in addition produced numerous well-recognized photographers; perhaps most celebrated today is James Nachtwey, Class of 1970, one of our foremost war photographers of recent decades. The Hopkins Center has crucially showcased all of these fields, but by the 1980s it was apparent that the museum functions of the College urgently needed consolidation and space for their coherent future growth. This sentiment led to the designing, funding, and construction of the Hood Museum of Art (fig. 11), a facility where the various collections and their presentation might be consistently treated. Since its opening in 1985, the Hood has allocated specific galleries to the comprehensive and logical display of both historic and modern American art, and these collections have developed accordingly.

Since the Hood's opening, interesting and representative works in many periods and areas of American art have enriched the survey of the field, and they provide a compelling backdrop for the admirable range of works on paper more recently assembled. The adding of characteristic portraits by Ralph Earl and Gilbert Stuart has built on the College's early strength in American portraiture, while fine landscapes by John F. Kensett, Samuel L. Gerry, and Worthington Whittredge have broadened the coverage of mid-nineteenth-century Hudson River landscapes. The first two of these works have further appeal as depictions of White Mountain scenery, a natural concentration in the collection. Largely new to the collection are its genre subjects and still lifes, plus works by women artists now well represented by examples from Lilly Martin Spencer and Maria Oakey Dewing (fig. 12). From the second half of the century small but characteristic oils by Eastman Johnson and Winslow Homer were added, showing the new, down-to-earth realism they introduced in the post–Civil War years. From the later Gilded Age, landscapes by Willard Metcalf and Abbott Thayer, as well as an unusual early landscape by Rockwell Kent, demonstrated aspects of American impressionism and its variants, while a bust-length portrait by James McNeill Whistler gives a nod to the expatriate generation. A classic Paul Sample scene and Georgia O'Keeffe's *Taos Mountain, New Mexico* (fig. 13) contrast different aspects of 1930s realism.

Finally, selected pieces of American sculpture have begun to round out the collections. Early in the twentieth century Daniel Chester French donated to the College his bronze bust of Ralph Waldo Emerson.[7] Complementing this work in more recent years have been gifts of additional bronzes by Thomas Ball, Frederic Remington, and Augustus Saint-Gaudens, while the recently acquired marble bust of Medusa by Harriet Hosmer (fig. 14) represents the neoclassical era of

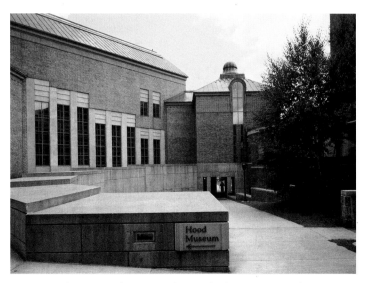

Fig. 11. Hood Museum of Art, opened 1985, Charles W. Moore, architect

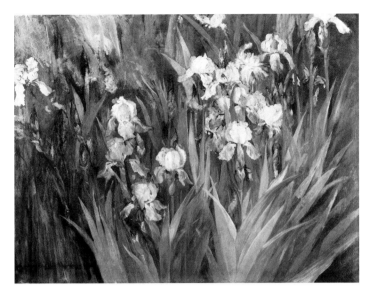

Fig. 12. Maria Oakey Dewing, *Iris at Dawn*, 1899, oil on canvas, 64.0 x 79.5 cm (25¼ x 31¼ in.). Hood Museum of Art, Dartmouth College; purchased through the Miriam and Sidney Stoneman Acquisition Fund and the Mrs. Harvey P. Hood W'18 Fund; P.999.11

the site-specific piece by Beverly Pepper. In sum, this accumulation now offers an impressive overview of the American artistic tradition and sets the stage for the recent concerted efforts to assemble an equally broad sequence of drawings and watercolors, one now highlighted in the present exhibition.

How does this gathering of works on paper tell its own story of national artistic developments as it moves from Copley's early colonial masterpiece to examples by some of the major figures of our own time? Among America's first arts, portraiture, with its conflation of artistic ambition and practical function, was a dominant mode of expression. Emerging at the forefront of all of his colonial predecessors and contemporaries, Boston's Copley brought a flattering and empathetic realism to the images of his patrons. He learned his technique largely through training in the graphic arts and working after prints and illustrated books, which gave him a solid grounding in line and tonal contrast. Those elements would generally inform much of his art, as may be seen in the firm colored drawing of his pastel portrait of Governor Wentworth (fig. 15).

So successful was Copley in Boston that he was able to satisfy equally both his Whig and his Tory patrons until the outbreak of hostilities, when he decided to settle permanently in London. But he was also lured abroad by his contemporary Benjamin West, born in Quaker Philadelphia, who had left years earlier to pursue his career in the English capital. There

the mid–nineteenth century. The tradition of carving in stone has continued into the early twentieth century in the Hood's collection, as can be seen in the simplified realism of John Flannagan's 1927 *Head*. All of these works constitute an instructive historical background for the commissioning of the large-scale modern sculptures selectively placed around campus, most notably the construction by Mark di Suvero and

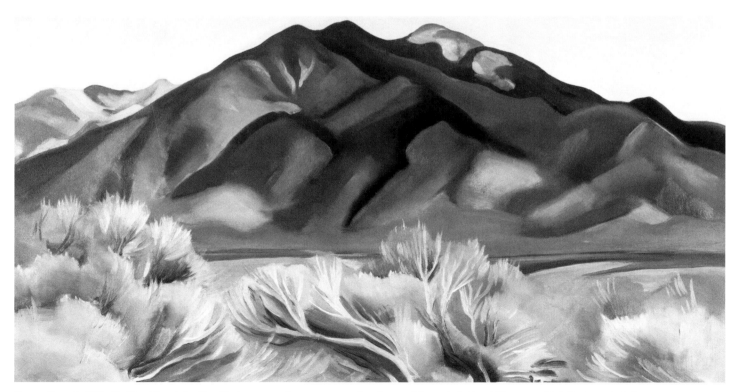

Fig. 13. Georgia O'Keeffe, *Taos Mountain, New Mexico*, 1930, oil on canvas, 40.6 x 76.2 cm (16 x 30 in.). Hood Museum of Art, Dartmouth College; gift of M. Rosalie Leidinger and Louise W. Schmidt; P.993.62. © 2004 The Georgia O'Keeffe Foundation / Artists Rights Society (ARS), New York

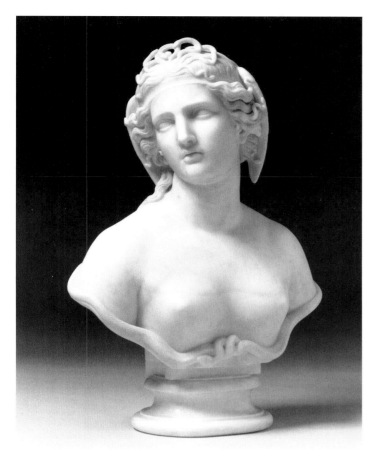

Fig. 14. Harriet Hosmer, *Medusa*, c. 1854, marble, 69.9 x 48.3 x 24.1 cm (27½ x 19 x 9½ in.). Hood Museum of Art, Dartmouth College; purchased through a gift from Jane and W. David Dance, Class of 1940; S.996.24

America. But regardless of the international currents affecting American art during the decades following the Revolution, portraiture remained a dominant subject for the early republic. It well served first the need for a new national history and heroes and later the growing sense of American individuality. With the rise of the common man during the age of Jacksonian Democracy, not only did established academic artists work in the field but also countless lesser-known or unknown individuals pursued their talents as painters of likenesses. Their efforts may be seen in the charming images of Mary Lane Miltimore Hale (cat. 5) and Daniel Webster (cat. 7) by Sarah Goodridge, and, closer to the anonymous folk tradition, the bold, unidentified profile portraits by C. Burton (cats. 11, 12). By midcentury the art of portraiture had moved toward a meticulous realism, likely in reaction to the new popularity of the daguerreotype, as is evident in the beautifully detailed and modeled features recorded in Daniel Huntington's triple portrait drawing *William Cullen Bryant, Daniel Webster, and Washington Irving* (cat. 14). Also suggesting a photographic sensibility are its arch-topped format and the strong tonal contrasts of white chalk against the dark tan paper ground.

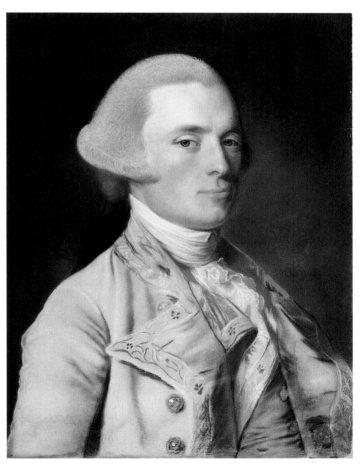

Fig. 15. John Singleton Copley, *Governor John Wentworth*, 1769 (cat. 1). Hood Museum of Art, Dartmouth College; gift of Mrs. Esther Lowell Abbott, in memory of her husband, Gordon Abbott; D.977.175

West, and soon Copley, mastered the current rococo tastes in painting and found favor as artists with the court. When Copley had sent one of his pictures to London for exhibition, West had written him that the major criticism with his work was that it was too tightly rendered, a characteristic we can readily see by comparing the Copley with West's own sinuous 1784 drawing entitled *Archangel Gabriel of the Annunciation* (cat. 2). Cofounder with Joshua Reynolds of the Royal Academy of Arts and its second president, West urged his American colleague to leave behind the limiting practicalities of portraiture in America and take on the higher and more ambitious calling of history, mythological, and religious painting in the modern European manner. In West's drawing we see something of his early so-called heroic style with its solidity of form merging into the more dramatic movement and emotional intensity associated with his later, more sublime manner.

As we know, West welcomed many American colleagues into his London studio, promoting the elegant painterliness and historical narratives of English and Continental practice, a hint of which may be seen in the wash drawing by Thomas Sully (cat. 4), one of those younger Americans who brought these academic standards back to his subsequent work in

Beginning around the second quarter of the century the idea and actuality of landscape increasingly captured the American imagination, as the country grew to envision its identity as articulated and embodied in the process of nature rather than the artifices of ancient mythology and history or biblical narratives. Physically and politically the country was turning its attention westward; intellectually and spiritually nature came to be seen as a special national possession, purer, wilder, and more inspiring than anything Europe had to offer. If the Lewis and Clark expedition at the outset of the century symbolized the beginning of American expansiveness, the California gold rush at midcentury signified the high noon of national promise and possibility. Meanwhile, back in New England, Ralph Waldo Emerson, Henry David Thoreau, and the transcendentalists, along with Thomas Cole and the new native school of landscape painters, were all articulating the face of nature as an embodiment of God's presence. Thomas Birch's drawing in the Dartmouth collection represents the work of the first generation of landscape artists, with its English picturesque characteristics and generalized treatment of the scene (cat. 6). The more primitive charms of the self-trained artist are apparent in the watercolors *Dartmouth College* by Ann Frances Ray (cat. 8) and *The Last of His Tribe* by Anna Elisabeth Lancaster Hobbs (cat. 10). In turn, James Bard's image of the steamer *Menemon Sanford* (cat. 15) reminds us of the emerging age of steam and the transformation of the countryside by rail and boat traffic.

A related aspect of the early nineteenth century—the fusion of art and science—is evident in the early pastel and graphite drawing of a hawk by John James Audubon (fig. 16). A recent acquisition, it embodies the rising interest in naturalism of the times as well as the principle of understanding and describing the world as an aesthetic design. Audubon's contemporary George Catlin was concurrently attempting to document all the Native American tribes across the continent, while Noah Webster continued to issue revised editions of his dictionary containing all the elements of an American language. Soon William Dunlap would publish the first history of American art and artists, significantly titled *The Rise and Progress of the Arts of Design in the United States*. Trained in the traditions of neoclassicism coming from Jacques-Louis David in France, Audubon developed a style of linear clarity and strong silhouettes that he applied to his lifelong obsession with recording the birds and mammals of North America. His forms were usually contained within clean, rhythmic outlines and carefully balanced on the sheet of paper, often conscious of their proximity to the framing edges. The silhouette at once perfectly suited the capturing of the individual character and posture of a species while also distilling the clarity and equipoise of artistic design.

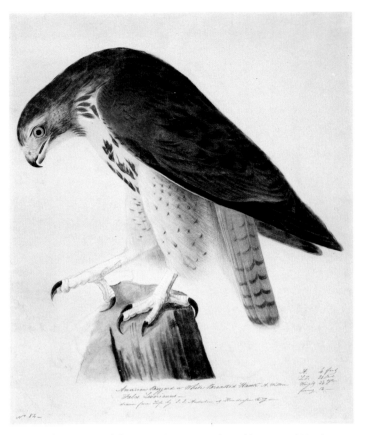

Fig. 16. John James Audubon, *American Buzzard or White Breasted Hawk . . . Falco Leverianus*, c. 1810–20 (cat. 3). Hood Museum of Art, Dartmouth College; purchased through the Katharine T. and Merrill G. Beede 1929 Fund and the Mrs. Harvey P. Hood W'18 Fund; D.2003.52

Increasingly, specific topographical sites drew the artist's attention in America, as we can see in Seth Eastman's *View of Concord, New Hampshire* (cat. 9) and John William Hill's *High Bridge* (cat. 13). The other major elements in these works from the 1840s and 1850s are the greater sense of openness and the emphasis on spatial recession and light-filled panoramas. In the drawing by Martin Johnson Heade (cat. 18) and watercolor by William Trost Richards, these elements culminate in what we now describe as the "luminist" sensibility, with their stress on brilliant spatial vistas and conscious horizontal formatting. Richards's *Beach Scene* is a marvel of luminism, nominally empty and abstract yet filled with the palpability of radiant light and atmosphere (cat. 21). The other quality evident in this work is the precision of his detailed drawing, seen just as explicitly in *Palms* (cat. 16). This, along with John Henry Hill's watercolor *Lake Scenery* (cat. 20), exemplifies the pervasive teachings of John Ruskin and his influence on the Pre-Raphaelite movement in America. Ruskin insisted on just this sort of obsessive scrutiny of nature's components, and Hill and Richards were among the masters of this style at midcentury.

After the Civil War a variety of changes began to affect

American landscape painting and drawing. Despite the turmoil and turbulence of the war period and Reconstruction, some artists simply maintained the Hudson River School manner of nature's celebration, sometimes, one suspects, as an escape from the troubling changes under way in American life. Others were interested in recording the new leisure life developing in the rising resort areas along the East Coast. Still others went abroad to study or emulate the practitioners of plein-air painting and the naturalism of their recording. Thus, American art became much more conscious of international stylistic currents, especially those of French realism and early impressionism. Something of these shifts in taste may be seen in the watercolor of Étretat, a haunt of Claude Monet's, by Samuel Colman (cat. 22) and the drawings of John Francis Murphy (cat. 23 and p. 241). Moreover, a major shift in subject took place in this period as artists gave new priority to the human figure over the wilderness of nature.

This shift was not surprising, given the slaughter of the recent war years, the continuing tensions of racial conflict during Reconstruction and after, and the vulnerability widely felt by both the encroachments of industry and the uncertainties of nature as proclaimed by Charles Darwin's *On the Origin of Species,* published in 1859. The unified vision of a heroic and spiritual landscape favored by the Hudson River School during the first half of the century no longer seemed relevant to the sobrieties of the Brown Decades. A new generation of realists led by Thomas Eakins, Eastman Johnson, and Winslow Homer came to its maturity during the years following the Civil War, and although these artists all painted landscapes, the human figure and mortality now occupied primary attention.

The beautiful early drawing by Eastman Johnson exemplifies his mastery of the charcoal medium, a technique he perfected early and employed extensively for figure and portrait drawings (cat. 17). Its soft textures and richness of tonal shading derive in good part from his initial training in a Boston lithography shop during the 1840s. Subsequently, Johnson became successful drawing portraits both in Washington and Boston of political and literary worthies. At the end of the decade he went to Germany and the Netherlands, where he encountered respectively the tight detailed manner of the Düsseldorf School and the more dramatic realism of the Dutch old masters. All of this inspiration coalesces in his tender depiction of a young girl contemplating a picture album on her lap, one of several such images he drew and painted from the 1850s to the 1870s of youths engaged in reading books or newspapers in a quiet interior setting. These works speak to the rising literacy among the American population around midcentury, the greater availability of inexpensive books, pamphlets, and newspapers, and, along

with Homer's slightly later schoolhouse series, the growth in public schooling. Johnson here celebrates not only the nostalgia for childhood but also a subtle awareness of the inner life of the mind.

Dartmouth's two Homers stand firmly at the center of his career, in fact at a crucial turning point in his style and subject matter. Trained in printmaking as a young man, he thereafter brought an underlying sense of line, silhouette, and tonal clarity to all his work in oil and watercolor. As we know, he spent his first summer in Gloucester, Massachusetts, in 1873 painting watercolors, focusing on the pleasures and leisure activities of youths playing along the wharves and shorefront of the harbor. These sheets have in fact been described as "colored drawings," and they are still rather tightly delineated and controlled. By the time of his second visit to the town at the end of the decade, when *Boys Bathing* (fig. 17) was executed, he had developed a new looseness and fluidity of brushwork as well as a greater openness of composition and atmospheric effect. Significantly, on this visit he stayed, not ashore in the midst of the town's busy life, but at the lighthouse keeper's cottage on Ten Pound Island in the middle of the outer harbor. There he absorbed a new feeling of detachment, if not isolation, painting the expanse of water around him and becoming much more aware of the changing play of light throughout the day and evening. On one level, his later focus on youths swimming around their boats continues narrative themes that had appealed to him and others throughout the Reconstruction years. At the same time, his work of 1880 shows a new technical boldness that looks forward to the brilliant achievements of his watercolors in later decades.

At the end of that summer Homer left for the north coast of England, where he continued to paint in watercolor. But he largely gave up drawings in pencil, now favoring the more dramatic effects of charcoal or pen and ink wash, as can be seen in *Beaching a Boat*, 1881–82 (cat. 28). His subjects also radically shifted from youths and relative innocence to the serious preoccupations of sturdy fishermen and -women pursuing a livelihood. This scene captures one of those moments of arduous labor along that rugged coast, often taking place in tumultuous weather. When Homer returned to Maine from his two-year stay there, his later art probed ever more deeply the great themes of the human condition and one's place within the combative forces of the natural world.

Contrasting with Homer's solid realism in the collection are fine examples by his expatriate contemporaries James McNeill Whistler, Mary Cassatt, and John Singer Sargent, who took up the more cosmopolitan styles of European art. Cassatt had first learned to draw the human figure at the Pennsylvania Academy of the Fine Arts in the 1860s, train-

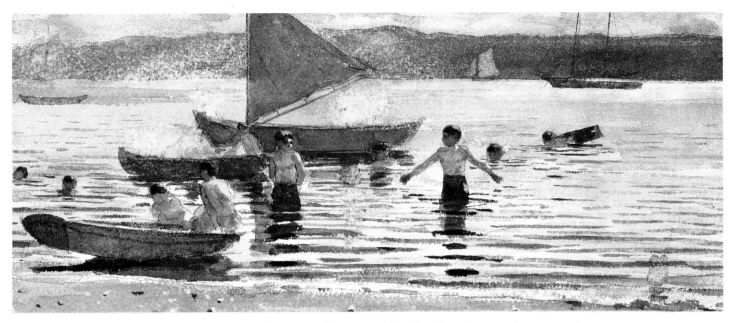

Fig. 17. Winslow Homer, *Boys Bathing*, 1880 (cat. 27). Hood Museum of Art, Dartmouth College; from the estate of Tatiana Ruzicka (1915–1995). Presented in 1996 by Edward Connery Lathem in memory of Rudolph Ruzicka (1883–1978); W.996.47

ing that she continued later in the decade under academic teachers in Paris. In the next decade she settled there for much of the remainder of her life, soon making the acquaintance of Edgar Degas and exhibiting with his impressionist colleagues. Degas introduced her to the techniques of etching and pastel, two media in which she would excel as her career advanced. In her *Drawing for "Evening"* (fig. 18), both the device of close-up positioning of the figures and the cropping of forms at the side edges are likely inspired by the French artist's work of the same time. But this piece is also an early example of Cassatt's special attention to the depiction of women as intelligent and industrious; here her sister and mother are engaged in needlework and reading, a favorite image in her work of the late 1870s and 1880s. It is a beautiful drawing in its own right, further interesting for its relationship to the subsequent print and as a sympathetic study of her subject's psychological presence.

Sargent of course was one of the most versatile artists of his generation, proficient in a range of media and genres, including landscape and mural painting. He was, above all, the consummate master of the portrait in the later nineteenth century, well trained by his academic teachers in France and able to wield a brush with a dazzling facility and matchless ability to flatter. But underlying this surface dexterity was a talent for solidly capturing facial features, the distinctive posture or positioning of form, and a judicious modeling of a figure in space. Such expressive clarity is evident in the charcoal studies he did for his major mural commission at the new Boston Public Library around the turn of the century; Dartmouth's drawing (cat. 36) is thought to be for a figure in Hell that appears in one of the lunettes. It makes an instruc-

tive comparison with the somewhat earlier drawing of the male nude by Hermann Dudley Murphy (cat. 30). Both the nude as a subject and mural decoration as a practice were hallmarks of artists of the American Renaissance.

Another strong stylistic current adapted from French precedents by American artists toward the end of the century was the impressionist manner, visible in the watercolors of Whistler, Childe Hassam, and Maurice Prendergast. The decorative touch and often off-center composition hint of the influence of Japanese prints, an aesthetic that became widely

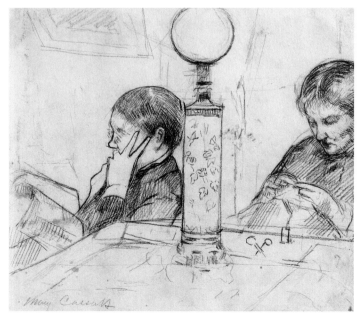

Fig. 18. Mary Cassatt, *Drawing for "Evening,"* 1879/80 (cat. 25). Hood Museum of Art, Dartmouth College; purchased through gifts from the Lathrop Fellows; D.2003.16

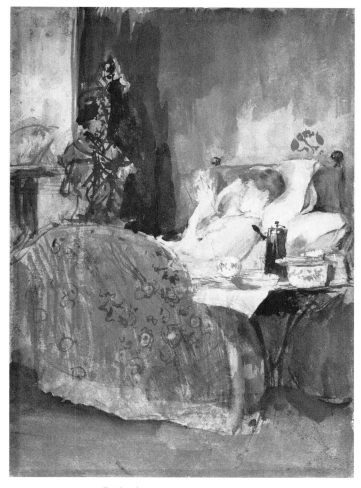

Fig. 19. James McNeill Whistler, *Maud Reading in Bed*, 1883–84 (cat. 29). Hood Museum of Art, Dartmouth College; gift of Mr. and Mrs. Arthur E. Allen Jr., Class of 1932; W.971.26

popular among Americans at the time, and particularly with Whistler (fig. 19). For his part, Hassam tended primarily to reference Monet in his work (cat. 34), while Prendergast, with his innovative, mosaic-like renderings of an urban middle class, looked more to the examples of several post-impressionists, including some of the pointillists (cats. 31, 32). But Americans took up impressionist elements almost a generation after the French had introduced them, and they tended to retain an American solidity in recording figures or space whereas their Continental counterparts allowed broken color and fragmented brushwork to dissolve form and its setting. The French were more theoretical and conceptual in how the eye perceived images, while the Americans loved the bright delicacies of color, especially in garden vistas. The American perpetuation of this style well into the early years of the twentieth century, as typified by the work of Hassam and Prendergast, suggests how well suited it was to capturing a lingering love of the pastoral, the increasing urge to escape into some wished-for edenic retreat in the face of new encroachments by industrialism, immigration, urbanism, and other upheavals in the new century.

The artists who would embrace the energies of the new age and celebrate the city landscape as an appropriate modern subject were disdainfully recognized as the "Ashcan School." Several of them are well represented in this collection, including Everett Shinn (cat. 33 and pp. 245–46), John Sloan (cats. 37, 42, and p. 246), George Bellows (cat. 39 and p. 227), and George Luks (cat. 41). They favored subjects such as the new immigrants, back streets, cafés and theaters, and traffic and crowds—images that expressed the quickened pulse of modern urban life. In the case of Sloan, of course, these drawings complement several major paintings of his that are already in the collection. Also early in the century, thanks to the huge exposition of modern international art shown at the Armory Show in 1913 and to the energetic efforts of the pioneering photographer, publisher, and art dealer Alfred Stieglitz, Americans were introduced to the new developments in abstraction. Stieglitz sent several of his own circle of artists abroad, and some of them—Arthur Dove, John Marin, and Marsden Hartley, for example—were among the first to incorporate abstract experimentations within their work. The fragmentations of cubism and the arbitrary color patterns of expressionism advanced by Europeans soon filtered into the American avant-garde, as we can see in the examples of Abraham Walkowitz (cat. 35), Blanche Lazzell (cat. 40), and the later pieces by Dove (fig. 20 and p. 232) and Marin (cat. 64 and p. 240).

Several variants of realism remained strong during this period, however, as Marguerite Zorach (cat. 44) and Stuart Davis (cat. 48) caught the bright rhythms of the Jazz Age in their city views on both sides of the Atlantic. The urban buildings drawn by Charles Burchfield (cat. 45) and George Ault (cat. 46) make an interesting comparison as well. Coming from rural Ohio, Burchfield frequently maintained an overwhelming mood of alienation in his city images. He often (as here) deeply shadowed his windows to suggest the fearful stare of eyes and a lonely emptiness in the scene. Ault seems more aware of cubist repetitions of form as well as the urban nooks of city dwellers in the Ashcan tradition. Other modernists who early on practiced variations of cubist or futurist expressions in their paintings of New York, such as Joseph Stella and Charles Demuth, appear in this collection via slightly later, more realist watercolors. The former's *Dying Lotus* (cat. 49) has a simplification and isolation of form that reminds us of Georgia O'Keeffe's flower studies of the same time, while Demuth's beach scene (cat. 54) displays the transparent delicacies familiar from his erotic figure watercolors as well as bouquets of flowers also reminiscent of his colleague O'Keeffe.

By the 1930s realism again had a stronghold on much American art, partly in response to the renewed attention to the American scene and to regionalist subject matter during

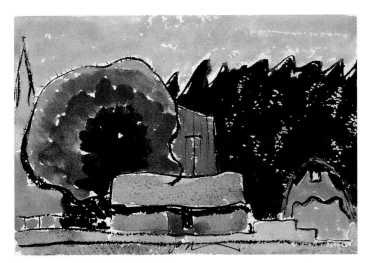

Fig. 20. Arthur Dove, *Boat Houses*, 1938 (cat. 55). Hood Museum of Art, Dartmouth College; bequest of Jay R. Wolf, Class of 1951; W.976.189

the Depression years. The new isolationism of the country in the wake of World War I had an artistic voice that turned away from European modernism for a time to concentrate on native landscapes and themes. Thomas Hart Benton, for instance, repudiated the early abstract work he had done in Paris to champion imagery of the American rural South and Midwest. The other foremost regionalist of the period, his contemporary Grant Wood (cats. 56, 57) of Iowa, favored a quasiprimitive style of flattened and simplified forms that was partially inspired by his early study of northern Renaissance art but also by nineteenth-century American examples of daguerreotype photography and Currier and Ives prints. The two watercolors by Wood bring welcome examples of still life into the collection and, like his larger landscape paintings, show his charming adaptation of past American traditions, in this case anonymous theorem paintings. Furthermore, these works make a fortuitous comparison with the recently acquired 1939 drawing *House with Figures and Animals* by the modern African American folk artist Bill Traylor (cat. 58). A self-taught craftsman working in the deep South, Traylor adds to the folk tradition already seen in various nineteenth-century precedents in Dartmouth's collection.

While the realist celebrations of American life and the countryside remained strong after the Depression and into the 1940s and 1950s, as the examples by Paul Sample (cats. 62, 63, and pp. 243–44), Edwin Dickinson (cat. 61), and Andrew Wyeth (cat. 67) demonstrate, by the end of the 1930s new artistic stimuli, primarily from Europe, were again prompting some American artists toward a new abstraction. Importantly, a number of surrealists of various nationalities were among the artists, architects, and scientists being driven from Europe and gravitating to New York in the years leading up to and during World War II, including Salvador

Dalí, Roberto Matta, and Man Ray. In addition, thanks to the Museum of Modern Art and other collectors, the works of Pablo Picasso and Henri Matisse were becoming more widely known to both the American public and American artists. Jackson Pollock was one artist who responded to these new currents. Having trained for a time in the 1930s with Thomas Hart Benton, he took on some of that artist's mannered figures and strong brushwork as well as a sense for composing on a mural scale. The strong totemic and symbolic figures of Southwest Indian art also fed Pollock's imagination and joined with the new influences of surrealist biomorphic imagery and automatic writing. We also know that Pollock admired the sharp expressionist distortions of Picasso's late 1930s work as well as the powerful emotional forms of Orozco's murals. Finally, his own nervous breakdown at this time prompted his therapist to guide him through multiple drawings of demonic forms to work out his inner torments. Touches of all these elements are visible in his psychoanalytic drawing *Number 37* (cat. 59). While they are in part evidence of Pollock's state of mind at the time, they also lead toward his increasingly abstract graffiti and finally in the later 1940s to his breakthrough to the allover drip paintings that cemented his reputation.

His peers, later to be associated under the name the New York School, were similarly moving toward abstracted figuration via totemic shapes and gestural notations. Classic examples of this work include the ink drawings by David Smith (fig. 21) and Adolph Gottlieb (cat. 68). Smith's sheet is of particular interest, for its bold black markings clearly relate to his work as a sculptor, first by echoing the forms of metal writing in space characteristic of his open, linear "landscapes" of the same time, and second by anticipating the

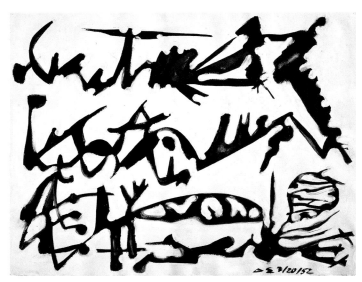

Fig. 21. David Smith, *3/20/52*, 1952 (cat. 66). Hood Museum of Art, Dartmouth College; purchased through the Miriam and Sidney Stoneman Acquisition Fund; P.997.42. Art © Estate of Larry Rivers / Licensed by VAGA, New York, NY

brushed-steel figures of his later wagons, Agricola series, tank totems, and even late Cubi series. (This drawing also contrasts amusingly to the line drawing of performing circus figures, executed years earlier by another prominent sculptor of the twentieth century, Alexander Calder [cat. 50].) Finally, the drawings of Joan Mitchell (cat. 70), Lee Bontecou (cat. 74 and p. 228), Eva Hesse (fig. 22), and Agnes Martin (cat. 77) represent other aspects of New York abstraction as it persisted through the 1950s into the 1960s.

The 1960s also saw the rise of pop art, an aggressive new realism responding to the flourishing of American consumer culture and celebrating the imagery and language of crass commercial advertising culture, especially as it was found in the supermarket, on the highway, and in comic books. Larry Rivers's *Double Money Drawing* of 1962 (cat. 71) is on the edge of pure pop but retains a looseness of execution still embedded in abstract expressionist practices. The late watercolors of Jacob Lawrence (cats. 73, 78) and Romare Bearden (cat. 80 and p. 227) make provocative parallels here in their colorful realism and contemporary subject matter, and they represent two of America's modern masters in recording the African American experience. In contrast, the work of Ivan Albright (cat. 79 and p. 225) brings to the collection a signature example by an artist long associated with the New England region, Albright having settled for his later years in nearby Woodstock, Vermont. Lastly, the ghostly drawing of Walter Murch (cat. 72) comes from one of the most imaginative realists to visit the College as artist-in-residence, soon after the formal codification of the program at Dartmouth in the 1960s.

Aside from presenting a distinctive survey of currents in American art from colonial to modern times, this collection offers numerous appropriate associations to New England and to Dartmouth itself, not least through its examples of Native American subject matter or authorship (such as cats. 26 and 47). Many of these drawings complement the more visible collection of paintings usually on view in the museum's galleries and as such are especially useful for teaching purposes. They range from unfinished sketches to fully finished sheets intended for sale or exhibition, and they cover a broad array of media ranging from pencil drawing, charcoal, crayon, and ink wash to watercolor, gouache, pastel, and collage, executed on paper primarily but also on board and even ivory. All told, they instruct and delight. What more can a fine college museum collection do for its students and the general public?

Fig. 22. Eva Hesse, Untitled, 1964 (cat. 75). Hood Museum of Art, Dartmouth College; purchased through gifts from the Lathrop Fellows; D.2004.1. © The Estate of Eva Hesse / Hauser & Wirth Zurich London

JOHN WILMERDING is currently the Christopher B. Sarofim '86 Professor of American Art at Princeton University and Visiting Curator in the Department of American Art at the Metropolitan Museum of Art. From 1965 to 1977 he taught art history at Dartmouth College, where he held the Leon E. Williams Professorship and served as chair of the Department of Art from 1968 to 1972 and the Humanities Division in 1971–72.

NOTES

1. Jacquelynn Baas, "A History of the Dartmouth College Museum Collections," in *Treasures of the Hood Museum of Art, Dartmouth College* (New York: Hudson Hills Press, in association with the Hood Museum of Art, 1985), 10–20, 102–21.

2. *Treasures*, 14.

3. *Treasures*, 16–17.

4. Churchill P. Lathrop, "A History of the Artist-in-Residence Program," photocopied brochure, Department of Studio Art Exhibition Program, Dartmouth College, 1983, rev. 1993, 2.

5. See Lathrop, "A History," 1, and *Treasures*, 103.

6. For a full listing of artists-in-residence at Dartmouth, see Lathrop, "A History," 5–7.

7. *Treasures*, 102.

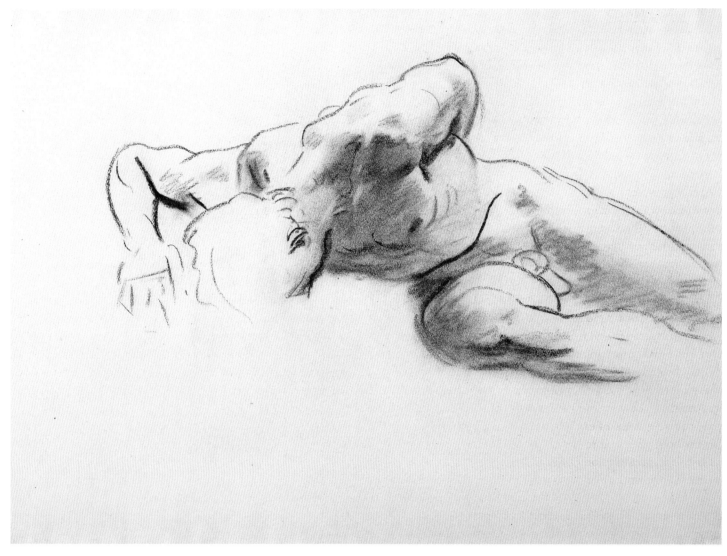

Cat. 36

American Drawings and Watercolors at Dartmouth: A History | Barbara J. MacAdam

Although American watercolors and drawings have long been at Dartmouth College, the more concentrated development of the Hood Museum of Art's collection of these holdings resulted largely from fortuitous gifts and purchases made over the past seventy-five years. The circumstances surrounding these acquisitions vary widely and reflect diverse intentions, interpersonal relationships, institutional developments, and curatorial prerogatives. Certain donors and staff members played truly pivotal roles in the formation of the collection and served as catalysts for further donations. Abby Aldrich (Mrs. John D. Jr.) Rockefeller, for instance, in 1935 bestowed on the College more than one hundred works of art, including the seventy-five American watercolors and drawings that would form the nucleus of the collection. Others, such as Mrs. Esther Lowell Abbott, donor in 1977 of the Copley pastel (cat. 1), with the gift of a single work of art cut a dramatically new facet on the museum's holdings and set extraordinary standards for quality. Many donors, including Dartmouth alumni and parents, already had strong ties to the College, but a surprising number of donors came to the institution through other circumstances and associations. A consistent theme in the correspondence surrounding these gifts of American drawings and watercolors to the museum is the very palpable sense of excitement and satisfaction—on the part of both giver and recipient—derived from enhancing the pleasure and instruction of future generations of students at a fine college with a deep and growing commitment to the arts.

Even though the collection of art and artifacts at Dartmouth College dates back to the last quarter of the eighteenth century, the growth of the American drawing and watercolor holdings emerged from the twentieth-century development of the College's art department and art galleries. Milestones in this expansion included the opening of the College's major arts facilities—Carpenter Hall in 1929, the Hopkins Center in 1962, and the Hood Museum of Art in 1985—with each addition inspiring a wave of new donations. Abby Aldrich Rockefeller, whose son Nelson graduated from Dartmouth in 1930, lent Whistler etchings to the gala opening of Carpenter Hall and graced the College in 1935 with her extraordinary donation. Leading collectors without Dartmouth affiliations—such as Los Angeles philanthropist William Preston Harrison and president of the Museum of Modern Art A. Conger Goodyear—took notice of this well-publicized benefaction and followed suit. Around the time of

the opening of the Hopkins Center, Jay Wolf, Class of 1951, determined to bequeath his growing art collection to Dartmouth. Since the 1985 opening of the Hood Museum of Art, which was designed by Charles Moore, the College's collection has enjoyed still greater institutional, regional, and national prominence, thereby encouraging further donations. The new building, enlarged museum staff, and increased programming facilitated fundraising in support of the museum's acquisitions funds, which have grown in number and size. As a result, the museum's staff has been able to shape and enhance the collection in a much more deliberate fashion. More than one-third of the eighty works receiving full catalogue entries in this publication came to the museum since 1985. Twenty-five of these were acquired by purchase, including works by such major figures as John James Audubon (cat. 3) and Mary Cassatt (cat. 25).

While some museums have been reluctant to prioritize the acquisition of fragile works on paper, this has generally not been the case at Dartmouth. Here, faculty and museum staff have long appreciated the aesthetic qualities and didactic utility of drawings and watercolors, even if their sensitivity to light precludes their frequent exhibition. Dartmouth began to purchase works on paper early in the twentieth century in a very modest manner, with the support of only one acquisitions fund that yielded just a few hundred dollars a year. Following the receipt of the Rockefeller collection in the mid-1930s, art professor and director of the College's art galleries Churchill P. "Jerry" Lathrop (fig. 23) chose to build on the strength of the galleries' collection—which at that time

Fig. 23. Prof. Churchill P. Lathrop arranging an exhibition in the Carpenter Hall Galleries, shown with a watercolor by Kenneth Shopen, 1950. Courtesy of Dartmouth College Library

was unquestionably American art, with contemporary drawings and watercolors forming a major component.[1] Lathrop's commitment to and appreciation for works on paper extended through his long term as director, from 1935 to 1974, and found continuity in the museum's later directors and curators.[2] The museum's recent sustained attention to researching, publishing, and enlarging its collection of American drawings and watercolors over the past decade mirrors a more widespread expansion of scholarly and popular interest in these often-neglected media. The Hood's present project is one of many recent ambitious museum publications and exhibitions devoted to American drawings and watercolors nationally.[3]

Early Developments

As John Wilmerding elucidated in his essay in this volume, the art collection at Dartmouth College began in the eighteenth century with portraits and other mementos pertaining to the institution's history, most of which resided in the College library. These included early views of the campus (fig. 24) and watercolors and drawings depicting such illustrious Dartmouth alumni as Daniel Webster, Class of 1801 (cat. 14 and p. 238), and other associates of the institution. A particularly large collection of Webster likenesses arrived at the College library in 1944 as a bequest from Edwin Allen Bayley, Class of 1885, including the lovely miniature watercolor on ivory by Webster's intimate, Sarah Goodridge (cat. 7). A variety of donors gave other noteworthy drawings and watercolors to the library as part of personal archival collections (cat. 5 and p. 235).

Only after the College first offered art history classes in the 1890s did the institution self-consciously collect art beyond its Dartmouth portraits. Although classical art formed

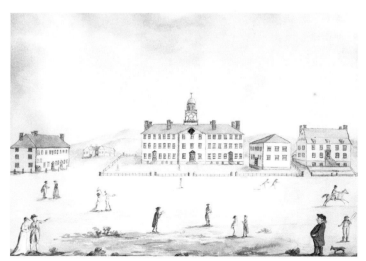

Fig. 24. Attributed to George Ticknor, *A View of the Principal Buildings of Dartmouth University*, 1803 (p. 247). Dartmouth College Library; W.X.451

the core of the new curriculum, Arthur Sherburne Hardy, originally a professor of engineering, offered a course on "modern" art, meaning the Renaissance through the nineteenth century, and also taught "Aesthetic History of the Fine Arts" through the philosophy department. Beginning in 1905 Homer Eaton Keyes, Class of 1900 (and, later, editor of *Antiques* magazine), served as assistant professor of modern art. George Breed Zug (donor of the John La Farge watercolor, p. 239) succeeded him in 1913 and added to the curriculum courses on less conventional topics, such as American painting, the graphic arts, and city planning.[4]

A generous benefactor of the College, financier and former educator Henry L. Moore, Class of 1877, established in 1905 the College's first art acquisition fund, in memory of his son, Guernsey Center Moore, Class of 1904, who died in 1901 during his sophomore year at Dartmouth. Moore indicated that the income of the fund was to be used "to purchase objects of artistic merit and value, to be kept, exhibited and used by [the Trustees of Dartmouth College] to encourage and promote the interest and education in art of the students."[5] Thus, from the outset the institution and its patrons recognized the educational importance of an art collection for an undergraduate college. The original $5,000 Moore fund, significantly enlarged through prudent investment over the past century, continues to be a useful resource for acquisitions.

The illustrious museum career of a Dartmouth professor, Arthur Fairbanks, Class of 1886, figured in the gift of ten charcoal studies by John Singer Sargent (fig. 25, cat. 36, and pp. 244–45). All appear to be preliminary studies for Sargent's mural decorations in the Boston Public Library and the Museum of Fine Arts, Boston. Fairbanks, a specialist in classical archaeology, had served as director of the Museum of Fine Arts from 1907 to 1925, during the inception and completion of Sargent's mural project on classical themes for that institution. Fairbanks returned to his alma mater as professor of fine arts in 1928.[6] In October of the following year, he received on behalf of Dartmouth an offer of preparatory drawings for the Boston murals from Thomas A. Fox, an architect friend of Sargent who had consulted on the projects and was then advising Sargent's sisters on the distribution of the sketches. Fox wrote: "It seems to me your Institution is entitled to some of the Sargent Charcoal Studies if you care for them. . . . I know that you were instrumental at the first in having the work undertaken and I am sure your College should have a reminder of it."[7]

These drawings counted among hundreds of preparatory mural sketches that, along with other works, had been inherited by Sargent's sisters, Miss Emily Sargent and Mrs. Francis (Violet Sargent) Ormond, both of London. They sold the

Fig. 25. John Singer Sargent, *Study for a Mural in the Boston Public Library or the Museum of Fine Arts, Boston*, c. 1890–1924 (p. 245). Hood Museum of Art, Dartmouth College; gift of Miss Emily Sargent and Mrs. Francis Ormond, sisters of the artist; D.929.10.7

bulk of their brother's paintings at an estate auction in July 1925, the year of his death. Overwhelmed at the prospect of handling such a large number of drawings, which were then unlikely to bring much money at sale, they enlisted the services of Fox to catalogue and distribute the sheets among appropriate American institutions. Such donations to scholarly centers, they reasoned, might also help to illuminate and eventually elevate the standing of this underappreciated phase of Sargent's career. The Museum of Fine Arts and the Boston Public Library, home to the murals themselves, were natural recipients. Fox, however, with the full assent of Sargent's sisters, recommended that drawings go not only to major public museums but also to collections affiliated with art schools and colleges, including Dartmouth.[8] Sargent's sisters readily agreed to Fox's proposals. Emily Sargent, herself an artist, wrote to him in 1927: "remember that Violet and I want you to do what you think best with them [the works], in the way of presenting them to any art school or schools you think that would like to have them and would find them useful."[9]

Dartmouth's new art facility, Carpenter Hall (fig. 26), opened just months before Fairbanks received the offer of Sargent drawings and may have given Fox further cause to consider Dartmouth an appropriate recipient for this generous gift of figure studies. Carpenter Hall contained studios for the practice of art, including life drawing, as well as gallery space, classrooms, and an art library. A member of the art faculty (mostly likely department chairman Artemas Packard) described to a College administrator the gift's importance to the College: "Considering our poverty in original works of art they constitute a rather important acquisition. They will be housed in Carpenter and used both for public exhibition and for teaching purposes."[10] The early hopes and

Fig. 26. Carpenter Hall Art Galleries, opened 1929. Courtesy of Dartmouth College Library

expectations of both the donors and the College appear to have been realized, as the Sargent drawings at Dartmouth have been used frequently for teaching and, along with the artist's other preparatory drawings, have received ever-increasing scholarly attention.

Three Donors and an Acquisition Fund Start the "Snowball Rolling," 1935–40

*Abby Aldrich Rockefeller (1874–1948),
Catalyst for Growth of the Collection*

The opening of Carpenter Hall provided the Department of Art an opportunity to establish a relation with one of the most socially prominent and adventurous collectors of contemporary American art, Abby Aldrich Rockefeller (fig. 27), wife to John D. Rockefeller Jr., the only son of the founder of the Standard Oil Trust, and mother to Nelson. Abby Aldrich Rockefeller lent a group of etchings by James McNeill Whistler, the Thames Set, as one component of the new facility's opening exhibition.[11] Six years later she made what was by far the College's largest donation of art to date.

Rockefeller likely felt deep gratitude to Dartmouth for furthering her attempts to instill in her son a love for art. At the time of the opening of Carpenter Hall, Nelson had only recently begun to share his mother's artistic passions. The winter before he entered Dartmouth, she wrote to him:

It would be a great joy to me if you did find that you had a real love for and interest in beautiful things. We could have such good times going about together, and if you start to cultivate your taste and eyes so young, you ought to be very good at it by the time you can afford to collect much. . . . To me, art is one of the great resources of my life. I feel that it enriches the spiritual life and makes one more sane and sympathetic, more observant and understanding, as well as being good for one's nerves.[12]

Nelson did indeed accompany his mother on visits to galleries during vacations, and following one such excursion he wrote to her in January 1928, "You don't know how much I enjoyed our two trips to Mr. [Arthur B.] Davies and the visit to the Downtown Galleries, I feel as if I had been introduced to a new world of beauty, and for the first time I think I have really been able to appreciate and understand pictures, though only a little bit."[13] In 1929–30 Nelson received a Dartmouth senior fellowship, which gave him the opportunity to involve himself in the arts to the fullest. He took just one academic seminar, the "Meaning of Art" taught by Professor Artemas Packard, and took up drawing and painting, spending "a great deal of time in the new studio in Carpenter and elsewhere" and benefiting from the suggestions of visiting artists Charles Herbert Woodbury and Thomas Hart Benton.[14] Nelson also took a leadership role in several campus

Fig. 27. Abby Aldrich Rockefeller, 1922. Courtesy of the Rockefeller Archive Center

arts organizations and explored the possibility of becoming an architect. By the time he wrote a June 1930 *Dartmouth Alumni Magazine* article titled "The Use of Leisure," which extolled the long-term merits of art education for the well-rounded individual, he had resigned himself to art as a personal avocation rather than a profession. During his senior year he began to expand his leadership role in the arts beyond his contributions at Dartmouth and served as chairman of the junior advisory committee to the Museum of Modern Art, an institution his mother helped to found in 1929.[15]

Before Abby Aldrich Rockefeller made her substantial art donation to the College, she advanced the arts at Dartmouth in another manner. She and her husband contributed to a discretionary fund that was used to support José Clemente Orozco's residency while he painted his monumental mural series in the reserve corridor of Dartmouth's Baker Library, *The Epic of American Civilization,* 1932–34 (see fig. 5). In April 1932 President Hopkins explained to the College treasurer, "I have offered to utilize $500 of the Rockefeller tutorial money to pay for [Orozco's] presence here, partly because he may be

that useful to the Department of Art and partly because of Mrs. Rockefeller's enthusiasm about these two Mexicans [Orozco and Diego Rivera]."[16] Although widely viewed as a strident critique of academia as well as capitalism, Orozco's Dartmouth mural fared much better than Rivera's controversial Rockefeller-sponsored mural at Rockefeller Center. With the implicit approval of Nelson and John D. Rockefeller Jr., Rivera's leftist visual manifesto was demolished in 1934, sparking an uproar among artists and free speech advocates (see entry for cat. 53) and fueling the early and unheeded calls for the removal of Dartmouth's own murals.[17]

Abby Aldrich's openness—at least initially—to such politically charged, avant-garde art revealed her adventurous eye for contemporary currents, which became her primary focus in collecting beginning about 1924. In contrast to her husband's more traditional attraction to porcelains and medieval tapestries, she responded to Italian primitives, German expressionist art, European and American modernism, and, later, American folk art. Aesthete and painter Arthur B. Davies helped to foster her appreciation for American contemporary art, just as he had advised her friends Lizzie P. Bliss and Mary Quinn Sullivan, with whom she would later found the Museum of Modern Art. Even more influential in directing her actual purchases, however, was Edith Gregor Halpert, director of the Downtown Gallery, whom Rockefeller met in 1927 or 1928. Halpert exhibited work by leading American modernists, including George Ault, Stuart Davis, Charles Sheeler, Max Weber, and William and Marguerite Zorach. By 1930 Halpert had also branched into nineteenth-century American folk art, which, reflecting the isolationist sentiments of the day, she confidently marketed as the true root of American modernism, displacing French art.[18] Assisted by the pioneering folk art scholar Holger Cahill, Halpert amassed for her prestigious client more than 170 examples of American folk art, the bulk of which Rockefeller later donated to Colonial Williamsburg. As Rockefeller became increasingly reliant on Halpert's gallery inventory and recommendations for acquisitions, her taste became almost indistinguishable from that of her dealer. Rockefeller's holdings became so extensive—and so opposite the taste of her husband—that she quit her attempts to incorporate her art into the décor of their primary living quarters and in 1928, with the assistance of designer Donald Deskey, transformed the seventh floor of her Fifty-fourth Street mansion into a private gallery.

Abby Aldrich Rockefeller from the start believed that art should be brought into the lives of the ordinary public. By 1935 she essentially stopped collecting and began to act on her convictions by distributing her holdings to museums and colleges. The Museum of Modern Art and Colonial Williams-

burg received the largest, most impressive selections of modern and folk art, respectively. Along with Dartmouth College, the Museum of the City of New York, the Newark Museum, the Rhode Island School of Design, and Fisk University also received portions of her collections. Cahill assisted her with the distribution and wrote to a client in February 1935, "I've been so busy trying to separate Mrs. Rockefeller's art collection into groups for various museums that I'm practically a hermit."[19]

Rockefeller's gift to Dartmouth consisted of 119 works, including a handful of European sculptures and works on paper, an oil portrait by Thomas Eakins (see fig. 6), several contemporary American paintings, sixteen examples of American folk painting and sculpture (fig. 28), and seventy-five contemporary American drawings and watercolors (fig. 29), including twenty-two watercolors by studio-trained Native American artists. Rockefeller acquired the vast major-

Fig. 28. Francis Portzline, *Birth and Baptismal Certificate for Maria Portzline*, c. 1820 (p. 243). Hood Museum of Art, Dartmouth College; gift of Abby Aldrich Rockefeller; D.935.1.105

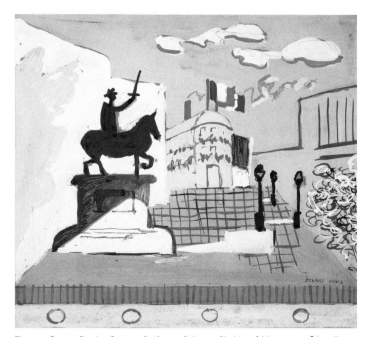

Fig. 29. Stuart Davis, *Statue, Paris*, 1928 (cat. 48). Hood Museum of Art, Dartmouth College; gift of Abby Aldrich Rockefeller; D.935.1.15. © Estate of Stuart Davis / Licensed by VAGA, New York, NY

ity of these works through Halpert. The collection overall reflected Rockefeller's preference—and clearly that of Halpert as well—for small, informal works on paper suited for a domestic environment and intimate study, as opposed to what she considered "museum pieces." Rockefeller also set budget limitations, generally spending no more than $1,000 on each personal acquisition and at times appearing to favor a generously wide representation over the very highest aesthetic standards.[20]

Nonetheless, Dartmouth took understandable pride in announcing this important acquisition to the Dartmouth community and beyond. In a press release, Artemas Packard boasted that the collection contained "perhaps the most comprehensive examples of contemporary paintings now in the possession of any college."[21] One news account of the gift credited Nelson Rockefeller with suggesting that Dartmouth receive a portion of his mother's collection. The same article reported that "in making the gift [Abby Aldrich Rockefeller] had in mind its use for instruction and study, rather than exhibition purposes."[22] Another commentator, revealing no knowledge of Rockefeller's support of the Orozco mural, welcomed the largely American gift as a corrective to Dartmouth's murals, finding "Aztec fable . . . malapropos" to Dartmouth's New England setting.[23]

It would be difficult to overstate both the immediate and the long-term positive impacts of Abby Aldrich Rockefeller's donation to the College. In 1951 Churchill Lathrop could still claim that "these objects of art [from the Rockefeller donation] have had greater use than any other group in the College collection."[24] Several of the drawings and watercolors receive full scholarly entries in this publication (cats. 44, 46, 47, 48, 53, 54), and well over a dozen others appear in the expanded checklist beginning on page 225. Not all of the works donated by Rockefeller have stood up as well over time, but the collection as a whole offers a fascinating window onto a vibrant period in American art-making and a time when Rockefeller's gallery purchases and direct commissions helped to sustain a fragile Depression-era art economy. The gift also reflects an era in which Rockefeller's advocacy of contemporary art gained for it unprecedented institutional recognition through the formation of the Museum of Modern Art. At Dartmouth, her gift affirmed and expanded the College's commitment to the arts and set a critical example for other collectors and patrons of national consequence.

William Preston Harrison (1869–1940)

Los Angeles–based collector William Preston Harrison (fig. 30), who had no direct ties to Dartmouth College, became interested in its art galleries after hearing about Rockefeller's donation. Harrison wrote to Churchill P. Lathrop in early

Fig. 30. Wayman Adams, *Portrait of William Preston Harrison*, 1924, oil on canvas, 132.2 x 101.8 cm (52¹⁄₁₆ x 40¹⁄₁₆ in.). Los Angeles County Museum of Art, Mr. and Mrs. William Preston Harrison Collection; 25.6.2. Photograph © 2004 Museum Associates / LACMA

1939, "Mrs. Rockefeller had the right idea—gave me my cue—so I took it up with Dartmouth."[25] His respect for gallery director Lathrop cemented his attachment to the College, which struck him as an institution that "stands for art."[26] According to Lathrop, Harrison

happened to drive through Hanover and stopped to visit our Art Gallery. Pleased with what he saw, he later wrote from California offering us some pictures by French and American moderns. A most happy relationship started between Mr. Harrison and the Art Department which continued until his death in 1940, and during that time he gave 32 [American and French] pictures in various media. . . . This fine gift of Mr. and Mrs. Harrison has been an excellent supplement to the Rockefeller nucleus.[27]

His gifts to the American collections included William Merritt Chase's Shinnecock canvas *The Lone Fisherman,* numerous prints, and watercolors and drawings by Prendergast (fig. 31), Walt Kuhn (p. 239), and Mary Cassatt (p. 230).

Harrison hailed from a prominent political family in Chicago and dabbled in real estate, journalism, politics, and world travel before settling in Los Angeles about 1918. There he became a leading patron of the Los Angeles Museum of

Fig. 31. Maurice Brazil Prendergast, *Woman with a Parasol (Reading in the Garden)*, c. 1893–94 (cat. 31). Hood Museum of Art, Dartmouth College; purchase made possible through the generosity of Mr. and Mrs. Preston Harrison; W.938.8

Arts and Sciences (later the Los Angeles County Museum of Art), donating two galleries devoted to French and American art. His cultural influence extended well beyond the museum. One art periodical claimed that "he was, in fact, largely responsible for the growth of civic interest in artistic things in Los Angeles."[28]

Harrison's pioneering interest in contemporary American works on paper, instrumental patronage of museums, and commitment to sharing art with the public, along with his working relationship with Edith Halpert, inspired frequent comparisons to fellow collector Abby Aldrich Rockefeller. Harrison was aware of the comparison and tried to compete with Rockefeller with an almost obsessive frequency. Early on in his relationship with Lathrop, he requested a complete inventory of her donation to Dartmouth. On receipt of the list he responded, "Your list of gifts from Mrs. Rockefeller Jr. disconcerted me—No matter what might happen it will be quite impossible to rival such a stupendous donation."[29] At the same time he subtly critiqued her donation by admitting that he did not recognize all of the artists on the list, whereas the artists he collected "seem to have 'arrived' to a degree." He

also raised the quality versus quantity issue, explaining, "Our name must rely on quality or discrimination—or originality—not on quantity or great importance of particular examples."[30] He shared his resentment of Rockefeller's fame in a letter to the assistant curator at the Los Angeles museum: "You would be amazed to see similarity between gifts made by Mrs. J. D. Rockefeller, Jr., and ours—Mrs. Rockefeller gets columns—we get a stick."[31] Lathrop knew how to appease Harrison's ego, however. He wrote to him in 1938, "I was happy to see Dorothy Miller's references to you in her article on 'Contemporary American Paintings in the Collection of Mrs. John D. Rockefeller, Jr.,' . . . especially as she acknowledges that you were one of the 'exceptional collectors' who bought American pictures before Mrs. Rockefeller."[32] Miller was correct in her assertion. Harrison began collecting in the 1910s and allied himself with Halpert before Rockefeller did, in 1926, when Halpert opened the Downtown Gallery. From the outset, he acquired works by some of Halpert's favorite discoveries, including George "Pop" Hart, whose watercolors Rockefeller later championed and avidly collected (see, for instance, p. 236).

Despite his apparent insecurities, Harrison was a passionate collector and an important benefactor of Dartmouth and other institutions. While he relished the prestige that such gifts brought to his name, he also held a very genuine hope that out of them "some good might result for art."[33]

A. Conger Goodyear (1877–1964)

The last in the triumvirate of notable collectors to support Dartmouth College's museum collection during the Great Depression was A. Conger Goodyear (fig. 32). According to Lathrop, Goodyear, along with Rockefeller and Harrison, "enabled [Dartmouth] to start the snowball rolling" in terms of

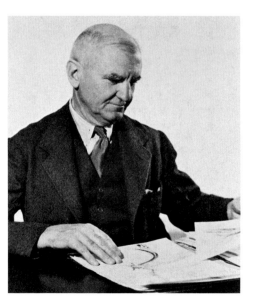

Fig. 32. Man Ray, *A. Conger Goodyear*, 1936, photograph. Image courtesy Albright-Knox Art Gallery. © 2004 Man Ray Trust / Artists Rights Society (ARS), NY / ADAGP, Paris

building a collection.[34] A prominent collector and museum trustee in Buffalo, Goodyear, at the request of Rockefeller, served as the first president of the Museum of Modern Art beginning in 1929. He naturally would have been aware of Rockefeller's 1935 donation through their close association. But Goodyear had another, earlier, connection with the region that may have figured into his gift. He and his first wife, Mary Foreman, summered about twelve miles south of Hanover in Cornish, New Hampshire, early in the century. In 1912 Mary's parents bought her High Court, the beautiful villa-style house designed in 1891 by Charles A. Platt, who also summered in Cornish. By 1930 the Goodyears had gone their separate ways, with Mary continuing to visit Cornish.[35] But Conger maintained some acquaintances in the region, which may have played into his 1940 gift of eleven mostly French and American drawings and watercolors, including the fine example by George Bellows (fig. 33), and his subsequent gift of works on paper in 1962, which included another Bellows drawing (p. 227).[36]

In Goodyear's initial communication to the College, he expressed a special interest in donating art to "colleges and schools," having previously donated works to the "Addison Gallery [of American Art at Phillips Academy] at Andover." Like Andover, he felt that "Dartmouth is . . . another institution which has done very fine work." Although a Yale graduate and later a donor to his alma mater, he at that point felt he "would not be interested in giving to such institutions as the Fogg Museum or the Yale School of Fine Arts which have already considerable collections, because one of my objects would be to interest others in giving to institutions that might be glad to have such works."[37] Goodyear therefore seemed aware that, as in the case of Abby Aldrich Rocke-

feller, the association of his name with a gift might reap additional benefits for the growing collection.

The Julia L. Whittier Fund, Established 1940

Aside from the critically important donations described above, the Depression era proved propitious for the growth of the collection in another way. In 1940 the College received a major bequest for the purchase of art from Julia L. Whittier, the daughter and "last survivor of an old-time Dartmouth professor, Dr. Clement Long, Professor of Intellectual and Moral Philosophy and Political Economy." Whittier was also the widow of Charles Mark Whittier, chief clerk and cashier for the Boston Concord & Montreal Railroad.[38] She bequeathed to the College securities and her house in Southwest Harbor, Maine, which the College subsequently sold. The resulting fund "more than doubled" the College's purchase resources for art and has since supported the acquisition of more than eighteen hundred works of art, more than seven hundred of them American.[39] The American drawings purchased through the Julia L. Whittier Fund include such diverse works as Thomas Nast's illustrations of Edgar Allan Poe's "The Raven" (cat. 19 and pp. 241–42), purchased in 1944; Benjamin West's fluid *Archangel Gabriel of the Annunciation* (cat. 2), acquired in 1959; and Joan Mitchell's painterly abstraction (cat. 70), purchased in 2002. Several Whittier fund purchases of White Mountain landscapes and New England folk art (cat. 10) during the 1950s and early 1960s reveal not only the rise in popularity of these genres but also a growing awareness of the College's regional audience.

Dartmouth Courts Its Community of Artists: John Sloan, Paul Sample, and Ilse Bischoff

Building on the success of earlier programs, gallery director Churchill P. Lathrop developed in the 1940s an ambitious series of contemporary art exhibitions and residencies that fostered close relationships with artists, several of whom became donors to the collection. Among them were John Sloan, who already had familial ties to the College; longtime artist-in-residence Paul Sample, Class of 1920; and Ilse Bischoff, who, having left New York, had just settled in the area.

John and Helen Farr Sloan (and Their Associate, Mary Fanton Roberts)

The College forged an especially fortuitous relationship with artist John Sloan (1871–1951), who was cousin to John Sloan Dickey, Dartmouth Class of 1929 and the institution's president from 1945 to 1970. This family connection may have influenced Lathrop to organize a 1946 exhibition of Sloan's

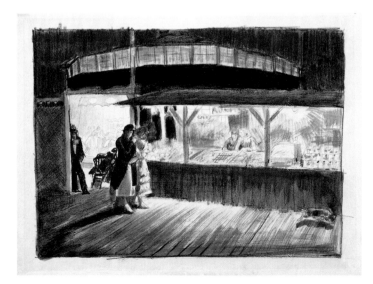

Fig. 33. George Wesley Bellows, *The Boardwalk*, c. 1915 (cat. 39). Hood Museum of Art, Dartmouth College; gift of A. Conger Goodyear; D.940.20

work in honor of the artist's seventy-fifth birthday. From that exhibition, the galleries purchased through the newly established Whittier Fund three major paintings by Sloan, three etchings, and one especially vibrant drawing, *Family on Fire Escape* (cat. 42).[40]

A pioneering urban realist in the first decades of the century, Sloan had since 1919 spent summers in Santa Fe, New Mexico. He did not see his 1946 exhibition in Hanover but received repeated encouragement from his cousin to visit. A very concrete invitation from President Dickey in February 1951 brought Sloan and his artist wife, Helen Farr, to Hanover that summer, where they sublet the apartment of a vacationing faculty member.[41] Although initially unaccustomed to painting such a verdant landscape, Sloan soon came to love both it and the Dartmouth community. According to his wife, "He said he would like to have thirty years to paint this place."[42] Unfortunately, their plans to build a summer studio in the area did not come to fruition, as Sloan died on September 7 at the age of eighty in Hanover's Mary Hitchcock Hospital.[43] Helen Farr Sloan, however, donated numerous works by Sloan to the College in her husband's name.[44] Especially noteworthy in this regard was her gift of his famous 1914 cover design for the leftist periodical *The Call,* a devastatingly graphic image of the aftereffects of a conflict between striking miners and the National Guard titled *Ludlow, Colorado* (fig. 34). This is the only work in the museum's sizable Sloan collection to represent the artist's often-overlooked socialist leanings in the early 1910s. Helen Farr Sloan also donated a large collection of prints and drawings by her own hand and others, including Joseph Stella's bold and evocative pastel *Dying Lotus* (cat. 49) and several drawings by Peggy Bacon (see, for example, p. 226).

John and Helen Farr Sloan's affection for Dartmouth inspired the 1957 bequest of their friend Mary Fanton Roberts (1864–1956), a noted journalist, art critic, and champion of the urban realists.[45] Roberts had served as editor of influential arts journals during her long career, including *The Craftsman* (1905–16), *The Touchstone* (1917–21), and *Arts and Decoration* (c. 1922–34). She also wrote for various New York newspapers and made her home for her last seven years at the Chelsea Hotel, where the Sloans had resided. She socialized with the artistic followers of Robert Henri and was one of their first and most ardent champions in the press. According to Avis Berman, Roberts "essentially turned the magazine [*The Craftsman*] over to the Henri circle."[46] Her donation to Dartmouth included drawings by Sloan (p. 246) and another supporter of modernist directions in American art, Arthur B. Davies (p. 231). Given that Roberts also aided the American debut of Isadora Duncan, it is fitting that she bequeathed to the College two images of the famed dancer,

Fig. 34. John Sloan, *Ludlow, Colorado,* 1914 (cat. 37). Hood Museum of Art, Dartmouth College; gift of John and Helen Farr Sloan; D.952.44

an Auguste Rodin drawing and F. Luis Mora's pastel of Duncan on stage, encircled by prancing nymphs (see p. 241).

Paul Sample (1896–1974)

Regionalist painter Paul Sample, Class of 1920, deepened his association with the College through an exceptionally long tenure as artist-in-residence, from 1939 to 1962. He inspired countless students and community members through extracurricular art classes and his own art, which he produced at a prodigious rate in his Carpenter Hall studio. Sample also gave several major paintings to the College over the years (see fig. 8), as well as all of his sketchbooks and preliminary studies. As a result, the Hood Museum of Art is by far the single largest repository for Sample's work, holding more than six hundred loose drawings and watercolors and one hundred sketchbooks (see, for example, fig. 35, cats. 62, 63, and pp. 243–44). These works cover the full span of Sample's career, from his early California social realist phase, to his stint as a World War II naval artist–correspondent for *Life*

Fig. 35. Paul Sample, *Two Men Seated with Small Town Backdrop, California,* 1935 (p. 244). Hood Museum of Art, Dartmouth College; gift of the artist, Class of 1920, to Dartmouth College Library, transferred 1983; W.983.34.225

magazine, to his regionalist New England landscapes, portraits, and genre scenes. Lathrop nurtured the College's relationship with Sample. He exhibited the artist's works on a frequent basis—in settings ranging from informal showings of recent watercolors to more elaborate loan exhibitions with catalogues.

Ilse Bischoff (1901–1990)

Churchill Lathrop also fostered a friendship with realist artist Ilse Bischoff, who moved from New York City to Hartland, Vermont, in the 1940s—initially for summers and eventually year-round. Bischoff (cat. 69 and p. 227) established her early reputation as a printmaker, illustrator, writer, and painter of the American scene. Beginning in the 1930s she came increasingly under the influence of her friends from the Art Students League Jared French and, especially, Paul Cadmus. Cadmus's painstaking realism and experimentation with old master techniques helped to shape her mature drawing style. Aware through mutual friends of Bischoff's recent move to Vermont, Lathrop offered her an exhibition in the summer of 1947. The following May, he asked whether she "would be willing to lend, or perhaps even give, one of [her] paintings to the College." She responded that she "couldn't be more flattered . . . at the idea of being asked by Dartmouth for the loan or gift of a painting," and added, "I think it is wonderful that the College is building up a collection of American paintings. Somewhere in my disorderly studio I have a few Cadmus drawings I would be very glad to give to the College as I think they are far too fine for private consumption."[47] Thus began her generous patronage of the Dartmouth collection. Over the years, Bischoff donated her manuscripts and illustrated books to the Dartmouth library and nearly two hundred ex-

amples of her drawings and paintings to the museum. She also gave works in various media by Jared French and Paul Cadmus, including seven drawings (fig. 36) and two watercolors by the latter (see, for example, cats. 51, 52, and p. 229). As it does with Sample, the College now boasts the largest public or private collection of works by Bischoff, a multitalented artist worthy of wider recognition.

Dartmouth Parents as Donors: Mr. and Mrs. Hersey B. Egginton

Over the years Dartmouth parents have generously supported the development of the College's art collection. In several poignant instances, such gifts honored the memory of a Dartmouth student who died at a tragically early age. This was the case in 1954, when the College received word that Mrs. Hersey B. Egginton wished to donate works collected by her recently deceased husband in memory of their son Everett Egginton, Class of 1921, who died of tuberculosis in 1925. This collection consisted of more than seven hundred works, comprising chiefly American prints from the first half of the twentieth century. It also featured European and American drawings, the latter including nine landscape and

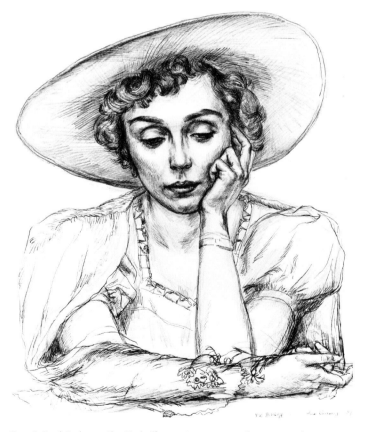

Fig. 36. Paul Cadmus, *Ilse Bischoff,* 1937 (p. 229). Hood Museum of Art, Dartmouth College; gift of Ilse Bischoff; D.975.85. Courtesy of the Estate of Paul Cadmus and DC Moore Gallery, New York

Fig. 37. John Francis Murphy, *Eupatorium*, 1877 (p. 241). Hood Museum of Art, Dartmouth College; gift of Mrs. Hersey Egginton in memory of her son, Everett Egginton, Class of 1921; D.954.20.657

Expanding Facilities, Expanding Collections: The Hopkins Center Era

In 1962 the Hopkins Center, designed by Wallace K. Harrison, opened with its facilities for music, drama, and the visual arts, including studios and additional galleries. These galleries, located along the mainstream of student traffic to mailboxes and a snack bar, supported an increasingly active and well-attended program of special exhibitions. In the years immediately preceding and following the Hop's opening, several notable additions entered the collection. In 1960 Robert S. Engelman, a member of the Class of 1934 and a 1935 graduate of the Tuck School of Business at Dartmouth, donated numerous American drawings, including Thomas Hart Benton's *"Routining" the Fish* (cat. 60) and Grant Wood's preliminary still-life drawings for his lithographs *Fruits* and *Vegetables* (cats. 56, 57). Engelman resided in Chicago and was president of Spiegel Inc. in the 1950s and 1960s.[51] He purchased the works in his gift from Associated American Artists in New York, which represented Wood, Benton, and other regionalist artists and acted as Engelman's agent in the transaction. President Dickey wrote Engelman in thanks: "the College stands in very real need of this kind of help and with the coming of the new facilities in the Hopkins Center we will be in a particularly strong position to make good use of our permanent collection in the educational program of the College."[52]

nature studies by J. Francis Murphy (see, for example, fig. 37, cat. 23, and p. 241) as well as drawings by Jerry Farnsworth (p. 232), Ernest Haskell (p. 236), and Abbott Thayer (p. 247).

The moving force behind the collection was Hersey Egginton, a member of the New York law firm of Rathbone, Perry, Kelley & Drye.[48] He apparently developed his art interest through his role as legal counsel for Milch Galleries, one of the leading dealers of American tonalism and impressionism, as well as more conservative art of the twentieth century. Egginton purchased through the gallery works on paper and paintings by such major turn-of-the-century figures as Thomas Wilmer Dewing, Childe Hassam, and Willard Metcalf. Entries in the Milch gallery account books from the mid- to late 1920s record Egginton purchasing American art on an almost monthly basis, the objects themselves generally described in no greater detail than "Hassam ptg," "Murphy drawings," or "Twachtman pastels."[49]

Understandably, the College extended deep gratitude to Egginton's widow for this munificent gift. For her part, Mary E. Egginton seemed encouraged that the collection would be well used at Dartmouth, echoing a sentiment expressed by many donors to the College: "If [the works] bring the pleasure and satisfaction to the students that they did to us, I will be indeed pleased."[50]

Also in this period, from 1960 through 1968, Daisy V. Shapiro donated sixteen late-nineteenth- and twentieth-century works, including the Feininger watercolor featured in this exhibition (cat. 43). Mrs. Shapiro's taste ranged from European and American impressionism and early modernism to contemporary Latin American art. In the tradition established by the pre–Hopkins Center Egginton donation, she gave her collection to Dartmouth in memory of her son, Richard David Shapiro, Class of 1943, who was killed in action on Leyte Island in 1944. The Hopkins Center exhibited the entire Richard David Shapiro 1943 Memorial Collection in 1968, on the occasion of the twenty-fifth reunion of his class. Little more is known of Daisy Viertel Shapiro, who was widow of Jack Shapiro, head of the M. Shapiro & Sons Construction Company in New York and Louisville. Her obituary described her simply as "teacher and ardent devotee of the arts and theatre."[53]

Peter A. Rübel, a graduate of Dartmouth's Tuck School of Business in 1939 and an established collector of French modernism, became an active art donor to the College's galleries beginning in 1961, when his son enrolled as a freshman. Correspondence indicates that the elder Rübel and Churchill P. Lathrop were already acquainted with one another at that time. In 1961 Rübel gave Dartmouth several contemporary

prints and in 1965 an elegant and whimsical Calder drawing executed in Paris, *Sorties* (cat. 50), which has fortified the collection's considerable strengths in twentieth-century American art. Rübel has also supported the collections of the Museum of Modern Art, especially of works by Calder.

The Bequest of Jay Wolf (1929–1976), Class of 1951

By far the most important gift of American twentieth-century works on paper during the Hopkins Center era was Jay Wolf's 1976 bequest of fifty works, primarily American drawings. By the time of his premature death at age forty-seven, Wolf (fig. 38) had assembled drawings and watercolors by Lee Bontecou (cat. 74 and p. 228), Arthur Dove (cat. 55 and p. 232), Louis Michel Eilshemius (p. 232), Robert Indiana (p. 238), Jacob Lawrence (fig. 39 and cat. 73), Rico Lebrun (p. 239), and Larry Rivers (cat. 71). He purchased several works from Terry Dintenfass, a progressive New York dealer of contemporary art who was especially active from the 1950s through the 1970s. Like her, Wolf took a vanguard interest in acquiring works by women and minority artists.

Born Julius Rosenthal Wolf, Jay Wolf was a casting director and theatrical agent in New York for much of his career, and in that role focused especially on seeking out "young talent in the black and regional theatres."[54] From 1962 to 1963 he gained professional gallery experience by serving as assistant director to Edith Halpert at the Downtown Gallery, which had been such an important source of art for Dartmouth's earliest collectors of American drawings and watercolors. His association with Halpert, no matter how brief, would have certainly increased his exposure to artists and the marketplace and developed his professed appreciation for "20th century American [art] & Folk Art."[55] From the gallery he corresponded with Churchill P. Lathrop at Dartmouth

Fig. 39. Jacob Lawrence, *Flight II*, 1967 (cat. 78). Hood Museum of Art, Dartmouth College; bequest of Jay R. Wolf, Class of 1951; W.976.204. © 2004 Gwendolyn Knight Lawrence / Artists Rights Society (ARS), New York

about potential acquisitions for the College but also ways in which he might advance the art collection. "I would like to get a group of alumni . . . together, with the purpose in mind of acquiring some things for your permanent collection."[56] In December 1975, less than a year before his death, he confirmed his personal plans in this regard and prophetically wrote to Lathrop, "As you know, I do intend for Dartmouth to be the recipient of my collection. (I trust that that is in the distant future, but these days one never knows from one instant to the next.)"[57]

Singular Gifts in the 1970s

In addition to such impressive donations of multiple works as the Jay Wolf bequest, gifts of stunning individual drawings and watercolors in the 1970s enhanced the collection immeasurably. In 1971, for instance, Mr. and Mrs. Arthur E. Allen Jr. donated the lyrical Whistler watercolor *Maud Reading in Bed* (cat. 29). Allen, as a member of the class of 1932 and the longtime Dartmouth sailing coach, had close ties to the College, whereas his wife, Deborah Elton Allen, was the daughter of a major collector of Whistler's work. Since its acquisition by the museum, Whistler's intimate scene has been widely exhibited and published and has become a cornerstone of the museum's representation of late-nineteenth-century aesthetics. The same is true of the innovative and

Fig. 38. Jay R. Wolf, Class of 1951. Courtesy of Dartmouth College Library

atmospheric watercolor by Maurice Prendergast, *The Harbor from City Point* (cat. 32), received in 1976 as a bequest from Warren F. Upham, Class of 1916.

By far the most momentous donation of a single drawing or watercolor was the 1977 gift of Mrs. Esther Lowell Abbott of John Singleton Copley's magnificent 1769 pastel portrait *Governor John Wentworth* (cat. 1). Mrs. Abbott and her family considered several of the most prominent art institutions in the country as possible repositories for this artistic treasure. Ultimately it was Mrs. Abbott's brother, Charles Cunningham, curator emeritus of the Sterling and Francine Clark Art Institute, who convinced her that this magnificent image of New Hampshire's last royal governor and the grantor of Dartmouth's original charter belonged in Hanover, at the College's art galleries.[58] Discussed extensively in this publication (see Wilmerding, pp. 18–19, and cat. 1), the Copley pastel remains arguably the most significant work of American art in the museum's collection. In parting with this family heirloom, the Abbott family took comfort in the fact that "the Governor would be 'going home'" and would be "seen in his own historical environment."[59] The timing of the gift, a year after the Bicentennial, increased its importance. The donor family and museum staff surely appreciated the national, as well as institutional and regional, significance of this extraordinarily deft portrayal of a distinguished colonial leader.

By coincidence, the same auspicious year that the museum received Copley's portrait of Wentworth—the earliest work in this exhibition—it received what would turn out to be its latest example, a powerful 1968 collage by Romare Bearden (cat. 80). This was presented by Dartmouth parents and distinguished collectors Jane and Raphael Bernstein, who have donated more than one hundred works to the collection since 1977, including another major Bearden collage from the 1960s (p. 227), two more that postdate the period covered by this exhibition, as well as works by Lyonel Feininger (see p. 233) and extensive photographic holdings.

New Purchase Funds

Two of the most important funds established during the Hopkins Center era that have supported the purchase of drawings and watercolors are the Phyllis and Bertram Geller 1937 Memorial Fund, founded in 1961, and the William S. Rubin Fund, instituted in 1973. The College's fortuitous association with Rubin, then soon-to-be-named curator of painting and sculpture at the Museum of Modern Art, began in the early 1960s. Churchill P. Lathrop recalled:

I first met Dr. Rubin in 1961 through an alumnus and former student of mine, Bertram Geller, Class of 1937,[60] at a time when Dr. Rubin was negotiating to buy from Mr. Geller a painting by Jackson Pollock. As part of the transaction I was fortunate in being able to

get for Dartmouth [a substantial monetary gift]. We called this "The Geller Fund" and it was a great help in enriching the College Art Collection in time for the opening of the Hopkins Center. Best of all, Dr. Rubin became more and more involved as a major lender and donor of art to the Hopkins Center Galleries.[61]

Rubin in 1961 was an influential art history professor at Sarah Lawrence College who had already established himself as an important collector of abstract expressionism. When he purchased the Pollock from Geller, Geller had previously donated one-quarter interest in the painting to Dartmouth. As part of the resulting settlement with the College, Rubin made a financial contribution that generated the Geller fund, donated major canvases by Mark Rothko and Kenneth Noland, and agreed to lend the Pollock and two other New York School paintings each summer. Over the next decade he donated additional paintings and in 1973 established the William S. Rubin Acquisitions Fund. This has supported the acquisition of African and contemporary art, as well as the Edwin Dickinson and Agnes Martin drawings in this exhibition (cats. 61, 77).

American drawings and watercolors acquired through the above-named Geller Fund include those by George Luks (cat. 41) and Childe Hassam (cat. 34), both purchased in 1962, and Charles Burchfield (cat. 45), acquired in 1963. Augmentation of the Geller Fund through memorial gifts after his death in 1981 and a bequest from his widow in 1987 have increased its importance as a source of funding in recent years.

The Hood Museum of Art: Acquisitions since 1985

The opening of the Hood Museum of Art in 1985 gave dramatic visibility to the permanent collection at Dartmouth College and generated new excitement about the vital place of the visual arts in a liberal arts college. In addition to special galleries dedicated to the permanent collection, including American art (figs. 40, 41), the 1989 opening of the Bernstein Study-Storage Center, funded by benefactors Jane and Raphael Bernstein, enabled Dartmouth classes to examine works of art firsthand and at close range (fig. 42). For such fragile works as watercolors and drawings, which cannot be exhibited on a regular basis, this facility has provided critically important accessibility, especially for class instruction. The intensive use of drawings and watercolors by faculty for teaching purposes has provided incentive for developing these holdings further, as has their systematic review as part of this exhibition and publication project. Happily, recent additions to the collection have helped to fill several significant gaps in the museum's representation of these media.

Three of the most important donations to the collection of American drawings and watercolors were presented by Ed-

Figs. 40, 41. Two views of the Israel Sack Gallery, Hood Museum of Art, 2004

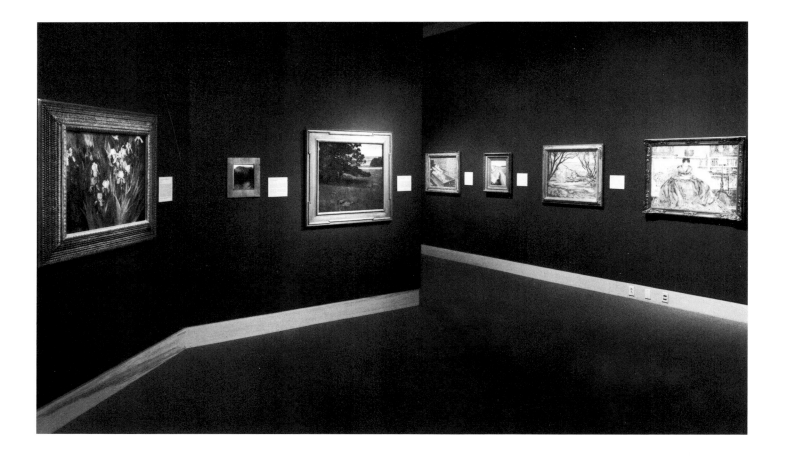

ward Connery Lathem, former dean of Dartmouth's libraries, longtime administrative officer at the College, and a member of the Class of 1951. In 1982 Mr. Lathem generously purchased for Dartmouth an evocative, virtuosic watercolor by Andrew Wyeth, *Winter Light* (fig. 43).[62] Friends and colleagues of Robert Frost originally gave this work to the poet on the occasion of his eightieth birthday, having perceived an affinity between the artistic visions of both figures. In 1996 Mr. Lathem also donated what was the museum's first water-

color by Winslow Homer, an 1880 Gloucester view entitled *Boys Bathing* (cat. 27). At the same time, he presented two other works by Homer, a vigorous pen-and-ink sketch, *Beaching a Boat,* done during the artist's 1881–82 stay in Cullercoats, England (cat. 28), and a classic childhood idyll, his 1874 painting *Enchanted*. The Homer and Wyeth watercolors in particular have enabled the museum to represent two of the most exceptional and influential American talents to work in this medium.

The other noteworthy gifts of American drawings and watercolors received after the opening of the Hood Museum of Art are far too numerous to enumerate completely. They include an evanescent 1962 still-life drawing by Walter Tandy Murch (cat. 72) given by Dartmouth alumnus artist Thomas R. George, Class of 1940, and his wife in 1995; a fine 1881 charcoal drawing by Benjamin Champney, *Cows Drinking in a Brook* (p. 230), which came to the museum as part of a large collection of art pertaining to New Hampshire's White Mountains, donated by Robert and Dorothy Goldberg in 1987; a watercolor by John Marin, given in 2000 as a partial and promised gift of L. Graeme Bell III, Class of 1966 (cat. 64); and a Philip Evergood drawing, *Hoboken,* donated in 2002 by Elizabeth E. Craig, Class of 1944W (p. 232).

Recent curatorial surveys of the collection have revealed its relative strength in the late nineteenth century and first half of the twentieth century—periods well covered by such early gifts to the College as that of Abby Aldrich Rockefeller. By contrast, the early to mid–nineteenth century called out for further development, as did the museum's representation of women artists and artists of color.

Recent acquisitions from the first half of the nineteenth century include three ink wash drawings by Thomas Sully (cat. 4), Thomas Birch (cat. 6), and Charles Warren Leslie (p. 240) that came from a scrapbook assembled for Philadelphia artist John Neagle by his artist colleagues. All done roughly within a decade of each other, they present a rare snapshot of contemporary approaches to literary illustration, landscape, and drawing from the classical tradition—all important genres of the era. The most noteworthy addition from this period, however, is the exquisitely drawn pastel by John James Audubon, *American Buzzard or White Breasted Hawk* (what we now know to be a juvenile red-tailed hawk), drawn between 1810 and 1820 (cat. 3). The College library holds

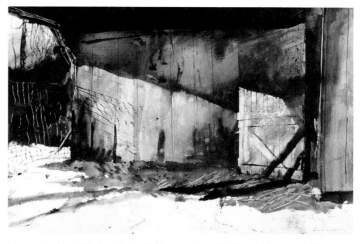

Fig. 43. Andrew Wyeth, *Winter Light,* 1953 (cat. 67). Hood Museum of Art, Dartmouth College; presented to Robert Frost in 1954, on the occasion of his eightieth birthday, and given to the College in 1982 by Mr. and Mrs. Edward Connery Lathem; W.987.20

Daniel Webster's elephant folio volumes of Audubon's famous *Birds of America,* but until this acquisition, the museum was unable to represent the extraordinary merger of artistic expression and scientific inquiry so characteristic of Audubon's achievements and of intellectual life in the early republic.

William Trost Richards, an influential nineteenth-century proponent of watercolor and a master draftsman, became the focus of three acquisitions in the 1990s made possible by descendants of the artist, Theodore and Ellen Conant. The sort of spare, luminist expression of *Beach Scene,* about 1870 (fig. 44), for instance—acquired in part by a gift of the Conants and a monetary contribution from Richard and Dianna Beattie—had no representation in the collection previously. Richards's extraordinary Pre-Raphaelite approach to drawing nature filled another gap in the collection and finds artful expression in *Palms,* 1856 (cat. 16), and *Along the River,* about 1860 (see fig. 57 on p. 84).

Other nineteenth-century additions to the collection include masterful charcoal drawings by Eastman Johnson (cat. 17) and Thomas Moran (p. 241), an impressive exhibition watercolor by John William Hill (cat. 13), as well as more intimate watercolors by Samuel Colman (cat. 22) and John Singer Sargent (cat. 24). Most recently the museum purchased the important *Study for "Evening"* by Mary Cassatt (cat. 25), which reveals the artist's remarkably daring approach to design and keen observations of her family and the domestic sphere. Three Native American ledger book drawings (cat. 26, pp. 230 and 248), dating from about the same time as the Cassatt and also acquired recently, broaden our perspective of nineteenth-century art and provide important prototypes for the later Native American studio watercolors in the collection.

Fig. 42. The Bernstein Study-Storage Center, Hood Museum of Art, opened 1989

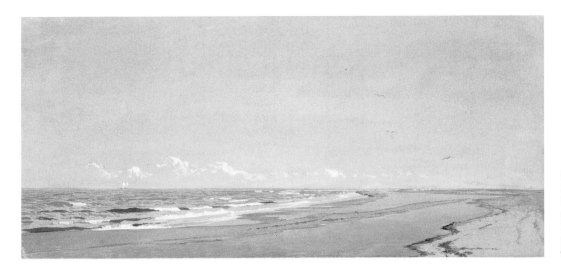

Fig. 44. William Trost Richards, *Beach Scene*, c. 1870 (cat. 21). Hood Museum of Art, Dartmouth College; purchased through gifts from Richard and Diana Beattie and a partial gift of Theodore and Ellen Conant; W.997.11

The financial resources for such purchases originated in acquisitions funds established relatively recently, including the Mrs. Harvey P. Hood W'18 Fund, instituted in 1981; the Robert J. Strasenburgh II 1942 Fund, established in 1983; the Miriam & Sidney Stoneman Acquisition Fund, founded in 1984 and designated principally for twentieth-century American art (such as the David Smith drawing, cat. 66); the Katharine T. and Merrill G. Beede 1929 Fund, established in 1987; the Virginia and Preston T. Kelsey '58 Fund, founded in 1994; and the Florence and Lansing Porter Moore 1937 Fund, established in 1997. With the 1989 founding of the museum's patron group, the Lathrop Fellows—named in honor of the beloved Dartmouth art historian and longtime museum director Churchill P. Lathrop—annual membership dues have financed major acquisitions. The Lathrop Fellows made possible, for instance, the purchase of the Mary Cassatt and Eva Hesse drawings in this exhibition (cats. 25, 75).

Further reflecting the museum's ongoing efforts to better represent the contributions of women artists and artists from diverse backgrounds, the Hood has recently acquired works by women active in the Provincetown Art Colony in the 1910s and 1920s, such as Edna Bois Hopkins (p. 237), Ada Gilmore (Chaffee) (cat. 38), and Blanche Lazzell (cat. 40), and, much later in the century, artists exploring abstract expressionist and minimalist modes of representation, including Joan Mitchell (cat. 70), Agnes Martin (cat. 77), and Eva Hesse (cat. 75). A newly acquired drawing by self-taught African American artist Bill Traylor (cat. 58) reflects a pictographic approach to design that suggests his familiarity not only with his rural Alabama heritage but with African visual, oral, and spiritual traditions.

Complementing the museum's acquisitions of twentieth-century American works on paper, the museum made the bold purchase in 1988 of more than three hundred prepara-

tory drawings and watercolors by José Clemente Orozco for his Dartmouth mural, *The Epic of American Civilization* (fig. 45). This critically important cache of drawings, made in Hanover, New Hampshire, in the early 1930s, recently served as the basis for the Hood's monumental 2002 traveling exhibition, *José Clemente Orozco in the United States, 1927–1934,* and remains one of the most significant acquisitions in the museum's history.

Fig. 45. José Clemente Orozco, *Study for Hispano-America (Panel 16) for "The Epic of American Civilization,"* 1932–34, graphite on cream paper, 41.3 x 37.5 cm (16¼ x 14¾ in.). Hood Museum of Art, Dartmouth College; purchased through gifts from Mr. and Mrs. Peter B. Bedford; Jane and Raphael Bernstein; Walter Burke, Class of 1944; Mr. and Mrs. Richard D. Lombard, Class of 1953; Nathan Pearson, Class of 1932; David V. Picker, Class of 1953; Rodman C. Rockefeller, Class of 1954; Kenneth Roman Jr., Class of 1952; and Adolph Weil Jr., Class of 1935; D.988.52.154. © 2002

Fig. 46. Sol Lewitt, *Untitled*, 1989, ink, wash and graphite on paper, 55.6 x 75.2 cm (21⅞ x 29⅝ in.). Hood Museum of Art, Dartmouth College; gift of Sarah-Ann and Werner H. Kramarsky; D.991.18.2. © 2004 Sol Lewitt / Artists Rights Society (ARS), New York

Although this project addresses American drawings and watercolors dating from 1769 to 1969, the cut-off date is not meant to slight the notable size and importance of the museum's collection of more contemporary works on paper. Beginning with Abby Aldrich Rockefeller's donation, contemporary drawings and watercolors have continued to join the Dartmouth collection, by both gift and purchase, to the present day. In terms of donations, the museum has been incredibly fortunate to receive numerous works on paper, including twenty-five minimalist and post-minimalist drawings, collages, and watercolors from Dartmouth parents Sarah-Ann and Werner "Wynn" H. Kramarsky. A passionate and generous collector of works on paper by both established and emerging contemporary artists, Wynn Kramarsky has donated to the Hood drawings by Alice Aycock, Nancy Haynes, Jene Highstein, Morgan O'Hara, and Sol Lewitt (fig. 46), to name but a few. Hugh J. Freund, Class of 1967, has been similarly instrumental in enhancing the museum's representation of American drawings and watercolors from the 1970s forward, including works by Dorothea Rockburne, Raymond Jenning Saunders, John McLaughlin, and Claes Oldenburg (fig. 47). In 1986 Josephine Albright donated nearly five hundred works by her late husband, Ivan Albright (cat. 79 and p. 225), most of which also postdate 1969. The Albrights settled in nearby Woodstock, Vermont, in 1963 and developed close ties to the museum.[63] Artist Thomas R. George, Class of 1940, has enhanced the collection in many ways, particularly by donating over the past two decades more than a hundred of his own drawings and watercolors (see, for example, p. 234)—most of which postdate the period covered by this exhibition. Dartmouth studio art professor

emeritus Varujan Boghosian has graced the collection with numerous and diverse gifts over the years, including contemporary drawings by Wolf Kahn, Gerald Auten, Thomas George, Rosemarie Beck, Bernard Chaet, and Edward Giobbi. Contemporary drawings and watercolors purchased by museum staff include works by Jake Berthot, Rackstraw Downes, Rupert Garcia, Brad Kahlhamer, Mel Kendrick, Ben Frank Moss, Sara Sosnowy, and Ursula von Rydingsvard.[64]

Whereas in the 1930s a handful of nationally known collectors started the American watercolor and drawing collection virtually from scratch, a much wider, more diverse group of patrons has been responsible for developing these holdings in recent times. Churchill Lathrop, who referred to the early donors as the "golden succession of benefactors," could not have imagined the collection's dramatic, vital growth in the two decades since the opening of the Hood Museum of Art, an occasion he fortunately lived to see.[65] The "snowball" effect set into motion by the early donations has continued to gain powerful momentum. Still, the qualities of intimacy and immediacy that Lathrop and his early coterie of collectors cherished in watercolors and drawings are still very much valued by the museum's donors and staff alike, as is the more general faith in art's potent ability to inspire, delight, challenge, and instruct. The Hood Museum of Art has ex-

Fig. 47. Claes Oldenburg, *Blue Saxophone*, 1992, crayon and watercolor on paper, 37.1 x 30.3 cm (14⅝ x 11¹⁵⁄₁₆ in.). Hood Museum of Art, Dartmouth College; gift of Hugh J. Freund, Class of 1967; W.2001.43.1

tended its professional reputation nationally in the decades since Lathrop's era, but the crux of the experience it offers its visitors—the Dartmouth community and now a much wider public—continues to be a direct, deeply personal engagement with original works of art. A passionate desire to share that experience with others continues to motivate the donors and museum staff who have developed this important collection of American drawings and watercolors over the past seventy-five years.

NOTES

1. The African, Native American, and historical collections were then housed and overseen by the Dartmouth College museum and administered separately until the founding of the Hood Museum of Art in the late 1970s. For a more complete history of museums at Dartmouth, see Jacquelynn Baas, "A History of the Dartmouth College Museum Collections," in *Treasures of the Hood Museum of Art, Dartmouth College* (New York: Hudson Hills Press, in association with the Hood Museum of Art, 1985), 9–20. I am very much indebted to Mark D. Mitchell for his thorough research assistance related to this essay.

2. Churchill P. Lathrop (1900–1995) joined the Dartmouth Department of Art faculty in 1928, after having received his Ph.D. from Princeton University. In 1933 he became chairman, a position that also involved running the galleries. He later recalled, "The next chairman hated running the galleries, but by then, I realized I liked doing that. It gave me contact with dealers and alumni who had art." He initially retired in 1966 but returned almost immediately to become chairman of the art department again until a second retirement in 1969. He next returned in 1972 as director of the galleries until his final retirement in 1974. In honor of his inspirational teaching and long stewardship of the College's art collection, friends and former students raised funds to name the Churchill P. Lathrop Gallery in the Hood Museum of Art. Georgia Croft, "Profile: Jerry Lathrop," *Echoes in the Valley*, vol. 1, issue 49 (September 3, 1985).

3. The following are just a few of these significant efforts: Linda S. Ferber and Barbara Dayer Gallati, *Masters of Color and Light: Homer, Sargent, and the American Watercolor Movement* (Washington, D.C.: Smithsonian Institution Press, in association with the Brooklyn Museum of Art, 1998); Kevin J. Avery, with an essay by Marjorie Shelley and contributions by Claire A. Conway, *American Drawings and Watercolors in The Metropolitan Museum of Art*, vol. 1 (New York: Metropolitan Museum of Art, 2002); Jane Myers, *Revealed Treasures: Drawings and Watercolors from the Amon Carter Museum* (Fort Worth, Tex.: Amon Carter Museum, 2001).

4. For an early history of the Department of Art, see Philip A. White, "Tenth Anniversary Report of the Carpenter Galleries," July 1939, typescript, Hood Museum of Art (hereafter HMA) archives. This particular report describes Arthur Hardy as "professor of esthetics in the Department of Philosophy from 1894 to 1896." His course "consisted of a study of various pictures and reproductions which Professor Hardy brought from Europe, along with the study of esthetics." For more on the later history of the Department of Art, see John Wilmerding's essay in this catalogue.

5. Churchill P. Lathrop, "To Promote Interest and Education in Art," *Dartmouth Alumni Magazine*, January 1951, 17. Henry Moore began his career in education, serving as a high school principal and superintendent in Minnesota. In 1886 he entered the real estate business and from 1895 to 1921 was connected with the Minnesota Loan and Trust Company as treasurer and director. He served as a trustee of the College from 1915 to 1925 and had previously served on the Alumni Council. In addition to the $5,000 art fund he established in 1905, he donated in 1917 $100,000 to fund lectures for the educational benefit of alumni.

6. In 1916 the Museum of Fine Arts, Boston, commissioned Sargent to decorate its rotunda with a painting and sculptural project, which he completed in 1925. Arthur Fairbanks (1864–1944) was born in Hanover, New Hampshire, the son of a Dartmouth professor, Henry Fairbanks, and grandson of the inventor of the Fairbanks scales. After graduation from Dartmouth as class valedictorian, he studied at Yale Divinity School and Union Theological Seminary and in 1890 received a Ph.D. degree from Freiburg im Breisgau University. From 1890 to 1892 he served as assistant professor of Greek at Dartmouth and from then until 1898 lectured on sociology and comparative religion at Yale Divinity School. In 1898 he was appointed fellow of the American School of Classical Studies at Athens. Dr. Frederic P. Lord, "Arthur Fairbanks '86: Greek Scholar and Art Director Had Notable Life," *Dartmouth Alumni Magazine*, March (1944?). Obituary, "Arthur Fairbanks, Long an Educator," *New York Times*, January 15, 1944.

7. Thomas A. Fox to Prof. Arthur Fairbanks, October 15, 1929, copy in HMA donor files. Sargent's classical themes suggest that he appreciated the importance of the classical collections developed at the Museum of Fine Arts under Fairbanks's guidance. Mary Crawford Volk, "Sargent in Public: On the Boston Murals," in Elaine Kilmurray and Richard Ormond (eds.), *John Singer Sargent* (London: Tate Gallery Publishing, 1998), 46, 52, 57nn.40, 41.

8. For an extended discussion of the distribution of the drawings, see Melinda Linderer, "Sargent's Legacy: An American Inheritance," in Miriam Stewart and Kerry Schauber (eds.), "Sargent at Harvard," *Harvard University Art Museums Bulletin* 7, no. 1 (fall–winter 1999–2000), 7–11; H. Barbara Weinberg and Stephanie L. Herdrich, "John Singer Sargent in the Metropolitan Museum of Art," *The Metropolitan Museum of Art Bulletin*, spring 2000, [3]–64; and Derrick R. Cartwright's entry for cat. 36, n.9.

9. Emily Sargent to Thomas Fox, February 18, 1927. Cited in "Sargent at Harvard," 8.

10. Artemas Packard(?) to Robert L. Strong, Office of the President, December 24, 1929, HMA donor files. The carbon copy is initialed below the text "P/M," most likely suggesting Packard/Morse (Mildred Morse was then the curator of the department); Fairbanks's correspondence bears the initials "F/M." Packard also suggested the flattering but erroneous scenario that Fox, "as a special courtesy to Mr. Fairbanks," gave Dartmouth "first choice" in selecting ten drawings. Dartmouth most certainly did not have "first choice," as large groups had already been given as early as 1928 to the Museum of Fine Arts and the Corcoran Gallery of Art. Weinberg and Herdrich, "John Singer Sargent in the Metropolitan," 56.

11. Churchill P. Lathrop, "To Promote Interest," 82.

12. Abby Aldrich Rockefeller to Nelson A. Rockefeller, January 1926, quoted in Judith Morgan, "Rockefellers: Gracious Living and a Love of Art," *Los Angeles Times*, newspaper clipping annotated "5/12/85," Dartmouth College Library, Nelson A. Rockefeller file.

13. Nelson A. Rockefeller to Abby Aldrich Rockefeller, January 1928, quoted in Bernice Kert, *Abby Aldrich Rockefeller: The Woman in the Family* (New York: Random House, 1993), 290.

14. Nelson A. Rockefeller, "The Use of Leisure," *Dartmouth Alumni Magazine*, June 1930, 522.

15. Nelson A. Rockefeller continued to serve the Museum of Modern Art, first as treasurer, then as trustee, and by 1939 as president. He was also a director of the Metropolitan Museum of Art and founded the Museum of Primitive Art. Gay Pauley, "Rocky Had Time for Everything, Even Art," undated United Press International clipping (following his death in January 1979). Dartmouth College Library, Nelson A. Rockefeller file.

16. Ernest Martin Hopkins to Halsey Edgerton, April 28, 1932, quoted in Jacquelynn Baas, "*The Epic of American Civilization:* The Mural at Dartmouth College (1932–34)," in Renato González Mello and Diane Miliotes (eds.), *José Clemente Orozco in the United States, 1927–1934* (Hanover, N.H.: Hood Museum of Art, in association with W. W. Norton, 2002), 155.

17. Ibid., 163.

18. Unidentified clipping, "Expand! Retort to Depression: Add New Floor at Downtown Gallery," Downtown Gallery Papers, reel ND/2, frame 216, Archives of American Art, Smithsonian Institution, Washington, D.C. (hereafter AAA). For more on the Downtown Gallery and Abby Aldrich Rockefeller's relationship with Halpert, see Diane Tepfer, "Edith Gregor Halpert and the Downtown Gallery Downtown, 1926–1940: A Study in American Art Patronage" (Ph.D. diss., University of Michigan, 1989), vol. 1, esp. 132–86 and 289–94.

19. Holger Cahill to Susan Higginson Nash (a decorator on the staff of Perry, Shaw, and Hepburn, the architectural firm that oversaw much of the early restoration work at Williamsburg), February 1, 1935, Abby Aldrich Rockefeller Folk Art Center Archives. I am grateful to Beatrix Rumford for providing me with a copy of this correspondence with her letter to me of November 21, 1983, when she served as director of the center. HMA donor files.

20. Aline B. Saarinen, *The Proud Possessors: The Lives, Times and Tastes of Some Adventurous American Art Collectors* (New York: Random House, 1958), 361.

21. Packard's quote originated in a College press release and appeared in "Dartmouth Gets $35,000 Gift of Rockefeller Art," *New York Herald Tribune,* March 12, 1935, 19.

22. Ibid.

23. Untitled, unpaginated clipping, *Town and Country,* April 1935, HMA donor files.

24. Lathrop, "To Promote Interest," 82.

25. William Preston Harrison to Churchill P. Lathrop, January 15, 1939, HMA donor files.

26. William Preston Harrison to Churchill P. Lathrop, June 5, 1938, HMA donor files.

27. Lathrop, "To Promote Interest," 83.

28. "Preston Harrison, Patron and Collector, Dies on Coast," *Art News,* August 17, 1940, 15.

29. William Preston Harrison to Churchill P. Lathrop, July 6, 1938, HMA donor files.

30. William Preston Harrison to Churchill P. Lathrop, June 5, 1938, HMA donor files.

31. William Preston Harrison to Louise Upton, June 11, 1935, quoted in Neil Harris in "William Preston Harrison: The Disappointed Collector," *Archives of American Art Journal* 33, no. 3 (1993), 24.

32. Churchill P. Lathrop to William Preston Harrison, May 16, 1938, HMA donor files. Dorothy Miller's article appeared in *Art News,* March 20, 1938.

33. William Preston Harrison to Churchill P. Lathrop, June 5, 1938, HMA donor files.

34. Draft of letter from Churchill P. Lathrop to A. Conger Goodyear, July 28, 1961, HMA donor files.

35. "Excerpts from GFG [George F. Goodyear] Autobiography: Summertime and Vacations," 2000, typescript courtesy Max Blumberg, Class of 1964, HMA donor files.

36. For instance, through either his early association with the region or a later acquaintance, Goodyear became good friends with Adelbert Ames Jr., professor and head of the Dartmouth Eye Institute and participant in the planning of Dartmouth's Hopkins Center.

37. A. Conger Goodyear to Dr. Artemas Packard, April 4, 1940, HMA donor files.

38. Obituary, "Julia Russell Long Whittier," *Hanover Gazette,* June 1, 1939, 5.

39. Lathrop, "To Promote Interest," 83.

40. The Sloan paintings are *McSorley's Back Room,* 1924 (P.946.24); *A Roof in Chelsea,* c. 1941, with additions in 1945 and 1951 (P.946.12.2); and *Negress, White and Gold,* c. 1929–30 (P.946.12.1).

41. John Sloan Dickey to Helen and John Sloan, February 1951; John L. Stewart, Department of English, to Mrs. Sloan, June 3, 1951, Dartmouth College Library, John Sloan Dickey Correspondence, 1931–51, Ms. 931208.

42. Handwritten draft of an apparent introduction to a small exhibition of Sloan's work at Dartmouth College, dated September 12, 1951. It began, "This exhibition of landscapes by my husband John Sloan was planned before his death." Dartmouth College Library, John Sloan Dickey Correspondence, 1931–51, Ms. 931208. Suggesting that the exhibition may have been

held at a somewhat later date, Professor Herbert F. West wrote Helen Farr Sloan on February 5, 1952, "the Sloan show is truly magnificent . . ." Dartmouth College Library, Gift Correspondence, DL 15 (17): SL–Smil.

43. For more on Sloan's summer in Hanover, see Helen Farr Sloan, "John Sloan at Eighty: A Reminiscence," *John Sloan: Paintings, Prints, Drawings* (Hanover, N.H.: Hood Museum of Art, Dartmouth College, 1981), 9–14, and Herbert Faulkner West, *John Sloan's Last Summer* (Iowa City: Prairie Press, 1952).

44. These donations included Sloan's 1914 Gloucester painting *Sailor Girl* (P.951.66), his *Self-Portrait, Working,* 1916 (P.952.43), and a later portrait of his wife, *Helen in Red,* 1946 (P.951.71). Additional paintings by Sloan donated by Dr. Charles E. Farr (Helen Farr Sloan's father) and John Sloan Dickey have added further breadth to the museum's Sloan holdings.

45. In a letter to College librarian Richard W. Morin of October 3, 1951, Helen Farr Sloan wrote: "there is an exceedingly valuable groups [sic] of letters, books, diaries, photographs and pictures belonging to Mary Fanton Roberts which she is most anxious to find a home for . . . and she is favorable to Dartmouth." In the same letter Helen Farr Sloan said that she would give Dartmouth her husband's papers, but she later changed her mind and gave the collection to the Delaware Art Museum, the library of which is now named in her honor. Dartmouth College Library, Gift Correspondence DL 15 (17): Sl–Smil.

46. Avis Berman, "'As National as the National Biscuit Company': The Academy, the Critics, and the Armory Show," in David B. Dearinger (ed.), *Rave Reviews: American Art and Its Critics, 1826–1925* (New York: National Academy of Design, 2000), 133. Roberts used the pseudonym "Giles Edgerton" in her early articles. For more on Roberts, see her obituary, "Mrs. W. C. Roberts, Writer, Editor, 85," *New York Times,* October 15, 1956, and her papers at the AAA.

47. Churchill P. Lathrop to Ilse Bischoff, May 4, 1948, and Ilse Bischoff to Churchill P. Lathrop, May 10, 1948, HMA donor files.

48. Obituary, "Hersey Egginton, Lawyer 54 Years," *New York Times,* August 2, 1951, 21.

49. Egginton acquired Dewing's 1891 canvas *The Song* from Milch Gallery by February 1924. Sotheby's, New York, "American Paintings, Drawings, and Sculpture," December 4, 2002, lot 37. The purchase notations appeared in Milch Gallery Sales Ledgers, Milch Gallery Records, 1911–1980, reel 4448 (January 3, 1924, November 27, 1926, and January 12, 1929), AAA.

50. Mary E. Egginton to John Meck, Dartmouth treasurer and vice president, c. November 1954, HMA donor files.

51. In addition to Engelman's Chicago-area philanthropic concerns, he was an active Dartmouth alumnus. He served on the Alumni Council, endowed a scholarship, and was agent for his class until his death.

52. John Sloan Dickey to Robert S. Engelman, November 29, 1960, HMA donor files.

53. Obituary, "Shapiro, Daisy Viertel," *New York Times,* October 22, 1984.

54. Typescript obituary intended for *Dartmouth Alumni Magazine,* September 1976, Dartmouth College Library, Julius R. Wolf 1951 file.

55. Questionnaire completed by Jay Wolf, "Dartmouth Class of 1951—25th Reunion, Dartmouth College Alumni Records Office," Dartmouth College Library, Jay Wolf file.

56. Jay Wolf to Churchill P. Lathrop, February 21, 1963, HMA donor files.

57. Jay Wolf to Churchill P. Lathrop, December 4, 1975, HMA donor files.

58. Undated clipping, Sarah Clayton, "'The Governor' Arrives at College," *Valley News,* c. March 14, 1978.

59. Gordon Abbott Jr. to Timothy Rub (director of the Hood Museum of Art), April 10, 1989.

60. Bertram Geller majored in philosophy at Dartmouth and became a renowned designer of women's shoes after the Great Depression put an end to his plans to become a city planner. He eventually became president of Andrew Geller Shoes, which had been formed by and named for his uncle in 1910. Geller created the patented Strada shoe and received two Clio awards

in 1978 and 1979. Obituary, *Dartmouth Alumni Magazine*, October 20, 1981.

61. Churchill P. Lathrop to President John G. Kemeny, February 5, 1973, HMA donor files.

62. Mr. Lathem presented the Wyeth watercolor to the museum in 1987.

63. Ivan Albright received an honorary degree from Dartmouth in 1978 and was named a visiting scholar in art in 1980. The museum's gallery of European art is named the Ivan Albright Gallery in his memory.

64. As with all of the works in the collection, a complete inventory of more recent watercolors and drawings may be found through the museum's online catalogue, accessible via the Hood's website (www.hoodmuseum.dartmouth.edu).

65. Lathrop, "To Promote Interest," 82.

Catalogue

A Reader's Guide to the Catalogue

SCOPE AND ORGANIZATION

This publication highlights two centuries of American drawings and water-colors in the Hood Museum of Art, Dartmouth College. Featured works date from 1769 (the year John Singleton Copley portrayed John Wentworth [cat. 1]) to 1969. The catalogue section of *Marks of Distinction* is divided into two primary parts. The first, "A Selection of Principal Works," comprises works selected for extended discussion and reproduction in color in the pages that immediately follow. These works also correspond to the watercolors and drawings that form the core of the traveling exhibition (with the exception of the Copley pastel, which, owing to its fragility, will only be shown at the Hood). To give a broader survey of the museum's strengths in this area, a second section, "Further Selected American Drawings and Watercolors in the Collection," lists and illustrates additional watercolors and drawings. A complete inventory of the American watercolors and drawings, as well as the museum's other holdings, may be found through the museum's online cata-logue, accessible via the Hood's website (www.hoodmuseum.dartmouth.edu).

The individual entries for "A Selection of Principal Works" are organized chronologically by object. Works in "Further Selected American Drawings and Watercolors in the Collection" are listed alphabetically by artist's name, then title. Items in this checklist receive abbreviated catalogue descriptions, without inscriptions or scholarly apparatus. Principal works with full cata-logue entries do not appear again in the checklist. The publication's index directs readers to references of works by a given artist, as well as cross-references to artists known by various names.

INSTITUTIONAL HISTORY

The Hood Museum of Art, funded in 1978 through the bequest of Harvey P. Hood and opened in 1985, was preceded by various museum and gallery set-tings on the Dartmouth College campus that date back to the eighteenth century. Most relevant to this project is the College's twentieth-century his-tory, during which there existed several art museum or gallery entities. They included the Carpenter Hall Galleries, which opened with the completion of Carpenter Hall in 1929, and the Hopkins Center Art Galleries, established with the opening of the College's new art and performing arts complex in 1962. As of September 1974 what was formerly called the Hopkins Center Art Galleries and the College Museum (which housed the anthropological and historical holdings) came to be known as the Dartmouth College Gal-leries and Collections and, in 1976, the Dartmouth College Museum and Galleries. The various permutations on these names are reflected in the ex-hibition and reference citations in this volume.

ARTISTS' AFFILIATION WITH THE
NATIONAL ACADEMY OF DESIGN

Artists' affiliation with the National Academy of Design is indicated with initials following their name: "N.A." for member and "A.N.A." for associate member.

DATES

Approximate dates within a few years are preceded with "c." (circa, or about). If a work bears no date and a date would be difficult to ascertain within a fairly narrow or precise range, "n.d." (no date) follows a work's title.

MEDIUM AND SUPPORT

The media used in preparing a given work of art are listed in order of pre-dominance. When the term "watercolor" is not modified, it refers to trans-parent watercolor. "Opaque watercolor" is used to describe what is often called "gouache." Paper is described as either laid or wove, with the manu-facturer's name included in parentheses when known. If the color of a sheet or other support is not indicated, it is presumed to be within the range of white, cream, or light tan.

DIMENSIONS

In measurements, height precedes width. Unless otherwise noted, dimen-sions indicate the size of the sheet or primary support. Centimeters are given first, followed by inches in parentheses. Works reproduced in this cata-logue are not enlarged, but shown actual size or smaller.

INSCRIPTIONS

Signatures and inscriptions, as well as their location on the support, are given for the "Selection of Principal Works." Inscriptions have been tran-scribed exactly as they appear, without the correction of spelling or other errors. A slash (/) indicates a line break.

PROVENANCE

Every attempt has been made to research the former ownership of a given work of art in "A Selection of Principal Works." However, many listings re-main incomplete. Previous owners or locations are listed chronologically, with a semicolon separating owners or transactions. When a transfer is known to be direct, it is preceded by "to." Whenever possible, the means of transfer (by gift or sale, for instance) is indicated.

EXHIBITIONS

Exhibitions are listed chronologically. Traveling exhibitions are indicated by the term "and others" following the name of the organizing institution.

REFERENCES

These listings refer to publications in which the work is referred to and sometimes illustrated. In general, reproductions without accompanying text and slight brochures are not included among the publications.

AUTHORS' INITIALS

Initials at the end of a catalogue entry indicate the author, whose full names follow.

DRC Derrick R. Cartwright
KWH Katherine W. Hart
BJM Barbara J. MacAdam
MDM Mark D. Mitchell
BT Barbara Thompson

A Selection of Principal Works

1 John Singleton Copley, 1738–1815

Governor John Wentworth, 1769

Pastel on laid paper, mounted on canvas, 59.8 × 45.0 cm (23½ × 17¾ in.)

Signed and dated, center right: JSC [in monogram] p. [f.(?)] 1769

Gift of Mrs. Esther Lowell Abbott, in memory of her husband, Gordon Abbott; D.977.175

PROVENANCE
Governor John Wentworth, the sitter, Portsmouth, N.H., November 1769; to Paul Wentworth, London, January 1770; to Mary Wentworth Nelson, daughter of the sitter; to Dr. James Lloyd (her husband's nephew); possibly with John Borland, Boston, 1873 (per Perkins, 1873); Gordon Abbott, Manchester, Mass., a direct descendant of Lloyd; to Esther Lowell Abbott, his widow; given to present collection, 1977.

RELATED WORK
Pastel replica drawn by Copley for John Hurd of Boston in 1769, before the sitter sent the original to Paul Wentworth (collection of Mrs. Everett Morss, Massachusetts, 1979).

EXHIBITIONS
Museum of Fine Arts, Boston, *John Singleton Copley, 1738–1815: Loan Exhibition of Paintings, Pastels, Miniatures and Drawings*, 1938, no. 83; National Gallery of Art, Washington, D.C., and others, *John Singleton Copley, 1738–1815*, 1965–66, no. 35; Dartmouth College Museum and Galleries, Hanover, N.H., *Portraits at Dartmouth*, 1978, no. 27; Dartmouth College Museum and Galleries, Hanover, N.H., *Acquisitions 1974–1978*, 1979 (no cat. no.); Dartmouth College Museum and Galleries, Hanover, N.H., *Hail, Holy Land: The Idea of America*, 1980, no. 1; Hood Museum of Art, Dartmouth College, Hanover, N.H., *Nineteenth- and Twentieth-Century Paintings*, 1982 (no cat.); Hood Museum of Art, Dartmouth College, Hanover, N.H., *From Copley to Dove: American Drawings and Watercolors at Dartmouth*, 1989 (no cat.).

REFERENCES
Guernsey Jones (ed.), *Letters and Papers of John Singleton Copley and Henry Pelham, 1739–1776* (Boston: Massachusetts Historical Society, 1914), 84–85, 87–88; Augustus Thorndike Perkins, *A Sketch of the Life and a List of Some of the Works of John Singleton Copley* (Cambridge, Mass.: privately printed, 1873), 121; Frank W. Bayley, *The Life and Works of John Singleton Copley, Founded on the Work of Augustus Thorndike Perkins* (Boston: Taylor Press, 1915), 261–62; Theodore Bolton, *Early American Portrait Draughtsmen in Crayons* (New York: F. F. Sherman, 1923), no. 56; Barbara Neville Parker and Anne Bolling Wheeler, *John Singleton Copley: American Portraits in Oil, Pastel, and Miniature* (Boston: Museum of Fine Arts, 1938), 6, 234 (as replica); National Gallery of Art, Washington, D.C., *John Singleton Copley, 1738–1815* (Washington, D.C.: National Gallery of Art, 1965), 55–56 (illus.); Jules David Prown, *John Singleton Copley in America* (Cambridge, Mass.: Harvard University Press for the National Gallery of Art, Washington,

This elegant portrait by America's leading artist of the day depicts a figure pivotal to the founding of Dartmouth College and to the history of New Hampshire on the eve of the American Revolution. John Wentworth (1737–1820), whose New Hampshire roots extended back five generations, served as the colony's last royal governor, from 1766 to 1775, when rising tensions finally forced him to flee the colonies for England, never to return to his native soil.[1]

This pastel is one of about fifty-five that John Singleton Copley is known to have produced, all of them between 1758 and 1774, the year he departed for Europe. As he had with oil painting, Copley developed his astounding talent with pastels primarily through self-instruction. He had little choice, given the limited opportunities for training in the colonies and the scarcity of original pastel, or "crayon," drawings available as models, despite their popularity abroad. In 1762 Copley wrote for assistance to the Swiss artist Jean-Étienne Liotard, whose accomplished portraits in the medium had met with great acclaim in London, where he worked from 1753 to 1755.[2] Copley unabashedly requested that Liotard send "one sett of Crayons of the very best kind . . . [for] liveliness of colour and Justness of tints. In a word let em be a sett of the very best that can be got."[3] Despite later abandoning the medium for oils, Copley wrote in 1766 to his American artistic mentor abroad, Benjamin West, soliciting elaboration on West's avowed disapproval of pastels, "for I think my best portraits [are] done in that way."[4]

This portrait exhibits Copley's total mastery of the medium and his ability to create a remarkably vivid yet fashionable likeness—a talent already well in evidence in his oil portraits. In this composition he silhouettes the handsome Wentworth against a dark gray background, which projects the figure forward and sets off the delicate tones of his fair complexion, powdered hair, and light gray suit. Strong lighting from the left heightens the sculptural presentation of the head, casting the far side of the face in shadow. Copley meticulously modeled the governor's features, blending countless discrete strokes of pigment to form smooth gradations of color. Revealing the artist's keen powers of observation, the flesh tones vary widely, from warm pink on the cheeks to a greenish tinge around the mouth and glistening, creamy highlights on the forehead, through which runs a faint blue vein. The relative absence of stroke on the face gives way to a much more linear treatment of the wiry hair and a broad, en-

ergetic rendering of the clothing. Copley deftly suggests the most stylish features of the governor's apparel—the silver buttons, lace jabot, and embroidered lapel—without detracting from the drawing's primary focus: Wentworth's direct and assessing gaze.

John Wentworth's elegant dress and magisterial bearing befit his standing as one of the wealthiest, highest-ranking government officials in the colonies. Born in Portsmouth in 1737, he was scion to a family that had dominated New Hampshire's mercantile, social, and political life for several generations. He followed in the political footsteps of his grandfather John Wentworth, lieutenant governor of the colony from 1717 to 1730, and his uncle Benning Wentworth, who served as governor from 1741 to 1767. Benning's brother and the sitter's father, Mark Wentworth, achieved his status as the richest man in New Hampshire largely through advantageous contracts for masts with the Royal Navy. His son's social connections, native abilities, and education at Harvard and Oxford prepared him well to assume the governorship when Benning Wentworth stepped aside in 1767.[5]

The residents of New Hampshire admired their new, young governor. Although extravagant in his pursuit of an aristocratic lifestyle, he was known for his forthrightness, practicality, and wholehearted dedication to the colony's welfare. He personally enticed prospective settlers to New Hampshire, which became one of the fastest-growing colonies during his administration.[6] He especially encouraged the settlement of northern New Hampshire and to that end oversaw the construction of roads that linked the Connecticut River with Portsmouth, the colony's only significant harbor. Wentworth promoted inland settlement by personal example as well. He established an opulent country seat some fifty miles north of the seacoast in Wolfeboro. Beginning in 1769, the year he sat for this portrait, he supervised construction of its enormous mansion (one hundred by forty feet) and numerous outbuildings on more than three thousand acres of land. Wentworth built the estate for more than social display, as he intended to play an active role in the day-to-day operations of the farm and reside there fully half the year.[7]

As tensions developed between the American colonies and Britain, Wentworth supported many of the colonists' grievances while maintaining an essential faith in the Crown's benevolent intentions. Even as political tensions spilled over into violence, he believed that reconciliation with the

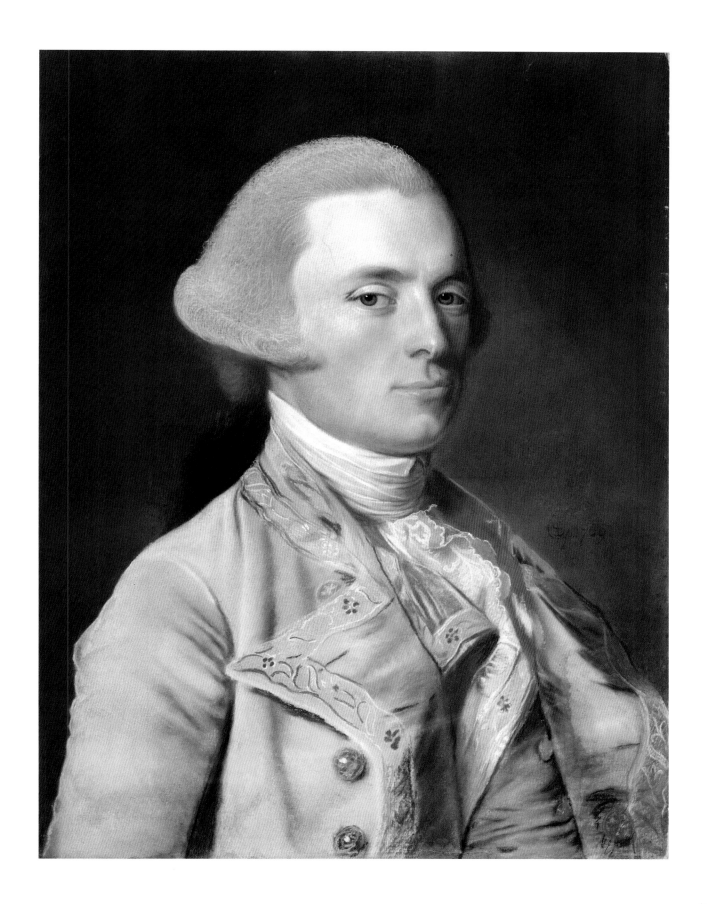

D.C., 1966), 1:234 (illus., n.p.); Arthur R. Blumenthal, *Portraits at Dartmouth* (Hanover, N.H.: Dartmouth College Museum and Galleries, 1978), 36–37 (illus.), cover (color illus.); Arthur R. Blumenthal, "J. S. Copley's *Portrait of Governor Wentworth*," in *Recent Acquisitions 1974–1978* (Hanover, N.H.: Dartmouth College Museum and Galleries, 1979), 32–35 (color illus.); Jacquelynn Baas et al., *Treasures of the Hood Museum of Art, Dartmouth College* (New York: Hudson Hills Press, in association with the Hood Museum of Art, Dartmouth College, 1985), 105 (color illus.); Jacquelynn Baas, "From 'A Few Curious Elephants Bones' to Picasso," *Dartmouth Alumni Magazine* 78, no. 1 (September 1985), 42 (color illus.); Barbara J. MacAdam, "American Paintings in the Hood Museum of Art, Dartmouth College," *The Magazine Antiques*, November 1985, 1021 (color illus.); David R. Starbuck (ed.), "America's First Summer Resort: John Wentworth's 18th-Century Plantation in Wolfeboro, New Hampshire," *The New Hampshire Archaeologist* 30, no. 1 (1989), entire issue (cover illus.); Michel de Grèce, *L'Art du Portrait* (Paris: Le Chène, 1992), 112–13 (color illus.); William Hosley, "Time Lines: The Twists and Turns of New Hampshire Furniture," *Art and Antiques* 9, no. 8 (October 1992), 54 (color illus.); Brock Jobe, *Portsmouth Furniture: Masterworks from the New Hampshire Seacoast* (Boston: Society for the Preservation of New England Antiquities, 1993), 26; Paul W. Wilderson, *Governor John Wentworth and the American Revolution: The English Connection* (Hanover, N.H.: University Press of New England, 1994), cover and 171–72; Carol Troyen, "A Choice Gallery of Harvard Tories: John Singleton Copley's Portraits Memorialize a Vanquished Way of Life," *Harvard Magazine* 99 (March–April 1997), 56–58 (color illus.); J. David Hoeveler, *Creating the American Mind: Intellect and Politics in the Colonial Colleges* (Oxford: Rowman and Littlefield Publishers, 2002), 207 (illus.); Dick Hoefnagel with the collaboration of Virginia L. Close, *Eleazar Wheelock and the Adventurous Founding of Dartmouth College* (Hanover, N.H.: Durand Press, 2002), ix, 57 (illus.).

mother country was possible. He reluctantly left New Hampshire in September 1776 and spent a couple of years in New York, in close association with the British army. In 1778 he finally relinquished hopes of a political reconciliation and sailed for England. Five years later he returned to North America as Royal Surveyor of Nova Scotia and, in 1792, was named governor. As late as 1791 he referred to New Hampshire as his "still dear native country."[8]

Copley's confident portrayal contrasts with another portrait of Wentworth painted just three years earlier in England by "Wilson," most likely Benjamin Wilson (1721–1788; fig. 48). Wentworth had just secured the governorship of New Hampshire from his friend, patron, and distant relation, the marquis of Rockingham, who commissioned the likeness. In comparison with Copley's portrayal, it presents a pale and diminutive Wentworth, well dressed but lacking a powdered coiffure. His posture is slightly hunched, with his head pushed forward and shoulders sloping at a sharp pitch as he lightly grasps a scroll inscribed "New Hams . . ." (presumably for "Hampshire"). By contrast, Copley's erect, robust, and sumptuously attired Wentworth—vividly portrayed at close range—requires no props to signify his rank.[9]

The date of the Copley portrait, 1769, marked a propitious crossroads for Wentworth, the artist, and Dartmouth College. Wentworth, still revered in New Hampshire and abroad, was soon to be married. He sat for this portrait in Portsmouth the first week in November, just a few days before his November 11 marriage to his cousin Frances Wentworth. This hasty union was made possible

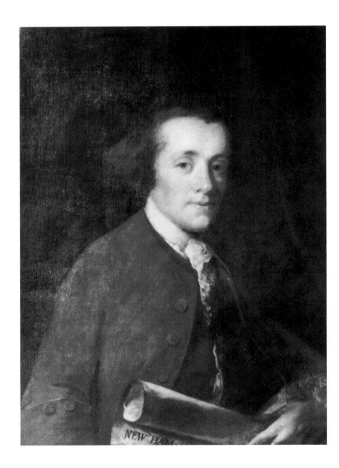

Fig. 48. Attributed to Benjamin Wilson, *John Wentworth*, 1766, oil on canvas, 73.7 x 58.4 cm (29 x 23 in.). Reproduced by permission of the Trustees of the Rt. Hon. Olive, Countess Fitzwilliam's Chattels Settlement and Lady Juliet Tadgell

by the death on October 28 of her first husband, Theodore Atkinson Jr. (also a cousin).[10] Wentworth's portrait seems not to have been generated by the wedding plans, however, but by a previous request for a likeness from his friend and kinsman in England, Paul Wentworth.[11]

Copley was also on the threshold of marriage, for on November 16 he wed Susannah Farnham Clarke, the daughter of the wealthy merchant Richard Clarke, agent of the British East India Company in Boston. Copley began his own fashionable portrait in pastels the same week he took Wentworth's likeness, no doubt in honor of his impending nuptials (fig. 49).[12] As evidenced by his assured gaze, elegantly styled hair, and silk damask morning coat, Copley was well aware that his union would elevate his status to that of his elite patrons.[13] He may have also felt justifiable

pride in his recent professional accomplishments, including the likeness of Wentworth, who was the highest-ranking American official he would ever portray.

Of great significance to Dartmouth College, on December 13, 1769 — about a month after sitting for his portrait by Copley — Governor Wentworth granted the College's charter to the Reverend Eleazar Wheelock. In so doing, he fulfilled Wheelock's long-held dream of founding a university to educate and convert Native Americans and reaffirmed his own commitment to education and to developing the northern reaches of New Hampshire.

BJM

Fig. 49. John Singleton Copley, *Self-Portrait*, 1770–71, pastel on paper, 58.7 x 44.5 cm (23⅛ x 17½ in.). Courtesy Winterthur Museum

2 Benjamin West, 1738–1820

Archangel Gabriel of the Annunciation, 1784

Pen and ink over black chalk with touches of red and blue chalk on laid paper, 44.2 × 30.9 cm (17½ × 12⅛ in.)

Signed and dated, lower right: B. West. 1784.

Purchased through the Julia L. Whittier Fund; D.959.104

PROVENANCE
Roland Robert (art dealer), Nice; sold to M. R. Schweitzer (art dealer), New York, 1959; sold to present collection, 1959.

EXHIBITIONS
Hopkins Center Art Galleries, Dartmouth College, Hanover, N.H., *Master Drawings from the College Collection*, 1978 (no cat.); Hopkins Center Art Galleries, Dartmouth College, Hanover, N.H., *The Napoleonic Era*, 1979 (no cat.); Colby-Sawyer College, New London, N.H., *Bicentennial Exhibition*, 1979 (no cat.); Hood Museum of Art, Dartmouth College, Hanover, N.H., *From Copley to Dove: American Drawings and Watercolors at Dartmouth*, 1989 (no cat.).

REFERENCES
John Dillenberger, *Benjamin West: The Context of His Life's Work with Particular Attention to Paintings with Religious Subject Matter* (San Antonio, Tex.: Trinity University Press, 1977), 212; Jacquelynn Baas et al., *Treasures of the Hood Museum of Art, Dartmouth College* (New York: Hudson Hills Press, in association with the Hood Museum of Art, Dartmouth College, 1985), 109 (color illus.).

Benjamin West was the first American artist to gain stature and exert influence in an international sphere, and he did so at a level that none of his compatriots could match for generations thereafter. Born in Springfield, Pennsylvania, he received informal instruction in Philadelphia. In 1760, at the age of twenty-one, he traveled to Rome for further study. Three years later he moved to London, where he rose to prominence and spent the remainder of his career. A founding member of the Royal Academy of Arts, West served as its elected president from 1792 to 1805—an extraordinary accomplishment for a foreigner. He also attracted a coterie of prestigious patrons, most notably King George III, who appointed him royal history painter in 1772 and for whom he painted about sixty pictures between 1768 and 1801. In terms of artistic contributions, West promoted and practiced the neoclassical style in advance of most of his European contemporaries and, through his later work, presaged key aspects of the romantic movement. As a teacher, he inspired and counseled three generations of British and American painters, the latter of whom included Charles Willson Peale, Gilbert Stuart, Ralph Earl, and John Trumbull.[1]

Benjamin West first won recognition through his precocious drawings made as a youth in rural Pennsylvania, and he continued to draw prolifically throughout his career. The surviving sheets by his hand—rendered primarily in black chalk or pen and ink—vary widely in style, technique, and intention. They include preparatory sketches, compositional studies, sketches from nature, and highly finished compositions, conceived independently from his paintings.[2]

Archangel Gabriel of the Annunciation likely falls into the latter category. Larger than most of West's preparatory sketches, it is also more finished in its execution and bears a prominent signature and date. West created many such large-scale, highly worked drawings during the 1780s, a particularly fruitful and successful period in his career.[3] Known initially for his portraits and theatrical history paintings, he had turned his attention increasingly to biblical subjects beginning in the 1770s. Several church and royal commissions influenced this shift in subject matter, especially the request from King George III for a series of paintings illustrating the History of Revealed Religion for the Royal Chapel at Windsor.[4] Although not clearly related to a specific painting associated with the project, this drawing's celestial subject stems from the general direction of West's work during this period.

Archangel Gabriel of the Annunciation shares with other West drawings from this era a remarkable elegance and verve. Here a single, fine line of ink outlines the angel's profile, and orderly networks of hatched chalk markings model the face, neck, and hands. By contrast, sweeping calligraphic strokes of the pen delineate the angel's flowing hair, wings, and drapery, as well as the buoyant cloud below. Instead of watercolor, which West used to highlight several finished drawings from this period, touches of red chalk enliven the face and hands, and small patches of blue shading indicate the sky. West's preference for pen and ink during this period and his animated, fluent drawing style reveal his debt to the baroque drawings represented in the extraordinary royal collection that he could see at Windsor. The seventeenth-century pen-and-ink sketches of Bolognese artist Giovanni Francesco Barbieri, known as Il Guercino—abundantly represented in the Windsor collection—appear to have exerted an especially strong influence on West's drawing technique. In this sheet, West combines the vibrancy of Guercino's handling with a restrained classicism more reflective of his own era.

This drawing entered the museum's collection simply as *Angel* but very soon acquired the more specific title *Archangel Gabriel of the Annunciation* for reasons not evident from the curatorial records. The angel depicted does not bear a lily, the traditional attribute of Gabriel, and no other documentation supports the more specific identification. However, the angel's rapt attention, heavenward gaze, and tender hand gestures suggest the receipt from on high of an important sacred message—conceivably even that of the Incarnation, which Gabriel would proclaim to Mary.[5]

BJM

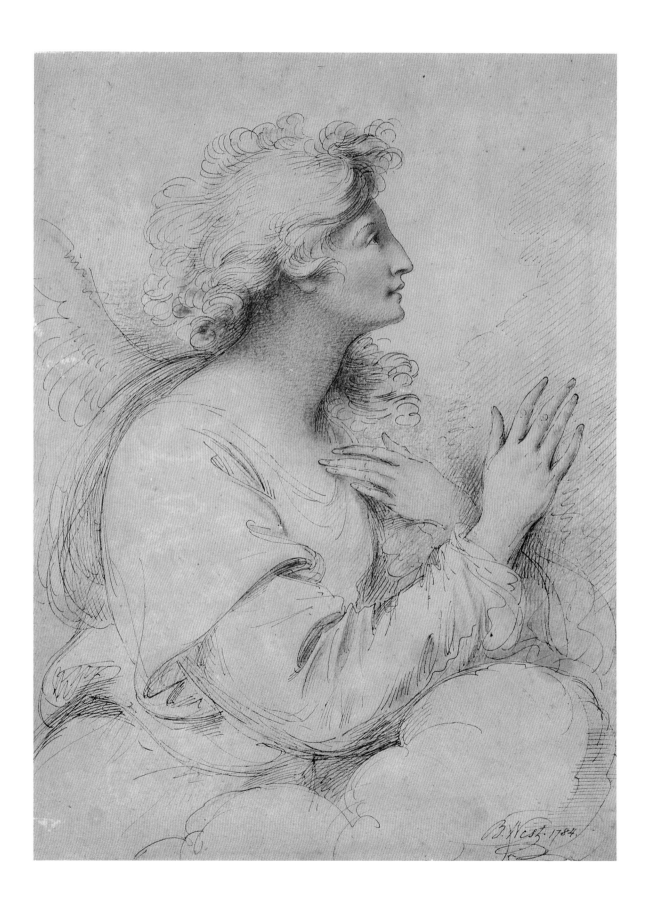

3 John James Audubon, N.A., 1785–1851

American Buzzard or White Breasted Hawk . . . Falco Leverianus, c. 1810–20

Pastel, graphite, chalk, and white opaque watercolor on wove (J. Whatman) paper, 53.0 × 43.1 cm (20⅞ × 16¹⁵⁄₁₆ in.)

Inscribed, signed, and dated, in pen and ink, lower center: American Buzzard or White Breasted Hawk A. Willson / Falco Leverianus — / drawn from Life by J. J. Audubon at Henderson K.Y—; numbered, in pen and ink, lower left: No 82—; inscribed, in pen and ink over graphite, lower right: A. 4 feet / L. T. 21 Inch / Weight 34 oz] / [illegible] 12—

Purchased through the Katharine T. and Merrill G. Beede 1929 Fund and the Mrs. Harvey P. Hood W'18 Fund; D.2003.52

PROVENANCE
The artist; Elizabeth Torrey Linzee Greene; John Torrey Linzee; to John Linzee Weld, his nephew, by 1897; Jane Weld Brown; by descent in the family; Christie's, New York, "Important American Paintings, Drawings, and Sculpture," December 4, 1996, lot 5; sold to Gerald Peters Gallery, New York and Santa Fe, N.Mex.; sold to private collection; Phillips, New York, "American Art," May 22, 2001, lot 6; sold to Audubon Galleries (a partnership of Donald A. Heald, New York, and William Reese Company, New Haven, Conn.); sold to present collection, 2003.

REFERENCE
Susanne M. Low, *A Guide to Audubon's "Birds of America"* (New Haven: William Reese Co. and Donald A. Heald, 2002), following p. 22 (color illus.).

Widely acclaimed as America's most innovative and influential artist-naturalist, John James Audubon is best known for his monumental illustrated publication *The Birds of America* (1826–38). A double-elephant folio of 435 hand-colored prints after Audubon's original watercolors and drawings, *The Birds of America* is one of the great achievements of American art and natural history.[1] Its vivid, stop-action portrayals of birds in their habitats significantly advanced the genre of naturalist art and pointed the way toward an environmental approach to the study of nature. Although self-taught as a naturalist, Audubon's extended, direct experience in the wilds afforded him an intimate understanding of ornithological behavior that in many ways surpassed the dry, taxonomic approach of more learned scientists and artist-naturalists.[2] His adventurous forays into the American wilderness preceded the sketching trips of the Hudson River School landscapists and took him as far south as Louisiana and Florida and as far north as Labrador. As evidenced in this early drawing, he was a gifted draftsman who blended an idealism associated with the French Academy with a fastidious realism based on direct observation. Aside from his professional accomplishments, Audubon's colorful personality contributed to his celebrity—and notoriety—at home and abroad. He fashioned himself at turns as a cultivated French nobleman, an enterprising entrepreneur, and a rugged "American woodsman" akin to the mythologized Daniel Boone.[3] Audubon shamelessly invented grandiose, contradictory accounts of himself and others, yet his very real achievements as an artist-naturalist remain unrivaled.

Audubon was born in Les Cayes, Saint-Dominique (now Haiti), to a French sea captain and his mistress, who died shortly thereafter. He grew up in Nantes, France, raised by his father and his legal wife. He presumably received some training in drawing as a youth, but there is no evidence to support his claim that "[Jacques-Louis] David had guided my hand in tracing objects of large size."[4] In 1803, at the age of eighteen, Audubon came to the United States to oversee Mill Grove, his father's property outside Philadelphia. To the detriment of his father's affairs and his own subsequent business ventures, he found himself repeatedly distracted by his long-held passion for hunting and drawing birds. Audubon drew more intensively during a yearlong visit in 1805 to France, where he created profile studies of birds in pastel. He returned to Mill Grove with a rekindled enthusiasm for drawing from nature. Dissatisfied with the faded color and unnatural poses of stuffed specimens, he devised his own system of using wire to position freshly killed birds in lifelike positions.

Despite Audubon's technical advances, drawing remained a part-time avocation for more than a decade following his return to the United States. He tried his hand at a number of business enterprises following the sale of Mill Grove about 1807. He ran a general store and import business in Louisville, Kentucky, then traveled farther down the Ohio River to Henderson, where he lived with his young family from 1810 to 1820 and operated a timber mill. The mill failed during the financial panic of 1819 and plunged Audubon into personal bankruptcy.

Forced to turn to drawing for his livelihood, Audubon determined about 1820 to create an encyclopedic study of American birds. In doing so, he drew inspiration from the Scottish-born artist-naturalist Alexander Wilson of Philadelphia.[5] Audubon and Wilson had met in Louisville in 1810, during Wilson's tour of the South to collect bird specimens and subscribers for his nine-volume *American Ornithology* (1808–14), two volumes of which had by then appeared. Wilson's ambitious publication joined Audubon's library as a primary reference for visual models and ornithological nomenclature. The encounter between artists no doubt nurtured whatever early hopes Audubon held eventually to publish his own drawings, which he continued to create sporadically throughout his Kentucky years.[6]

This sheet's inscription, "drawn from Life by J. J. Audubon at Henderson K.Y," dates it to between 1810 and 1820. Another notation credits "Willson" for the identification of the species, suggesting a date of 1812 or later, since Wilson's "American Buzzard" debuted in volume six of his *American Ornithology* that year. Yet Audubon frequently inscribed his drawings after the fact, making a date as early as 1810 for this work possible, if less likely.[7] Although Audubon adapted many of his early drawings for use in *The Birds of America,* he would have rejected this example because in it he, like Wilson before him, mistook a juvenile specimen—in this case a young red-tailed hawk—for a new species.[8] He realized his error by 1820, and his final watercolor illustration of the red-tailed hawk featured just two adults, male and female (fig. 50).

A comparison with Alexander Wilson's drawing of the "American buzzard" (later reclassified as a "red-tailed hawk" [fig. 51]) reveals both Audubon's reliance on and deviation from his

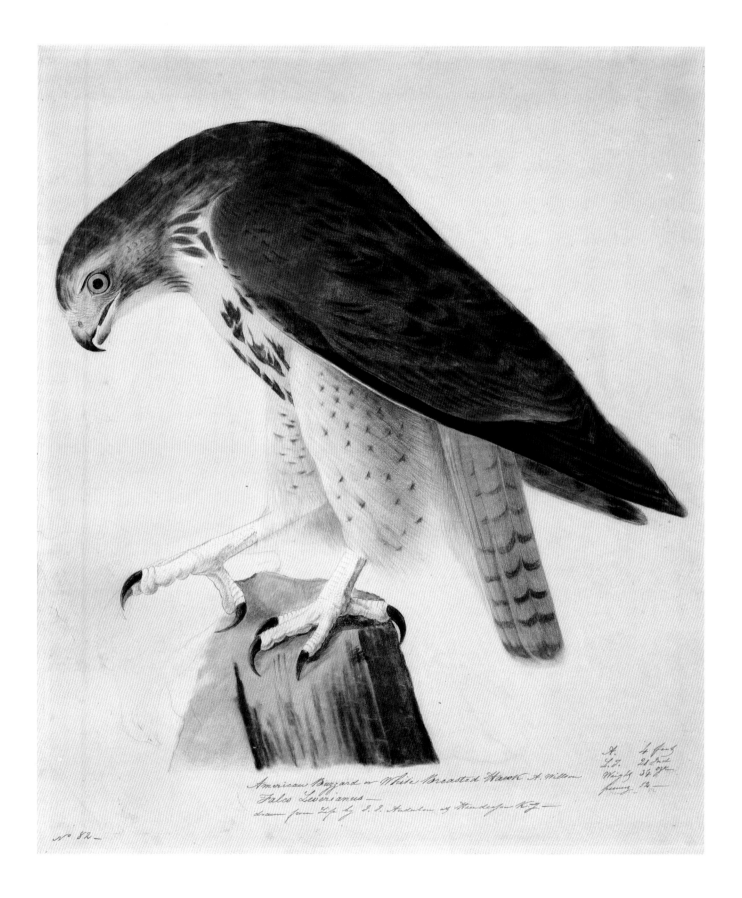

American Buzzard or White Breasted Hawk A. Wilson
Falco Leverianus —
drawn from Life by J. J. Audubon at Henderson Ky —

N.º 82 —

predecessor's example. Both artists portrayed the raptor in profile and in relative isolation, following long-established conventions. Wilson's alert, upright specimen appears stately in demeanor, although somewhat rigid in its stance and in the artist's linear treatment of its patterned plumage. Audubon's life-size raptor retains the nobility of Wilson's model, yet it stretches its neck down and forward, creating a bold, hill-like contour along the upper back. Like Wilson's model, this bird opens its beak as if ready to feed and lifts the leg that clasps its prey. Its pose recalls Audubon's unusually animated 1806 pastel of another raptor, *Fish Hawk (Osprey)* (fig. 52). Both drawings convey the artist's striving for a greater naturalism and mark a transition between his previous static poses and his more active manner associated with images for *The Birds of America*. In the extraordinarily dynamic watercolor of the red-tailed hawk (fig. 50), for instance, Audubon captures a male and female adult in aggressive combat over prey, showcasing his groundbreaking emphasis on motion and behavior.

Audubon's *American Buzzard* also exemplifies his masterful handling of pastel and graphite, which remained his primary media until about 1821, when he switched predominantly to watercolor.[9] The faint, incomplete drawing of the small bird in the hawk's grasp shows us how Audubon began all of his drawings by "outlining" his subjects in graphite. He then used a dazzling variety of marks in pastel and graphite to build up the

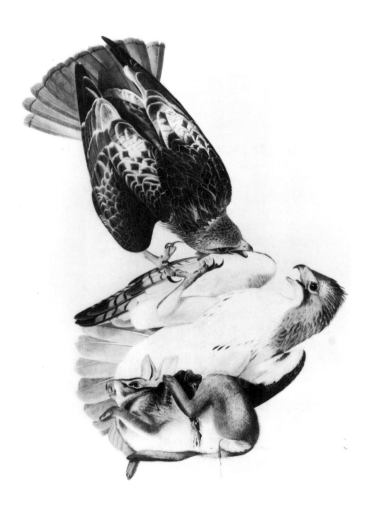

Fig. 50. John James Audubon, *Red-Tailed Hawk*, 1821, watercolor, pastel, graphite, and selective glazing on paper, 95.6 x 64.8 cm (37⅝ x 25½ in.). Collection of The New-York Historical Society, 1863.17.051

Fig. 51. Alexander Wilson, *Red-Tailed Hawk*, c. 1812, graphite, pen and ink, and ink wash on paper, 47.0 x 28.6 cm (18½ x 11¼ in.). Ernst Mayer Library of the Museum of Comparative Zoology, Harvard University

forms and create the varied colors and textures of the species. Note for instance the contrast among the wispy graphite lines that suggest the downy feathers on the upper legs; the wiry, perfectly arcing lines that describe the whiskerlike feelers around the beak; and the complexly layered and blended pastel marks that indicate the subtly variegated patterning of the plumage. The artist highlighted the legs with opaque white watercolor, which he then articulated with graphite to simulate their scaly texture. Through his complex, seemingly effortless, technique, Audubon finessed an image of stunning verisimilitude.

This and other masterful—often dramatic—renditions of raptors suggest that Audubon held this class of bird in particularly high regard. Some scholars have theorized that he identified personally with raptors, particularly the bald eagle, our national emblem.[10] Because he drew his hawks and eagles to life scale, as was his general practice, they gain stature by virtue of their size alone. Beyond their formidable dimensions, however, their fierce, noble beauty, predatory habits, and perceived bravery and independence obviously struck a chord with Audubon. A competitive spirit and ardent determination certainly abetted Audubon's outstanding contributions to American art and natural history that culminated in his incomparable *The Birds of America*.

BJM

Fig. 52. John James Audubon, *Fish Hawk (Osprey)*, 1806, graphite, pastel, and watercolor on paper, 52.4 x 63.2 cm (20⅝ x 24⅞ in.). By permission of the Houghton Library, Harvard University, pfMS Am 21 97

4 Thomas Sully, N.A., 1783–1872

The Last Moments of Tom Coffin, 1824

Black ink wash with traces of pen and brown ink over graphite on wove paper, with watercolor wash border, sheet: 18.7 × 15.9 cm (7⅜ × 6¼ in.); mount: 22.2 × 28.6 cm (8¾ × 11¼ in.)

Signed and dated, lower left: TS [in monogram] 1824; inscribed, on mount, lower center: "The last moments of Tom Coffin" Designed from Coopers novel of the "Pilot". Presented by Thos. Sully / to his friend J. Neagle. 1827; inscribed, by Neagle, on mount lower left: (NB [in monogram]. The above is written by Mr. Sully)

Purchased through the Katharine T. and Merrill G. Beede 1929 Fund; D.999.39

PROVENANCE
The artist; to John Neagle, 1827; by descent to Neagle's great-granddaughter, Mrs. E. H. Brodhead Jr.; Sotheby's Arcade Auction, New York, "American Paintings, Drawings and Sculpture," March 25, 1997, lot 108A; to Spanierman Gallery, LLC, New York; sold to present collection, 1999.

Thomas Sully was Philadelphia's leading portraitist in the early nineteenth century, admired for his flattering likenesses painted in a fluid, graceful style. An exceedingly prolific artist, he created more than two thousand portraits during his long career and captured on canvas such luminaries as General Andrew Jackson, actress Fanny Kemble, and Queen Victoria. Born in England, Sully immigrated to America with his family in 1792, settling first in Richmond, Virginia. He moved frequently early in life in an attempt to gain painting instruction and commissions. After stays in New York and Boston, where he received some advice from Gilbert Stuart, Sully settled permanently in Philadelphia in 1809. He departed almost immediately thereafter for England to study under Benjamin West (see cat. 2), who in turn referred him to British portraitist Thomas Lawrence. The British painter's influence on Sully was so potent and immediate that he returned to Philadelphia in 1811 as the "American Lawrence."

In addition to his enormous production in portraiture, Sully executed about five hundred subject pictures—landscapes, copies of old masters, and history and literary paintings—some intended as book illustrations or as studies for engravings, others conceived simply as "fancy pictures." This wash drawing illustrates a scene from James Fenimore Cooper's novel *The Pilot,* a tale set during the American Revolution and published in 1823. So far as is known, Sully's drawing, dated 1824 and presented to Philadelphia painter John Neagle three years later, was never published, and its original purpose remains unclear.[1] Sully is known to have completed at least three works inspired by the novel, including a watercolor of Long Tom Coffin that may relate to this wash drawing.[2] Certainly, there would have been demand for images illustrating Cooper's book, which was widely popular in its day and has since been acknowledged as the first American sea adventure tale.

Sully captures one of the book's most dramatic moments—and the incident most favored by illustrators—the wreck of the American schooner *Ariel.* The drawing features the ship's coxswain, Tom Coffin, stretched out on the sorry remains of the vessel, moments before his death at sea. After having saved the captain's life, Coffin resolutely stayed with the ship until the rising waves engulfed it. Shortly before his death the weathered

Nantucket whaler said, "God's will be done with me, . . . I saw the first timber of the *Ariel* laid, and shall live just long enough to see it torn out of her bottom; after which I wish to live no longer."[3] Sully's drawing echoes this mood of solemn resignation. Surrounded by raging surf and with harpoon in hand, the lanky Coffin rests against the torn mast and gazes soberly upward toward his Maker.

Tom Coffin's plight provided Sully with a visually compelling subject that touched on grand themes tantalizing to the romantic imagination of the early nineteenth century. This scene highlights mankind's impotence in the face of the sublime forces of nature and celebrates the redemptive power of Christian faith, as revealed in the simple heart of a rugged coxswain. Given the strong pedagogical underpinnings of art and literature of the period, Coffin's intense loyalty to his ship and brave acceptance of his divinely ordained fate elevated him to the status of moral hero. In terms of its composition and subject, Sully's drawing recalls Théodore Gericault's romantic masterpiece, *The Raft of the Medusa,* 1818–19 (Musée du Louvre, Paris), a theatrical, multifigure work depicting survivors of a shipwreck clinging to a raft in the high seas. This famed, colossal canvas was surely known to Sully through print sources.

The Last Moments of Tom Coffin displays Sully's expert control of the ink wash medium, which well suited his subject. Over mere traces of graphite, he carefully applied ink washes in various dilutions to describe forms and create rich tonal contrasts. Sully reserved portions of the white sheet to suggest the frothy surf and the network of highlights that animate the composition. Finally, with a fine pen and brown ink, he strengthened the outlines of certain details, such as the figure's feet and trousers. Sully employed ink wash for many of his literary subjects, perhaps considering this monochromatic medium more advantageous for possible future translation into engraving and for his immediate aesthetic aims. The absence of color arguably heightens the work's graphic power and its narrative clarity. Sully's fluid washes, ranging from stark black to pale gray, stand as visual equivalents for his sobering themes of death and transcendence at sea.

BJM

5 Attributed to Sarah Goodridge, 1788–1853

Possibly Mary Lane Miltimore Hale, c. 1824–27

Watercolor on ivory, 10 × 7.8 cm (3¹⁵⁄₁₆ × 3 in.)

Gift of Mrs. D. G. Brummett to Dartmouth College Library; transferred 2002; W.999.28.35

PROVENANCE

Mrs. D. G. Brummett; given to Dartmouth College Library, date unknown; transferred to present collection, 2002.

RELATED WORK

The work was donated to the College library along with another miniature attributed to Goodridge (W.999.28.34; see p. 235) that likely depicts Dolly Miltimore Rousseau (b. 1787), sister of Mary Lane Miltimore Hale. The museum also holds an oil portrait by an unknown artist of their father, the Reverend James Miltimore (1755–1836), Class of 1774 (P.945.86), and a miniature by a different hand of their brother, James Miltimore (1789–1852), Class of 1813, non-graduate (W.984.54), the latter also donated by Mrs. D. G. Brummett.

(Miniature shown at actual size.)

Often exchanged as tokens of love or markers of personal rites of passage, miniature portraits more often accentuate a sitter's private persona than professional status. Owing to their diminutive size, they rarely hung in public settings and were better suited to being held in one's hand, worn as jewelry, or displayed unobtrusively in private quarters. Portrait miniatures gained popularity in America during the second half of the eighteenth century and followed the stylistic example of British, rather than Continental, models. Initially enjoyed by an American aristocracy, these precious likenesses became popular among members of an expanding middle class during the prosperous years of the young republic. Following on the heels of such pioneering American miniaturists as Charles Willson Peale, James Peale, John Trumbull, and Edward Green Malbone, Sarah Goodridge attained prominence among a later generation of artists that met the burgeoning demand for miniatures during the first half of the nineteenth century.

In an era when many avenues of art were closed to women, Goodridge's accomplishments in miniature painting distinguished her as one of the most talented female artists of her day. Her success in obtaining commissions to depict illustrious sitters seems especially remarkable in light of her gender and humble origins. Born to a shoemaker in Templeton, Massachusetts, west of Fitchburg, Goodridge received scant formal instruction. She reportedly took some drawing lessons in Boston as a young adult and received instruction from a miniaturist from Hartford, Connecticut, who taught her how to paint on ivory. By 1820 she had opened a studio in Boston and established herself as a miniaturist. A friend introduced her to Boston's preeminent portraitist, Gilbert Stuart, who offered her guidance, allowed her to copy his full-size portraits in miniature, and sat for Goodridge on two occasions.[1] One of the few miniatures attributed to him, an image of General Henry Knox from about 1820 (Worcester Art Museum), is inscribed on its backing paper: "for Miss Sarah Goodridge the miniature painter to show her how to do it."[2] Rather than his rare efforts in miniature, Stuart's flattering yet sufficiently detailed approach to portraiture likely provided the more influential example for Goodridge. Her association with the talented and well-connected Stuart, combined with the relative lack of competition in the field of miniature painting in Boston at that time, no doubt enhanced her ability to make a living from the sale of her captivating likenesses. She remained active through the mid-1840s, when failing eyesight restricted her artistic pursuits.[3]

The graceful turn of the head, frothy, lace-trimmed gown, and rich coloration of this miniature reveal how quickly Goodridge absorbed the lessons of Stuart. Other features point to Goodridge's mature style, such as the rectangular format that she favored and the hatched background that modulates from blues to browns so as to set off variously the sitter's hair, skin, and costume. This work beautifully captures the porcelain-like complexion of the youthful sitter with pale washes overlaid with extremely delicate rose-tinted hatchings that follow the contours of her face. As she did in other works (see cat. 7), she took full advantage of the translucent properties of the ivory support, letting it shine through portions of the composition to create luminous highlights.

This miniature was donated to the College with Miltimore family papers, but the sitter's identity cannot be determined for certain. The most likely subject would be Mary Lane Miltimore Hale (b. 1797), the daughter of Dolly Wiggin (1757–1824) and the Reverend James Miltimore (1755–1836), Dartmouth Class of 1774, who served as a minister in Newbury, Massachusetts, for fifty years beginning in 1808. On the basis of the sitter's hairstyle and clothing, the work would most logically date to 1825–27, when Mary Miltimore would have been in her late twenties or early thirties—conceivably a bit older than the young woman portrayed here. Goodridge may have idealized the sitter's age slightly, while she carefully detailed her fashionable jewelry and elaborate coif.[4] Mary Miltimore married Moses Little Hale of Boston in 1824, making the mid-1820s a natural time for the commissioning of such a portrait. The image's mix of idealism and tangible realism accentuates both the sitter's beauty and her social station, qualities especially valued in a new or prospective wife. As with so many miniatures removed from their original contexts, however, the circumstances surrounding the origins of this work must remain somewhat speculative.

BJM

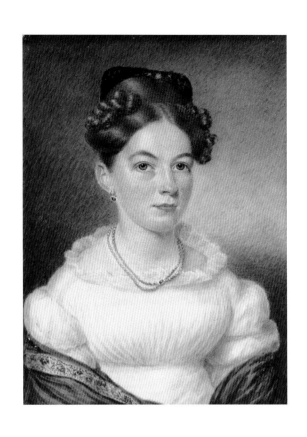

6 Thomas Birch, N.A., 1779–1851

Landscape with a River, 1827

Ink wash over charcoal on laid paper, sheet: 17.8 × 24.7 cm (7 × 9¾ in.); mount: 22.1 × 28.0 cm (8¾ × 11¼ in.)

Signed and dated, lower right: T Birch / 1827; inscribed (probably by John Neagle), on mount, bottom center: Sketch by Thomas Birch 1827. / A composition—

Purchased through the Miriam and Sidney Stoneman Acquisitions Fund; D.999.41

PROVENANCE
The artist; to John Neagle, Philadelphia, 1827; by descent to Neagle's great-granddaughter, Mrs. E. H. Brodhead Jr.; Sotheby's Arcade Auction, New York, "American Paintings, Drawings, and Sculpture," March 25, 1997, lot 108A; to Spanierman Gallery, LLC, New York; sold to present collection, 1999.

Landscape did not emerge as a popular genre in this country until the early years of the new republic. It rose dramatically in popularity and stature by the mid–nineteenth century, owing largely to a widespread romantic identification between the promise of the young nation and its vast natural resources. Before this surge of interest in landscape, which began to take hold in the late 1820s, American forays into the subject tended to fall into one of two categories: the transcriptive view, sometimes made in the service of geographical expeditions; or the romanticized pastoral composition, based less on direct observation than on eighteenth-century European landscape theories.[1]

Thomas Birch's landscapes touched on both of these traditions at various points in his career. Born in England, Birch moved to Philadelphia in 1794 with his father, William Birch, a painter and engraver from whom he received his artistic training. Together they painted topographic cityscapes, several of which were engraved. In the British tradition, the younger Birch also painted numerous Philadelphia estates and public landmarks. By 1811, the first year that the Pennsylvania Academy of the Fine Arts held what came to be an annual exhibition, he had also turned to pure landscape—his efforts in this arena preceding by almost a decade those of his better-known successors, including Thomas Doughty and Thomas Cole. Birch also advanced the rising genre of marine painting. In addition to portraying harbors and seafaring vessels, he gained particular renown for his dramatic images of naval engagements from the War of 1812, storms at sea, and shipwrecks. Birch continued to paint documentary images throughout his career but expressed a more romantic sensibility through his tempestuous marines and such idealized landscapes as this pastoral composition.[2]

In *Landscape with a River* Birch depicts a quiet stream meandering through a rugged boulder-filled foreground to a clearing and wooded hills beyond. The fence that crosses the field provides a subtle, but nonetheless significant, record of human intervention. American artists in the late eighteenth and early nineteenth centuries, like their British counterparts, generally sought out comforting, domesticated landscape vignettes rather than the scenes of a disquieting raw wilderness that would become the mainstay of the nascent Hudson River School. As echoed in this composition, the tamed and improved landscape signified progress and a harmonious relationship between man and nature.

In terms of structure and technique, this wash drawing harkens back to British and ultimately Claudian conceptions of the picturesque. In addition to favoring pastoral motifs, these aesthetic traditions encouraged artists to manipulate landscape elements in order to create the most harmonious composition. Here the country stream, framed by trees on either side, leads our eyes into the distance, with the spatial recession further indicated by the artist's use of progressively more dilute washes and reserves of the white paper toward the horizon. In the hands of another artist the prominent overhanging boulders in the foreground might serve as awe-inspiring invocations of the continent's dramatic geologic past.[3] In *Landscape with a River*, however, they contribute primarily to the formal, rather than symbolic, impact of the work. Their rough projecting contours provide a visual contrast to the otherwise placid scene in a manner advocated by such eighteenth-century British aestheticians as watercolorist William Gilpin, whose treatises on picturesque beauty influenced several generations of artists internationally. With its balance between irregular and regular forms and light and shade, Birch's drawing exhibits the "happy union of simplicity and variety" espoused by Gilpin.[4] Certain idiosyncratic touches, however—such as the jagged cloud forms and the manner in which the cantilevered rock bisects the tree beyond—suggest that Birch had not yet wholly mastered the picturesque formula. The work's first owner, Philadelphia portraitist John Neagle, likely added the inscription on the sheet's mount, "a composition." Such an epithet suggests that even in its own day the drawing was perceived as a synthetic work originating in landscape theory and imagination rather than a sketching excursion. In addition to being familiar with the writings of Gilpin and other British painters and theorists, Birch also came to know old master and contemporary European works through the collection of his father. Unlike most old master drawings that utilize wash, however, this work is delineated in wash alone, without the strengthening lines of pen and ink or other drawing media.

In addition to this landscape drawing, Neagle collected wash drawings by Sully and Charles Robert Leslie also in the museum's collection (see cat. 4 and p. 240) for a scrapbook he compiled of thirty-eight works on paper by various artists, many with ties to Philadelphia. Ranging from landscapes and portraits to literary and mythological subjects, they provide an intriguing snapshot of artistic concerns from that era.[5]

BJM

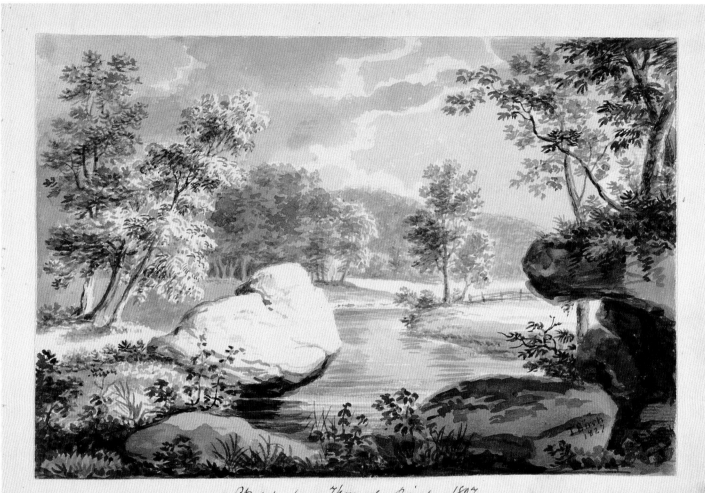

Sketch by Thomas Birch 1827.
A Composition —

7 Sarah Goodridge, 1788–1853

Daniel Webster, c. late 1830s

Watercolor on ivory, 9.0 × 7.0 cm
(3½ × 2¾ in.)

Gift of Edwin Allen Bayley, Class of
1885; W.X.47.1

PROVENANCE
Edwin A. Bayley, Class of 1885, Boston;
given to present collection, 1944.

RELATED WORKS
Goodridge painted as many as twelve
portraits of Webster over the course of
two decades. Among them are an 1827
miniature in the collection of the
Massachusetts Historical Society,
Boston, and an undated miniature
nearly identical to the present example
in the collection of the Mead Art
Museum, Amherst College.

EXHIBITIONS
Hopkins Center Art Galleries, Dart-
mouth College, Hanover, N.H., *Portraits
at Dartmouth*, 1978, no. 45; National
Portrait Gallery, Washington, D.C., *The
Godlike Black Dan: A Selection of Portraits
from Life in Commemoration of the Two
Hundredth Anniversary of the Birth of
Daniel Webster*, 1982, no. 9; Hood
Museum of Art, Dartmouth College,
Hanover, N.H., *From Copley to Dove:
American Drawings and Watercolors at
Dartmouth*, 1989 (no cat.).

REFERENCES
James Barber and Frederick Voss, *The
Godlike Black Dan: A Selection of Portraits
from Life in Commemoration of the Two
Hundredth Anniversary of the Birth of
Daniel Webster* (Washington, D.C.: Pub-
lished for the National Portrait Gallery
by the Smithsonian Institution Press,
1982), 24–25 (illus.), 47; Arthur R. Blu-
menthal, *Portraits at Dartmouth* (Han-
over, N.H.: Dartmouth College Museum
and Galleries, 1978), 52 (illus.).

(Miniature shown at actual size.)

Fig. 53. Sarah Goodridge, *Beauty Revealed
(Self-Portrait)*, 1828, watercolor on ivory,
6.7 x 8.0 cm (2⅝ x 3⅛ in.). The Metropoli-
tan Museum of Art; lent by Gloria Manney,
L.1988.67.74

This is one of several images of famed orator, lawyer, and statesman Daniel Webster (1782–1854) attributed to Boston miniaturist Sarah Goodridge (see cat. 5).[1] Over the course of three decades, Goodridge and Webster developed an es-pecially close relationship, as evidenced not only by the many miniature portraits she painted of him and his family but by the forty-four letters he wrote her between 1827 and 1851.[2] It is hard to be-lieve that the two were not also lovers at one time, given the existence of an extraordinary 1828 miniature that, according to Webster's descen-dants, Goodridge painted of her own breasts and presented to Webster for his eyes only (fig. 53).[3] Such an intimate and explicit love token is ab-solutely unprecedented in the history of Ameri-can art and is all the more stunning in light of restrictive nineteenth-century attitudes toward nudity and sexuality. Aside from their profes-sional association and personal friendship or ro-mance, we also know that Webster frequently turned to Sarah Goodridge—as he did to other close friends—for financial assistance in order to support his extravagant lifestyle. In 1851 he owed her a total of $2,000, only a portion of which could conceivably pertain to outstanding pay-ments for miniatures.[4]

Given Webster's fame, it is not surprising that scores of artists preserved his countenance through oil portraits, prints, and sculptures—all formats well suited for public display. Miniatures, however, often functioned in a more private arena. By virtue of their size, delicacy, and jewel-like presentation, they traditionally served as pri-vate tokens of affection and captured likenesses more tender than imposing. Goodridge offers us a privileged glimpse of a distinguished yet seem-ingly more accessible Webster through her diminutive portrayals of the statesman, who was by all accounts "larger than life."

Goodridge painted her first miniature of Web-ster in 1827 for the family's longtime intimate Eliza Buckminster Lee (Massachusetts Historical Society, Boston). Another, seemingly later, exam-ple at the Mead Art Museum, at Amherst College, descended in the family, not of the sitter, but of the artist, further attesting to their friendship. Unfortunately, the circumstances surrounding the creation of the Dartmouth miniature are un-known, as is its early provenance. It likely dates from the late 1830s, based on comparative images of the statesman.[5] His receding hairline reveals to

some degree his advancing years (he would have been in his fifties in the 1830s), yet his complex-ion remains youthful and vibrant. Although Goodridge flattered him in this regard, she indi-vidualized his features and limned him in a con-ventional pose. The result is a refreshingly sympathetic depiction of a serious but kindly Webster. The image stands in contrast to the many theatrical portrayals of the statesman that attempt to convey—often in an exaggerated man-ner that approaches caricature—his piercing in-telligence and fiery oratorical powers. In similar fashion this likeness differs from Goodridge's 1827 miniature of Webster, which presents a more vigorous and flamboyant figure with tou-sled hair and an intense gaze.

Technically, the miniature reveals Goodridge's extraordinarily refined technique. The translucent ivory support glistens through Webster's rosy flesh tones to create luminous highlights across his cheeks and imposing forehead. Impossibly fine, hairlike strokes and stipples in blue and brown define the jawline and nose and subtly suggest his reemerging beard. More opaque, heavily applied pigments draw attention to his thick eyebrows and penetrating eyes. Utterly con-vincing and beautifully realized, Webster's soulful eyes reveal no individual strokes and thereby no hint of the artist's labors. By contrast, Goodridge shaded the background of this portrait, as she generally did, with more prominent hatchings of brown and blue-gray watercolor that grow lighter and more transparent above the shoulders.

Webster's professional accomplishments in the national arena would have been more than enough to secure his status as one of Dart-mouth's most illustrious alumni (he graduated from the College in 1801). The College commu-nity also claims him, however, as no less than the institution's second founder. In 1819 Webster suc-cessfully argued before the Supreme Court in support of the sanctity of the school's original charter against those who wished to restructure his alma mater as a state university. Over the years, the campus has naturally become a center for Webster studies and for portraits of the orator, most of them donations from Dartmouth alumni. Edwin Allen Bayley, a member of the Class of 1885, bequeathed this miniature to the College, along with nearly two hundred engravings, photo-graphs, paintings, and sculptures of the revered alumnus.

BJM

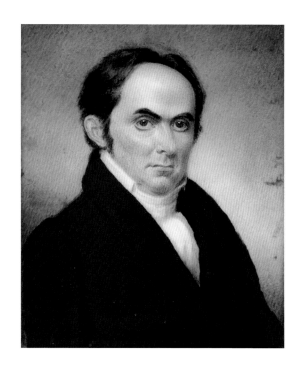

8 Attributed to Ann Frances Ray (Mrs. Gilbert Pillsbury), nineteenth century

Dartmouth College, c. 1840

Transparent and opaque watercolor over graphite indications (with pen-and-ink border) on wove paper, 18.2 × 28.2 cm (7⅛ × 11⅛ in.)

Inscribed, in pencil, on reverse: Dartmouth College / Painted by a Frances Ray (Mrs. A. F. Pillsbury) [not artist's hand]

Purchase made possible through a gift from the Class of 1951, with the assistance of Dartmouth College Library; W.989.15

PROVENANCE
Howard Feldman collection; Hirschl & Adler Folk, New York; sold to present collection, 1989.

Dartmouth Hall (1784–91) and its flanking buildings, Thornton and Wentworth Halls (1828–29), have come to symbolize the institution of Dartmouth College and its long and revered history.[1] Set on a hill overlooking the College green, these buildings stand somewhat isolated from the bustle of campus life, elevated in both physical and symbolic stature. Symmetrically configured and classically inspired, they suggest the lofty aspirations of discipline and self-realization that are central to a liberal arts education. The campus has since expanded dramatically in all directions—often with distinguished structures by notable architects. No other buildings have carried quite the metaphorical resonance or pictorial appeal, however, of this trio of structures known as the old "Dartmouth Row."[2] As a result, this handsome stand of buildings has been rendered in all media and reproduced extensively.

Prints and drawings of varying quality and accuracy recorded the buildings within the first decades following their completion, when Dartmouth Row formed the functional, as well as symbolic, heart of the college. Many of the surviving drawings are by girls or young women who worked from print sources or perhaps in some cases attended nearby female academies and sketched the buildings firsthand.[3] The exercise of drawing Dartmouth Row provided a perfect opportunity to reinforce lessons in perspective and classical proportion and to pay homage to the ambitious educational enterprise for which these buildings stood.

This precisely drawn watercolor is the earliest known depiction of Dartmouth Row after the completion of Reed Hall (1839–40), pictured to the right. The drawing misconstrues to some extent the proportions of the buildings and their windows but otherwise documents the original appearance of the Row with considerable accuracy: Reed Hall, designed by Ammi Burnham Young, is painted yellow, and Dartmouth Hall, white, while Thornton and Wentworth are left in their natural brick.[4] The artist also recorded for posterity more domestic details not usually featured in architectural renderings, such as the configuration of shutters (some open, many closed), and the tie-back curtains in the windows of Thornton and Wentworth Halls. Now academic buildings, these structures initially served as dormitories.

The inscription on the reverse of the watercolor ascribes it to "a Frances Ray (Mrs. A. F. Pillsbury)." An Ann Frances Ray of Ludlow, Massachusetts, married Gilbert Pillsbury (1813–1894), Dartmouth Class of 1841, in November of that year. After marriage the couple taught in private schools in New York City and Somerville, New Jersey, and in 1854 they established the Winding Wave Boarding School for Young Ladies in the artist's native Ludlow (east of Springfield), which they conducted until the outbreak of the Civil War. Mrs. Pillsbury served with her husband as coprincipal of the school and as "teacher of French, German, music, etc."[5]

Ann Frances Ray's accomplishments in watercolor and her pursuit of a teaching career suggest her own high level of education. Born into a prominent Ludlow family, she almost certainly attended a boarding school—or "female seminary," as they were called—as part of the standard upbringing of upper-class women in the early nineteenth century. The academic program she oversaw at Winding Wave School likely mirrored her own training. An 1859 brochure for the school boasted that "all branches, both Useful and Ornamental, which are requisite for a thorough and accomplished Education, can be successfully prosecuted." Not surprisingly, the school offered watercolor instruction among its numerous courses.[6]

Ray used great care and a variety of techniques in this lovingly rendered scene. After lightly outlining the design in graphite, she applied pale blue washes to the sky and Dartmouth Hall, and both thick and transparent applications of watercolor elsewhere. Incredibly fine touches of opaque white pigment indicate the brickwork on Thornton and Wentworth Halls, and somewhat broader applications describe their granite door lintels and windowsills. She achieved delightful textural effects by stippling the walkways to suggest gravel and overlaying faint stripes and squiggles of blue on College Street in the foreground—a treatment more ornamental than realistic. Revealing, perhaps, a familiarity with needlework as well as rudimentary painting techniques, she rendered the tree in the foreground with linear strokes that recall herringbone stitches commonly used in embroidery landscapes of the same period and slightly earlier. The work's feminine technique and domestic details project a warm, inviting atmosphere unusual among the countless surviving images of Dartmouth Row. Perhaps no other depiction conveys as successfully both the College's aspirations and its approachability to students as a home away from home.

BJM

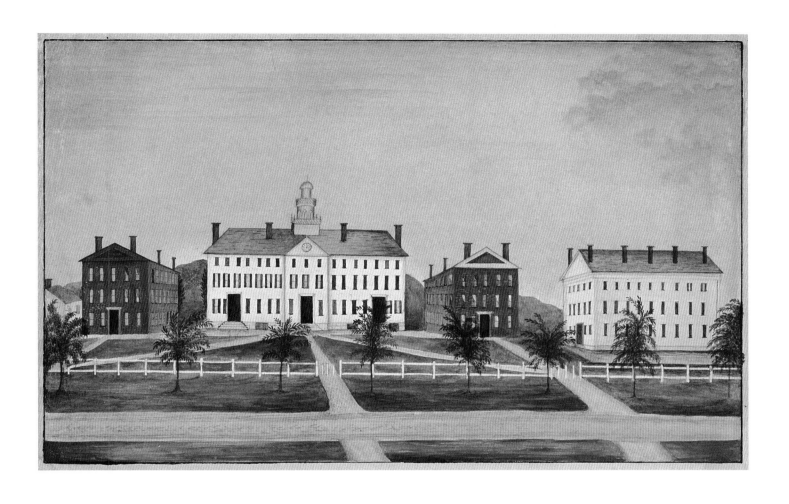

9 Seth Eastman, N.A., 1808–1875

View of Concord, New Hampshire, July 1841

Watercolor over graphite on wove paper, 11.3 × 18.1 cm (4⅜ × 7⅛ in.)

Initialed, titled, and dated, in brown ink, on reverse: View of Concord New Hampshire / July 1841 / S. E.

Purchased through the Julia L. Whittier Fund, W.998.3

PROVENANCE
Estate of the artist; by descent in the family to his great-great-great-grand-daughter, Pamela Miller, 1970s; J. N. Bartfield Fine & Rare Books, New York; W. Graham Arader III (art dealer), Philadelphia; Bruce and Natalie Larson, Williamsburg, Va., 1990; Richard Miller (art dealer), Lebanon, N.H.; sold to present collection, 1998.

It should be little surprise that *View of Concord, New Hampshire,* one of the earliest American watercolor landscapes in the museum's collection, is by a military topographic artist rather than a formally trained easel painter. Admired for its portability, adaptability, and low cost, watercolor had played an important role in the work of artist-explorers at least since the late sixteenth century. By contrast, nineteenth-century landscape painters associated with the Hudson River School, including Thomas Cole and Asher B. Durand, relied heavily on pencil or oil sketches when gathering material for their paintings. No painters from this circle championed watercolor as a medium for sketching or as a serious form of artistic expression. Their contemporaries who worked as survey artists, however, including Titian Ramsay Peale, Charles Deas, Alfred Jacob Miller, Karl Bodmer, and Seth Eastman, exploited transparent watercolor for landscape purposes on a regular basis, particularly when in the field.

Seth Eastman made his reputation primarily as a military topographic artist and as a recorder of Native American life in the western territories. He enrolled at the U.S. Military Academy at West Point in 1824, graduating in 1829. There he undertook early instruction in drawing with Thomas Gimbrede, a French-born miniaturist and engraver. Eastman's first assignments were at Fort Crawford, Wisconsin, and later Fort Snelling, Minnesota. In 1833 orders brought him back to West Point to serve as assistant teacher of drawing, initially under the English painter Charles Robert Leslie and then his successor, Robert M. Weir. Weir was an important influence on Eastman and may have encouraged his efforts in painting. Eastman began to exhibit Hudson River and western landscapes at the National Academy of Design in 1836, and in 1838 he was elected an "honorary member amateur." In 1840 Eastman reported for duty in Florida for the Seminole Campaign, a period during which he produced both landscapes and American Indian scenes, many in watercolor.[1]

It was during a four-month sick leave from his duties in Florida—most of which he spent in Virginia—that he also made the trip north to New Hampshire and painted this watercolor set near Concord, the state's capital.[2] Although Eastman was born in Maine, his father and ancestors hailed from Concord. Seth Eastman was, in fact, a great-great-grandson of Captain Ebenezer Eastman of Haverhill, Massachusetts, who in 1729 was one of the original proprietors of the Plantation of Penacook (later Concord, New Hampshire) and the first moderator and selectman of the town. The artist's wife and children made Concord their home beginning in 1848, while Eastman was out west gathering material for Henry Rowe Schoolcraft's six-volume treatise on Native American life entitled *Historical and Statistical Information Respecting the History, Condition and Prospects of the Indian Tribes of the United States. . . . ,* published in 1851–57. Eastman also made his military headquarters in Concord when he served as lieutenant colonel of the First Infantry during the Civil War.[3]

In composition and technique, this work typifies Eastman's approach to sketching the landscape. He recorded the scene from a hill overlooking an expansive, picturesque valley. Although he inscribed the sheet "View of Concord New Hampshire," the city is barely discernible in the far distance. Eastman focused instead on the circular sweep of the enormous foreground, through which a fence and stands of dark-foliaged trees wind back and forth into the distance. The high horizon, panoramic vista, and animated, peach-toned sky are features of many of Eastman's landscapes, as is the relatively free handling of the watercolor medium. Eastman worked up the composition from lights to darks, beginning with pale washes in the sky and meadow, overlaid with delicate touches of a fine brush to indicate the distant architectural and topographic details. By contrast, he rendered the foreground vegetation with vigorous dabs of a brush laden with more saturated color. Unlike the many topographic artists who created highly detailed images of towns and landscapes, Eastman here relied very little on drawing—either with pencil or brush. His lively paint handling and interest in atmospheric effects point to his later, sweeping landscape studies of the western territories and to an approach toward watercolor that American artists would embrace more extensively in the last quarter of the nineteenth century.

BJM

10 Ann[-e/-ie/-a] Elisabeth L. Hobbs, 1828–1886

The Last of His Tribe (Indian Hunter with Bow), c. 1845–50

Pastel on marble-dusted drawing board, 43.8 × 52.4 cm (17¼ × 20⅝ in.)

Inscribed, in pencil, on reverse (probably not artist's hand): Drawn by / Miss Anna Elizabeth [sic] Lancaster [sic] Hobbs / East Sanbornton / N. H.

Purchased through the Julia L. Whittier Fund; D.961.7

PROVENANCE
Pine Cupboard Antique Shop, Franklin, N.H.; sold to present collection, 1961.

EXHIBITIONS
Dartmouth College Museum and Galleries, Hanover, N.H., *Hail, Holy Land: The Idea of America*, 1980, no. 6 (as *Indian Hunter with Bow*); Currier Gallery of Art, Manchester, N.H., et al., *By Good Hands: New Hampshire Folk Art*, 1989, no. 90 (as *Indian Hunter with Bow*).

REFERENCES
Timothy Burgard et al., *Hail, Holy Land: The Idea of America* (Hanover, N.H.: Dartmouth College Museum and Galleries, 1980), inside cover (illus.) and 32–34; Robert M. Doty, *By Good Hands: New Hampshire Folk Art* (Manchester, N.H.: The Currier Gallery of Art, 1989), 106 (illus.).

Only a few facts are known of Ann (also listed as Anne, Annie, and Anna) E. L. Hobbs, whose only identified works are this pastel and a few elaborately flourished penmanship drawings.[1] She was born in Sanbornton, New Hampshire, and attended the equivalent of secondary school at the New Hampshire Conference Seminary in Northfield (later relocated to Tilton), from which she graduated in 1850. She appears to have taught at several private schools throughout New England and at some point at the Sanbornton district schools. Her longest association, however, was with her alma mater, where she taught Spanish, French, Italian, mathematics, and rhetoric and was named preceptress in 1877. She never married and resided for many years with relatives in Laconia.[2]

Hobbs probably created this lively "sandpaper painting" while a student, perhaps in the late 1840s. Such "paintings" were actually drawings in charcoal or pastel on glittery marble-dusted drawing boards. They provided a staple in the artistic repertoire of young women, particularly those attending female academies. To create the tooth and glint of sandpaper, the support was first coated with white paint, then sprinkled with sifted marble dust. Highlights could be added by applying white chalk or scratching through the charcoal or pastel to reveal the contrasting light ground. Book illustrations and prints provided the inspiration for most of these textured drawings. Hobbs here worked from an engraving by George Loring Brown entitled *The Last of His Tribe* (fig. 54). The engraving accompanied a poem of the same title in the 1838 edition of *The Token and Atlantic Souvenir,* an annual gift book of selected stories and poetry by American authors. The poem recounts the woeful tale of a fictional chieftain, Etlah, who led his people in combat against the "white men," only to suffer the loss of his entire family and tribe. Brown's image corresponds to the poem's last stanza:

> Beneath a tree scathed by the lightning's stroke,
> Meet emblem of his fate, a warrior rests.
> No living heart beats tenderly for him!
> Brothers and kinsmen, sister, wife, and mother,
> All are no more,—his heart is desolate!
> And for the shadowy hunting-grounds he sighs,
> And prays to the Great Spirit for release!
> > 'Tis the aged Etlah,
> > Last of all his tribe!
> > Who remains to cheer him?
> > Who remains to mourn?
>
> > > E. S.[3]

Rather than using a Native American figure as incidental staffage, as did most American roman-

tic landscapists of the period, Brown—and later Hobbs—gave the recumbent Indian particular prominence, thereby accentuating the work's underlying narrative. The poem and image evoke the ubiquitous nineteenth-century conceptions of "the vanishing race"—the belief that Native Americans were doomed to eventual extinction—and the "Noble Savage." Isolated from the corrupting forces of civilization, Hobbs's chieftain occupies a pristine natural setting and proudly displays his native accoutrements. His reclining position conveys both an unself-conscious ease and a sense of a physical and spiritual connection to the earth. That a young woman (or her instructor) in central New Hampshire selected Brown's composition as an artistic subject demonstrates the pervasive appeal of this romantic mythology in the popular imagination.[4]

Hobbs's colorful, stylized rendering of the engraved image gives this work its graphic strength and winning charm. She abbreviated the contours of the hills and clumps of foliage into repetitive patterns of line and texture and used bright primary hues to highlight the figure's clothing. In attempting to depict the folds in the mantle draped over his shoulder, she caused it to resemble the skin of a tiger, thereby heightening the subject's exotic air. Hobbs downplays the mournful narrative implicit in Brown's composition by abandoning his melancholy skyward gaze for a frank look forward, as if assessing the viewer. Such variations from the original—whether intentional or not—distinguish this vernacular drawing from a mere copy and add to its visual appeal.

In creating this work Hobbs drew on the full repertoire of techniques associated with sandpaper or "marble dust" drawings. She made the crisp lines of the bow and arrow by scoring the pastel to reveal the light-colored ground below. She employed the same subtractive method to create clusters of white, cross-stitch-like scratches that echo the print's highlights and enliven the right foreground. Other marks in pastel also resemble common needlework stitches, such as the French knot and the herringbone stitch. The apparent merging of needlework and drawing techniques appears in many other watercolors and drawings by amateur women artists during the first half of the nineteenth century (see cat. 8). The production of embroidered needlework "paintings" formed an important element in the private schooling of upper-class women and may have been part of Hobbs's artistic training as well.

BJM

Fig. 54. George B. Ellis after George Loring Brown, *The Last of His Tribe*, 1838, engraving on paper, 9.4 x 12.1 cm (3¹¹⁄₁₆ x 4¾ in.), published in Samuel G. Goodrich, *The Token and Atlantic Souvenir* (Boston: American Stationers' Company, 1838), opp. p. 277. Collection of Randall L. Holton

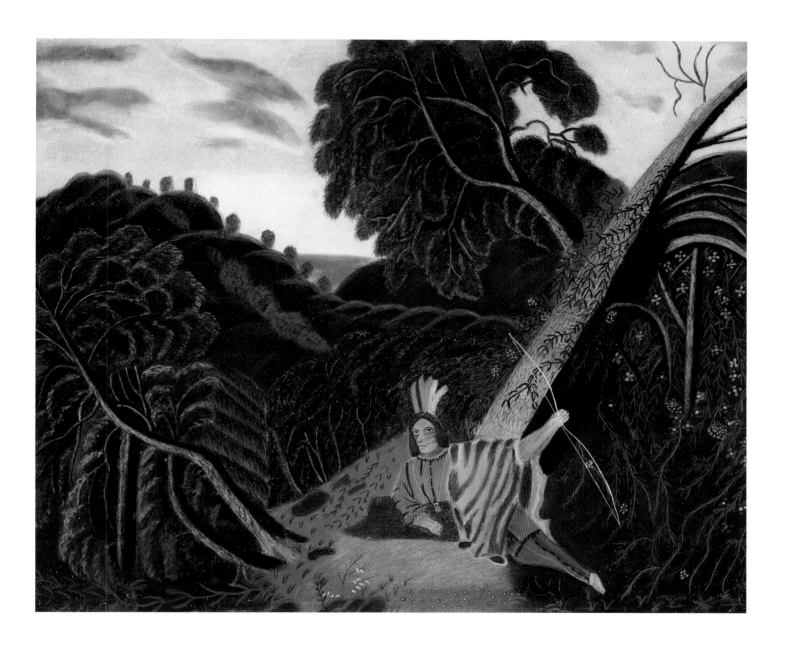

11, 12 C. Burton, nineteenth century

Profile Portrait of a Man, 1847 | *Profile Portrait of a Woman, 1847*

The professional practice of art in nineteenth-century America was not confined to cities. Itinerant portraiture, in particular, flourished early in the century as demand from a burgeoning agrarian middle class steadily increased. Patrons' shared aspiration to "urban gentility in a rural idiom" gave rise to a coherent aesthetic tradition that cultural historian David Jaffee has eloquently termed "village vernacular."[1] Given its clearest written expression by folk artist Rufus Porter in 1825, the mode appealed to "repetition and rule" as the keys to its formal recipe, ensuring a standardized, predictable product that patrons desired.[2] Artists further offered a consistently "correct" representation by the use of various mechanical devices that enabled them to trace their sitter's features, advertising "No Likeness, No Pay."[3] Skill emerged only in the understanding of the proper employment of the technology, and creativity (or the lack thereof) was seemingly obviated. Tightly bound both to Enlightenment principles of scientific objectivity and to Puritanism's distaste for ostentation, this portrait idiom reassured patrons even as it introduced a new, figurative visual tradition to rural America.

Despite the strictures of its theory, nineteenth-century vernacular portraiture was remarkably diverse in its practice. Individual artists' works are often immediately recognizable and are valued today for their inventiveness (ironically enough) and formal strength. The graphite medium of these two drawings, for instance, renders them highly unusual among extant profile portraits of the period, almost all of which are either painted, drawn in polychromatic pastel, or simply cut out as silhouettes.[4] Atypical as they are, the works exhibit a degree of stylistic virtuosity that contradicts the common stereotype that vernacular artists relied almost entirely on mechanical drawing aids rather than artistic skill. Despite the often unique qualities of their work, the nature of their profession has limited our knowledge of their individual lives and largely consigned their works to anonymity. Constantly traveling and therefore carrying little in the way of personal effects, the vast majority of itinerant artists left virtually no written records of their careers and lives. The signature on these two profiles, "C. Burton," may correlate to either of two known Charles Burtons who worked in America during the early nineteenth century, but neither is documented extensively enough to be certain that they

are the same individual as this artist.[5] Despite their biographical lacunae, artists like C. Burton produced portraits that are themselves articulate about the culture in which they lived and worked.

By 1847 C. Burton's art form was widely considered obsolete, yet here we find two exceptionally refined examples. The invention of photography in 1839 and its rapid dissemination in the United States during the early 1840s bankrupted many professional portraitists working in any medium except photography. The accuracy so valued in the vernacular tradition was superseded by the inarguable precision of the photograph. The first victim of the rise of photography was, however, not larger-scale portraiture such as these profiles, but miniature painting, which rivaled the new medium in scale and cost. For public display in the home, large-scale images were still needed and remained both prohibitively expensive and unwieldy in photographic form.[6] For this reason, many portraitists became photographers in the 1840s and complemented their photographic offerings with artistic ones such as these.

The enduring viability of vernacular portrait painting and drawing into midcentury may also testify to an aesthetic resonance beyond its "correctness." Burton's two profiles, probably of a married couple, address one another as well as their viewers. The artist may well have used a mechanical tracing device, camera obscura, or even a photograph as a tool to create these works—as their exceptionally well-proportioned contours and idiosyncratic features suggest—but the shading, patterning, hair treatments, and elaborate backdrops are the artist's own distinctive style. The sweeping curves of the man's hair and the rich laces of the woman's bonnet are painstaking, flattering depictions of the couple's self-presentation and conservative affluence. The dark, cloud-like backdrops, evocative of Burton's now better-known peer Erastus Salisbury Field, accentuate the artist's careful modeling within the figures and project them forward in space by their sharp contrast to the sitter's contours. As the depiction of a couple, their values, and their relationship, Burton's drawings far exceeded the technological capacities of photography in the late 1840s and stress an underlying meaning within their visual tradition that "correctness" alone failed to address.

MDM

13 John William Hill, A.N.A., 1812–1879

High Bridge, c. 1848

Watercolor over graphite on wove paper, 55.8 × 80.9 cm (21¹⁵⁄₁₆ × 31⅞ in.)

Signed, lower right: J. W. Hill.

Purchased through the Katharine T. and Merrill G. Beede 1929 Fund; W.999.6

PROVENANCE
The artist; probably purchased by the American Art-Union, New York, as *High Bridge;* probably Charles D. Rossiter, Brooklyn, N.Y. (received distribution of *High Bridge* from the American Art-Union exhibition by lottery, 1848); Ben Rifkin Fine Arts, c. late 1980s; to Paul W. Worman (art dealer), New York, c. 1990; to Richard York Gallery, New York, c. 1992; to Paul W. Worman, New York; sold to present collection, 1999.

EXHIBITIONS
Probably at the American Art-Union, New York, 1848, no. 84, as *High Bridge;* Hudson River Museum of Westchester, Yonkers, N.Y., *The Old Croton Aqueduct: Rural Resources Meet Urban Needs*, 1992–93 (no cat. no.).

REFERENCES
Bulletin of the American Art-Union, Containing the Plan of the Institution, List of Its Officers, and Catalogue of Paintings and Other Works of Art, no. 5, June 25, 1848, 7, no. 84; Laura Vookles Hardin, "Celebrating the Aqueduct: Pastoral and Urban Ideals," in *The Old Croton Aqueduct: Rural Resources Meet Urban Needs* (Yonkers, N.Y.: Hudson River Museum of Westchester, 1992), 52 (illus.), 63.

John William Hill's extensive work in watercolor made him a pioneer amid the burgeoning interest in the medium that began in the mid–nineteenth century in New York and came to full flower in the following decades. Hill was born in Britain and at the age of seven immigrated to Philadelphia with his family. In 1822 he moved to New York, where for seven years he was apprenticed to his father, John Hill, one of the most important American printmakers of the nineteenth century. The younger Hill probably acquired his predisposition toward watercolor—particularly the well-established British watercolor tradition—from his father and from Irish-born William Guy Wall. Both Hills worked on aquatint plates after Wall's watercolors for his influential *Hudson River Portfolio*, which appeared in 1821–25. John William would have deepened his exposure to British watercolors through his trip to London in 1833 to study the old masters. On his return, he worked as a topographic artist and illustrator through the mid-1840s.[1] In 1850 Hill became a founding member of an important organization to foster the appreciation of watercolor in this country, the Society for the Promotion of Painting in Water Colors, later reconstituted as the New York Water Color Society.

This watercolor features an especially early depiction of the elevated conduit High Bridge, a key component of the Croton aqueduct that conveyed upstate water across the Harlem River to the rapidly growing city of New York. Under construction from 1839 to 1848, High Bridge represented an enormously ambitious and costly engineering project within a much larger, state-of-the-art aqueduct system. Engineer John B. Jervis designed High Bridge in the form of a Roman aqueduct, with stone arches spanning the Harlem River from the Westchester mainland (now the Bronx) to Manhattan at what is now One Hundred Seventy-third Street. A temporary pipe crossing at the Harlem River allowed for the aqueduct to begin its delivery of water in 1842, amid great celebration. The new source of clean water brought with it hopes of increased health, an end to the city's devastating fires, and even a reduction in drunkenness (the theory being that it would no longer be necessary to disguise the water's foul taste with alcohol). Technical difficulties delayed the completion of High Bridge for six more years.[2]

Picturesque in form and rich in cultural associations, High Bridge became a favorite subject for artists up through the early twentieth century.

It provided an identifiably American image but at the same time suggested continuity with great civilizations of the past. John William Hill clearly followed the larger aqueduct project from its inception, having provided two aquatint plates for *Illustrations of the Croton Aqueduct*, an 1843 publication by the project's assistant engineer, Fayette B. Tower.[3] With the production of this watercolor, Hill appears to be the first established artist to depict High Bridge after its completion. Legions of painters followed suit, including such well-known figures as Sanford Robinson Gifford, David Johnson, and, after the turn of the twentieth century, Ernest Lawson, who painted the water-conveying bridge repeatedly in an impressionistic mode. Book illustrations and popular prints of High Bridge, such as the 1849 lithograph published by Currier and Ives, further disseminated images of the majestic span.

Like most of the nineteenth-century painters of High Bridge, John William Hill depicted the bridge comfortably nestled into a larger landscape setting. He thereby emphasized its pictorial rather than technological function. The stone-arched aqueduct's visual references to its Roman antecedents would not have been lost on its early admirers. The ruins of the Claudian aqueduct along the Appian Way had lured artists for centuries and provided a mainstay for mid-nineteenth-century American painters eager to capitalize on the widespread popularity of Italian scenery. Thomas Cole was among the first wave of American landscapists taken with the ancient grandeur of Roman ruins, which he bathed in crepuscular light in his *Aqueduct near Rome*, 1832 (fig. 55). Echoing Cole's romantic portrayal of his subject, Hill rendered High Bridge in soft blue washes that contrast with the earthy tones of the foreground and suggest the structure's distance—perhaps temporally as well as spatially. Veiled in atmosphere, the span appears to have graced this bucolic locale for ages rather than months.

If Hill's aqueduct points simultaneously toward modern technological advances and the classical past, the two figures in the foreground engage in the quotidian rural labor of the artist's own time. Their specific activity and relation to each other are not entirely clear, however. Is this a chance meeting, or do both men accompany the oxen pulling an empty sledge, perhaps in an attempt to smooth the dirt path? If a work team, the European American figure seems to be the supervisor, as he assumes a slightly more dominant po-

sition in the composition, sports a tailcoat, and holds a long stick over his shoulder. The African American laborer holds the whip that drives the oxen.

It is tempting to probe the image for any commentary by Hill on the relation between these two figures and race relations in general, especially given the nation's sectional tensions during this period. Nothing in the artist's career before or after this work, however, would suggest an interest in social issues. Given Hill's background as a topographic artist, he may well have based this vignette on personal observation of an actual scene. The agrarian regions surrounding New York City had supported an especially large African American population dating back to the eighteenth century, when New York State had been the heaviest user of slave labor north of the Mason-Dixon Line.[4] In light of the identifiably New York setting, one could read this as a "Northern"—admittedly Euro-American—view of egalitarian race relations in the free states. Social interpretations aside, however, the image clearly celebrates the pastoral landscape and rustic agricultural labor that had defined early American life but by 1848 was becoming outmoded in the face of industrialization.

The watercolor's large scale and obviously American subject matter made it an ideal work for submission to the influential American Art-Union in New York, which displayed what is almost certainly this work in 1848. The Art-Union

Fig. 55. Thomas Cole, *Aqueduct near Rome*, 1832, oil on canvas, 113.0 x 171.0 cm (44½ x 67¼ in.). Washington University Gallery of Art, St. Louis; University purchase, Bixby Fund, by exchange, 1987

promoted the "advance of American art" and prided itself on presenting paintings that celebrated national subjects and held broad appeal. According to an 1848 account, "the retired merchant from Fifth Avenue, the scholar from the university, the poor workman, the news-boy, the beau and the belle, the clerk with his bundle—all frequent the Art-Union."[5] Supported by subscription fees from members nationwide, the Art-Union supplied them with several benefits for their annual five-dollar fee. These included a subscription to the organization's bulletin, a copy of one or more engravings made after the most highly esteemed paintings shown at the Art-Union's annual exhibition, and a chance to be presented with an original work of art through the institution's annual lottery (the union purchased exhibited works for this purpose).

Hill produced watercolors for the remainder of his career, but his style shifted radically when he came under the influence of John Ruskin about 1855. Deeply inspired by the British aesthetician's famous treatise *Modern Painters,* Hill abandoned the broad washes and wide vistas seen in this and other early works, adopting instead a far tighter, more detailed, and more intimate style that typified the work of the American Pre-Raphaelites. His son, John Henry Hill, carried on his father's work in the Pre-Raphaelite tradition (see cat. 20).

BJM

14 Daniel Huntington, 1816–1906

William Cullen Bryant, Daniel Webster, and Washington Irving, 1852

Graphite and brown and black ink, heightened with white chalk and opaque white watercolor on tan (discolored to brown) illustration board, 33.5 (irreg.) × 44.8 cm (13¼ [irreg.] × 17⅝ in.)

Signed, dated, and inscribed, in ink, lower right: D. Huntington del / at Cooper Festival / 24 Feby 1852 / Irving Webster & Bryant [last two names in graphite; "Irving" written in ink over area of the board that has been scraped down]

Dartmouth College Library; D.968.66

PROVENANCE
Dartmouth College Library by 1968.

RELATED WORKS
Albumen print(?) of the drawing by "Huffnagel" published by G. P. Putnam, New York, 1860 (Dartmouth College Library). Undated print (unidentified technique) "reproduced from a sketch by Dan Huntington through the kindness of Mr. F. H. Day (of Messrs. Copeland & Day), Boston" (Dartmouth College Library).

EXHIBITIONS
Dodworth's Hall, New York City, "Artists Reception," March 1860; National Portrait Gallery, Washington, D.C., *The Godlike Black Dan: A Selection of Portraits from Life in Commemoration of the Two Hundredth Anniversary of the Birth of Daniel Webster*, 1982, no. 17; Hood Museum of Art, Dartmouth College, Hanover, N.H., *From Copley to Dove: American Drawings and Watercolors at Dartmouth*, 1989 (no cat.).

REFERENCES
"The Last Artists Reception for the Season," *New-York Tribune*, March 2, 1860, sec. 5, 6; *New-York Tribune*, March 6, 1860, sec. 6, 6; "Art Items," *New-York Tribune*, March 10, 1860, sec. 6, 5–6; James Barber and Frederick Voss, *The Godlike Black Dan: A Selection of Portraits from Life in Commemoration of the Two Hundredth Anniversary of the Birth of Daniel Webster* (Washington, D.C.: Published for the National Portrait Gallery by the Smithsonian Institution Press, 1982), 47.

In this work Daniel Huntington, master of the formal portrait, reveals his ability to render convincingly three of America's best-known cultural figures in an unusually candid, documentary fashion, much in the manner of photography. Pictured here are the poet William Cullen Bryant (at left), United States senator and orator Daniel Webster (center), and novelist Washington Irving (right).[1] Huntington captured the luminaries seated at a testimonial meeting held in New York City on February 25, 1852, to honor the memory of James Fenimore Cooper, who had died the previous September.[2] Cooper, author of such popular works as *The Last of the Mohicans*, *The Deerslayer*, and *The Pilot* (see entry for cat. 4), was already held in high esteem as the first important American novelist. Irving, Webster, and Bryant all played key roles in the Cooper event. Irving chaired the memorial effort, Webster commemorated Cooper in what would be his last major address (Webster died later that year), and Bryant, who in the drawing holds a sheaf of papers penciled "Cooper Address," spoke on the "Life, Character, and Genius of James Fenimore Cooper." He concluded by describing the nation's feeling of loss on the author's death: "It was as if an earthquake had shaken the ground on which we stood, and showed the grave opening by our path."[3]

Although Huntington may have drawn this group portrait as a personal souvenir of the historic evening, it seems more likely that he created it for publication. G. P. Putnam—who published the meeting's proceedings, served on its planning committee, and had issued many works by New York's so-called Knickerbocker writers—may have commissioned the drawing. His publishing firm appears not to have reproduced it until 1860, however (see Related Works above), the same year the drawing was exhibited at an "Artists Reception" at Dodworth's Hall in New York.[4] Aside from the still undetermined circumstances surrounding this work's creation, the study remains an anomaly in Huntington's career. The many portrait drawings that survive in the artist's sketchbooks and elsewhere are generally preparatory works related to his formal portraits in oil. He was not widely known for the sort of reportage sketching represented by this sheet.[5]

There is no question that Huntington, a prominent figure in the cultural and social circles of New York, would have attended the illustrious Cooper gathering, with or without a drawing

commission in hand.[6] Talented, well trained, and well connected through his distinguished family, Huntington had already established himself as the preeminent portraitist of New York's social elite, following his initial success as a landscape and history painter. He undoubtedly was acquainted with all three sitters, especially Bryant.[7] Many New York artists, particularly the Hudson River landscapists, felt a special kinship with the romantic nature poet and socialized with him through the Sketch Club. This convivial association of artists, writers, and art enthusiasts met on a regular basis for socializing and occasional sketching and writing.[8] Huntington joined the group in 1847, when it became the more staid Century Association, and presided over the organization from 1879 to 1895. He would assume an increasingly prominent position in New York's artistic establishment, holding lengthy terms as president of the National Academy of Design and as vice president of the Metropolitan Museum of Art.[9] During his auspicious career Huntington painted more than one thousand portraits, including one of Bryant in 1866 (Brooklyn Museum of Art).

In this drawing, Huntington renders his celebrated subjects with a vivid naturalism that captures them in an informal, almost snapshotlike, pose. An alert Bryant appears perched on his seat, perhaps ready to stand and address the crowd. Webster, with arms and legs crossed, anchors the center of the composition and seems more contained, even sullen. His serious demeanor recalls many of the widely circulated images of the orator—many of them based on daguerreotypes—that may have informed this likeness. Irving, by contrast, wears a relaxed, genial expression and rests against the sofa in perfect ease. Huntington convincingly modeled the features of the men with fine hatchings of pen and ink, while he rendered their clothing more broadly and only partially indicated the contours of the sofa. Because the acidic support for this drawing has darkened over time, the white highlights today stand out more than initially intended, giving the distinguished figures an unfortunate spectral pallor. This alone detracts from the striking verisimilitude of this accomplished group portrait, which reflects a level of detail and candor consonant with the recent proliferation of photography.

BJM

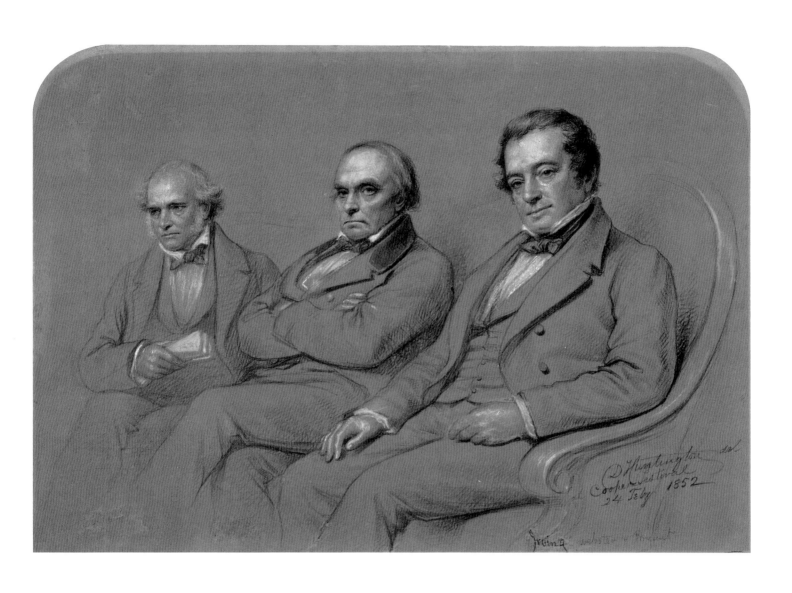

15 James Bard, 1815–1897

The Steamer, Menemon Sanford, 1854–55

Graphite heightened with watercolor and white chalk on wove paper, 67.8 × 119.4 cm (26¾ × 47 in.)

Signed and inscribed, lower right: DRAWN & PAINTED. BY JAMES BARD. NY / 162 PERRY ST; signed and inscribed, across top: The Steamer Menemon Sanford. Built under the superintendence of Charles B. Sanford—Commander / John Englis Builder N.Y. 1854. [ornamental device] J. D. Comstock, Purser [ornamental device] Picture Drawn & Painted JAMES BARD. N.Y. 162 PERRY ST. / Guion.[?] Boardman & Co Engine Builders. Neptune Iron Works N.Y. [ornamental device] Hiram Perry Joiner N.Y. [ornamental device] John A. Boutelle Ship Painter N.Y.

Purchased through the Julia L. Whittier Fund; D.964.133

RELATED WORK
James Bard, Menemon Sanford, 1855, oil on canvas, 29¾ × 50¾ in., collection of Mr. and Mrs. Everett F. Britz Jr. (fig. 56; reproduced in color in A. J. Peluso Jr., J. & J. Bard: Picture Painters [New York: Hudson River Press, 1977], 28).

PROVENANCE
Kennedy Galleries, Inc., New York; sold to Terry DeLapp Gallery, Los Angeles; sold to present collection, 1964.

EXHIBITIONS
Hopkins Center Art Galleries, Dartmouth College, Hanover, N.H., *Nineteenth-Century American Drawings*, 1976 (no cat.); The Hudson River Museum, Yonkers, N.Y., *J. & J. Bard: Picture Painters*, 1977 ("newspaper catalogue" reproducing Jean Lipman, "The Hudson River Museum: J. & J. Bard, Picture Painters, 5 June–11 September," *New York Times*, June 5, 1977 [no checklist or reference to this work]).

REFERENCES
George Hilton, *The Night Boat* (Berkeley, Calif.: Howell-North Books, 1968), 100 (illus.) (caption erroneously notes owner as "Mariners Museum"); A. J. Peluso Jr., *J. & J. Bard: Picture Painters* (New York: Hudson River Press, 1977), 57 (illus.).

James Bard made a specialty of rendering the steamships, schooners, and yachts that plied the Hudson River and Long Island Sound during the mid–nineteenth century. He initially worked in partnership with his twin brother, John, with whom he produced fairly rudimentary watercolors of steamships in the 1830s. By the 1840s the Bard brothers had refined their technique and adopted oil on canvas as their primary medium. Their partnership dissolved about 1849, but James Bard continued to paint successfully on his own for the next four decades, portraying with remarkable clarity the steamboats that so fascinated his generation.[1] Over this period, he established a remarkable network of patrons among New York's most prominent shipbuilders, captains, and -owners (including Cornelius Vanderbilt)—clients who repeatedly commissioned him to depict their prized vessels.

This is one of relatively few full-size, highly finished steamship drawings by James Bard. He most likely presented it to his shipbuilding client John Englis, of Greenpoint, New York, as a means of clinching a commission and approximating the appearance of the eventual painting of the same subject (fig. 56).[2] It is not known if Bard studied naval architectural drawing, but, as seen here, he somehow acquired the ability to draw with great accuracy and confidence.[3] In this work he probably relied on rudimentary drafting aids, such as triangles and T squares, to outline the steamer, while he used a softer, freehand approach in rendering the water and the delicate stream of smoke trailing behind the ship's stack. Departing from his linear manner, he rendered this evanescent effect of vapor by rubbing traces of graphite into the sheet. At the base of the paddle box, he scraped away at the paper and applied white chalk to suggest the frothy water churned up by the paddle wheel. Despite these restrained textural effects, the overall impact of the work is decorative and flat, with minimal shading. As in almost all of his works, he populated the deck with rather crudely drawn men in dark frock coats and top hats. Generally portrayed out of scale with their ships, these curious figures serve nonetheless as rhythmic visual accents and add a note of conviviality to Bard's exacting compositions.

Despite his individualistic style and lack of academic training, Bard reveals through his work a familiarity with long-standing traditions in maritime painting and printmaking. His water-level perspective and decorative inscriptions recall eighteenth- and nineteenth-century European prints of maritime vessels, examples of which he would surely have seen. Even his somewhat idiosyncratic signature, "drawn and painted by James Bard," echoes a common printmaking practice in which more than one individual is responsible for the work: the artist who provides the design, and the printmaker who executes the design on the stone or plate. Bard's standard signature, as seen here, leaves no doubt that he created his works from start to finish. (For the convenience of potential clients, he included his street address as well.) His linear, profile views also echo the images of steamships that ornamented contemporary broadsides advertising the various boat lines and their schedules. In addition to print conventions, Bard knew the work of other American artists who specialized in ship portraits during the second half of the nineteenth century, most notably James Buttersworth and Antonio Jacobsen. The three artists were acquainted but did not compete with one another directly. Bard depicted inland steamers, Jacobsen specialized in transatlantic steamers, and Buttersworth captured the yachting market.

Named for a steamboat magnate of the day, the *Menemon Sanford* was built in 1854 by the John Englis shipyard for E. H. Sanford's New York and Philadelphia Line via the Delaware Capes. Business in this division did not live up to expectations, however, and in 1856 the firm transferred this steamer and the others to the Boston and Bangor run, where Sanford had begun his business. After running aground in the northern waters on two occasions—fortunately incurring minimal damage—the *Menemon Sanford* met her final demise in 1862, while chartered by the U.S. War Department. She ran clear into the Carysfort Reef off the Florida Keys in broad daylight and, after safe removal of her passengers, disintegrated in the surf. As recounted by steamboat historian Erik Heyl, "Naval officers generally were of the opinion that the *Menemon Sanford* had either been steered deliberately onto the reef by her pilot, who was suspected of being a Southern sympathizer, or that there was gross negligence on the part of her navigator."[4]

BJM

Fig. 56. James Bard, *The Steamer: Menemon Sanford*, 1855, oil on canvas, 75.6 x 128.9 cm (29¾ x 50¾ in.). Collection of Mr. and Mrs. Everett F. Britz Jr.

The Steamer *Menemon Sanford*. Built under the superintendence of **Charles B. Sanford** Commander
John Englis Builder N.Y. 1854. S. D. Comstock Purser. Picture Drawn & Painted JAMES BARD N.Y.
James Breedman & Co Engine Builders Neptune Iron Works N.Y. Hiram Ferry Joiner N.Y. John E. Boutelle Ship Painter N.Y.

16 William Trost Richards, N.A., 1833–1905

Palms, 1856

Graphite on wove paper, 18.5 × 18.3 cm (7⅜ × 7¼ in.)

Dated, lower right: Jan 1856; on reverse of sheet is a faint graphite sketch of lake scenery, with smaller inset sketch of trees on a bank, above a stream

Purchased through a gift from the estate of Josephine P. Albright; D.997.12

RELATED WORK
The previous month Richards executed a larger and even more fastidious drawing of palms, with numerous notations (The Metropolitan Museum of Art, New York, reproduced in Kevin J. Avery and Claire A. Conway, *American Drawings and Watercolors in The Metropolitan Museum of Art* (New Haven: Yale University Press, 2002), 261 (color illus.). Both drawings were once in a scrapbook assembled by the artist.

PROVENANCE
The artist; to Theodore Richards (son); to Grace Thayer Richards (daughter); to Ellen and Theodore Richards Conant (son and daughter-in-law), c. 1980; to Beacon Hill Fine Art, New York, 1997; sold to present collection, 1997.

EXHIBITION
Beacon Hill Fine Art (in association with Jill Newhouse), New York, *William Trost Richards: Rediscovered / Oils, Watercolors, and Drawings from the Artist's Family*, 1997, no. 7.

REFERENCE
Beacon Hill Fine Art (in association with Jill Newhouse), *William Trost Richards: Rediscovered / Oils, Watercolors, and Drawings from the Artist's Family* (New York: Beacon Hill Fine Art, 1997), 1, 32 (illus.).

Fig. 57. William Trost Richards, *Along the River*, c. 1860 (p. 243). Hood Museum of Art, Dartmouth College; gift of Ellen and Theodore Conant, in memory of Grace Richards Conant; D.996.35

William Trost Richards was one of the most talented and indefatigable American draftsmen of the nineteenth century. Drawing was central to his art, beginning with his early work as a designer and illustrator of ornamental metalwork in Philadelphia in the early 1850s, encompassing his countless sketching forays during succeeding decades, and continuing through the 1890s, when he would block out his marine compositions in small pencil sketches. Few artists have left such a large and impressive legacy of works in graphite, including both sketchbooks and individual sheets. During an era in which pencil sketches were considered ancillary to paintings and generally escaped public notice, Richards's accomplishments in the medium attracted praise. The critic George Sheldon, for instance, wrote in 1879 that "the trained and honest pencil of Mr. Richards has secured him the very hearty respect of many competent connoisseurs."[1]

By the time Richards produced this drawing in the mid-1850s, he was beginning to absorb the Pre-Raphaelite precepts of British aesthetician John Ruskin, who espoused the virtues of humble natural subjects drawn with painstaking realism. Richards became one of Ruskin's most passionate American adherents, as evidenced particularly by the detailed plant studies he created between about 1858 and 1865. Aside from the important influence of the Pre-Raphaelite movement, however, the artist's tendency to particularize detail had earlier roots in his artistic training in Philadelphia, and in his long-standing and deep devotion to nature. Linda Ferber has noted that Richards's intense brand of realism began with his early work as a designer and illustrator of metalwork, from about 1850 to 1853. Already committed to landscape by this time, he would take every opportunity to break from the "tedious life of an ornamental copyist" and sketch along the banks of the nearby Schuylkill and Wissahickon Rivers.[2] He honed his drafting skills further through studies with Paul Weber, a German painter of landscapes and portraits who had immigrated to Philadelphia in 1848. Weber's fastidious graphic technique characterized midcentury German art and influenced not only Richards but also Weber's other Philadelphia students, including William Stanley Haseltine. Encouraged by his teacher, Richards began to venture farther afield in pursuit of landscape subjects. In 1853, for instance, he made a three-week pilgrimage to the Catskills, the famous painting grounds of the Hudson River School artists he so admired, especially Thomas Cole and Frederic Edwin Church. Richards shared with these influential celebrants of the American landscape a devout, moralizing attitude toward nature that fueled his artistic mission.

Richards produced this drawing during the winter of 1855–56 in Florence, where, like many American artists traveling abroad, he aspired to complete "another stage of Artistic education."[3] He intended to study the figure, but as seen in this work and numerous sketches of the local landscape, his passion for nature often steered his artistic efforts elsewhere. He was clearly captivated by this clump of palms, which he scrupulously observed, presumably in a local conservatory. The drawing's dense arrangement of spiky leaves—some thrusting upward, others bent over—creates a flickering play of light and shadow that animates this richly textured study. Viewed from below and filling the sheet without any clear reference to scale, the fronds take on a monumental quality and resemble majestic, tree-like forms. The artist's close perspective and precise delineation of the palm leaves reveal his fascination with the plant's botanical structure. In the more abbreviated and tonal rendering of the undergrowth, however, the composition stops short of the uniformly sharp focus associated with his more fully developed Pre-Raphaelite style. Nonetheless, this masterful sheet presages future directions in Richards's work and reflects the quiet awe with which he viewed the natural world throughout his career.

Richards's style became even more "Ruskinian" by about 1860, as can be seen in another meticulously detailed drawing in the museum's collection (fig. 57). Its round-arched format evokes the sense of an ecclesiastical window or a vaulted cathedral and makes even more explicit the artist's worshipful view of nature.[4] In March 1863 Richards was elected to membership in the newly formed Association for the Advancement of Truth in Art, an American counterpart to the British Pre-Raphaelite Brotherhood of 1848. He soon became the most widely known American artist associated with the movement.[5]

BJM

Jan 1856

17 Eastman Johnson, N.A., 1824–1906

The Album, 1859

Charcoal on wove paper, 33.5 × 38.0 cm (13⅛ × 15 in.)

Signed, lower right: E. Johnson [slight traces of artist's initials, just below signature: E. J.]; inscribed, in graphite, lower margin: Dessiné Par E. Johnson en 1859, Encadré a chez Mr.[?] Goupil a New-york Par J. Labarriere[?] Juillet 5; [Drawn by E. Johnson in 1859 Framed at Mr.(?) Goupil's in New York by J. Labarriere(?) July 5]; [additional, partially legible framing notations along lower and right edges of sheet]

Purchased through the Katharine T. and Merrill G. Beede 1929 Fund; D.2003.17

PROVENANCE
Kennedy Galleries, New York, 1972; Richard and Gloria Manney, New York; sold to private collection, Beverly Hills, Calif., 1999; consigned to Debra Force Fine Art, Inc., New York, 2000; sold to present collection, 2003.

RELATED WORKS
The Picture Book, 1855, graphite on brown paper, 11½ × 13⅛ in., Christie's, New York, sale no. 5472, December 9, 1983, lot 23; *The Art Lover,* 1859, oil on canvas, 12⅜ × 15½ in., National Academy Museum of Fine Arts, New York.

EXHIBITION
Kennedy Galleries, New York, *American Masters, 18th and 19th Centuries,* 1972, no. 41.

PUBLICATIONS
Kennedy Galleries, New York, *American Masters, 18th and 19th Centuries,* March 22–April 8, 1972, 44, no. 41 (illus.); David B. Dearinger, catalogue entry on *The Art Lover* in Abigail Booth Gerdts, *An American Collection: Painting and Sculpture from the National Academy of Design* (New York: National Academy of Design, 1989), 34.

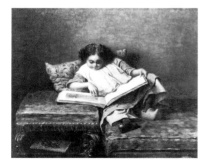

Fig. 58. Eastman Johnson, *The Art Lover,* n.d., oil on canvas, 31.4 x 39.4 cm (12⅜ x 15½ in.). National Academy Museum, New York; bequest of James A. Suydam, 1865, 670-P

In *The Album,* Eastman Johnson conveys a romantic appreciation for both the innocence of childhood and the Dutch culture that he so warmly embraced during his four-year stay in The Hague in the mid-1850s. Johnson executed this drawing and a painted version of the same subject (fig. 58) in New York in 1859, and both works were presumably based on an 1855 drawing of a Dutch child that he produced in The Hague (*The Picture Book,* 1855, see Related Works). Johnson's repeated production of this theme suggests that its subject matter and exquisitely detailed realism may have held commercial as well as personal appeal.[1] Executed in the extraordinary chiaroscuro charcoal or "crayon" technique for which Johnson first gained acclaim, this work recalls his early successes in the medium and demonstrates an increased mastery he owed to his sustained contact with both seventeenth-century and contemporary Dutch art.[2]

Johnson first displayed his exceptional talent for drawing as a youth in Maine. After two years of working in a Boston lithography shop beginning about 1840, he established his reputation as a portrait artist in crayon back in Augusta and Portland. As a writer for the *Portland Advertiser* observed in 1845, "Considering the extreme simplicity of [Johnson's] process, for he uses only black crayon, with very little white for lights, the results are extraordinary. . . ."[3] The following year, while in Washington, D.C., and Boston, he portrayed some of his most distinguished sitters, including Dolley Madison, John Quincy Adams, Henry Wadsworth Longfellow, and Ralph Waldo Emerson. Despite these successes, Johnson yearned for further study and in 1849 sailed for Düsseldorf, where he studied in the atelier of American painter Emanuel Leutze. Wishing "to see the fine pictures of Holland," he traveled to The Hague in 1851—a stay that extended into several years' duration.[4]

Johnson's contact with Dutch art—by both the old masters and contemporary realists—heightened his sensitivity to lighting effects, broadened his handling, and encouraged his exploration of introspective figure subjects. His familiarity with Dutch painting shaped not only his work of the 1850s but his later light-bathed interiors and meticulous transcriptions of the most humble material objects. In achieving his realism, Johnson moved away from the hard-edged delineation associated with the Düsseldorf School in his paintings and drawings, creating a softer yet still precise description of form through gradations of value. In this work, he covered the sheet with light charcoal strokes to create overall tone, and then articulated the forms further with darker black strokes and deft erasures. Although the drawing's original function remains unclear, its signature, clearly defined edges, and high degree of finish throughout suggest that Johnson intended it as a complete work in itself.[5]

Aside from its technical achievements, *The Album* effectively captures both the youthful abandon and the innate, developing intelligence associated with children. The girl has kicked off one of her clogs (revealing the stocking's worn toe) and reclines in a delightfully unself-conscious pose. The shoeless—or partially shoeless—child was a familiar motif in romantic images of children, conveying their freedom from some of the trappings of adult propriety and their closer proximity to a natural state.[6] This child's physical abandon contrasts with her seemingly complete absorption in viewing the art album before her. Her unusually refined fingers press delicately against the volume, almost as if physically absorbing information from the page. The visual and intellectual similarities between viewing a picture book and reading link this work to many later compositions by the artist on the theme, particularly children reading or being read to.[7] In the eyes of Johnson and his audience, such images of intellectually engaged children gave hope for a new generation of enlightened adults—in this case, a class of future art patrons as well.

The child's wooden clogs, smock, and traditional foot warmer clearly place the scene in Holland—an association that would have resonated with Johnson's New York audience. Aside from aspiring artists, a wider public admired and identified with Dutch culture, perhaps owing to the social and political parallels between the seventeenth-century Dutch republic and nineteenth-century America.[8] This image dates to a period in which depictions of everyday life in other cultures also provided a novelty and, as Elizabeth Johns argues, a distraction for the social tensions conveyed in many earlier American genre images.[9] This work would have been perceived, therefore, as mildly exotic in its allusions to Dutch material culture and reassuringly familiar in its celebration of themes universal to middle-class childhood.

BJM

18 Martin Johnson Heade, 1819–1904

Two Studies of Islands from *The Thousand Islands Sketchbook*, c. 1860

Graphite on wove paper, 16.2 × 25.7 cm
(6⅜ × 10⅛ in.)

Inscribed, center right: Thousand Islands; center left: 25 ft. long; upper right, within island: very near; numbered, upper right (by Spanierman Gallery): 5 [encircled]

Purchased through the Julia L. Whittier Fund; D.999.40

PROVENANCE
The artist; by descent to Sam Heed (the artist's nephew), Lumberville, Pa.; to Mrs. Elsie Heed Housley (his daughter), Lumberville, Pa., until 1969; to Ross Kepler, N.J., until 1993; Sotheby's, New York, "American Paintings, Drawings, and Sculpture," May 27, 1993, in lot 202, as the Housley Sketchbook; sold to Spanierman Gallery, New York, 1993; sold to present collection, 1999.

REFERENCES
Theodore E. Stebbins Jr., *The Life and Works of Martin Johnson Heade* (New Haven: Yale University Press, 1975), 290, no. 398.3; Theodore E. Stebbins Jr., *The Life and Works of Martin Johnson Heade: A Critical Analysis and Catalogue Raisonné* (New Haven: Yale University Press, 2000), 360, no. 622.3.

In the summer of 1860 Martin Johnson Heade embarked on an extended journey through New England in search of subject matter for his paintings. The trip bore the hallmarks of a voyage of self-discovery for an artist who undertook landscape painting in earnest only the year before. As he traveled through Vermont's majestic Green Mountains, Heade remarked, "It's a little singular that I've seen nothing yet that I cared to sketch!"[1] Not until he had traversed the state's mountainous terrain and arrived on the banks of Lake Champlain and, later, New York's Thousand Islands did he find inspiration. His experience of New England's flatter shoreline topography reinforced his predisposition toward low-lying, expansive landscape features, which was very different from the prevailing taste of many of his peers in New York City, including Frederic Edwin Church and Albert Bierstadt, who generally depicted grandiose mountain scenery viewed from high above.[2] Along the waterways of the Thousand Islands, located in the St. Lawrence River at the outlet of Lake Ontario, Heade wrote, "I've seen a great deal of the scenery here, & have made some studies — enough for all my purposes."[3]

When working outdoors, Heade sometimes preferred to focus his energies on form and composition rather than color and light. His *Two Studies of Islands* bears no color indications at all, suggesting that the luminous atmosphere for which Heade's landscape paintings, such as *Dawn* (1862, fig. 59), are best known today was often a later studio contrivance.[4] The artist's only written notations on this drawing describe scale ("25 ft."), proximity ("very near"), and location ("Thousand Islands"). Perspective was arguably his central concern in both of these studies, which are organized into two separate visual registers on the page, very different from his clearly integrated aerial landscapes. Both scenes are viewed from a low, "worm's-eye" vantage, accentuating the islands' profiles rather than their recession into space.[5] Again, this may have constituted part of Heade's exploration of the for-

mal aspects of landscape painting. Unlike portraiture, which he had already practiced for twenty years before he "successfully reinvented himself" as a landscapist, Heade's new genre required a considerable awareness of the laws of spatial recession.[6] By lowering his vantage point, the artist could treat topographical features as compartmentalized elements — isolated by water below and sky above — independent entities separated from their specific contexts. The result, however, is that islands and peninsulas appear remarkably two-dimensional in many of his early painted landscapes, such as *Dawn*. As a largely self-taught artist, Heade relied on his own ingenuity to simplify the inordinate spatial complexity of landscape. *Two Studies of Islands* shows one of the tools, compartmentalization, that he employed in that effort.

In this drawing, winnowed of recession, color, and atmosphere, Heade was able to concentrate on line, shadow, and form. The low, rounded geological formations of the Thousand Islands, punctuated by pines and dwarf vegetation, offered the artist an amply diverse array of scenery to study. This modest, nuanced scenery conveys a sense of intimacy and quietude even without reference to weather.[7] The islands' attenuated fingers in the upper register reach toward one another in the center of the composition, emphasizing the lateral movement that is characteristic of Heade's art more generally. The agitation of his pencil strokes also expresses a sense of specificity and detail in every rock, hill, and tree, rather than generalizing the features into a single broad, sweeping contour. That slight arrhythmia in Heade's handling complements the asymmetry of the landscape itself — trees grow only at the left, with no corresponding, counterbalancing vegetation at the right. His painted landscapes of this period, like his drawings, are noted for their intense specificity. In his selection of the Thousand Islands landscape, among other waterfront subjects, Heade made explicit his awareness of landscape's expressive potential.

MDM

Fig. 59. Martin Johnson Heade, *Dawn*, 1862, oil on canvas, 31.1 × 61.6 cm (12¼ × 24¼ in.). Museum of Fine Arts, Boston; gift of Maxim Karolik for the M. and M. Karolik Collection of American Paintings, 1815–1865, 47.1143. Photograph © 2004 Museum of Fine Arts, Boston

Thousand Islands

25 yds long

19 Thomas Nast, 1840–1902

Illustration for Edgar Allan Poe's "The Raven," 1862

Brush and ink and white opaque water-color over graphite on wove paper, sheet: 21.6 × 21.6 cm (8½ × 8½ in.); mount: 31.1 × 25.2 cm (12¼ × 9⅞ in.)

Signed and dated, lower left: Th. Nast / July 30, 1862

Purchased through the Julia L. Whittier Fund; D.944.31.2

PROVENANCE
Sold to Cora McDevitt Wilson (art dealer), Hanover, N.H.; sold to present collection, 1944.

RELATED WORKS
Three other watercolor illustrations of "The Raven" by Nast in the collection of the Hood Museum Museum of Art (see pp. 241–42).

By the summer of 1862, when Thomas Nast drew the set of four illustrations of Edgar Allan Poe's famous poem "The Raven" now in the collection of the Hood Museum of Art, America was fully and bitterly embroiled in civil war. Within months, Nast would become one of the Union's leading propagandists, but he remained as yet outside the public spotlight. It was at this moment that the New York magazine *Harper's Weekly* hired him as an illustrator. "And so, quietly enough, began a pictorial epoch which was to endure almost unbrokenly for a quarter of a century and stand in history without parallel in the combined career of any man and publication."[1] That bold estimation, made in 1904 by Nast's authoritative biographer, Albert Bigelow Paine, remains unchallenged. Nast and *Harper's Weekly* became synonymous during the Civil War and in subsequent decades as the artist did battle with corruption and malfeasance by politicians and industrialists alike throughout the nation. In 1862, however, having been married only a year and with his first child newly born, the artist kept his priorities close to home. His wife reportedly read to him as he worked in their New York apartment, which he preferred to the *Harper's* offices.[2] Perhaps one of her readings was Poe's "The Raven," first published in 1845 and soon hailed as a poetic masterwork.

As the work of a relatively inexperienced young artist, Nast's illustration of the second stanza of "The Raven" offers a bold departure from Poe's original text and anticipates the iconoclasm that would characterize Nast's later art. Poe's narrator, grieving for his lost love, Lenore, seeks solace in reading on a late winter's night, only to be confronted by a raven that answers "nevermore" to the narrator's repeated interrogation about the bird's significance. In this first illustration of the text, Nast seized on an early phrase in the poem's second stanza, "each separate dying ember wrought its ghost upon the floor," to represent the narrator's delusional state well before the raven's arrival.[3] In the poem, by contrast, the narrator begins lucidly enough, though his paranoia builds as the raven persists in its lugubrious call. Instead of depicting the stanza's emphasis on the narrator's sorrow and his efforts to distract himself from his loss, Nast has attached particular significance to the ghosts projected by the embers, including among them a central figure that is presumably Lenore herself, and the narrator's extratextual response. For the artist, the poem offered an excuse for a foray into the phantasmagoric. His interest in the poem extended beyond the text itself, as he latched on to symbolic elements and words and endowed them with symbolism beyond their immediate context in Poe's work.

This particular illustration also inaugurated several motifs that would recur in Nast's Civil War–era imagery, particularly the hearth grate and the coronated angel. The entire nocturnal library scene reappeared in 1864 as an emblematic depiction of the South in Nast's *New Year's Day*.[4] Contrasted with the festive gathering used to represent the North (presumably celebrating New Year's Eve) in the same print, the closeted Southern reader can only be interpreted as a pariah whose prospects for the coming year bode ill. Given that "The Raven" also takes place "in the bleak December," Nast's recycled composition suggests that the South is haunted by loss in a way that is similar to Poe's narrator. The hearth grate, radiating redemptive warmth and light in Nast's illustration, reappears in an 1864 engraving entitled *Emancipation,* in which an African American family warms itself by a stove with a similar grate that bears the inscription "Union."[5] The spirit of a young woman wearing a coronet is an even more common figure in Nast's work, usually as an allegorical embodiment of Liberty or America. The artist's repetition of motifs in works from this period reflects his search for a universal visual idiom that would be readily interpreted by a national audience. Whether Nast's use of these motifs first appeared in these illustrations or before, they clearly offered a pool from which to draw in later years.

Throughout his career, Nast characterized himself as an artist rather than an illustrator or caricaturist, viewing his creative work in all media as a type of "symbolic history painting."[6] He was erudite in his awareness of artistic precedents, and his illustrations of "The Raven" equally demonstrate his mastery of romanticism. This particular image's affinity with Francisco de Goya's iconic *The Sleep of Reason Produces Monsters* (fig. 60) is striking. Although Goya's figure is haunted by owls and cats and Poe's by a raven (and a spirit, in Nast's interpretation), their visions of seated scholars visited by supernatural specters resonate more than they differ. Both subjects are tormented by their own imaginations, to the point where their fears and dreams manifest themselves in what Bryan Wolf has termed the "narcissistic sublime."[7] As Wolf has described it, artists "understood the capacity of the mind to annex the world around it for its own purposes, together with its apparent inability to distinguish

what Emerson would . . . call the 'Me' from the 'Not Me.'"[8] Such solipsistic self-absorption remained a central tenet of the romantic during the nineteenth century, appearing as well in the works of Nast's European contemporaries. He was therefore not only an exponent of American romanticism but also a cosmopolitan modernist nearly a decade before it became fashionable in this country.

Appropriately, Nast had no patience for artistic nationalism. His work was profoundly influenced both by English printmakers, including William Hogarth and James Gillray, and a wide range of French draftsmen and painters of the nineteenth century, from Honoré Daumier to Jean-Léon Gérôme.[9] The most significant of the latter group was Gustave Doré, a prominent contemporary caricaturist, illustrator, and painter. When cartoonist Art Young visited Nast's home in 1897, he recalled seeing "many Doré drawings on his walls there," and Nast remembered that "the editors of *Harper's Weekly* had accused him of plagiarizing Dore's mannerisms" in his work from 1862 to

Fig. 60. Francisco José de Goya y Lucientes, *The Sleep of Reason Produces Monsters*, 1797, etching on paper, 21.6 x 15.2 cm (8½ x 6 in.). Hood Museum of Art, Dartmouth College; purchased through a gift from Dorothy and Jerome R. Goldstein, Class of 1954; PR.986.26

1870.[10] The two artists' similarities even extended to their physical appearance and led to Nast's appellation "the American Doré." At the end of Doré's life in 1884, a remarkable parallel with Nast's work occurred when *Harper's* (Nast's employer) commissioned Doré to illustrate Poe's "The Raven" for its publication in book form. Doré could not have seen Nast's 1862 illustrations, since they were never published, but Doré's illustration for Poe's second stanza (fig. 61) nevertheless bears remarkable similarities to Nast's depiction of the same scene except in its tone, which differs dramatically between Doré's wistful dreaming and Nast's wide-eyed shock. The group of angels surrounding the dead Lenore, the mysterious firelight, and the narrator seated in his overstuffed chair all coincide. Although Doré also included a skeletal figure of Death hunched beside the narrator's chair, the relation of symbolism between the two artists' works is considerable. Here, it seems, the two artist's roles were reversed, as Nast's depiction predates Doré's by more than two decades.

MDM

Fig. 61. Gustave Doré, *Eagerly I Wished the Morrow*, published in Edgar Allan Poe, *The Raven* (New York: Harper and Brothers, Publishers, 1884), n.p. Dartmouth College Library

20 John Henry Hill, A.N.A., 1839–1922

Lake Scenery (Lake Winnepesaukee, New Hampshire), 1866

Watercolor over graphite on wove paper, 26.8 × 38.9 cm (10½ × 15⅜ in.)

Signed and dated, lower right: J. Henry Hill 1866

Purchased through the Julia L. Whittier Fund; W.957.1

PROVENANCE
Pine Cupboard Antique Shop, Franklin, N.H.; sold to present collection, 1957.

EXHIBITIONS
Tamworth Bicentennial Art Exhibit, Tamworth, N.H., *Painting in the White Mountains, 1820–1900: The Bicentennial of Tamworth, New Hampshire, 1766–1966,* 1966 (no cat. no.); The White Mountain School, Saint Mary's-in-the-Mountains, Littleton, N.H., *Nineteenth-Century Landscape Paintings of the White Mountains,* 1976 (no cat.); Dartmouth College Museum and Galleries, Hanover, N.H., *The New England Image: Nineteenth-Century Landscapes from the College Collection,* no. 17; Belknap Mill Society, Laconia, N.H., *Mirrors of the Soul: Reflections on the Lakes Region,* 1988 (no cat.); Hood Museum of Art, Dartmouth College, Hanover, N.H., *"A Sweet Foretaste of Heaven": Artists in the White Mountains, 1830–1930,* no. 29; Hood Museum of Art, Dartmouth College, Hanover, N.H., *From Copley to Dove: American Drawings and Watercolors at Dartmouth,* 1989 (no cat.).

REFERENCES
Tamworth Bicentennial Art Exhibit, *Painting in the White Mountains, 1820–1900: The Bicentennial of Tamworth, New Hampshire, 1766–1966* (Tamworth, N.H.: Tamworth Bicentennial Committee, 1966), 10; Glenna Waterman, cat. entry in Margaret Moody Stier (ed.), *The New England Image: Nineteenth-Century Landscapes from the College Collection* (Hanover, N.H.: Dartmouth College Museum and Galleries, 1982), 44, 45 (illus., as *Lake Winnepesaukee, New Hampshire*); Barnett L. Silver, cat. entry in *"A Sweet Foretaste of Heaven": Artists in the White Mountains, 1830–1930,* by Robert L. McGrath and Barbara J. MacAdam (Hanover, N.H.: Hood Museum of Art, Dartmouth College, 1989), 68 (illus., as *Lake Winnepesaukee, New Hampshire*).

John Henry Hill represented the third generation in a family of well-established landscape artists. He was the grandson of British-born topographic engraver John Hill and son of draftsman and watercolorist John William Hill (see cat. 13). Having benefited from studies and extensive sketching excursions with his father, John Henry Hill began to exhibit at the National Academy of Design in 1856 at the age of seventeen and contributed watercolors, aquatints, and etchings periodically through 1891.[1] Both father and son came under the influence of the Pre-Raphaelite writings of John Ruskin about 1855 and, as a result, became increasingly devoted to creating complete, highly detailed landscapes and nature studies in situ. Like many of Ruskin's American adherents, the Hills took Ruskin's "truth to nature" philosophy to obsessive ends. In watercolor, as in other media, they abandoned their broader handling and adopted the exacting approach to draftsmanship espoused by the British critic. In 1864–65 John Henry Hill spent about eight months in England, where he studied the work of the British Pre-Raphaelites and the earlier work of J. M. W. Turner. On his return from this inspirational trip, he became a founding and active member of the Society for the Advancement of Truth in Art, the American organization of Ruskinian devotees.

Although titled *Lake Winnepesaukee* at the time of its acquisition, the locale depicted in this watercolor does not conform clearly to identifiable scenes around New Hampshire's largest lake—despite the artist's association with the region at this time.[2] Hill is known to have worked in the vicinity of the White Mountains of New Hampshire as early as 1858, and the dates of other works suggest that he visited the region frequently in the 1860s and 1870s, and as late as 1895.[3] Hill traveled broadly in search of painting subjects, however. Other favorite haunts included the Hudson River Valley, near his home in Nyack, New York; the area of Ashfield, Massachusetts, where many of his Pre-Raphaelite compatriots summered; and, beginning in the late 1860s, Lake George. While Hill is not known to have visited Lake George until the year after he painted this watercolor, the cluster of stately conifers in this composition bears a strong resemblance to the lake's island pines, which he depicted in a strikingly similar manner in 1869 and 1871.[4]

Even without knowing the precise location of the scene, important aspects of the work are still accessible. In contrast to the sublime compositions of Hill's Hudson River School predecessors, his works did not, as a rule, feature subjects selected for their grandeur, literary or historical associations, or status as celebrated landmarks.[5] He instead favored quotidian, almost nondescript bits of nature, which he rendered in exquisite detail. This work, laboriously described with the minute hatchings and stipplings of a fine brush, in no way resembles a sketch. It epitomizes the approach advocated by a contributor to the Ruskinian-influenced periodical *The Crayon* (probably William J. Stillman), who wrote: "the true method of study is to take small portions of scenes, and thereto explore perfectly, and with the most insatiable curiosity, every object presented, and to define them with the carefulness of a topographer. . . . To make a single study of a portion of landscape in this way, is more worth than a summer's sketching."[6] Hill lavished particular attention on the tall pines in the left midground, delineating each twig and needle in a detailed manner reminiscent of his pen-and-ink drawings. Despite its unassuming subject, the work's brilliant coloration and fastidious technique evoke a sense of awe.

BJM

21 William Trost Richards, N.A., 1833–1905

Beach Scene, c. 1870

Transparent and opaque watercolor over graphite on tan wove paper, 16.7 × 34.6 cm (6⁹⁄₁₆ × 13⅝ in.)

Numbered, in pencil, on reverse: HS9 [dealer's inventory number?]

Purchased through gifts from Richard and Diana Beattie and a partial gift of Theodore and Ellen Conant; W.997.11

PROVENANCE
The artist; to Theodore Richards (son); to Grace Thayer Richards (daughter); to Ellen and Theodore Richards Conant (son and daughter-in-law), c. 1980; consigned to Berry-Hill Galleries, Inc., New York, c. 1989–96; returned to Ellen and Theodore Richards Conant, 1996; sold to present collection, 1997.

EXHIBITIONS
Berry-Hill Galleries, Inc., New York, *Watercolors by William Trost Richards*, 1989, no. 7.

REFERENCES
Berry-Hill Galleries, Inc., with an essay by Linda S. Ferber, *Watercolors by William Trost Richards* (New York: Berry-Hill Galleries, Inc., 1989), 15 (color illus.).

Philadelphia artist William Trost Richards was at the forefront of the American watercolor revival of the late 1860s and 1870s. He had begun to work in the medium by 1860, when he created an elaborately detailed botanical study entitled *Red Clover, Butter-and-Eggs, and Ground Ivy* (Walters Art Museum). He was no doubt encouraged in his early efforts by the writings of British critic John Ruskin, who advocated use of the medium in his *Elements of Drawing*, 1857, and had been the source of Richards's earlier conversion to the Pre-Raphaelite style (see entry for cat. 16). A trip to Europe in 1867, during which he saw watercolors by J. M. W. Turner, may have renewed his interest in the medium. On his return, Richards did not immediately exhibit with the American Watercolor Society in New York, which had been founded in 1866, but by the early 1870s his watercolors were nevertheless widely exhibited, collected, and praised. A critic writing in 1873 referred to him as one of America's "best known watercolor painters."[1]

Richards's intensive work in watercolor coincided with a new stylistic direction for the artist and an emerging fascination with shoreline subjects that he would indulge regularly for the rest of his career. During the summer of 1869 he rendered the coasts of Massachusetts and New Hampshire in small watercolors, and for the next several years he vacationed and painted primarily along the unbroken expanses of the New Jersey shore. His son recalled how Richards "stood for hours . . . with folded arms, studying the motion of the sea, until people thought him insane."[2] Watercolor proved an ideal medium for expressing his preoccupation with surf and the moist, hazy atmosphere of the summer shore. Richards rendered his coastal scenes in a characteristically precise manner, but the transparent medium gave these spare subjects a broad, airy quality that contrasted with his earlier, intricately detailed works. The timing of Richards's shift toward elegant coastal watercolors was fortuitous, for by 1870 the fastidious realism of the ever-controversial Pre-Raphaelite style had come under more severe and widespread criticism for its apparent lack of poetry and "imaginative suggestion."[3] Through his new work, Richards appears to have satisfied the recurring American desire for both "fidelity and poetry" in art.[4]

Beach Scene is a prime example of the watercolors by Richards that critics and collectors so admired in the early 1870s. Its reductive, horizontal format, near-monochromatic palette, and diffuse, aerial glow liken the work to the luminist compositions by John Frederick Kensett and Sanford Robinson Gifford of the same period. Its striking lack of geologic detail and particular approach to the watercolor medium contrasts with Richards's previous work and that of his Pre-Raphaelite peers of the 1860s. When working in watercolor, such Ruskinian disciples as John Henry Hill (cat. 20), Henry Roderick Newman, and Charles Herbert Moore generally used white papers, on which they applied an infinite number of hairline hatchings of transparent watercolor. By the early 1870s, Richards favored broader washes on lightly tinted papers, perhaps inspired by Turner's practices. The colored, absorbent sheets required that he apply touches of opaque watercolor (also known as gouache, or body color) for his highlights. Here the tan color of the sheet shows through some areas of the thinly applied pigment and is left exposed in others, contributing to the hazy summer glow and tonal harmony of the work. Richards employed opaque watercolor to describe the distant sail, gently breaking waves, and wispy clouds. Three faintly drawn distant gulls soar against the sky, bringing the taut work into exquisite balance.

In 1874 Richards spent the first of many summers in Newport, Rhode Island, and in 1881 selected the site for his summer home, Graycliff, which he built on nearby Conanicut Island. With its studio overlooking Narragansett Bay and Newport, this residence extended the artist's opportunities to paint the varied New England coastline for years thereafter. Richards continued to work in watercolor for the remainder of his career, but he generally adopted a richer palette and more opaque technique. Like some of the other artists associated with the watercolor revival, including Samuel Colman (cat. 22), Richards occasionally worked on a monumental scale that underscored his steadfast belief in the legitimacy of watercolor as a medium equal to oil painting.

BJM

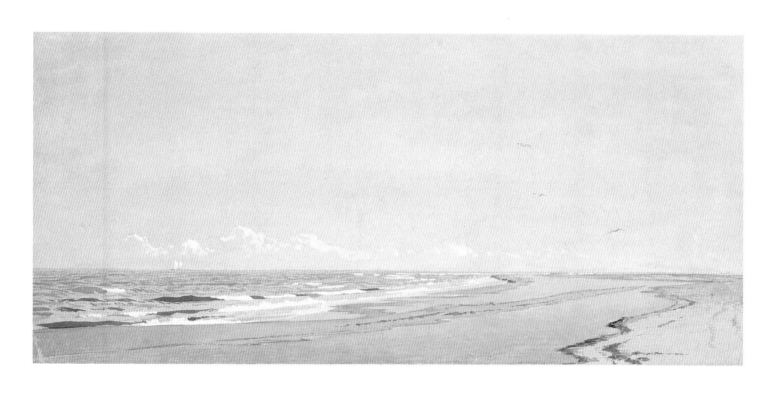

22 Samuel Colman, N.A., 1832–1920

Fishing Boats, Étretat, 1873 | Verso: *Étretat*

Transparent and opaque watercolor over graphite on gray wove paper, 23.0 × 34.4 cm (9 × 13½ in.)

Inscribed and dated, lower left: Etretat. Aug. 9th 1873; inscribed, on reverse, lower left: Etretat: Aug 1873.

Purchased through the Katharine T. and Merrill G. Beede 1929 Fund; W.998.11

PROVENANCE
The artist; by descent in the artist's family; to Mary Lublin Fine Arts, Inc., New York, by 1988; sold to present collection, 1998.

EXHIBITION
Possibly in American Watercolor Society, New York, *Annual Exhibition,* 1876, no. 61 (as *Boats at Étretat, France*).

Fig. 62. Jean-Baptiste-Camille Corot, *The Beach, Étretat,* 1872, oil on canvas, 35.6 x 57.2 cm (14 x 22½ in.). The Saint Louis Art Museum; purchase

As the founding president of the American Watercolor Society, 1867–70, and a long-term practitioner of the medium in a variety of styles and formats, Samuel Colman has been called "the personification of the Watercolor Movement" in America at the height of its revival.[1] By the time Colman embarked on an extended sojourn in Europe and North Africa in 1872, he was at the pinnacle of his fame and influence. His light-filled, panoramic landscapes provided a handsome income during the 1860s and considerable authority within American institutions of art, particularly the National Academy of Design. He bore leadership easily, it seems, and his gregarious personality made him an excellent advocate for the watercolor movement. Early on, Colman primarily practiced the medium in a more finished style and in a larger format than his later watercolors, with heavy emphasis on opaque watercolor. Typical of the work produced by members of the Watercolor Society, those early paintings deliberately competed with oil painting in both scale and complexity.[2] The early 1870s brought a considerable change in his art, however, toward a looser, more cosmopolitan aesthetic that kept pace with changing American tastes. By 1871 he was employing watercolor as a sketching medium in earnest, as manifested in *Fishing Boats, Étretat.*

Colman visited the French resort town of Étretat on the Normandy coast during the height of the summer season in 1873. The town's iconic scenery attracted a number of influential European artists of the later nineteenth and early twentieth centuries—from Jean-Baptiste-Camille Corot and Gustave Courbet to Claude Monet, Henri Matisse, and Georges Braque—and as Colman explored Europe and undertook a new, more painterly style, he could hardly have hit on a more popular artistic venue. As *Fishing Boats, Étretat* attests, however, Colman's approach and choice of subjects were more sympathetic with the aesthetics of the Barbizon painters than with the airy brilliance with which Monet treated the area in the mid-1880s.

Instead of the scenic cliffs that so fascinated his contemporaries, however, in this watercolor Colman concentrates on the fishing boats and tools of the local townspeople. For an artist who had spent much of his life depicting the natural wonders of the American landscape in painstaking detail, this turn away from awe-inspiring scenery toward vignettes of local culture and activity constituted a significant, if brief, shift, similar to that of his American peers William Stanley Haseltine and Winslow Homer at about the same time. When Colman returned to the United States in 1875, he exhibited these smaller-scale watercolor sketches in New York and became a catalyst for the introduction of plein-air European aesthetics to America, with one critic remarking that the works were likely to "give a new impetus to water-colour painting in the country."[3]

Country life was the primary subject for the French Barbizon artists, with whose works Colman's watercolor appears to have a close affinity. Just months before Colman's visit to Étretat, in fact, Corot, the "patriarch of landscapists," visited the town in the fall of 1872.[4] Corot's *The Beach, Étretat* (fig. 62) is remarkable for its sympathy in style and subject to Colman's composition and suggests the latter's admiration for the aging master's work. Art historian Robert Herbert has remarked on the characteristic qualities of earlier Barbizon art, particularly the painters' search for an authentic, preindustrial French peasant culture. The "poignant melancholy" and "uprootedness" that the Barbizon artists felt in response to rapid industrialization led them to seek out rural villages in search of an unsullied rusticity.[5] They averted their eyes from sites of industry and signs of modernity, much as both Corot and Colman did in their renderings of Étretat, by avoiding the fashionable bathers of the nearby resort. Plein-air realism, such as that practiced by Colman in this watercolor, and the peripatetic wanderings that characterized his late career suggest a close kinship with Barbizon escapism and discomfort with modernization.

MDM

23 John Francis Murphy, N.A., 1853–1921

Pride of the Meadow (Flower Studies, New Jersey), 1876

Graphite on tan wove paper, 35.6 × 17.7 cm (14 × 7 in.)

Signed, lower right [in margin]: J. F. Murphy; inscribed and dated, lower right: N. Jersey / 10/4/76-; inscribed, on reverse: Pride of the Meadow

Gift of Mrs. Hersey Egginton in memory of her son, Everett Egginton, Class of 1921; D.954.20.659

PROVENANCE
American Art Association, Inc., New York, "Paintings and Drawings by J. Francis Murphy. . . . ," November 26, 1926, lot 19 (illus.); Milch Galleries, New York; sold to Hersey Egginton, Garden City, N.Y., probably November 27, 1926 [Milch Gallery records]; the Estate of Hersey Egginton (Mrs. Hersey Egginton), 1951; given to present collection, 1954.

The nine drawings by J. Francis Murphy in the Hood Museum of Art collection (see, for example, p. 241) date from 1876 to 1883, a formative period in the young artist's career following his arrival in New York from Chicago. They predate by a few decades the artist's scumbled, reductive canvases of vacant farmlands that brought him critical acclaim and financial success. Although typically far more particularized than these broadly rendered, sparse paintings, the Hood drawings reveal nonetheless Murphy's long-standing fascination with the homely landscape, or what one scholar has termed a "lapsed rural culture."[1]

Murphy grew up in an impoverished family, first in his native Oswego, New York, and later in Chicago, where the family moved in 1868. There he took a job as a scene painter and, according to his account book, spent $1.50 for five weeks of "life school" with a James Gookins in 1875. It is not known whether he attended classes at the Chicago Academy of Design (later the Art Institute of Chicago), but he had been made an academy associate in 1873. The following year he spent the summer and fall sketching in Keene Valley, New York, an artistic mecca in the Adirondacks that, over the years, attracted such established figures as Asher B. Durand, Alexander H. Wyant, George Inness, and Winslow Homer.[2] Murphy quickly abandoned his initial efforts to exploit the grand themes and scale associated with the earlier Hudson River School artists who had painted in the region and turned his attention to unassuming, domesticated landscapes. In November 1875 Murphy settled in New York City but made frequent trips to the rural community of Denmark, New Jersey, to visit friends formerly from Chicago, the A. S. Roorbachs.[3] In September 1876 Murphy moved in with the Roorbachs, having found it difficult to make ends meet in the city, and he stayed until November of the following year. In exchange for paying minimal rent and assisting with chores, he received room and board and ample opportunity to sketch the local countryside, as testified by this and other drawings.

Although he was not usually considered in the circle of American Pre-Raphaelites, Murphy's detailed renderings of humble plant life reveal the influence of British critic John Ruskin, who encouraged the faithful documentation of nature's more modest expressions. Murphy's reverence for nature was at least partially grounded in the transcendentalist treatises of Henry David Thoreau and Ralph Waldo Emerson, whom he frequently cited as formative influences.[4] Murphy also honed his precise approach to draftsmanship through his work as an illustrator, which augmented his income over the next few decades.[5] Given the many exacting botanical studies of wildflowers in his sketchbooks—similar in character to this sheet—it is perhaps not surprising that in 1879–80 he attempted to interest the naturalist John Burroughs in a joint project on wildflowers. The plan never came to fruition, perhaps because of differing viewpoints. In response to Murphy's proposal, Burroughs suggested instead that the artist illustrate a story on a hunter in pursuit of a bee, claiming that such an article had "more popular interest than one simply on weeds."[6]

Murphy's loving portrayal of this wildflower, which he termed "Pride of the Meadow," reveals that he considered it anything but a mere "weed." The elongated format of the sheet reinforces the plant's majestic verticality, as does the low vantage point, which places the lacy heads above the already high horizon line and on a level with the hillside tree. Murphy's careful delineation of each sprig and leaf invests the plant with dignity and a sense of importance within its more generalized setting. Using a drawing technique common among near-contemporaries such as William Trost Richards (see cat. 16), Murphy shades some of the leaves and describes others simply in outline, especially when set against a darkened area of the composition. The resulting play between negative and positive spaces adds visual interest and heightens the effect of sun-dappled light that is so central to Murphy's drawings from this period.

Murphy continued to sketch bits of nature and a "lapsed rural culture"—abandoned mills and old farmsteads—for the rest of his career. In 1887 he and his wife built a summer studio in Arkville, a modest gathering spot for artists in the Catskills.[7] Here he created his most atmospheric, generalized landscapes, which prompted some critics to dub him "the American Corot." One writer noted his increasing "fondness for vapor, shadow and mystery" but credited his "earlier pencilings" for helping his later works to retain "correctness as an underlying principle."[8]

BJM

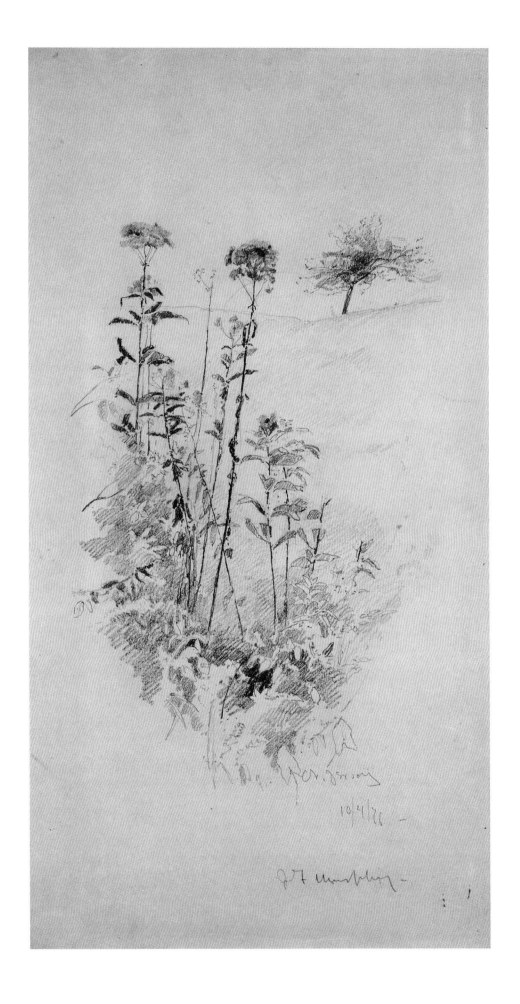

24 John Singer Sargent, N.A., 1856–1925

The West Portals of the Cathedral of Saint Gilles du Gard (Venetian Facade), c. 1879

Transparent and opaque watercolor and metallic gray paint[?] over graphite on cream wove paper, 24.6 × 33.1 cm (9¹¹⁄₁₆ × 13 in.)

Inscribed, in graphite, on verso [not in Sargent's hand]: Chairman of Christie / Sir Alec Martin / Leicester Gallery

Purchased through the Robert J. Strasenburgh II 1942 Fund and the Julia L. Whittier Fund; W.988.54

PROVENANCE
The artist; bequeathed to Emily Sargent (his sister), 1925; possibly by descent to Guillaume Ormond (her nephew); to Mrs. Morton Baum, by 1969; to Shepherd Gallery, New York, by 1981; sold to Coe Kerr Gallery, New York, 1981; sold to present collection, 1988.

EXHIBITIONS
Davis Galleries, New York, *Turn of the Century English Watercolors and Drawings*, 1969 (as *Venetian Façade;* no cat.); Carol Taylor Art, Dallas, *Americans: 19th and 20th Century*, 1982 (no cat.); Taittinger Gallery, New York, 1983 (no cat.); David S. Ramus Ltd., Atlanta, 1987 (no cat.); Hood Museum of Art, Dartmouth College, Hanover, N.H., *From Copley to Dove: American Drawings and Watercolors at Dartmouth*, 1989 (no cat.).

REFERENCE
Richard Ormond and Elaine Kilmurray, *John Singer Sargent: Catalogue Raisonné,* forthcoming.

Fig. 63. Édouard Denis Baldus, *St. Gilles*, 1853, printed c. 1861, albumen silver print from glass negative, 34.5 x 42.8 cm (13½ x 16⅞ in.). From the album *Chemins de fer de Paris à Lyon et à la Méditerranée.* Gilman Paper Company Collection

John Singer Sargent was already an experienced watercolorist when, as an eighteen-year-old artistic prodigy, he entered the atelier of his primary French teacher, Carolus-Duran, in May 1874.[1] He had sketched in watercolors during a peripatetic youth spent traveling through Europe with his American-born parents, and his earliest experiments in the medium were likely encouraged by his mother, Mary Newbold Singer, an accomplished amateur artist.[2] Once settled into serious study with Carolus-Duran in Paris, Sargent quickly adopted the older painter's bravura approach to depicting the figure in oil. His first submission to the Paris Salon, in 1877, was accepted and treated as a promising debut by critics.[3] Although he was destined to become a sought-after portraitist, Sargent continued to produce small watercolors throughout his apprenticeship with Carolus-Duran. He showed these works publicly as early as 1881. Today, Sargent is widely regarded as one of the most successful watercolorists in the history of American art. Scholars have tended to privilege the larger, brilliantly controlled landscapes and contemporary genre scenes that the artist executed after 1900, however, and have neglected as juvenilia the earlier efforts, of which the *Cathedral of Saint Gilles du Gard* is an especially strong example.[4]

Beginning in 1875, Sargent escaped from Paris during the summer months for a break from his arduous training. Most often he spent several weeks with his family in Nice, along the Côte d'Azur, or else joined them in the mountains at Aix-les-Bains, near the Swiss and Italian borders, before venturing farther on his own or returning to the French capital. It seems probable that the Hood's watercolor dates from the summer of 1879, when Sargent traveled overland from the French Alpine resort to Madrid,[5] a route that conceivably took him through the town of Saint Gilles du Gard.[6] The Benedictine abbey of Saint Gilles was deemed an important architectural landmark, and, because it was located just a short distance from the ancient Roman colonial outpost of Nîmes, it would likely have been recommended to a young foreigner as an interesting site to visit. The sources and dating of the complex decorative program at Saint Gilles were then being debated by French historicists like Viollet-

le-Duc, who linked the west portal's monumental carvings to the sculptural ornament on the facade of the church of Saint Trophîme in nearby Arles. The partially reconstructed facade was painstakingly documented in the nineteenth century (fig. 63), and subsequent scholars continue to celebrate — and question — the west portal at Saint Gilles as a fundamentally unique expression of medieval French architecture.[7] We know that Sargent was drawn to other historical monuments for such reasons. But even without possessing deep background about the history surrounding Saint Gilles du Gard, the young artist would have readily admired the imposing form of the church, just as he would have been challenged to capture the play of light across its sculptural decorations.

Cathedral of Saint Gilles du Gard is a resolutely frontal, coloristically restrained study of the imposing Romanesque portals and the stairway to those elements. The work is reminiscent of several other architectural studies that Sargent produced in watercolors around this time.[8] Here the artist divided his sheet of paper into two nearly equal halves, with the top section devoted to the horizontal spread of the heavily ornamented portals and the lower portion suggesting an empty courtyard and a long flight of steps leading up to the church doors. Light washes of watercolor barely animate an otherwise undisturbed foreground space, an effect that contrasts sharply with the graphic and stylistic complexity of the carefully described facade above. This visual tension is further heightened by the composition's fundamental asymmetry: the cut-off depiction of the rightmost doorway, tympanum, and jamb read as a dense, incomplete formal mass, while the left edge of the image opens out onto a deep, blank recessional space. In an effort to achieve an iridescent effect of sunlight glittering off the variegated stone surfaces, Sargent applied touches of a dense, opaque gray pigment with an oddly metallic appearance that is unusual both for this period and within the artist's broader oeuvre.[9] This technique testifies to the artist's highly experimental ambitions for his lifelong watercolor practice and an early willingness to take risks in pursuit of an elegant, personally satisfying imagery.

DRC

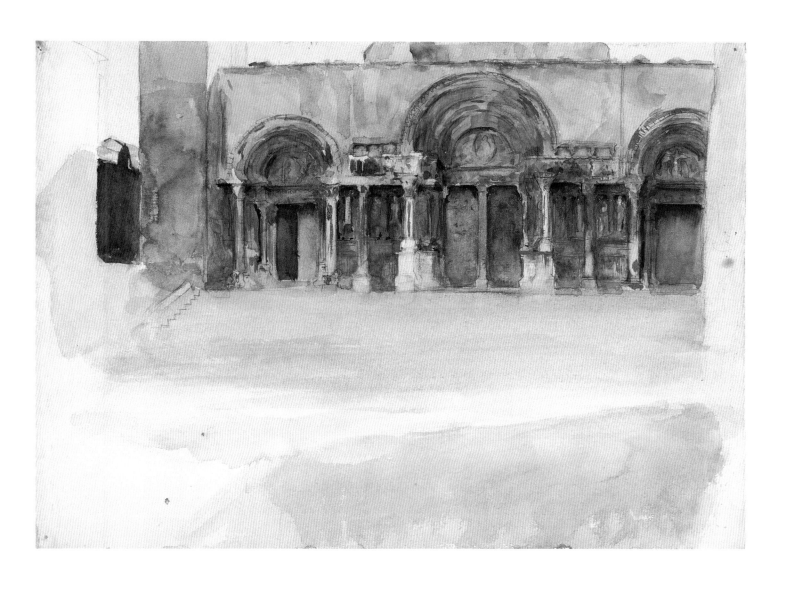

25 Mary Cassatt, 1844–1926

Drawing for "Evening" (Under the Lamp; Two Women at a Lamp; Drawing for "Under the Lamp"), 1879/80

Conte crayon on wove paper, 20.1 × 22.1 cm (7⅞ × 8⅝ inches)

Signed, in graphite, lower right: Mary Cassatt

Purchased through gifts from the Lathrop Fellows; D.2003.16

PROVENANCE
Mr. Samuel H. Nowak, Philadelphia, as of 1967; sold to Dr. and Mrs. Jeb Stewart, Georgia, about 1982; consigned to Debra Force Fine Art, Inc., New York, 2002; sold to present collection, 2003.

RELATED WORK
Evening (Le Soir), 1879/80, soft-ground etching and aquatint, 7¾ × 8¾ in. (Adelyn Dohme Breeskin, *The Graphic Work of Mary Cassatt: A Catalogue Raisonné* [New York: H. Bittner, 1948], 71 [as *Under the Lamp*, c. 1883]).

EXHIBITIONS
The Museum of Graphic Art, New York, and others, *The Graphic Art of Mary Cassatt*, 1967–68, no. 17 (as *Under the Lamp*); High Museum of Art, Atlanta, and others, *American Women of the Etching Revival*, 1989, no. 14 (as *Under the Lamp*); Georgia Museum of Art, University of Georgia, Athens, and others, *American Impressionism in Georgia Collections*, 1993 (as *Under the Lamp [Two Women at a Lamp]*); The Art Institute of Chicago, and others, *Mary Cassatt: Modern Woman*, 1999, no. 39.

REFERENCES
Adelyn D. Breeskin, *The Graphic Art of Mary Cassatt* (New York: The Museum of Graphic Art and Smithsonian Institution Press, 1967), no. 17, illus.; Adelyn D. Breeskin, *Mary Cassatt: A Catalogue Raisonné of the Oils, Pastels, Watercolors, and Drawings* (Washington, D.C.: Smithsonian Institution Press, 1970), 257, no. 748 (illus.); Phyllis Peet, *American Women of the Etching Revival* (Atlanta: High Museum of Art, 1988), 20–21 (illus.); Donald D. Keyes, *American Impressionism in Georgia Collections* (Athens: Georgia Museum of Art, University of Georgia, 1993), 22–23 (color illus.); Nancy Mathews, "Mary Cassatt and the Changing Face of the 'Modern Woman' in the Impressionist Era," in William U. Eiland (ed.), *Crosscurrents in American Impressionism at the Turn of the Century* (Athens: Georgia Museum of Art, University of Georgia, 1996), 28, fig. 3; Judith A. Barter et al., *Mary Cassatt: Modern Woman* (Chicago: The Art Institute of Chicago, in association with Harry N. Abrams, Inc., 1998), 262, no. 39 (color illus.).

This remarkably innovative study for a print dates from an especially formative and experimental period in Mary Cassatt's career, one in which she explored subjects and approaches to design that would prove central to her art. It was also during this time that Cassatt, who was prodigiously talented and open to modern artistic trends, earned widespread acceptance by prominent patrons and leading French impressionist artists. The ease with which she moved in the circles of the French avant-garde testifies in particular to her ready absorption of bold new strategies of representation.

Cassatt began her studies at the Pennsylvania Academy of the Fine Arts, Philadelphia, in 1860, at the age of sixteen. In the late 1860s she spent four years abroad, studying in France with Jean-Léon Gérôme, Charles Chaplin, and Thomas Couture, and in Rome with Charles Bellay. After further trips back and forth across the Atlantic, she settled in Paris in 1874 and fell under the influence of Couture, Gustave Courbet, and especially Edgar Degas, who became a close friend and significant mentor. It was Degas who invited her to exhibit with the impressionists at their fourth annual exhibition in 1879. She went on to exhibit with the group as its only American participant in 1880, 1881, and 1886.

Degas also encouraged Cassatt's efforts in printmaking. She previously had only minimal experience in this form of artistic expression, having been introduced to printmaking during her studies in Parma, Italy, in 1872 (none of her prints from this early period survives). Around the time that she created this drawing and related print, she was working with Degas and Camille Pissarro on a planned journal, *Le Jour et la nuit* (Day and Night), which was intended for publication in conjunction with the 1880 impressionist exhibition but never appeared. The title referred to the black-and-white medium of etching but also to the quotidian activities, set both during the day and at night, that would form the bulk of the imagery. This project inspired great experimentation and considerable collaboration among the three artists. For her intended contributions, Cassatt used soft-ground and aquatint, the tonal nature of the latter providing her with a natural transition from painting.[1]

This drawing and the subsequent print (fig. 64) touch on themes pivotal to Cassatt's art, her personal circumstances, and the period in which she worked. In 1877 Cassatt took in her aging parents and her sister, Lydia, who by 1879 had been diagnosed with a painful and terminal illness of the kidneys. The artist's increasing familial re-

sponsibilities led her to focus on her family and the domestic sphere in her art. Her work also took on a more meditative quality. Just as previously she had been intrigued by public nighttime entertainments, especially the theater, here she turned to the private, inward evening activities that occupied her sister and mother. Cassatt's sympathy for other women is clearly apparent in this intimate image, as elsewhere. Yet despite the close proximity of the figures, they do not face each other. The lamp's prominent placement between them divides the composition and creates a separate physical and psychological space for each of the women, who are absorbed in their own activities and thoughts.

As she does in so many of her portraits of women, Cassatt captures her family members in productive engagements. She shows her mother reading, as she had in several other etchings and in her 1878 oil painting of Mrs. Cassatt reading a newspaper (*Portrait of a Lady*, private collection). The act of women reading was a favorite subject for Cassatt and other impressionists, as it provided a relaxed, candid pose that gave a sense of immediacy while following social decorum by appropriately averting the eye of the sitter.[2] Reading also signaled a woman's education, a degree of intellectual independence, and upper-middle-class status. In this work, Mrs. Cassatt's strong fingers press upward against her temple in concentration, as if pointing to the source of her intellect.[3] Lydia is equally engaged in her knitting or sewing. The implied interaction of her hands animates the otherwise stilled pose while alluding to her considerable skills in handwork.[4]

The tall table lamp, which was situated in the artist's library, provides an important formal element in this and many images from the period. Cassatt was enthralled by the visual effects of artificial illumination, especially gaslight, which in the mid–nineteenth century transformed the appearance and utility of both public and private settings at nighttime. In the aquatint, the lamp's illumination creates flat, abstract patterns of light and dark that give the image particular graphic strength. The dramatic contrast between the luminous gaslight globe and the dark surroundings vividly recalls prints that Degas created during the same time that explore lighting effects in the cafés, streets, and theaters of Paris (fig. 65). In this drawing, which is linear rather than tonal, the lamp's chief function is compositional. It boldly divides the pictorial space and the two women, who are otherwise drawn together by the shared light. The large globe also echoes the

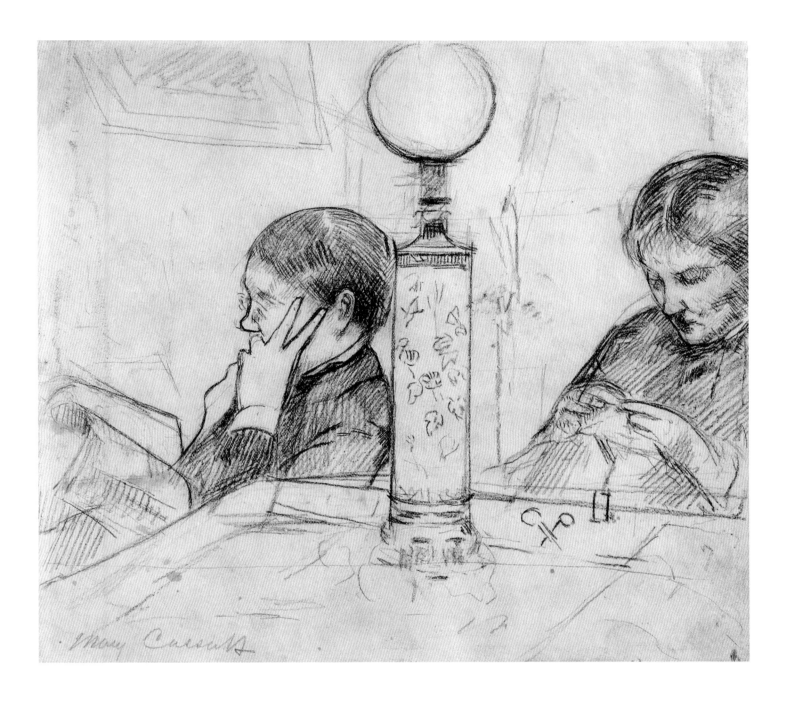

rounded shapes that appear elsewhere in the work, such as in the contours of the women's heads and the handles of the sewing scissors.

Cassatt's divided and abruptly cropped composition reveals the influence of Degas and the Japanese woodblock prints that both artists collected. This drawing's starkly accentuated contours, flattened surface patterning of the lamp, and minimal spatial recession also point to Japanese aesthetics. Its compressed space creates an uncomfortable sense of constriction, especially around the figure of Lydia, who is bounded by the

table, the wall behind her, and the radical cropping on the right. There is little elaboration of the setting, which is devoid of the patterned wallcovering and fabrics that adorn many of Cassatt's interiors. Instead, the composition is boldly severe, accentuating essential formal relationships and intensifying the work's restrained, introspective mood.

The drawing is very close in size and design to the subsequent print (its imaged reversed through the printing process), with many lines corresponding precisely. Cassatt appears to have

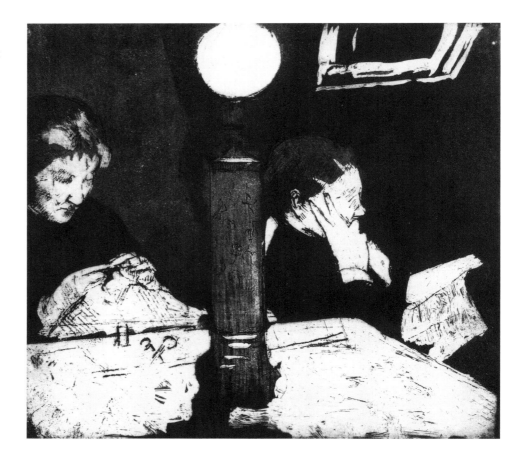

Fig. 64. Mary Cassatt, *Evening*, 1879–80, soft-ground etching and aquatint on cream laid paper, 19.7 x 22.1 cm (7¾ x 8¹¹⁄₁₆ in.). The Albert H. Wolf Memorial Collection, 1938.33, reproduction, The Art Institute of Chicago

traced key contours of the drawing either directly onto the soft-ground etching plate or an intermediary tracing paper.[5] Certain outlines have been reinforced, such as the profile of the mother and the contours of her splayed fingers pressed against her face. Perhaps while transferring the image to the plate, Cassatt revised certain passages, such as the angle of the edge of the table. By retaining such alterations in the print and drawing she revealed her working method and gave both images a more transitory, active quality consistent with impressionism. Cassatt appar-

ently admired the final soft-ground etching, for it was one of eight prints she exhibited in the fifth impressionist exhibition in 1880. She also exhibited it at the 1888 Union League Club of New York of Women Etchers of America, and at her 1893 exhibition at Durand-Ruel Galleries in Paris.[6] This preparatory drawing has gained a critical stature of its own and can be considered the first expression of one of her most adventurous compositions.

BJM

Fig. 65. Edgar Degas, *The Dog Song*, c. 1877–78, lithograph on paper, 35.2 x 23.1 cm (13⅞ x 9 in.). Cabinet des Estampes, Bibliothèque Nationale, Paris

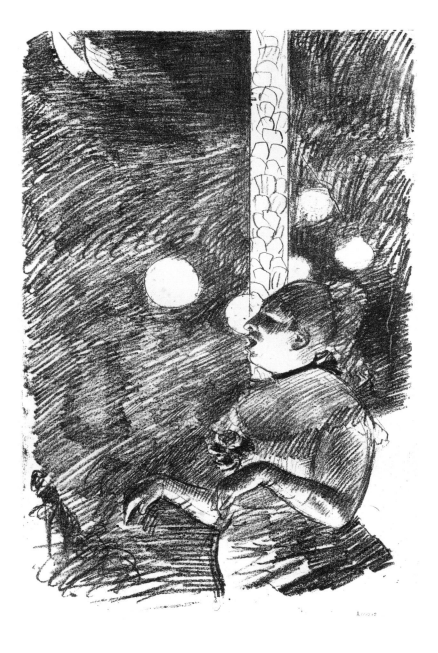

Osage Dance, 1880

Graphite and colored crayon on laid ledger paper, 19.2 × 31.1 cm (7⁹/₁₆ × 12¼ in.)

Stamped, in blue ink, upper left: 11; inscribed, in pen and ink, center: Osage / Osage / Pawnee / Kiowa. / Pawnee; bottom: A scene in a war dance, Kiowas, Pawnees, & Osages participating

Purchased through the Robert Strasenburgh '42 Acquisition Fund; D.2003.18.2

PROVENANCE
Julian Scott; by descent in the family; sold to Morning Star Gallery, Santa Fe, N.Mex., 1986; sold to Mark Lansburgh, Class of 1949, 1986; sold to present collection, 2003.

RELATED WORK
Reproduction by unknown Comanche boy at Fort Sill, in *Report on Indians Taxed and Indians Not Taxed in the United States (Except Alaska) at the Eleventh Census: 1890* (United States Census Office, Washington, D.C.: Government Printing Office, 1892–96).

EXHIBITIONS
Morning Star Gallery, Santa Fe, N.Mex., 1987; Morning Star Gallery, Santa Fe, N.Mex., 2003.

REFERENCE
Ronald McCoy, *Kiowa Memories: Images from Indian Territory, 1880* (Santa Fe, N.Mex.: Morning Star Gallery, 1987), 2, pl. 7.

Traditionally, Plains Indian pictorial drawing centered on the chronicling of history, life, and visionary experiences on rock, buffalo skins, robes, horse trappings, shields, and tipis. Before European American contact, warriors and chiefs adorned their clothing, personal objects, and shelters with autobiographical images of war, hunting, courtship, religious experiences, and scenes from everyday life. While some images validated and memorialized individual, family, and band history and publicly conveyed the warrior-artist's place within the broader history of his community, others—called "winter counts"—recorded important yearly events as visual mnemonics for oral historians.

The influx of European Americans to the Plains in the nineteenth century irrevocably changed traditional pictorial arts, which shifted from rock and hide drawings to works on paper using ink, pencils, and watercolors. Acquiring ledger books, notebooks, drawing books, muslin, pens, and pencils from the white settlers, the warrior-artists appropriated these materials into their pictorial practices.[1] After the 1860s, however, their repertoires expanded to include images of the changes brought on by white dominance, Native captivity, and reservation life. Used as tools for intercultural communication, the drawings expressed Native ideas about history, resistance, autonomy, and artistry while also educating non-Natives about indigenous life and perspectives.

The drawing *Osage Dance* was once part of a ledger book that belonged to the Vermont artist Julian Scott. Employed as a special agent for the 1890 census of Native Americans, Scott traveled to Indian Territory (later Oklahoma) to document the disappearing modes of traditional Indian life. About 1890 he acquired the ledger book of fifty multicolored graphite, crayon, and tempera drawings now called the Julian Scott Ledger.[2] Janet Berlo has identified three signature styles of the unknown Kiowa artists who created the book and refers to them as "Julian Scott Ledger Artist A, B, and C."[3] Artist A, who drew *Osage Dance,* was most likely the artist-owner of the ledger, since forty-three of the fifty drawings can be attributed to his hand.[4]

Osage Dance depicts the war dance, a common theme in Plains art and in the popular imagination of European American society. It is a conventional drawing in its traditional theme, spatial flatness, and linear composition, but it reveals how Kiowa life and artistic conventions changed in the reservation period after the 1860s. Typical of older Plains conventions, *Osage Dance* exhibits the artist's great interest in and close observation

of the individuality of the dancers, whose tribal affiliations can be identified through meticulous detailing of facial decoration, clothing, accoutrements, and gesture.[5] Nevertheless, the representation of Kiowa, Pawnee, and Osage performers in *Osage Dance* reflects the pantribal mix of cultures on reservations such as the Kiowa, Comanche, and Wichita Agency, where the ledger book was created.[6]

Pantribalism is even more pronounced in other drawings by Kiowa ledger artists who were imprisoned at Fort Marion, Florida, from 1875 to 1878.[7] With the support of their jailor, Captain Richard Pratt, imprisoned Kiowa warrior-artists such as Etahdleuh Doanmoe were exposed to and experimented with Western conventions of perspective, landscape, modeling, and composition. Doanmoe's drawing *An Omaha Dance* (25) from 1876–77 (fig. 66) depicts a performance of a war dance staged at Fort Marion under the direction of Captain Pratt. The dance featured some of the Kiowa, Cheyenne, and Arapahoe captives, who "thrilled" St. Augustine residents with the "remarkable posing and posturing" of the Osage war dance.[8] Doanmoe's dancers are depicted as generic "Indian Braves" who lack the individuality and tribal specificity of the Julian Scott Ledger drawing. This form of deindividuation echoes the tastes of Fort Marion art patrons rather than Kiowa conventions.

Although the Julian Scott Ledger artists were not among the Fort Marion captives, eight of the ten known Kiowa captives returned to the reservations in 1878, where they influenced reservation artists in their use of perspective and modeling. After 1878 Kiowa reservation artists such as the Julian Scott Ledger artists and the former Fort Marion captives continued to produce ledger drawings for sale to European Americans. They also mentored subsequent generations with their distinctive hybrid fusion of Native and non-Native conventions and themes and contributed directly to the development of twentieth-century Native artists, the most well-known being the "Kiowa Five," who owed their legacy to ledger book art. These artists—James Auchiah (see p. 225), Spencer Asah, Jack Hokeah, Monroe Tsatoke, and Stephen Mopope (see p. 241)—worked with the older ledger artists, including former Fort Marion artists, but also received Western art training and subsequently formed the early Oklahoma School of Native American painting.[9] Combining older conventions of ledger art with European American modernism, the Kiowa Five completed the transition from ledger art to modern painting and mural art.

BT

Fig. 66. Etahdleuh Doanmoe, *An Omaha Dance* (25), 1876–77, pencil and crayon, 21.6 x 28.6 cm (8½ x 11¼ in.). Yale Collection of Western Americana, Beinecke Rare Book and Manuscript Library, New Haven, Connecticut, 1174

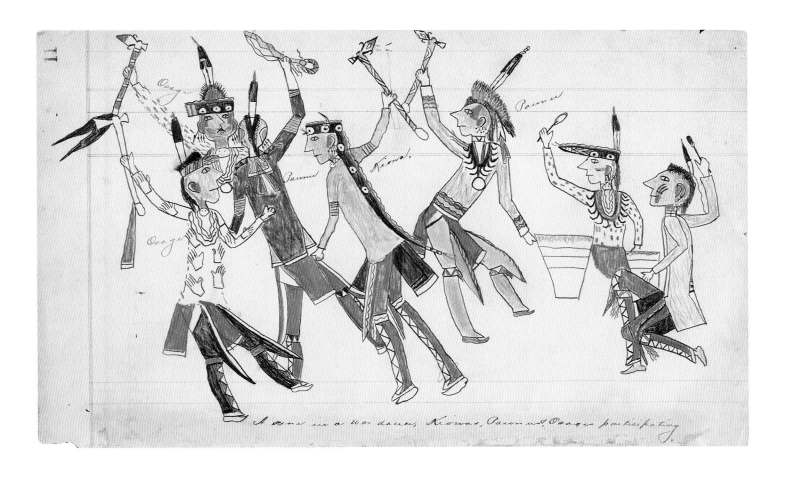

A scene in a War dance, Kiowas, Pawnee and Osage participating

27 Winslow Homer, N.A., 1836–1910

Boys Bathing, 1880

Watercolor over graphite on wove paper, 14.5 × 33.6 cm (5¾ × 13¼ in.)

Signed and dated, lower left (on stern of skiff): HOMER / 1880; inscribed, in pencil, on reverse (not in artist's hand): 32– [within lozenge][1]

From the estate of Tatiana Ruzicka (1915–1995). Presented in 1996 by Edward Connery Lathem in memory of Rudolph Ruzicka (1883–1978); W.996.47

PROVENANCE
Estate of the artist; to Charles Savage Homer Jr. (brother of the artist), c. 1917; given to Dr. William S. Dennett and Maria H. B. Dennett, New York, by 1939; bequeathed to Rudolph Ruzicka, 1942; bequeathed to Tatiana Ruzicka (his daughter), 1978; bequeathed to Edward Connery Lathem, 1995; given to present collection, 1996.

EXHIBITION
Probably included in the exhibition of Homer watercolors at Doll and Richards, Boston, December 1880.

Fig. 67. Winslow Homer, *Ship Building, Gloucester Harbor*, 1873, wood engraving on paper, 23.2 x 34.3 cm (9⅛ x 13½ in.). Hood Museum of Art, Dartmouth College; purchased through the Appleton 1792 Memorial Fund; PR.943.80

By 1880 Winslow Homer had long been recognized as a prominent, even leading American artist—a reputation that time has only enhanced. His work of this period in both oil and watercolor garnered critical ambivalence, however, as he charted a new aesthetic course attuned to changing American culture and tastes.[2] Beginning his career as a newspaper illustrator in the late 1850s, Homer developed exceptional skill at recording the essential characteristics of events as they happened. That ability was particularly suited to watercolor, a medium long out of favor among professional artists that enjoyed a revival beginning in the late 1860s.[3] After Homer first seriously used watercolor while on an extended visit to Gloucester, Massachusetts, during the summer of 1873, he quickly became a celebrated figure in the watercolor movement. In this medium, he enjoyed perhaps his greatest influence, sales, and critical recognition among his contemporaries.

Within a decade of taking it up, Homer had transformed the practice of watercolor in America. In the summer of 1880 he moved from carefully composed, finished compositions painted in a combination of opaque and transparent watercolor to vividly colorful, expressionistic scenes largely rendered in transparent watercolor alone. Homer reexamined his media in favor of a greater romantic evocation, initiating one of the key stylistic shifts of his career.[4] He traded his earlier idyllic aesthetic for a greater psychological intensity. *Boys Bathing* was painted on the early side of that change, but its acidic palette and interpersonal tension point to an unease with the relative levity of his playful subject matter.

Childhood enjoyed particular resonance in post–Civil War American culture, part of a national nostalgia for the country's own lost innocence. For Homer, the subject inspired fascination throughout the 1870s, though he repeatedly depicted threatening subtexts lurking in even the most seemingly idyllic environments. The precarious balance of Homer's boys as they perch on the bows of beached dories, atop rocky cliffs, or along the edges of listing sailboats is one such motif in his work of the later 1860s and 1870s, picked up by a figure in the lower left of *Boys Bathing*. Even in his most optimistic depictions of boyhood, danger is never far off, setting the stage for the mortal themes that occupied the artist in his later career.

Homer also often portrayed the parallels between the games of boys and the work of men.

Here, the boys' play with their boats sets the stage for their futures aboard the schooners in the background. His *Ship Building, Gloucester Harbor* (fig. 67) of 1873 works in the same manner, as boys building toy boats in the foreground echo the full-scale production behind them. In *Boys Bathing*, however, the boys' society appears less coherent than it does in the earlier work. The primary interaction of *Boys Bathing* is an exchange between the two boys standing in the center foreground.[5] The outstretched arms and turned head of the right-hand figure serve more as a compositional device mimicking the boats' rigging than as a representation of naturalistic action, though he may be drying himself. His friend, meanwhile, is a study in opposition, his arms clutched tightly behind his back as he returns the first boy's over-the-shoulder gaze, their regards not quite meeting. The remaining figures are so loosely rendered that their expressions are indecipherable. Amid the chaos of a group of boys at play, Homer has placed this estranged pair, introducing a sense of alienation that would later become a key theme in his work.

Boys Bathing also accentuates Homer's working method.[6] The ten boys and six boats in the composition attest to the artist's ambition in both scope and complexity but stretch the limits of his increasingly fluid, active technique in pursuit of such intricacy. The painting creates a veritable society of figures, hinting at the nature of their interactions through arrangement and careful geometry rather than detail. The strength of Homer's watercolors, like his oils, often derives from such balancing acts as he organizes figures and topography to echo one another and unify the composition. *Boys Bathing*, however, demonstrates how difficult such balances can become when elements proliferate, and it shows Homer's efforts to contain them. Despite careful blotting and scraping—two innovative subtractive techniques that Homer used to revise his watercolors—the abrasions to the paper and vestiges of effaced elements remain visible: a sail for the boat in the upper left and possibly figures removed from each of the two boats in the middle ground.[7] As Homer explored transparent watercolor with greater intensity during the summer of 1880, he moved toward simpler, more expressive scenes that favored the medium's innate characteristics.

MDM

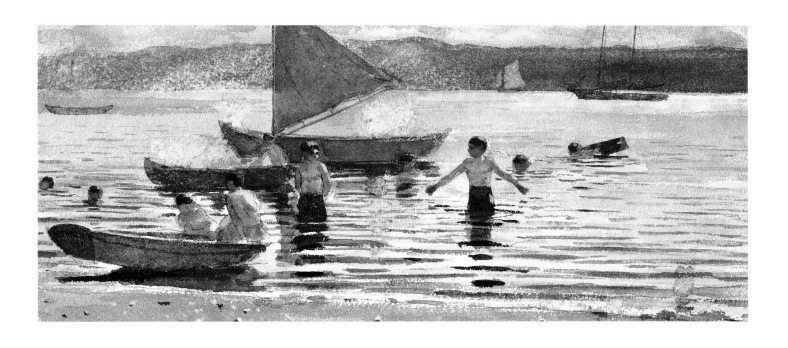

28 Winslow Homer, N.A., 1836–1910

Beaching a Boat (Figures in the Water, Prout's Neck), c. 1881–82

Pen and brown iron gall ink on laid paper, 7.6 × 20.6 cm (3 × 8⅛ in.)

Inscribed, in ink, on laid paper (probably originally part of the same sheet as the drawing) mounted on backing on frame backing: From / Winslow Homer's Studio / August 20th 1931 / Martha E. Homer.

From the estate of Tatiana Ruzicka (1915–1995). Presented in 1997 by Edward Connery Lathem in memory of Rudolph Ruzicka (1883–1978); D.997.44

PROVENANCE
Estate of the artist; to Charles Savage Homer Jr. (brother of the artist), c. 1917; to Mrs. Charles S. (Martha E.) Homer Jr.; to Rudolph Ruzicka, 1931; bequeathed to Tatiana Ruzicka (his daughter), 1978; bequeathed to Edward Connery Lathem, 1995; given to present collection, 1997.

After Homer visited Gloucester in the summer of 1880, when he painted *Boys Bathing* (cat. 27), the artist embarked for England in March 1881. He passed briefly through London but settled in Cullercoats, a small fishing village on the tempestuous North Sea, where he remained for a year and a half. There, he found several of the most compelling subjects of his career. The daily struggles and risks undertaken by the fishermen and their families confronted Homer with a harsh reality utterly opposed to the fashionable affluence common in his earlier work. The indomitable people of Cullercoats presented him with a brand of modern-day heroism that commanded his attention for the duration of his creative life.

Though rendered in little more than a rapid pen-and-ink shorthand, *Beaching a Boat* demonstrates Homer's masterful draftsmanship. The confidence of his line, the force of the drawing's action, and its immediacy render this an exceptionally potent artistic expression. Groups of men cluster around four fishing boats, known as cobles, pushing them ashore stern first so that they will be ready to launch again the next day. Homer shows both their direction and their force by the angle at which the men lean forward as they propel the boats ahead of them.[1] Their strenuous task is abetted by a single two-wheeled trolley, on which they must balance their enormous

load and convey it across the wet sand. Inside the village's protected bay, the water is quiet, but in the distance long lines in diagonal succession indicate the turbulent sea from which the men have come.

Unlike many of Homer's more elaborate compositions from this period, *Beaching a Boat* lacks suspense. The drawing's primary dynamic is not expectancy, as with fishwives counting the boats arriving home, or tragedy, as with men rushing out in search of a lost man or vessel, but simple force. Without the emotive surrogates shown waiting ashore, *Beaching a Boat* depicts the activity of the fishermen themselves rather than the anxieties created by their absence. Perhaps because of its spontaneity and reductiveness, *Beaching a Boat* also conveys greater cogency than his more elaborate compositions, including the closely related *Fishermen Beaching a Dory* (fig. 68).[2] These two drawings show a similar scene, but the more fully developed figures and landscape drain *Fishermen Beaching a Dory* of its essential energy. Homer's emphasis on drawing and watercolor during his time in Cullercoats suggests that the artist felt that these more spontaneous and portable media better served his purposes and his subjects, as the vitality of *Beaching a Boat* suggests.[3]

Beaching a Boat was never intended to make its way into the gallery of a museum. Art historian Lloyd Goodrich believed that the drawing may have been cut from one of the artist's letters.[4] The work's scale and simplicity corroborate Goodrich's theory. They also lend credibility to Homer scholar Paul Provost's thesis that during the artist's stay in England he interwove style and content in his art, particularly his drawings, as never before.[5] Unlike the majority of the artist's sketches, usually charcoals, this pen-and-ink drawing stresses the medium's hallmarks of fluidity and calligraphic line, exhibiting Homer's virtuosic control over his medium despite its rarity in his work. The drawing shares more with the artist's handwriting, which is virtually always in mellifluous pen and ink, than his charcoal sketches. As an extemporaneous, perhaps epistolary, description of life at Cullercoats, *Beaching a Boat* makes a remarkable (if diminutive) contribution to our understanding of the artist's diverse creative practices.

MDM

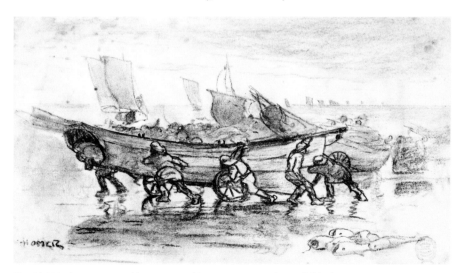

Fig. 68. Winslow Homer, *Fishermen Beaching a Dory*, 1881, charcoal, black and white chalk on cream wove paper, 17.6 x 30.0 cm (6¹⁵⁄₁₆ x 11¹³⁄₁₆ in.). Cooper-Hewitt, National Design Museum, Smithsonian Institution; Gift of Charles Savage Homer, Jr., 1912–12–41

29 James McNeill Whistler, 1834–1903

Maud Reading in Bed (Interior: Study of a Woman in Bed; Interior, Woman Resting in Bed; Maud in Bed), 1883–84

Opaque and transparent watercolor and pen and brown ink over graphite on tan cardboard, 25.1 × 17.8 cm (9⅞ × 7 in.)

Signed, upper right: [butterfly device]

Gift of Mr. and Mrs. Arthur E. Allen Jr., Class of 1932; W.971.26

PROVENANCE
Whistler family, Baltimore; Frederick Keppel (art dealer), New York; Mr. and Mrs. John P. Elton, Waterbury, Conn., by 1949; bequeathed to Mr. and Mrs. Arthur E. Allen Jr. (son-in-law and daughter), 1950s; given to present collection, 1971.

RELATED WORKS
Four watercolors show modest variations on the same subject and probably share close dates: *Maud Reading in Bed* (cat. rais. no. 899; Walters Art Museum, Baltimore); *Pink Note—The Novelette* (cat. rais. no. 900, Freer Gallery of Art, Washington, D.C.); *Resting in Bed* (cat. rais. no. 901; Freer Gallery of Art, Washington, D.C.); and *Convalescent* or *Petit Déjeuner; Note in Opal* (cat. rais. no. 903, private collection, Great Britain). These watercolors all have similar dimensions to *Maud Reading in Bed* and may have been taken from the same book; the Hood watercolor is painted on the back cover of a watercolor block. *Convalescent* is the closest compositionally to *Maud Reading in Bed* but is on a white paper.

EXHIBITIONS
Lyman Allyn Museum, New London, Conn., *James McNeill Whistler*, 1949, no. 34 (as *Interior: Study of a Woman in Bed*); Dartmouth College Collections, Hanover, N.H., *Works on Paper: Nineteenth and Twentieth Century Drawings and Watercolors from the Dartmouth College Collection*, 1975, no. 7; Carpenter Hall Galleries, Dartmouth College, Hanover, N.H., *Image of Woman*, 1976; Hopkins Center Art Galleries, Dartmouth College, Hanover, N.H., *Nineteenth-Century American Drawings*, 1976 (no cat.); University of Michigan Museum of Art, Ann Arbor, *Whistler: The Later Years*, 1978 (no cat. no.); M. Knoedler and Company, Inc., New York, *Notes, Harmonies, and Nocturnes: Small Works by James McNeill Whistler*, 1984, no. 24; Hood Museum of Art, Dartmouth College, Hanover, N.H., *James McNeill Whistler: Works from the Dartmouth Collection*, 1988 (no cat.); Hood Museum of Art, Dartmouth College, Hanover, N.H., *From Copley to Dove: American Drawings and Watercolors at Dartmouth*, 1989 (no cat.); Tate Gallery, London, and others, *James McNeill Whistler*, 1994–95, no. 133; The Art Institute of Chicago and National Gallery of Canada, Ottawa, *Songs on Stone: James McNeill Whistler and the Art of Lithography*, 1998, no. 20.

REFERENCES
Eugenia S. Robbins, "College Museum Notes," *Art Journal* 32, no. 1 (fall 1972), 45–46 (illus., as *Interior, Woman Resting in Bed*); Peter Kolack, "Interior, Woman Resting in Bed," in Franklin W. Robinson (ed.), *Works on Paper: Nineteenth and Twentieth Century Drawings and Watercol-*

James McNeill Whistler stands out as one of the most audacious figures in modern art history. During his lifetime, his unconventional lifestyle and flamboyant persona invited nearly as much speculation as did his prodigious talents as a painter, etcher, lithographer, decorator, book designer, and watercolorist. Indeed, debates about his numerous attention-seeking escapades have fueled a voluminous literature up to the present day. There can be little doubt that Whistler delighted himself while playing the role of provocateur—usually settling for nothing less than notoriety. He antagonized patrons and art critics alike, preferring open controversy to private suffering, most often to his eventual detriment.[1] His confrontational behavior produced several memorable legal disputes, to say nothing of a revealingly self-titled collection of public statements, *The Gentle Art of Making Enemies*.[2]

Whistler was born in New England but spent six of his childhood years in Russia.[3] Not yet ten years old, Whistler received training at the Imperial Academy of Fine Arts in Saint Petersburg before illness caused him to relocate to London. In 1849 the Whistler family returned to the United States, and the youngest son enrolled at the U.S. Military Academy at West Point, where he continued his artistic education. Although Whistler distinguished himself in drawing courses, he was ultimately discharged from the academy for otherwise poor academic performance in 1854. The following year, he left for Europe, never again to return to the United States.

Whistler refashioned himself as a bohemian type while abroad, and Paris's Latin Quarter provided him with his first sustained exposure to professional artists and their milieu. His closest associates were young British and French painters—Edward Poynton, Henri Fantin-Latour, and Alphonse Legros—who, like Whistler, were serious about making ambitious, vanguard representations and who likewise shared his passion for contemporary aesthetic theories. His first submissions were accepted into the Paris Salon in 1859. Simultaneously, he excelled at etching, which he shrewdly marketed in both France and England. He is perhaps best known to the general public today for *Arrangement in Grey and Black (Portrait of the Painter's Mother)* (1871, Musée d'Orsay, Paris), which was shown at the Paris Salon in 1883 to mixed reviews and was later purchased by the French State.[4] Although he came to be idolized by the other Americans who flocked to Paris's art academies in search of professional credentials from the 1860s through the 1890s,

Whistler remained fundamentally aloof from his own generation of expatriates.[5] Especially as a young artist, he looked to Gustave Courbet and Édouard Manet as primary influences, and he sympathized with the occasional secessionist, self-promotional displays that these men created outside official Salon contexts.[6] Ultimately Whistler disavowed the French realist model of finding beauty in "modern life"—as evoked by Charles Baudelaire[7]—in favor of a rarefied aestheticism whose roots lay in the appreciation of extreme artifice, as articulated most vividly at the time in the pronouncements of Oscar Wilde and the comte de Montesquiou.[8]

In pursuit of non-narrative, nondescriptive, and therefore "purely decorative" imagery, Whistler repudiated historical, moralizing subject matter and aimed for more transcendent forms of creative expression. Indeed, his devotion to "art for art's sake" ideals assumed quasireligious proportions.[9] He assigned titles to his works using a musical lexicon—dubbing them symphonies, arrangements, and so on—a move that underscored a wider commitment to the abstract experience of these creations. Especially in his watercolors, Whistler took care to suggest subjects rather than depict them with the precision favored by his close contemporaries working in the same media, such as the British Pre-Raphaelites. Whistler's first significant exhibition of watercolors took place in London in 1884, when they were grouped with oil paintings and etchings under the elaborate label "Notes, Harmonies, Nocturnes: Arrangement in Fleshcolour and Grey."[10] While the Hood watercolor seems not to have been shown on that occasion, it almost certainly dates from this time.

A number of the images first displayed in the 1884 exhibit feature a young, red-haired woman—Maud Franklin—who is recognizable here as well. Much has been written about the tumultuous relationship between Whistler and his female models, and perhaps the greatest attention has been paid to Franklin.[11] The two met when she was still a teenager and the artist already a mature man in his forties. They lived and traveled together despite the fact that she was not permitted to accompany him on formal social occasions. Over a fifteen-year period Whistler produced about sixty independent works of art in which Franklin figures as a presence. She often served as a stand-in for female portraits in oil, which took too long for most sitters to endure.[12] She was also a favorite interpretative type: either assertively alert—as in the full-length figure study

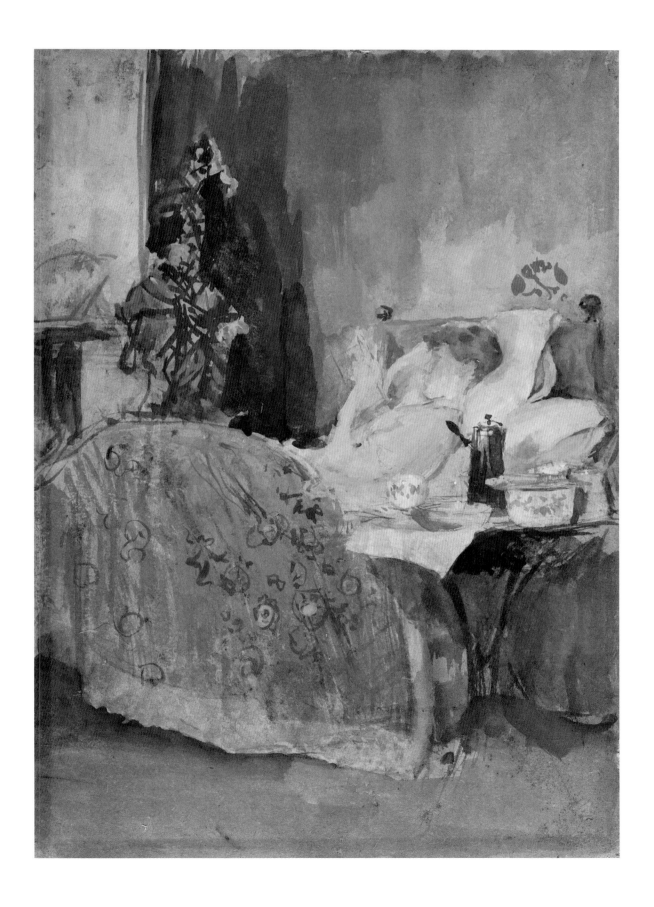

ors from the Dartmouth College Collection (Hanover, N.H.: Dartmouth College Collections, 1975), 17–18 (illus., n.p.); Nesta Spink, *Whistler: The Later Years* (Ann Arbor: University of Michigan Museum of Art, 1978), n.p. (as *Interior, Woman Resting in Bed*); Margaret F. MacDonald, *Notes, Harmonies, and Nocturnes: Small Works by James McNeill Whistler* (New York: M. Knoedler and Co., 1984), 32 (illus., as *Woman Reading in Bed*); Jacquelynn Baas et al., *Treasures of the Hood Museum of Art, Dartmouth College* (New York: Hudson Hills Press, in association with the Hood Museum of Art, Dartmouth College, 1985), 118–19, no. 107 (color illus.); Jacquelynn Baas, "From 'a Few Curious Elephants Bones' to Picasso," *Dartmouth Alumni Magazine* 78, no. 1 (September 1985), 41 (color illus., as *Maud in Bed*); Barbara J. MacAdam, "American Paintings in the Hood Museum of Art, Dartmouth College," *The Magazine Antiques* 128, no. 5 (November 1985), 1025 (color illus., as *Maud in Bed*); Richard Dorment and Margaret F. MacDonald, *James McNeill Whistler* (London: Tate Gallery Publications, 1994), 215 (color illus.); Margaret F. MacDonald, *James McNeill Whistler: Drawings, Pastels, and Watercolours; A Catalogue Raisonné* (New Haven: Yale University Press, 1995), 342 (illus.), no. 902; *Connaissance des Arts*, "Whistler" special issue, February 1995, 66, inside back cover, fig. 68 (color illus.); Martha Tedeschi and Britt Salvesen, "Early Experiments: Images of Maud Franklin" *Songs on Stone: James McNeill Whistler and the Art of Lithography,* (The Art Institute of Chicago) *Museum Studies* 24, no. 1 (1998), 28 (color illus.), 31, fig. 11; Annette Carroll Compton, *Drawing from the Mind, Painting from the Heart* (New York: Watson-Guptill, 2002), 34 (color illus.).

Arrangement in White and Black (c. 1879, Freer Gallery of Art, Washington, D.C.)—or an unselfconscious, somnolent object, as shown here. It has been suggested that Franklin may have been pregnant or was recuperating from an illness related to childbearing in this watercolor. Except for the later poetic retitling of a clearly related work, nothing in the image supports that particular interpretation of her condition.[13] It seems more plausible that Whistler was sensitive to the idea of an imaginatively absorbed female subject, a theme that had repeatedly engaged him throughout his career. The pose would have also been a relatively easy one for Franklin to maintain and certainly Whistler never tired of it.[14] A related watercolor (fig. 69) shows her relaxing in bed, wholly unembarrassed about her "unproductive" reading habit. A man's top hat and cane are

clearly visible on a bureau in the background. These male-coded inclusions cut sharply against any melodramatic interpretation of Franklin as helpless invalid; instead, they associate her with the role of a *grisette*—a popular stereotype of the cheap prostitute—which most late-nineteenth-century consumers of realist representations would have immediately identified.[15]

Maud Reading in Bed is painted on a piece of thick cardboard that was the back support for a block of watercolor paper.[16] For this reason, Whistler painted with a more loaded brush than he might normally. Although he left many parts of the card bare, exploiting its tan color for harmonious effect, the heavy watercolor was not fully absorbed into the dark porous background in the passages he painted. The interior space is deftly described around Franklin. She is shown in her

Fig. 69. James McNeill Whistler, *Resting in Bed*, c. 1883–84, watercolor on paper, laid down on card, 16.9 x 24.0 cm (6¹¹⁄₁₆ x 9⁷⁄₁₆ in.). Freer Gallery of Art, Smithsonian Institution, Washington, D.C.; gift of Charles Lang Freer, F1907.172

nightgown, propped up by pillows, with the lower half of her body shrouded by a coverlet on which Whistler energetically inked a floral motif. A neatly organized breakfast tray with coffeepot and porcelain bowls sits on a café table just to the left of the bedpost, while a fan is spread out flat against the far wall on a mantel. Whistler thus defines the limits of his chosen pictorial space and suggests the scene's morning hour. The shallow, profile structure of the composition is not unlike the artist's pair of monumental seated portraits of the early 1870s — *Arrangement in Grey and Black, No. 1* and *Arrangement in Grey and Black, No. 2* (the artist's mother and Thomas Carlyle, Glasgow Museum and Art Gallery) — except for the fact that in this image the sitter's gaze is focused, not beyond the picture frame, but on a book held close to her face. The tonally restrained color scheme — predominantly grays and purple, with faint touches of red and yellow — also links this image to these earlier breakthrough paintings. There is, however, a fundamental quality of intimacy attached to *Maud Reading in Bed,* a sentiment that one does not necessarily expect from Whistler's aesthetically restrained — sometimes bordering on detached — interiors. Whistler had a profound, if complicated, emotional attachment to this model. For this reason, he may have deliberately placed his famous butterfly monogram just above her head, at once supervising Franklin's reading and, thus, functioning as an emblem of her perceived vulnerability, but equally serving as an emblem of his long veneration.

DRC

30 Hermann Dudley Murphy, N.A., 1867–1945

Standing Male Nude, 1893

Charcoal on laid paper, mounted on cardboard, 62.9 × 31.8 cm (24¾ × 12½ in.)

Signed, dated, and inscribed, lower right: H. Dudley Murphy / Academie Julian / Paris 1893

Hood Museum of Art, Dartmouth College; D.X.151.1

PROVENANCE
Hopkins Center Art Galleries, Dartmouth College, by 1966.

Life drawing has been a pillar of art education in the Western tradition since the Renaissance. The nude's complexity of form and virtually infinite repertory of poses render it one of the richest challenges for students and professional artists alike. Until the late nineteenth century, life drawing was considered a culminating experience for students as they progressively mastered shape, volume, proportion, and perspective. Students often worked from a single pose for a month at a time.[1] Study from life even took on metaphorical significance, as the artist's appreciation of the nude was considered "the paradigm for the study of nature" in general.[2] In its historic role, the body, particularly the male body, was endowed with philosophical and moral resonance as "the principal signifier for elevated public values (civic, ethical, heroic)."[3] Over the course of the nineteenth century, that symbolism eroded, but it left behind a vestige of transcendent meaning. As naturalism supplanted idealism in life drawing, the full-length figure came to symbolize "the idea of the whole" in nature, which translated well into other artistic genres as a metaphor for compositional unity and coherence.[4] For an artist like Hermann Dudley Murphy, who primarily painted still lifes and landscapes in his later career, the lessons learned as a student in life class, where he drew *Standing Male Nude,* nevertheless endured. Despite the paucity of figures in his mature paintings, Murphy enjoyed a distinguished thirty-five-year tenure as professor of life drawing at Harvard from 1902 until 1937.[5]

After the conclusion of the Civil War in 1865, an increasing number of American aspirants traveled abroad to complete their art training in European academies. Notable among these institutions was Paris's Académie Julian, where instruction "concentrated on drawing, mainly of the human figure, in search for the truth in nature."[6] The absence of an entry exam and the relative informality of Rodolphe Julian's new academy (fig. 70), founded in 1868, attracted students by the hundreds and permitted greater stylistic and creative latitude than its primary competitor, the venerated École des Beaux-Arts. The team-teaching approach employed at the Académie Julian, in which two or more professors supervised the same class, insulated students against the excessive imitation of a single instructor.[7] Murphy was listed on the Julian's student roster for five years, 1891–95, and served as a studio supervisor, or *massier.* Although the *massier* was elected by

the students rather than appointed on the basis of merit, Murphy's position indicates a balance between his popularity and respect for his accomplishments.[8] According to art historian William Coles, Murphy "won four prizes each in drawing and composition" in the two years 1892–93, when he drew *Standing Male Nude.*[9] The spirit of competition among students for those prizes, with their attendant monetary awards, invigorated the climate in the studios, which were famously crowded and unventilated. Although some students complained about the working conditions, they continued to enroll in ever larger numbers well into the twentieth century. For American expatriates in Paris like Murphy, the Académie Julian offered a welcoming haven and community in which to learn.

Murphy's *Standing Male Nude* testifies both to the priorities of the Académie Julian and to the dynamism of the evolving life-drawing tradition. Drawings of the nude during the later nineteenth century no longer pursued the so-called *beau idéal,* in which artists negotiated "the discrepancies between the flawed shape of the individual live body and the ideal" masculine form embodying "humankind's greatest and noblest characteristics."[10] In place of the muscular Adonis came models whose features resembled a laborer's. At a time when physical type was considered symbolic of personal character, the decline of well-paid models whose features approximated classical ideals signaled a change in the nature of life drawing. Murphy's drawing belongs on the late side of that transformation. The figure's large, heavily veined hands and ankles manifest the effect of time standing in a single pose. His gaunt facial features, slim neck, and visible ribcage in no way resemble the smooth, toned forms of classical sculpture. In lieu of a reconstituted ideal, however, Murphy's figure excels in expressivity. The slight twist of his upper body stretches the skin across his stomach, creating thin lines of tension; his chest is depicted with incredible sensitivity to tonal gradation; and the outer contours of his thighs are busy with indications of leg hair. This is not a classical model but rather a new masculine type. The figure's sinewy strength, his angular features, and his movement collectively convey a rugged, labor-marked male body, redolent of the modern industrial age rather than the classical past.

MDM

Fig. 70. Jefferson David Chalfant, *Bouguereau's Atelier at the Académie Julian, Paris,* 1891, oil on wood panel, 28.6 x 36.8 cm (11¼ x 14½ in.). Fine Arts Museums of San Francisco; gift of Mr. and Mrs. John D. Rockefeller 3rd to The Fine Arts Museums of San Francisco, 1979.7.26

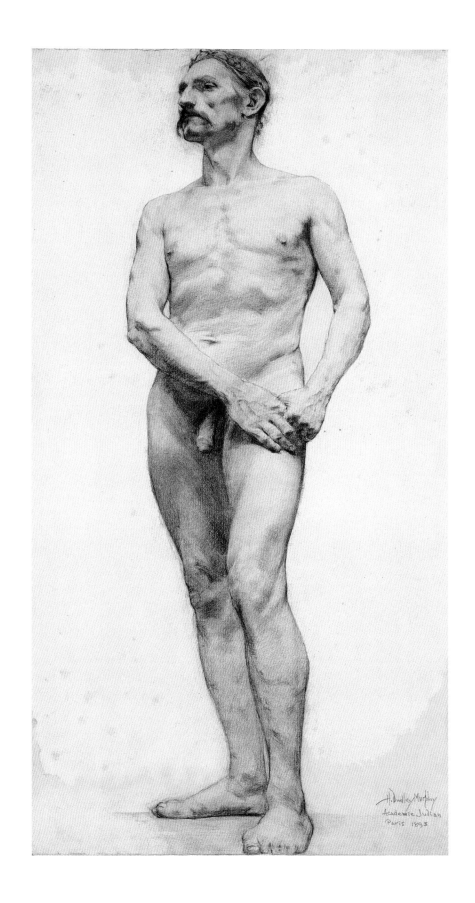

31 Maurice Brazil Prendergast, 1859–1924

Woman with a Parasol (Reading in the Garden), c. 1893–94

Watercolor over graphite on wove paper, 21.9 × 16.5 cm (8⅝ × 6½ in.)

Signed, in pen and ink, lower right: Prendergast

Purchase made possible through the generosity of Mr. and Mrs. Preston Harrison; W.938.8

PROVENANCE
James Wilson Morrice; by descent in the family; to Scott, Montreal; to C. W. Kraushaar Art Galleries, New York; sold to present collection, 1938.

EXHIBITIONS
Jaffe-Friede Gallery, Hopkins Center, Dartmouth College, Hanover, N.H., *Director's Choice*, 1966 (no cat. no.); Dartmouth College Collections, Hanover, N.H., *Works on Paper: Nineteenth and Twentieth Century Drawings and Watercolors from the Dartmouth College Collection*, 1975, no. 15; Utah Museum of Fine Arts, University of Utah, Salt Lake City, *Graphic Styles of the American Eight*, 1976, no. 82; Sterling and Francine Clark Art Institute, Williamstown, Mass., *Watercolors by Maurice Prendergast from New England Collections*, 1978, no. 25; Hood Museum of Art, Dartmouth College, Hanover, N.H., *From Copley to Dove: American Drawings and Watercolors at Dartmouth*, 1989 (no cat.).

REFERENCES
Kevin O'Brien, "Reading in the Garden," in Franklin W. Robinson (ed.), *Works on Paper: Nineteenth and Twentieth Century Drawings and Watercolors from the Dartmouth College Collection* (Hanover, N.H.: Dartmouth College Collections, 1975), 27 (illus., n.p.); Sheldon Reich, *Graphic Styles of the American Eight* (Salt Lake City: Utah Museum of Fine Arts, University of Utah, 1976), 76; Gwendolyn Owens, *Watercolors by Maurice Prendergast from New England Collections* (Williamstown, Mass.: Sterling and Francine Clark Art Institute, 1978), 57–58, fig. 25 (illus.); Jacquelynn Baas et al., *Treasures of the Hood Museum of Art, Dartmouth College* (New York: Hudson Hills Press, in association with the Hood Museum of Art, Dartmouth College, 1985), 118–19, no. 108 (color illus.); Carol Clark, Nancy Mowll Mathews, and Gwendolyn Owens, *Maurice Brazil Prendergast, Charles Prendergast: A Catalogue Raisonné* (Williamstown, Mass.: Williams College Museum of Art; Munich: Prestel, 1990), 345, no. 578 (illus.).

Maurice Prendergast is widely recognized as one of the finest watercolorists in the history of American art. Prendergast's lively brushwork and bright palette contribute to the distinctive brand of cheerful and evocative poetics for which he is now well known. *Woman with a Parasol* (previously titled *Reading in the Garden*) is a charming example of the artist's early work in the medium and depicts a frequent subject in his art of the early 1890s: women in public spaces.[1] Prendergast was fascinated by fashionably attired women at leisure in Parisian parks and along the city's tree-lined boulevards. As art historian Carol Clark has written, "These images set forth Prendergast's discerning attention to dress and carriage, for although he did not individualize them by facial characteristics, he observed anew each figure's comportment."[2] Emerging from life studies at the Académie Julian (see cat. 30), Prendergast demonstrates a thorough understanding of the figure in his early watercolors, even as he undertook an increasingly fluid stylistic approach to its depiction.[3]

Moving away from the more rigid "colored drawings" typical of his watercolors earlier in the 1890s, *Woman with a Parasol* charts the artist's way forward with greater spontaneity and technical virtuosity.[4] The rhythmically spaced, pollarded trees in the background, the vertical of the parasol's handle, and the second chair in the foreground all reinforce an informal sense of compositional abstraction. Despite the artist's gestural handling of his medium, the watercolor's prominent structural elements, strongly reiterated by the vibrant blue framing line, enforce awareness of the picture plane. Prendergast has virtually suspended spatial recession and perspective in favor of a rich, dense visual arrangement. His compression of open space and attention to surface are clear indicators of his nascent interest in modernist aesthetics.

A degree of concentration, even constriction, emerges in *Woman with a Parasol* as well. Again in a manner at least partially derived from the emphasis on the human figure at the Académie Julian, *Woman with a Parasol* directs attention to the sitter.[5] The figure is the central focus, with little attempt at the evocation of a casual glance—ours is instead a direct stare. Arms crossed at her waist and her upper body enveloped by the saturated violet backdrop of her parasol, the woman has tightly arranged herself. She looks out of the composition to her left, averting her gaze from our scrutiny. As a study, the watercolor demonstrates remarkable sympathy between the figure's closed posture and the overall density of the composition. In Prendergast's later work that sense of constriction diminished, but his intensity of focus on the surface and patterning remained a major aspect of his mature style.

Widely explored by many artists during the period, the decorative arrangement of women in both public and private spaces was typical of Prendergast's work of the 1890s. Inspired by James McNeill Whistler's compositions and "arrangements," such as *Maud Reading in Bed* (cat. 29), human figures, particularly women's, were represented more and more as "props in a decorative design."[6] Whistler differentiated art from work, and in his style too he adopted an apparently effortless ideal that watercolor exemplified by its intrinsic properties. Weightless, massless, and transparent, the medium offered artists an excellent metaphor for artistic modernity. Art historian Robert Herbert has written, "Work was despised because the growing industrial revolution was separating it from inventiveness, originality, and individualism," and as a result, "culture and leisure are inseparable [in modern society] because they are the opposite of work."[7] For artists like Prendergast, trained intensively in the meticulous representation of the human form, modernist aesthetics furnished a welcome reprieve from the strictures of life study. *Woman with a Parasol* balances those competing forces of restraint and license, focus and fluidity, as Prendergast tentatively made his initial modernist gambit.

MDM

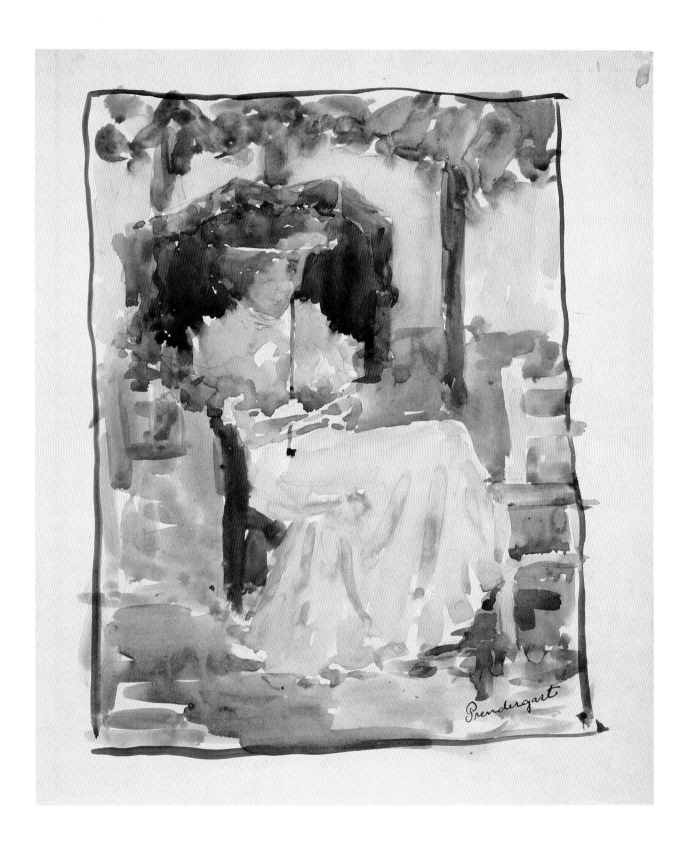

The Harbor from City Point (New England Shore and Harbor Scene; also possibly *The Harbour), 1895*

Watercolor over graphite on wove paper, 35.6 × 25.4 cm (14 × 10 in.)

Signed and dated, in graphite, lower left: 1895 / M.B. Prendergast; signed, in ink, below: Maurice B. Prendergast [numerous initials and signatures inscribed in graphite]

Bequest of Warren F. Upham, Class of 1916; W.976.136

PROVENANCE
Possibly C. O. Elliett (art dealer), Malden, Mass., 1897; Middleby Estate, Malden, Mass.; sold to Margie and Warren F. Upham, Malden, Mass., probably early 1930s; given to present collection, 1976.

EXHIBITIONS
Possibly C. O. Elliett, Malden, Mass., *Artists' Exhibition and Sale,* 1897, no. 84 (as *The Harbour*); Sterling and Francine Clark Art Institute, Williamstown, Mass., *Watercolors by Maurice Prendergast from New England Collections,* 1978, no. 3; Hood Museum of Art, Dartmouth College, Hanover, N.H., *From Copley to Dove: American Drawings and Watercolors at Dartmouth,* 1989 (no cat.).

REFERENCES
Gwendolyn Owens, *Watercolors by Maurice Prendergast from New England Collections* (Williamstown, Mass.: Sterling and Francine Clark Art Institute, 1978), 19–20, fig. 3 (as *New England Shore and Harbor Scene*); Carol Clark, Nancy Mowll Mathews, and Gwendolyn Owens, *Maurice Brazil Prendergast, Charles Prendergast: A Catalogue Raisonné* (Williamstown, Mass.: Williams College Museum of Art; Munich: Prestel, 1990), 350, no. 596 (illus.).

Adopting the tools of European modernism—particularly impressionism and post-impressionism—Prendergast's depictions of seaside recreation and Venetian cityscapes have garnered critical attention since the early twentieth century, though they received little serious study during his lifetime.[1] The steep, "climbing" perspective, active brushwork, and leisure subject matter found in *The Harbor from City Point* are all characteristics of both his mature style and his affinity with impressionism as it was practiced on either side of the Atlantic. In some respects, however, *The Harbor from City Point* demonstrates Prendergast's mature style in germination.[2] The mottled, purpuric tone suggests an overcast day, while the few and distant figures invoke a sense of estrangement.[3] Moreover, the shipyards in the background visually interweave industry into a landscape of relaxation, the latter conveyed by children balancing along the water's edge at the right and the strolling promenaders.[4] Within a year of painting *The Harbor from City Point,* Prendergast perfected his signature style, subsuming this painting's ambivalent and provocative juxtapositions under the beguiling, cheerful parasol of leisure. In this work of 1895, however, those underlying elements remain discernible and inflect our understanding of his later work along Boston's shore.

Prendergast's artistic project also comes into sharper relief in the light of his personal history. Certainly, he never attained the social standing of John Singer Sargent or William Morris Hunt, Boston's reigning artistic masters at the end of the nineteenth century. Art historian Trevor Fairbrother has summed up the likely reasons for Prendergast's absence from the city's top artistic stratum: "He came from a modest background, was hard of hearing, and never married; he was not a teacher in any of the local art schools, and does not seem to have taken any private pupils. But the more important factor was the independent course he steered in art."[5] To those conditions we can further append Prendergast's Irish immigrant parentage.[6] As the artist developed his mature style during the mid-1890s, the relevance of his class and heritage became clear. He favored portraying groups of people at leisure at venues like Revere Beach on Boston's North Shore and South Boston's Marine Park, the culminating point in Frederick Law Olmsted's master plan for the city's so-called Emerald Necklace of parks. These newly reformed and renovated recreation

areas, easily accessible from the city by omnibus, were huge draws for Boston's working-class population, which was heavily Irish American. Prendergast himself was raised in poor, predominantly Irish South Boston, which was viewed by affluent Bostonians and social reformers as an urban blight.[7] At the city's beaches, then, were Prendergast's people, rather than the wealthy who traveled farther afield in search of leisure activity. His artistic celebrations of working-class life during the 1890s struck a note very different from that favored by Boston's upper class.

According to landscape historian Cynthia Zaitzevsky, Marine Park "was the most popular part of the [Boston park] system in Olmsted's [and Prendergast's] day," attracting between ten and fifteen thousand visitors on any given Sunday.[8] In later paintings, those crowds became the artist's primary subjects, but in *The Harbor from City Point,* the landscape remains virtually deserted and decidedly unscenic, despite the fact that the park's main attraction, a temporary bridge linking the peninsula to historic Castle Island, had opened to great fanfare and popularity three years earlier.[9] In *The Harbor from City Point,* Prendergast has turned his back on the famous bridge and its "very noble sea-views," which riveted his attention in subsequent years, facing instead toward the industrial harbor along a muddy, rutted roadway.[10] Art historian Margaretta Lovell has found that this type of subject recurs in Prendergast's work, and she has equated such deliberately nontraditional scenes with literary theorist Northrop Frye's "low mimetic mode," a method of "incorporating yet repudiating high heroic monuments . . . not so much to see them in partial or sliced frontal views as to see them 'backwards,'" rather than from their more famous side.[11] As Nigel Blake and Francis Frascina have written, an avant-gardist is "someone who works on representations of contemporary society by means of a critical engagement with the codes, conventions and political assumptions of the ideologically dominant class."[12] In *The Harbor from City Point,* Prendergast has averted his gaze from the carefully contrived beauties of Olmsted's park to look back at the urban environment from which it and its visitors emerge.[13] As he developed his characteristic mode of depicting beachfront leisure, Prendergast was clearly aware of the harsh reality of city life from which his subjects sought refuge.

MDM

M.B. Prendergast 1895

33 Everett Shinn, N.A., 1876–1953

Trafalgar Square, London, 1900

Pastel on tan wove paper, 25.1 × 35.5 cm
(9⅞ × 14 in.)

Signed and inscribed, along lower edge:
E SHINN TRAFALGAR SQUARE — LONDON;
inscribed by artist, in pen and ink, on reverse upper right: Everett Shinn / 122
East 19th St. / New York; in later hand,
in graphite, lower left: Bought May 4,
1951 / from Prof. Rees H. Bowen / 8
Downing Road, Hanover

Purchased through the Julia L. Whittier
Fund; D.951.48

PROVENANCE
[Kraushaar Galleries, New York?]; Rees
Higgs Bowen, Hanover, N.H.; sold to
present collection, 1951.

EXHIBITIONS
Boussod, Valadon, and Co., New York,
*Exhibition of Pastels: Paris Types by Everett
Shinn*, January–February 1901, not included in checklist; Pennsylvania Academy of the Fine Arts, Philadelphia,
*Second Annual Exhibition of the Fellowship of the Pennsylvania Academy of the
Fine Arts*, 1901, no. 174; Cincinnati Museum Association, *Eighth Annual Exhibition of American Art*, 1901, no. 86; St.
Louis Museum of Art, *Special Exhibition
of Oil Paintings by American Artists*, 1901,
no. 45; City Club, [New York?], 1901–2;
Dartmouth College Collections,
Hanover, N.H., *Works on Paper: Nineteenth and Twentieth Century Drawings
and Watercolors from the Dartmouth College Collection*, 1975, no. 25; Utah Museum of Fine Arts, University of Utah,
Salt Lake City, *Graphic Styles of the American Eight*, 1976, no. 100; Hood Museum of Art, Dartmouth College,
Hanover, N.H., *From Copley to Dove:
American Drawings and Watercolors at
Dartmouth*, 1989 (no cat.).

REFERENCES
James Dell, "Trafalgar Square, London,"
in Franklin W. Robinson (ed.), *Works on
Paper: Nineteenth and Twentieth Century
Drawings and Watercolors from the Dartmouth College Collection* (Hanover, N.H.:
Dartmouth College Collections, 1975),
39–40 (illus., n.p.); Sheldon Reich,
Graphic Styles of the American Eight (Salt
Lake City: Utah Museum of Fine Arts,
University of Utah, 1976), 55 (illus.), 77.

Fig. 71. Edgar Degas, *Place de la Concorde*, 1875,
oil on canvas, 78.4 x 117.5 cm (30⅞ x 46¼ in.).
The State Hermitage Museum, St. Petersburg

Everett Shinn once remarked that Edgar Degas
was "the greatest painter France ever turned
out."[1] Over the course of the twentieth century,
that statement gradually accustomed scholars to
the fact of foreign influence on the otherwise vocally nativist Ashcan School of social realism, of
which Shinn was a participant.[2] Richard Kendall
has recently expanded on Shinn's confessed admiration for Degas to characterize him as the
French impressionist's "most brazen" American
follower, calling Shinn's one-man exhibition at
New York's Boussod, Valadon, and Company
gallery early in 1901 "like an act of homage to his
European master."[3] According to Shinn's record
book, that exhibition included *Trafalgar Square,
London*.[4] Shinn certainly had access to Degas's art
even before his own first visit to Paris in 1900.
Robert Henri, whom Shinn knew from his studies at the Pennsylvania Academy of the Fine Arts,
had brought photographs of impressionist art
back from Paris by 1895, and Shinn admitted that
during the 1890s he and his peers "tried to see all
the new publications from abroad," including art
journals and illustrated books.[5] Understanding
Degas's significance for Shinn, however, has
proven to be a greater challenge than establishing
the two artists' stylistic affinity.

Unlike Shinn's ballerinas, bathers, horse
races, and theater scenes, subjects that appear on
their face to owe much to Degas's example, his
dramatic and varied renderings of public squares
like this one reveal more about his artistic individuality than about his debts. Predominant in
Trafalgar Square is Shinn's agitated, "ragged"
stroke, derived from his years working as a newspaper illustrator in Philadelphia and New York.
Combining that active stroke, stark chiaroscuro,
and a more completely rendered composition
than was common in commercial illustration,
Trafalgar Square marked a turning point in
Shinn's work, as he cultivated his artistic career
outside professional illustration about 1900.[6] The
trip to Europe, sponsored by his gallery, was a
speculative venture undertaken specifically to
help the artist develop new ideas and material as
he made the transition from illustration to
fine art.

In *Trafalgar Square*, Shinn transforms the dynamism so characteristic of his early illustrations,
which he called "scenes of action," into his primary subject.[7] He employs bright, saturated areas
of color in nearby objects and graduates his use of
line so that objects in the foreground are heavily
contoured and project forward from the atmospheric background of the buildings. As three om-

nibuses jockey in and out of spaces along the
curb, a man dressed in the uniform of a recruiting sergeant and a woman dressed in black stand
in the foreground.[8] Neither the figures' relationship nor their activity is easily understood,
though their proximity to the busy curb implies
that they wait for a bus. As for the omnibuses
themselves, Shinn's style subsumes specific direction to a general state of activity. Only on attentive examination can we determine that the
omnibus at the right is headed in the opposite direction of the other two. The staircase at its rear is
recognizable by its diagonal sweep rather than by
any sense of mass. Likewise, the team pulling the
center omnibus is virtually indistinguishable,
though its driver is evident atop the carriage. At
the drawing's near left, the horses' blurred legs
and agitated contours only add to the pervasive
state of nervous energy. *Trafalgar Square* simultaneously harnesses London's constant motion and
showcases a characteristic dimension of Shinn's
art.

Moreover, *Trafalgar Square* is also a useful foil
for comparison with Edgar Degas's rendering of
Paris's equally important intersection, the place
de la Concorde (fig. 71). Although several of
Shinn's depictions of New York and Paris squares
revolve around empty spaces in a manner similar
to Degas's *Place de la Concorde*, his depiction of
Trafalgar Square does not. Instead, it accentuates
the artist's interest in urban flow. As Albert Gallatin observed very early in the twentieth century,
"Shinn has only gone to Degas for inspiration, for
ideas; not slavishly and unintelligently to copy
him."[9] By one account, when Shinn hired dancers
as models while he was working in Paris in 1900,
he had them dance around his studio while he
sketched, consciously differing from Degas's well-
known practice of working from models in static
poses.[10] *Trafalgar Square* demonstrates how Shinn
integrated Degas's sense of the incidental by
bleeding the horses off the edge of the composition and avoiding a central narrative, but it also
contributes a new dimension: agitation. *Trafalgar
Square* is a long way from the contrived informality of Degas's *Place de la Concorde*, asserting instead the lack of control inherent in such active
and heterogeneous urban spaces.

MDM

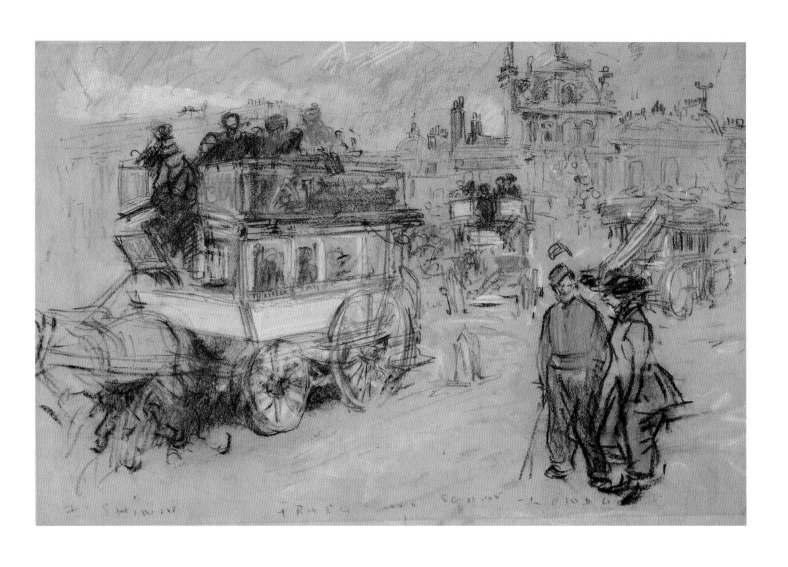

34 Childe Hassam, N.A., 1859–1935

Weir's Garden, 1903

Transparent and opaque watercolor and pen and brown ink over charcoal on wove paper, 37.0 × 54.6 cm (14⅝ × 21½ in.)

Signed and dated, in ink, lower left: Childe Hassam 1903

Purchased through the Phyllis and Bertram Geller 1937 Memorial Fund; W.962.90

PROVENANCE
Consigned to Milch Galleries, New York, 1928; Babcock Galleries, New York; given to the American Federation of Arts; Parke-Bernet Galleries, Inc., New York, *Modern Paintings, Drawings, Sculptures Belonging to the American Federation of Arts*, April 11, 1962, lot 69 (illus.); sold to M. R. Schweitzer (art dealer), New York, 1962; sold to present collection, 1962.

EXHIBITIONS
Montross Gallery, New York, 1915, *Exhibition of Pictures by Childe Hassam*, no. 65; Memorial Art Gallery, Rochester, N.Y., *An Exhibition of Paintings, Pastels and Etchings by Childe Hassam*, 1916, no. 35; The Art Institute of Chicago, *Exhibition of Paintings, Water Colors, Pastels and Etchings by Childe Hassam*, 1917, no. 37; City Art Museum of Saint Louis, *Paintings, Watercolors, Pastels and Etchings by Childe Hassam*, 1917, no. 40; The Art Institute of Chicago, *The Third International Water Color Exhibition*, 1923, no. 126; Milch Galleries, New York, *Important Exhibition of Early and Recent Works*, 1928, no. 8 (watercolor section); Saint-Gaudens National Historic Site, Cornish, N.H., *The Garden*, 1991; Weir Farm Trust, Wilton, Conn., *J. Alden Weir: An American Painter at His Home*, 2000.[1]

REFERENCES
Kathleen Burnside, *Childe Hassam in Connecticut* (Old Lyme, Conn.: Lyme Historical Society, Florence Griswold Museum, 1987), 11; Child Associates, Inc., and Cynthia Zaitzevsky, *Cultural Landscape Report for Weir Farm National Historic Site*, Olmsted Center for Landscape Preservation, Cultural Landscape Publication no. 6 (Washington, D.C.: National Park Service, U.S. Department of the Interior, 1996), 76 (illus.).

This work testifies to Childe Hassam's talent as a watercolorist and to his friendship with fellow American impressionist J. Alden Weir, whose rustic Connecticut garden Hassam recorded here in 1903. Sketching in watercolor outdoors, often in the company of artist friends, had long been a favorite summertime occupation of Hassam, who grew up outside Boston and later resided in New York. Like many of his impressionist colleagues based in Manhattan, he explored New England's scenic charms at every opportunity and congregated with others at popular summer destinations—on Appledore Island off the coast of New Hampshire and at the art colonies centered in Cos Cob and Old Lyme, Connecticut. He also made frequent visits to the Connecticut homes of his especially close friends John Henry Twachtman in Greenwich and J. Alden Weir in Branchville, a small hamlet near Ridgefield. Such excursions inspired many of his greatest artistic accomplishments in oil painting and in watercolor—a medium for which he is less well known today.

Hassam, in fact, first received critical attention for his work in watercolor in the early 1880s, and he returned to the medium repeatedly throughout his career.[2] In 1890 Hassam was elected a member of the American Watercolor Society, where he first met Weir, and helped to found the New York Water Color Club. Some of his most acclaimed watercolors date from visits to the Isles of Shoals in the early 1890s, during the height of his friendship with the poet, gardener, and aspiring artist Celia Thaxter, who attracted a circle of vacationing artists and writers to her summer home on Appledore. Hassam, influenced in part by his exposure to European developments during a three-year trip abroad in the late 1880s, had by this time adopted a more impressionistic mode in watercolor, as in oil painting. He abandoned his earlier reliance on broad washes and subdued earth tones, adopting instead a vivid palette and the broken brushstrokes that brilliantly captured the dazzling effects of Thaxter's sun-drenched garden.[3] During the late 1890s he relied on a more subdued, tonalist manner for several views of New York at night and in rain and snow. By the turn of the century, however, he reverted to a brighter palette and more active brushstroke that suited the fair-weather subjects he sought outside

the city, especially at several painting haunts in Connecticut. In 1903, for instance, the year he painted this watercolor in Branchville, he also visited the art colonies in Cos Cob and, for the first time, Old Lyme.

While these larger gatherings of artists offered convivial companionship and a lively esprit de corps, Hassam relished his more intimate visits with Weir at his rural retreat.[4] The rolling hills, weathered buildings, and carefree gardens on Weir's extensive property were central to that artist's work but also appealed to Hassam, who had repeatedly sought out as subjects emblematic images of rural New England and its historic past.[5] It is therefore not surprising that Hassam gravitated toward this informal corner of Weir's property, with its rustic, rose-covered trellises, birdhouse in the form of an old New England cape, and fruit trees and hillsides beyond.[6] Hassam also probably knew Weir's much earlier painting of the same spot taken from a different angle (*The Grey Trellis*, 1891 [fig. 72]) and may have consciously paid homage to its maker through this watercolor. The works differ in medium but share compositional similarities. As had Weir, Hassam uses here a portion of the wooden structure—in this case, the fencing at far right—to indicate a diagonal recession into space. The bulk of the trellis, however, spans the work like a decorative screen, flattening the composition and impeding visual access to the landscape beyond. Perhaps in an attempt to clarify the tangle of forms in this compressed space, Hassam outlined the trees, blossoms, and fences with pen and ink, a technique he occasionally used in other watercolors as well.[7] Hassam's vigorous handling of a fluid medium conveys a sense of sketchlike immediacy. The palette is vivid yet naturalistic, centering on the richly variegated greens and blue-greens of high summer, which set off the clear pink floral accents. *Weir's Garden* reminds us of Hassam's fundamental dual concern with color and line, the latter emphasis stemming perhaps from his early work in illustration. Unlike some impressionists who dissolved form in an attempt to capture fleeting atmospheric effects, Hassam remained devoted to the particularities of the subject at hand—in this case a beloved rustic sanctuary for roses, birds, and two like-minded friends.

BJM

Fig. 72. Julian Alden Weir, *The Grey Trellis*, 1891, oil on canvas, 66.0 x 53.3 cm (26 x 21 in.). Mr. and Mrs. Willard G. Clark, courtesy of Vance Jordan Fine Art

35 Abraham Walkowitz, 1878–1963

New York (New York Impressions), c. 1910–20

Pen and ink and ink wash over graphite on wove paper, mounted on gray wove paper, 24.7 × 15.6 cm (9¾ × 6⅛ in.)

Signed and dated, lower right: A. WALKOWITZ / 1910; signed and dated, on mount, lower left: A. Walkowitz—1910

Purchased through the Julia L. Whittier Fund; D.996.8

Reproduction permission courtesy of Zabriskie Gallery

PROVENANCE
Private collection, Woodstock, N.Y.; to Mr. and Mrs. Douglas M. Duffy, Bethesda, Md., 1976; sold to present collection, 1996.

EXHIBITION
Hood Museum of Art, Dartmouth College, Hanover, N.H., *Picturing New York: Images of the City, 1890–1955*, 1992, no. 78.

REFERENCE
Barbara J. MacAdam, *Picturing New York: Images of the City, 1890–1955* (Hanover, N.H.: Hood Museum of Art, 1992), n.p.

Fig. 73. A page from Abraham Walkowitz's *Improvisations of New York: A Symphony in Lines* (Girard, Kans.: Haldeman-Julius Publications, 1948), n.p.

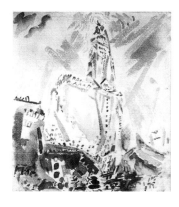

In an era when the uniqueness of an artwork was valued, Abraham Walkowitz turned out hundreds, sometimes thousands, of related drawings and watercolors in a single series. He would explore individual themes over the course of a decade or more, an unprecedented approach among the American modernists.[1] Contemporary critic Carl Van Vechten offered the most eloquent appraisal both of the city series that included *New York* and of Walkowitz's intellectual debt for his serial approach generally:

In his sketches for this tortured, terrifyingly aspiring and ambitious metropolis, the artist has borrowed an idea from Gertrude Stein and employs repetition for emphasis. None of these pictures is exactly like its predecessor, but each of them carries the intention one step further. Towers shoot upward in endless carefully arranged projections, now as flames, now as rhomboids, now as stalagmites, now as phallic obelisks, growing out of the sewers below and overshadowing the grovelling populace.[2]

Walkowitz, like Van Vechten, knew Stein in Paris during the early years of the century while he was there as an art student.[3] Stein's innovative, repetitious poetry has often been considered by art historians as an influence on American modernists like Charles Demuth, but not Walkowitz.[4] The artist himself reprinted Van Vechten's text, however, at the very beginning of his 1948 publication *Improvisations of New York: A Symphony in Lines,* a compilation of drawings on the same theme as *New York*. That estimate offers a useful, artist-sanctioned tool for the interpretation of Walkowitz's work. His city scenes share with his other series, to employ art historian Jerome Mellquist's words, a basic "skeleton indication" from which the artist created his variations.[5]

New York illustrates Van Vechten's point at least in part. The drawing's unique characteristics inflect our understanding of the rest of the series, just as the other drawings inflect it. That cumulative aesthetic is reflected in the format of Walkowitz's eventual publication of these works as a book, photographing large installation views of dozens of his works hung cheek-by-jowl and making meaning through juxtaposition (fig. 73). Over time, using the artist's dates as at least a relative guide, the *Improvisations* series grew in ambition and complexity, visible in several of the works included on the page of Walkowitz's book illustrated here. The buildings in *New York* are relatively unimposing, very different from the robust, soaring behemoths of his later works in the series. Instead of accentuating the surging rise of the buildings, the artist here balances them against the human energy in the street, not yet Van Vechten's "grovelling populace." Compositionally, the work recalls social realist George Bellows's iconic *Cliff Dwellers* (1913, Los Angeles County Museum of Art). Walkowitz's drawing depersonalizes Bellows's teeming street, reducing individual figures to calligraphic pen strokes, but it retains enough humanity in its scale to offer an intermediary between the social content of the Ashcan artist's work and the dynamism characteristic of several Stieglitz Circle artists. Critic Henry McBride observed, "Judging entirely from his pictures I should say Mr. Walkowitz has an overwhelming sympathy with the working-classes."[6]

Unfortunately, identifying precisely when this drawing was created remains impossible. In later years, Walkowitz retroactively backdated many of his works, most likely including *New York*. As art historian Sheldon Reich has observed, "Many of these [dates] are obviously capricious—too early or too late—and deter a chronological survey of his accomplishments."[7] Scholars differ in their opinions of when Walkowitz may have actually begun his extended New York series, with estimates ranging from 1912 to 1917, though the artist dated some works as early as 1909.[8] Consensus, however, holds that Walkowitz developed his dynamic series in response to the early-1910s city scenes of his peers John Marin, in works such as *Woolworth Building, No. 31* (fig. 74), and Max Weber. In 1981 art historian Kent Smith succinctly reviewed the prevailing critical opinion of Walkowitz's work that emerged after the artist's death: "Walkowitz instinctively gravitated towards the best minds and most significant talents of his era. His originality lay in his ability to continuously expand and enrich the underlying premises of his art through interpretation of the ideas and discoveries of others."[9] His various debts to Stein, Marin, Weber, and others are diverse in both nature and degree, portraying a method of selective adaptation rather than imitation. As *New York* conveys, Walkowitz's stippled windows, active background washes, and calligraphic figures create a unique, rhythmic distillation of urban life, growth, and energy.

Fig. 74. John Marin, *Woolworth Building, No. 31*, 1912, watercolor over graphite on paper, 47.0 x 39.8 cm (18½ x 15¹¹⁄₁₆ in.). National Gallery of Art, Washington, D.C.; gift of Eugene and Agnes E. Meyer. Image © 2004 Board of Trustees, National Gallery of Art, Washington, D.C. © 2004 Estate of John Marin / Artists Rights Society (ARS), New York

MDM

Preliminary Figure Study for "Hell," Boston Public Library Mural Project, c. 1910

Charcoal on laid (Michallet) paper, 47.6
× 62.2 cm (18¾ × 24½ in.)

Inscribed, in graphite, at lower left:
S.4.30 [partially effaced]; at lower right:
4 [encircled]; on reverse twice, in
graphite, at lower left and upper right:
S.4.30.

Gift of Miss Emily Sargent and Mrs.
Francis Ormond, sisters of the artist;
D.929.10.5

PROVENANCE
The artist; by descent to Emily Sargent
and Violet Sargent (Mrs. Francis) Or-
mond (the artist's sisters), 1925; given to
present collection, 1929.

EXHIBITION
Hopkins Center Art Galleries, Dart-
mouth College, Hanover, N.H., *John
Singer Sargent: Drawings from the Corco-
ran Gallery of Art*, 1983 (not in cat.).

REFERENCES
Dartmouth College, Hanover, N.H., *Cat-
alogue of Portraits, and Other Works of Art
at Dartmouth College* (Hanover, N.H.:
Dartmouth College, 1932), 52, no. 225
(as *Ten Drawings*); Charles M. Mount,
"Some Works by Sargent at Dartmouth,"
Bulletin (Hopkins Center Art Galleries,
Dartmouth College) 1 (January 1966),
n.p., fig. 6.

Fig. 75. John Singer Sargent, *Hell*, c. 1909–14,
oil on canvas, 84.5 x 168.3 cm (33¼ x 66¼
in.). Smith College Museum of Art,
Northampton, Massachusetts; gift of Mrs.
Dwight W. Morrow (Elizabeth Cutter, Class of
1896), 1932

Fig. 76. John Singer Sargent, *Study of the Mon-
ster for "Hell," the Boston Public Library Decora-
tions*, c. 1895–1910, charcoal on paper, 47.6 x
61.9 cm (18¾ x 24⅜ in.). Smith College Museum
of Art, Northampton, Massachusetts; gift of
Emily Sargent and Mrs. Francis Ormond, 1930

Although John Singer Sargent is most often re-
membered by art historians as a portraitist of sin-
gular inventiveness, and then as a painter of
dramatically described figures in dramatically lit
interiors and sun-dappled landscapes, his aspira-
tion to be recognized as a creator of monumental
public works has typically been less well re-
garded. As a mature artist he produced several
separate mural projects for institutional settings.[1]
Arguably, the most ambitious of these commis-
sions was at the Boston Public Library. The first
reports of Sargent's interest in the commission
appear about 1890, at which time the New York–
based architects Stanford White and Charles
Follen McKim approached the thirty-four-year-old
painter as one of several artists who they hoped
would contribute memorable wall paintings for
the new civic library they were building at Copley
Square.[2] The artist's paternal family was origi-
nally from Boston, and he had numerous loyal
friends and patrons in the city, such as Isabella
Stewart Gardner and Edward Darley Boit. Sargent
eagerly signed on to the project, first proposing
an encyclopedic narrative detailing the history of
Spanish literature. After a short while, however,
he dismissed that idea in favor of a more elabo-
rate historical program: The Triumph of
Religion.[3] He traveled widely to study historic ele-
ments for inclusion in the carefully sequenced
mural panels and painted the works on stretched
canvases in his London studio before supervising
their installation in Boston. The murals were well
received by the public and critics at the outset.[4] As
Sargent continued to work intermittently on the
project over the next quarter century, however,
controversies surrounding the style and content
of the Boston Public Library work ensued; he
abandoned the still unfinished project about
1919.[5]

The Triumph of Religion consists of twenty
large-scale scenes that, taken as an ensemble,
suggests a teleological narrative of religious his-
tory in the West from polytheism to early Christ-
ian times.[6] Finished sections of the mural were
described in advance by Sargent with explana-
tions that were printed in the official guidebooks
published by the library trustees. These instruc-
tional texts were meant to be carried in hand by
the public and serve as valuable interpretative
keys to the murals.[7] For his part, the artist
painstakingly planned each panel by preparing
studies of the hall and also by producing reduced-
scale versions of many of the individual panels.
He drew hundreds of pencil and charcoal
sketches on sheets varying in size and degree of
finish. These works were carefully catalogued by

an architect, Thomas A. Fox, an assistant to the
mural projects and the executor of these works of
art in the artist's estate.[8] The vast majority of
these drawings were held by the artist until his
death, at which point his two sisters donated large
groups of these sketches to museums throughout
New England and the midatlantic region.[9] The
Hood Museum of Art received a group of ten
charcoal drawings from mural projects as a gift of
Emily Sargent and Violet Ormond Sargent in late
1929.[10]

This particular charcoal drawing clearly relates
to a lunette entitled *Hell*, which was placed in the
northwest corner of Special Collections Hall in
1916 (fig. 75). Sargent's selection of this theme re-
ceived considerable attention because of the ex-
treme violence with which he described the
damned and their torment: "With the grewsome-
ness [*sic*], the terrific horror, of a medieval depic-
tion, [Hell] also combines a quality that seems
derived from the Far East . . . as in the Satanic
monster swimming in a sea blended of flame and
an endless mass of the eternally damned. . . .
With all of its repugnance of subject this amazing
decoration will amply repay study in its details."[11]
The Hood's *Preliminary Figure Study for "Hell"* is
representative both of the anguished appearance
of its human subject and the energetic, academic
style that is typical of the best of these mural stud-
ies. Even quickly dashed off, the nude male figure
in this drawing is recognizably close to several
other charcoal sketches that suggest the composi-
tion's central monstrous form, as well as the
writhing figure that covers his head in the lower
right corner (fig. 76).[12] It was not unusual for the
artist to reuse drawings in his mural practice.[13] In
any case, he seems not to have thrown away too
many of the studies on completing the panels. It
has been suggested that Sargent maintained a
deep, personal attachment to these nudes, and
the premium placed on capturing muscular exer-
tion and the expressive use of the human body
certainly intrigued the artist.[14] Their technical fa-
cility and interest in the male body have ensured
that sketches like this one have an enduring place
in debates surrounding Sargent's art.[15]

DRC

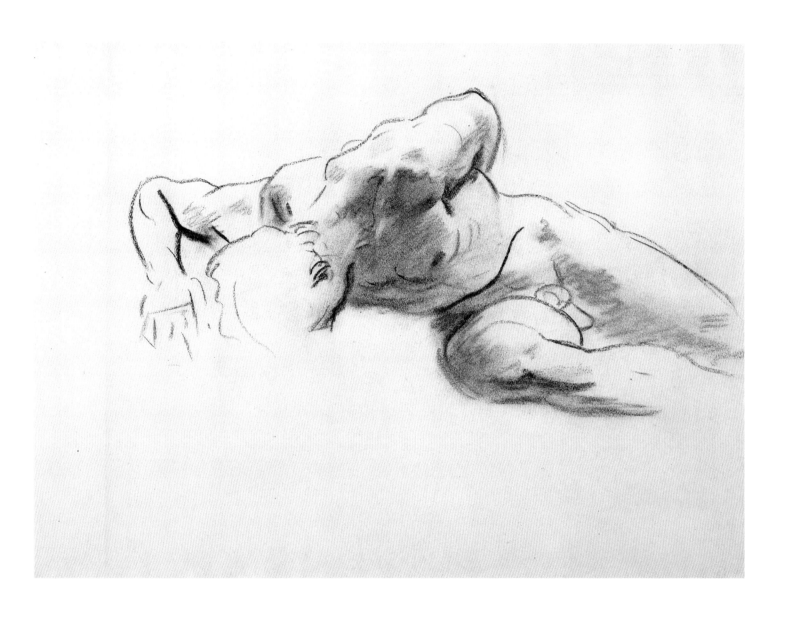

37 John Sloan, 1871–1951

Ludlow, Colorado (Class War in Colorado), 1914, drawing for an illustration
in *The New York Call,* April 25, 1914

Lithographic crayon on wove paper, 47.6
× 31.7 cm (18¾ × 12½ inches)

Signed, lower right: John Sloan–; in-
scribed and dated, in graphite, lower left:
"LUDLOW, COL. 1914."

Gift of John and Helen Farr Sloan;
D.952.44

PROVENANCE
The artist; given to present collection,
1952.

RELATED WORK
Modified version reproduced as a cover
illustration for *The Masses* 5, no. 9 (June
1914).

EXHIBITIONS
Robert Hull Fleming Museum, Univer-
sity of Vermont, Burlington, *John Sloan,*
1967 (no cat.); National Gallery of Art,
Washington, D.C., and others, *John
Sloan, 1871–1951,* 1971–72, no. 92 (as
Class War in Colorado); Utah Museum of
Fine Arts, University of Utah, Salt Lake
City, *Graphic Styles of the American Eight,*
1976, no. 139; Delaware Art Museum,
Wilmington, *City Life Illustrated, 1890–
1940: Sloan, Glackens, Luks, Shinn —
Their Friends and Followers,* 1980 (as
Class War in Colorado, no cat. no.); Hood
Museum of Art, Dartmouth College,
Hanover, N.H., and others, *John Sloan:
Paintings, Prints, Drawings,* 1981–83;
Neuberger Museum, College at Pur-
chase, Purchase, New York, *The Artist as
a Reporter, 1897–1917,* 1984, no. 12 (as
Class War in Colorado); Hood Museum
of Art, Dartmouth College, Hanover,
N.H., *From Copley to Dove: American
Drawings and Watercolors at Dartmouth,*
1989 (no cat.); Delaware Art Museum,
Wilmington, and others, *John Sloan:
Spectator of Life,* 1988–89, no. 83; Ka-
tonah Museum of Art, Katonah, N.Y.,
and others, *In Good Conscience: The Rad-
ical Tradition in Twentieth-Century Ameri-
can Illustration,* 1992–93 (no cat. no.).

REFERENCES
The New York Call, April 25, 1914, 1; John
Sloan, *Gist of Art* (New York: American
Artists Group, Inc., 1939), 239 (illus.);
National Gallery of Art, Washington,
D.C., *John Sloan, 1871–1951* (Boston:
Boston Book & Art, Publisher; Washing-
ton, D.C.: National Gallery of Art, 1971),
23, 133 (illus.); George S. McGovern and
Leonard F. Guttridge, *The Great Coalfield
War* (Boston: Houghton Mifflin Com-
pany, 1972), opp. p. 242 (illus.); David
Scott, *John Sloan* (New York: Watson-
Guptill Publications, 1975), 114, 115
(illus.); Sheldon Reich, *Graphic Styles of
the American Eight* (Salt Lake City: Utah
Museum of Fine Arts, University of
Utah, 1976), 70 (illus.), 78; Delaware Art
Museum, Wilmington, *City Life Illus-
trated, 1890–1940: Sloan, Glackens, Luks,
Shinn — Their Friends and Followers*
(Wilmington: Delaware Art Museum,
1980), 116 (as *Class War in Colorado*);
Hood Museum of Art, Dartmouth Col-
lege, Hanover, N.H., *John Sloan: Paint-
ings, Prints, Drawings* (Hanover, N.H.:
Trustees of Dartmouth College, 1982),
93 (illus.); Zeese Papanikolas, *Buried
Unsung: Louis Tikas and the Ludlow*

In the nine decades since its initial publication as
a cover illustration both for a socialist newspaper,
the *New York Call,* and soon thereafter for the
magazine *The Masses,* John Sloan's drawing of a
coal miner's suicidal vengeance after the murders
of his wife and children has become an icon of
American labor history. Depicting "the most fero-
cious conflict in the history of American labor
and industry," *Ludlow, Colorado* is an enduring
memorial to the thirteen women and children
shot and burned to death when Colorado National
Guardsmen opened fire on an undefended union
tent colony on April 20, 1914, in what was quickly
dubbed the Ludlow Massacre.[1] Despite the draw-
ing's widespread recognition, however, during
much of his life Sloan would not have considered
it part of his artistic oeuvre.[2] A socialist in his pol-
itics and a realist in his art, Sloan drew a sharp
distinction between political illustration and fine
art during his early career.[3] That division was later
exacerbated when the artist renounced socialism,
an excuse that art historians have intermittently
used to deny or omit Sloan's activism during the
early 1910s from their accounts of his life and
art.[4] Even after he left the Socialist Party, Sloan
still believed that "The direct action of the work-
ing class through unions seemed the way to bring
socialism in this country," a stance well illustrated
by *Ludlow, Colorado.*[5] Following Sloan's lead, how-
ever, art historians have consistently separated the
political illustrations from his paintings of urban
working-class subjects. *Ludlow, Colorado,* however,
complicates that simple distinction, appealing as
it does to the distinguished tradition of artist-
printmakers like Francisco de Goya and Honoré
Daumier, whom Sloan greatly admired.[6]

The Ludlow Massacre was a signal event in
American history, dramatizing the rampant abuse
of unregulated authority by industrialists and
their agents. Strikebreakers and hired "guards"
were often the instruments that owners and man-
agers used to dissuade workers from organizing
into unions and to prevent strikes. The collusion
of National Guardsmen with mine administrators
at Ludlow and their flagrant waste of innocent life
firmly aligned national opinion on the side of the
miners. Roused by the miners' plight, Sloan cre-
ated one of his most effective and arresting cri-
tiques of contemporary injustice. Using
confident, powerful strokes of black crayon,
Sloan's "rude, raw drawing" shows a miner sil-
houetted against the inferno of his burning tent,
protectively straddling the bodies of his family
while clutching his dead child to his chest.[7] The
remains of his makeshift home are symbolized by

only a stove, kettle, and chair; everything else has
been consumed by fire; the obliteration of the
family's home and community reiterates the
artist's horror at the unfolding events.[8] *Ludlow,
Colorado* was used as the cover illustration for a
special issue of the pro-union *New York Call* (fig.
77) just five days after the massacre, heroizing the
futile resistance of a miner who has arrived from
a distant skirmish too late to save his family.[9] In
Sloan's composition, the miner confronts the un-
seen guardsmen's machine guns with only a pis-
tol, most likely sealing his own fate as well. In
death he will at least fall by the side of his family.

Sloan and the *Call*'s editors clearly appreciated
the significance of contemporary events in the
light of modern history. Like many working-class
communities of the period, the miners of Ludlow
were predominantly either descended from or
were themselves immigrants to the United States
from a single nation, in this case Greece.[10] The
drawing's caption — "Strike! for your homes and
your firesides, God, and your native land" — up-
dates the battle cry from Fitz-Greene Halleck's
well-known 1823 poem "Marco Bozzaris," about a
leader of the Greek Revolution who died in battle,
an apt cultural reference for the Ludlow miners.[11]
Sloan's image and its caption offered the *Call*'s
sympathetic readers a new hero for the war then
raging in Colorado.[12] Appropriate to the cause,
Sloan invoked a more generalized, proletarian
figure for the Ludlow conflict, wearing a miner's
helmet instead of a revolutionary's Phrygian cap.

As Patricia Hills has remarked of *Ludlow, Col-
orado,* "What is radical about this illustration is
that the worker is firing back."[13] Unlike his artis-
tic influences, Goya and Daumier, whose victims
often die piteously at the hand of arbitrary or un-
just violence, such as Daumier's massacred fam-
ily in the iconic lithograph *Rue Transnonain*
(1834), Sloan's miner embraces the motto of the
Call, "The emancipation of the Working Class
must be accomplished by the workers them-
selves."[14] Combining indignation at the slaughter
of innocents with an inspiring model of resist-
ance to oppression, Sloan articulately positioned
the Ludlow conflict in the axis of modern history.
The image was powerful enough that when *The
Masses,* another socialist publication that Sloan il-
lustrated, published its own description of the
conflict two months later, *Ludlow, Colorado* was re-
cycled, slightly revised and in two colors, for its
full-page cover image.[15]

Women are a central motif in Sloan's art, just
as they were central to many social discourses of
the early twentieth century. Working-class

"LUDLOW, COL. 1914."

John Sloan

Massacre (Salt Lake City: University of Utah Press, 1982), cover (illus.); Patricia Janis Broder, *The American West: The Modern Vision* (Boston: Little, Brown and Company, 1984), 47 (illus.), 48; Rowland Elzea and Elizabeth Hawkes, *John Sloan: Spectator of Life* (Wilmington: Delaware Art Museum, 1988), 18, 119 (illus.); Clark Secrest, "Ludlow: A Colorado Horror," *Colorado Heritage*, winter 1992, 16 (illus.); Paul Buhle and Edmund B. Sullivan, *Images of American Radicalism* (Hanover, Mass.: Christopher Publishing House, 1998), 148 (illus.); Paul P. Somers Jr., *Editorial Cartooning and Caricature: A Reference Guide* (Westport, Conn.: Greenwood Press, 1998), 142.

Fig. 77. Cover page, *New York Call*, April 25, 1914

women—young, robust, and full of vigor—were perhaps his favorite models.[16] These depictions have often been considered redemptive, treating the subjects as competent individuals rather than a downtrodden, homogenous type. In Sloan's paintings, women are generally depicted as powerful, independent, and liberated, the diametric opposite of the emaciated, huddled corpse shown in *Ludlow, Colorado*. Any separate discussion or differentiation between Sloan's paintings and his prints seems precipitous in light of a shared subject. In this drawing, as in his depictions of the Triangle Shirtwaist Fire in 1911, Sloan's paternal attitude toward female subjects emerges in sharp relief.[17] Clearly, the workers who must rise up to defend their homes are men alone; Sloan offers no place in the ranks to working women. In light of these drawings, the relative autonomy of urban women presented in Sloan's paintings is more likely a product of the artist's indulgent paternalism than any progressive egalitarianism.

The history of *Ludlow, Colorado* has an impressive postscript. In the absence of photographs depicting the massacre and the ensuing week of battles between the miners and Colorado National Guardsmen, Sloan's drawing has become the defining visual document of the conflict. In historical accounts, biographies, and social histories alike, *Ludlow, Colorado* has been deployed as a central visual reference point. That historians now routinely equate one of Sloan's most politically incendiary drawings with reportorial accuracy is perhaps the single greatest testament to the work's conviction.

MDM

38 Ada Gilmore (Chaffee), 1883–1955

In the Garden, 1915

Opaque and transparent watercolor over graphite on card, tipped onto mount with painted border, card: 8.2 × 14.0 cm (3¼ × 5½ in.); mount: 22.5 × 28.4 cm (8⅞ × 11⅛ in.)

Initialed, in graphite, lower right, on mount: A. G.

Purchased through the Katharine T. and Merrill G. Beede 1929 Fund; W.2001.21

PROVENANCE
Estate of the artist; consigned to Mary Ryan Gallery, New York, 2001; sold to present collection, 2001.

EXHIBITIONS
Mary Ryan Gallery, New York, and Provincetown Art Association and Museum, Mass., *Ada Gilmore: Woodcuts and Watercolors*, 1988 (not in cat.); Mary Ryan Gallery, New York, *Ada Gilmore, The Summer of 1915: Watercolors from Provincetown* (no cat.).

The summer of 1915, when Ada Gilmore painted this sparkling watercolor, was surely one of the most artistically and socially fertile periods in the history of the art colony in Provincetown, Massachusetts. Although this picturesque village on the tip of Cape Cod has attracted artists since the late nineteenth century, a number of expatriate artists settled there in 1915 following the outbreak of war and made Provincetown an innovative center for the production of color woodblock prints.[1] Some of the founding members of what would become the Provincetown Printers had arrived that spring from Paris, including Ethel Mars and Maud Squire, and their protégés Ada Gilmore and Mildred McMillen. They were soon joined by printmakers Juliette Nichols and B. J. O. Nordfeldt, who, like the first arrivals, had formerly been in Paris. Together they concentrated on making woodblock prints during a very productive and collaborative period that extended through the following winter. It was then that Nordfeldt built on an experimental two-block woodblock technique used by Mars to create what was considered the first "Provincetown" or "white line" print—a woodblock print made from a single block rather than the Japanese-derived technique of using separate blocks for each color. The method involved carving grooves, which would print as white lines, between separately colored design elements. The approach accentuated the stylized, mosaic-like appearance of the compositions. As seen in Gilmore's watercolor, this printmaking technique formalized a tendency toward post-impressionist design and color that had already found expression in her previous work.

Not all of the aspects of Gilmore's stylistic development are well understood, but her Parisian phase seems to have been especially formative. Following early studies at the Belfast School of Design in Ireland, the Art Institute of Chicago, and with Robert Henri in New York about 1910, Gilmore arrived in Paris in 1913.[2] There, she sought out instruction in creating woodblock prints from Mars, who had by then attained an international artistic reputation.[3] Under Mars's tutelage, Gilmore developed a strong, simplified sense of design inspired by a commingling of Japanese aesthetics, the Arts and Crafts movement, post-impressionism, and the decorative work of the Nabis. Within months of painting her charming watercolors in Provincetown in 1915, she directed her efforts primarily toward creating white-line woodcuts depicting bucolic local subjects, which she exhibited widely.[4] Following her

1923 marriage to fellow Provincetown artist Oliver Chaffee, she returned to watercolor and painted exotic flowers and plants that she observed during her extensive travels.

This is one of more than twenty inviting watercolor images of Provincetown that Gilmore painted on U.S. Postal Service postcards in 1915. She actually mailed some to friends, perhaps in hopes of luring them to visit, and included the word "PROVINCETOWN" along the lower edge of a few of the architectural compositions, demonstrating her pride in her newly discovered haunt. The figural images frequently show women hanging colorful laundry, such as quilts, or tending flowers in dooryard gardens, as seen here. Such motifs enabled Gilmore to exploit her interest in exuberant colors and decorative patterning while suggesting an air of feminine domesticity and old-fashioned small-town life. She painted a border around each image and, perhaps in an attempt to give these intimate works a greater sense of artistic importance, she later mounted some of them onto larger sheets of card stock that she also edged in bright color.

This watercolor effectively captures a summer idyll by the sea while it points toward Gilmore's mature work as a graphic artist. She created a very fluid boundary—technically and iconographically—between her watercolors and her prints. In this watercolor, for example, she builds up the composition through discrete areas of color separated by reserves of the white support in a manner that presages her white-line woodblock prints. In corresponding fashion, her prints convey an unusual degree of painterliness. She printed these with watercolor pigments and dampened paper—a combination that achieved softened contours and subtly modulated colors.[5] Characteristic of her production in both media is the manner in which Gilmore here flattens space, utilizes a cheerful yet bold color scheme, and portrays the female protagonist in profile, with little individualization. The figure seems more absorbed in contemplation than actively tending flowers, giving the work a reflective, as well as celebratory, quality. Gardening and art making went hand in hand at many summer art colonies, from Cornish, New Hampshire, to Old Lyme, Connecticut. Here the garden in full flower mirrors the concurrent blossoming of Gilmore's career and an important new phase of artistic production centered in Provincetown.

BJM

39 George Wesley Bellows, N.A., 1882–1925

The Boardwalk (The Merry-Go-Round), c. 1915

Black, salmon, and blue crayon and tan wash over graphite on slightly textured cream wove (Natoma) paper, 40.9 × 55.8 cm (16⅛ × 22 in.)

Signed, in graphite, lower right: George W. Bellows / ESB; inscribed, in graphite, lower right margin: The Board Walk; lower left margin: 700.; inscribed, in graphite, on reverse: The Merry go Round / EB

Gift of A. Conger Goodyear; D.940.20

PROVENANCE
Milch Gallery, New York; sold to A. Conger Goodyear, Buffalo, N.Y., 1925; given to present collection, 1940.

RELATED WORK
Study for The Boardwalk (Outside the Big Tent), crayon on paper, 4¼ × 5¾ in., private collection, courtesy H. V. Allison and Co.

EXHIBITIONS
Buffalo Fine Arts Academy, Albright Art Gallery, Memorial Exhibition of the Work of George Bellows, 1882–1925, 1926, no. 3 under "Catalog of Drawings"; Carnegie Institute, Pittsburgh, Drawings from the Collection of Mr. and Mrs. A. C. Goodyear, 1928; Dartmouth College Collections, Hanover, N.H., Works on Paper: Nineteenth and Twentieth Century Drawings and Watercolors from the Dartmouth College Collection, 1975, no. 30; Dartmouth College Museum and Galleries, Hanover, N.H., Light in Art, 1978 (no cat.); Hood Museum of Art, Dartmouth College, Hanover, N.H., From Copley to Dove: American Drawings and Watercolors at Dartmouth, 1989 (no cat.).

REFERENCE
David M. Graham, "The Boardwalk," in Franklin W. Robinson (ed.), Works on Paper: Nineteenth and Twentieth Century Drawings and Watercolors from the Dartmouth College Collection (Hanover, N.H.: Dartmouth College Collections, 1975), 44–45 (illus., n.p.).

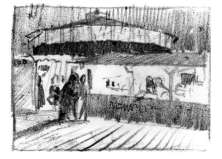

Fig. 78. George Bellows, Study for "The Boardwalk," c. 1915, crayon on paper, 10.8 x 14.6 cm (4¼ x 5¾ in.). Private collection, courtesy of H. V. Allison and Co.

One of the greatest realists of the twentieth century, George Bellows frequently drew artistic inspiration from public amusements where ethnic and social classes mingled and where he felt most keenly the gritty vitality of modern life. Bellows first honed his reportorial eye under the guidance of Robert Henri, his instructor at the New York School of Art and the spiritual and intellectual leader of the progressive urban realist artists. Popularly dubbed the Ashcan School, Henri's circle included John Sloan (cats. 37, 42), William Glackens, Everett Shinn (cat. 33) and George Luks (cat. 41), all of whom began their careers as newspaper illustrators in Philadelphia. Like them, Bellows found a wealth of artistic material in his everyday surroundings, particularly in New York. He said of his subjects:

Wherever you go, they are waiting for you. The men of the docks, the children at the river edge, polo crowds, prize fights, summer evening and romance, village folk, young people, old people, the beautiful, the ugly.... It seems to me that an artist must be a spectator of life; a reverential enthusiastic, emotional spectator.... There are only three things demanded of a painter: to see things, to feel them and to dope them out for the public.[1]

Although New York's street life and its public entertainments provided abundant fodder for "a spectator of life," Bellows began to spend increasing periods away from the city once he married in 1910 and started a family. Summer vacations to Maine, New Jersey, California, and Woodstock, New York, provided the opportunity to explore maritime and landscape subjects as well as studio-based portraiture.

Occasionally, works he produced at these country destinations convey a surprisingly urban flavor, as seen in this nocturne that depicts, not Coney Island, but the boardwalk at Old Orchard Beach, Maine. Bellows made several summer trips to the Maine coast between 1911 and 1916. It seems most likely that he visited Old Orchard Beach in 1915, when he and his family vacationed with the Henris and fellow artist Leon Kroll at the burgeoning art colony of Ogunquit, about thirty miles to the south.[2] In this drawing Bellows explored themes and motifs characteristic of his New York images—the lively, somewhat disreputable atmosphere of a nighttime public amusement and women bearing the scrutiny of male observers.[3]

In a manner characteristic of Bellows's night subjects, this work's shadowy illumination enhances its graphic power and its narrative complexity. He sets up a contrast between the gaily lit carousel and concessions, and the dark, slightly forbidding atmosphere outside. Bellows only faintly rendered and largely obscured the enclosed carousel itself, emphasizing instead the apparent vulnerability of the two respectably dressed women who stroll the boardwalk huddled together. Silhouetted against the doorway, a loitering man appears to leer at the women, while the youngsters behind the concession stand also shoot glances their way. One of the female strollers, as if assessing the security of her surroundings or the intentions of the male onlooker, warily directs her gaze out and back. Echoing perhaps these more veiled human investigations, a trotting beagle, nose to the ground, openly prowls the boardwalk ahead. Such subtle gestures and glances animate the protagonists and give the work a tone of ambiguity and unease that is further dramatized through the nighttime lighting.

Bellows enhances this drawing's evocative mood by using color more extensively than is typical of his drawing method. He used just black crayon, for instance, in the rough preliminary sketch to this drawing (fig. 78), which records the basic structure of the carousel enclosure but only barely indicates the figures. In the larger, more elaborated drawing, red crayon enlivens the festive concession area, while an overlay of blue over black crayon renders the sky a rich midnight blue. Especially unusual is the extensive use of a tan wash that unifies the composition, enveloping all but the reserved highlights in a warm, earthy tone. Bellows may have used this drawing as a study for a painting never completed or, less likely, a lithograph.[4] Whatever its original function, its degree of finish and its bordered placement on its sheet suggests that the artist valued it in and of itself. Bellows prized his drawings highly and, from an early date, frequently exhibited and sold them alongside his paintings.

BJM

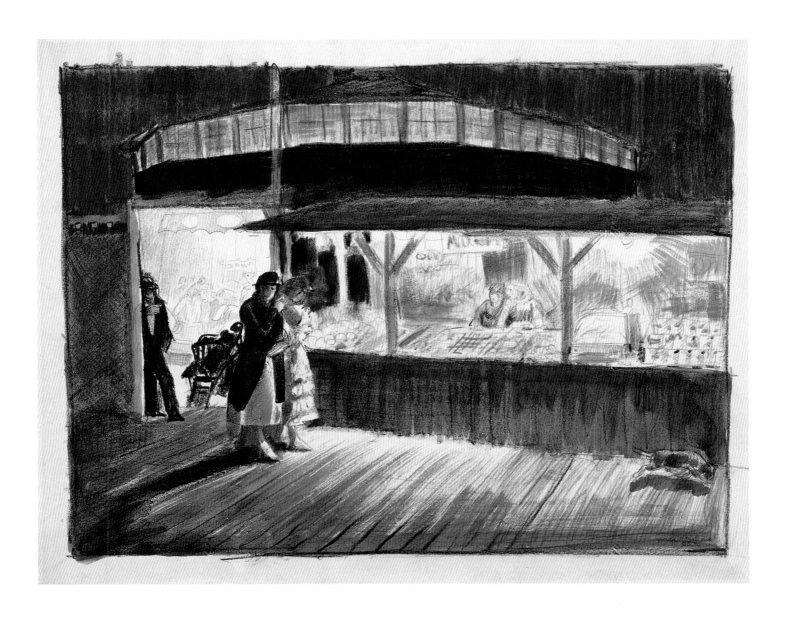

40 Blanche Lazzell, 1878–1956

Fox Glove (Foxgloves), 1920

Charcoal on gray laid (Arches Ingres MBM) paper, 41.4 × 31.8 cm (16⅜ × 12½ in.)

Signed and dated, in graphite, lower right: Blanche Lazzell 1920; inscribed, in graphite, lower center: Fox Glove; inscribed, in graphite, on reverse: #11

Purchased through the Katharine T. and Merrill G. Beede 1929 Fund; D.2002.24

PROVENANCE
Estate of the artist; sold to Martin Diamond (art dealer), New York; to Michael Rosenfeld Gallery, New York, 2000; sold to present collection, 2002.

RELATED WORK
Fox Glove, 1920, color woodblock print, reproduced in Charles T. Lazzell and Dorothy P. Lazzell (comps.), Blanche Lazzell: A Compilation of Her Art Work (West Virginia: the compilers, 1998), woodblock no. 34 (color illus.). Only four impressions of the print were made, according to John Clarkson, Blanche Lazzell (1981; reprint, Provincetown, Mass.: Cape Cod Pilgrim Memorial Association, 1989), p. 29, block 34.

EXHIBITIONS
Michael Rosenfeld Gallery, New York, Blanche Lazzell: American Modernist, 2000 (no cat. no.); Hood Museum of Art, Dartmouth College, Hanover, N.H., The Decade of Modernism: Selected Paintings, Sculptures, and Works on Paper, 1910–1920, 2002–3 (no cat.).

REFERENCE
Michael Rosenfeld Gallery, Blanche Lazzell: American Modernist (New York: Michael Rosenfeld Gallery, 2000), 19 (color illus.), 30.

Blanche Lazzell, the most admired artist associated with the innovative Provincetown "white line" woodcut, made this forceful drawing as a study for her 1920 color woodblock print Fox Glove. The drawing and related print reveal her sophisticated sense of design, her passion for flowers, and her belief that "natural form may be used as a means to expression, but never as an end in itself."[1]

By the time Lazzell arrived at the art colony in Provincetown, Massachusetts, in 1915, she had studied art extensively—first in her native West Virginia, then under William Merritt Chase at the Art Students League in New York, and in 1912–13 at the Académie Julian and Académie Moderne in Paris. While abroad, she also encountered the fauve and cubist works by Henri Matisse, Pablo Picasso, and Georges Braque that would inspire her throughout her career. At the outbreak of World War I, she joined other like-minded artist friends who retreated from Paris to Provincetown, including Ethel Mars, Maud Squire, and Ada Gilmore (cat. 38). They had already begun to experiment with reductive approaches to design through color prints made from multiple blocks in the Japanese tradition. As soon as their Provincetown compatriot B. J. O. Nordfeldt developed the single-block "white line" woodblock method during the winter of 1915–16 (described in the entry for cat. 38), these artists embraced the technique, as did Lazzell the following summer.[2] Despite Lazzell's critically acknowledged early accomplishments in this medium, she honed her talents over the next few years through study with such progressive modernists as Homer Boss, William E. Schumacher, William Zorach, and Andrew Dasberg.[3]

Some of Lazzell's most famous woodblock prints depict flowers from her luxuriant studio garden. In addition to painting, printmaking, ceramic decoration, and the creation of hooked rugs, gardening provided Lazzell with yet another vehicle of artistic expression—one that lured admiring tourists and artist friends alike to her "fish house studio."[4] She lavished attention on the blooms that grew profusely from containers on her wharf and on the vines that embowered her converted fishing hut. Titles of her prints suggest some of her favorite varieties: Star Phlox, Violet Petunias, and Iris, for instance.

Whereas in her pictorial art Lazzell often rendered flowers in tabletop still lifes, in this instance she cropped out the setting and filled the sheet with her monumental, confidently drawn blossoms. This gives a lively, modernist twist to the depiction of foxglove—long considered an "old-fashioned" staple of New England gardens. The drawing's emphasis on key contours rather than texture and depth reflects its purpose as a study for the block, in which corresponding carved grooves define the discrete design elements.[5] The resulting fractured forms in both media appear modern, yet they also echo craft traditions from mosaics and stained glass to the stylized ceramic tiles of the Arts and Crafts movement.[6] In this image, Lazzell likely modified her subject to suit her artistic aims. Rather than growing upright as they usually do, these stalks curve gracefully, echoing the arched leaves. The swelling forms radiating out from the center suggest vitality and growth, while recalling the arcing boat hulls, clouds, and hills in other compositions from this period. Lazzell's modified cubism capitalizes on the inherently rhythmic and geometric construction of flowers, with their similarly shaped buds and blossoms that repeat to create a cadenced pattern. Fox Glove evokes what she considered to be the essence of cubism—"the delineation of shapes, not perspective."[7]

Lazzell's studio log indicates that she pulled just four impressions of the color woodblock print Fox Glove, all between 1920 and 1926.[8] She generally varied the colors for each print. A rare, poor-quality photograph of one impression suggests a particularly expressionistic color scheme, dominated by an almost black background and fiery coral blooms that contrast with the cool pinks typically associated with foxglove.[9] The print thereby radically transforms the authoritative lines of the drawing to a more diffuse, almost sultry image that reminds us of Lazzell's desire to convey meaning in her work by avoiding the literal. As in the commanding, stylized floral subjects by Georgia O'Keeffe (a former classmate at the Art Students League)[10] and, in some cases, by Joseph Stella (as in cat. 49), Lazzell's dynamic flowers appear to suggest larger physical or spiritual forces. She once wrote, "Art is not photography—it is an expression of the inner man. We find in the artist's canvas his conception of life. His philosophy and his religion are revealed to the spectator who is able to read it."[11]

BJM

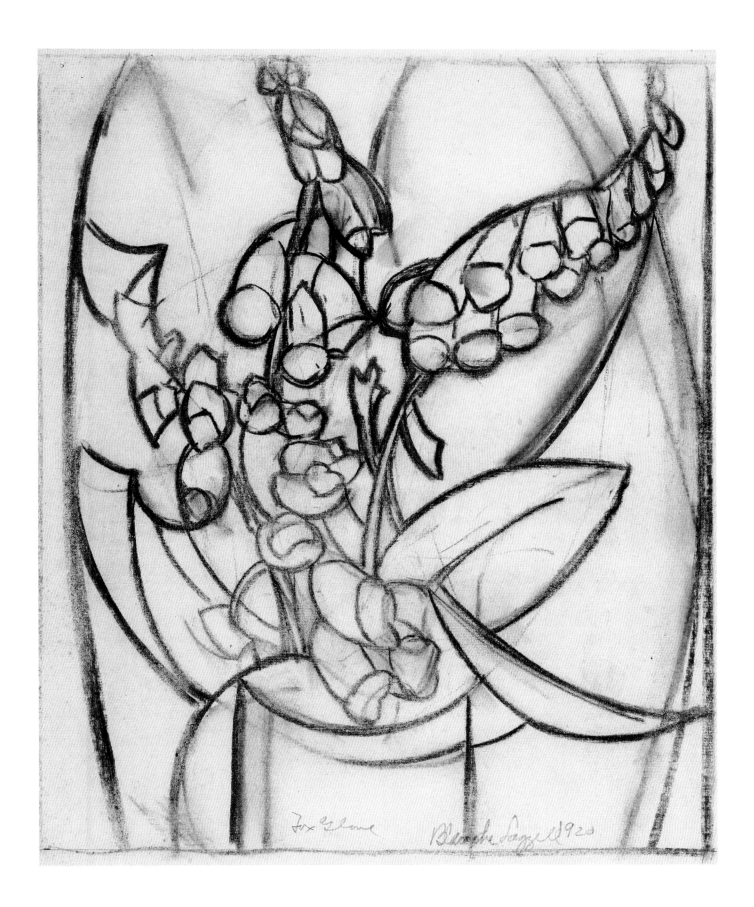

Fox Glove Blanche Lazzell 1920

41 George Benjamin Luks, 1866–1933

Sketch of Two Men, c. 1920s

Black crayon on wove paper, 17.5 × 21.1 cm (6⅞ × 8⁵⁄₁₆ in.)

Purchased through the Phyllis and Bertram Geller 1937 Memorial Fund; D.962.108

PROVENANCE
Bea Evan, New York; sold to Schweitzer Gallery, Inc., New York, April 1962; sold to present collection, September 1962.

EXHIBITION
Dartmouth College Collections, Hanover, N.H., *Works on Paper: Nineteenth and Twentieth Century Drawings and Watercolors from the Dartmouth College Collection,* 1975, no. 21.

REFERENCE
Michael Mosher, "Sketch of Two Men," in Franklin W. Robinson (ed.), *Works on Paper: Nineteenth and Twentieth Century Drawings and Watercolors from the Dartmouth College Collection* (Hanover, N.H.: Dartmouth College Collections, 1975), 34–35.

George Luks was a realist in art and an enigma in life, a chronic liar, alcoholic, and showman whom not even his closest associates knew well. Seven decades after his death, art historians are still struggling to disentangle his life history from the many fictions that Luks himself propagated. Moreover, scholars tend to interpret his art primarily through association with that of the other Ashcan artists, rather than on its own. Luks dated few of his works, and his artistic career, like his biography, is generally recounted on the basis of only scanty verifiable information.[1] With what remains, scholars have gradually and sporadically begun the process of evaluating the dynamics within his career and his significance to the history of American art. Luks was no collaborator. As John Loughery wrote in 1987, the artist "rarely wrote letters and never kept a diary, so that to bring off a successful Luks biography today would border on the miraculous."[2] The artist reveled in the invention of his own larger-than-life public persona. Arrogant and mercurial, the public Luks glared down audiences and blithely destroyed some of his finest works based on the criticism of even uninformed viewers.[3] One author who knew the artist personally, Ira Glackens, was forced to conclude that "George Luks was a bluff, except when he painted his pictures."[4]

Instead of a diary, Luks kept a sketchbook, and therein may lie a key to the artist's mystery. In his sketchbooks, or on any scrap of paper that came to hand, Luks recorded the interactions and characters that he encountered on the streets of New York with concentrated vigor and often caustic humor. *Sketch of Two Men* is one such offhand quip. The eye of the figure at the right nearly pops out of his head in conspicuously inconspicuous scrutiny, hidden only from the other man, of something outside the composition. Luks's caricature of this individual, especially his unkempt hair, balding pate, knitted brow, and bulging eyeball, echoes with absurdity. The sense of humor on display in the drawing gravitates closer to Luks's early cartoons than to his mature paintings. The confident handling and rich crayon used in the drawing, however, make *Sketch of Two Men* stylistically consistent with Luks's later work, in which, as Theodore Stebbins has written, "one feels . . . little conscious artistry, but rather the

drawing of a man who knew what he wanted to say."[5] In 1923 Guy Pène Du Bois agreed as to the economy of Luks's technique but differed in his conclusion, writing that the drawings "are the scribblings of a man too sure of the importance of every mark he makes and not meaty enough."[6] Whereas one estimate finds a succinct, reportorial tenor, the other finds superficial arrogance. *Sketch of Two Men* seems to navigate between these polarities of critical opinion, as Luks recorded the moment with alacrity, while caricaturing the essential aspect of the scene that captured his attention in the first place.

If *Sketch of Two Men* may be said to have a primary narrative, it is the ostentatiously furtive look of the figure at the right, his head unturned as he stares out of the corner of his eye. Critic Elizabeth Luther Cary was perhaps the first to observe that amid the vigor of Luks's figure drawings, "In faces only the eyes detain him."[7] Eyes, appropriately enough, are the focal points of this drawing as well, carrying most of its substance. Though their precise meaning remains elusive, their significance is not. The second figure's eyes are coarsely blacked out, not at all the carefully delineated forms seen in most of Luks's works, both painted and drawn. In contrast with the other figure's bulging eyeball and ray symbolizing his gaze, the taller figure's blindness further stresses the question of vision in the work through opposition. The general physical features of the right-hand figure even suggest a self-portrait, as the artist was famously known to take in his subjects "in an eye-shot."[8] Luks's treatment of the objects in the foreground is too general to identify the sitter's activity with certainty, though at least one writer has suggested that the right-hand figure may hold a sketchbook.[9] Luks strove for the unguarded moment, when his sitters (witting or unwitting) were "quite natural and spontaneous."[10] His search for impulse, rather than essence, is perhaps a relatively fine distinction but is nevertheless significant. Be the subject his iconic wrestlers, street waifs, beggars, or any other, including those figures in *Sketch of Two Men,* the search for "impulsive" action characterizes Luks's art and distinguishes it from that of his Ashcan peers.

MDM

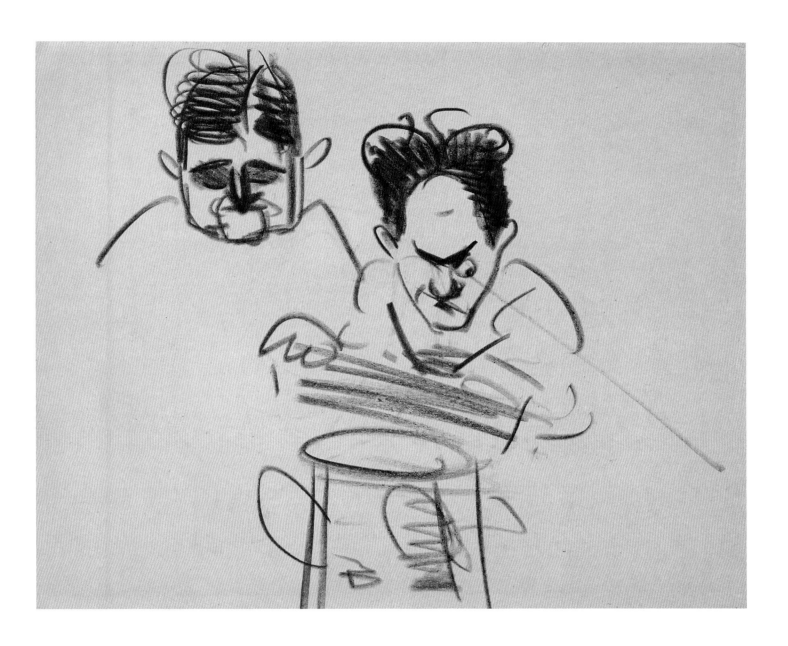

42 John Sloan, 1871–1951

Family on Fire Escape (Ella Was a Washtub Woman), 1922,
drawing for illustration in *Hearst's International,* August 1922

Ink wash, charcoal, and graphite on wove (Strathmore) paperboard, 43.5 × 58.5 cm (17⅛ × 23 in.)

Signed, in conté crayon, lower left: – John Sloan–; inscribed, in graphite, lower center margin: (Hearst's) Family on Fire Escape [underlined]

Purchased through the Julia L. Whittier Fund; D.946.12.3

PROVENANCE
C. W. Kraushaar Art Galleries, New York; sold to present collection, 1946.

EXHIBITIONS
Carpenter Hall Galleries, Dartmouth College, Hanover, N.H., *John Sloan Paintings and Prints,* 1946, no. 120; Robert Hull Fleming Museum, University of Vermont, Burlington, *John Sloan,* 1967 (no cat.); Dartmouth College Collections, Hanover, N.H., *Works on Paper: Nineteenth and Twentieth Century Drawings and Watercolors from the Dartmouth College Collection,* 1975, no. 24; Hood Museum of Art, Dartmouth College, Hanover, N.H., and others, *John Sloan: Paintings, Prints, Drawings,* 1981–83, no. 44; Delaware Art Museum, Wilmington, and others, *John Sloan: Spectator of Life,* 1988–89, no. 99; Hood Museum of Art, Dartmouth College, Hanover, N.H., *From Copley to Dove: American Drawings and Watercolors at Dartmouth,* 1989 (no cat.); Hood Museum of Art, Dartmouth College, Hanover, N.H., *Picturing New York: Images of the City, 1890–1955,* 1992, no. 53.

REFERENCES
Clifford Raymond, "Brothers under the Sod," *Hearst's International* 42 (August 1922), 66 (illus.); Richard H. Clark, "Family on Fire Escape," in Franklin W. Robinson (ed.), *Works on Paper: Nineteenth and Twentieth Century Drawings and Watercolors from the Dartmouth College Collection* (Hanover, N.H.: Dartmouth College Collections, 1975), 37–39 (illus., n.p.); Hood Museum of Art, Dartmouth College, Hanover, N.H., *John Sloan: Paintings, Prints, Drawings* (Hanover, N.H.: Hood Museum of Art, 1981), 18–19 (illus.), 91; Rowland Elzea and Elizabeth Hawkes, *John Sloan: Spectator of Life* (Wilmington: Delaware Art Museum, 1988), 135 (illus.); Barbara J. MacAdam, *Picturing New York: Images of the City, 1890–1955* (Hanover, N.H.: Hood Museum of Art, 1992), n.p.

John Sloan and his Ashcan School peers — including Robert Henri (p. 237), Everett Shinn (cat. 33), and George Luks (cat. 41) — rejoiced in the vibrant, often bawdy lives of New York's urban underclass at the dawn of the twentieth century. In the neighborhoods where muckraker journalists like Jacob Riis and Lincoln Steffens found grime, alcoholism, and desperation, the Ashcan artists saw energy, spunk, and grit. Sloan's optimistic vision of the poor is well represented by *Family on Fire Escape,* published as an illustration for Clifford Raymond's short story "Brothers under the Sod" in *Hearst's International* in 1922. In Sloan's drawing, a healthy family is shown at leisure on their impromptu balcony, enjoying a summer day. The mother brings in her laundry and converses amiably with a woman at the next window, while her husband reads a newspaper and her children entertain themselves. A picture of domestic tranquillity, the work is a romanticized celebration of simple pleasure in working-class life. The peculiar aspect of Sloan's drawing is that it bears almost no resemblance to either the story that it ostensibly illustrates or the lives of working-class families in urban America.[1]

"Brothers under the Sod" contains no scene similar to the one in Sloan's drawing. Moreover, the artist ignored the tale's bleak tone and downplayed its murderous protagonist, Honey Dew. Even the caption for the illustration in its published version is an invention and appears to be a loose editorial concoction intended to rationalize the illustration. It reads, "Ella was a wash-tub woman. She loved plain cleanliness. 'You ought to look like something,' said Honey [her husband]. Ella's thought was rapid and comprehensive. He might be wanting another woman," presumably not the one shown in Sloan's composition, who has no role in Raymond's story.[2] Four of the five illustrations that Sloan drew for Raymond's story center on Honey Dew's relationship with his wife, a relatively minor subplot in a tale that revolves around Dew's moral indifference, corruption, and violent death.[3] Sloan's disproportionate attention to Dew's wife, Ella, testifies both to the artist's prevailing interest in female subjects and to his disregard for Raymond's plot. Sloan's long-standing resistance to editorial control and his commitment to artistic prerogative are the more likely motives for his highly selective visual accompaniment to the story. Small wonder, then, that Sloan was in decreasing demand as a magazine illustrator during his later career.[4]

Despite his shortcomings as a collaborator, Sloan's composition in *Family on Fire Escape* is wonderfully articulate, highlighting his ability to endow technique with symbolic import. From our vantage point, presumably from across the street, we find the Dew family clustered on its balcony, its rigid bars contrasting with the breeze that catches the women's hair and dries the shirt and socks on the clothesline. Ella reaches up and out of the grid that restrains her. Likewise, her son and daughter test the limits of their confined area, her son reaching down to the balcony below with a string and her daughter pointing her foot into the world beyond their balcony. The family's arrangement offers a charming visual corollary to their liberty. Juxtaposed to her neighbor at the right, Ella is a picture of dynamism, precisely the sort of carefree energy and freedom that Sloan often highlighted in his depictions of working-class women. The neighbor, in contrast, is highly self-contained. With her arms crossed to form a static triangle within the frame of her window, she appears unaffected by the summer breeze. Situated at the center of the composition both figuratively and literally, Ella's character is recast into Sloan's mold for ideal working-class womanhood: young, confident, and irrepressible.

In a polemical 1978 article, John Baker asserted that "an idiosyncratic predisposition" in Sloan's work "is discernible in several of his illustrations, where discrepancies between text and illustration provide a glimpse of the artist's subjective tendencies and their direction."[5] For Baker, the prevalence of voyeurism as a theme that Sloan superimposed on his illustrations — often more prurient than in *Family on Fire Escape,* though generally sympathetic in nature — demonstrates his art's affinity for the romantic tradition and twentieth-century surrealism. Instead of direct derivations from the accompanying texts, Sloan's more interpretative illustrations are, in Baker's opinion, visualizations of his sublimated sexual desires.[6] As Laurel Weintraub has observed more recently, however, Sloan was not only a conventional spectator of urban life, "he was also an idiosyncratic and self-conscious observer who invested much of his work with a critique of spectatorship itself" earlier in his career.[7] If the illustrations are seen as similarly self-aware constructions rather than projections of the artist's unsettled subconscious, *Family on Fire Escape* is more readily understood as an idealist's romanticization of working-class life than as a projection of latent sexual frustration.[8]

MDM

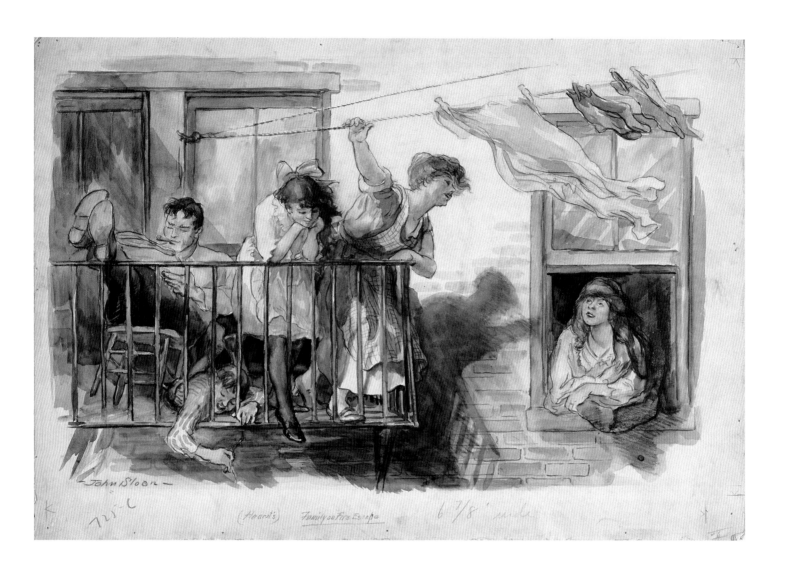

43 Lyonel Feininger, 1871–1956

Seascape with Cloudy Sky (Marine mit bewölktem Himmel), 1922

Pen and ink over watercolor on laid paper, 29.4 × 35.8 cm (11⅝ × 14⅛ in.)

Inscribed, in ink, lower left: Feininger; inscribed, lower center: MARINE mit / bewölktem Himmel; dated, lower right: Sonntag d. 4. Juni. 1922

Gift of Mrs. Daisy V. Shapiro, in memory of her son, Richard David Shapiro, Class of 1943; W.962.190

PROVENANCE
Adolf Hess, Erfurt, Germany; consigned to Stuttgarter Kunstkabinett (auction house), Stuttgart, Germany, sale 5, April 6–8, 1949, lot 1426; Max Fischer, Stuttgart; consigned to Stuttgarter Kunstkabinett (auction house), Stuttgart, sale 22, November 29–December 1, 1955, lot 1127; Walter Bareiss, Greenwich, Conn., 1955; The New Gallery, Inc., New York, by 1960; sold to Daisy V. Shapiro, New York, 1960; given to present collection, 1962.

EXHIBITIONS
Akademie der Schönen Künste, Munich, and others, *Lyonel Feininger,* 1954–55, no. 43; Barrows Print Room, Hopkins Center, Dartmouth College, Hanover, N.H., *The Richard David Shapiro 1943 Memorial Collection,* 1968, no. 6; Dartmouth College Collections, Hanover, N.H., *Works on Paper: Nineteenth and Twentieth Century Drawings and Watercolors from the Dartmouth College Collection,* 1975, no. 36; M. Knoedler and Co., New York, *The Protean Century, 1870–1970,* 1970, no. 12.

REFERENCES
Emil Preetorius and Alfred Hentzen, *Lyonel Feininger* (Hannover: Die Gesellschaft, 1954), n.p.; M. Knoedler and Co., Inc., *The Protean Century, 1870–1970* (New York: M. Knoedler and Co., Inc., 1970), n.p.; Marcy G. Glenn, "Seascape with Cloudy Sky," in Franklin W. Robinson (ed.), *Works on Paper: Nineteenth and Twentieth Century Drawings and Watercolors from the Dartmouth College Collection* (Hanover, N.H.: Dartmouth College Collections, 1975), 36–37 (illus., n.p.); Jacquelynn Baas et al., *Treasures of the Hood Museum of Art, Dartmouth College* (New York: Hudson Hills Press, in association with the Hood Museum of Art, Dartmouth College, 1985), 134, no. 124 (color illus.).

"Without sun and warm air one often asks why one puts up with so many inconveniences [to visit the coast] only to freeze, but no, it is always good to be here to walk at the water's edge even under an umbrella in the rain. There is so much to be seen and observed, and I go through inner experiences as never inland."[1] So the American Lyonel Feininger wrote to his wife while he was traveling on his annual pilgrimage to Germany's coast in 1922, just months after painting *Seascape with Cloudy Sky.*[2] Art was a spiritual communion for Feininger, and the sea encouraged his introspection. As Hans Hess, the artist's authoritative biographer, has observed, "Every summer he [Feininger] stayed, for as long as he could, on the Baltic Sea. His whole being was refreshed; his whole life unwound after the winters of painting and struggle."[3] As a leading teacher in the famed German school of fine and applied arts known as the Bauhaus, Feininger endured considerable popular misunderstanding and criticism for his modernist aesthetics throughout his mature career, culminating in his 1937 return to the United States to escape mounting Nazi harassment. At the seaside, Feininger enjoyed temporary respite from both public controversy and the distractions of teaching, allowing him both the time and the privacy he cherished.

The Bauhaus was founded in Weimar, Germany, in 1919 by architect Walter Gropius, who included Feininger in his plans from the very beginning. Gropius later remembered that "Feininger's paintings had attracted me greatly, and I saw a specific architectural quality in his presentation of space relations. He was the first to whom I offered a [professor's] chair."[4] That "architecture of space," visible in the structural gridwork of sea and sky in this watercolor, combines the defining qualities of art and architecture into painting, illustrating a primary objective of the Bauhaus: to reintegrate a premodern tradition of craftsmanship into the practice of contemporary

architecture and design. Gropius based his opinion of Feininger's work on his own vision of the potential of art in the service of architecture, leading Hess to write that Feininger "was the one painter of the time who in his work practiced what Gropius preached."[5] Feininger, however, felt from the beginning that there was a fundamental difference between their approaches. In 1919, the same year in which he joined the Bauhaus, Feininger observed, "Gropius sees the craft—I the spirit—in art."[6] That distinction, however, had no appreciable impact on their mutual admiration, and Feininger remained a major figure at the school for nearly two decades.

Seascape with Cloudy Sky summarizes Feininger's musical affinity. The thin, intersecting lines that establish sea and sky are deliberately rhythmic. In Feininger's art, the fluctuating frequency of lines evokes the compact, classical expression that the artist admired in Johann Sebastian Bach's compositions, particularly his contrapuntal fugues. Feininger wrote, "What I consider of utmost importance is to simplify means of expression. Again and again I realize this when I come to Bach. His art is incomparably terse, and that is one of the reasons it is so mighty and eternally alive."[7] An accomplished musician himself, Feininger utilized his art to embody the rhythms and tones of the world around him, not as a literal translation of music, but rather as "visible shapes that obey 'fugal' laws."[8] The monochromatic blue watercolor of *Seascape with Cloudy Sky,* in conjunction with the sharp pen lines that crisscross the composition, is an excellent testimonial to the artist's pursuit of Bach's aural counterpoint in a visual idiom. The succinct, intimate quality of *Seascape with Cloudy Sky* is precisely what renders it such a poignant representative of Feininger's artistic achievement.

MDM

Feininger MARINE MIT Sonntag d. 4 . Juni , 1922
 bewölktem Himmel

44 Marguerite Thompson Zorach, 1887–1968

Sixth Avenue "L," 1924

Watercolor and graphite on heavy wove paper, 56.7 × 39.5 cm (22⁵⁄₁₆ × 15⁹⁄₁₆ in.)

Signed and dated, in graphite, lower right: Marguerite-Zorach / 1924

Gift of Abby Aldrich Rockefeller; W.935.1.75

PROVENANCE
The artist; consigned to Downtown Gallery, New York, January 1930; consigned to Grand Central Art Galleries, New York, January 1930; sold to Abby Aldrich Rockefeller, New York, January 1930; given to present collection, 1935.

EXHIBITIONS
Grand Central Art Galleries, New York, *33 Moderns: The Downtown Gallery Exhibition of Paintings, Sculpture, Watercolors, Drawings and Prints by Thirty-three American Contemporary Artists,* 1930, no. 122; Hood Museum of Art, Dartmouth College, Hanover, N.H., *Picturing New York: Images of the City, 1890–1955,* 1992, no. 82.

REFERENCES
Barbara J. MacAdam, *Picturing New York: Images of the City, 1890–1955* (Hanover, N.H.: Hood Museum of Art, 1992), n.p.; Annette Carroll Compton, *Drawing from the Mind, Painting from the Heart* (New York: Watson-Guptill, 2002), 122 (color illus.).

California-born Marguerite Thompson Zorach was one of the most adventurous of the early American modernists, known initially for her expressive homages to a primordial nature. From 1908 to 1911 she circulated in the avant-garde circles of Paris, where she encountered post-impressionism through visits to the Salon d'Automne and the Salon des Indépendants, as well as through studies at the progressive art school La Palette.[1] She quickly embraced the bright, arbitrary colors of the fauves and the fractured forms of the cubists, which she applied to abstracted landscapes of forests, waterfalls, and mountains following her return to the United States in 1912. That same year she married fellow modernist artist William Zorach, who also drew inspiration from nature. The couple settled somewhat reluctantly in New York, pledging to spend each summer in the country, which they did. Visits to Randolph and Plainfield, New Hampshire; Provincetown, Massachusetts; Yosemite, California; and Robinhood, Maine, where they purchased a summer home in 1923, provided both artists with rich subject matter and a welcome antidote to city living. Although her New York residence facilitated Marguerite Zorach's opportunities for exhibitions and gallery representation (as did her marriage to an artist of rising prominence), she for the most part loathed urban life.[2]

The explicitly urban subject of *Sixth Avenue "L"* represents a rare and lesser-known aspect of Marguerite Zorach's career. Despite a strong initial preference for natural subjects, neither she nor her husband completely ignored the artistic potential of New York City. William recalled, "We sketched all over the city—Central Park, along the waterfront, across the Hudson on the Palisades—and painted wild pictures at home from imagination."[3] Some of Marguerite's nominally urban scenes, such as *Spring in Central Park,* 1914 (The Metropolitan Museum of Art), were purely allegorical compositions. With the birth of their children in 1915 and 1917, Marguerite turned increasingly to more tangible subjects available from their apartment—interiors, still lifes, and images of her family. Her surviving works only rarely offer more than glimpses of urban life as seen through the windows in these compositions.[4] A handful of her city scenes gained visibility in a 1930 exhibition at the Downtown Gallery featuring her "Recent Paintings of 'New York and New England,'" but, perhaps reflecting the regionalist sentiments of the day, her New England subjects predominated in this selection,

both in terms of numbers and positive critical reception.[5]

Sixth Avenue "L" is also unusual for its medium, since by the 1920s Marguerite had largely abandoned watercolor for her ambitious embroidered tapestries and, when time permitted, oil paintings. She found the practice of making embroideries, which sold well, better suited to the many interruptions caused by her responsibilities to her children and her active participation in exhibition organizations that advanced the cause of women modernists.[6]

Sixth Avenue "L" is a lively, if somewhat unsettling, depiction of a station for the elevated railroad not far from the couple's apartment on West Tenth Street and Sixth Avenue. The work's bright, arbitrary colors recall Zorach's fauve-inspired watercolors from the 1910s, as does the compressed, decorative approach to form. Despite the jaunty palette and the syncopated rhythm established by the selectively rendered windows, the composition conveys an undercurrent of physical and emotional disequilibrium. Taking full advantage of the vertical proportions of the sheet, Zorach accentuated the towering height of the skyscrapers, which lean in precariously, crowding out the sky. The spatially ambiguous rendition of the train platform in the foreground, only lightly toned, seems to provide no solid support for the couple straddling the train's entrance. Similarly, in the narrow untoned band that indicates the bustling street life below, truncated legs and pushcarts appear to hover in space. Zorach's dynamic yet unsteady view of the city calls to mind the more dramatically swaying, looming skyscrapers portrayed by John Marin and Abraham Walkowitz (cat. 35) and Stuart Davis's slightly later, collage-like street scenes (cat. 48). As one reviewer observed of Zorach's imaginative approach to composition, "it is an idea of the world we live in, recomposed in a kaleidoscopic pattern of form and color."[7] Echoing on a reduced scale the archetypal figures central to many of her allegorical landscapes, a couple embraces on the far platform, protectively enclosed by the rounded-arch entry. Striking a note of apparent irony, a graffiti-like scrawl on the side of the train reads "open air." In the absence of the "open air" that Marguerite Zorach relied on for emotional sustenance and artistic inspiration, she celebrates the bonds of human attachments that offer comfort in the dizzying, claustrophobic city.

BJM

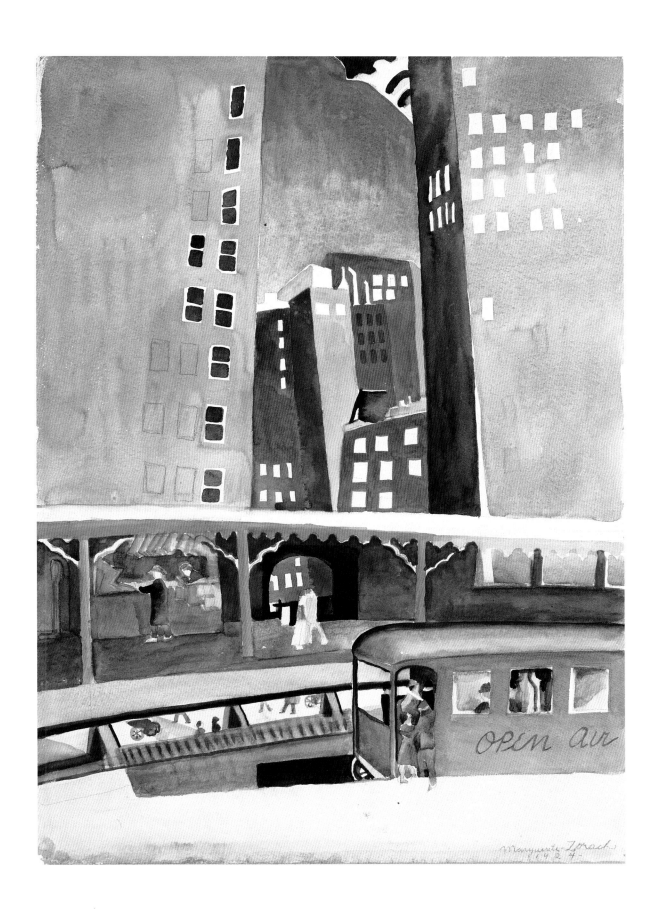

45 Charles Ephraim Burchfield, N.A., 1893–1967

Early Morning, 1925

Conté crayon and brush and ink over graphite on two sheets (joined) of heavy newsprint mounted on thin cardboard, 36.7 × 22.5 cm (14⁷⁄₁₆ × 8⅞ in.)

Signed and dated, lower left: CEB [monogram] / 1925

Purchased through the Phyllis and Bertram Geller 1937 Memorial Fund; D.963.3

PROVENANCE
The artist; sold to Frank M. Rehn Gallery, New York; sold to G Contemporary Gallery, Buffalo, N.Y., 1962 (renamed James Goodman Gallery in 1963); sold to present collection, 1963.

EXHIBITION
Park Lane Gallery, Buffalo, N.Y., *Contemporary Paintings, Fall 1962*, 1962, no. 8; Boston Athenaeum, Boston, and others, *An American Visionary: Watercolors and Drawings of Charles E. Burchfield*, 1986–87, no. 58.

REFERENCES
Boston Athenaeum, *An American Visionary: Watercolors and Drawings of Charles E. Burchfield* (Boston: Boston Athenaeum, 1986), n.p.; Colleen Lahan Makowski, *Charles Burchfield, An Annotated Bibliography* (Lanham, Md.: Scarecrow Press, Inc., 1996), 73, 167.

Charles Burchfield's biographers have routinely divided his career into three distinct periods. The first, dating from about 1916 to 1919, saw the production of his imaginative, exuberant paintings of the natural and man-made environment around his home in Salem, Ohio. The second, from 1921 to 1942, constituted his "realist" phase, during which he focused primarily on his urban and industrial setting in Buffalo, New York, initially while also working as a wallpaper designer.[1] The third phase, from 1943 until his death in 1967, marked his production of expressionistic, symbolist homages to nature. Art historians have generally minimized the importance of his realist phase, from which this drawing dates, privileging instead his early and final nature paintings.[2] To neglect Burchfield's work from the 1920s and 1930s, however, would be to ignore some of his essential qualities, including his social conscience and his extraordinary sensitivity to the structure, character, and poetry of the built environment.

Burchfield's Buffalo years nurtured these interrelated strengths. His empathy for the working class was surely heightened by his own financial struggles to support his growing family and the constraints imposed by his demanding day job. During this period, forces beyond Buffalo also shaped Burchfield's artistic direction. He responded positively to the local flavor and realism of such American Scene writers as Sherwood Anderson and Edgar Lee Masters, and he was surely also influenced by—although less inclined to acknowledge—his counterparts in painting. By the late 1930s he in fact made every effort to distance himself from the "provincial" American Scene artists and regionalists, who were then falling out of favor, even though he clearly embraced what was local and familiar in his own work.[3]

Burchfield's distinctive brand of social realism emerged from his enduring fascination with buildings as stand-ins for humanity. He explored this theme initially through his paintings of quasi-anthropomorphic dwellings based on Victorian houses in his hometown of Salem. In these images, windows and doors become wildly expressive faces that lend a hallucinatory quality to his townscapes. His buildings from the 1920s and 1930s are more restrained and three-dimensional, yet they are full of empathy for the lives they shelter and what one critic called "a real love of them, penetrated into their very being."[4] Despite the lack of any overt social content in this and other works from the period, we know that Burchfield entertained socially critical views at this time. In his journal entry for March 12, 1925,

he wrote: "Choose the raw elementary life to portray. . . . Are you softening up? Get back the ability to paint fearless indictments of modern society & life—Pick out spots in Buffalo to hold up to scorn."[5]

In this drawing, Burchfield's attitude toward his Buffalo subject seems closer to "real love" than scorn. His affection for this building likely grew out of familiarity, as he viewed it from his third-floor apartment at 459 Franklin Street, where he and his family lived from 1923 until April 1925. Scattered color notations on the sheet reveal the artist's concentrated observation of this backyard scene and suggest his intention to use the image as a study for a watercolor (although no related work is known). Clearly intrigued with formal, architectonic relationships, nonetheless in this drawing Burchfield accentuates the character of the structure. He rejects the clean, ruled lines used by his precisionist contemporaries (see George Ault's backyard urban scene, cat. 46), using instead an expressive, wavering line that animates even the architectural silhouettes. The building's slightly canted outlines (which Burchfield has narrowed to emphasize its verticality), irregularly sized windows, and rich textural effects convey a sense of individuality and a time-worn appearance rich with human association.[6] The soft light and undulating pools of melting snow add visual interest and echo the contemplative mood. Like many of his works, *Early Morning* reflects Burchfield's preference for the quiet, crepuscular hours of dawn and dusk and the transitions between seasons, particularly winter: "I love the approach of winter, the retreat of winter, the change from snow to rain and vice versa."[7] Here, to extend the vertical proportions and maximize the expressive contours of the puddles, he expanded the foreground with an additional strip of paper, as was often his method.[8]

Rather than being considered apart from or at odds with Burchfield's early and late landscapes, such nominally realist architectural compositions as *Early Morning* are better understood as reflections of his all-embracing appreciation for the energy and poetry found in ordinary surroundings, whether natural or man-made. As he summarized so well in a diary entry for April 1968: "[The March wind] sweeps along blending all dissimilar things—winter-hardened hills, marshes, cement roads with their blatant automobiles, railroads, nondescript towns—into one grand harmonious whole."[9]

BJM

46 George Ault, 1891–1948

Back of Patchin Place, 1927

Graphite on heavy wove paper, 39.9 × 29.8 cm (15¾ × 11¹¹⁄₁₆ in.)

Signed and dated, lower right: G.C. Ault '27.; inscribed on reverse, upper left: Title: Back of Patchin Place / By: Geo. C. Ault. / Price: $30⁰⁰ / 192 [end of inscription obscured by old matting tape]

Gift of Abby Aldrich Rockefeller; D.935.1.98

Provenance: The artist; consigned to Downtown Gallery, New York, 1928; sold to Abby Aldrich Rockefeller, New York, November 1928; given to present collection, 1935.

EXHIBITIONS
Downtown Gallery, New York, *George C. Ault: Recent Work*, 1928, no. 11; Dartmouth College Collections, Hanover, N.H., *Works on Paper: Nineteenth and Twentieth Century Drawings and Watercolors from the Dartmouth College Collection*, 1975, no. 37; Dartmouth College Museum and Galleries, Hanover, N.H., *Gifts of Abby Aldrich Rockefeller*, 1976 (no cat.); Hood Museum of Art, Dartmouth College, Hanover, N.H., *From Copley to Dove: American Drawings and Watercolors at Dartmouth*, 1989 (no cat.); Hood Museum of Art, Dartmouth College, Hanover, N.H., *Picturing New York: Images of the City, 1890–1955*, 1992, no. 4.

REFERENCES
William B. McCormick(?), "Ault and Others Return to Local Art Galleries," *New York American*, November 25, 1928, 10(M); John R. Hokans, "Back of Patchin Place," in Franklin W. Robinson (ed.), *Works on Paper: Nineteenth and Twentieth Century Drawings and Watercolors from the Dartmouth College Collection* (Hanover, N.H.: Dartmouth College Collections, 1975), 52–53; Barbara J. MacAdam, *Picturing New York: Images of the City, 1890–1955* (Hanover, N.H.: Hood Museum of Art, 1992), n.p.

In most art historical surveys, George Ault's name surfaces, if at all, within the context of the American precisionists, who during the 1920s through the 1940s celebrated modern technological progress with their pristine, reductive urban and industrial landscapes. Like such pioneering precisionists as Charles Sheeler, Charles Demuth (cat. 54), and Preston Dickinson, Ault distilled or "crystallized" his urban surroundings in an attempt to convey the city's underlying geometric structure. His work was more multidimensional, however, than such easy categorization might imply. Ault often imbued his architectonic compositions, many of them nocturnes, with a psychological intensity and otherworldliness that give them a haunting, surrealist edge. In the catalogue for Ault's 1949 memorial exhibition, critic John Ruggles observed the emotive resonance and complex, often opposing impulses that distinguished Ault's compositions: "In his pictures, which are flawlessly designed, precision, austerity and careful definition merge with a poetic sense, mystery and awe. Definite realism is welded with certain and strong abstraction. Quietude and gentle melancholy are combined with tension, a 'pull' akin to gravity."[1]

The disquieting mood cast by some of his works may be rooted in the artist's intense personal struggles and ambivalence toward his urban subject matter. Ault was physically impaired by a weakened heart and suffered an extraordinary number of personal losses in a relatively short period of time, including the death of both parents and the suicides of three brothers.[2] Not surprisingly, Ault himself struggled with depression, marital problems, heavy drinking, and a tendency toward reclusiveness. The uneasy, introspective quality of his urban scenes may also have stemmed from his deep concerns about the social implications of the city. He once referred to New York as "the Inferno without the fire" and to its skyscrapers as "tombstones of capitalism."[3] Although powerfully drawn to urban forms, Ault's health problems and his conflicting attraction to natural subjects and a rural lifestyle finally led him to abandon his Greenwich Village studio in 1937 for the artists' haven of Woodstock in upstate New York.[4]

Drawn during a period of commercial success and personal strife, *Back of Patchin Place* exhibits the formal elegance and subtle psychological ambiguities for which Ault is known. He identifies the locale in the title, capitalizing on the fame of this quaint, tree-lined Greenwich Village alley off West Tenth Street that had been home to such literary figures as e. e. cummings, Theodore Dreiser, and John Reed.[5] Patchin Place was later described by Elizabeth McCausland as "a backwater of historical association, . . . with ailanthus trees picturesquely veiling the Victorian Gothic tower of Jefferson Market Court. In unexpected places these cul-de-sacs relieve the twentieth century gigantism of the metropolis."[6] Ault conveys the calm of this neighborhood, but rather than its nineteenth-century facades adorned with cast-iron railings, he depicts the back of one of the buildings, with its more utilitarian, streamlined fenestration, tubular railings, and angular structural additions. Erased by the artist at the lower left, a barely visible clothesline with billowing laundry reminds us of the practical functions of this private space. It also graphically demonstrates Ault's practice of eradicating the quotidian details that appealed to earlier urban realists (for example, John Sloan, cat. 42) but detracted from the clean, geometric underpinnings of the composition. Revealing his essential dual attractions in subject matter, he creates an exquisite counterpoint between the rigid geometry of the primary façade and the gracefully curving ailanthus branches that sweep up and then sharply downward in the foreground. The exaggeration of this tree's growth habit gives a lyrical, melancholy quality to the work that is accentuated by the enclosed urban setting, which is devoid of people and activity.

Further adding to the mysterious atmosphere are the seemingly arbitrary lighting effects and the gentle shadings that modulate the hard, precisely drawn surfaces of stone and glass. In response to Ault's 1928 one-man exhibition at the Downtown Gallery, in which this drawing was included, critics applauded what they perceived to be a somewhat warmer, more realistic and three-dimensional character to his recent work, perhaps owing to such delicate effects.[7] Nonetheless, Ault's debt to precisionism reveals itself here in the dynamic recession of jagged building additions. The foreground building projections zigzag across the composition, breaking up into a cubist-inspired conjunction of planes at the upper right. With its psychological intensity and its subtle interplay between realism and abstraction, organic and architectural form, line and tone, *Back of Patchin Place* is, as a critic in 1928 observed, "rich in all the qualities one associates with Ault's work at its best."[8]

BJM

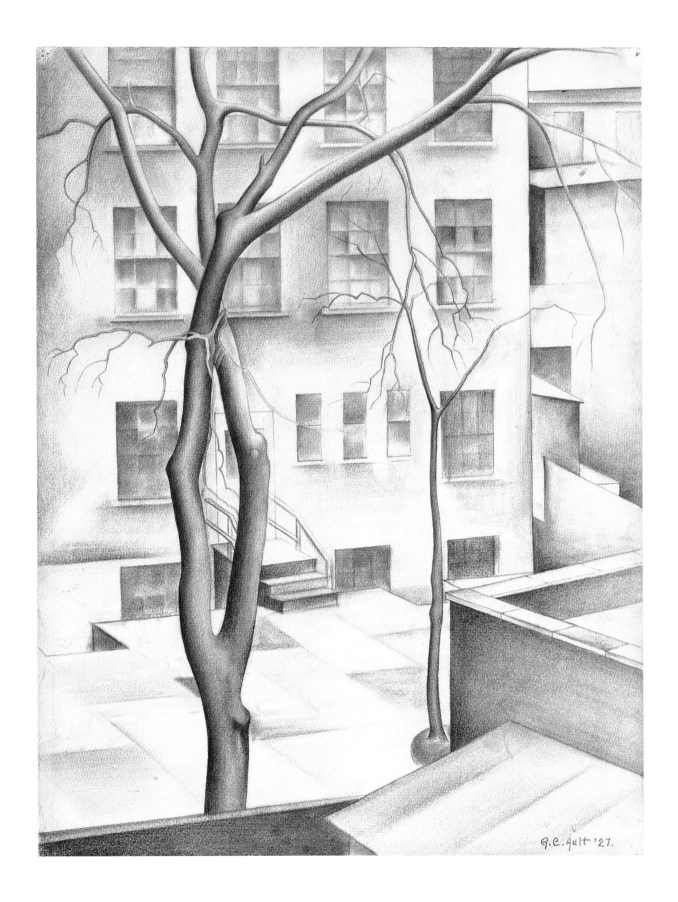

G.C.Ault '27.

47 Velino Shije Herrera (Ma-Pe-Wi), American/Pueblo, 1902–1973

Rain Dance—Annual Fiesta—Zia Pueblo, c. 1927

Opaque watercolor on tan wove (Canson & Montgolfier) paper mounted on cardboard, 48.0 × 62.7 cm (18⅞ × 24¹¹⁄₁₆ in.)

Signed, lower right: MA-PE-WI

Gift of Abby Aldrich Rockefeller; W.935.1.80

PROVENANCE
The artist; to the Spanish and Indian Trading Post, Santa Fe, N.Mex., 1927; sold to Abby Aldrich Rockefeller, March 28, 1927; given to present collection, 1935.

RELATED WORK
An undated watercolor, *Christmas Dance,* reproduced in *The Studio* 102 (December 1931), 389.

EXHIBITIONS
Vassar College Art Gallery, Poughkeepsie, N.Y., *Exhibition of American Indian Painting and Crafts of the Southwest, 1915–1940,* 1941, no. 72; Dartmouth College Museum and Galleries, Hanover, N.H., *The Arts of Native America: Studio Painting,* 1979 (no cat.); Hood Museum of Art, Dartmouth College, Hanover, N.H., *Images of the West: Selections from the Permanent Collection,* 1994 (no cat.); Hood Museum of Art, Dartmouth College, Hanover, N.H., *Survival/Art/History: American Indian Collections from the Hood Museum of Art,* 2000–2001, no. 27.

The early work of Pueblo watercolorist Velino Shije Herrera, known during his lifetime by several names including Ma-Pe-Wi, constitutes a case study in the complex hybridization of modernist art and Indian cultures that emerged during the early twentieth century in New Mexico. Herrera began his artistic career in 1918 while a teenage student at the Santa Fe Indian School, a boarding school administered by the American government for the education and acculturation of Indians into European American society. In his decision to adopt tribal rituals as his subject matter, the young artist may have been aware that European American anthropologists and museums had recently commissioned Native American artists to record Indian customs from personal experience. Herrera soon received critical acclaim for his renderings of the costumes and ceremonies at his home pueblo, Zia, located northwest of Albuquerque. Ironically, Herrera's art was celebrated in European American society as a continuation of Native narrative visual tradition despite the fact that he came from a Pueblo culture that did not have one.[1] The artists of Herrera's circle, including Fred Kabotie and Otis Polelonema, emerged from a government-run school at which diverse tribal cultures and aesthetics commingled, producing a composite aesthetic native only to the school itself. To European American eyes, the many Native American artistic traditions remained virtually indistinguishable and Herrera's boarding-school aesthetic only further condensed Native traditions in the European American imagination.

As traditional as it appeared to European American sensibilities, however, Herrera's art was heresy at Zia Pueblo. Religion was a topic of considerable negotiation since the tribe's conversion to Catholicism by Spanish missionaries in the early seventeenth century. Although the tribe was ostensibly converted, the brand of Christianity practiced at Zia was by no means orthodox and fluctuated considerably during the early twentieth century. One observer, Leslie White, rhetorically asked whether the Zia people were Christian and then answered, "No, emphatically not, with possibly a few exceptions."[2] Over the centuries, the Zia and the Catholic Church observed an increasingly symbolic association, with the Zia practicing their traditional rituals out of sight of the Catholic clergy—who only visited the pueblo on holy days—and the priests not interfering with local customs so as not to antagonize the tribe and risk complete expulsion. Late in the 1920s the Herrera family, led by Velino Herrera's brother

George, precipitated a crisis in that uneasy religious balance by converting to an evangelical Pentecostal church. Herrera, who resided primarily in Santa Fe throughout his adult life, and the other converts were initially ostracized from Zia and eventually disavowed by the tribe by 1933. The artist consequently spent most of his working life outside the faith and culture he depicted in his art.[3]

During the 1920s Herrera's painting underwent a dramatic split that coincided with both his religious conversion and the end of the economic support from the School of American Research in Santa Fe, which until 1924 was a significant patron and employer of Indian artists. As J. J. Brody has observed, whereas early in his career Herrera had committed his art to ethnographic accuracy alone, during the 1920s he produced work in two distinct aesthetic modes: one abstracted and stylized, the other more naturalistic and descriptive.[4] *Rain Dance—Annual Fiesta—Zia Pueblo* is an excellent example of the former aesthetic and illustrates the artist's initial steps toward a highly symbolic visual language that would predominate in his later oeuvre. Here, the formal qualities of balance, shape, and color take priority over accuracy of observation and individuality, precisely the opposite emphases of his naturalistic mode, which is apparent in the varied dress and informal arrangement of figures in his earlier *Corn Dance at Zia* (fig. 79). Ironically, it was primarily through his later stylization of the dances and human forms that Herrera most closely approximated traditional Zia art forms, in which painted imagery consistently emphasizes symbolic meaning over naturalism.

Not surprisingly, as Herrera and other Indian artists depended increasingly on sales to mainstream European American art collectors, such as Abby Aldrich Rockefeller, instead of ethnographic institutions for their livelihoods during the later 1920s, many altered their stylistic approaches to appeal to that audience.[5] In Herrera's case, several variations from known costuming and ritual practice appear in his works from this period, including this ostensible *Rain Dance.*[6] In *Rain Dance—Annual Fiesta—Zia Pueblo,* we find male dancers wearing women's *tablita* headdresses and the two central figures carrying women's rasps and sound boxes. These departures from known usage may have been aesthetic decisions made to unify the composition and render the costumes more elaborate and decorative, and they create a dramatic variation from the costuming seen in *Corn Dance at Zia.*[7] This gender elision may also

Fig. 79. Velino Shije Herrera (Ma-Pe-Wi), *Corn Dance at Zia,* n.d., opaque watercolor on illustration board, 35.5 x 56.0 cm (14 x 22 in.). Museum of Indian Arts and Culture / Laboratory of Anthropology, Museum of New Mexico; donated by Edgar L. Hewitt, 24003/13

have been calculated to appeal to European American audiences that expected Indian art to "express a primitive and barbaric virility coupled with subtle emotion."[8]

In the press, Herrera and his artist peers defended his portrayal of Zia rituals as an effort to preserve endangered traditions. While that rationale may have played well in European American society, it failed to assuage the concerns of his tribe. Over time, Herrera cultivated a sense among his patrons that his art was illicit and was the real reason that he had been disowned by his tribe, rather than because of his faith. One patron, Mrs. Charles H. Dietrich, wrote of a watercolor in her collection, "Velino Herrera of Zia was put out of his pueblo for painting the 'Spring Cer-

emonial Dance.' . . . It is a secret ceremonial which he should not have represented, but the painting of the figure is extraordinarily forceful and beautiful."[9] In European American society, an artist's resistance to persecution by a strict and backward society was considered noble, and Herrera actively played that role for the media. Created at a time when ostensibly "primitive" cultures were admired by European Americans for their perceived proximity to nature and dearth of guile, we may more accurately study Herrera's "abstract innovations" in terms of the European American modernist discourse than in the context of Zia Pueblo tradition.[10]

MDM

48 Stuart Davis, 1894–1964

Statue, Paris (Statue; Paris Street), 1928

Opaque watercolor over graphite on tan wove paper, 37.2 × 39.1 cm (14⅝ × 15⅜ in.)

Signed, lower right: STUART DAVIS

Gift of Abby Aldrich Rockefeller; W.935.1.15

© Estate of Stuart Davis / Licensed by VAGA, New York, NY

PROVENANCE
The artist; consigned to Downtown Gallery, New York, 1928; sold to Abby Aldrich Rockefeller, New York, November 1928; given to present collection, 1935.

RELATED WORK
Study for Statue, Paris, 1928, graphite on paper (fig. 80, collection of Lois Borgenicht).

EXHIBITIONS
Downtown Gallery, New York, *Paris by Americans: Exhibition of Work by Americans in Paris*, 1928, no. 5 (as *Statue*); Dartmouth College Collections, Hanover, N.H., *Works on Paper: Nineteenth and Twentieth Century Drawings and Watercolors from the Dartmouth College Collection*, 1975, no. 42; Carpenter Galleries, Dartmouth College Museum and Galleries, Hanover, N.H., *Gifts of Abby Aldrich Rockefeller*, 1976 (no cat.); Whitney Museum of American Art at Philip Morris, New York, *Stuart Davis: An American in Paris*, 1987 (no cat. no.); Hood Museum of Art, Dartmouth College, Hanover, N.H., *From Copley to Dove: American Drawings and Watercolors at Dartmouth*, 1989 (no cat.); Terra Museum of American Art, Chicago, and others, *The Drawings of Stuart Davis: The Amazing Continuity* (organized by the American Federation of the Arts, New York), 1992–93, no. 32.

REFERENCES
Edward Alden Jewell, "Art Galleries Offer a Rich Display: French Art Now Here in Abundance—Native Painters Reveal Present Trend—British and American Etchings," *New York Times*, October 14, 1928, sec. 10, 13 (as *Paris Street*); "Dartmouth Gets $35,000 Gift of Rockefeller Art," *New York Herald Tribune*, March 12, 1935, 19; Alan Jackson, "Art," *Town and Country* 90 (April 1, 1935), 60; Michael Mosher, "Statue, Paris," in Franklin W. Robinson (ed.), *Works on Paper: Nineteenth and Twentieth Century Drawings and Watercolors from the Dartmouth College Collection* (Hanover, N.H.: Dartmouth College Collections, 1975), 59–60 (illus., n.p.); Lewis Kachur, *Stuart Davis: An American in Paris* (New York: Whitney Museum of American Art at Philip Morris, 1987), 3 (illus.), 6, 15; Karen Wilkin and Lewis Kachur, *The Drawings of Stuart Davis: The Amazing Continuity* (New York: The American Federation of Arts, in association with Harry N. Abrams, Inc., 1992), 73 (color illus.); David Bourdon, review of *The Drawings of Stuart Davis: The Amazing Continuity*, by Karen Wilkin and Lewis Kachur, *Drawing* 15, no. 2 (July–August 1993), 40.

Stuart Davis emerged as a pioneer of cubist-inspired abstraction during the mid-1920s. By breaking form and space into flat, geometric planes of color, Davis suspended the dimension of depth in his art and accentuated the two-dimensionality of the picture plane. His explorations of form according to "intuitive and intellectual unity" crescendoed in a series of abstracted still lifes that he painted in 1927–28. Beginning in early 1928, however, Davis radically reoriented his art during a yearlong visit to Paris. He employed a more figural, naturalistic mode to depict the city's historic quarters and organized his compositions according to his own "emotional and intellectual needs."[1] Davis's frequent use of the terms "intuitive" and "emotional" are uncommon when describing cubism and yet he invoked them often throughout his career. The terms arise more frequently in discussions of another contemporary movement with which Davis is generally thought to have had virtually nothing in common: surrealism. Davis was clearly not a surrealist, at least not primarily.[2] Nevertheless, the specter of the movement's pervasive influence in the later 1920s hovers around the body of work, including *Statue, Paris,* that Davis created during his residence in the city. These were years in which the surrealists and their fascination with the unconscious reigned in the French capital.[3] Despite Davis's inevitable contact with the movement's leaders—including André Breton, Jean Cocteau, and Giorgio de Chirico—in publications and galleries, if not in person, art historians have widely maintained that Davis persisted in his *retardataire* cubist experiments and was "unaffected by the avant-garde styles then predominant—Surrealism and various forms of geometric abstraction."[4] *Statue, Paris,* among other works, appears to contradict that appraisal.

In 1930, after his return to the United States, Davis himself rhetorically asked, "Why should an American artist today be expected to be oblivious to European thought when Europe is a hundred times closer to us than it ever was before?"[5] *Statue, Paris* manifests Davis's awareness of not only the early cubism of Pablo Picasso and Georges Braque but also the metaphysical paintings of Giorgio de Chirico, such as *The Departure of the Poet* (1914, private collection), which were widely published and exhibited in both Paris and New York during the 1920s.[6] Equestrian statues and unpopulated urban landscapes, often loose composites of several recognizable landmark buildings, are hallmarks of de Chirico's works of the 1910s. The resurgence of those devices in *Statue, Paris* is difficult to dismiss, despite a con-

siderable difference in tone between the two artists' works. Whereas de Chirico's statues loom with psychological intensity, for example, Davis's sags with parody. Davis, it seems, employs the grammar of surrealism, if not its philosophy.[7] If Davis internalized one aspect of the movement's intellectual underpinnings, however, it was play. While artists like de Chirico and Breton more frequently strove to tap the irrational fears and anxieties of childhood, Davis mined a more humorous vein.[8] Critic Henry McBride described it well when he wrote that of all the modernists, both American and European, "Stuart Davis is alone in giving you the hearty laughter of outdoors."[9]

Despite its apparent surrealist undertones, the prevailing aesthetic of *Statue, Paris* is cubist. In Paris, Davis used specific sites only as points of departure, as he would in much of his mature work. The equestrian statue of King Henry IV that stands on the tip of Paris's Île de la Cité, for example, is believed to be the immediate inspiration for *Statue, Paris,* but the artist has taken considerable liberties with both the location and the statue itself.[10] In a preparatory pencil drawing for the painting (fig. 80), Davis remained closer to his source, particularly by keeping the king's arms by his sides. The heroic, sword-raised pose adopted in the final composition was apparently an invention. In lieu of the seemingly armless (and literally disarmed) figure in the pencil drawing, Davis has placed a military leader. Despite the heroic posture, however, Henry is emasculated by his horse's sagging back and his own unimpressive silhouette. Moreover, the statue stands in the midst of a modern square, surrounded by recently constructed buildings, including what art historian William Agee has interpreted as the new Samaritaine department store building, surmounted by flags.[11] Davis's depiction of Paris utilizes a composite approach of surrealist and cubist techniques to create an ironic commentary on the role of history in modern France as one of the nation's greatest leaders salutes its reigning bastions of commerce.

MDM

Fig. 80. Stuart Davis, *Study for "Statue, Paris,"* 1928, graphite on paper, 13.0 x 22.5 cm (5⅛ x 8⅞ in.). Collection of Lois Borgenicht. © Estate of Stuart Davis / Licensed by VAGA, New York, NY

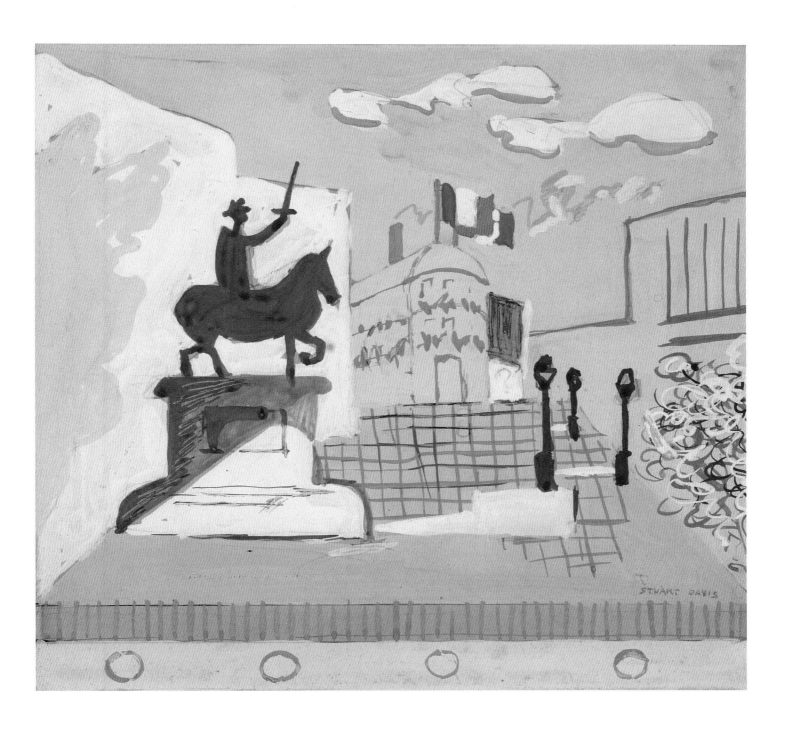

49 Joseph Stella, 1877–1946

Dying Lotus, c. 1930–32

Pastel, colored crayon, metalpoint (probably silverpoint), and possibly graphite over an artist-prepared ground on wove paper, 40.4 × 29.7 cm (15⅞ × 11¾ in.)

Signed, lower right, in graphite: Jo. Stella; inscribed, in graphite, on reverse [probably not artist's hand]: Stella, Dying Lotus

Gift of Helen Farr Sloan; D.952.133

PROVENANCE
Helen Farr Sloan, New York; given to present collection, 1952.

EXHIBITIONS
Hood Museum of Art, Dartmouth College, Hanover, N.H., *From Copley to Dove: American Drawings and Watercolors at Dartmouth*, 1989 (no cat.); Hood Museum of Art, Dartmouth College, Hanover, N.H., *The Decade of Modernism: Selected Paintings, Sculptures, and Works on Paper, 1910–1920*, 2002–3 (no cat.).

Although best known as America's foremost futurist painter, Italian-born Joseph Stella was also an indefatigable draftsman who seems to have truly lived by his belief in *"nulla dies sine linea* [not one day without a line]."[1] He achieved an astounding mastery in drawing early in life and produced a large and diverse body of works on paper throughout his career, including preparatory drawings for his paintings as well as independent works in charcoal, silverpoint, crayon, and pastel. Stella's drawings are nearly as varied in manner and subject as his paintings, which range from the famous futurist abstractions on urban themes (for example, *Brooklyn Bridge*, 1919–20, Yale University Art Gallery) to still lifes, tropical fantasies, and Madonnas inspired by devotional Italian folk art. Produced in far greater number than his paintings, Stella's drawings form a sort of visual (albeit undated) diary, as Stella scholar Joann Moser has noted. They therefore provide more direct access to his daily thoughts, his influences, and the themes central to his art.

Flowers emerged as an important motif in Stella's paintings after about 1919, but they became truly predominant in his drawings, reflecting a profound fascination with the subject. On a material level, the exotic tropical blooms that Stella favored appealed to him as the antithesis of gray New York, recalling for him the warm sunshine and vibrant colors of his frequent travel destinations—his beloved native Italy, North Africa, and Barbados. Long a symbol of ideal beauty and the fragility of life, flowers also served as an expressive vehicle for Stella's deeply held, often conflicting personal passions: his sensual nature and his drive for spiritual transcendence.

Stella's expression of emotion and spirituality through semi-abstracted natural forms corresponds with the works and beliefs of such influential pioneers of abstraction as Wassily Kandinsky and the most prominent members of the later Stieglitz circle—particularly Arthur Dove (cat. 55), Georgia O'Keeffe, and Marsden Hartley. Comparisons can be drawn, for instance, between Stella's stylized tropical flowers and O'Keeffe's magnified blossoms, with all their implied sensuality. Stella did not ally himself closely with the Stieglitz circle, however, and preferred to think of himself as working independently, free from the dictates of any particular school or philosophy. Nonetheless, he shared with many of his artistic contemporaries—Hartley among them—a tendency to explore wide-ranging philosophical and spiritual beliefs. Despite Stella's roots in Catholicism, he was intensely curious about Eastern religions and passionate about American transcendentalism, especially as later expressed through the expansive poetry of Walt Whitman.[2] As Barbara Haskell has observed, Stella "preferred the vague aura of association . . . over concrete iconography. . . . What he desired was the sense of revelation, not the revelation itself."[3]

Given Stella's loose, multivalent approach to spirituality, it is difficult to propose a single metaphorical reading of *Dying Lotus*. Despite the drawing's title (the origins of which are unknown), the work describes a remarkably vital lotus set against an active, almost iridescent blue background. Stella was certainly aware of the symbolic resonance that lotus blossoms and water lilies held for diverse cultures and religious traditions, from ancient Egypt to Buddhist and Hindu India. In these contexts, the lotus has been associated variously with the resurgence of life, fertility, the sun, enlightenment, and purity.[4] As in so many of Stella's depictions of flowers, here we look down into the tilted blossom, which reveals its luminous yellow stamen—the pollen-producing male organ of the specimen—thereby allowing a sensual reading as well.[5] Stella magnifies the blossom's importance and visual impact by nearly filling the sheet with its cupped petals, which twist and arch upward, set against the rich blues he so often favored. Acutely aware of the expressive potential of color, Stella noted over the years his positive associations with the color blue, all of them fitting in this context. Blue for him signified serenity, the heavens, and "the pure blue of the Dawn of our life."[6] He used it to describe the decoration of what is likely an Asian porcelain bowl, but he manipulated it more suggestively and broadly in the background, where it conveys the sense of an energized aura radiating from the splayed petals. Despite the apparent vigor of the cut blossom, the title reminds us of its imminent fate. Stella once described flowers as symbols "of the daring flights of our spiritual life."[7] In this instance, his expressive treatment of the lotus suggests that its essence has already entered the mythic realm.

BJM

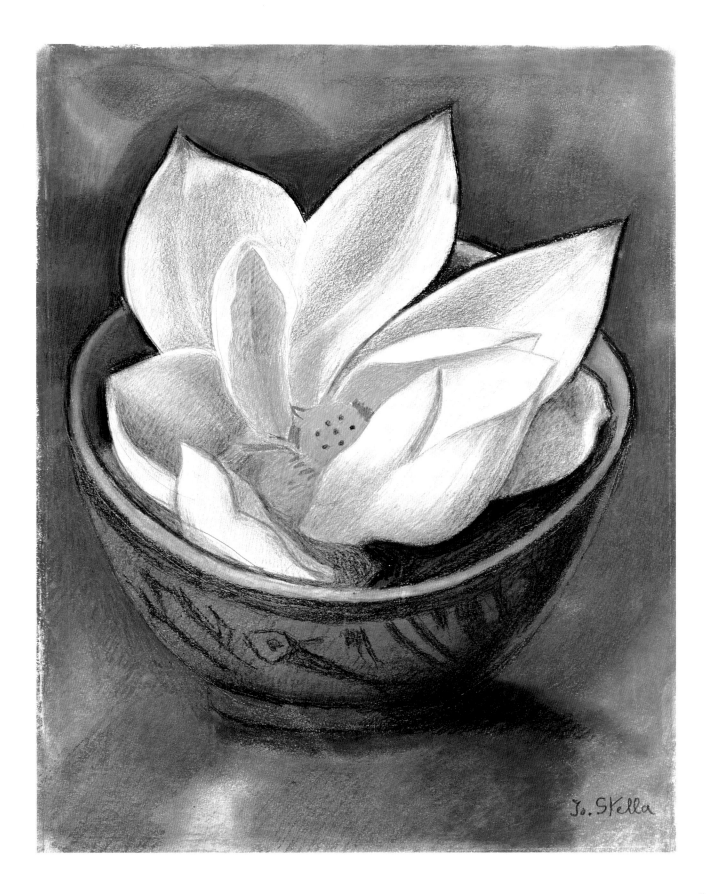

50 Alexander Calder, 1898–1976

The Exits (Les Sorties), 1931

Pen and black ink on wove (L.L.F.) paper, 57.8 × 78.5 cm (22¾ × 30⅞ in.)

Signed and dated, lower right: calder / 1931; inscribed twice, upper left and upper right: SORTIE

Gift of Peter A. Rübel, Tuck 1938; D.965.61

© 2004 Estate of Alexander Calder / Artists Rights Society (ARS), New York

PROVENANCE
The artist; consigned to Perls Galleries, New York, 1964; sold to Peter Alexander Rübel, Conn., 1964; given to present collection, 1965.

RELATED WORK
Handstand on the Table, 1931, ink drawing (collection of Philip A. Straus, Larchmont, N.Y., 1972); both works part of a group of about a hundred circus drawings that Calder created in 1931–32.

EXHIBITIONS
Perls Galleries, New York, Calder: Circus, Ink Drawings, 1931–1932, 1964; Hopkins Center Art Galleries, Dartmouth College, Hanover, N.H., Director's Choice, 1966 (no cat. no.); Rivier College Art Gallery, Nashua, N.H., Art of the 1930's, 1983 (no cat.); Dartmouth College Collections, Hanover, N.H., Works on Paper: Nineteenth and Twentieth Century Drawings and Watercolors from the Dartmouth College Collection, 1975, no. 44.

REFERENCE
Lisa Ehret, "Les Sorties," in Franklin W. Robinson (ed.), Works on Paper: Nineteenth and Twentieth Century Drawings and Watercolors from the Dartmouth College Collection (Hanover, N.H.: Dartmouth College Collections, 1975), 62–63 (illus., n.p.).

Best known for his innovative contributions to sculpture—particularly the abstracted, aerial mobile and its stationary counterpart, the stabile—Alexander Calder created a prodigious number of works in various media depicting the circus. These included paintings, gouaches, wire sculptures, more than one hundred ink drawings, and his remarkable miniature Cirque Calder (1926–30, Whitney Museum of American Art). This handmade circus features hundreds of show figures and animals that Calder manipulated to enact stunts during private performances throughout his career. Occasionally dismissed as an idiosyncratic prelude to his nonobjective sculpture, Calder's two- and three-dimensional circus art served as a vital laboratory for ideas about space, balance, motion, and improbability that he explored throughout his career.

Calder's distinctive approach to circus imagery stemmed in part from his unusual training and diverse artistic influences. His precisely drawn line and mechanical intuition flourished initially at the Stevens Institute of Technology in Hoboken, New Jersey, where he received a degree in mechanical engineering in 1919. Under the direction of such Art Students League instructors as John Sloan, who encouraged his work in painting, and Boardman Robinson, who emphasized the virtues of the continuous contour, Calder developed a sketchlike manner based on quick observation and an economy of line. He put his talents to use as a freelance illustrator of sporting events and circus performances for the National Police Gazette beginning in 1924.[1] Two years later Calder traveled to Paris, where he took drawing classes at the Académie de la Grande Chaumière, attended the Cirque Médrano at every opportunity, and initiated work on his Cirque Calder. Early performances of his Cirque attracted the notice of the European artistic avant-garde, including Joan Miró, Le Corbusier, and especially Piet Mondrian, whose work inspired Calder's embrace of abstraction in painting and sculpture.

In 1931, the year he drew this and so many other circus drawings, Calder was immersed in one of the most fertile, creative phases of his career. He worked interchangeably in wire sculpture (creating figures, animals, and portrait heads) and drawing ("when you have no workshop you can always draw"), and he exhibited his first nonobjective painting and sculpture.[2] He also created the motorized sculptures—christened "mobiles" by Marcel Duchamp—that

evolved into his famous wind-powered constructions.[3] The approximately one hundred figurative circus drawings Calder executed from memory in 1931–32 were integral to his exploration of weightlessness, equilibrium, and movement. Like mobiles that alternate between stillness and motion, these drawings divide between those that capture a moment of stasis (such as The Exits) and those that arrest an instant of propulsion or unresolved suspension. Thomas Messer has noted that "to appreciate it fully, Calder's motion must be seen in relation to his repose; the mobile must be contemplated with the stabile."[4] Taken as a whole, Calder's drawings mimic the rhythms of the circus itself, which, as Donna Gustafson has observed, forms a ceaseless cycle of equilibrium and disequilibrium.[5] His acrobats perform their gravity-defying feats, balancing on two hands (as seen in The Exits) or on an impossibly fine tightrope, much as Calder's monumental stabiles perch precariously on diminutive points of contact with the ground. Echoing the planetary orbits that always fascinated Calder, his performers circulate—even float—within a large, ovoid arena. He recalled, "I was very fond of the spatial relations. I love the space of the circus. . . . The whole thing of the vast space."[6]

In The Exits, Calder suggests the setting with extremely spare contours, so that the whiteness of the sheet stands in for the air that infiltrates form, giving the drawing a sense of weightlessness. In a manner suggesting modernist approaches to structure and, most closely, Calder's own continuous-line wire sculptures of circus performers, the drawn figures are transparent and overlapping, revealing multiple vantages at once. In The Exits we see the furthest extension of the acrobats' stunt, just seconds before a tumble will propel the bodies into a new relationship with one another. The composition's symmetrical configuration, in which flanking diagonal courses of stairs lead to two disembodied exit signs, echoes this moment of supreme balance. Levity, both physical and psychological, imbues the space and its caricature-like figures. The work's extreme reduction also gives it a dreamlike quality that links it to surrealism. As in much circus art of the twentieth century, we are left to question the degree to which the performance serves as a metaphor for this or other worlds. And more specifically, in this work, from what realm do we exit? As Calder reticently remarked on the circus, "Most people see the surface that's funny, but there's a lot that goes on."[7]

BJM

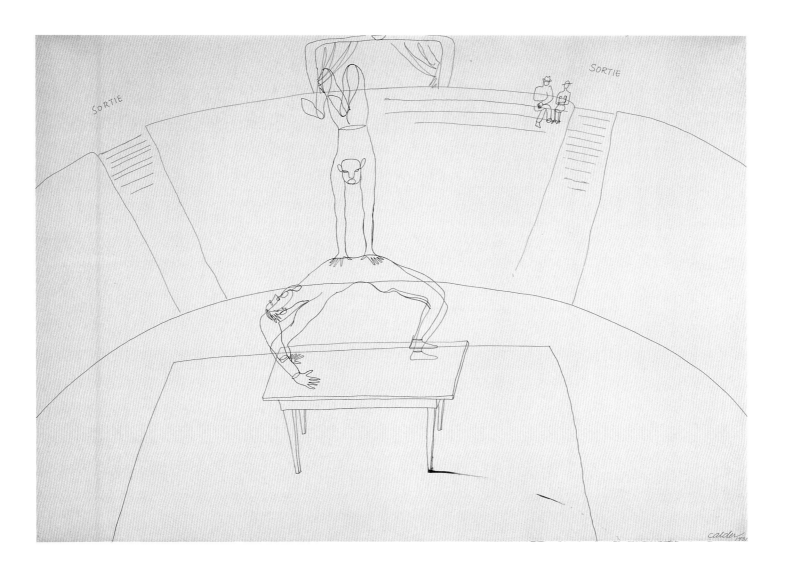

51 Paul Cadmus, N.A., 1904–1999

Deposition (Bewailing of Christ), 1932

Transparent and opaque watercolor and ink over graphite on heavy, handmade wove (J. Whatman) paper, 28.6 × 39.1 cm (11¼ × 15⅜ in.)

Signed and dated, in ink, lower right: Paul / Cadmus-32

Gift of Ilse Bischoff; W.956.45

Courtesy of the Estate of Paul Cadmus and DC Moore Gallery, New York

PROVENANCE
Ilse Bischoff, Hartland, Vt.; given to present collection, 1956.

EXHIBITIONS
Rivier College, Nashua, N.H., 1972; Miami University Art Museum, Miami University, Oxford, Ohio, and others, *Paul Cadmus, Yesterday and Today,* 1981–82, no. 2; Print and Drawing Study Room, Grinnell College, Grinnell, Iowa, *Paul Cadmus,* 1990, no. 2.

REFERENCES
Paul Cummings, *American Drawings: The 20th Century* (New York: Viking Press, 1976), 108–9 (illus., as *Bewailing of Christ*); Philip Eliasoph, *Paul Cadmus: Catalogue Raisonné, Paintings, 1931–1977* (Fairfield, Conn.: published by the author, 1977), 2, no. 7; Philip Eliasoph, *Paul Cadmus, Yesterday and Today* (Oxford, Ohio: Miami University Art Museum, 1981), 39 (illus.); Lincoln Kirstein, *Paul Cadmus* (New York: Imago Imprint, 1984; rev. ed., New York: Chameleon Books, Inc., 1992), 12–13 (illus.), 132; Print and Drawing Study Room, Grinnell College, Grinnell, Iowa, *Paul Cadmus* (Grinnell, Iowa: Grinnell College, 1990), n.p.; David Leddick, *Intimate Companions: A Triography of George Platt Lynes, Paul Cadmus, Lincoln Kirstein, and Their Circle* (New York: St. Martin's Press, 2000), 44; Justin Spring, *Paul Cadmus: The Male Nude* (New York: Universe Publishing, 2002), 17–18, fig. 19.

As the only religious subject painted by Paul Cadmus, *Deposition* contrasts dramatically with better-known aspects of his career—from his earthy, satirical depictions of urban debauchery to his later, intimate drawings of male nudes. Cadmus, who was not overtly religious, pays homage in this early watercolor to the Italian Renaissance art he had recently admired firsthand and explores what would become a lifelong fascination with the male body. He investigated this focus initially within the context of complex, multifigure compositions and later in precisely drawn, private images of a single nude model.

Although rendered in watercolor, this work demonstrates the artist's firm grounding in traditional approaches to drawing. As he did with both dry and fluid media, he applied the pigment in a linear manner that relies on orderly hatchings and cross-hatchings to model and color his highly particularized forms. In the development of his painstaking style—which American critics termed "magic realism"—he looked to the exquisite draftsmanship of Ingres, the mannerist engravings of Marcantonio Raimondi, and especially the meticulously modeled, muscular nudes in the Orvieto frescoes by Luca Signorelli.[1] Cadmus came to know the quattrocento painter's work during a tour of Europe with his lover and fellow student at the Art Students League, Jared French, who had convinced Cadmus to quit his advertising job to become a full-time artist. They left New York in 1931 and raced through France, Germany, Italy, and Spain, drawing in museums and churches along the way. At the end of the year, they settled in the tiny fishing village of Puerto de Andraitx on Mallorca, off the coast of Spain, where they stayed for over a year to concentrate on their art.

Cadmus's Mallorcan period resulted in twelve paintings and five watercolors, including *Deposition*. He and French relished the beautiful setting (see *Puerto de Andraitx: Mallorca,* p. 229) and the rugged, seemingly unself-conscious physicality of the fishermen. Handsome, swarthy locals figured prominently in his 1932 paintings *Mallorcan Fisherman, Juan,* and *Francisco* (see fig. 82, p. 166). Toward the end of his stay he created some of his best-known multifigure works,

including *Y.M.C.A. Locker Room* and *Shore Leave,* both based on memories of New York. The latter composition was a raucous satire of sailors drinking and cavorting with their female (and male) consorts in a New York park. It anticipated *The Fleet's In!* of 1934, a lusty painting that was banned from exhibition at the Corcoran Gallery of Art at the request of the navy establishment and earned Cadmus his reputation as the enfant terrible of the 1930s.[2]

Knowing the provocative imagery that followed on its heels, *Deposition* seems sedate and conventional by contrast. But while Cadmus relied on traditional organizing principles, draftsmanship, and iconography for this work, he took certain liberties with the scene. He situated a scantily clad Mary Magdalene at Christ's head rather than his feet, her identifying locks spilling down and around him in Pre-Raphaelite fashion. Displaced from her usual post at Christ's head, the modest Virgin Mary clasps his bare leg from the side. The swarthy young man at left, seemingly attired for sunbathing on a Mallorcan beach, is either new to the ensemble or a radically reworked John. His taut bronze flesh contrasts with the languid gray body of Christ, reputedly posed by French.[3] The rhythmic configuration of surrounding figures and undulating drapery enlivens the composition and draws further attention to the supine Christ. Indications of blood on his torso and right hand hint at the Crucifixion, but the low vantage point emphasizes the body's elegant diagonal thrust and its subtly varied topography, viewed—in Cadmus fashion—as if from a "fly crawling over the model."[4]

Cadmus's *Deposition* prefigures not only the artist's late nudes but also other compositions that feature reclining male figures and touch more explicitly on the theme of violence. This is especially evident in his *To the Lynching,* 1935, and *Herrin Massacre,* 1940 (fig. 81), both brutal images of extreme social violence that rely on the artful arrangement of prostrate male figures for their graphic and emotional impact.[5] In contrast to the mournful aftermath of Christ's death shown in *Deposition,* these later works depict violence in process, with the perpetrators displaying horrific enthusiasm as they ply their crimes. In *Herrin Massacre,* the victims lie on the ground with trousers removed or partially open, conveying a homoerotic overtone that is unsettling within this context. Although considerably more veiled in *Deposition,* sexual innuendo is integral to the male figural studies Cadmus produced throughout his career.

BJM

Fig. 81. Paul Cadmus, *Herrin Massacre,* 1940, tempera and oil on panel, 90.2 x 67.9 cm (35½ x 26¾ in.). Columbus Museum of Art, Ohio; gift of Thomas J. Lord and Robert E. White, Jr. in memory of Arthur and Marie Bell Lord and R. Emmett and Irene Foster White; 1998.022. Courtesy of the Estate of Paul Cadmus and DC Moore Gallery, New York

52 Paul Cadmus, N.A., 1904–1999

Factory Worker: Francisco (Francisco Femenias), 1933

Graphite on newsprint, 32.7 × 25.1 cm (12⅞ × 9⅞ in.)

Signed and inscribed, lower right: Paul Cadmus / Francisco Femenias[1]

Purchased through gifts by exchange; D.996.18

Courtesy of the Estate of Paul Cadmus and DC Moore Gallery, New York

PROVENANCE
Midtown Galleries, New York, probably before 1980; Dr. Leo Lese, by 1992; Sotheby's, New York, *American Paintings, Drawings and Sculpture,* March 20, 1996, lot 283 (illus.); sold to present collection, 1996.

RELATED WORKS
The artist later revisited this drawing as the basis for *Francisco,* c. 1937, black-and-white watercolor on gray paper (private collection, Maryland, 1996), which was a cover image for *Bachelor* magazine in July 1937. Another version of the subject is *Francisco,* 1933 and 1940, oil on canvas (Hood Museum of Art, fig. 82).

EXHIBITION
Hood Museum of Art, Dartmouth College, Hanover, N.H., *American Paintings from the Dartmouth Collection, 1910–1960,* 1998 (no cat.).

REFERENCES
Lincoln Kirstein, *Paul Cadmus* (New York: Imago Imprint, 1984; rev. ed., New York: Chameleon Books, Inc., 1992), 114 (illus.); David Leddick, *Intimate Companions: A Triography of George Platt Lynes, Paul Cadmus, Lincoln Kirstein, and Their Circle* (New York: St. Martin's Press, 2000), 46 (illus.).

Fig. 82. Paul Cadmus, *Francisco,* 1933/40, oil on canvas, 38.3 x 30.4 cm (15⅛ x 12 in.). Hood Museum of Art, Dartmouth College; gift of the Estate of C. Morrison Fitch, Class of 1924; P.969.64.4. Courtesy of the Estate of Paul Cadmus and DC Moore Gallery, New York

This powerful likeness is one of several life drawings Paul Cadmus recalled having made of factory worker Francisco Femenias on the island of Mallorca during the artist's productive and idyllic stay there in 1932–33 (see entry for cat. 51).[2] The image clearly resonated with Cadmus over a long period of time. He used this drawing as a reference for his oil painting *Francisco* (fig. 82), which he worked on in both 1933 and 1940, as well as a much more mannered, fine-line watercolor drawing that appeared as a cover for *Bachelor* magazine in July 1937.[3] As is even more evident in the painted version, this drawing's format and introspective mood owe a debt to the classical and Renaissance portraits Cadmus admired during his recent tour of Europe and throughout his career. Nonetheless, this commanding male portrayal reflects Cadmus's affinity with the art of his own time, as well as a seemingly intense personal engagement with his subject.

Cadmus's steady reliance on conventional modes of representation isolated him from the artistic mainstream in the postwar years, but in the 1930s and early 1940s his traditional manner and figurative subjects allied him with many of his American Scene and regionalist contemporaries.[4] He favored during this time the head-and-shoulders portrait format, viewed at strikingly close range, that also appealed to regionalist painter Grant Wood, for instance (for example, his *Self-Portrait,* 1932 [Davenport Art Gallery, Iowa]). Like Cadmus, Wood looked for inspiration to early Renaissance compositions and techniques. Instead of the overall-clad farmers that populated Wood's midwestern scenes, however, Cadmus chose the strong and handsome villagers of Puerto de Andraitx as his common-man subjects. In another Mallorcan-period portrait head, *Juan* (1932, oil on canvas, Hood Museum of Art), he painted in jewel-like Renaissance tones what appears to be a fisherman dressed in rugged outdoor attire. Revealing once again his appreciation for both local color and art historical sources, Cadmus rendered his purported "Juan," not from life, but from "a reproduction of a sculpted head of Caracalla."[5] Cadmus continued to mine his Mallorcan subjects following his return to New York. In 1934 he completed an oil portrait of Francisco's brother, Miguel (*Miguel,* private collection, 1992), that echoes the painting *Francisco* (fig. 82) in its frontal pose, sideways glance, and proximity to the picture plane. Soon thereafter

Cadmus moved away from his elegantly portrayed working-class subjects and depicted primarily New York friends in the arts, including photographer George Platt Lynes and painter Ilse Bischoff (fig. 36, cat. 69, and p. 227). Also recalling Renaissance painting conventions, he composed these primarily as three-quarter views in mixed media (oil and tempera) and, after 1940, pure tempera. Although Cadmus worked on *Francisco* again in 1940, he shunned portraiture in later years, concentrating instead on male figures — often nude and, to the viewer, anonymous.

Cadmus's bold, coarse handling of the graphite medium in this drawing complements the sturdy features and thick, heavy hair of the sitter, whom Cadmus identified in this likeness — but not others — as a factory worker.[6] The drawing contrasts dramatically with the artist's more stylized and meticulously wrought depictions of Francisco in oil and watercolor, as well as with Cadmus's characteristic, stroke-by-stroke drawing manner. Executed with apparent speed and verve, *Factory Worker: Francisco (Francisco Femenias)* gives the sense of being a direct, preparatory likeness, freed from concerns of detail and finish. Cadmus conveys the head's volume with broad, chisel-like strokes suggestive of sculpting. He reinforced the outline of the face with especially thick, heavily applied lines and shadings of graphite, probably to make a tracing of the contour (as he often did) for one or both related works.[7] The sitter's downcast eyes give a sense of autonomy and reserve, while his closeness to the viewer suggests accessibility and projects a regal monumentality befitting a Renaissance-era patron. His large, strong features and sober expression convey a sense of physical strength and emotional reticence often associated with masculinity. By contrast, the more stylized related drawing that appeared in *Bachelor*—which Cadmus said he "concocted" from the earlier drawing—suggests a younger, more effeminate Francisco, one in which the title *Factory Worker* would have been less credible. Therefore, while representing an important phase in his integration of old and new approaches to art, this drawing—along with Cadmus's other images of Francisco—appears to represent the artist's experimentation with portraying various manifestations of masculinity. Such explorations remained central to his art throughout his career.

BJM

53 Peggy Bacon, N.A., 1895–1987

Morris Ernst, 1934

Pastel on gray wove (Canson & Mont-golfier) paper, 43.6 × 35.9 cm (17¼ × 14⅛ in.)

Signed, in white pastel, lower right: Peggy Bacon

Gift of Abby Aldrich Rockefeller; D.935.1.99

PROVENANCE
The artist; consigned to the Downtown Gallery, New York; sold to Abby Aldrich Rockefeller, New York, February 1934; given to present collection, 1935.

RELATED WORKS
Morris Ernst, 1934, drawing, reproduced in Peggy Bacon, *Off With Their Heads!* (New York: Robert M. McBride and Co., 1934), n.p.; also a series of *Morris Ernst* drawings on five sheets (Hood Museum of Art, D.2002.18.1–5, see p. 226), probably studies for both *Off With Their Heads!* and this pastel.

EXHIBITIONS
Rockefeller Center, New York, *First Municipal Art Exhibition,* 1934, no. 36; National Collection of Fine Arts, Smithsonian Institution, Washington, D.C., *Peggy Bacon: Personalities and Places,* 1975–76, no. 29.

REFERENCES
"Radical Picture of Radical, Mrs. John D. Jr. Buys It!" *New York Evening Post,* March 3, 1934, 1 (illus.), 2; "Dartmouth Gets $35,000 Gift of Rockefeller Art," *New York Herald Tribune,* March 12, 1935, 19 (illus.); Janet Flint and Roberta K. Tarbell, *Peggy Bacon: Personalities and Places* (Washington, D.C.: Smithsonian Institution Press, 1975), 56n.30, 79; Roberta K. Tarbell, "Peggy Bacon's Pastel and Charcoal Caricature Portraits," *Woman's Art Journal* 9, no. 2 (fall 1988–winter 1989), 37n.20.

Fig. 83. Peggy Bacon, *Morris Ernst,* published in Peggy Bacon, *Off with Their Heads!* (New York: Robert M. McBride and Co., 1934), n.p. Dartmouth College Library. Reproduced by permission of the Estate of Peggy Bacon

This exuberant caricature of liberal civil rights lawyer Morris Ernst received an unexpected bit of celebrity when it was exhibited at the *First Municipal Art Exhibition* at Rockefeller Center in 1934 and purchased by Abby Aldrich (Mrs. John D.) Rockefeller. With a two-column illustration of the drawing on its front page, the *New York Evening Post* declared: "Radical Picture of Radical Bought at Art Show by—Yes, by Mrs. Rockefeller Jr."[1] The work's notoriety appears to have owed less to the "radical" nature of Bacon's unflattering characterization than to a confluence of circumstances and divergent personalities, all shaped by the distinct sociopolitical milieu of the day.

Peggy Bacon's sharp-witted likenesses had already amused countless viewers and mortified others, especially her sitters. She developed her powers of observation under the tutelage of veteran social spectator John Sloan (cats. 37, 42) in the 1910s. From early in her career she created delightfully satirical etchings that revealed her wry humor and insight into human foibles. These presaged her individual caricatures of artistic celebrities—executed initially in charcoal and, beginning in 1927, also in pastel. She published thirty-nine such characterizations, along with written commentary, in her 1934 book, *Off With Their Heads!* Critics and viewers have debated ever since whether Bacon's devastating, often highly distorted "decapitations" constituted malicious intent or affectionate teasing.[2] Perhaps to guard herself against accusations of meanspiritedness, she opened the book with a dedication "to the faces I love" and closed it with an especially scathing self-portrait in profile, accompanied by self-deprecating text.[3]

By 1934 Bacon had expanded her list of beloved victims to include progressive journalists, politicians (including New York mayor Fiorello La Guardia), and, as seen here, a prominent civil rights advocate, Morris Ernst. Ernst won his most famous case just months before Bacon drew his likeness, in December 1933, when he overturned a federal ban on James Joyce's novel *Ulysses* on the grounds of obscenity.[4] In *Off With Their Heads!* Bacon reproduced a black-and-white drawing of Ernst (fig. 83) that was nearly identical to the pastel and, like it, based on preliminary sketches (see p. 226). In characteristic fashion, her accompanying caption probed his physiognomy and personality, without reference to his professional accomplishments:

Hard nut to crack. Face yanked up at left in uncanny grin. Deep wide laughing Punch-mouth. Wiggly

hair. Eyebrows like the devil. Eyes deepset black buttons, twisted askance. Nose long, sinewy with eel ripple. Upper lip clever and crooked. Lower protuberant, argumentative and broad. Skin dark curry against fine light gray suit, lavender necktie and green socks. Hungry fiery, dancing mind, glitteringly unoriginal. Wits dart like a waterbug.[5]

The dynamic contours and flaming orange background in the pastel suggest Ernst's "fiery" character, while the dark hair and exaggerated nose accentuate his Eastern European ancestry. The pastel is slightly more restrained than the crayon version, which further accentuates his swarthy complexion and "wiggly" hair. Although one writer felt that Bacon "made Morris Ernst a little too diabolic," his wide grin in both portrayals projects a genial disposition.[6]

Bacon's dealer, Edith Halpert of the Downtown Gallery, avidly promoted her art and this drawing in particular. She selected it as one of three caricatures to represent Bacon at the February 1934 *First Municipal Art Exhibition,* of which Halpert was a prime organizer.[7] Officially sponsored by La Guardia, the exhibition featured art "by living American artists identified with the New York Art World."[8] The dealers participating in this sweeping "mile of art" invited top clients to preview the works in hopes that advance purchases would increase sales and public interest. It is unlikely that Halpert—or even Rockefeller—perceived the symbolic potency of Mrs. Rockefeller's purchase of Bacon's *Morris Ernst.* The *Post* reporter who publicized the acquisition delighted in the irony of her honoring the anticensorship champion when, that same month, Diego Rivera's controversial Rockefeller Center mural, commissioned by the Rockefeller family, had been destroyed, largely at the behest of the collector's husband and her son Nelson.[9] Abby Rockefeller may have acquired the pastel solely on the basis of its lively visual appeal, likely at the urging of her advisor, Halpert. It is also plausible, however, that as a former patron of Rivera and an adventurous collector of contemporary art—much of it by left-leaning artists—she consciously paid tribute to the liberal values espoused by Ernst and by Bacon, who had protested Rivera's dismissal.[10] Whatever Rockefeller's motivation, the charged political climate in late February 1934 transformed this modest private transaction into a very public affair that drew attention to artist, sitter, and patron—all players in recent controversies regarding censorship.

BJM

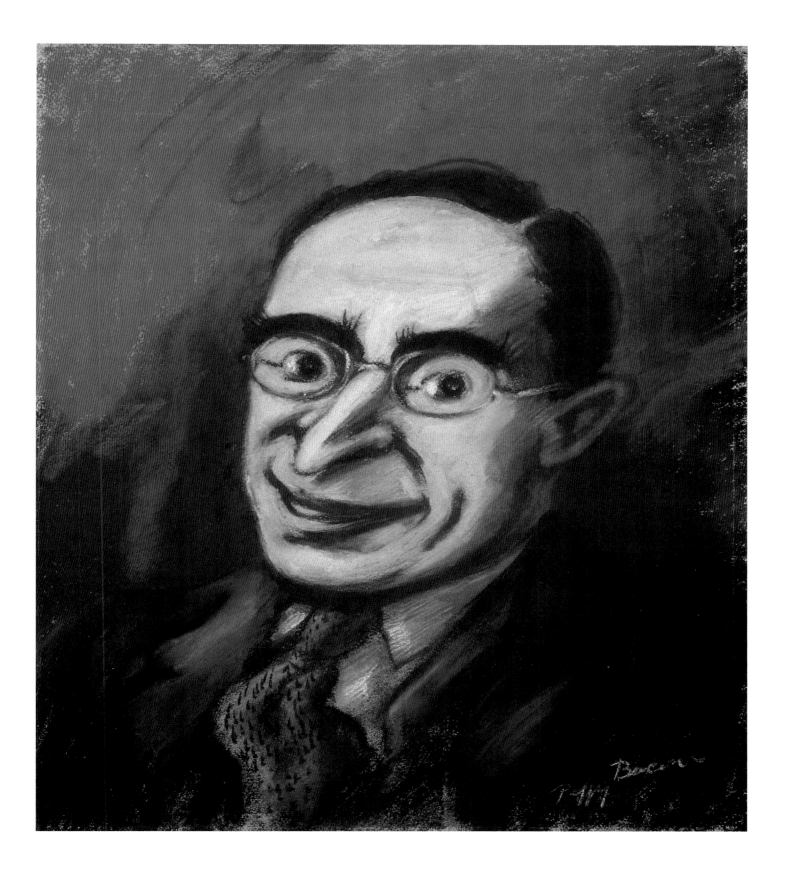

54 Charles Demuth, 1883–1935

Beach Study No. 3, Provincetown, 1934

Watercolor and graphite on wove paper,
21.5 × 28.1 cm (8½ × 11¹/₁₆ in.)

Signed and dated, in graphite, lower left:
C. Demuth '34

Gift of Abby Aldrich Rockefeller;
W.935.1.16

PROVENANCE
The artist; consigned to Kraushaar
Gallery, New York; sold to Abby Aldrich
Rockefeller, New York, February 1935;
given to present collection, 1935.

EXHIBITIONS
Pennsylvania Academy of the Fine Arts,
Philadelphia, *32nd Annual Philadelphia
Watercolor Exhibition*, 1934, no. 417;
William Penn Memorial Museum, Har-
risburg, Pa., *Charles Demuth of Lancaster*,
1966, no. 141; The Art Galleries, Univer-
sity of California, Santa Barbara, and
others, *The Mechanical Encrusted on the
Living*, 1971–72, no. 122; Dartmouth Col-
lege Collections, Hanover, N.H., *Works
on Paper: Nineteenth and Twentieth Cen-
tury Drawings and Watercolors from the
Dartmouth College Collection*, 1975, no.
32; Dartmouth College Museum and
Galleries, Hanover, N.H., *Gifts of Abby
Aldrich Rockefeller*, 1976 (no cat.); Her-
itage Plantation of Sandwich, Mass.,
Cape Cod as an Art Colony, 1977 (no cat.
no.); Hood Museum of Art, Dartmouth
College, Hanover, N.H., *From Copley to
Dove: American Drawings and Watercolors
at Dartmouth*, 1989 (no cat.).

REFERENCES
Emily Farnham, "Charles Demuth: His
Life, Psychology and Works" (Ph.D.
diss., Ohio State University, 1959),
2:639–40, no. 569; Emily Farnham,
Charles Demuth: Behind a Laughing Mask
(Norman: University of Oklahoma
Press, 1971), 210; David Gedhard and
Phyllis Plous, *Charles Demuth: The Me-
chanical Encrusted on the Living* (Santa
Barbara: The Art Galleries, University of
California, Santa Barbara, 1971), 21, 76
(illus.), 85; James Dell, "Beach Study No.
3," in Franklin W. Robinson (ed.), *Works
on Paper: Nineteenth and Twentieth Cen-
tury Drawings and Watercolors from the
Dartmouth College Collection* (Hanover,
N.H.: Dartmouth College Collections,
1975), 46–47 (illus., n.p.); Alvord L. Eise-
man, "A Study of the Development of an
Artist: Charles Demuth" (Ph.D. diss.,
New York University, 1976), 2:552
(illus.); H. R. Bradley Smith et al., *Cape
Cod as an Art Colony* (Sandwich, Mass.:
Heritage Plantation of Sandwich, 1977),
13 (illus.); Jacquelynn Baas et al., *Trea-
sures of the Hood Museum of Art, Dart-
mouth College* (New York: Hudson Hills
Press, in association with the Hood Mu-
seum of Art, Dartmouth College, 1985),
137, no. 129 (color illus.).

Charles Demuth played a major role in the devel-
opment of American modernist art during his
short career. The Lancaster-born painter preferred
to hover at the periphery of avant-garde activity
despite his presence in a wide variety of legendary
contexts: he encountered Gertrude Stein and was
photographed by Man Ray in Paris,[1] vacationed in
Bermuda with Marsden Hartley,[2] frequented the
bohemian salons of the Stettheimer sisters in
Manhattan,[3] inspired characters in Eugene
O'Neill's plays during summers in Province-
town,[4] and befriended the poet William Carlos
Williams while an art student at the Pennsylvania
Academy of the Fine Arts.[5] Demuth was also a
regular visitor to Alfred Stieglitz's gallery 291,
which served as the primary venue for vanguard
art in New York City in the years surrounding the
Armory Show. He accompanied Marcel Duchamp
around Manhattan's speakeasies and even pub-
lished a poem in defense of *Fountain* after the
dadaist's "readymade" was deemed immoral by
the sponsors of an exhibition in 1917.[6]

Although they had met a decade earlier, Alfred
Stieglitz only began showing Demuth's work reg-
ularly in 1925.[7] Stieglitz then included the forty-
two-year-old's paintings in the pivotal exhibition
Seven Americans, along with works by Arthur G.
Dove, Georgia O'Keeffe, John Marin, Marsden
Hartley, Paul Strand, and Stieglitz himself. Even
after his flattering inclusion among the Stieglitz
circle, Demuth remained characteristically aloof
from the more heroic strain of modernism prac-
ticed by these artists. In contrast to their celebra-
tions of pure abstraction and their bold repre-
sentations of contemporary urban space,
Demuth's mature oil paintings seem like coy re-
buses with their prismatic treatment of decidedly
inauspicious architecture, fragmentary lettering,
and ironic titles. Alongside his precisionist
efforts, Demuth's cubist-inspired still-life practice
deserves to be counted among the most accom-

plished work in watercolor of the twentieth cen-
tury.[8] He used that same medium to depict New
York's vivid nightlife—the speakeasies, circuses,
and vaudeville stages of the Jazz Age—a milieu
that he wholeheartedly embraced from the early
1910s until at least 1930.[9] Less broadly known but
equally important to subsequent scholarship and
museum displays, Demuth's watercolors of these
years also featured remarkably frank depictions of
gay flirtation and sex, imagery that flaunted his
"outsider" status even among his avant-garde
friends.[10]

When not abroad, Demuth summered on the
Massachusetts seashore, splitting his time be-
tween Gloucester and Provincetown.[11] Both
towns were established art colonies with working
ports and scenic ocean views that served to dis-
tract the artist from the painful diabetes that he
suffered throughout his adult life. In 1934 he pro-
duced his last major efforts in watercolor in
Provincetown.[12] A rare self-portrait of the artist
shows him straining to complete a sketch on the
beach there (fig. 84).[13] *Beach Study No. 3, Province-
town* is formally related to the self-portrait but is
more typical of the spirit of the other works in
this final series.[14] First drawn in the fine mean-
dering line that distinguishes all of Demuth's il-
lustrative works, the sheet is centered on a
pyramidal family group of two adults and a small
boy. Their gazes and ungainly bodies are directed
away from the viewer, perhaps toward the coming
surf. By using close complementary colors that he
blotted carefully to model the principal forms,
Demuth suggests the bathers' lightweight sum-
mer clothing and their sunburned skin, as well as
the sturdy beach umbrella that provides a visual
counterbalance to the figures. The rest of the
drawing is untouched by color, a strategy that has
the effect of isolating the group in a limitless
space.[15] Despite the cheery palette and the recre-
ational theme, a vague sense of ambivalence per-
vades this family scene and other works painted
at this time. An inveterate loner, Demuth might
astutely observe his fellow vacationers, but he
chose to remain fundamentally detached from
their summertime play.

DRC

Fig. 84. Charles Demuth, *The Artist on the Beach
at Provincetown*, 1934, graphite and watercolor on
paper, 21.4 x 27.9 cm (8⁷/₁₆ x 11 in.). Carnegie Mu-
seum of Art, Pittsburgh; bequest of Mr. and Mrs.
James H. Beal

55 Arthur Dove, 1880–1946

Boat Houses, 1938

Watercolor over graphite on wove paper, mounted on original secondary support, sheet: 12.7 × 17.8 cm (5 × 7 in.); mount: 25.4 × 35.4 cm (10 × 13¹⁵⁄₁₆ in.)

Signed, in pen and ink, lower center: Dove; machine-printed label on reverse: TITLE_____ / By ARTHUR DOVE / Care of ALFRED STIEGLITZ / 509 MADISON AVENUE / NEW YORK CITY; inscribed by artist, in pen and ink, on label: Boat Houses / '38; inscribed in another hand, in graphite, on label: 38/32; stamped, in ink: SEP 21 1960 / FEB 22 1967

Bequest of Jay R. Wolf, Class of 1951; W.976.189

PROVENANCE
The artist; consigned to An American Place, New York (not sold); with Downtown Gallery, New York; to Terry Dintenfass, Inc. (art dealer), New York; sold to Jay R. Wolf, New York; bequeathed to present collection, 1976.

EXHIBITIONS
An American Place, New York, probably 1938 or 1939; Hopkins Center Art Galleries, Dartmouth College, Hanover, N.H., *The Jay Wolf Bequest of Contemporary Art*, 1977 (no cat.); Hopkins Center Art Galleries, Dartmouth College, Hanover, N.H., *Twentieth Century Masters from the Permanent Collection*, 1978 (no cat.); Hood Museum of Art, Dartmouth College, Hanover, N.H., *From Copley to Dove: American Drawings and Watercolors at Dartmouth*, 1989 (no cat.).

Arthur Dove worked at the leading edge of American abstraction. Influenced by European modernists—particularly Paul Cézanne and Henri Matisse—while traveling in France from 1907 to 1909, Dove was soon "extracting" from nature the rhythms and forms that he perceived to be its essence. He insisted that his art was derived from specific features in the landscape, though it often bordered on nonrepresentation. During the early 1910s, his works' affinity with Italian futurism and the German Blue Rider group, particularly the work of Wassily Kandinsky, placed him in the midst of mainstream modernism and closed a lengthy time lag between European and American stylistic developments that persisted into the twentieth century.[1] The visual rhythms and small scale of Dove's later works continued to develop the harmony between sound and art, or synesthesia, as defined by Kandinsky in his influential treatise *Concerning the Spiritual in Art* of 1912.[2]

Illness at least partially induced the last major stylistic evolution of Dove's career. In 1938 he suffered a precipitous decline in his health, aggravated by pneumonia and a heart attack, that sapped the stamina and strength needed for larger artistic undertakings. In response to the first exhibition of the resulting, more intimate watercolors in May 1938, however, critic Martha Davidson saw no weakening of the artist's skills and instead hailed the works as "each a jewel of perfection."[3] Her estimate has endured—art historians and critics alike have discerned Dove's desire to achieve "serenity through simplification" in the series.[4] Encroaching illness was undoubtedly a factor in his diminished scale, as watercolor and drawing were often the only media that he could comfortably practice.[5] Out of whatever combination of practical and aesthetic considerations, Dove's relationship to watercolor was transformed. Instead of treating watercolor as a preparatory medium for oil painting, he made it a primary mode of expression, far more complete in conception than before. The watercolors, of which *Boat Houses* is a good example, offered an opportunity to achieve what Dove wrote was "one of the important principles of modern art" as early as 1914: "elimination of the non-essential."[6]

Location may also have played a role in Dove's stylistic realignment in the late 1930s. In the spring of 1938 the artist and his wife moved from Geneva, New York, to Centerport on Long Island, where they occupied a one-room house on a pond adjoining the Long Island Sound.[7] The waterfront was well suited to Dove's later style, facilitating his shift from biomorphic naturalism toward more emblematic geometric structures. From his vantage across the pond to the Methodist Episcopal Church and nearby buildings, the artist could easily distill the far shore with its retaining wall and the sky above into flattened bands of color, subordinating spatial recession to overall form.[8] *Boat Houses* is a work of counterpoint in which Dove's seemingly disparate naturalistic and geometric modes coexist, albeit uneasily. He echoed formal elements in the scene, counterbalancing the organic shape of the tree at the left with the shed roof of the boathouse at the right, and the lateral movement of the undulating treetops at the upper right with the elongated house at the lower center. Despite the small scale of *Boat Houses*, Dove pursued a remarkably ambitious parallelism between natural and man-made forms. Those parallels further adopt typological significance as the cross atop the church steeple at the composition's left repeats the cruciform electrical pole at its center.

Although Dove's spiritualism pervades his depictions of nature, his invocations of overt religious iconography are scarce. Despite the paucity of direct representation, Sherrye Cohn has insisted that Dove's art "was a deliberate, highly conscious effort to give form to the spiritual feelings he had toward life."[9] The artist's occasional depictions of churches and crosses, employed as generic emblems of spirituality rather than sectarian symbols, bear out Cohn's thesis. Perhaps the most resonant with *Boat Houses* is *A Cross in the Tree* (1935, Collection of Mr. and Mrs. Anthony Fisher, New York, 1984, Morgan. no. 35.10), in which the artist mounted a cross to a radiating tree form similar to the one in *Boat Houses*, asserting the divine as nature's generative source.[10] When compared with the visual logic of *A Cross in the Tree*, *Boat Houses* may be interpreted similarly, with the foreground tree projecting outward from the church behind it like a synesthetic sermon or hymn. Although one of only a few of Dove's works to contain overt religious imagery, *Boat Houses* articulates the degree to which nature and spirituality converge in his art.

MDM

56, 57 Grant Wood, 1892–1942

Fruit, 1938 | *Vegetables,* 1938

FRUIT

Watercolor over graphite on illustration board, 29.8 × 37.8 cm (11¾ × 14⅞ in.)

Signed, in graphite, lower right: GRANT WOOD

Gift of Robert S. Engelman, Class of 1934; D.960.90.2

© Estate of Grant Wood / Licensed by VAGA, New York, NY

PROVENANCE
The artist; to Reeves Lewenthal, Associated American Artists, New York; sold to Robert S. Engelman, Highland Park, Illinois; given to present collection, 1960.

RELATED WORK
This is a preliminary drawing for Grant Wood's 1938 hand-colored lithograph *Fruits* (Hood Museum of Art, PR.984.35.1).

EXHIBITIONS
Art Institute of Chicago, *Memorial Exhibition of Paintings by Grant Wood* in *The Fifty-third Annual Exhibition of American Paintings and Sculpture,* 1942, no. 31 (as 1940); Cedar Rapids Museum of Art, Cedar Rapids, Iowa, *One Hundredth Birthday Anniversary Exhibition,* 1991 (no cat.).

VEGETABLES

Watercolor over graphite on illustration board, 29.2 × 37.1 cm (11½ × 14⅝ in.)

Signed, in graphite, lower left: GRANT / WOOD

Gift of Robert S. Engelman, Class of 1934; D.960.90.1

© Estate of Grant Wood / Licensed by VAGA, New York, NY

PROVENANCE
The artist; to Reeves Lewenthal, Associated American Artists, New York; sold to Robert S. Engelman, Highland Park, Ill.; given to present collection, 1960.

RELATED WORK
This is a preliminary drawing for Grant Wood's 1938 hand-colored lithograph *Vegetables* (Hood Museum of Art, PR.984.35.2).

EXHIBITIONS
Art Institute of Chicago, *Memorial Exhibition of Paintings by Grant Wood* in *The Fifty-third Annual Exhibition of American Paintings and Sculpture,* 1942, no. 32 (as 1940); Dartmouth College Collections, Hanover, N.H., *Works on Paper: Nineteenth and Twentieth Century Drawings and Watercolors from the Dartmouth College Collection,* 1975, no. 40; Rivier College Art Gallery, Nashua, N.H., *Art of the 1930's,* 1983 (no cat.); Cedar Rapids Museum of Art, Cedar Rapids, Iowa, *One Hundredth Birthday Anniversary Exhibition,* 1991 (no cat.).

REFERENCE
John R. Hokans, "Vegetables," in Franklin W. Robinson (ed.), *Works on Paper: Nineteenth and Twentieth Century Drawings and Watercolors from the Dartmouth College Collection* (Hanover, N.H.: Dartmouth College Collections, 1975), 56–57.

Extolling the bounties of the American heartland, these studies for Grant Wood's mass-marketed lithographs embody both the comforting imagery and the pristine, highly legible aesthetic that appealed to a national audience during the Great Depression. Partly on the basis of his iconic canvas *American Gothic* (1930, Art Institute of Chicago), Grant Wood enjoyed extraordinary public favor during the 1930s, as did his midwestern regionalist cohorts Thomas Hart Benton and John Steuart Curry. Wood applied to his agrarian subjects a painstakingly precise, decorative style that drew from sources as diverse as fifteenth-century Netherlandish painting, the Arts and Crafts movement, the streamlined machine aesthetic, and contemporary German art, which he encountered during a 1928 trip to Munich.[1] Just as Wood's professed nationalist sentiments tended to mask his reliance on European artistic influences, his commonplace, folksy subjects often obscured their highly calculated conception and treatment.

These drawings originated from Wood's intensive efforts in lithography in the late 1930s under the encouragement of Reeves Lewenthal and Maurice Liederman, founders of Associated American Artists (AAA) in New York. As part of AAA's innovative entrepreneurial effort, Lewenthal and Liederman paid American Scene artists to create lithographs that would be marketed via department store and mail order sales for $5 apiece. Like many of his depression-era colleagues, Wood welcomed the income and endorsed the populist ideal of bringing art into the homes of average Americans.[2] He produced nineteen lithographs over four years, including a set of four— *Fruits, Vegetables, Wild Flowers,* and *Tame Flowers*—which his sister Nan Wood Graham and her husband tinted in watercolor.[3] Wood regarded this project as being allied in spirit and technique with the inexpensive hand-colored lithographs published by Currier and Ives in the nineteenth century.[4] In honor of his warm friendship with his agents at AAA, he eventually gave them the exquisitely detailed graphite and watercolor studies for the lithographs. He presented *Fruit* and *Vegetables* to Lewenthal and the floral subjects to Liederman.[5]

The set of drawings and the lithographs after them relate to Wood's 1932 commission to paint murals in the Hotel Montrose coffee shop in Cedar Rapids, Iowa. Titled *Fruits of Iowa,* the series featured a still life, *Basket of Fruit* (Coe College, Cedar Rapids, Iowa), that is nearly identical in composition to the later drawing and the litho-

graph entitled *Fruits,* a farm landscape, and individual, full-length oil portraits of an idealized farm household (figs. 85, 86).[6] In these portraits, Wood situates each of the upright, frontal figures on a pedestal of sod, which also supports accompanying vegetables, fruits, pigs, or poultry. Reflecting Wood's humorous touch, these footed and silhouetted figures with round, freshly scrubbed faces resemble paper dolls or board game figures, in contrast to the aggrandized farmers found in much regionalist imagery. Wood clearly conceived of them in gendered, male-female pairs: the woman and girl oversee kitchen foodstuffs and poultry, while the boy bears a knife and freshly cut wedge of watermelon, and the man holds at his groin an overflowing bushel of corn.[7]

Wood revisited similar themes and formal devices in the 1938 drawings and resulting lithographs, which AAA published in 1939. Wood silhouetted all four still lifes and situated them on shaped platforms of earth. Wanda Corn has pointed out the implied contrast between country and city conveyed by the lithographs *Wild Flowers* and *Tame Flowers.*[8] The drawings (and prints) for *Fruits* and *Vegetables,* by contrast, seem to recall the gendered pairings of the earlier series. Pieces of fruit, which have long signified femininity and fertility in art, are here perfectly formed and neatly contained in the rustic splint basket. By contrast, the more energized composition of vegetables seems rife with phallus-like forms that project outward from the center of the bowl or stretch diagonally along the ground. Wood's presentation of the humble, homegrown produce is far from casual. According to his general practice, the highly finished drawings would have followed a series of rougher sketches, including one on a squared-off sheet. At this stage he would draw diagonals through the squares to guide his placement of design elements so as to create intersecting angles that would animate his pristine compositions. Aside from their studied design, these finished drawings are no less remarkable for their extraordinary elaboration of textural detail, most evident in the finely crackled grain pattern of the wooden basket. Through these carefully crafted drawings Wood serves up images of plenty and of a clear societal and visual order— attributes that were especially welcome in the lean, uncertain years leading up to World War II.

BJM

Fig. 85. Grant Wood, *Farmer's Daughter*, 1932, oil on canvas, mounted on (Homasote) panel, 115.6 x 45.7 cm (45½ x 18 in.). Stewart Memorial Library, Coe College, Cedar Rapids, Iowa; gift of the Eugene C. Eppley Foundation, Omaha, Nebraska. Reproduced by permission

Fig. 86. Grant Wood, *Farmer's Son*, 1932, oil on canvas, mounted on (Homasote) panel, 116.2 x 48.9 cm (45¾ x 19¼ in.). Stewart Memorial Library, Coe College, Cedar Rapids, Iowa; gift of the Eugene C. Eppley Foundation, Omaha, Nebraska. Reproduced by permission

58 Bill Traylor, c. 1854–1949

House with Figures and Animals (House with Figures; House with Figures and Snake), 1939

Colored pencil and graphite on cardboard, 56.0 × 36.2 cm (22 × 14¼ in.)

Inscribed [by Charles Shannon, dictated by artist], in graphite, verso lower center: 7/39 / goose grabs little boys penis through fence / boy ties himself to the calf who dashes / through a hole in fence—little boy caught; inscribed on label, in felt-tip pen, verso upper right: D-23 HOUSE; inscribed [by another hand], verso upper left, in red pencil: [shaded circle] < 7

Purchased through the Florence and Lansing Porter Moore 1937 Fund; D.2003.53

PROVENANCE
The artist; given to Charles Shannon, c. 1939; sold to Margo and Joseph Wilkinson, 1981; by settlement to Margo Russell Wilkinson, 1982; sold to Luise Ross Gallery, New York, 1986; sold to present collection, 2003.

EXHIBITIONS
Arkansas Arts Center, Little Rock, and Mississippi Museum of Art, Jackson, *Bill Traylor (1854–1947)*, 1982, no. 17 (as *House with Figures*); African American Museum, Nassau County Division of Museum Services, Hempstead, N.Y., *Black Folk Artists: Minnie Evans and Bill Traylor*, 1989 (no cat. no.); Museum Overholland, Amsterdam, *Black USA*, 1990 (no cat. no.); Wichita Art Museum, Wichita, Kans., *Visionary Artists: Bill Traylor and Minnie Evans*, 1992, no. 8 (as *House with Figures*); Luise Ross Gallery, New York, *Bill Traylor: Paintings and Drawings*, 1992, no. 23 (as *House with Figures*); Fukui Fine Arts Museum, Fukui, Japan, and others, *Dream Singers, Story Tellers: An African-American Presence*, 1992, no. 21 (as *House with Figures*); Museum of American Folk Art, New York, *A Place for Us: Vernacular Architecture in American Folk Art*, 1996–97 (no cat.); Greg Kucera Gallery, Seattle, *Bill Traylor, A Vision Set Free*, 1997 (no cat.); Intuit: The Center for Intuitive and Outsider Art, Chicago, *Ongoing Outsider*

Bill Traylor was born into slavery, worked on a farm most of his life, and only began to draw at the age of eighty-five, when he was homeless in Montgomery, Alabama. He produced about twelve hundred drawings from 1939 to 1942. The obsessive drive with which he "all day, every day" filled sheets of scrap cardboard with bold, rhythmic imagery that was deeply resonant with personal and cultural associations is one of the great marvels of twentieth-century American art.[1]

Traylor grew up a slave on a plantation near Selma, Alabama, where he continued to labor well after emancipation. He probably left the plantation in the mid-1930s and then worked in a shoe factory in Montgomery. Forced to quit owing to rheumatism, he slept in the back room of a funeral parlor and began drawing on the city's streets in 1939. That year a young white artist, Charles Shannon (1914–1996), discovered Traylor. He gave him poster paints and colored pencils (Traylor initially used just pencil and a stick for a straightedge) and in 1940 organized his first of only two lifetime exhibitions.[2] Beginning in 1942 Traylor lived with family in Northern cities. He returned to Montgomery in 1946, having lost a leg to gangrene, and died three years later. Shannon continued to champion Traylor's work, which received widespread attention beginning in the early 1980s.[3]

Many scholars have scrutinized Traylor's imagery and his sketchy biography for clues that might explain his extraordinary artistic production. His carefully ruled buildings prompted Peter Morrin to conjecture that carpentry might have been part of his past, and that "the distribution of physical weight in loading a horse wagon . . . may have provided Traylor with a habit of mind that translated into the calculation of visual weights and balances."[4] Betty Kuyk has attempted to tease out his African roots. She provocatively conjectures that Traylor's intensive art-making was akin to a spiritual divination, in which he atoned for misdeeds in his past in preparation for his approaching death.[5] Others perceive Afro-Caribbean elements in Traylor's iconic animals, top-hatted men, and graphic designs in clothing.[6]

This work showcases Traylor's humorous storytelling abilities, mastery of design, and haunting vocabulary of stylized motifs. Character-

Fig. 87. Bill Traylor, *Exciting Event with Man and Snake*, c. 1939, graphite on cardboard, 55.9 x 35.6 cm (22 x 14 in.). Private collection. Reproduced from Ricco/Maresca Gallery, *Bill Traylor: Observing Life* (New York: Ricco/Maresca Gallery, 1997), 49

istically, he composed the drawing without spatial recession, in a tiered fashion reminiscent of ancient art of the Near East. He described the events portrayed in the top portion: "goose grabs little boy[']s penis through fence / boy ties himself to the calf who dashes / through a hole in fence—little boy caught." In the center, Traylor conflated the front and side elevations of a propped-up "double pen" house—a common vernacular building type of the South—and artfully distinguished its structural sections with different colors.[7] The house provides an anchor of reassuring order amid the curious surrounding scenes. The rattlesnake that undulates across the composition segregates the lower, enigmatic vignette from the primary narrative and marks a distinct shift in mood as we view a boy—what Kuyk would call a spirit figure—pointing to the crotch of a one-legged man. Traylor elsewhere used a serpent to divide a composition, as in *Exciting Event with Man and Snake*, 1939 (fig. 87), where a snake separates the vignette of a farmer plowing from a raucous chase scene that includes a boy prodding an old, cane-bearing woman. Are these boys merely irreverent, or do they prompt dark memories or foretell death?

Such recurring motifs in Traylor's repertoire as snakes, birds on roofs, and people chasing or probing each other are on one level humorous and on another mysteriously expressive. Their frequent appearances hint at the artist's relentless exploration of particular stories, observations, and perhaps spiritual metaphors. Although Traylor's specific African roots remain undocumented, his motifs and pictographic approach to design point to a deep familiarity with African visual, oral, and spiritual traditions. His stylized birds, for instance, recall the iron birds that crown Yoruba staffs honoring Orisha Oko, the deity of farming, and those associated with the cult of Osayin, god of herbalistic medicine.[8] Other African cultures might interpret birds as messengers to the spirit world or symbols of feminine power. Traylor's birds could represent any of these—or simply be mischievous farmyard chickens.

Although embedded in the African American culture of the South, Traylor's imagery is also elemental and timeless. Its pictographic language recalls such diverse expressions as prehistoric cave drawings and twentieth-century modernism. Perhaps Pamela Wye summed it up best: "Traylor's deceptively simple shapes hit us like a tattoo on the brain, like some primal single image that's always been there, that may get forgotten but never goes away."[9]

BJM

Exhibition, 2000 (no cat.); O'Kane Gallery, University of Houston–Downtown, *Bill Traylor,* 2001 (no cat. no.); Mennello Museum of American Folk Art, Orlando, Fla., *Bill Traylor: Drawings,* 2003 (no. cat.).

REFERENCES
Arkansas Arts Center, Little Rock, *Bill Traylor (1854–1947)* (Little Rock: Arkansas Arts Center; New York: Luise Ross Fine Art, 1982), n.p., back cover (illus.); Luise Ross Gallery, New York, *Bill Traylor: Exhibition History, Public Collections, Selected Bibliography* (New York: Luise Ross Gallery, 1991), 20 (illus.); Ricco-Maresca Gallery, New York, *Bill Traylor: His Art — His Life* (New York: Ricco-Maresca Gallery, 1991), 60 (color illus.); Jane Livingston, "Black Folk Art in Amerika," *Kunstforum International* (May–June 1991), 260 (illus.); Carla Maria Verdino-Sullwold, "A Matter-of-Fact Strangeness: Bill Traylor at the Ross Galleries," *Crisis* 99, no. 2 (February 1992), 9 (illus.); Fukui Fine Arts Museum, Fukui, Japan, *Dream Singers, Story Tellers: An African-American Presence* (Fukui, Japan: Fukui Fine Arts Museum, 1992), 105 (color illus.), 225, 230; O'Kane Gallery, University of Houston–Downtown, *Bill Traylor* (Houston: O'Kane Gallery, University of Houston–Downtown, 2001), n.p. (color illus.); Betty M. Kuyk, *African Voices in the African American Heritage* (Bloomington: Indiana University Press, 2003), pl. 15 (color illus.).

59 Jackson Pollock, American, 1912–1956

Untitled (*Number 37*), c. 1939–40

Pen and brown and black ink, graphite, and orange colored pencil on smooth coated paper, 35.6 × 27.9 cm (14 × 11 in.)

Purchased through a gift from Olivia H. and John O. Parker, Class of 1958, the Guernsey Center Moore 1904 Memorial Fund, and the Hood Museum of Art Acquisitions Fund; D.986.8

PROVENANCE
The artist; given to Joseph L. Henderson, New York, c. 1939–40; sold to Maxwell Galleries, San Francisco, 1969; probably sold to Hoover Gallery, San Francisco, 1977; consigned to Nielsen Gallery, Boston, 1985–86; sold to present collection, 1986.

EXHIBITIONS
Whitney Museum of American Art, New York, and others, *Jackson Pollock: Psychoanalytic Drawings*, 1970–72, no. 37; Städtische Kunsthalle, Düsseldorf, and others, *Surrealität-Bildrealität, 1924–1974*, 1974–75, no. 277 (one of eight drawings sharing that cat. no.); possibly Berry-Hill Galleries, New York, 1977; Hood Museum of Art, Dartmouth College, Hanover, N.H., *Twentieth-Century Works from the Dartmouth Collection*, 1988 (no cat.); Duke University Museum of Art, Durham, N.C., *Jackson Pollock's "Psychoanalytic" Drawings*, 1992, pl. 53; Hood Museum of Art, Dartmouth College, Hanover, N.H., *Representations of the Body in Space from the Renaissance to the Present: Selections from the Permanent Collection*, 1998 (no cat.); Hood Museum of Art, Dartmouth College, Hanover, N.H., *Visual Proof: The Experience of Mathematics in Art*, 1999, no. 9; Hood Museum of Art, Dartmouth College, Hanover, N.H., exhibited with the presentation of *Abstraction at Mid-Century: Major Works from the Whitney Museum of American Art*, 2001 (no cat.).

REFERENCES
Clyde Leo Wysuph, *Jackson Pollock: Psychoanalytic Drawings* (New York: Horizon Press, 1970), 69 (illus.), pl. 37; Städtische Kunsthalle, Düsseldorf, *Surrealität-Bildrealität, 1924–1974* (Düsseldorf: Städtische Kunsthalle, 1974), 128; Francis Valentine O'Connor and Eugene Victor Thaw (eds.), *Jackson Pollock: A Catalogue Raisonné of Paintings, Drawings, and Other Works* (New Haven: Yale University Press, 1978), 3:99 (illus.), no. 526; Ellen G. Landau, *Jackson Pollock* (New York: Harry N. Abrams, Inc., 1989), 53 (illus.), 272; Hilliard Goldfarb, "Recent Accessions at the Hood," *Dartmouth Alumni Magazine* 78, no. 7 (April 1986), 44–45 (illus.); Claude Cernuschi, *Jackson Pollock: "Psychoanalytic" Drawings* (Durham, N.C.: Duke University Press, 1992), 84, 100 (color illus.), 141, pl. 53; D. I. Wallace (ed.), *Visual Proof: The Experience of Mathematics in Art* (Hanover, N.H.: Trustees of Dartmouth College, 1999), 32 (color illus.), 33–35, 62.

Jackson Pollock's name is virtually synonymous with abstract expressionism. His skeins of enamel paint—poured, flung, and dripped across expansive canvases set down on the floor of his Long Island studio—are celebrated as quintessential manifestations of the creative act, unencumbered by subject matter or stylistic convention. Pollock's painted creations were not, however, merely aesthetic musings. The artist deliberately invested his mature works with psychological intensity, imbuing them with a vibrancy, force, and energy of deeply personal significance. To experience the tangled webs of paint in Pollock's work of the 1940s and 1950s is, at least in part, to reflect on the insoluble mysteries of the unconscious mind.

Pollock's interest in psychology, particularly psychoanalysis, emerged early in his career as he struggled with alcoholism and crippling emotional instability.[1] In 1938 alcoholism finally forced him to admit himself to a hospital for extended treatment and psychotherapy. During that period he began to draw as an outlet rather than merely as an aesthetic or social exercise. It was in the medium of drawing that Pollock first embarked on his explorations of the artistic unconscious, a fact that had a profound impact on the subsequent development of his signature painterly abstractions. Contemporary with his therapy of 1939–40, the artist made a group of sixty-nine drawings, known collectively as the "psychoanalytic drawings," of which the Hood's work is one.[2] Here the artist contemplates the symbols of violence and aggression, often repressed, that characterize the darker elements of the psyche.[3] Using only schematic forms, Pollock's barely representational aesthetic is intended to signify directness of expression, evocative at once of both children's artwork and non-Western cultural traditions, both of which were perceived to be more genuinely intuitive modes.

Despite the drawings' symbolic subject matter, however, art historians have become increasingly skeptical of the early opinion that the drawings actually document Pollock's analysis itself and represent the artist's innermost preoccupations.[4] In a recent study, art historian Michael Leja has offered a more balanced interpretation, asserting that psychoanalytic theories and symbols, like artistic influences, were under constant reassessment in Pollock's early work. Leja has argued that Pollock "was in no sense illustrating preformed [psychoanalytic] ideas, but rather forming, assimilating, and testing propositions in representa-

tion—whether mental or pictorial. Both beliefs and forms were highly synthetic—made up of bits of information collected and absorbed from all sorts of sources."[5] The Hood drawing lends currency to Leja's assertion. Pollock created the work in several successive media, gradually resolving and sharpening the contours of his emergent forms and ideas in pen and ink from the looser orange pencil and graphite underdrawing. Some of the forms never cohere, remaining instead loose, illegible pencil strokes. Where he did find logic, Pollock applied his pen and rendered the forms intelligible. That progression, sometimes abortive and sometimes excessive, as found in a vignette at the lower right of the composition, offers a kind of stylistic metaphor for artistic creation. Pollock's initial, unchaperoned doodles evolve into at least seven separate comprehensible vignettes in addition to the central figure, and even that tortured form is a metonym. We recognize diagonals as ribs, flaring contours as hips, and a rounded shape as a head. On reflection, none of these elements bears more than a passing resemblance to what it is intended to represent. Collectively, however, and in conjunction with the horseshoe on the figure's right foot, the form resolves itself as a sort of man-beast composite. The Hood drawing intimates rather than describes, offering a vision of the artist's evolving creative process at a pivotal moment in his career.

Pollock's artistic sources remain in evidence in this work, validating art historian Donald Kuspit's assertion that the psychoanalytic drawings "represented a struggle between the old and new in Pollock's sensibility."[6] More than most of the works in the group, the Hood drawing demonstrates Pollock's struggle with Pablo Picasso's contemporary authority. In 1939 the Spanish artist received a monumental retrospective at New York's Museum of Modern Art that included his epoch-making composition *Guernica* (1937, Museo Nacional Centro de Arte Reina Sofía, Madrid).[7] That image, portraying the horror and suffering of war in symbolic terms, revivified the historical genre for the twentieth century and apparently affected Pollock considerably. Art historian William Rubin has written that Pollock's early work was essentially Oedipal, "struggling against symbolic father figures, one of whose crucial embodiments is easily identified in the paintings of 1938–46 as Picasso."[8] Rubin continued, "Pollock's 'triumph' in his contest with Picasso's art was a matter of the individuality and the abstractness of the allover poured pictures, and his sense of having gone beyond Picasso certainly had

some role in triggering their quality of exhilaration and exaltation. When painter-critic Paul Brach asked him why he went into that style, Pollock replied, 'to get rid of Picasso.' He was only half joking."[9]

In the Hood drawing, Pollock prominently incorporated the simplified, expressive figuration typical of Picasso's later work, including *Crucifixion* (1930, Musée Picasso, Paris), a painting that was also included in the 1939 retrospective.[10] Pollock, however, reorganized and distilled Picasso's approach into a sort of evocative language of the unconscious. Easily discerned among the forms surrounding Pollock's central

skeletal figure are the contoured heads and figures that invoke Picasso's distinctive method of transforming the human body. Picasso reached the zenith of his American reputation in the very year that Pollock's alcoholism forced him into therapy, a coincidence that may have affected the younger man's perspective on Picasso's art.[11] The flayed figures, aggressive teeth, and violent torment that abound in Pollock's drawing suggest that anxiety accompanied his appropriation of Picasso's style.

The central skeletal figure in the drawing, meanwhile, shows a debt to Mexican muralist José Clemente Orozco as well. Throughout the

Fig. 88. José Clemente Orozco, *Gods of the Modern World (Panel 17)*, of *The Epic of American Civilization*, 1932–34, fresco, 304.8 x 302.3 cm (120 x 119 in.). Commissioned by the Trustees of Dartmouth College, Hanover, N.H. © 1934

group of psychoanalytic drawings, Pollock vacillated between Picasso's and Orozco's models. The skeletal figure in this drawing probably relates to Orozco's *Gods of the Modern World* from the mural cycle *The Epic of American Civilization* (fig. 88) located in Dartmouth's Baker Library. Pollock was undoubtedly aware of Orozco's landmark commission and may even have seen it in person.[12] As a critique of the American educational and capitalist system, its leaders presiding over the stillbirth of knowledge from a skeletal mother, Orozco's composition would have been a poignant source for Pollock as he emerged from his own studies and sought his artistic independence in the later 1930s. The skeleton motif offers a modernist's vision both of what Orozco called the "dead hand of the Academy" and of scholars' indifference to contemporary social injustice.[13] In this particular manifestation of Pollock's early experiments, the intersection of Orozco's message and Picasso's forms portrays the young artist's lingering debt to contemporary masters even as he began to look inward for the vitality and spontaneity that would become his trademarks.

MDM

60 Thomas Hart Benton, N.A., 1889–1975

"Routining" the Fish (Rowling the Fish; Rolling the Fish), 1943

Fig. 89. Thomas Hart Benton onboard the *Dorado*, 1943, published in Thomas Hart Benton and Georges Schreiber, *The Silent Service* (North Chicago, Ill.: Abbott Laboratories, 1944), n.p. Reproduced by permission of Abbott Laboratories

War had a profound impact on Thomas Hart Benton's artwork. Confronted by the harsh reality of World War I while still a young man, Benton felt thereafter that art held little meaning unless it was directly tied to national concerns through subject matter. Working for the navy as a draftsman and reporter, he abandoned his early pursuit of abstraction, recognizing its minimal utility for the war effort, and adopted the mannered realism with which he is generally identified. A regionalist for the balance of his career, Benton celebrated rural American life and history and became one of America's leading painters, particularly of murals, during the 1930s. By the mid-1940s, when he drew *"Routining" the Fish,* however, even the celebrations of American life that had become his stock-in-trade felt insufficient as wartime service. He nevertheless returned to document military life during World War II on commission from a private company, Abbott Laboratories, as a professional artist, though neither a soldier nor a young man at that point. For an artist who prided himself on his virility, war twice proved his deficiency.[1] Even in his documentary depictions of military life during World War II, we feel the undercurrents of Benton's estrangement, as he stood apart from the activities of the soldiers and sailors in the performance of their duties.

As part of a series documenting the Submarine, or "Silent," Service in early October 1943, Benton drew *"Routining" the Fish* while on board the newly commissioned USS *Dorado* during a shakedown excursion near New London, Connecticut (fig. 89).[2] The drawings, and later paintings based on them, focus attention on the sailors' daily lives and duties, accentuating the informal discipline that prevailed onboard. Despite his documentary mission, Benton exercised a considerable degree of artistic license in the work, incorporating a series of actions into a single visual moment. Probably a depiction of the *Dorado*'s forward torpedo room, the drawing shows four men performing routine maintenance on a torpedo (or "fish") partially loaded into a launch tube at the right of the composition, while another man sleeps on a bunk overhead. Benton's composition is unusual for its contrasts between activity and rest, pushing and pulling, instead of a unified action. In contrast to the actual submarine's cramped quarters, the *Dorado*'s torpedo

room appears cavernous in the drawing, with the vantage point located virtually outside the submarine's hull. Although Benton's vision for the subject was clearly greater than realism would permit, he would not have had an opportunity to return and make corrections. Just days after Benton and his colleague, Georges Schreiber, returned to shore, the *Dorado* was lost at sea with all hands on the way to the Panama Canal.[3]

Benton's relationship with his media was an ongoing negotiation. When asked during a 1943 interview whether he would describe his approach to art as objective, Benton characterized all art as "a performance with materials which exist outside of the mind of the artist—an objective performance. These materials are dynamic. They have a way of directing performance themselves . . . you may start with the intention to express an internal image but end with something determined, in the main, by the materials and procedures used."[4] In his drawings, Benton arguably came closest to exerting conscious control over his medium, particularly in his post-1940 works, in which Matthew Baigell has observed that "profiles and shapes began to grow increasingly taut and sharp. The action of the figures appeared frozen, immobilized by their carefully defined edges."[5] That increased angularity and edge of Benton's drawings is well represented in *"Routining" the Fish,* as his crisp pen lines lend a far greater sense of order than in his earlier, more sensuous and curvaceous works.

Drawing simultaneously functioned for Benton as a mode of resistance to the competing modernist aesthetics that he reviled. As Karal Ann Marling has written, "Benton's emphasis upon the primacy of drawing set him apart from the New York modernists with whom he had associated during the teens and twenties. . . . Benton had insisted [in 1916] on 'the importance of drawing, of line, . . . because of its . . . control of the idea of form, and I believe that no loveliness of color can compensate for deficiency in this respect.'"[6] Throughout his mature career, drawings like *"Routining" the Fish* offered a reassuring, if limited, sense of conscious control that diametrically opposed the explorations of the unconscious favored by younger artists.

MDM

"Routing" the fish

61 Edwin Dickinson, N.A., 1891–1978

The Bee: Lothrup Weld's House, 1943

Graphite on smooth wove paper, 24.9 × 29.1 cm (9¹³⁄₁₆ × 11½ in.)

Inscribed, lower left: The Bee / Lothrup Weld's House / Built 1740 E W. Dickinson / Wellfleet 1943 / on the introduction of the stove, / the original chimneys & fireplaces were taken out in order to make closets.

Purchased through the Claire and Richard P. Morse 1953 Fund and the William S. Rubin Fund; D.991.15

PROVENANCE
The artist; to Ansley and Esther Hoyt Sawyer, Buffalo, N. Y.; given to Mr. and Mrs. A. Douglas Dodge, 1944; consigned to Babcock Galleries, New York, 1991; sold to present collection, 1991.

Many writers have noted Edwin Dickinson's somewhat isolated position in the art world of his day. He seemed to be caught between—or perhaps to transcend—the cultural and stylistic divide separating the nineteenth and twentieth centuries. He owed a powerful debt to the more traditional aesthetics of a previous generation, while he at the same time responded, albeit indirectly, to modernist trends. His singular manner is borne out in a group of fractured, dreamlike canvases he labored on for years, which convey both an academic approach to the figure and an awareness of cubism and surrealism. His divergent leanings also reveal themselves through his more plentiful, quickly worked paintings, usually landscapes that were often created on-site. Although he exhibited several such canvases with the abstract expressionists in the early 1950s, these atmospheric, distilled compositions remained apart for their essential grounding in direct observation and emphasis on structure. In fact, a firm and exacting armature underlies all of his work, including his most ethereal drawings.

Dickinson's fascination with form only partially explains the artist's long-standing affinity for depicting building exteriors, particularly domestic dwellings. He made a few elegant drawings of skyscrapers in the summer of 1944, but even with their evocative shading and stumping, these lack the resonance of his lyrical—even mysterious—images of older homes shown at odd angles. Although at first glance these depictions seem entirely realistic, on closer inspection one sees that Dickinson has rendered the windows blank and often either omitted the doorways or obscured them in shadow, giving the sense of a resolutely inaccessible structure. As Donald Kuspit observed, "Buildings were personages to him; they have character and hold their own against the elements, which weathers them but doesn't wreck them. Dickinson projected his own determination and solitude, his fierce inwardness, into them."[1]

Like the fossils he collected beginning as a child in upstate New York, Dickinson's houses often preserve a haunting impression of the past.[2] He found similar resonance in the remains of edifices. On January 1, 1943, the same year that Dickinson drew this image, he embarked on his ambitious canvas *Ruin at Daphne* (1943–53, The Metropolitan Museum of Art). This work begins with a Roman ruin in Syria but fancifully conflates the original structure, built in 40 C.E., with later additions and images of the ancient site from the artist's imagination. As painter Elaine de Kooning noted in her 1949 article on the painting, which was then in its sixth year of production, "it has its own history of invention, destruction and rebuilding."[3]

By contrast, Dickinson executed this intimate drawing of an old cape—another historic relic of sorts—in just two sessions, separated by approximately a month. According to the artist's journal, he began drawing the house of a friend, Lothrup Weld, in Wellfleet, Massachusetts, on August 25, but was interrupted when he received a severe wasp sting close to his eye.[4] Dickinson's prominent inscription on the face of the drawing documents what he believed to be misguided modifications to the historic structure, known to him as the Bee. He noted: "on the introduction of the stove, / the original chimneys & fireplaces were taken out in order to make closets." The artist thereby pointed out the alterations that to his mind formed a tragic yet integral aspect of this building's history and identity.[5]

Any further events or memories associated with this house can only be hinted at by Dickinson's characteristic drawing technique, which is as suggestive as it is precise. The soft, selective shading gives the work a silvery, evanescent quality that belies its understated structure. Beneath the flickering effects of light and shadow emerge fine lines drawn with a rule that define the clapboards, the windowpanes, and the building's primary outlines. Seen from an oblique angle, the house—which appears to be two early capes butted together—sweeps diagonally into the distance. Yet its recessional course is not without irregularities. Partly owing to the building's age, the two sections of the house cant in slightly different directions, forming the "mobile, dissolving planes" that de Kooning observed in Dickinson's work.[6] Here, the subtly altered repetition of the twin facades gives the sense of adjacent frames in a film, of change over time, and of the juts in the history of a house, or a life.[7] In a manner that echoes the artist's own synthesis of past and current traditions, the drawing alludes to both a resonant history and the vital immediacy of the present.

BJM

62 Paul Starrett Sample, N.A., 1896–1974

Will Bond, c. 1948

Graphite on wove paper, 30.5 × 45.7 cm (12 × 18 in.)

Inscribed, in pen and ink, lower center: Will Bond

Gift of the artist, Class of 1920, to Dartmouth College Library; transferred 1983; D.983.34.7

PROVENANCE
The artist; given to Dartmouth College Library; transferred to present collection, 1983.

EXHIBITION
Hood Museum of Art, Dartmouth College, Hanover, N.H., *Paul Sample: Painter of the American Scene,* 1988 (no cat. no.).

REFERENCE
Robert L. McGrath and Paula F. Glick, *Paul Sample: Painter of the American Scene* (Hanover, N.H.: Hood Museum of Art, Dartmouth College, 1988), 81 (illus.).

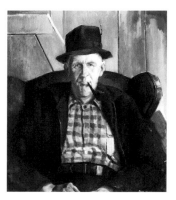

Fig. 90. Paul Sample, *Will Bond,* 1940, oil on canvas, 76.2 x 63.5 cm (30 x 25 in.). Hood Museum of Art, Dartmouth College; gift of the artist, Class of 1920, in memory of his brother, Donald M. Sample, Class of 1921; P.934.126.2

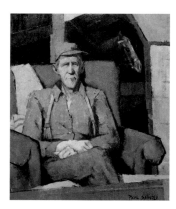

Fig. 91. Paul Sample, *Will Bond,* 1945, oil on canvas, 76.2 x 63.5 cm (30 x 25 in.). Private collection

Perhaps New England's best-known regionalist painter, Paul Sample did not himself know the region until he enrolled at Dartmouth College in 1916. More than a decade later, after establishing himself as an artist in California, he started painting New England imagery when he and his wife began to make summer visits to her family in Vermont.[1] He moved to the region permanently when he became Dartmouth's artist-in-residence in 1938, a position he held until 1962. Sample undertook his first artistic instruction from painter Jonas Lie while recuperating from tuberculosis in upstate New York. Determined to be "a painter and a damned good one," Sample achieved rapid success in his chosen field, first honing his skills as a draftsman.[2] He studied at the Otis Institute in Los Angeles in 1925 and just one year later began teaching drawing at the University of Southern California. By the mid-1930s he was chairman of the art department and exhibiting his paintings nationally. During Sample's early career, he explored a remarkable variety of styles and subjects, from social realist and precisionist urban imagery to regionalist interpretations of rural themes, especially those set in New England.[3]

For his celebratory images of New England's landscape and traditions, Sample sought out subjects that readily met popular expectations regarding the region's pastoral beauty and its mix of rugged individualism and community spirit. His compositions featured panoramic vistas of quaint villages and farms nestled into surrounding hills, as well as small-town gatherings, such as country auctions and church suppers. From the mid-1930s through the early 1940s, Sample presented his New England imagery in the rounded, stylized manner associated with Grant Wood (cats. 56, 57), who, along with Thomas Hart Benton (cat. 60) and John Steuart Curry, had launched the nationally popular regionalist style through a nostalgic embrace of preindustrial midwestern subjects. Sample, too, featured reminders of a passing agrarian epoch in his New England compositions, especially aged farmers, whose very presence signified a bygone era and whose customs and dress best exemplified the region's "Yankee" characterization.

Beginning about 1940, Sample conveyed his affection for his elderly Norwich, Vermont, neighbor, Will Bond, through numerous portrayals, including this pencil sketch, two charcoal studies, a watercolor, at least two oil portraits, and a multi-figure genre painting.[4] Most of these images depict Bond in work clothes, posed frontally with gaunt features, clenched lips, and a direct gaze.

Sample thereby accentuated the stereotypical reticence and underlying force of character associated with the native New Englander in a manner that recalls Grant Wood's almost comically severe portrayal of a midwestern farmer in his famous 1930 canvas, *American Gothic.* Sample's images of Bond, however, are more individualized and imbued with a deep underlying fondness and respect for the artist's friend, who boarded his beloved horses and from whom he purchased the land for his home.

Although this likeness in many respects resembles Sample's 1940 oil portrait of Bond (fig. 90) and stylistically recalls his elaborately annotated sketches done about 1944 as an artist–war correspondent for *Life,* the subject's pose and costume relate more closely to his 1948 portrayals of Bond in oil (fig. 91) and charcoal (private collection).[5] This graphite sketch may have served as an initial study for the oil, but whereas in the drawing Sample clearly relished portraying the details of Bond's rustic horse-barn setting, in the oil and charcoal portraits he eliminated most of the background, choosing instead to dignify his sitter through the closely cropped, vertical format associated with conventional portraiture.[6] Sample's more erect, stylized portrayal of Bond in the oil portrait, which he repainted in 1951, gives the sitter greater prominence but lacks the rich textural quality and wonderful sense of ease—on the part of both artist and sitter—conveyed in the confidently drawn pencil sketch. Will Bond's hands rest naturally in his lap in this drawing, and his frail body sinks comfortably into an upholstered armchair that seems surprisingly at home in its incongruous barn setting.

Sample shunned pure abstraction throughout his career, but the abbreviated, planar description of Bond's features in the drawing and the angular outlines in the painting reveal his developing interest in dynamic, interlocking forms. These subtle stylistic shifts demonstrate Sample's early efforts to integrate more schematic approaches to form with his beloved New England subjects. For Sample and many Americans then and now, New England's landscape and its Yankee heritage—in the figure of people like Will Bond—have represented a link to a mythic, seemingly stable agrarian past that has perhaps become all the more comforting with the passage of time.

BJM

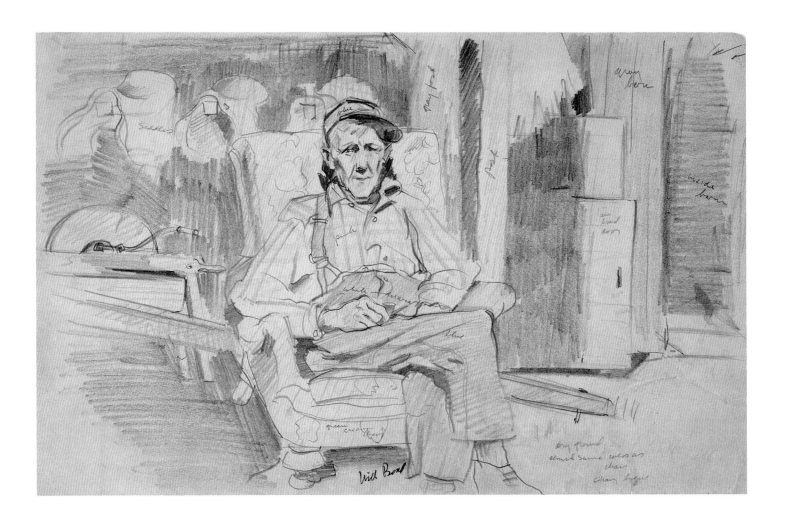

63 Paul Starrett Sample, N.A., 1896–1974

Approach to White River, 1946

Transparent and opaque watercolor over graphite on heavy wove paper, 39.0 × 57.4 cm (15¼ × 22⅝ in.)

Signed, in watercolor, lower left: Paul Sample

Gift of the artist, Class of 1920, in memory of his friend Albert Inskip Dickerson, Class of 1930 and Dean of Freshmen, 1956–1972; W.972.222

PROVENANCE
The artist; given to present collection, 1972.

EXHIBITIONS
Associated American Artists Galleries, New York, *Paul Sample*, 1949 (no cat.); American Art Association, Chicago, 1949 (no cat.); Publick House, Sturbridge, Mass., *Paul Sample*, 1950, no. 9; J. B. Speed Art Gallery, Louisville, Ky., *Recent Paintings by Paul Sample, Native of Kentucky*, 1951, no. 28; Robert Hull Fleming Museum, University of Vermont, Burlington, 1954 (no cat.?); Hopkins Center Art Galleries, Dartmouth College, Hanover, N.H., 1974 (no cat.); Montshire Museum of Science, Hanover, N.H., *North Country Landscapes: Exhibit of Watercolors, Oils, Lithographs, and Sketches by Paul Sample*, 1976, no. 4.

REFERENCES
C. J. Bulliet, "Sample Show Portrays Christmasy New England," *Chicago Daily News*, December 2, 1949, 27; Peter M. Gish, "An Artist's Appreciation of Paul Sample," *Dartmouth College Library Bulletin*, n.s., 9, no. 2 (April 1969), 77, pl. 4.

In this work Paul Sample, a well-known painter of the New England scene (see cat. 62), demonstrates his less widely appreciated facility in watercolor and his ability to convey a strength of feeling through the most ordinary subject. He achieves this effect by means of thoughtful composition, suggestive atmospheric effects, and the depiction of themes of personal yet universal significance. Sample claimed to subscribe to no particular artistic theory but readily admitted to a deep admiration for artists as recent as John Marin (cat. 64) and as historic as Pieter Brueghel the Elder. His approach more obviously reflected the American Scene and regionalist movements that flourished in the 1930s and 1940s.[1] In a 1938 article on Sample, Alfred Frankenstein grouped him with such figures as Edward Hopper, Thomas Hart Benton, and Reginald Marsh, who held "a complex attitude toward the subject, an attitude compounded of romantic emotion and realistic delineation, of a desire to expose the plain, unvarnished facts of American life plus a strong, even sentimental love for the facts that finally emerge. . . . The American scene thus depicted is basically the human scene."[2]

Sample's obvious sympathy for the human condition and desire to create accessible imagery found a potent model in Brueghel, whose work inspired other regionalist artists as well, including Grant Wood (cats. 56, 57).[3] Sample responded not only to the Flemish master's kindly portrayal of peasant life but to his rhythmic compositions and reductive style featuring rounded, pneumatic figures. By the time Sample painted this watercolor, he had moved away from Brueghel's characteristic figuration. Nonetheless, *Approach to White River* clearly pays homage to the earlier artist's famous painting *Hunters in the Snow*, 1565 (Kunsthistorisches Museum, Vienna). As in the Flemish composition, Sample's two hunters return homeward near the end of the day under gray skies, their figures starkly silhouetted against white snow as they enter the composition from one side. An avid hunter himself, Sample frequently touched on this age-old theme, beginning with his especially Brueghelian canvas of 1938, also set in winter, *Lamentations V:18 (Fox Hunt)* (Addison Gallery of American Art).[4]

As it had for artists from Brueghel to Andrew Wyeth (cat. 67), winter provided an important backdrop for Sample's compositions. A blanket of snow adds a lyrical quality to his New England scenes and accentuates their underlying structure. Notably, Sample rarely sought out the region's brilliant, blue-sky winter days, gravitating

instead toward overcast weather that dictated subdued tones reminiscent of Brueghel's restricted palette. Winter in Sample's era, however, had lost some of its potency as an explicit metaphor for death. Nonetheless, when combined here with the theme of hunting, winter contributes to the sense of an enduring, elemental relationship between mankind and nature.

Sample perhaps most successfully evoked the atmospheric and metaphorical moods of winter through the medium of watercolor. Here, the soft, wet-on-wet bleeding of pigments simulates the damp, thawing conditions of late winter and suggests an enveloping, hazy atmosphere that unifies the built and natural environments. The work's fluidity, diffuse lighting, and somber tones contrast with Sample's more sharp-edged, sun-filled watercolor style, which he had developed in the early 1930s, when he lived in southern California and participated in an influential circle of watercolorists that included Phil Dyke, Millard Sheets, and Barse Miller.[5] At that time, he portrayed light-struck vernacular architecture and railroad subjects in a manner similar to Hopper (see fig. 35 and *Santa Fe Station*, p. 244). In some regards, *Approach to White River* forms a transition between Sample's early and later watercolor styles. It combines his initial preoccupation with industrial forms and relatively tight handling of buildings with a freer, more expressive description of landscape that would increase in his later works, perhaps reflecting a growing admiration for John Marin's dynamic watercolors.

Ultimately, it is the balanced integration of nature and industry that distinguishes Sample's variation on Brueghel's theme. Here the hunters return, not to a pastoral Flemish hamlet, but to White River Junction, Vermont, an important crossroads for rail and road traffic situated at the confluence of the White and Connecticut Rivers. The clustered buildings nestle comfortably between the hillside and the river, their gray and reddish brown tones echoing the earthy palette of their grayed-out surroundings. As he had in some of his early precisionist paintings, Sample assumes an uncharacteristically low vantage point, thereby aggrandizing the iron bridge that serves as both the physical and visual link between city and country. By mediating in this image both mankind and nature, modern production and the ancient hunt, mood and fact, Sample revitalizes Brueghel's winter idyll for a twentieth-century audience.

BJM

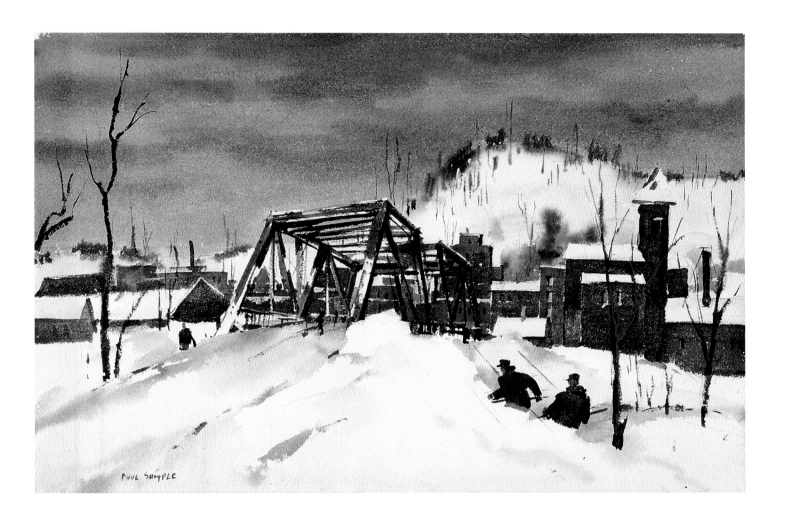

64 John Marin, 1870–1953

Sea Piece in Red (Sea Piece, 3), 1951

Opaque and transparent watercolor over graphite with touches of red crayon on heavy wove paper, 38.8 × 53.4 cm (15¼ × 21 in.)

Signed, in watercolor, lower right: Marin 51

Partial and promised gift of L. Graeme Bell III, Class of 1966; W.2000.51

PROVENANCE
The artist; sold to Edith Gregor Halpert, Downtown Gallery, New York, May 1952; by descent to Nathaly Baum (her sister), Washington, D.C.; by descent to Romano R. and Patricia Baum Vanderbes (her daughter), New York; sold to L. Graeme Bell III, Washington, D.C., 1992; partially given to present collection, 2000.

EXHIBITIONS
Downtown Gallery, New York, *John Marin Exhibition, Oils and Watercolors, 1951*, 1952, probably no. watercolors 3; possibly in Pennsylvania State University, College Park, *John Marin Retrospective*, 1956 (no cat.); Corcoran Gallery of Art, Washington, D.C., and Currier Gallery of Art, Manchester, N.H., *John Marin in Retrospect: An Exhibition of His Oils and Watercolors*, 1962, no. 89; Corcoran Gallery of Art, Washington, D.C., *The Edith Gregor Halpert Collection*, 1962 (no cat. no.).

REFERENCES
Henry McBride, "John Marin 1951," *Art News* 50, no. 9 (January 2, 1952), 47 (illus., as *Sea Piece, 3*); Charles E. Buckley, *John Marin in Retrospect: An Exhibition of His Oils and Watercolors* (Washington, D.C.: Corcoran Gallery of Art; Manchester, N.H.: Currier Gallery of Art, 1962), 35 (illus.), 37; Corcoran Gallery of Art, Washington, D.C., *The Edith Gregor Halpert Collection* (Washington, D.C.: Corcoran Gallery of Art, 1962), n.p.; Sheldon Reich, *John Marin: A Stylistic Analysis and Catalogue Raisonné* (Tucson: University of Arizona Press, 1970), 2:799 (illus.), no. 51.48.

As a leading exponent of American modernism for four decades, John Marin necessarily transcended any single stylistic movement with his art.[1] In 1910, on returning to New York after several years of European training, Marin established a perpetually waxing reputation as both a painter and a printmaker. In his mature work, he fused elements of several European movements, including the forceful and colorful dynamics of futurism and Orphism, to great effect, and he continued to experiment stylistically throughout his career. By 1951, when he painted *Sea Piece in Red*, Marin had attained the pinnacle of American artistic fame: his work was on permanent display at Edith Halpert's renowned Downtown Gallery in New York, and he had been voted the greatest living American artist by a poll of museum directors and critics.[2] These distinctions did not, however, ease his isolation of later life, as family members and friends of his generation passed away, including his wife, Marie, in 1945 and dealer Alfred Stieglitz in 1946.[3] Despite his own deteriorating health, Marin remained prolific and innovative in his art to the very end of his life. In the context of his late career, *Sea Piece in Red* is an articulate summation of the artist's evolving approach to art and relationship to nature.

In old age, Marin relished the role of the Ancient Mariner, a persona directly engaged in his late seascapes.[4] Undoubtedly amused by the pun on his name, the artist was well read and would have recognized the term's origin in Samuel Taylor Coleridge's celebrated "Rime."[5] The subject of *Sea Piece in Red,* its boat perilously wedged between the writhing water and unforgiving cliffs, may be interpreted as a parable of mortality akin to Coleridge's. In the painting, the red of the work's title evokes blood in the water, lightning against the backdrop of the mountains, and fire onboard the ship. Like his literary alter ego, Marin increasingly enjoyed sharing his accumulated wisdom in words as well as art, often encouraging personal interviews and publications of his correspondence.[6] Rife with poetic aphorisms and enigmatic turns of phrase, Marin's writing demonstrates his mastery of the role of wise, often cryptic, sage.[7] *Sea Piece in Red* resonates with both the voice of experience and the confidence of expression that characterize Marin's writing, visually paralleling his self-identification with Coleridge's protagonist.

Music and motion are defining characteristics of Marin's art. A description of his creative process in 1946 by his biographer, MacKinley Helm, offers a revealing analogy: "With his right hand he roughed in, with black crayon, the three elements of the picture—sky, headland, and bay; and laid on the color with furious strokes of a half-inch brush in his left hand. His hands fought each other over the paper as they had done while he played [Bach's] *Two-Part Invention* [on the piano]."[8] As Helm's passage suggests, line and tone are autonomous in much of Marin's later art, including *Sea Piece in Red*. Helm's reference to the pianist's hands suggests an almost classical relationship between melody/line and harmony/tone in Marin's work. Moreover, as is often the case, the painting's title invokes a musical composition and key signature. The artist's musical muses were not, however, the same contemporary composers who inspired many of his artistic peers. Instead, they were major figures of the baroque, including Johann Sebastian Bach, Henry Purcell, and Orlando Gibbons, whom Marin cited for their music's "real action."[9] The staccato lines of *Sea Piece* beautifully reflect Marin's interest in that period and convey his transition to what Sheldon Reich has called the "brittle rhythms" of his late work.[10] Liberated from the simple description of form, Marin's emphatic line signaled his conversion to a more internal vision, here utilizing a storm as a means for expressionistic projection within his customary grammar of essentialized natural forces.[11]

In the context of American art, Marin's late seascapes, including *Sea Piece in Red,* simultaneously demonstrate an acute consciousness of his artistic forebears and a sensitivity to contemporary artistic directions. Thematically, the paintings place Marin in a veritable tradition of aging American masters in contemplation of the sea, and they invoke the late, brooding works of Winslow Homer and Marsden Hartley by turns.[12] Stylistically, however, his calligraphic approach borders on abstraction and often resembles Jackson Pollock's pourings and David Smith's hieroglyphs. Though scholars often disagree on whether Marin remained in the avant-garde by the 1940s and 1950s, the psychological aspect of paintings such as this one clearly demonstrates an affinity with contemporary abstract expressionist exploration of the artistic unconscious.[13]

MDM

65 Ralston Crawford, 1906–1978

Box Car & New Orleans, 1951

Pen and ink on wove paper, 28.1 × 39.1 cm (11¹/₁₆ × 15⁵/₁₆ in.)

Signed, center: Ralston Crawford; inscribed, lower left: 1–4,5–51 A. [encircled]; lower right: 1–5–51; above center: 1–5–51

Purchased through the Claire and Richard P. Morse 1953 Fund and the Guernsey Center Moore 1904 Memorial Fund; D.996.33

By permission of the Ralston Crawford Estate, courtesy Salander O'Reilly Galleries

PROVENANCE
Estate of the artist; consigned to Hirschl and Adler Galleries, New York, 1996; sold to present collection, 1996.

RELATED WORKS
Several related photographs, including *Untitled (New Orleans Still Life)*, c. 1951, silver gelatin print (Estate of Ralston Crawford, New York); *Cemetery Scene, New Orleans*, n.d. (Estate of Ralston Crawford, New York, 1983); and *Box Cars, Minneapolis*, n.d. (fig. 92, Estate of Ralston Crawford, New York); also a drawing, *Box Car*, c. 1949, pen and ink on paper (Estate of Ralston Crawford, New York); and several paintings from the *New Orleans Still Life* series, including *New Orleans Still Life*, 1951, oil on canvas (Estate of Ralston Crawford, New York), and later *New Orleans No. 8*, 1957, oil on canvas (Estate of Ralston Crawford, New York).

EXHIBITION
Hirschl and Adler Galleries, New York, *Ralston Crawford's America*, 1996, no. 41.

The painter and photographer Ralston Crawford often abstracted his subject matter to the degree that it becomes unrecognizable, but without fail he painted scenes that he had actually seen. He concentrated on favorite subjects—ships, bridges, construction sites, dams, and torn wall signs—with an intensity that appears contrary to his disinterest in the particulars of descriptive detail. He distilled various drawn and photographic views of these subjects into crystallized compositions of light and dark created in planes of flat color.[1]

When Crawford died of cancer in 1978 at the age of seventy-one, he chose to be buried in St. Louis Cemetery in New Orleans, a site that to this day draws as many tourists as mourners. Established in 1789, it is the oldest cemetery in the city; because of high groundwater levels, the dead are buried in distinctive walled or raised vaults. Accompanying his funeral cortege was a traditional New Orleans jazz brass band. Although Crawford was based in New York City for the greater part of his life, he was particularly intimate with the jazz scene in New Orleans and had repeatedly photographed the city's musicians, marching bands, shop fronts, street life, and cemeteries during his extended visits (the first of which was in 1949–50) over a twenty-eight-year period. St. Louis Cemetery, in addition to becoming the artist's final resting place, was also the subject of a number of his paintings, drawings, and photographs. This dilapidated burial ground with its raised brick and plaster sepulchers inspired a total of thirteen paintings between 1951 and 1961. By the time Crawford first visited there in 1950, the cemetery already possessed a long and colorful history, and no doubt its patina of decay held a special fascination for him, as it had for Edward Weston, who had taken photographs there ten years earlier.

Writing of Crawford's affinity with this site, art historian Barbara Haskell offered this description: "Attracted by the intense white light which bathed these plaster graves, Crawford created works of fine-tuned abstract integrity in which space was compressed into planes and deployed into patterns."[2] The conical form in the two drawings on the right-hand side of the sheet *Box Car & New*

Orleans is a metal flower holder attached to a grave in St. Louis Cemetery that is unrecognizable unless one is informed of its context. In these two studies, Crawford is working out variations in composition, one of which is very close to his design for a painting in his cemetery series *New Orleans Still Life* (1951, Estate of Ralston Crawford).[3] The same is true of the drawing of the boxcar on the left-hand side of the sheet—one's ability to read the drawing is compromised by the disruption of spatial clues in the sharp transitions between light and dark.

All three drawings on the sheet were created over two days, January 4 and 5, 1951. They reveal Crawford's involved working method, which employed both photography and drawing in the development of his painted compositions. In describing his process in the mid-1940s, Crawford wrote, "These pictures grow out of many stimuli. They vary in degree of directness of response to things seen. Some are synthetic expressions of many visual experiences, others constitute a distorted but accentuated vision of quite simple forms."[4] He also wrote that his drawings were "the record of my inquiry, my quest. . . . In any case they are the immediate source of my work."[5]

His drawings and paintings were inextricably linked as well to his black-and-white photography. He used the latter medium to create studies for drawings and paintings but also for its own expressive qualities. Photography is a monocular method of recording images, and the forms captured by Crawford's camera invariably emphasize the two-dimensional. He was attracted to the harsh light of midday, which flattened and silhouetted shape and form. Enhanced by the decontextualizing framing of the photographic source, the flat areas of light and dark translate in his drawings into abstractions. Without doubt Crawford used photographs to create the drawings on this sheet, as there are existing vintage prints of both the New Orleans cemetery flower holder and the end of the train boxcar (fig. 92). When set alongside the photographs of these same scenes, the drawings on this sheet show the idiosyncratic working process of this independent artist.

KWH

Fig. 92. Ralston Crawford, *Box Cars, Minneapolis*, n.d., silver gelatin print, 13.3 x 8.9 cm (5¼ x 3½ in.). By permission of the Ralston Crawford Estate, courtesy Salander O'Reilly Galleries

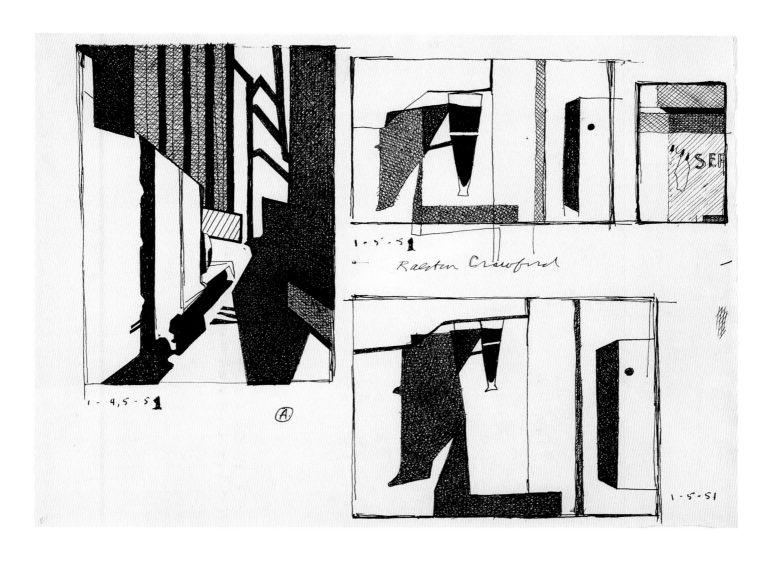

1 - 5 - 51

Ralston Crawford

1 - 4,5 - 51

Ⓐ

1 - 5 - 51

3/20/52, 1952

Brush and egg ink and opaque water-
color on wove paper, 46.6 × 59.7 cm
(18⅜ × 23⅝ in.)

Signed, in brush and egg ink, lower
right: ΔΣ 3/20/52

Purchased through the Miriam and
Sidney Stoneman Acquisition Fund;
P.997.42

Art © Estate of David Smith / Licensed
by VAGA, New York, NY

PROVENANCE
The artist; to the Estate of David Smith,
New York, 1965 [estate number 73–
52.155]; consigned to Anthony d'Offay
Gallery, London, 1988; sold to Susan
Sheehan Gallery, New York, June 1988;
sold to present collection, 1997.

EXHIBITIONS
Anthony d'Offay Gallery, London, *David
Smith: Drawings of the Fifties*, 1988, no.
11 (color illus.); exhibited with Hood
Museum of Art, Dartmouth College,
Hanover, N.H., *Abstraction at Mid-
Century: Major Works from the Whitney
Museum of American Art*, 2001 (no cat.).

Drawing was at the core of David Smith's creative
process. A prominent abstract expressionist
whom critic Clement Greenberg unabashedly
proclaimed "the best sculptor of his generation,"
Smith erected large welded-steel abstractions of
gravity-defying lightness that were aptly charac-
terized as "aerial drawing in metal."[1] The artist
described his practice of more conventional two-
dimensional drawing and its relationship to
sculpture during a lecture in 1952, just days after
he created *3/20/52*:

I make 300 to 400 large drawings a year, usually with
egg yolk and chinese ink and brushes. These drawings
are studies for sculpture, sometimes what is, some-
times what sculpture can never be. Sometimes they are
atmospheres from which sculptural form is uncon-
sciously selected during the labor process of producing
form. Then again they may be amorphous floating di-
rect statements in which I am the subject, and the draw-
ing is the act. They are all statements of my identity and
come from the constant work stream. I title these draw-
ings with the noting of month day and year. I never in-
tend a day to pass without asserting my identity, my
work records my existence.[2]

Smith perceived the fluidity and freedom of
drawing as a metaphor for creative invention. "I
draw a lot to increase my mind or my vision," he
wrote.[3] Drawing offered the benefits of speed and
ease that enabled him to push out the edge of art,
"to keep the edge moving, to shove it as far as
possible towards that precipitous edge where
beauty balances but does not topple over the edge
of the vulgar."[4]

The years 1952–53 represented a particular
height in the artist's emphasis on drawing and co-
incided with the debut of his "mature" sculptural
style.[5] Although Smith wrote in his application
for a renewal of his Guggenheim fellowship that
drawing was "lighter work, evening work . . . only
to be considered as supplementary" to sculpture,
he developed a series of sculptures in 1953 that he
actually called "drawings" and titled with the date,
in the same manner that he used for his ink
drawings.[6] Rosalind Krauss has theorized that the
sculpted drawings were Smith's response to crit-
ics who had remarked on the draftsmanship of
his sculpture, as Greenberg later would.[7] Smith
certainly felt that there was an ambiguous border
between the media: "I do not recognize the limits
where painting ends and sculpture ends," he as-
serted. He would also invoke the innate character-
istics of one medium while working in the other.[8]

Smith increased the viscosity of his ink by
adding egg yolk, but in *3/20/52* the effect of that
mixture remains relatively minimal.[9] The more
substantive material in the drawing is the white
opaque watercolor used to reinforce the drawing's
negative space. Virtually the same color as the
paper itself, the white is thickly and gesturally ap-
plied. Instead of obscuring the black in areas
where it overlaps, however, the water-soluble pig-
ment from the ink leeched through the gouache,
creating a striking pink halo. In places, the pink
effect appears highly intentional, as Smith ap-
plied the watercolor thinly over several of the
darkest blacks in the composition. How soon this
effect would have become apparent is difficult to
determine, but certainly some pentimento, or ves-
tige, of the black would have been immediately
visible. The result is a tension between positive
and negative spaces in the drawing, as the white
surges up and over the black at its edges, and the
black spiders out into otherwise pristine areas of
white. The interaction of positive and negative
spaces, considered a quintessential characteristic
of Smith's sculpture, is here interpreted in the
language of drawing.

Probably the most immediate association of
3/20/52, however, is with handwriting. The undu-
lating, interconnected forms wending their way
across the page certainly evoke a sort of calli-
graphic script. Yet, as Paul Cummings has ob-
served, the relationship of Smith's abstract
writing to any specific tradition, such as Chinese
calligraphy, was loose, more a philosophical kin-
ship than imitation.[10] In *3/20/52*, the almost picto-
graphic cursive zigzags down the page along
three registers. Sharp, jagged edges and points
set an aggressive tone without establishing a nar-
rative. Although Smith's writing is purely ab-
stract, viewers may find symbols and images
within the composition. As in the writings of
James Joyce, whom Smith admired, a seemingly
inscrutable text resolves itself into meaning for
each viewer independently with thought and
rereading, and even then only in pieces.[11] Explain-
ing why he signed drawings like this one with his
initials in the Greek alphabet, Smith wrote,
"Greek because 'Greek' is something you don't
understand."[12]

MDM

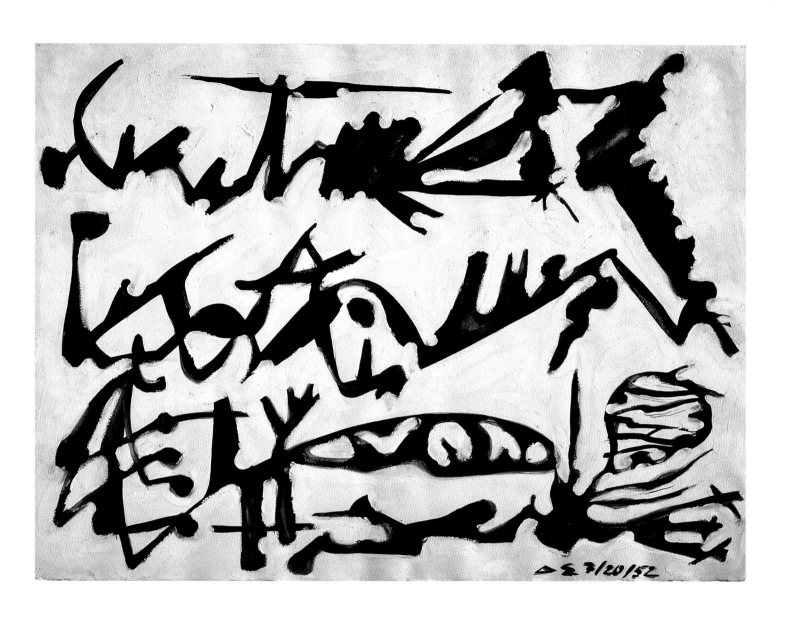

67 Andrew Wyeth, N.A., born 1917

Winter Light (Winter Sunset), 1953

Transparent and opaque watercolor over graphite on heavy wove paper, 50.9 × 71.2 cm (20 × 28 in.)

Signed, in pen and black ink, lower right: Andrew Wyeth; inscribed, in graphite, on reverse, lower right: S2621; inscribed by Robert Frost, in ink, on original backing [now in object file]: This to Kay from 1954 on' / RF—Aetat LXXX; inscribed by Kathleen Morrison, in ballpoint pen, below Frost's inscription: And from Kay to Anne Morrison Gentry—/ to be Smyth—/ July 1, 1968.

Presented to Robert Frost in 1954, on the occasion of his eightieth birthday, and given to the College in 1982 by Mr. and Mrs. Edward Connery Lathem; W.987.20

© Andrew Wyeth

PROVENANCE
The artist; to Knoedler Gallery (as agent), New York, 1953; sold to Edward Hyde Cox, Frederick Baldwin Adams, Clifton Waller Barrett, Ray Nash, Charles Woolsey Cole (president of Amherst College), and others, January 1954; presented to Robert Frost in honor of his eightieth birthday, March 1954; given to Kathleen Johnston Morrison (his secretary-manager), 1954 (physically retained by Frost until his death in 1963); given to Anne Morrison Gentry (her daughter), July 1968 (physically retained by Kathleen Morrison until 1987); sold to the Trustees of Dartmouth College (made possible by a donation from Mr. and Mrs. Edward Connery Lathem), Hanover, N.H., 1982; transferred to present collection, May 1987.

EXHIBITION
Albright-Knox Art Gallery, Buffalo, N.Y., *Andrew Wyeth: Temperas, Water Colors and Drawings*, 1962, no. 48.

REFERENCE
Museum of Fine Arts, Boston, *Andrew Wyeth* (Boston: Museum of Fine Arts, 1970), 19.

A 1962 feature article in *Time* magazine aptly described Andrew Wyeth's singular position in American art, one he still holds today: "He is in a sense one of the most isolated of America's top artists, yet his appeal is universal. . . . His paintings, so static at first glance, are charged with emotion; his surface realism is a window to a higher reality beyond."[1] Wyeth's ability to give an air of beauty and transcendence to the most time-worn, drab elements of American rural life—weathered facades, empty sheds, and winter-dry meadows—has led art historian Wanda Corn to dub him a "metaphoric realist," thereby highlighting his affinities with the work of Edward Hopper and such depression-era photographers as Walker Evans and Dorothea Lange. Yet Corn also observed the deeply personal, psychological dimension of Wyeth's art, which she compared with the psychological explorations—albeit not the style—of his surrealist and abstract expressionist contemporaries active in the 1940s through the 1960s.[2] Defying easy categorization in visual terms, it is perhaps not surprising that Wyeth's soulful yet highly particularized works have been likened frequently to poetry—especially that of Robert Frost.[3]

Fittingly enough, Robert Frost originally owned this watercolor, which he received as a gift from friends at a dinner commemorating his eightieth birthday in 1954. The donors, primarily associates from Amherst and Dartmouth Colleges, recognized a "spiritual kinship between Wyeth's paintings and Robert's poetry" and were well aware that Frost admired the work of Wyeth, and vice versa.[4] Both figures valued structure and shared similar themes and settings, especially winter in rural America. Significantly, both also believed that objects must be appreciated in all their specificity to be effective carriers of meaning.[5] The deceptively simple realism that resulted from this approach advanced the popular reputations of both figures but tended to mask the ambiguities underlying their work.

Although Wyeth's haunting images are most often associated with his exacting temperas, watercolor also serves as an expressive vehicle for his evocative realism. Executed quickly and on-site, his watercolors record his initial, intense observations of his subjects, almost all of which he found within a few miles of his winter home in Chadds Ford, Pennsylvania. Wyeth often used fluid watercolors as notations for works in other media, but he also created many, including this example, as independent compositions. Historically, watercolors constituted his first exhibited material in the late 1930s, and they gained him a professional reputation distinct from that of his famed illustrator father, N. C. Wyeth.[6] In the 1940s the younger Wyeth turned primarily to tempera and dry brush to create remarkably vivid yet unsettling images suggestive of loss, memory, and the passage of time. These themes became even more palpable in his work after his father's tragic death in 1945. Wyeth's fluid watercolors followed suit, gaining greater weight and psychological resonance through unusual vantage points, spare compositions, subdued colors, and a dramatic use of light.

Winter Light exhibits all of these qualities while drawing particular attention to Wyeth's reliance on light as an expressive and graphic device. The wedge of light entering at left is the work's chief actor, suggesting an ambiguous presence both within and beyond the ostensibly empty shed. A linear shadow, its source unclear, shoots across the ground and up the partially open door, drawing our eye to a nexus of angled forms that anchors the work's abstract structure. Wyeth's keenly observed angle of light adds to the work's immediacy, suggesting "an exact moment of vibrating time."[7] While light clarifies form in this composition, it also heightens its spatial ambiguity. The image depicts a specific outbuilding in Chadds Ford, but we cannot be sure whether we stand inside or outside the structure.[8] An exterior wall appears at right, but the artist cropped any evidence of a supporting wall to the left and fills the foreground with sunlight. Snow—indicated by the white sheet itself—spills onto the hay-strewn floor and further erases the boundary between interior and exterior, a prominent theme in Wyeth's art. It also signals the season that Wyeth claimed as "my time of year."[9] Given winter's traditional association with death, blank white snow heightens the emotional impact of this and other winter subjects by the artist. It also obscures extraneous detail and provides a visual counterpoint to the rich, earth-toned palette. In this case, the result is a masterful, contemplative study of a seemingly familiar yet mysterious scene, filled with both tangible fact and elusive poetry.

BJM

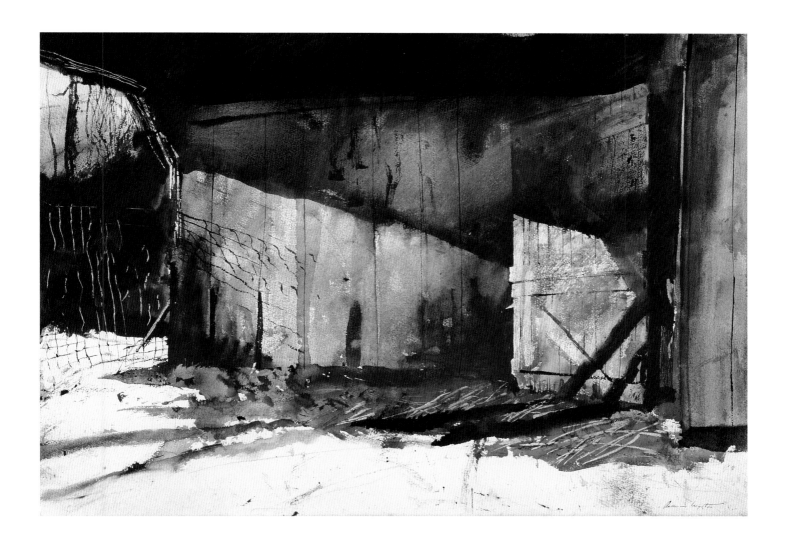

68 Adolph Gottlieb, 1903–1974

Male and Female, c. 1955–56

Brush and ink over graphite on wove paper, 33.7 × 25.4 cm (13¼ × 10 inches)

Signed and inscribed, in pen and ink, on reverse: Adolph Gottlieb / 130 State St. / Brooklyn, N.Y.; inscribed, in graphite, on reverse: #39.

Bequest of Lawrence Richmond, Class of 1930; D.978.164

© Adolph and Esther Gottlieb Foundation/Licensed by VAGA, New York, NY

PROVENANCE
Lawrence Stanton Richmond; bequeathed to present collection, 1978.

RELATED WORK
The Couple, 1955, oil and enamel on canvas (Adolph and Esther Gottlieb Foundation, New York).

Adolph Gottlieb was one of the philosophical founders of abstract expressionism in the early 1940s. He remains best known, however, for his late work, celebrated in the canon of art history as a rare reconciliation of the movement's two predominant forms: action and color field painting. Although Gottlieb's significance is often eclipsed by legendary names like Jackson Pollock (cat. 59) and Barnett Newman, his art remains an eloquent summation of a divided movement.

By the mid-1950s, when Gottlieb drew *Male and Female,* he had already distinguished himself in an impressive succession of styles and subjects: realism, surrealism, pictograms, and abstract landscapes, most prominently. By 1957, however, the artist arrived at a new art form, his signature creation: the burst. Critic and art historian Irving Sandler has described the bursts in their most coherent form:

[E]ach [is] composed of a large disk within a halo suspended above a jagged area. The upper orb is luminous, modulated, contained; the lower expanse flat but loosely painted, erupting. The two planes set up a dialogue of pictorial elements, but they also suggest meanings beyond their formal attributes, the two contrasting yet interacting abstract elements symbolizing duality in all of its varied manifestations: earth and sun (or moon); the kinetic and the static; the gesturally free and the controlled; shape and field.[1]

These are the themes of *Male and Female.* The drawing is a considerably distilled reinterpretation of an oil painting that the artist created in 1955, *The Couple* (fig. 93).[2] In the drawing, Gottlieb contracted the central form of the conjoined male and female bodies from the painting, accentuating the countervailing forces pulling them apart and holding them together. Their limbs are simultaneously figurative and abstract representations of the explosive energy radiating outward. The drawing wavers at the threshold of pure abstraction. From here, there remained only a small step to the artist's burst imagery.

At the center of Gottlieb's art, like that of the other abstract expressionists, was a fascination with the working of the unconscious mind. As art historian David Anfam has observed in the context of Jackson Pollock's earlier oil painting of the same subject, *Male and Female* (1942, Philadelphia Museum of Art), the artist was almost certainly aware of and referring to the psychoanalytic archetypes of "animus" and "anima," as defined by Carl Jung earlier in the century.[3] Gottlieb was reportedly more interested in Jung than any other theorist of the unconscious and later recalled that he had read Jung's work in the early 1940s.[4] According to Jung, the animus and anima are "un-

conscious mate-ideals," the animus a woman's ideal male partner and the anima a man's ideal female partner. Ultimately, Jung believed that individuals of both sexes balance elements of both archetypes to some degree. What varied from individual to individual was the relationship between the two.[5] Gottlieb's drawing refers to that perpetual state of paradoxical tension and codependence. The theme of male and female resurfaced with such frequency in Gottlieb's work of the 1940s to the mid-1950s that it almost certainly carried such symbolic weight.[6]

Scale was also an important consideration to the abstract expressionists, whose large compositions are popularly equated with the movement, and it therefore superficially argues against the significance of *Male and Female* in Gottlieb's career. In the group's 1943 manifesto, which Gottlieb coauthored, the artists themselves proclaimed, "We are for the large shape because it has the impact of the unequivocal."[7] Sandler, however, has argued persuasively that the "idea of the big picture" was less central for artists like Gottlieb, Willem de Kooning, and Franz Kline, in that their large and small works could be similarly expansive without encountering a "qualitative difference."[8] This is the case in *Male and Female,* in which the reaching, outward energy of the central figure extends indefinitely into space. Gottlieb here transformed the static, restrictive grid lines of his earlier pictographs, including *Male and Female* of 1950 (fig. 94), into more organic, dynamic rays. The drawing compresses many of Gottlieb's principal themes—symbols of the unconscious, male and female subjects, expressive gesturalism, and burst imagery—at a major turning point in his career.

MDM

Fig. 93. Adolph Gottlieb, *The Couple,* 1955, oil and enamel on canvas, 182.9 × 152.4 cm (72 × 60 in.). Collection of the Adolph and Esther Gottlieb Foundation. © Adolph and Esther Gottlieb Foundation / Licensed by VAGA, New York, NY

Fig. 94. Adolph Gottlieb, *Male and Female,* 1950, oil, opaque watercolor, and casein on burlap, 121.6 × 152.4 cm (47⅞ × 60 in.). Private collection. © Adolph and Esther Gottlieb Foundation / Licensed by VAGA, New York, NY

69 Ilse Martha Bischoff, 1901–1990

Still Life: Fungus, 1957

Casein on (Whatman) illustration board, toned gray by artist, 43.1 × 55.8 cm (17 × 22 in.)

Signed and dated, in pencil, lower right: Ilse Bischoff / 1957; on reverse: [label for] Winsor + Newton's / Watercolor Sketching Board / Whatman's Drawing Paper

Gift of the artist through the Friends of the Dartmouth Library; W.962.61

PROVENANCE
The artist, Hartland, Vt.; given to Dartmouth College, 1962.

EXHIBITION
Hopkins Center Art Galleries, Dartmouth College, Hanover, N.H., *Ilse Bischoff: A Retrospective,* 1966 (no cat. no.).

Despite her considerable accomplishments as a painter, draftsman, book illustrator, and printmaker, Ilse Bischoff remains relatively unknown today. In an introduction to a 1966 exhibition of Bischoff's work at Dartmouth College, her friend and fellow realist Paul Cadmus speculated as to why such a "rare talent" did not enjoy a wider reputation. He pointed to the unpopularity of what he called her (and his) "Precise Representationalism" but also to her disinterest in sales and to the number and diversity of her creative pursuits. In addition to her art, Bischoff assembled a substantial collection of eighteenth-century decorative arts and authored several biographies and articles. While her extensive writings may have detracted from the quantity of art she produced, her passion for collecting beautiful objects—from the most refined German porcelain to the most humble bits of nature from her Vermont property—seems to have fueled, rather than diminished, her particular aesthetic sensibility.[1]

Despite Bischoff's eventual residency in Vermont, her roots were urban and cosmopolitan. She was born in New York City to wealthy German American parents and traveled abroad frequently in her youth. From 1920 through 1923 she studied costume design at Parson's School of Design—in both New York and Paris—and, beginning in 1924, took classes at the Art Students League in New York.[2] There she developed lifelong friendships with fellow students Jared French and Paul Cadmus (cats. 51, 52), the latter of whom exerted a profound influence on her work. By the late 1920s Bischoff was showing her wood engravings in national exhibitions, and during the 1930s and 1940s she followed suit with her paintings. Never attracted to modernism, she adopted the stylized figurative realism and everyday subject matter associated with American Scene painting. In her genre scenes and informal portraits from this period, she displays a lively, inventive sense of color and a keen awareness of clothing and accessories that may have stemmed from her early interest in costume.[3] Bischoff's eye for the decorative also manifests itself in the still-life oils of the 1940s and 1950s and especially in her casein drawings beginning in the mid-1950s.

Bischoff's association with Vermont—seasonally, beginning about 1942, and eventually full-time—precipitated a new focus in her art. After purchasing a stately federal home in Hartland, Bischoff spent increasing periods of time outdoors. Through her walks in the nearby woodlands she developed a passion for the subtle perfection of nature's forms.[4] Increasingly, she ignored exhibition opportunities elsewhere and shifted her attention to painting in casein (in a drawinglike manner) sparse arrangements of dried weeds, mushrooms, feathers, and bird's nests. In 1964 she wrote:

Returning from long walks into country . . . I learned to keep my eyes on the ground in search for treasures to paint. Soon the rewards of those walks mounted up; a fox's skull, absolutely symmetrical; . . . shining crows' feathers with blue lights, . . . snails, shells, . . . a twist of white birch bark. . . . Not only had my whole way of life changed with the move to Vermont but a new kind of impetus had come to my desire to paint. I wanted to render the objects as they were and turned to the old masters for lessons.[5]

Bischoff frequently cited Albrecht Dürer's naturalist drawings as a source of inspiration, but as seen in this work she clearly also owed a significant debt to her friend Cadmus. An admirer of Italian Renaissance techniques, Cadmus introduced Bischoff to the use of egg tempera in the 1930s and to the more modern casein about 1955.[6] His meticulous, linear approach to his classical subjects clearly served as a model for Bischoff. Working from darks to lights, she built up her casein compositions with precisely drawn hatched lines that convincingly articulate the varied textures and forms of her naturalist treasures. Because Bischoff frequently alluded to the sights and smells of the decaying forest in her writings, one might easily interpret her drawings as elegies on the passage of time. Her *Still Life: Fungus,* however, seems to lack the weight of profound metaphor. Despite its autumnal elements, this still life seems less a memento mori than an evocation of a fashionably trimmed hat. Rather than setting a melancholy tone, the black feathers and brittle, swirling ferns give the work a sprightly character and reveal once again Bischoff's eye for the decorative. When asked what her still lifes were meant to convey, she responded, "I don't think I was trying to convey anything but the sheer pleasure of painting."[7]

BJM

70　Joan Mitchell, A.N.A., 1926–1992

Untitled, c. 1959

Oil pastel and oil paint on wove paper, 35.0 × 42.8 cm (13¾ × 16¾ in.)

Signed, in graphite, lower right: J. Mitchell

Purchased through the Julia L. Whittier Fund; D.2002.28

PROVENANCE
The artist; given to Carl Planski, New York; to Elliot Bossman, Long Island City, N.Y. (art dealer); to Marcia Blum, Old Westbury, N.Y. (art dealer), 1991; sold to Dr. Larry Wells, Brookville, N.Y., in 2002; consigned to Robert Miller Gallery, New York; sold to present collection, 2002.

EXHIBITION
Robert Miller Gallery, New York, *Joan Mitchell*, 2002 (no cat.).

Joan Mitchell has only recently been widely appreciated as one of the most important women artists associated with abstract expressionism. Her contributions may have been underestimated initially because of her gender, her early stylistic debt to such pioneers of the movement as Franz Kline and Willem de Kooning, and especially her removal from New York to France in the mid-1950s. Mitchell's gestural art took many turns throughout her long career, but in the tradition of her early mentors Kline and de Kooning, it consistently projected a sense of having sprung directly from her emotions. Rarely transparent in their readings, however, her works usually suggest a complex mixture of angst and lyricism, overlaid with a palpable joy in the act of painting itself. At times she drew inspiration from the writings of contemporary authors, such as her friends Frank O'Hara and Samuel Beckett. Far more often, however, her works evoke a personal response to landscape, expressed in a totally abstract manner.[1]

Mitchell was raised in Chicago and studied initially at Smith College in Northampton, Massachusetts (1942–44), and then at the Art Institute of Chicago (1944–47) and Columbia University in New York (1950). During the early 1950s she maintained a studio in New York's Greenwich Village and formed close friendships with writers and other abstract painters. She was particularly influenced by the paintings of Kline, de Kooning, and Arshile Gorky. Although her mature style did not evolve until she moved to France, she had regular solo exhibitions at the Stable Gallery in New York and was one of only a few women invited to join the exclusive artists' forum, the Club, on Eighth Street.[2] Mitchell's affinity for France began with a year abroad in 1948–49. She began to spend part of each year in Paris beginning in 1955 and four years later moved abroad permanently, living first in Paris and later at Vétheuil. Although in the 1960s attention in the art community turned away from abstract expressionism toward pop art and minimalism, Mitchell continued to paint in an expressionist vein for the remainder of her career.

Known primarily for her powerful, large canvases, Mitchell also worked on a more intimate scale, as seen in this mixed-media sketch that Mitchell created about 1959. This oil pastel and oil on paper drawing mirrors the artist's approach to painting on canvas during the late 1950s and early 1960s. By 1956 she was applying both gentle arcing strokes of the brush and vigorous whiplash lines to her canvases—gestures integral to the creation of this sketch. Here, too, the exposed cream paper stands in for the light backgrounds that were a key component of her paintings. The concentration of dark marks near the center of the sheet reflects a compositional strategy she used especially in her canvases about 1960. Klaus Kertess described this phenomenon as "storm clouds of paint" gathering in the center of her work.[3] Such tempestuous passages give the image an emotional and visual edge, suggesting a quality of "lyrical desperation" that O'Hara ascribed to Jackson Pollock's paintings.[4] In this study, arcing lines in vivid, springlike colors give way in the center to vigorously applied slashes of black and gray pigment that are disrupted by smudging. With its complex layering of marks, this tumultuous center gives depth to the composition and energizes the lines that whip into and out of the nexus. Although Mitchell resented the attempts by critics to read her emotions through her brushstrokes, there is no doubt that her work—even at its most lyrical—conveys an element of tension and struggle that is likely personal as well as aesthetic. As Kertess said of her works of this period, "Mitchell was probing a beauty that is the beginning of terror."[5]

BJM

71 Larry Rivers, N.A., 1923–2002

Double Money Drawing, 1962

Crayon and graphite on wove paper,
30.6 × 31.4 cm (12 × 12⅜ in.)

Signed, right center, in graphite: Rivers

Bequest of Jay R. Wolf, Class of 1951;
D.976.194

© Estate of Larry Rivers / Licensed by
VAGA, New York, NY

PROVENANCE
The artist; consigned to Tibor de Nagy
Gallery, New York, October 1962; sold to
Jay R. Wolf, New York, December 1962;
bequeathed to present collection, 1976.

RELATED WORKS
Another drawing, *Double French Money,*
1962, crayon on paper (collection of the
artist, 1979); final version of this compo-
sition, *Double French Money,* 1962, oil on
canvas (collection of Mr. and Mrs.
Charles B. Benenson, N.J., 1989); later
print version, *Double French Money,*
1966, screenprint on Plexiglas (Citi-
group Art Collection, New York, 2002).

EXHIBITIONS
Tibor de Nagy Gallery, New York, *Larry
Rivers,* 1962, no. drawings 1; Hopkins
Center Art Galleries, Dartmouth Col-
lege, Hanover, N.H., *The Jay Wolf Be-
quest of Contemporary Art,* 1977 (no cat.);
University Art Galleries, University of
New Hampshire, Durham, N.H., *Con-
temporary Drawings from University Col-
lections,* 1978 (no cat.).

Fig. 95. French one hundred nouveau franc
note, recto and verso, reproduced from
Claude Fayette, *Les Billets Français du
Vingtième Siècle* (Jard-sur-Mer: Édition l'Au-
réus, 1990), no. 59. Courtesy of The Ameri-
can Numismatic Association, Colorado
Springs

Among the 1960s pop artists, often noted for
their irreverent humor, Larry Rivers was a head-
liner.[1] He routinely poked fun at the seriousness
of art history, appropriating artistic icons like
Emanuel Leutze's *Washington Crossing the
Delaware* and Jacques-Louis David's *Napoleon in
His Study* for parodic reinterpretation. *Double
Money Drawing* participated in one such reassess-
ment. The work was an early study in a series de-
picting the French hundred-franc note, with its
prominent reproduction of another famous,
though unfinished, portrait of Napoleon by David
(1798, Musée du Louvre, Paris). Rivers's drawing
also displays his technical virtuosity, an uncharac-
teristic trait among the pop artists.[2] His emphatic,
gestural style was a paradox in the midst of a
movement that belittled the idea of artistic ge-
nius. In reaction to the abstract expressionist
movement of the previous decade, pop artists like
Andy Warhol and Roy Lichtenstein favored prints
and photoreproductive techniques that disguised
the artist's hand. Rivers cultivated his masterful
technique, despite persistent criticism, and made
draftsmanship a central component of his cre-
ative process, actively drawing, erasing, and
reconfiguring his subjects.[3] As art historian Bar-
bara Rose has written, the accumulations of
Rivers's technique carried meaning for the artist,
serving "as reminders that the figures have a past
and also as a general reference to the layers of
memory encrusted in the artist's interpretation of
his subject."[4] Remarkably, Rivers's amused art
historical reassessments and his idiosyncratic
technique ran on parallel courses.

History was a living backdrop in Rivers's work,
an idea that he derived from reading Leo Tolstoy's
epic *War and Peace.* He recalled, "By enmeshing
Napoleon's invasion of Russia with contemporary
life, Tolstoy set me on a course that produced
Washington Crossing the Delaware," the first of his
artistic parodies, in 1953.[5] History was lived
through the lens of everyday life, and the heroic
icon of Napoleon during the Directory embla-
zoned on the French national currency was a su-
perlative metaphor: past triumph parlayed into
modern money (fig. 95). For Rivers, however, that
contemporary lens was ironic. He must have
been aware of France's sharp currency revaluation
just three years earlier. In 1959 this same bill was
a ten thousand franc note. Creating the *nouveau*

franc in that year, the French central bank re-
tained the bill's format but lowered Napoleon's
net worth to just one hundred francs.[6] In *Double
Money Drawing,* the elaborate banners and em-
blems of Napoleonic military history—the Arc de
Triomphe, the Invalides (which houses Napo-
leon's tomb), and an array of regimental stan-
dards—fade or are transformed by farce, most
notably the proud golden dome of the Invalides
represented as a clown's face.[7] In his *Double
Money Drawing,* Rivers seized on the popular
practice of using historical association to create
an aura of legitimacy around modern institu-
tions.[8] He then skewered that practice with
parody.

As a basis for comparison with the work of
other pop artists, Andy Warhol's *Two Dollar Bills,
Front and Back* (Museum Ludwig, Cologne, Ger-
many) was also completed in 1962.[9] Warhol
adopted similar subject matter but with divergent
methods. Both artists incorporated both sides of
their respective currencies and the idea of repro-
ducibility or even forgery. The famous likenesses
portrayed on the bills lend credibility to the cur-
rencies and immortality to the sitters, while the
artists assail both. Warhol, however, was printing
money, running it off the press, so to speak.
Whereas Warhol critiqued by repetition, Rivers
took apart the note itself. Rivers even signed his
drawing over the "NF," creating a new world cur-
rency and bill simultaneously, the hundred-
Rivers-nouveau-franc note. In 1970 the artist
expressed some humorous concern over the value
of his funny money: "the exchange rate will esca-
late rapidly; the value of even the lowest denomi-
nation pieces will obviously be priced for resale,
as works of art in one series, at the top figure paid
for any of them."[10] Rivers's pop credentials are
unassailable, yet his art transcends the move-
ment, lending credibility to Vivien Raynor's 1963
review of Rivers's work: "No doubt about it, this is
a racehorse grazing in a field of more bovine tal-
ents, and too clever by half."[11]

MDM

72 Walter Tandy Murch, 1907–1967

Study #18, 1962

Transparent and opaque watercolor and charcoal on very thick wove paper, 58.4 × 44.5 cm (23 × 17½ in.)

Gift of Mr. and Mrs. Thomas R. George, Class of 1940; D.995.61

PROVENANCE
Betty Parsons Gallery, New York, 1962; sold to Mr. and Mrs. Thomas R. George, Princeton, N.J., 1963; on loan to present collection, 1987–95; given to present collection, 1995.

EXHIBITIONS
Betty Parsons Gallery, New York, *Walter Murch*, 1962 (no cat.); Hopkins Center Art Galleries, Dartmouth College, Hanover, N.H., *Hopkins Center 25th Anniversary Exhibition: Artists-in-Residence at Dartmouth*, 1988 (no cat.); Hood Museum of Art, Dartmouth College, Hanover, N.H., *Art since 1945: Selections from the Permanent Collection*, 1992–93 (no cat.).

Throughout his artistic career the painter Walter Murch created still lifes. His subjects were both human-made and natural objects—clocks, bricks, teapots, stone architectural fragments, bits of ribbon, lemons, potatoes, melons, and other quotidian inhabitants of his home and studio. Often in Murch's work the organic is inexplicably paired with the mechanical or architectural: onions with a car lock, or pieces of bread with an old machine. His concentration on realism, as opposed to the abstractions that figured in the work of his contemporaries—the practitioners of surrealist and gestural painting in the 1940s and 1950s—made him a continual outsider to current artistic trends.[1]

Although primarily a painter, Murch found drawing to be an equally compelling medium in the early 1950s, just at the time when he began to be successful in selling his work.[2] As the decade progressed, his handling of graphite and wash gradually became less descriptive and his drawings took on an increasingly modulated surface. The wash marks that play across the surface of the paper make the objects he portrays appear disembodied, their edges dissolving in the artificial light that washes over them. The Hood's drawing from 1962, *Study #18*, clearly shows this effect. In assembling the subjects of this drawing, Murch employed studio props—taken from the usual repertoire of Euclidian spheres, cylinders, pyramids, and rectangular solids, and a white cloth—that were used to train students in the fundamentals of depicting form and volume. These types of objects can be found in one other drawing of this period, *Sphere and Cloth Study* (1964, private collection, N.J.), and in paintings such as *Geometrics II* (1957) and *Fragments* (1962).

The sphere in *Study #18* was made by a succession of small touches of wash that cohere into the rounded form. These marks are neither regular nor applied in a formulaic manner. The sphere sits on a rough-edged cylinder or block, which is in turn mostly obscured by the cloth that is bunched around it. The light falls from above on the left and dissolves the upper left side of the sphere as well as all but the deepest shadows in the crevices and folds of cloth. Even these seem to reflect the light, never becoming deeper than a translucent gray. In using this narrow range of tone, Murch appears to have captured on paper the air that lies between viewer and still life. This lends his work an otherworldly quality, a trademark of his later paintings and drawings. Touches of opaque white float on the surface, almost, but not quite, serving as highlights on the forms. They appear to emanate from the sphere rather than reflect off its surface.

After Murch's death in 1967, a sheet of paper was discovered in his studio with notes that outlined his thoughts about drawing. He organized drawings into three types: those that "record what is seen," those that "visualize what is imagined," and those that "symbolize ideas and concepts." These types, he stated, are not exclusive of one another; indeed, drawings that "achieve their full emotional power" do so because of the "grandeur with which they fulfill all three of these esthetic purposes." Thus, for Murch, drawing at its best combined what we see with what we know, demanding "imaginative involvement to complete the meaning of the work."[3] His deeply held belief that the onlooker completed the work, that its essence existed somewhere between the work of art itself and the mind of the beholder, perhaps explains the timeless nature of his images. The objects in his canvases and drawings have been described as possessing a hyper-reality that imbues them with a life beyond their utilitarian existence. The forms of *Study #18* look as though they exist in a Neoplatonic realm, in which the sphere takes on an authoritarian presence, equally at home in the absolutist vision of a utopian architect or the hermetic world of an artist who throughout his life sought to distill the essence of objects.

KWH

73 Jacob Lawrence, N.A., 1917–2000

Soldiers and Students, 1962

Opaque watercolor over graphite on
wove (Arches) paper, 57.0 × 77.3 cm
(22½ × 30³⁄₁₆ in.)

Signed and dated, lower right: Jacob
Lawrence 62

Bequest of Jay R. Wolf, Class of 1951;
W.976.187

© Gwendolyn Knight Lawrence / Artists
Rights Society (ARS), New York

PROVENANCE
The artist; with Terry Dintenfass, Inc.
(art dealer), New York, 1963; sold to Jay
R. Wolf, New York, by 1967; bequeathed
to present collection, 1976.

EXHIBITIONS
Terry Dintenfass, Inc., New York, *Jacob
Lawrence*, 1963, no. 12; probably Na-
tional Academy of Design, New York,
138th Annual Exhibition, 1963 (not listed
in cat.); Wollman Hall, New School Art
Center, New School for Social Research,
New York, *Protest and Hope: An Exhibi-
tion of Contemporary American Art*, 1967,
no. 28; Hood Museum of Art, Dart-
mouth College, Hanover, N.H., *Works by
Jacob Lawrence in the Collection of the
Hood Museum of Art*, 1999 (no cat.).

REFERENCES
Wollman Hall, New School Art Center,
New School for Social Research, New
York, *Protest and Hope: An Exhibition of
Contemporary American Art* (New York:
New School for Social Research, 1967),
8, 38 (illus.); Patricia Hills, "Jacob
Lawrence's Paintings during the Protest
Years of the 1960s," in Peter T. Nesbett
and Michelle DuBois (eds.), *Over the
Line: The Art and Life of Jacob Lawrence*
(Seattle: University of Washington Press,
in association with Jacob Lawrence Cata-
logue Raisonné Project, 2000), 177, 178
(color illus.); Peter T. Nesbett and
Michelle DuBois with Stephanie Ellis-
Smith, *Jacob Lawrence: Paintings, Draw-
ings, and Murals (1935–1999): A
Catalogue Raisonné* (Seattle: University
of Washington Press, in association with
Jacob Lawrence Catalogue Raisonné
Project, 2000), 151 (color illus.), no.
P62–09.

Fig. 96. Jacob Lawrence, *American Revolution*, 1963,
opaque watercolor and tempera on paper, 58.4 x 38.1 cm
(23 x 15 in.). Private collection, courtesy of Peg Alston
Fine Arts, New York. © 2004 Gwendolyn Knight
Lawrence / Artists Rights Society (ARS), New York

The spirit of African American community per-
vades Jacob Lawrence's art and finds particular
poignancy in his 1962 *Soldiers and Students*. A
leading American artist by the 1960s, Lawrence
and others rallied to the civil rights movement, as-
piring to the degree of solidarity among intellec-
tual colleagues that had prevailed during the
Harlem Renaissance in the 1920s. In 1969
Lawrence remarked that all African American
artists "relate to the civil rights movement, and we
all make contributions. We give because we want
to give. [Creating art is] an obvious way of helping,
not a spiritual one, but it's a way that has an im-
mediate, definite benefit."[1] As the rising tide of
social activism swept the country, Lawrence em-
braced the often anonymous participants in the
movement as his subjects, just as he had earlier
depicted such admired historical figures as Tous-
saint L'Ouverture, Frederick Douglass, and Har-
riet Tubman. Milton Brown has noted that in
Lawrence's reconceptualization of the heroic
genre, "the emphasis is on the natural endow-
ment, will to achieve and personal courage of the
hero as a symbol of racial pride, but goes beyond
to extol education, organization and cooperation
with all progressive elements of society, including
whites."[2] In *Soldiers and Students*, Lawrence en-
capsulated one permutation of that ideal in which
a community acts collectively to precipitate re-
form, paralleling his own desire for the commu-
nity of artists to collaborate in promoting social
change.[3]

Throughout his career, Lawrence employed a
modified cubist aesthetic based on flat planes of
local color that reinforced the symbolic aspect of
his work. As Richard Powell has observed,
"Lawrence's paintings during this tumultuous pe-
riod in America stand out for their deep, intro-
spective character, [and they] present black
experience as something unique, as seen in its
various configurations, and universal, as evident
in its common themes and goals."[4] The artist's
stylistic choice in the present work elevates his de-
piction of contemporary struggle to a more ab-
stract plane, on which the morality of the
students' struggle is laid bare. Lawrence adapted
the cubist mode, in which objects are converted
into metonymic emblems, to prioritize the sym-
bolic over the specific.[5] Art historian Patricia Hills
has noted that this aspect of Lawrence's art com-
plements the abundant news photographs of civil

rights protests published at the time.[6] In works
like *Soldiers and Students*, Lawrence utilized an al-
legorical approach to universalize the notion of a
people rising up against oppression, compelling
the viewer's recognition of contemporary events
in the light of human history.[7]

Much of the initial impact of Lawrence's *Sol-
diers and Students* derives from its principal
conflict between the groups in the work's title,
though their confrontation is not the source of the
impending violence pictured. Despite the fact that
federal soldiers were more often the students' pro-
tection in the early days of school desegregation,
here they clearly obstruct the students' path. Only
the two central students face the soldiers directly,
however, one physically, the other with her gaze.
Although compositionally opposed, most mem-
bers of both groups appear irresolute and fearful.
Unlike Lawrence's *American Revolution* (1963, fig.
96), in which an African American figure is bru-
tally assailed, or his *Invisible Man among the Schol-
ars* (1963, collection of Mr. and Mrs. Harold A.
Sorgenti), in which the African American student
is ignored altogether, *Soldiers and Students* asserts
only wavering resolve by several principal protago-
nists.[8] The students converge from both sides of
the composition and project strength by their
numbers rather than by their self-confidence.
These two groups are distinguished from the ar-
riving adults in the background, one clearly
armed with a rock and eager to fight. Lawrence's
Soldiers and Students delves into the complexity of
contemporary events, incorporating a dimension
of human empathy for soldier and student alike.

The viewer of Lawrence's *Soldiers and Students*
is no passive bystander. Offered a clear path to the
military picket and aligned on the students' side
of the standoff, the viewer faces three principal vi-
sual foci, all human: the wall of soldiers in the
middle ground, the pleading regard of the second
student from the right edge of the composition,
and the menace of the approaching figures in the
background. Critic Aline Saarinen remarked of
Lawrence's work in 1960, "everything is stripped
away except the essential gesture, the salient
'prop,' the indispensable detail . . . , these are
grandly emphasized."[9] Atop the kaleidoscopic
array of figures, the viewer's eye is arrested by a
female African American doll thrust upward by
one of the oncoming assailants. As in Lawrence's
American Revolution, the doll may embody the
racists' belief in their control over their victims.
Instead of dangling the doll in front of the victim,
as in *American Revolution*, however, it is posi-
tioned above the composition in *Soldiers and Stu-
dents*, taunting the viewer with his or her own
impotence to prevent the impending violence.

MDM

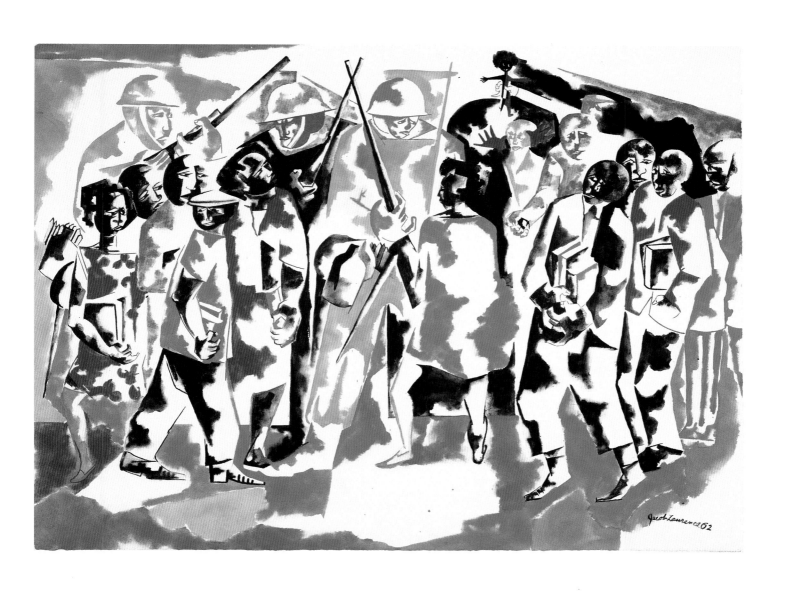

74 Lee Bontecou, born 1931

Untitled, 1964

Graphite on wove graph paper, 42.0 ×
54.9 cm (16½ × 21⅝ in.)

Signed and dated, lower right: Bontecou
'64

Bequest of Jay R. Wolf, Class of 1951;
D.976.217.1

PROVENANCE
Jay R. Wolf, New York; bequeathed to
present collection, 1976.

RELATED WORK
A second drawing of the same dimen-
sions, date, and subject (Hood Museum
of Art, Dartmouth College, Hanover,
N.H., bequest of Jay R. Wolf,
D.976.217.2, see p. 228).

EXHIBITIONS
Hopkins Center Art Galleries, Dart-
mouth College, Hanover, N.H., *The Jay
Wolf Bequest of Contemporary Art*, 1977
(no cat.); Hood Museum of Art, Dart-
mouth College, Hanover, N.H., *Figural
Sculpture: Selections from the Permanent
Collection*, 1994 (no cat.).

Sculptor Lee Bontecou remains best known today
for her abstract wall reliefs of the early 1960s.
Constructed with strips of fabric (and other mate-
rials) stretched over metal frames and organized
around a central void, Bontecou's biomorphic
sculptures attracted attention as representations
of vaginal imagery. Created at the height of the
women's movement, Bontecou's reliefs were al-
lied in the minds of critics (both sympathetic and
antagonistic) with the works of other New York
artists who actively supported the feminist politi-
cal movement.[1] Bontecou herself never consented
to the elision, however, and insisted that she nei-
ther participated directly in the feminist cause
nor intended for her art to be read anatomically.[2]
After years of such misinterpretation, Bontecou's
desire for creative autonomy led her to a sharp
stylistic redirection in 1967, after which she also
withdrew from the public eye. She has, however,
remained artistically active ever since. Bontecou's
current work reconsiders that early period in her
career and suggests that her artistic concerns of
the 1960s continue to resonate with her across
the intervening decades.[3]

The continuing misrepresentation of her work
by critics led Bontecou to clarify her intentions
and agenda of the early 1960s retrospectively.
Above all, Bontecou asserted that she responded
angrily in her work to the specter of war that
loomed in the 1960s and to her personal memo-
ries of her upbringing during World War II. She
recalled, "I used to work with the United Nations
program on the short-wave radio in my studio. I
used it like background music, and, in a way, the
anger became part of the process."[4] To her, how-
ever, there was an important division among her
works between what she termed "open work" and
"war equipment." Explaining the former, Bonte-
cou said, "I'd get so depressed [with the horrors
of the world] that I'd have to stop and turn to
more open work, work that I felt was more opti-
mistic—where, for example, there might be just
one single opening, and the space beyond it was
like opening up into the heavens, going up into
space, feeling space."[5] Whereas her war machines
are characterized by saws, grills, and blades—
recognized in recent years for their "sinister"
quality—the smoother, rounded forms of the
studies that constitute this 1964 drawing are
more hopeful than militaristic.[6] Bontecou's draw-
ing engages us by virtue of its multifarious and
evolutionary nature; it is not a linear narrative but
an eclectic distillation of experience and insight.

Bontecou's untitled drawing constitutes an im-
portant documentation of her ongoing creative
process and artistic range. Inspiration abounds on
Bontecou's sheet, as she interspersed small
sketches of insects and crustaceans with detailed
studies of her sculpture, melding the two together
in places. This vibrant creative ecosystem recalls
the artist's own description of her inspirations in
the natural world. Looking at her drawing, we
have the impression of looking down at the mud
flats of Nova Scotia, where Bontecou spent time as
a child, and observing their inhabitants.[7] In Bonte-
cou's creative ferment (or firmament) in the nearly
twenty separate sketches on this sheet, she dy-
namically portrayed the manifold sources that her
sculptures invoke. With the gamut of Bontecou's
references juxtaposed, we discern the cockroach's
articulated body and the crab's claw in even her
most abstracted sketches. In the light of her draw-
ing, Bontecou's "symbiotic" sculptural oeuvre
from the period is perhaps more accurately char-
acterized as a fusion of nature and modernity than
as an interpretation of female anatomy.[8]

Perhaps more than most of Bontecou's draw-
ings from this period, this untitled work under-
scores her stylistic modernity. In 1964 the artist
reached the pinnacle of her early reputation when
she received a commission from architect Philip
Johnson to create a major installation for a stair-
case in the lobby of the New York State Theater at
Lincoln Center, where it still hangs (fig. 97). De-
spite several elements of the drawing that might
relate specifically to that commission, Bontecou
does not recall that the drawing was a study for
the sculpture.[9] The artist has elaborated, "Many of
my drawings at that time [were] and still are work
drawings for different sculptures. Many elements
in the drawings are used in various ways over the
years."[10] Although this particular drawing may
not have directly contributed to her New York
State Theater commission, it integrates the mod-
ernist considerations present in that sculpture
with an awareness of the contemporary architec-
tural contexts of many of her works. That aware-
ness manifested itself most visibly in the
rectilinear grid of the graph paper on which she
drew. Bontecou's success at contextualizing her
work may be measured by Johnson's delighted
appraisal after the sculpture's installation: "Lee
Bontecou seems to have had an empathy (which
she denies possessing) for the space and coloring
[of the theater]. Her piece fits as well as a baroque
statue in the niche of a baroque hall. The stair
hall is a better stair hall for her efforts."[11] Al-
though potentially derogatory from the artist's
standpoint, Johnson's appreciation parallels the
artist's integration of her sculptures' modern con-
texts into her working method.

MDM

Fig. 97. Lee Bontecou, *Untitled*, 1964, welded
steel, canvas, epoxy, resin, and Plexiglas, 167.6 ×
650.0 x 61.0 cm (66 x 256 x 24 in.). Lincoln Cen-
ter for the Performing Arts, Inc., New York State
Theater; gift of the Albert A. List Foundation, Inc.

75 Eva Hesse, 1936–1970

Untitled, 1964

Opaque and transparent watercolor, pen and black ink, felt-tip marker, and crayon on wove paper, 57.0 × 72.3 cm (22⅜ × 28½ in.)

Signed and dated, in pen and ink, lower center: Eva Hesse 1964

Purchased through gifts from the Lathrop Fellows; W.2004.1

© The Estate of Eva Hesse. Hauser & Wirth Zurich London

PROVENANCE
The artist; given to a private collector, 1965 or early 1966,[1] to Senior and Shopmaker Gallery, New York; sold to present collection, 2004.

Fig. 98. Eva Hesse, *And He Sat in a Box*, 1964, paper collage with ink and opaque and transparent watercolor on paper, 76.1 x 56.0 cm (30 x 22 in.). Ulmer Museum, Germany. © The Estate of Eva Hesse / Hauser & Wirth Zurich London

The year 1964 was pivotal in the too-short life of Eva Hesse. In June she and her sculptor husband, Tom Doyle, were lured by the opportunity of "an unusual kind of 'Renaissance patronage'" to leave their Bowery studios and relocate temporarily to Kettwig-am-Ruhr, a small town halfway between the cities of Düsseldorf and Bochum in West Germany.[2] Hesse spent the next fourteen months working in a bright, skylit space on the top floor of an enormous textile factory, months during which she was plagued by physical ailments, self-doubt, and devastating nightmares.[3] The Yale University–trained artist at first found it extraordinarily difficult to make oil paintings under these conditions, but her drawing practice flourished. In diaries from this time she confided a mounting sense of artistic breakthrough with both exasperation — "I have been working harder than ever in my life and under a lot of pressure"[4] — and excitement — "Worked like crazy, did 5 more groovy drawings."[5] In August 1965 she was given her first one-person museum show at the Studio für Graphik in Düsseldorf, which passed without much critical notice.[6] Toward the end of her European sojourn, however, Hesse spontaneously began making sculpture out of industrial materials — twine, plaster, wire mesh, electrical cord — that she found lying about the factory.[7] With these self-described "non-beautiful" elements she embarked on what would become her lasting and much-admired contribution to postminimalist art.[8]

The ambitious, serial sculpture practice for which Hesse is best known today traces its origins back to Kettwig and, specifically, to works such as this one. In a long letter to a trusted friend, the American conceptual artist Sol LeWitt, Hesse classified her German drawings in a way that surely connects them to the wall reliefs and freestanding sculptures that followed:

I have done drawings. Seems like hundreds although much less in numbers. There have been a few stages. First kind of like what was in past, free crazy forms — well done and so on. They had wild space, not constant, fluctuating and variety of forms. . . .

2nd Stage. Contained forms somewhat harder[,] often in boxes and forms become machine like, real like, as if to tell a story in that they are contained. . . .

3rd Stage. Drawings — clean, clear — but crazy like machines, forms larger and bolder, articulately described. So it is weird. They become real non-sense.

So I sit now after two days working on a dumb thing which is 3 dimensional — supposed to be in continuity with the last drawings.[9]

Squares of irregular sizes proliferate across the surface of this impressive, mixed-media drawing. Wildly energetic line animates the left edge of the sheet, while the forms that hover in the upper right look forward to the laconic latex sculptures that predominate in her later work. All of these loosely geometric forms, with their jigsaw puzzle–like sense of containment and absurdist repetitions, link this work to the "second stage" of Hesse's effort, as outlined in the correspondence with LeWitt. The drawing was probably done in late 1964, therefore. Other works on paper from this moment demonstrate the artist's preoccupation with cellular progressions and fluid, improvisational markings of different densities, tension, and value. Occasionally these compositions are further enlivened by bold directional arrows and readable texts suggesting narratives (fig. 98: *And He Sat in a Box*). Here, instead, stiff calligraphic forms and childlike numerals rendered in black ink gently dissolve into pools of transparent watercolor, conjuring an elusive sense of order, an eccentric and highly personal periodic table.[10] Subsequent drawings — at first carefully delineated and then almost numbingly obsessive — stand out as exercises in control and monochromatic nuance. Those later, iconic images often served as studies for the large-scale sculptural projects that consumed the artist during the last five years of her life.[11]

On her return from Germany, the artist gave this drawing to a friend, who kept the work unframed and unmatted in a drawer until long after Hesse's death from cancer in 1970. For this reason, Untitled — with its marginal thumbprints, stray spatter, and nearly pristine surface — represents a wholly fresh glimpse at a vulnerable, transitional moment in Eva Hesse's career.

DRC

76 Charles Wilbert White, 1918–1979

Exploding Star (Awake), 1965

Charcoal on (Crescent) illustration board, 102.0 × 76.4 cm (40⅛ × 30¹⁄₁₆ in.)

Signed and dated, lower right: Charles White '65

Purchased through a gift from Frank L. Harrington, Class of 1924; D.968.24

PROVENANCE
ACA Galleries, New York; sold to present collection, 1968.

EXHIBITIONS
Heritage Gallery, Los Angeles, 1965 (no cat. located); Hopkins Center Art Galleries, Dartmouth College, Hanover, N.H., *Six Black Artists*, 1968 (no cat. no.).

REFERENCE
Lucinda Heyel Gedeon, "Introduction to the Work of Charles W. White with a Catalogue Raisonné" (master's thesis, University of California, Los Angeles, 1981), 169, 300 (illus.), cat. D187.

The byword often invoked to describe Charles White's art is dignity. Throughout his life and career, which included the socially turbulent 1960s, this leading African American artist persisted in the belief that the human spirit is basically good, and he strove to identify and depict universal symbols that would inspire viewers of all races. His masterful draftsmanship—monochromatic drawing was his primary medium—set him apart from his contemporaries and appealed to diverse audiences during a challenging period in American history. As African American artists and art students searched for direction in the predominantly white art world at midcentury, White offered a positive example that became a pillar of inspiration to peers and students alike.

By the 1960s, when he created *Exploding Star,* White was reaching the height of his fame. In 1956 he had relocated from New York to Los Angeles, a move that marked a substantial stylistic shift in his work. Art historian Lucinda Gedeon has articulately described the nature of that transition: "he had given up all traces of his earlier stylization and the formal complexity of his work of the '40s and was working toward a greater simplicity and depth of feeling. His new environment and more or less self-imposed isolation gave him more time for introspection, making White more the philosopher and less the political activist. As a result his work became more symbolic of and less a chronicle of the times."[1] Contemporary Janice Lovoos added, "Days, sometimes months of contemplation, of re-evaluating, and reworking ideas, may precede the actual physical work."[2] *Exploding Star* has an aura of careful premeditation and reflection, both in its style and in its subject. Its rapturous flames balance strong, deliberate design and unconstrained naturalism, conveying the artist's depth of feeling.

Exploding Star is a highly representative work, relating closely to White's *J'Accuse! No. 3* (1965, private collection). The rich textures and beautifully modeled figures of both drawings evoke a sublime transcendence of the individual. The artist described his working process: "I often work in charcoal, layers of it, because this gives richness. I take a little dry color and smear it wherever I like with a chamois or Kleenex to obtain a tone or certain effects. I work back and forth from dark to light, establishing my dark tones first. When you work on top of charcoal that has been 'fixed,' it has a body. I use this way of working, not just for the sake of darkness, but to give the drawing a particular quality."[3] Here, that quality is a sense of emergent potential. The figure's lips nearly erupt with voice or song in a manner similar to White's earlier depictions of singers with their upward gazes and projecting energies. If anything, *Exploding Star* is even more subtle and potent than his earlier singers, by virtue of its tension between the relative stillness of the figure and the power that she exudes.[4]

White's use of drawing was itself symbolic. Artist Benny Andrews remarked in 1980 that for many poor African American students, the cost of art materials was prohibitive. Consequently, aspiring artists would often rely on their drawings to establish themselves. White almost single-handedly validated the medium as a primary means of artistic expression, so when asked about their fields of interest, young artists could legitimately reply, "I want to be a drawer like Charles White."[5] He inspired with his subjects, his convictions, his mastery, and even his medium.

MDM

77 Agnes Martin, 1912–2004

Untitled, 1967

Pen and red and gray ink and gray wash on wove paper, 30.2 × 29.6 cm (11⅞ × 11¹¹⁄₁₆ in.)

Inscribed, in graphite, upper center: Top; inscribed, in graphite, lower left: 77 [inventory number, Robert Elkon Gallery]; signed and dated, in pen and ink, on frame backing: a. martin / 1967

Purchased through the William S. Rubin Fund and the Contemporary Art Fund; D.2003.51

PROVENANCE
The artist; Robert Elkon Gallery, New York; Pace Gallery, New York; private collection, New York; private collection, Switzerland; represented by James Kelly Contemporary, Inc. (art dealer), New York, by 2003; sold to present collection, 2003.

From the early 1960s through 1967, Agnes Martin made a series of "square" drawings, many of which contained lines or marks that delineated a grid. She also worked concurrently on related paintings, in which she marked lines of the grid in pencil onto the canvas. In 1967, feeling burdened by the growing demands of her career, Martin retired from making art and abruptly left New York City, where she had lived since 1957.[1] She traveled in Canada and the western United States for over a year, finally settling on a mesa outside Cuba, New Mexico, where she turned to other pursuits, mainly building her home and making notes on her thoughts about life and her art. In retrospect, the transcendental purity of her mature work before 1967 was the prelude to what followed in her writings.[2] In New Mexico, her life was as spare and disciplined as her art had been; she lived without running water or electricity and spent much of her time alone. She desired to create a balanced life — free of ego and dedicated to getting past the existential fear caused by isolation and solitude. She did not draw or paint for six years, then resumed working in 1974.[3]

During the crucial decade of the 1960s, Martin's art was inspired by a personal and deeply felt philosophy that was influenced by Taoism and Zen precepts as well as the Bible. Through her work she strove to reach into what she later termed "the inner mind," detached from ego and pride. Nonobjective art was a means toward this transcendent state in part because its language is silent and meditative, part of an immaterial reality that is separated from the concrete environment of the world.[4] Although she has been associated with minimalism — the movement whose ascendance in the art world in the 1960s mirrored her own — the spiritual dimension of Martin's art came from an entirely different ethos. Unlike the minimalists, Martin was not concerned with the art object and its place within art historical discourse but with how her work caused the viewer to experience the visual. In both paintings and drawings, she concentrated the eye and mind on the subtle variations of her lines and the patterns they formed on the surface of the canvas or paper. These slight perceptual changes in her work transcend language. The making and the seeing itself becomes, in Martin's words, a manifestation of the "perfect," even if the work itself is not.[5]

In speaking about her drawings in 1967, Martin stated: "My formats are square, but the grids never are absolutely square, they are rectangles a little bit off the square, making a sort of contradiction, a dissonance, though I didn't set out to do it that way. When I cover the square surface with rectangles, it lightens the weight of the square, destroys its power."[6] By concentrating on the square and grid during this period, she was able to explore the seemingly endless permutations of line and proportion, even subtle gradations of color, within a restricted range of forms. The grid's lack of hierarchy appealed to Martin. No one element was dominant over the other; there is a perfect balance of elements within the field of vision. The untitled drawing in the Hood collection demonstrates Martin's sensitivity to her materials and the subtlety of her touch. She has laid a light wash on the paper and used guide marks outside the square to set up the drawing. Within the square she has drawn a grid whose proportions result in vertical rectangles. Some of the vertical lines are softer than others, creating a slight spatial rhythm as they progress across the square. Other lines are gone over twice. At first glance the eye does not perceive the vertical red ink lines, but eventually they become more prominent. Martin apparently had her drawings from this period matted right to the edge of the square, eradicating any peripheral distraction or indication of process.[7] The focus is simply the square with its mesmerizing network of lines.

KWH

78 Jacob Lawrence, N.A., 1917–2000

Flight II, 1967, painting for illustration (in slightly modified form) in *Harriet and the Promised Land*

(New York: Windmill Books, Simon and Schuster, 1968; reprint, New York: Simon and Schuster, 1993)

Opaque watercolor and tempera over graphite on wove paper, 39.2 × 35.0 cm (15½ × 13⅞ in.)

Signed and dated, lower right: Jacob Lawrence 67; inscribed, lower right: 13

Bequest of Jay R. Wolf, Class of 1951; W.976.204

© Gwendolyn Knight Lawrence / Artists Rights Society (ARS), New York

PROVENANCE
The artist; consigned to Terry Dintenfass, Inc. (art dealer), New York, 1968; sold to Jay R. Wolf, New York; bequeathed to present collection, 1976.

EXHIBITIONS
Terry Dintenfass, Inc., New York, *Jacob Lawrence: Paintings for Harriet and the Promised Land*, 1968 (no cat.); Beaumont-May Gallery, Hopkins Center Art Galleries, Dartmouth College, Hanover, N.H., *The Jay Wolf Bequest of Contemporary Art*, 1977 (no cat.); Hood Museum of Art, Dartmouth College, Hanover, N.H., *Works by Jacob Lawrence in the Collection of the Hood Museum of Art*, 1999 (no cat.); The Phillips Collection, Washington, D.C., and others, *Over the Line: The Art and Life of Jacob Lawrence*, 2001–3 (no cat. no.).

REFERENCES
Jacob Lawrence, *Harriet and the Promised Land* (New York: Windmill Books, Simon and Schuster, 1968; reprint, New York: Simon and Schuster, 1993), n.p.; Peter T. Nesbett and Michelle DuBois with Stephanie Ellis-Smith, *Jacob Lawrence: Paintings, Drawings, and Murals (1935–1999): A Catalogue Raisonné* (Seattle: University of Washington Press, in association with Jacob Lawrence Catalogue Raisonné Project, 2000), 166 (color illus.), no. P67–01–14.

In his art, Jacob Lawrence often coupled past and present, creating powerful visual equivalents in contemporary artistic terms for chapters of African American history that were systematically excluded from mainstream texts. His serial portraits of early African American heroes—including Toussaint L'Ouverture, Frederick Douglass, and Harriet Tubman—are among his most compelling works. As a late representative of one of these series, *Flight II* is one of twenty works painted on commission from Windmill Books to illustrate a children's book on Tubman's life.[1] The 1967 series, published as *Harriet and the Promised Land* that same year, was Lawrence's second depiction of the Underground Railroad's legendary conductor.[2] Completed during the civil rights movement of the 1960s, however, these paintings should be interpreted in light of contemporary events. For the artist, Tubman's indefatigable leadership in the abolitionist movement a century earlier offered continuing inspiration as a model for African American resistance of the present day.

Lawrence's knowledge of African American history derived from a number of sources, including oral histories, published accounts, and artistic renderings, which influenced his art. In interviews with art historian Patricia Hills, Lawrence identified two textual sources from which his Tubman series primarily derived—Sarah H. Bradford's *Scenes from the Life of Harriet Tubman* (1869, expanded 1886) and Hildegard Swift's *Railroad to Freedom: A Story of the Civil War* (1932)—while maintaining that other sources inspired him as well.[3] Of these two texts, only Bradford's book includes a scene that relates to Lawrence's composition:

With a daring almost heedless, [Tubman] went even to the very village where she would be most likely to meet one of the masters to whom she had been hired; and having stopped at the Market and bought a pair of live fowls, she went along the street with her sun-bonnet well over her face, and with the bent and decrepit air of an aged woman. Suddenly on turning a corner, she spied her old master coming towards her. She pulled the string which tied the legs of the chickens; they began to flutter and scream, and as her master passed, she was stooping and busily engaged in attending to the fluttering fowls. And he went on his way, little thinking that he was brushing the very garments of the woman who had dared to steal herself, and others of his belongings.[4]

Flight II clearly integrates Bradford's account with those of others to create a new version, perhaps representing the moment just after Tubman's former master has passed and appending two fleeing children as surrogates for the youthful readership of the final publication. Bradford's description differs markedly, however, from the text that accompanies *Flight II* in *Harriet and the Promised Land:* "They gave Harriet chickens / To disguise / The runaway slave / From spying eyes."[5] Even this minimal narrative introduces greater nuance to the image than it contains on its own, adding an element of collusion to Tubman's ruse. Collaborative, too, is Lawrence's visual retelling of Tubman's tale, abetted by storytellers, authors, and artists past and present.[6]

The grace of *Flight II* derives from its deceptive simplicity. Unlike Lawrence's first Tubman series of 1940, which emphasized a more abstracted, symbolic aspect of Tubman's struggles, this later visual account focuses on the figure of Tubman herself and employs a greatly essentialized realist aesthetic with buildings and forms reduced to geometric planes of color. Here, we immediately perceive Tubman striding across the foreground with her two young charges, despite her nominal concealment by the two flailing chickens.[7] Her strong hands, surreptitious backward glance, and long step convey power and confidence.[8] Notably, the mouths of the children in the published version of *Flight II* (fig. 99) have been extended into smiles, creating an unsettling disparity between their grins and their overall expressions and body language. The malnourished boy in the foreground, for example, his ribs sharply defined and his stomach distended, is transformed from an anxious escaped slave into a parodic fool.[9] Even this slight alteration dilutes both the children's reliance on Tubman and the gravity of their situation, and it underscores the psychological aspect of Lawrence's original composition. Although symbolism takes a secondary role in this more naturalistic rendering of Tubman's flight, as it did not in Lawrence's 1940 series, the frequent recurrence of motifs such as the guiding star unifies the series and reinforces the hope and inspiration that Lawrence found in the life story of this legendary heroine.

MDM

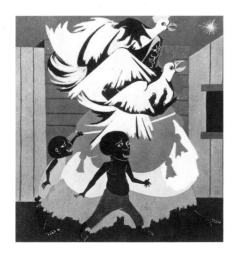

Fig. 99. Jacob Lawrence, *They Gave Harriet Chickens*, published in Jacob Lawrence, *Harriet and the Promised Land* (reprint, New York: Simon and Schuster Books for Young Readers, 1993), n.p. Reprinted with the permission of Simon and Schuster Books for Young Readers, an imprint of Simon and Schuster Children's Publishing Division. Copyright © 1968, 1993 Jacob Lawrence. © 2004 Gwendolyn Knight Lawrence / Artists Rights Society (ARS), New York

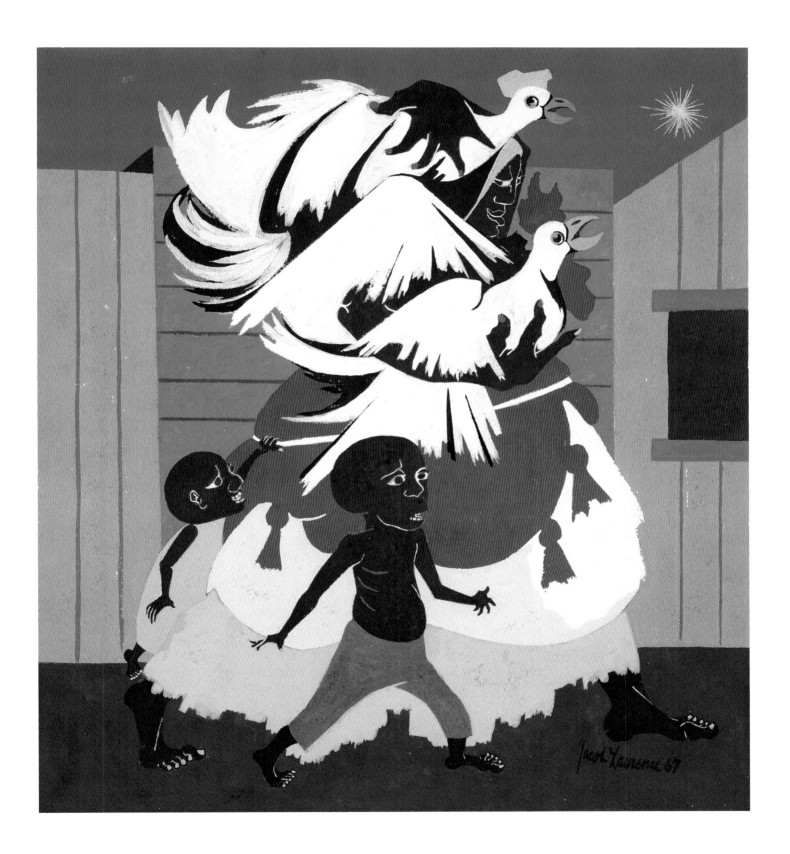

79 Ivan Albright, N.A., 1897–1983

Persepolis, Iran, 1967

Watercolor and brush and ink on light-weight cardstock, 38.4 × 50.5 cm (15⅛ × 19⅞ in.)

Signed and dated, lower left: 1967 Albright; inscribed, lower center: Persepolis; inscribed, lower right: Iran; inscribed, in ink, on verso: Persepolis, Iran

Gift of Josephine Patterson Albright; W.986.56.32

PROVENANCE
The artist; to Josephine Patterson Albright (artist's wife), Woodstock, Vt.; given to present collection, 1986.

EXHIBITION
Hood Museum of Art, Dartmouth College, Hanover, N.H., and others, *Ivan Albright as Draftsman and Printmaker,* 1987–88, no. 49.

REFERENCE
Phylis Floyd, *The Ivan Albright Collection* (Hanover, N.H.: Hood Museum of Art, 1987), 13 (mistakenly listed as 1969).

Fig. 100. *Western Guardian Bull, Portico of Hundred Columns' Hall, Persepolis, Iran,* reproduced by permission from Ann Britt Tilia, *Studies and Restorations at Persepolis and Other Sites of Fars* (Rome: Istituto Italiano per il Medio ed Estremo Oriente, 1972), frontispiece, pl. A

Ivan Albright is best known for revolutionizing the *vanitas* genre—in which viewers are reminded of their mortality—for the twentieth century.[1] Although his work is not readily associated with a particular aesthetic movement of his time, the artist distinguished himself by developing an abject mode of expressionism in the late 1920s that he practiced until his death in 1983.[2] With fastidious technique, the artist painted primarily in oil, depicting still lifes and human models through the merciless lens of time.[3] As French modernist Jean Dubuffet once observed of Albright's art, "A crumbling, rotting, grinding world of excrescences is offered to us in place of the one in which we had believed we lived."[4] Time and its passage were arguably Albright's main subjects, well suited to his laborious style; he sometimes required more than a decade to complete a single oil painting. Given his fascination with the ravages of time, Albright's interest in ancient ruins like those in *Persepolis, Iran* appears natural. Despite his claim in 1950 that "Traveling around the world wouldn't move me any more than sitting right here in my studio,"[5] within a decade he was visiting vestiges of ancient civilizations at the farthest reaches of the earth on an almost annual basis and continued to do so throughout his career.[6] With a parallel, though inverse logic, he rendered the ancient sites that he visited in spontaneous, pellucid watercolor, whereas at home he was known to dissect a single modern object with his fine oil brushes over the course of weeks or even months.[7]

On the surface, Albright's watercolors could not be much further removed from his oil painting technique and appear to have offered the artist a reprieve from the intensity of his work in oil.[8] Whereas his oils are meticulous and dark, his watercolors are fluent and brilliant; whereas his oils are dense with philosophical preoccupation, his watercolors are extemporaneous impressions of nature.[9] In *Persepolis, Iran,* however, Albright incorporated a number of stylistic tropes shared by his work in both media, including fragmentation, unified lighting, and allover composition. The first of these, along with the artist's orientalist subject matter, most readily situates this watercolor within conventional Western modernism.[10] Unlike Albright's oil paintings, in which he explored the corruption wrought by time by projecting into the future, visits to sites like Persepolis

enabled him to study the effects of time while remaining firmly in the present. Against a saturated blue sky, Albright's monochromatic depiction of the archaeologically restored bull at least temporarily defies a boneyard of supersized column fragments in the foreground. A photograph of the scene from the same period (fig. 100) shows how the artist has expanded the scale of destruction at the bull's feet to suit his purposes. In Albright's watercolor, the ongoing archaeological restoration of Persepolis is imperceptible, integrated instead into the gradual process of deterioration. The emblematic bull's fate, like that of Albright's subjects in his oil paintings, is inevitable.

In Iran, the restoration of the portion of the ancient Persian capital of Persepolis shown in Albright's watercolor began in September 1965 and lasted into the early 1970s. The effort was conducted by an Italian expedition under the sponsorship of Iran's shah, Mohammad Reza Shah Pahlavi.[11] Like the several other major excavations and restorations under way in Iran at the time, the project was motivated by the shah's desire to legitimize his reign by association with the glory of the nation's pre-Islamic past.[12] Persepolis was the ceremonial center of the Persian Achaemenian monarchy beginning with Darius the Great, who initiated much of its major construction during his reign of 522–486 B.C.E. When Albright visited the site late in 1967, the monumental guardian bull shown in his watercolor had only just been reconstructed.[13] Because of its relatively complete state of preservation and its craftsmanship, the bull quickly became the site's hallmark. The restored bull's metaphoric value for the shah was manifold but particularly significant for its ancient symbolism of the monarch as benevolent shepherd.[14] The bull also represented hubris, however. Its large scale was representative of the vast Hall of a Hundred Columns, for which it was part of the portico.[15] Built under Darius's successors Xerxes I and Artaxerxes I, the hall exceeded in grandeur even Darius's *apadana,* or main hall, seen elevated behind the bull in Albright's watercolor. The ancient Achaemenid and modern Pahlavi dynasties shared both ambition and a precarious hold on power, however, and for both the construction of the Persepolis bull portended their demise.

MDM

1951 allright Persepolis Iran

80 Romare Howard Bearden, A.N.A., 1911–1988

Two Figures, 1968

Collage of commercially prepared, coated, colored paper, prepared photographic paper, and transparent and opaque watercolor on cream wove paper, with additions of graphite and black ink on card, mounted on smooth-surfaced plywood panel, 50.8 × 40.8 cm (20 × 16¹⁄₁₆ in.)

Signed, in red ballpoint, upper left: romare bearden

Gift of Mr. and Mrs. Raphael Bernstein; P.977.179

PROVENANCE
The artist; consigned to Cordier and Ekstrom, Inc. (art dealer), New York, January 1969; sold to Mr. Raphael Bernstein, New York, January 1969, consigned to Cordier and Ekstrom, Inc., New York, by December 1974; returned to Mr. and Mrs. Raphael Bernstein, Ridgewood, N.J., 1977; given to present collection, 1977.

EXHIBITIONS
Hood Museum of Art, Dartmouth College, Hanover, N.H., *Romare Bearden: Collages,* 1998 (no cat.); Kalamazoo Institute of Arts, Kalamazoo, Mich., *Art and the American Experience,* 1998, no. 3.

REFERENCE
Jan van der Marck, *Art and the American Experience* (Kalamazoo, Mich.: Kalamazoo Institute of Arts, 1998), 6, 8.

Romare Bearden was born in Charlotte, North Carolina, and raised in Harlem and Pittsburgh during the 1910s and 1920s.[1] His childhood and years as a young man in these northern cities would become the center of his art, which was fueled by memories of urban African American life and culture as well as the strong impressions created by his visits South to see relatives. Bearden's early paintings were figurative images with southern themes. Like many other artists of his generation, he was influenced by the graphic mural paintings of the Mexican artists José Clemente Orozco and Diego Rivera, who were working in New York in the mid-1930s.[2] He was almost fifty years old and a practicing artist for twenty-five years when he first started to experiment with collage in the late 1950s and early 1960s.[3]

In the summer of 1963 Bearden met with a group of black artists who wanted to contribute to the emerging civil rights movement through their art. Bearden suggested that they work collaboratively on a photomontage but ended up as the sole member working in this method. The artist had an instinctive feel for arranging bits of photographs and paper, and dynamic images flowed out of his imagination and memory. In these early works Bearden created a small collage and then enlarged it via photostat, calling the resulting work a "projection." When he first exhibited these projections at his gallery in the fall of 1964, the response was enthusiastic. Bearden's first museum show soon followed at the Corcoran Gallery in Washington, D.C., in 1965. Appearing as they did during the height of the civil rights struggle, when much of the nation was focused on the inner cities and the legacy of slavery and segregation, Bearden's images of black life in the rural South and industrial North touched a chord with black and white audiences alike.

His success was also economic, enabling Bearden to retire in 1967 from his day job as a New York City social service caseworker. *Two Figures* dates to the year after this transition to full-time artistic work, and it reflects Bearden's gradual move away from his earlier method of radically shifting the scale between different details within the faces, bodies, and background. In *Two Figures* the faces are simply colored areas of paper with no detail, a change from the photographic faces of his earlier work. The collage's subject is the impending departure of a male figure; Bearden frequently worked on images that reflected on the mass migration of young blacks to the North to find work and the resulting fragmentation of families.[4]

The focus of the composition is a man and a woman standing near a corniced window, its left side made up of either cinderblocks or granite. Bearden rendered the ground and architectural detail with monochromatic sections of photostat reproductions. He set the figures partially against a wall that is made up in part of bright ocher paper, perhaps representing the sun falling on a building's exterior. As in many of Bearden's images, the female wears a patterned kerchief, but her face is a cutout of blank brown paper and her dress a solid blue, its right jagged edge reinforcing the movement of her photographic hand as it grabs the arm of the male figure. A significant narrative detail in this collage is the man's satchel—without doubt he is leaving the woman, perhaps to work in a factory in the North or to return South to his original home. A typical Bearden detail is the expressive blue wash of the piece of paper, which perfectly mimics faded blue jeans, standing out among the flat commercial paper and photostat fragments.

Unlike some of his other collages, such as *The Dove* (1964, The Museum of Modern Art, New York), this work speaks more strongly of narrative than of place; it is also more restrained, its angles rigidly horizontal and vertical. Though the flat color areas and photo-based sections of the background jar with one another, *Two Figures* lacks some of the dynamism and energy of his contemporaneous work. Nevertheless, it lies at a juncture in the development of Bearden's oeuvre. The artist was pushing himself toward more integrated scenes that contained a greater proportion of wash-colored sections of paper as well as more bright patches of commercially prepared paper, an indication that he was expanding his visual and his artistic vocabularies.

KWH

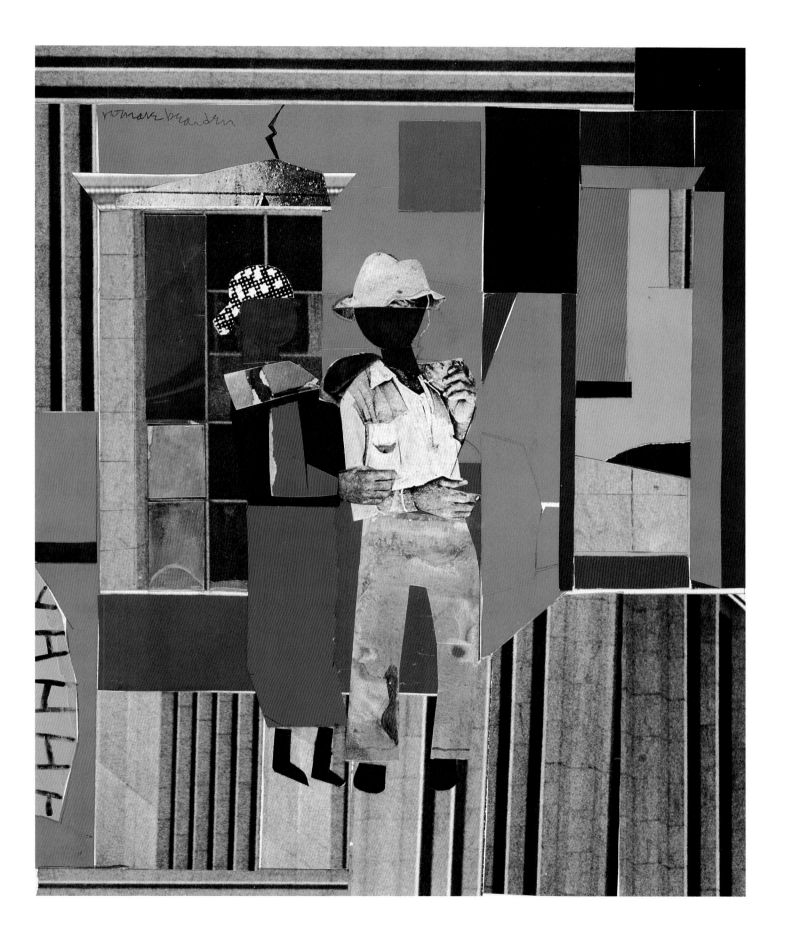

Further Selected American Drawings and Watercolors in the Collection of the Hood Museum of Art

The following selection of works surveys the broad scope of American drawings and watercolors in the collection of the Hood Museum of Art dating through 1969. Its objective is to provide general readers, students, and scholars with a starting point for further study of the collection. The listing is not comprehensive, however, and should be employed in conjunction with the preceding entries and the museum's complete on-line database, accessible through the Hood's website, www.hoodmuseum.dartmouth.edu.

The list is organized alphabetically by artist's last name, then by title; when an artist's name is not known, the work appears under the designation "unidentified artist." For the dimensions of works in the following list, height precedes width. Works preceded by an asterisk (*) will be included in the expanded installation of *Marks of Distinction* at the Hood Museum of Art venue.

When a work of art included in the checklist is used previously in the catalogue as a comparative or textual illustration, it is not reproduced in the following list. Instead, a figure number indicates where an illustration of the work may be found in the catalogue.

Four artists in this list are represented in the collection by especially large bodies of work: Ivan Albright, Ilse Martha Bischoff, Thomas George, and Paul Starrett Sample. These artists' entries are accompanied by an indication of the scope of the museum's collection of their works to facilitate future study.

Ivan Albright, N.A., 1897–1983
Albright is represented by 208 drawings and watercolors in the Hood Museum of Art's collection, most of which document his extensive travels (and most dating after 1969).

Tel Aviv, Israel, 1968
Opaque watercolor on cardstock, 40.5 × 42.5 cm (15¹⁵⁄₁₆ × 16¾ in.)
Gift of Josephine Patterson Albright; W.986.56.22

John Taylor Arms, N.A., 1887–1953
The Golden Web, Venice, 1929
Graphite on cardstock, 32.2 × 35.0 cm (12¹¹⁄₁₆ × 13¾ in.)
Gift of Katharine T. and Merrill G. Beede, Class of 1929; D.988.58.1

James Auchiah, Kiowa/American, 1906–1975
Old Time War Dancer, 1930
Opaque watercolor on green wove paper, 24.0 × 16.8 cm (9⁷⁄₁₆ × 6⅝ in.)
Gift of Abby Aldrich Rockefeller; W.935.1.76

Milton Avery, 1885–1965
**Autumn Sea,* 1948
Transparent and opaque watercolor on wove paper, 58.2 × 78.5 cm (22⅞ × 30⅞ in.)
Gift of Stephen F. Mandel, Class of 1952; W.994.32
© 2004 Milton Avery Trust / Artists Rights Society (ARS), New York

Awa Tsireh (Alfonso Roybal), Pueblo/American, 1898–1955
Rainbow and Deer Design, before 1931
Transparent and opaque watercolor over graphite on wove (Canson & Montgolfier) paper, mounted on board, 48.1 × 62.9 cm
(18¹⁵⁄₁₆ × 24¾ in.)
Gift of Abby Aldrich Rockefeller; W.935.1.96

Peggy Bacon, N.A., 1895–1987
Morris Ernst, 1934
Crayon on wove paper, 27.2 × 19.5 cm
(10¹¹⁄₁₆ × 7¹¹⁄₁₆ in.)
Purchased through the Hood Museum of Art Acquisitions Fund; D.2002.18.1

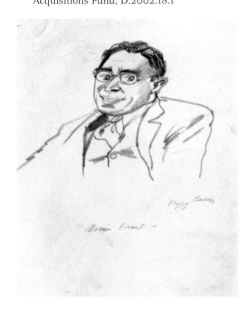

Morris Ernst, Reading, 1934
Crayon on wove paper, 27.2 × 20.9 cm
(10¹¹⁄₁₆ × 8¼ in.)
Purchased through the Hood Museum of Art Acquisitions Fund; D.2002.18.5

Too Fat to Be Happy, n.d.
Black crayon on wove paper, 35.5 × 24.5 cm
(14 × 9⅝ in.)
Gift of Helen Farr Sloan; D.952.127

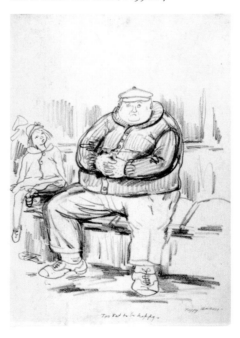

Leonard Baskin, 1922–2000
* *Janus* (recto); *Study for "Abraham and Isaac"* (verso), 1961
Recto and verso: ink wash over graphite on heavy wove (Grumbacher) paper, 57.0 × 78.3 cm
(22⁷⁄₁₆ × 30⅞ in.)
Gift of Dr. Frederick R. Mebel, Class of 1935, in honor of Churchill P. Lathrop; W.978.154

Gifford Reynolds Beal, N.A., 1879–1956
Barnum and Bailey Circus (recto); *Figure Studies* (verso), n.d.
Recto: opaque watercolor over graphite on cardboard; verso: crayon, 29.9 × 40.0 cm
(11¾ × 15¾ in.)
Gift of Abby Aldrich Rockefeller, W.935.1.4

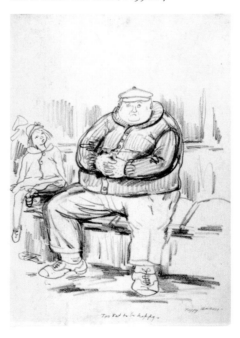

** Riverside Drive*, n.d.
Transparent and opaque watercolor over graphite
 on blue-gray laid paper, 24.1 × 31.4 cm
 (9½ × 12⁵⁄₁₆ in.)
Gift of Abby Aldrich Rockefeller; W.935.1.7

Romare Howard Bearden, A.N.A., 1911–1988
Palm Sunday Procession, 1967–68
Collage of paper and synthetic polymer paint on
 composition board, 142.2 × 111.8 cm
 (56 × 44 in.)
Gift of Jane and Raphael Bernstein; P.986.77.4
© Romare Bearden Foundation, Inc. / Licensed
 by VAGA, New York, NY

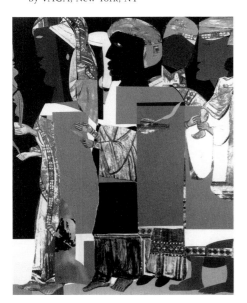

George Wesley Bellows, N.A., 1882–1925
Nude Reclining, n.d.
Crayon on wove paper, 25.4 × 35.7 cm
 (10 × 14¹⁄₁₆ in.)
Gift of A. Conger Goodyear; D.962.69.1

William Harry Warren Bicknell, 1860–1947
Untitled, 1927
Charcoal on wove paper, 34.9 × 51.2 cm
 (13¾ × 20⅛ in.)
Gift of Professor Varujan Boghosian;
 D.984.40.2F

Ilse Martha Bischoff, 1901–1990
Bischoff is represented by 127 drawings and
watercolors in the Hood Museum of Art's collec-
tion, many of which are studies for book illustra-
tions, figure sketches, and finished still lifes.

Fred Barber, No. 1, 1951
Graphite and casein on discolored blue laid
 paper, 42.2 × 32.9 cm (16⅝ × 12¹⁵⁄₁₆ in.)
Bequest of Carola B. Terwilliger; D.986.37.21

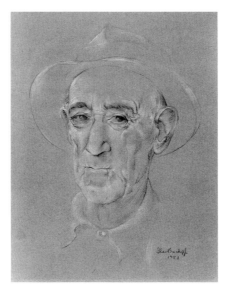

** Still Life: Lemons*, 1958
Casein over graphite on wove paper, toned gray
 by artist, 21.4 × 36.0 cm (8⁷⁄₁₆ × 14⅛ in.)
Purchased through a gift from the Friends of
 Dartmouth Library and the Julia L. Whittier
 Fund; W.958.245

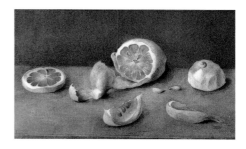

Weeds and Feather, c. 1963
Casein on wove paper, toned brown by artist,
 48.8 × 33.3 cm (19³⁄₁₆ × 13⅛ in.)
Gift of Carola B. Terwilliger, P.986.37.12

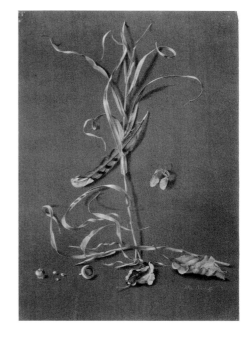

Isabel Bishop, N.A., 1902–1988

** Sleeping Child,* c. 1935

Pen and ink and ink wash over graphite, with
 framing indications in graphite, on wove
 paper, 24.7 × 15.3 cm (9¾ × 6 in.)

Purchased through the Class of 1935 Memorial
 Fund; D.2003.75

Courtesy of the Estate of Isabel Bishop and DC
 Moore Gallery, New York

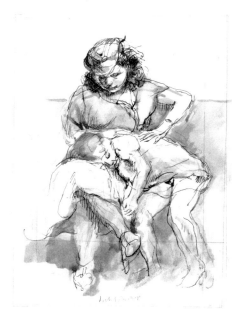

Emil Bisttram, 1895–1976

Indian Dance: The Earth Spirits, 1933

Watercolor over graphite on wove paper,
 61.0 × 48.5 cm (24 × 19¹⁄₁₆ in.)

Gift of Mrs. Howard Giles; W.959.71.6

Poppies, 1933

Transparent and opaque watercolor over graphite
 on wove paper, 61.0 × 48.5 cm (24 × 19¹⁄₁₆ in.)

Gift of Mrs. Howard Giles; W.959.71.7

**Taos Mountains,* 1932

Transparent and opaque watercolor over graphite
 on heavy wove paper, 48.3 × 63.5 cm
 (19 × 25 in.)

Gift of Mrs. Howard Giles; W.959.71.4

Julius T. Bloch, 1888–1966

Travelers, c. 1910s

Watercolor and pen and ink over graphite on
 wove paper, 35.0 × 28.8 cm (13¾ × 11⁵⁄₁₆ in.)

Gift of Abby Aldrich Rockefeller; W.935.1.8

Lee Bontecou, born 1931

Untitled, 1964

Graphite on wove graph paper, 42.1 × 54.9 cm
 (16½ × 21⅝ in.)

Bequest of Jay R. Wolf, Class of 1951;
 D.976.217.2

Alfred Thompson Bricher, A.N.A., 1838–1908

Maple — Jefferson, N.H. (recto);
 Franconia Ridge (verso), 1869

Recto and verso: graphite and opaque white
 watercolor on buff paper, 24.8 × 16.9 cm
 (9¾ × 6⅝ in.)

Gift of Mr. and Mrs. Jeffrey R. Brown, Class of
 1961; D.991.21

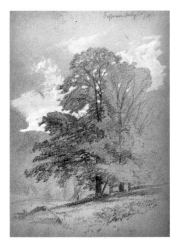

Fidelia Bridges, A.N.A., 1835–1923
* *Pansies*, c. 1875
Graphite on wove paper, 17.1 × 14.5 cm
(6¾ × 5¹¹⁄₁₆ in.)
Purchased through a gift from the Estate of
David Hull, Class of 1960; D.2003.5

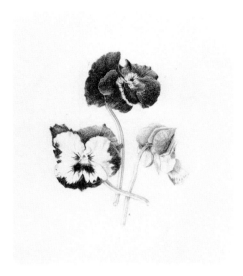

Sarah Broome
* *View on the River Dee near Bala*, 1795
Watercolor over graphite on laid paper,
45.8 × 54.9 cm (18 × 21⅝ in.)
Purchased through the Hood Museum of Art
Acquisitions Fund and a partial gift from Neil
Kamil; W.2004.20

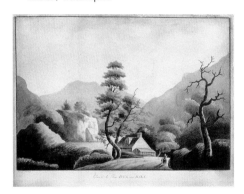

Horace R. Burdick, 1844–1942
Long Lake, 1870
Graphite and ink wash on tan wove paper,
21.2 × 26.3 cm (8⁵⁄₁₆ × 10⅜ in.)
Gift of Robert A. and Dorothy H. Goldberg;
D.986.66.5

Paul Cadmus, N.A., 1904–1999
* *Ilse Bischoff*, 1937
Pen and India ink and graphite on wove paper,
35.5 × 30.2 cm (14 × 11⅞ in.)
Gift of Ilse Bischoff; D.975.85
Courtesy of the Estate of Paul Cadmus and
DC Moore Gallery, New York
(see fig. 36)

* *Puerto de Andraitz: Mallorca (Majorcan
Landscape)*, 1932
Transparent and opaque watercolor over graphite
on wove paper, 23.2 × 28.7 cm (9⅛ × 11¼ in.)
Gift of Ilse Bischoff; W.975.86
Courtesy of the Estate of Paul Cadmus and
DC Moore Gallery, New York

* *Self-Portrait*, 1948
Transparent and opaque watercolor on green
wove paper, 22.1 × 15.8 cm (8¹¹⁄₁₆ × 6¼ in.)
Gift of Ilse Bischoff; D.975.83
Courtesy of the Estate of Paul Cadmus and
DC Moore Gallery, New York

Clarence Holbrook Carter, N.A., 1904–2000
* *Coal Draw*, 1955
Graphite heightened with white opaque water-
color on wove (Strathmore Bond) paper,
20.6 × 28.5 cm (8⅛ × 11¼ in.)
Purchased through the Katharine T. and
Merrill G. Beede 1929 Fund; D.999.30

Mary Cassatt, 1844–1926
Head of a Woman, c. 1901
Pastel on tan wove paper, 39.6 × 29.8 cm
 (15⁹⁄₁₆ × 11¾ in.)
Gift of Mr. and Mrs. Preston Harrison; D.940.55

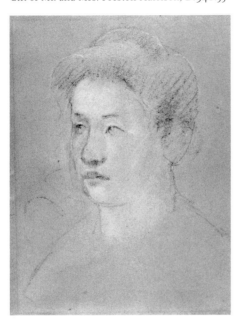

Benjamin Champney, 1817–1907
Cows Drinking in a Brook, 1881
Charcoal heightened with white opaque water-
 color on discolored blue laid paper,
 50.6 × 36.7 cm (19¹⁵⁄₁₆ × 14⁷⁄₁₆ in.)
Gift of Robert A. and Dorothy H. Goldberg;
 D.987.34.10

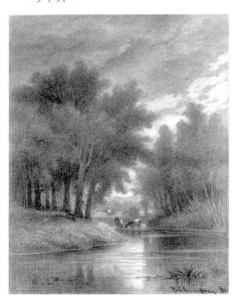

Resting in the Country, c. 1880s
Charcoal heightened with white transparent and
 opaque watercolor on discolored blue laid
 paper, 21.8 × 27.9 cm (8⁹⁄₁₆ × 11 in.)
Gift of Robert A. and Dorothy H. Goldberg;
 D.987.34.14

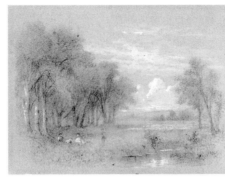

James Chapin, 1887–1975
Outbuildings, 1926
Watercolor over graphite and charcoal on card-
 board, 45.8 × 56.0 cm (18 × 22¹⁄₁₆ in.)
Gift of Abby Aldrich Rockefeller; W.935.1.13

**Chief Killer (Noh-Hu-Nah-Wih), Cheyenne,
Central Plains, 1849–1922**
School at Fort Marion (recto); *Sioux Lodge* (verso),
 1875–78
Recto and verso: pen and ink and colored crayon
 with graphite inscriptions on paper,
 21.9 × 28.6 cm (8⅝ × 11¼ in.)
Purchased through the Robert J. Strasenburgh II
 1942 Fund; D.2003.18.1

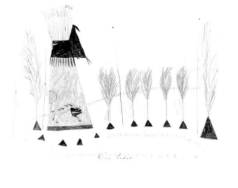

Howard Norton Cook, N.A., 1901–1980
Silver Night, c. 1950
Pastel on wove paper, laid down on particle
 board, 56.0 × 43.8 cm (22¹⁄₁₆ × 17¼ in.)
Purchased through the Julia L. Whittier Fund;
 D.953.73

Russell Cowles, 1887–1979
Harlem Belle, n.d.
Watercolor over graphite on wove (Grumbacher)
 paper, 58.0 × 39.8 cm (22¾ × 15¹¹⁄₁₆ in.)
Gift of the Estate of Russell Cowles, Class of
 1909; W.980.68

Joseph Frank Currier, 1843–1909
Trees, c. 1880
Charcoal on wove paper, 15.9 × 25.6 cm
 (6¼ × 10⅛ in.)
Purchased through the Katharine T. and
 Merrill G. Beede 1929 Fund; D.999.26

Felix Octavius Carr Darley, N.A., 1822–1888
Sketch for Story by James Fenimore Cooper, n.d.
Graphite on wove paper, 11.2 × 15.0 cm
 (4⁷⁄₁₆ × 5¹⁵⁄₁₆ in.)
Dartmouth College Library, Gift of James F.
 Beard Jr. in 1951; D.999.28.17

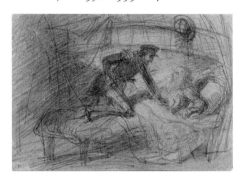

Arthur Bowen Davies, 1862–1928
Female Nude, n.d.
Charcoal on green laid paper, 26.1 × 25.1 cm
 (10⁵⁄₁₆ × 9⅞ in.)
Bequest of Mary Fanton Roberts; D.957.13

Joseph H. Davis, active 1832–37
* *Obed Varney, Age 24,* 1835
Opaque and transparent watercolor and graphite
 on wove paper, 30.9 × 23.0 cm
 (12³⁄₁₆ × 9¹⁄₁₆ in.)
Gift of Nancy and Lane Woodworth Goss, Class
 of 1955; W.997.52

John Stockton de Martelly, 1903–1979
Pensive, 1935
Graphite on wove paper, 28.1 × 21.8 cm
 (11¹⁄₁₆ × 8⁹⁄₁₆ in.)
Gift of Robert S. Engelman, Class of 1934;
 D.960.89.6

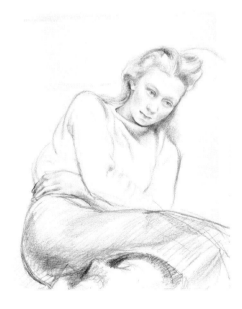

Preston Dickinson, 1891–1930
River Scene, c. 1920s
Graphite and pastel on wove (Michallet) paper,
 24.7 × 44.9 cm (9¾ × 17¾ in.)
Purchased through the Julia L. Whittier Fund;
 D.950.63

Stevan Dohanos, 1907–1985
Company Houses, 1934
Watercolor over graphite on (Whatman) illustra-
 tion board, 49.6 × 99.4 cm (19½ × 39⅟₁₆ in.)
Purchased through the Julia L. Whittier Fund;
 W.950.7

Arthur Garfield Dove, 1880–1946
Study for "Reminiscence," c. 1937
Graphite on textured wove paper, mounted on
 cardstock, 12.7 × 17.8 cm (5 × 7 in.)
Bequest of Jay R. Wolf, Class of 1951; D.976.227

Guy Pène Du Bois, 1884–1958
Illustration for Story by John Galsworthy for
 Harper's Weekly, published 1914
Opaque and transparent watercolor over graphite
 on (Strathmore) drawing board, 50.4 × 36.9
 cm (19¹³⁄₁₆ × 14½ in.)
Gift from Karl Schmidt Collection; W.937.7.2

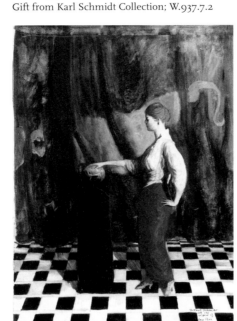

Louis Michel Eilshemius, 1864–1941
Just a Pattern? c. 1930
Pen and ink on wove (Right-of-Way Bond) paper,
 27.9 × 21.6 cm (11 × 8½ in.)
Bequest of Jay R. Wolf, Class of 1951; D.976.188

Philip Evergood, A.N.A., 1901–1973
* *Hoboken,* c. 1930s
Brush and ink and crayon on wove paper,
 33.0 × 47.7 cm (13 × 18¾ in.)
Gift of Elizabeth E. Craig; D.2002.30.5

Jerry Farnsworth, N.A., 1895–1982
Portrait Head, c. 1940s
Graphite and brush and ink on wove paper,
 26.9 × 21.4 cm (10⁹⁄₁₆ × 8⅜ in.)
Gift of Mrs. Hersey Egginton in memory of her
 son, Everett Egginton, Class of 1921;
 D.954.20.648

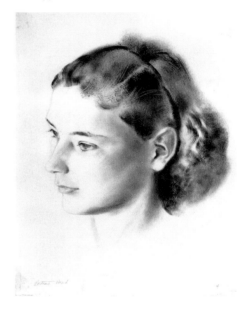

Lyonel Feininger, 1871–1956
Tank Steamer, 1933
Watercolor and pen and ink on laid paper,
 23.3 × 30.4 cm (9³⁄₁₆ × 11¹⁵⁄₁₆ in.)
Gift of Mr. and Mrs. Raphael Bernstein;
 W.977.181
© 2004 Artists Rights Society (ARS), New York /
 VG Bild-Kunst, Bonn

James Edward Fitzgerald, 1899–1971
Sea Gulls, c. 1960s
Transparent and opaque watercolor over graphite
 on wove paper, 57.6 × 74.3 cm
 (22¹¹⁄₁₆ × 29¼ in.)
Gift of Mr. and Mrs. Edgar Hubert; W.974.161

William Merchant Richardson French, 1843–1914
Helen Soule French as a Child, Knitting (recto);
 Sketches of Cats (verso), 1884
Recto: transparent and opaque watercolor over
 graphite on wove paper; verso: graphite,
 17.8 × 15.2 cm (7 × 6 in.)
Charlotte Wood Jewett Collection given by Mr.
 and Mrs. Kenneth E. Jewett; W.981.87

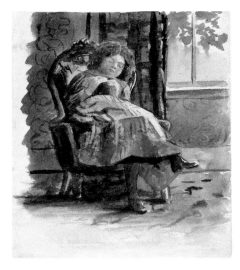

Lucia Fairchild Fuller, A.N.A., 1870–1924
Baby with Gold Necklace, c. 1910
Watercolor over graphite on ivory, 3.9 cm
 (1⁹⁄₁₆ in.) diameter
Gift of Lucia Fairchild Taylor Miller; W.995.65.12

Charles Wellington Furlong, 1874–1967
* *Profile of a Standing Male Figure,* 1902
Charcoal and graphite on laid paper, mounted on
 board, 62.3 × 48.3 cm (24⁹⁄₁₆ × 19 in.)
Purchased through the Julia L. Whittier Fund;
 D.966.113.3

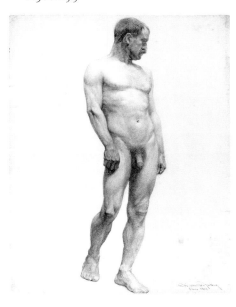

* *Seated Female Figure,* 1902
Charcoal and graphite on laid paper, mounted on
 board, 62.4 × 48.5 cm (24⁹⁄₁₆ × 19⅛ in.)
Purchased through the Julia L. Whittier Fund;
 D.966.113.5

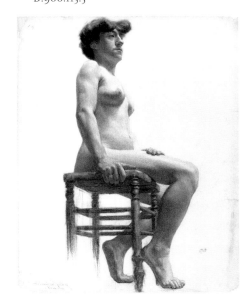

Emil Ganso, 1895–1941
Nightfall in Paris, c. 1929
Opaque watercolor over graphite on illustration
 board, 38.3 × 32.1 cm (15¹/₁₆ × 12⅝ in.)
Gift of Abby Aldrich Rockefeller; W.935.1.21

Hugo Gellert, 1892–1985
H.L.M. [H. L. Mencken], *Dayton, Tennessee,*
 Scopes Trial, 1925
Crayon and graphite on newsprint, 28.0 × 20.3
 cm (11 × 8 in.).
Dartmouth College Library, from the H. L.
 Mencken Collection assembled by Richard H.
 Mandel, Class of 1926, and given by him to
 Dartmouth College through the Friends of
 the Library; D.999.28.29

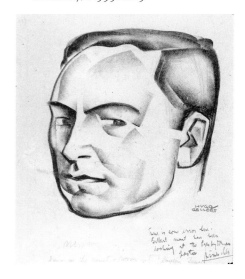

Thomas George, born 1918
George is represented by 118 drawings and
watercolors in the Hood Museum of Art's collec-
tion, many of which are semi-abstracted land-
scape drawings, including his forty-seven-piece
White Mountain Suite of 1979.

*Untitled, c. 1954–55
Pen and ink and brush and ink on wove paper,
 43.7 × 30.4 cm (17³/₁₆ × 12 in.)
Gift of the artist, Class of 1940, and his wife,
 LaVerne George; D.989.45.7

Sanford Robinson Gifford, N.A., 1823–1880
Italian Views (recto and verso), c. 1860s
Recto: graphite, heightened with white opaque
 watercolor, on tan wove paper; verso: graphite
 and colored crayon, heightened with white
 opaque watercolor, 12.3 × 22.0 cm
 (4⅞ × 8⅝ in.)
Gift of Jeffrey R. Brown, Class of 1961; D.982.27

William James Glackens, N.A., 1870–1938
Self-Portrait, n.d.
Charcoal on blue laid paper, 12.5 × 20.2 cm
 (4¹⁵/₁₆ × 7¹⁵/₁₆ in.)
Purchased through the Julia L. Whittier Fund;
 D.960.43

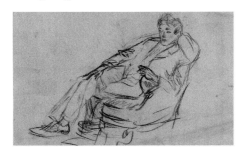

Fritz Glarner, 1899–1972
Tondo Study for a Relational Painting, 1962
Charcoal and colored crayon on wove (Umbria)
 paper, 52.0 × 33.6 cm (20½ × 13¼ in.)
Gift of Mr. and Mrs. Wallace K. Harrison, Class
 of 1950, in honor of Nelson A. Rockefeller,
 Class of 1930; D.968.8

Attributed to Sarah Goodridge, 1788–1853
** Possibly Dolly Miltimore Rousseau,* c. 1822–23
Watercolor on ivory, 11 × 8.6 cm (4¼ × 3⅜ in.)
Gift of Mrs. D. G. Brummett to Dartmouth College Library, transferred 2002; W.999.28.34

Chaim Gross, N.A., 1904–1991
Artist and Floating Head, 1927
Pen and ink on wove paper, 31.6 × 24.3 cm (12⁷⁄₁₆ × 9⁷⁄₁₆ in.)
Gift of the artist; D.983.15.2

George Grosz, A.N.A., 1893–1959
Seated Female Nude, 1944
Graphite on wove (Atlantic Bond) paper, 42.8 × 35.0 cm (16⅞ × 13¹³⁄₁₆ in.)
Gift of Ilse Bischoff; D.957.53.6
© Estate of George Grosz / Licensed by VAGA, New York, NY

Morris Graves, 1910–2001
State of the World, 1948
Opaque and transparent watercolor on laid paper, mounted on cardboard, 25.3 × 32.8 cm (9¹⁵⁄₁₆ × 12⅞ in.)
Bequest of Lawrence Richmond, Class of 1930; W.978.166

Dieppe, France, 1949
Pen and ink on wove paper, 28.0 × 21.3 cm (11 × 8⅜ in.)
Gift of the artist; D.983.15.1

Dimitri Hadzi, N.A., born 1921
** Sculpture Studies,* 1969
Pen and ink with white opaque watercolor corrections on wove paper, 25.5 × 37.9 cm (10¹⁄₁₆ × 14¹⁵⁄₁₆ in.)
Gift of the artist; D.969.34

Philip Leslie Hale, A.N.A., 1865–1931
Portrait of a Woman, n.d.
Graphite and white chalk on brown wove paper,
 sheet folded in half along right edge,
 51.3 × 64.0 cm (20³⁄₁₆ × 25⅛ in.)
Gift of Dr. Daniel C. Shannon in memory of
 Mary O'Donnell Shannon; D.995.66.5

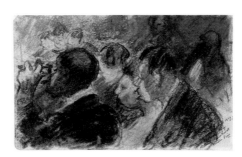

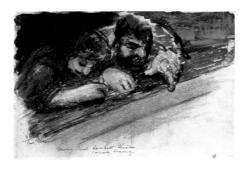

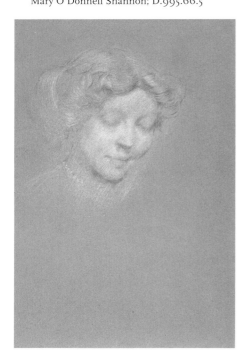

Samuel Halpert, 1884–1930
Artists' Shacks, Ogunquit, Maine, 1926
Watercolor over graphite on wove paper,
 37.1 × 54.7 cm (14⅝ × 21½ in.)
Gift of Abby Aldrich Rockefeller; W.935.1.25

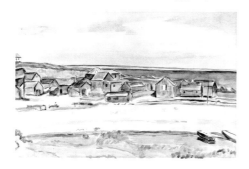

George Overbury Hart, 1868–1933
* *Comedy Play at Sarah Bernhardt Theater, Paris*
 (recto); *Gallery Sarah Bernhardt Theater,
 Comedy Drama* (verso), 1929
Recto and verso: pastel and watercolor over
 graphite on wove paper, 13.3 × 20.8 cm
 (5¼ × 8³⁄₁₆ in.)
Gift of Abby Aldrich Rockefeller; D.935.1.27

*Hundreds of Pack Animals Crowd the Streets on
 Market Day, Mexico*, 1926
Watercolor over graphite on primed and textured
 cardstock, 36.1 × 49.3 cm (14¼ × 19⅜ in.)
Gift of Abby Aldrich Rockefeller; D.935.1.33

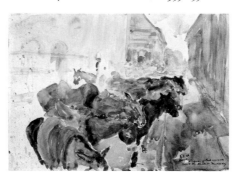

Amy Hartung, 1897–1985
In Provincetown, c. 1934
Watercolor over graphite on wove paper,
 31.3 × 39.6 cm (12³⁄₁₆ × 15⁹⁄₁₆ in.)
Gift of Abby Aldrich Rockefeller; W.935.1.34

William Stanley Haseltine, N.A., 1835–1900
Tivoli, Temple of the Sibyl, 1858
Watercolor, pen and ink, and graphite on wove
 paper, 39.0 × 54.7 cm (15⁵⁄₁₆ × 21½ in.)
Gift of Mrs. Roger H. Plowden; W.952.8

Ernest Haskell, 1876–1925
The Little Corinthian, before 1925
Graphite on wove (Amies) paper, 25.0 × 18.7 cm
 (9⅞ × 7⅜ in.)
Gift of Mrs. Hersey Egginton in memory of her
 son, Everett Egginton, Class of 1921;
 D.954.20.650

Robert Henri, N.A., 1865–1929
Spanish Lady, c. 1907
Ink wash on wove paper, 22.7 × 14.7 cm
(8¹⁵⁄₁₆ × 5¾ in.)
Purchased through the Julia L. Whittier Fund;
D.962.76

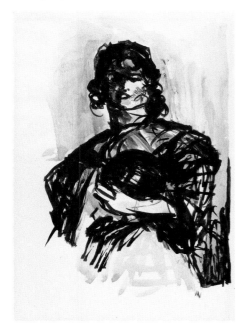

Where the Trees Are Dying, 1918
Pastel on heavy wove paper, 31.6 × 50.5 cm
(12½ × 19⅞ in.)
Gift of Mr. and Mrs. John L. Huber, Class of
1963; D.2004.39

Velino Shije Herrera (Ma-Pe-Wi),
American/Pueblo, 1902–1973
Comanche Dance, before 1930
Opaque and transparent watercolor over graphite
on (Crescent) illustration board, 25.1 × 38.0
cm (9⅞ × 15 in.)
Gift of Abby Aldrich Rockefeller; W.935.1.79

John Henry Hill, A.N.A., 1839–1922
Fishing in the Rapids, 1873
Watercolor over graphite on wove paper,
22.2 × 34.8 cm (8¾ × 13¹¹⁄₁₆ in.)
Purchased through the Julia L. Whittier Fund;
W.958.356

Attributed to John Henry Hill, A.N.A., 1839–1922
On the Hudson (River Scene), 1896
Watercolor over graphite on wove paper,
24.1 × 35.4 cm (9½ × 13¹⁵⁄₁₆ in.)
Purchased through the Julia L. Whittier Fund;
W.948.89

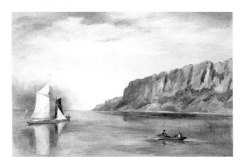

Edna Bois Hopkins, 1872–1937
Study for "Datura," c. 1910
Graphite on tan tracing paper, 45.6 × 30.8 cm
(17¹⁵⁄₁₆ × 12⅛ in.)
Purchased through the Virginia and Preston T.
Kelsey '58 Fund; D.997.47.3

Charles Sidney Hopkinson, N.A., 1869–1962
The Bathing Place (Rocky Coast) (recto); *Seascape
Sketch* (verso), 1920s
Recto and verso: watercolor on wove paper,
25.5 × 35.6 (10 × 14 in.)
Gift of Abby Aldrich Rockefeller; W.935.1.36

William Fowler Hopson, 1849–1924
* *Boat on a Marsh,* 1890
Transparent and opaque watercolor and pen and
ink over graphite on wove paper,
13.5 × 13.8 cm (5⁵⁄₁₆ × 5⁷⁄₁₆ in.)
Purchased through the Adelbert Ames Jr. 1919
Fund; W.983.37.2

William Morris Hunt, N.A., 1824–1879
New England Coast, n.d.
Charcoal on laid paper, 22.0 × 28.3 cm
(8⅝ × 11⅛ in.)
Gift of Professor John Wilmerding; D.970.49

Two Girls by a Lamp, c. 1870
Charcoal on wove paper, 46.7 × 28.9 cm
 (18⅜ × 11⅜ in.)
Purchased through the Julia L. Whittier Fund;
 D.962.78

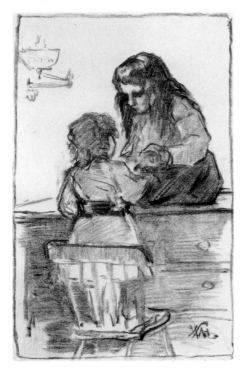

Robert Indiana, born 1928
* *The American Way — Hug #1*, 1964
Conté stencil rubbing, 76.2 × 55.9 cm
 (30 × 22 in.)
Bequest of Jay R. Wolf, Class of 1951; D.976.144
© 2004 Morgan Art Foundation Ltd. / Artists
 Rights Society (ARS), New York

David Johnson, N.A., 1827–1908
Old Man of the Mountain (recto); *Eagle Cliff,
 Franconia Notch* (verso), c. 1876
Recto and verso: graphite on wove paper,
 36.3 × 23.4 cm (14¼ × 9³⁄₁₆ in.)
Gift of Paul W. Worman Fine Art; D.999.9.1

David Claypoole Johnston, 1799–1865
Daniel Webster (1782–1852), Class of 1801, 1831
Black and white chalk with traces of red, yellow,
 and blue chalk on tan wove paper,
 30.5 × 23.5 cm (12¹⁄₁₆ × 9³⁄₁₆ in.)
Gift of Matt B. Jones to Dartmouth College
 Library, transferred c. 1990; D.968.108

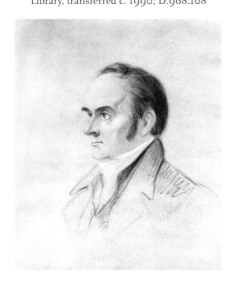

Wolf Kahn, N.A., born 1927
Studies of Geese, 1956
Charcoal on wove paper, 35.2 × 42.8 cm
 (13⅞ × 16⅞ in.)
Gift of Frank H. Hogan; D.994.42.2
© Wolf Kahn / Licensed by VAGA, New York,
 NY

William Jurian Kaula, 1871–1953
Aug. 2. "Fernhill" (on the roof) 3:15 pm [page 49 in
 the New Ipswich Sketchbook], c. 1915
Graphite on wove paper, 17.8 × 20.9 cm
 (7 × 8¼ in.)
Gift of Neil Denenberg; D.979.136

Penniman's Hill from the Club House. July 11. '11
 [page 37 in the St. Johnsbury Sketchbook],
 1911
Graphite on wove paper, 17.0 × 21.0 cm
 (6¹¹⁄₁₆ × 8¼ in.)
Gift of Neil Denenberg; D.979.136

Leon Kelly, 1901–1982
Page of Studies, 1925
Pen and ink and graphite on gray laid paper,
 30.8 × 23.0 cm (12⅛ × 9¹/₁₆ in.)
Purchased through the William S. Rubin Fund;
 D.984.38.2

Dong Kingman, N.A., 1911–2000
* *Philadelphia*, 1948
Watercolor over graphite on wove paper,
 57.5 × 38.6 cm (22⅝ × 15³/₁₆ in.)
Purchased through the Julia L. Whittier Fund;
 W.951.73

Walt Kuhn, 1880–1949
* *Culture*, n.d.
Pen and ink and graphite with white watercolor
 and green pastel on cardstock, toned brown
 by artist, 25.4 × 45.1 cm (10 × 17¾ in.)
Gift of Mr. and Mrs. Preston Harrison; D.940.35

Yasuo Kuniyoshi, 1889–1953
Girl with Cigarette (recto); *Figure Study with Sun*
 (verso), 1945
Recto: brush and ink and watercolor on card-
 stock; verso: brush and ink, 54.0 × 41.1 cm
 (21¼ × 16³/₁₆ in.)
Gift of Wallace K. Harrison, Class of 1950H;
 D.966.4
© Estate of Yasuo Kuniyoshi / Licensed by
 VAGA, New York, NY

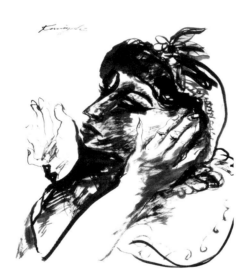

**John La Farge, N.A., 1835–1910, after Rembrandt
Harmensz. van Rijn, Dutch, 1606–1669**
Christ and the Disciples at Emmaus, 1856
Opaque and transparent watercolor over graphite
 on wove paper, 32.8 × 44.0 cm
 (12¹⁵/₁₆ × 17⅜ in.)
Gift of Professor George B. Zug; W.921.40

Rico Lebrun, N.A., 1900–1964
The Peachum and Mac the Knife, 1961
Brush and ink and ink wash on textured wove
 paper, 101.3 × 70.3 cm (39⅞ × 27⅝ in.)
Bequest of Jay R. Wolf, Class of 1951; D.976.181

Charles Robert Leslie, N.A., British of American parents, 1794–1859

** Bust of Homer*, c. 1811–15

Ink wash over graphite on wove paper, mounted on a separate sheet inscribed in pen and ink, sheet: 12.2 × 9.5 cm (4¹³⁄₁₆ × 3¹¹⁄₁₆ in.); mount: 22.2 × 28.4 cm (8¾ × 11⅛ in.)

Purchased through the Katharine T. and Merrill G. Beede 1929 Fund; D.998.12.2

Jack Levine, N.A., born 1915

Tenement Dweller, c. 1939

Pen and ink on wove paper, 20.1 × 12.5 cm (7¹⁵⁄₁₆ × 4¹⁵⁄₁₆ in.)

Purchased through the Adelbert Ames Jr. 1919 Fund; D.988.47

© Jack Levine / Licensed by VAGA, New York, NY

John Marin, 1870–1953

Sea Fantasy (recto); *Seascape* (verso), 1942

Recto: watercolor and black chalk over graphite on wove paper; verso: watercolor and graphite, 25.4 × 31.9 cm (10 × 12⁹⁄₁₆ in.)

Bequest of Jay R. Wolf, Class of 1951; W.976.191

© 2004 Estate of John Marin / Artists Rights Society (ARS), New York

Ferdinand Schuyler Mathews, 1854–1938

Franconia Mountain from N. Woodstock, N.H. (recto); *Study of Flowers* (verso), 1881

Recto: watercolor over graphite on wove paper; verso: watercolor over graphite, 24.8 × 34.2 cm (9¾ × 13⁷⁄₁₆ in.)

Purchased through the Julia L. Whittier Fund; W.959.6

William McClellan, 1803–1879

Dartmouth College from Top of Medical College, c. 1865

Transparent watercolor heightened with and with corrections in white opaque watercolor over graphite on wove paper, 26.0 × 37.5 cm (10¼ × 14¾ in.)

Dartmouth College Library; W.X.455

Dartmouth Medical College, c. 1865

Transparent and opaque watercolor over graphite on wove paper, 25.8 × 37.4 cm (10³⁄₁₆ × 14¹¹⁄₁₆ in.)

Purchased jointly by the Dartmouth College Library and by the Hopkins Center Art Galleries, through the Julia L. Whittier Fund; W.966.140

John M. McLenan, 1827–1866

Newsboy, 1858

Watercolor over graphite on wove paper, 24.7 × 17.1 cm (9¾ × 6¾ in.)

Purchased through the Julia L. Whittier Fund; W.945.82

Stephen Mopope, Kiowa/American, 1898–1974
Gourd Dance, before 1930
Opaque and transparent watercolor over graphite
 on gray wove paper, 21.4 × 29.4 cm
 (8⅜ × 11½ in.)
Gift of Abby Aldrich Rockefeller; W.935.1.84

F. Luis Mora, N.A., 1874–1940
* *Isadora Duncan,* c. 1920s
Pastel on brown laid (Arches Ingres MBM)
 paper, 45.1 × 43.8 cm (17¾ × 17¼ in.)
Bequest of Mary Fanton Roberts; D.957.19

Thomas Moran, N.A., 1837–1926
* *Solitude,* 1865
Charcoal and white chalk on tan wove paper,
 75.1 × 62.4 cm (29⁹⁄₁₆ × 24⅝ in.)
Purchased through the Katharine T. and
 Merrill G. Beede 1929 Fund; D.998.12.1

John Francis Murphy, N.A., 1853–1921
Catskill — Old Tannery, 1878
Graphite heightened with opaque watercolor on
 green wove paper, 24.0 × 31.5 cm
 (9⁷⁄₁₆ × 12⅜ in.)
Gift of Mrs. Hersey Egginton in memory of her
 son, Everett Egginton, Class of 1921;
 D.954.20.656

Eupatorium, 1877
Pen and ink on wove paper, 27.9 × 17.7 cm
 (11 × 7 in.)
Gift of Mrs. Hersey Egginton in memory of her
 son, Everett Egginton, Class of 1921;
 D.954.20.657
(see fig. 37)

New Jersey, 1876
Graphite highlighted with white watercolor on
 gray wove paper, 19.0 × 25.4 cm (7½ × 10 in.)
Gift of Mrs. Hersey Egginton in memory of her
 son, Everett Egginton, Class of 1921;
 D.954.20.662

* *Yellow Birch, Adirondacks,* 1883
Graphite on wove paper, 35.4 × 25.4 cm
 (13¹⁵⁄₁₆ × 10 in.)
Gift of Mrs. Hersey Egginton in memory of her
 son, Everett Egginton, Class of 1921;
 D.954.20.663

Thomas Nast, 1840–1902
Illustration for Edgar Allan Poe's "The Raven,"
 1862
Brush and ink and white opaque watercolor over
 graphite on tan wove paper with machine-
 printed text on wove paper mounted below
 image, 31.5 × 24.8 cm (12⁷⁄₁₆ × 9¾ in.)
Purchased through the Julia L. Whittier Fund;
 D.944.31.1

Illustration for Edgar Allan Poe's "The Raven,"
1862
Brush and ink and white opaque watercolor over
graphite on brown wove paper with machine-
printed text on wove paper mounted below
image, 30.2 × 25.8 cm (11⅞ × 10³⁄₁₆ in.)
Purchased through the Julia L. Whittier Fund;
D.944.31.3

Illustration for Edgar Allan Poe's "The Raven,"
1862
Brush and ink and white opaque watercolor over
graphite on wove paper with machine-printed
text on wove paper mounted below image,
33.3 × 26.0 cm (13⅛ × 10³⁄₁₆ in.)
Purchased through the Julia L. Whittier Fund;
D.944.31.4

Woman and Two Children, n.d.
Pen and ink on wove paper, 30.9 × 24.6 cm
(12³⁄₁₆ × 9¹¹⁄₁₆ in.)
Museum purchase; D.974.307

Irving Norman (Irving Noachowitz), 1906–1989
* *Great Orator*, 1944
Graphite and colored pencil on wove paper,
30.5 × 56.1 cm (12 × 22⅛ in.)
Purchased through the Julia L. Whittier Fund;
D.2002.68

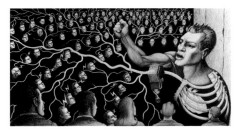

Mildred Bernice Nungester, born 1912
Mountain Valley Creek, 1943
Graphite and crayon on wove paper,
32.4 × 43.2 cm (12¾ × 17 in.)
Gift of Mrs. Hersey Egginton in memory of her
son, Everett Egginton, Class of 1921;
D.954.20.664

Ivan G. Olinsky, N.A., 1878–1962
Nada (Our Handy Man), c. 1950s
Charcoal on laid paper, 36.8 × 31.7 cm
(14½ × 12½ in.)
Gift of Leonore O. Miller, Richard H. Miller, and
John L. Miller; D.986.3

**Tonita Vigil Peña (Quah Ah), Pueblo/American,
1893–1949**
Buffalo Dance, before 1931
Opaque and transparent watercolor over graphite
on green wove paper, laid down on card-
board, 55.7 × 76.3 cm (21¹⁵⁄₁₆ × 30¹⁄₁₆ in.)
Gift of Abby Aldrich Rockefeller; W.935.1.85

Joseph Pennell, N.A., 1860–1926
Brooklyn Bridge, c. 1922
Black and white crayon on textured wove paper, 22.0 × 28.9 cm (8¹¹⁄₁₆ × 11⅜ in.)
Gift of Mrs. Hersey Egginton in memory of her son, Everett Egginton, Class of 1921; D.954.20.665

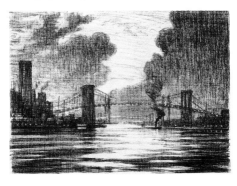

Francis Portzline, 1771–1857
Birth and Baptismal Certificate for Maria Portzline, c. 1820
Watercolor and watercolor with gold inclusions, and inscriptions in pen and ink on wove paper, 32.2 × 39.9 cm (12¹¹⁄₁₆ × 15¾ in.)
Gift of Abby Aldrich Rockefeller; D.935.1.105 (see fig. 28)

Jacques Reich, 1852–1923
Self-Portrait, n.d.
Pen and ink and brush and ink over graphite on wove paper, 22.8 × 14.8 cm (9 × 5⅞ in.)
Gift of Oswald D. Reich; D.966.64.62

William Cullen Bryant, 1893
Charcoal on wove paper, 57.9 × 45.9 cm (22¹³⁄₁₆ × 18¹⁄₁₆ in.)
Gift of Oswald D. Reich; D.965.79.56b

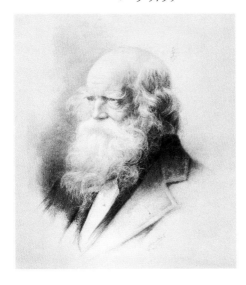

William Trost Richards, N.A., 1833–1905
* *Along the River*, c. 1860
Graphite on laid paper, 19.5 × 14.7 cm (7¹¹⁄₁₆ × 5¹³⁄₁₆ in.)
Gift of Ellen and Theodore Conant, in memory of Grace Richards Conant; D.996.35 (see fig. 57)

James Rosati, born 1912
Untitled, 1962
Transparent and opaque watercolor and pen and ink over graphite on wove paper, 39.4 × 28.5 cm (15½ × 11¼ in.)
Museum purchase; D.963.99.1

Augustus Saint-Gaudens, N.A., 1848–1907
Striding Liberty Study for the U.S. Twenty Dollar Gold Piece of 1907, c. 1905
Graphite on wove paper, 26.1 × 19.7 cm (10⁵⁄₁₆ × 7¹³⁄₁₆ in.)
Dartmouth College Library, gift of the Saint-Gaudens Memorial, Cornish, New Hampshire, 1964; D.999.28.27

Paul Starrett Sample, N.A., 1896–1974
Sample is represented by 617 loose drawings and watercolors and 103 sketchbooks in the Hood Museum's collection, including both preparatory and finished studies of landscapes, figures, and World War II naval subjects.

Church Interior with Sculpted Figure of Mary (recto); *Figure Sketch for "Field Hospital in a Church (Delirium Is Our Best Deceiver)"* (verso), c. 1944
Recto and verso: graphite on wove paper, 30.3 × 45.6 cm (12 × 17¹⁵⁄₁₆ in.)
Gift of the artist, Class of 1920, to Dartmouth College Library, transferred 1983; D.983.34.269

Punching the Bag (recto); *Landscape* (verso),
 c. 1940–42
Recto and verso: watercolor over graphite on
 wove paper, 38.9 × 28.9 cm (15⁵⁄₁₆ × 11³⁄₈ in.)
Gift of the artist, Class of 1920, to Dartmouth
 College Library, transferred 1983;
 W.983.34.134

Santa Fe Station, c. 1935
Watercolor over graphite on textured wove
 (J. Whatman) paper, 31.4 × 49.6 cm
 (12³⁄₈ × 19½ in.)
Gift of the artist, Class of 1920, to Dartmouth
 College Library, transferred 1983;
 W.983.34.123

Switching Cars, n.d.
Watercolor over graphite on watercolor board,
 29.0 × 39.0 cm (11⁷⁄₁₆ × 15³⁄₈ in.)
Gift of the artist, Class of 1920, to Dartmouth
 College Library, transferred 1983;
 W.983.34.116

Town Meeting, n.d.
Transparent and opaque watercolor over graphite
 on (Arches) watercolor board, 29.6 × 38.7 cm
 (11⁵⁄₈ × 15¼ in.)
Gift of the Estate of Harold G. Rugg, Class of
 1906; W.957.118.2

Turntable, White River, c. 1938
Watercolor on wove paper, 40.3 × 56.0 cm
 (15⁷⁄₈ × 22 in.)
Purchased through the Julia L. Whittier Fund;
 W.946.4

* *Two Men Seated with Small Town Backdrop,
 California* (recto); *Railroad Scene* (verso), 1935
Recto and verso: watercolor over graphite on
 wove paper, 28.6 × 39.0 cm (11¼ × 15³⁄₈ in.)
Gift of the artist, Class of 1920, to Dartmouth
 College Library, transferred 1983;
 W.983.34.225
(see fig. 35)

John Singer Sargent, N.A., 1856–1925
*Studies for a Mural (Possibly "The Fall of Gog and
 Magog," Boston Public Library, c. 1895–1910)*
Charcoal and graphite on laid (Michallet) paper,
 47.8 × 63.6 cm (18⁷⁄₈ × 25 in.)
Gift of Miss Emily Sargent and Mrs. Francis
 Ormond, sisters of the artist; D.929.10.10

*Studies for a Mural (Possibly "Classical and
 Romantic Art," Museum of Fine Arts, Boston,
 c. 1916–21)*
Charcoal on laid (L. Berville) paper,
 48.3 × 63.3 cm (19 × 24¹⁵⁄₁₆ in.)
Gift of Miss Emily Sargent and Mrs. Francis
 Ormond, sisters of the artist; D.929.10.9

*Study for a High-Relief Plaster Figure Crowning the
 "Prometheus" Mural, Museum of Fine Arts,
 Boston*, c. 1917–19
Charcoal on laid (Arches Ingres MBM) paper,
 47.6 × 63.3 cm (18¾ × 24¹⁵⁄₁₆ in.)
Gift of Miss Emily Sargent and Mrs. Francis
 Ormond, sisters of the artist; D.929.10.2

*Study for a Mural in the Boston Public Library or
 the Museum of Fine Arts, Boston*, c. 1890–1924
Charcoal on wove (O.W.P. & A.C.L.) paper,
 42.4 × 53.6 cm (16¹¹⁄₁₆ × 21⅛ in.)
Gift of Miss Emily Sargent and Mrs. Francis
 Ormond, sisters of the artist; D.929.10.1

* *Study for a Mural in the Boston Public Library or
 the Museum of Fine Arts, Boston*, c. 1890–1924
Charcoal on laid (Ingres) paper, 48.1 × 62.5 cm
 (19 × 24⅝ in.)
Gift of Miss Emily Sargent and Mrs. Francis
 Ormond, sisters of the artist; D.929.10.7
(see fig. 25)

*Study for a Mural in the Boston Public Library or
 the Museum of Fine Arts, Boston*, c. 1890–1924
Charcoal on laid (L. Berville) paper, squared in
 graphite for transfer, 63.0 × 48.1 cm
 (24¹³⁄₁₆ × 18¹⁵⁄₁₆ in.)
Gift of Miss Emily Sargent and Mrs. Francis
 Ormond, sisters of the artist; D.929.10.8

*Study for a Mural in the Boston Public Library or
 the Museum of Fine Arts, Boston*, c. 1895–1924
Charcoal on laid (Michallet) paper,
 47.8 × 62.1 cm (18¾ × 24½ in.)
Gift of Miss Emily Sargent and Mrs. Francis
 Ormond, sisters of the artist; D.929.10.6

*Study for a Mural (Possibly "Ganymede and the
 Eagle," Museum of Fine Arts, Boston,
 c. 1916–24)*
Charcoal on laid (L. Berville) paper,
 63.2 × 48.8 cm (24⅞ × 19³⁄₁₆ in.)
Gift of Miss Emily Sargent and Mrs. Francis
 Ormond, sisters of the artist; D.929.10.3

* *Study for a Mural (Possibly "Judgment," Boston
 Public Library, c. 1895–1910)*
Charcoal on laid (Ingres) paper, 48.5 × 62.6 cm
 (19⅛ × 24⅝ in.)
Gift of Miss Emily Sargent and Mrs. Francis
 Ormond, sisters of the artist; D.929.10.4

Edward Seager, 1809–1886
Franconia Notch, New Hampshire, c. 1840s
Graphite on wove (Bristol, Heath & Co.) paper,
 20.4 × 26.1 cm (8 × 10¼ in.)
Purchased in honor of Robert A. and Dorothy H.
 Goldberg; D.996.2

Everett Shinn, N.A., 1876–1953
* *Illustrated Letter to Augustus Saint-Gaudens from
 Everett Shinn, Depicting the "Masque of Ours,"*
 1906
Pen and brown ink on blue wove (Marcus Ward's
 Monarch Bond) paper, 16.2 × 25.2 cm
 (6⅜ × 9¹⁵⁄₁₆ in.)
Dartmouth College Library; D.999.28.28

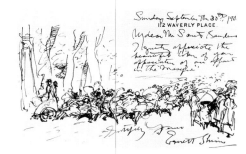

Two Lovers, 1907
Conté crayon on tan wove paper, 28.2 × 36.9 cm
 (11⅛ × 14½ in.)
Purchased through the Julia L. Whittier Fund;
 D.960.72

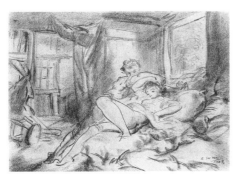

John Sloan, 1871–1951
Cup of Coffee, 1913
Crayon on wove paper, 26.7 × 20.4 cm
 (10½ × 8 in.)
Purchased through the Julia L. Whittier Fund;
 D.962.81

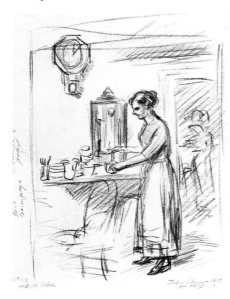

Nude Woman, Seated (recto); *Partial Figure Study*
 (verso), n.d.
Recto: black and brown crayon on tan wove
 paper; verso: black and brown crayon and
 graphite, 31.0 × 25.5 cm (12³⁄₁₆ × 10¹⁄₁₆ in.)
Bequest of Mary Fanton Roberts; D.957.21

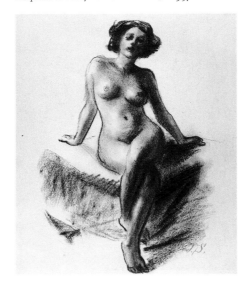

*Their Hands Touched (Illustration for "An Eye for
 an Eye" by F. H. Lancaster in "McClure's,"
 November 1905)*, 1905
Crayon over graphite on illustration board,
 29.6 × 40.3 cm (11⅝ × 15⅞ in.)
Purchased through the Julia L. Whittier Fund;
 D.965.4

William Louis Sonntag, N.A., 1822–1900
Setting Sun, 1890
Opaque and transparent watercolor over graphite
 on wove paper, 33.3 × 25.3 cm (13⅛ × 9¹⁵⁄₁₆ in.)
Purchased through the Julia L. Whittier Fund;
 W.974.47

Lilly Martin Spencer, N.A., 1822–1902
Two Children Seated in a Landscape, 1842–48
Graphite on wove paper, 20.6 × 31.9 cm
 (8⅛ × 12⁹⁄₁₆ in.)
Gift of Alexander Reeves Fine Art; D.994.13

B. D. Stanhope
* *New York Fashions*, c. 1830
Watercolor on wove paper, 20.6 × 15.5 cm
 (8⅛ × 6¹/₁₆ in.)
Gift of Abby Aldrich Rockefeller; W.935.1.59

Attributed to Joseph Steward, 1753–1822
Samuel S. Gray (1751–1836), Class of 1771, c. 1790s
Pastel on tan wove paper mounted on canvas on
 strainer, 46.0 × 40.5 cm (18⅛ × 16 in.)
Gift of Robert Cooper Byrne, Class of 1928;
 D.928.17

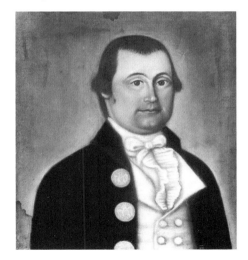

Abbott Handerson Thayer, N.A., 1849–1921
Portrait of a Little Girl, n.d.
Graphite on brown wove paper, 48.4 × 35.0 cm
 (19¹/₁₆ × 13¹³/₁₆ in.)
Gift of Mrs. Hersey Egginton in memory of her
 son, Everett Egginton, Class of 1921;
 D.954.20.672

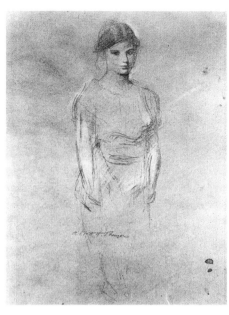

Samuel J. F. Thayer, 1842–1893
*Dartmouth College Library (Wilson Hall), Westerly
 Elevation*, c. 1884
Watercolor and pen and ink and graphite on
 wove paper, 40.2 × 68.3 cm (15⅞ × 26⅞ in.)
Hood Museum of Art, Dartmouth College;
 D.983.50

Attributed to George Ticknor, 1791–1871
*A View of the Principal Buildings of Dartmouth
 University*, 1803
Watercolor and pen and ink over graphite on
 wove paper, 27.5 × 33.5 cm (10¹³/₁₆ × 13³/₁₆ in.)
Dartmouth College Library; W.X.451
(see fig. 24)

Ross Sterling Turner, 1847–1915
Train Yard, 1897
Opaque and transparent watercolor over graphite
 on wove paper mounted on acidic board,
 64.5 × 97.5 cm (25⅜ × 38⅜ in.)
Bequest of Ellen T. Turner; W.2001.33

Unidentified artist
* *Dartmouth College*, c. 1835
Black, white, and colored chalk on marble-dusted
 drawing board, 26.3 × 39.4 cm
 (10⅜ × 15½ in.)
Dartmouth College Library; D.999.28.4

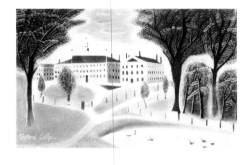

Unidentified artist
Lucia Murdock Olcott Streeter, 1825–30
Watercolor on ivory, 7.3 × 5.6 cm (2⅞ × 2³/₁₆ in.)
Gift of Mrs. Lucia Dunlop Dillon; W.991.22.2

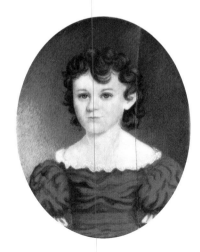

Unidentified artist
Still Life: Fruit, c. 1840s
Pastel on sandpaper, 35.4 × 45.6 cm
 (13¹⁵/₁₆ × 18 in.)
Purchased through the Guernsey Center Moore
 1904 Memorial Fund; D.965.66.1

Unidentified artist
*Yorktown and York River—As Seen from Top of a
 Tree at Camp Winfield Scott,* 1862
Watercolor and graphite on wove paper,
 18.1 × 27.6 cm (7⅛ × 10⅞ in.)
Purchased through the Guernsey Center Moore
 1904 Memorial Fund; W.963.106

Dorothy Varian, 1895–1985
The Champ, 1938
Opaque and transparent watercolor and graphite
 on wove paper, 35.7 × 46.1 cm
 (14¹/₁₆ × 18⅛ in.)
Gift of the Estate of Victor Borella, Class of 1930;
 W.976.234

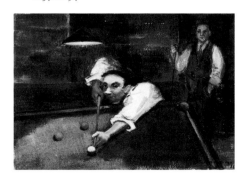

Elihu Vedder, N.A., 1836–1923
*Illustration for "The Book of Mushrooms": Mush-
 room and Sections, No. 2,* c. 1900
Graphite and colored crayon on wove paper,
 19.7 × 26.8 cm (7¾ × 10⁹/₁₆ in.)
Purchased through the Katharine T. and
 Merrill G. Beede 1929 Fund; D.998.37.3

*Illustration for "The Book of Mushrooms": No. 1,
 Covigliaio,* 1900
Graphite and colored crayon on wove paper,
 26.3 × 19.2 cm (10⅜ × 7⁹/₁₆ in.)
Purchased through the Katharine T. and
 Merrill G. Beede 1929 Fund; D.998.37.1

*Illustration for "The Book of Mushrooms": No. 1,
 Viareggio,* 1898
Graphite and colored crayon on wove paper,
 19.6 × 27.3 cm (7¹¹/₁₆ × 10¾ in.)
Purchased through the Katharine T. and
 Merrill G. Beede 1929 Fund; D.998.37.2

**Vincent Price Ledger Artist (C?), Cheyenne,
 Central Plains**
Untitled (Drawing #138), c. 1875–78
Graphite and colored pencil on blue- and red-
 lined ledger paper, 14.5 × 29.6 cm
 (5¾ × 11¹¹/₁₆ in.)
Purchased through the Hood Museum of Art
 Acquisitions Fund; D.2004.9

Max Weber, 1881–1961
Still Life, 1911
Transparent and opaque watercolor over graphite
 on wove paper, mounted on board,
 30.9 × 24.0 cm (12³/₁₆ × 9⁷/₁₆ in.)
Gift of Abby Aldrich Rockefeller; W.935.1.71

Benjamin West, 1738–1820
Saul Prophesying (Compositional Study for "Saul before Samuel and the Prophets"), c. 1812
Pen and brown ink on wove paper,
14.0 × 23.0 cm (5½ × 9¹⁄₁₆ in.)
Purchased through the Julia L. Whittier Fund;
D.962.85

Edwin Whitefield, 1816–1892
Wild Roses, 1845
Watercolor over graphite on wove paper,
25.3 × 19.7 cm (10 × 7¾ in.)
Given in memory of Ernest R. Drosdick, Class of
1958; W.986.34

Henry Williams, 1787–1830
* *Clarissa*, c. 1805–10
Watercolor on ivory, 10.2 × 7.6 cm (4 × 3 in.)
Gift of the Estate of Elizabeth Marsh; W.981.79

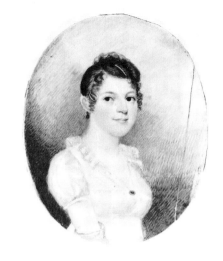

Mabel J. Williams, 1870–1944
White Mountain Landscape, c. 1930
Transparent and opaque watercolor on wove
paper, mounted on board, 14.0 × 10.1 cm
(5½ × 4 in.)
Gift of Frances S. MacIntyre, Class of 1990
MALS, in honor of Barbara J. MacAdam;
W.990.29

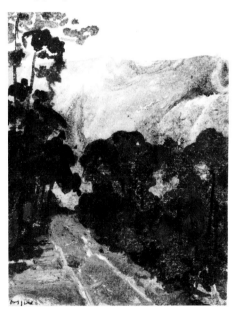

**Helen Covell Wolcott, about 1830–1857, and/or
Elizabeth "Lizzie" Sarah Wolcott, 1828–1867**
The Fisherman's Home, n.d.
Graphite on wove paper, 17.8 × 22.6 cm
(7 × 8¹⁵⁄₁₆ in.)
Gift of Margaret E. Spicer; D.2002.63.4

William Zorach, 1889–1966
Milking the Cow, 1918
Graphite on textured wove paper, 25.4 × 20.1 cm
(10 × 7⅞ in.)
Gift of the artist's children; D.988.56
Reproduction permission courtesy of Zabriskie
Gallery

Mowing the Hay, 1915
Watercolor over graphite on laid paper,
27.7 × 36.6 cm (10¹⁵⁄₁₆ × 14⁷⁄₁₆ in.)
Purchased through a gift from the Cremer Foun-
dation in memory of J. Theodor Cremer;
W.988.55
Reproduction permission courtesy of Zabriskie
Gallery

Notes

1. Copley, *Governor John Wentworth*

1. For further information on this work, including documentation of numerous later copies, see Arthur R. Blumenthal, "J. S. Copley's *Portrait of Governor Wentworth*," in *Recent Acquisitions 1974–1978* (Hanover, N.H.: Dartmouth College Museum and Galleries, 1979), 32–35.

2. For more on Copley's pastel technique and the use of the medium in colonial America, see Marjorie Shelley, "Painting in Crayon, the Pastels of John Singleton Copley," in *John Singleton Copley in America* (New York: The Metropolitan Museum of Art, 1995), 127–41.

3. *Letters and Papers of John Singleton Copley and Henry Pelham, 1739–1766*, ed. Guernsey Jones (Boston: Massachusetts Historical Society, 1914), 26.

4. Ibid., 50.

5. John Wentworth was named governor in 1766 but did not assume his office until 1767, when his uncle finally resigned (or, more likely, was asked to do so). See Paul W. Wilderson, *Governor John Wentworth and the American Revolution: The English Connection* (Hanover, N.H.: University Press of New England, 1994), 293n.40.

6. Between 1767 and 1773 New Hampshire's population grew from 52,000 to 72,000 (ibid., 106).

7. For further information on Wentworth's estate, see ibid., 123–26, and David R. Starbuck (ed.), "America's First Summer Resort: John Wentworth's 18th-Century Plantation in Wolfeboro, New Hampshire," *The New Hampshire Archeologist* 30, no. 1 (1989), entire issue.

8. Wentworth to Jeremy Belknap, May 15, 1791, quoted in Wilderson, *Governor John Wentworth*, 275.

9. Wilderson attributed the portrait to Benjamin Wilson in consultation with John Hays of the National Portrait Gallery of London (Wilderson, *Governor John Wentworth*, 294n.43). In a letter dated October 27, 1769, Wentworth wrote to Paul Wentworth, "I expect Copley here next Week to take my Picture which I kindly thank you for accepting—Wilson of Great Queenstreet Long Acre did one for me which Lord R. said he wou'd accept is it a likenefs?" (John Wentworth Letter Book no. 1, 1767–1778 [transcript of first three of nine volumes in Nova Scotia Public Records, Halifax], New Hampshire Archives, Concord, 306). Wentworth inquired as to the portrait's success, having most likely left England before its completion.

10. Copley painted a portrait of Theodore Atkinson Jr. about 1757–58 (Museum of Art, Rhode Island School of Design, Providence) and of Frances Deering Atkinson (later Wentworth) in 1765 (New York Public Library). Although Atkinson's death date is widely recorded as October 28, Wentworth wrote in a letter to Paul Wentworth dated (or perhaps misdated) October 27: "my good friend Mr. Atkinson junᵣ after many years decline is at length gone to rest & now lays dead in his House being Secretary of the Province" (Wentworth Letter Book, 305). Family and friends apparently supported the new union, despite rumors of Wentworth and Frances Atkinson indulging in a love affair well before her husband's death—a rumor supported by the birth of a child (who was baptized but did not live long) seven months after the wedding (Wilderson, *Governor John Wentworth*, 173).

11. Paul Wentworth was likely indebted to John Wentworth for helping to advance his career, having recommended him as agent of New Hampshire grantees (ibid., 152–53, 192).

12. Both the self-portrait and a pastel likeness of his bride (c. 1770) are in the collection of the Winterthur Museum, Winterthur, Del.

13. Within the year, Copley was able to purchase a house and considerable property on Boston Common. For more on Copley's changing social status during this period, see Susan Rather, "Carpenter, Tailor, Shoemaker, Artist: Copley and Portrait Painting around 1770," *The Art Bulletin* 79 (June 1997), 269–90.

2. West, *Archangel Gabriel of the Annunciation*

1. The most authoritative work on West's career is *The Paintings of Benjamin West*, by Helmut von Erffa and Allen Staley (New Haven: Yale University Press, 1986). I am grateful to Professor Staley for his observations on this drawing (letter, HMA object files, February 23, 2001).

2. The most comprehensive study of West's drawings is a catalogue of the Pierpont Morgan Library's holdings by Ruth S. Kraemer, *Drawings by Benjamin West and His Son Raphael Lamar West* (New York: Pierpont Morgan Library, 1975).

3. Comparable drawings from this period include *Hagar and Ishmael*, 1789, pen and ink with blue wash, 18 1/16 × 20 5/8 in., Addison Gallery of American Art, Andover, Mass.; *The Blind Belisarius*, 1784, brown ink and brown and pale blue washes with stylus lines, 17 1/8 × 19 3/4 in., Philadelphia Museum of Art; and *The Three Sisters*, 1783, graphite, ink, wash, and watercolor on paper, 15 9/16 × 12 5/16 in., The Nelson-Atkins Museum of Art.

4. West completed eighteen large canvases and many preparatory studies for the series, but the paintings were never installed. For more on the project, see Nancy L. Pressly, *Revealed Religion: Benjamin West's Commissions for Windsor Castle and Fonthill Abbey* (San Antonio, Tex.: San Antonio Museum Association, 1983).

5. A smaller, undated pen-and-ink sketch by West in the British Museum also depicts the profile of an angel, quite similar in pose, although the figure is three-quarter length, faces the opposite direction, and extends one arm down and forward. In the early twentieth century, Laurence Binyon catalogued the sheet as *The Angel of the Annunciation*—presumably on the basis of the angel's gesture, since the sheet is not inscribed (e-mail from Dr. Kim Sloan, Assistant Keeper, Department of Prints and Drawings, The British Museum, February 21, 2001).

3. Audubon, *American Buzzard or White Breasted Hawk . . . Falco Leverianus*

1. The double-elephant folio edition of *The Birds of America*, issued by subscription in eighty-seven parts, was published in London by Robert Havell Jr. At least 175 individuals and institutions completed subscriptions for this extravagant $1,000 folio. The Philadelphia firm of J. T. Bowen produced more than one thousand copies of a seven-volume octavo version between 1840 and 1844. All of the original watercolors for *The Birds of America* are in the collection of The New-York Historical Society.

2. The first naturalists to study the New World were European explorers and travelers, such as the Englishman Mark Catesby, whose *Natural History of Carolina, Florida and the Bahama Islands* (1731–47) proved especially influential. See Amy R. W. Meyers, " 'The Perfecting of Natural History': Mark Catesby's Drawings of American Flora and Fauna in the Royal Library, Windsor Castle," *Mark Catesby's "Natural History" of America: The Watercolors from the Royal Library, Windsor Castle* (London: Merrell Holberton, Publishers, 1997), 11–27.

3. Audubon greatly admired the Kentucky frontier hero Daniel Boone and claimed, probably erroneously, to have traveled with him. Ella M. Foshay suggests that Boone served as an alter ego for the artist-naturalist; see her *John James Audubon* (New York: Harry N. Abrams, Inc., in association with the National Museum of American History, Smithsonian Institution, 1992), 92.

4. John James Audubon, *Ornithological Biography*, 1:viii, cited in Theodore E. Stebbins Jr., "Audubon's Drawings of American Birds, 1805–38," in *John James Audubon: The Watercolors for the Birds of America* (New York: Random House and The New-York Historical Society, 1993), 3. Stebbins contends that Audubon likely studied under a follower of David, perhaps at the Free Academy of Drawing in Nantes.

5. Philadelphia became a center of naturalist study in the late eighteenth and early nineteenth centuries, with John Bartram's botanical garden and Charles Willson Peale's museum playing predominant roles. Alexander Wilson and Peale's son Titian Ramsay were the leading artist-naturalists associated with the city. For more on the naturalist contributions of the Peale family, see Brooke Hindle, "Charles Willson Peale's Science and Technology," in *Charles Willson Peale and His World* (New York: Harry N. Abrams, Inc., 1982).

6. Wilson's publication superseded the *Histoire naturelle des oiseaux* of George Louis Leclerc, comte de Buffon (Paris: De l'Imprimerie Royale, 1770–81), as Audubon's key reference for nomenclature. Linda Dugan Partridge argues that Audubon remained reliant on a host of earlier illustrated encyclopedias throughout his career and modeled several of his drawings closely after existing illustrations. She also

points out that, contrary to their common characterization, many of these earlier sources had already diverged from the conventional profile view. See "By the Book: Audubon and the Tradition of Ornithological Illustration," in Amy R. W. Meyers (ed.), *Art and Science in America: Issues of Representation* (San Marino, Calif.: Huntington Library, 1998), 97–129.

7. Audubon inscribed several of his 1810 drawings "Red Banks," as Henderson had been called. In 1811 he began to use "Henderson" in his inscriptions, making it unlikely that this drawing, inscribed "Henderson," dates from as early as 1810. Audubon's extensive use of graphite with pastel in this drawing does make it consistent stylistically with works from about 1810, as described by Stebbins, "Audubon's Drawings," 8. More than one hundred of Audubon's early drawings reside in the manuscript department of Houghton Library, Harvard University, and most of these were catalogued by Edward H. Dwight in *Audubon Watercolors and Drawings* (Utica, N.Y.: Munson-Williams-Proctor Institute; New York: Pierpont Morgan Library, 1965).

8. Even in Wilson's first edition, the author expressed "some doubt and reservation" that *Falco leverianus* (American buzzard) was different from *Falco borealis* (red-tailed hawk). (He did cite two previous sources for the origin of the term "American buzzard," one of which was "Peale's *Museum*.") When the book's second edition was published in 1828, after Wilson's death in 1813, the entry for *Falco leverianus* was annotated by George Ord, who added, "Wilson's suspicions of this [*Falco leverianus*] and the preceding [*Falco borealis*] being the same bird, have been confirmed by Prince Musignano [Charles Lucien Bonaparte, presumably in his own *American Ornithology*, published by subscription 1825–33]. This is the young [bird], the preceding the adult bird" (rev. ed., 85). Audubon was undoubtedly aware of Bonaparte's correction and omitted *Falco leverianus* from *The Birds of America*. Audubon frequently mistook immature examples for new species (for example, his "Bird of Washington" depicted a juvenile bald eagle). He did, however, recognize twenty-three valid new species and twelve subspecies of birds. Carole Anne Slatkin, catalogue entry for "Bald Eagle," in *John James Audubon: The Watercolors for the Birds of America*, 108.

9. Most of his mature watercolors exhibited a complex combination of media that could include watercolor, graphite, pastel, oil paint, chalk, ink, overglazing, and collage. Reba Fishman Snyder, "Complexity in Creation: A Detailed Look at the Watercolors for *The Birds of America*," in *John James Audubon: The Watercolors for the Birds of America*, 55.

10. Audubon portrayed himself crawling across a chasm on a log in the background of his drawing for the golden eagle (plate CLXXI, in Robert Havell Jr.'s edition of *The Birds of America*). Like the eagle shown grasping its prey, Audubon carries a large dead bird. Amy R. W. Meyers, "Observations of an American Woodsman: John James Audubon as Field Naturalist," in *John James Audubon: The Watercolors for the Birds of America*, 48.

4. Sully, *The Last Moments of Tom Coffin*

1. This drawing is one of thirty-eight works on paper by various artists that John Neagle assembled about 1825–30, apparently for his own instruction and pleasure (see also the wash drawings by Thomas Birch [cat. 6] and Charles Robert Leslie [p. 240], originally from the same scrapbook). The younger, less-established Neagle looked especially to Sully for artistic advice. The two painters became good friends, and in 1826 Neagle married Sully's stepdaughter. Although Neagle closely modeled his flattering style of portraiture after that of Sully, he never attained the rank of his mentor. For more on Neagle, see Robert Wilson Torchia, *John Neagle: Philadelphia Portrait Painter* (Philadelphia: The Historical Society of Pennsylvania, 1989), and Marguerite Lynch, "John Neagle's 'Diary,'" *Art in America* 37 (April 1949), 79–99.

2. The artist's register lists "'Long Tom Coffins.' Water color, copied from a former study for Mr. Childs. Painted March 12th, 1824. Size 12" × 10"." Sully also painted the dungeon scene from *The Pilot* in 1841 (37 × 28 in.; collection of Victor D. Spark in 1974), and another of "Tom Coffin" in 1865 (20 × 24 in.). See Edward Biddle and Mantle Fielding, *The Life and Works of Thomas Sully (1783–1872)* (Philadelphia: Wickersham Press, 1921), cats. 2394, 2506, and 2507, pp. 367, 378–79.

3. James Fenimore Cooper, *The Pilot: A Tale of the Sea*, ed. with a historical introduction and explanatory notes by Kay Seymour House (Albany: State University of New York Press, 1985), 285. This annotated edition reproduces many of the best-known illustrations from various legitimate and pirated editions of the book, including images by James Hamilton, F. O. C. Darley, Tony Johannot, Thomas Griffith Wainwright, and others.

5. Goodridge, *Possibly Mary Lane Miltimore Hale*

1. The miniatures of Stuart by Goodridge are in the collections of the Museum of Fine Arts, Boston, and the Metropolitan Museum of Art, respectively.

2. Cited in the entry for the miniature of Knox in Susan Strickler, *American Portrait Miniatures: The Worcester Art Museum Collection* (Worcester, Mass.: Worcester Art Museum, 1989), 108–9.

3. For more on Goodridge's biography, see Agnes M. Dods, "Sarah Goodridge," *The Magazine Antiques* (May 1947), 328–29; Strickler, *American Portrait Miniatures*, 65–66 and 108–9; and Dale T. Johnson, *American Portrait Miniatures in the Manney Collection* (New York: The Metropolitan Museum of Art, 1990), 125–26.

4. I am grateful to Margaret E. Spicer, professor of theater, Dartmouth College, and adjunct curator of the museum's costume collection, for her assistance in dating this miniature and the other attributed to Goodridge that may depict the sitter's sister (see p. 235). About the mid-1820s Goodridge limned several other female likenesses, including her own self-portrait (Smithsonian American Art Museum), that feature identical hair arrangements, with tight curls framing the face and the remaining tresses pinned back with a large tortoiseshell comb.

6. Birch, *Landscape with a River*

1. For more on early American landscapes and their critical reception, see Edward Nygren et al., *Views*

and Visions: American Landscape before 1830 (Washington, D.C.: Corcoran Gallery of Art, 1986), and William H. Gerdts, "American Landscape Painting: Critical Judgments, 1730–1845," *The American Art Journal* 17 (winter 1985), 28–59.

2. William H. Gerdts published seminal research on Birch in *Thomas Birch, 1779–1851: Paintings and Drawings* (Philadelphia: Philadelphia Maritime Museum, 1966), and in Gerdts, "American Landscape Painting."

3. Geological phenomena formed a subject of great interest to the American scientific community (then largely centered in Birch's Philadelphia) and to later landscapists drawn to nature's more sublime manifestations. See Rebecca Bedell, *The Anatomy of Nature: Geology and American Landscape Painting, 1825–1875* (Princeton: Princeton University Press, 2001).

4. William Gilpin, "Picturesque Beauty," in *Three Essays on "Picturesque Beauty"; on "Picturesque Travel"; and on "Sketching Landscape": with a poem, on Landscape Painting* (London: T. Cadell and W. Davies, Strand, 1808), 28.

5. Although Neagle dated the scrapbook "1825," the works included bore dates up to 1839. Among the other artists represented in the scrapbook, since disassembled and the works dispersed through sale, were William Birch, Felix Octavius Carr Darley, Henry Inman, Joseph Jefferson, John Neagle (with seven works, including a sketch of Sully now in the collection of The Metropolitan Museum of Art), John R. Penniman, C. R. Leslie, and Gilbert Stuart. Neagle clearly knew Birch, to whom he paid tribute in an 1836 portrait of the older artist with palette in hand, situated in front of a dramatic coastal scene (Pennsylvania Academy of the Fine Arts).

7. Goodridge, *Daniel Webster*

1. "Webster sat to have his likeness taken by Goodridge at least twelve times over two decades." Dale T. Johnson, *American Portrait Miniatures in the Manney Collection* (New York: The Metropolitan Museum of Art, 1990), 125–27. James Barber and Frederick Voss reported that "seven Webster miniatures by Goodridge—two of them replicas of others—are extant today." Barber and Voss, *The Godlike Black Dan: A Selection of Portraits from Life in Commemoration of the Two Hundredth Anniversary of the Birth of Daniel Webster* (Washington, D.C.: Published for the National Portrait Gallery by the Smithsonian Institution Press, 1982), 24.

2. The letters are preserved in the Massachusetts Historical Society and Museum of Fine Arts, Boston. The earliest miniature Goodridge limned for Webster was that of his daughter Julia, in October 1819; the latest were likenesses of two grandchildren, in 1850.

3. His heirs, who inherited the astonishing miniature (along with the artist's paint box and a more conventional self-portrait), referred to her as his "fiancée." Moreover, Goodridge, who otherwise never left the Boston area, made extended visits to Washington, D.C., in 1828–29 and 1841–42, after Webster's first wife had died and when he was physically separated from his second wife. Goodridge's painted miniature of her breasts has generated considerable thoughtful analysis and creative specula-

tion. See, for example, Robin Jaffee Frank, *Love and Loss: American Portrait and Mourning Miniatures* (New Haven: Yale University Press, 2000), 259–65; Johnson, *American Portrait Miniatures*, 125–27; and John Updike, "The Revealed and the Concealed," in *Art and Antiques*, February 1993, 71–76.

4. Irving H. Bartlett, *Daniel Webster* (New York: W. W. Norton, 1978), 203.

5. This and other similar images of Webster have often been dated to "c. 1827." However, this work clearly portrays an older Webster than depicted in life portraits from the 1820s. His longer, straight coif and receding hairline begin to approximate his appearance in the early 1840s. According to one account, Webster had at least three sittings with Goodridge in the 1830s: in 1831, 1833, and 1836 (Charles Henry Hart, "Life Portraits of Daniel Webster," *McClure's Magazine*, May 1897, 619). Barber and Voss dated this work to "c. 1838" in *The Godlike Black Dan*, 24–25, 47.

8. Ray, *Dartmouth College*

1. Although the identity of the designer for Dartmouth Hall is unclear, Ammi Burnham Young designed Wentworth and Thornton Halls at the same time that he completed renovations to Dartmouth Hall. For more on the early development of the Dartmouth campus, see Bryant F. Tolles Jr., "The Evolution of a Campus: Dartmouth College Architecture before 1860," in *Historical New Hampshire* 42 (winter 1987), 328–82.

2. When the original wood clapboard Dartmouth Hall burned to the ground in 1904, the college community rallied with unprecedented speed and financial commitment to rebuild the structure on the same site, with modest exterior alterations. Architect Charles A. Rich supervised the reconstruction of the building in "fireproof" brick at a cost of $101,700. See Tolles, "Evolution," 351.

3. The Dartmouth College Library holds many such drawings. Several young ladies' academies were active in Hanover during the nineteenth century. See John King Lord, *A History of the Town of Hanover, New Hampshire* (Hanover, N.H.: Printed for the Town of Hanover by the Dartmouth Press, 1928), 238–41.

4. Both Thornton and Wentworth Halls remained either unpainted or whitewashed until 1868, when, along with several other Dartmouth buildings, they were painted yellow in preparation for the College's centennial celebration. According to colonial revival taste, they were later painted white, a color often mistakenly ascribed to the colonial period and in the present day considered simply traditional "Dartmouth."

5. Brochure, *Winding Wave Boarding School for Young Ladies*, 1859 (American Antiquarian Society, Worcester, Mass.). The leaflet features an engraving of the building, a large, three-story Italianate residence "recently enlarged and re-furnished for the reception of twenty Pupils, with accommodations and conveniences unsurpassed by any similar Institution in the State." According to a history of Ludlow, the school was held in the house of Daniel Ray, Mrs. Pillsbury's father, and accommodated thirty-five or forty day pupils in addition to the boarders. By this account it was also at some point and to some degree coeduca-

tional (Albert Noon, *The History of Ludlow, Massachusetts: With Biographical Sketches of Leading Citizens. . . .*, 2nd ed. [Springfield, Mass.: Springfield Printing and Binding Company, 1912]). In 1863 the Pillsburys moved to Hilton Head, South Carolina, where he was made agent for the freedmen and later elected mayor of Charleston.

6. The brochure continued: "In addition to the Common branches, Pupils may pursue the higher Mathematics—the Greek, Latin and French Languages—Instrumental and Vocal Music—drawing, including Pencil, Crayon, Monochromatic, &c—Various kinds of Painting, viz: Oil, Grecian and Water Colors." *Winding Wave Boarding School for Young Ladies.* "Grecian" painting at this time referred to coloring an engraving with oil paint. Randall Holton and Tanya Holton, "Sandpaper Paintings of American Scenes," *The Magazine Antiques* 150, no. 3 (September 1996), 364n.4.

9. Eastman, *View of Concord, New Hampshire*

1. For biographical information on Eastman, see esp. John Francis McDermott, *Seth Eastman: Pictorial Historian of the Indian* (Norman: University of Oklahoma Press, 1961).

2. This watercolor comes from an unrecorded and unpublished scrapbook assembled by the artist (letter from Richard Miller, December 5, 1997, HMA object files).

3. Following his term in Concord, Eastman returned to Fort Snelling as a captain in 1841. During this time he made studies of frontier life and Native Americans that would become the basis for his later work. In addition to his illustrations for Schoolcraft's ambitious project, Eastman also collaborated with his author wife, Mary Henderson, on several books, including *Dakota: Life and Legends of the Sioux* (New York, 1849), *Romance of Indian Life*, and *Aboriginal Portfolio*, both published in 1853. Late in his career, Eastman painted twenty-six canvases for the U.S. Capitol and decorations for the rooms of the Committee on Indian Affairs and on Military Affairs of the Senate and House of Representatives. His last commission was to paint seventeen pictures of forts for the House Committee on Military Affairs.

10. Hobbs, *The Last of His Tribe (Indian Hunter with Bow)*

1. The undated penmanship drawings, held by a descendant of the artist, are based on print sources. Penmanship or calligraphic drawings incorporate the decorative flourishes of calligraphy with penned renderings of figures or objects. The largest, most striking example by Hobbs is after Jacques-Louis David's *Napoleon Crossing the St. Bernard Pass*, 1801.

2. The artist was born to James Hobbs (1789–1864) and Polly (Fogg) Pearson (d. 1857). Biographical information on the artist is drawn from the Rev. M. T. Runnels, *History of Sanbornton, New Hampshire* (Boston: Alfred Mudge and Son, 1881), 1:399, 494, 2:354; from the *Annual Catalogue of the New Hampshire Conference Seminary and Female College* (Tilton, N.H.: Charles F. Hill, 1878); as well as from correspondence and telephone conversations with Mildred B. Shaw of the Sanbornton Historical Society,

1990 (HMA object files). Hobbs taught at the New Hampshire Conference from roughly 1851 to 1860 and from 1877 to 1885. She also taught at a Miss Merrill's School in Concord, New Hampshire, for an interval in the early 1860s (letters to her niece, Harriet Burleigh, in the Harriet Burleigh Janes Papers, Dartmouth College Library), and possibly at the Ripley Female College in Poultney, Vermont, in 1868 (her name does not appear in the archival records, but her sister wrote her there, lamenting that "It seems a long time before your school will be done." Harriet G. K. Burleigh to Anne E. L. Hobbs, c. 1868 [collection of Colleen B. King]). Hobbs probably also taught at the Lapham Institute in North Scituate, Rhode Island, c. 1872 (letter written from the Lapham Institute, probably December 1872, from Annie E. L. Hobbs to her sister, Harriet G. K. Burleigh: "the term is almost half done"). I am deeply grateful to Colleen B. King, who wrote her Dartmouth Master of Arts in Liberal Studies thesis on Harriet Burleigh Janes, for making me aware of these letters and also that Hobbs's middle name appears to be "Lemist," not "Lancaster," as inscribed on this drawing. As for the variations on Hobbs's first name, the work's inscription (almost certainly by another hand) refers to her as "Anna," and she signed her name variously as "Ann," "Anne," and "Annie" (uncatalogued correspondence in the Harriet Burleigh Janes Papers, Dartmouth College Library). The Methodist Episcopal Church founded the New Hampshire Conference Seminary in 1845, but according to one report the school was "by no means sectarian." Although Hobbs is never listed as an art instructor, the art classes were offered as late as 1880, when a "lady" teacher at the New Hampshire Conference Seminary offered "crayoning and pastel" along with "drawing from nature, cast drawing, crayon portraiture, oil painting, and watercolors." "New Hampshire Conference Seminary and Female College," *Granite Monthly*, July 1880, 445. As with most secondary education for young women, one of the seminary's primary goals was to train future teachers for the "common" or district schools. The seminary instituted a "female college" program in 1852 to "connect with its academic work 'the higher and more perfect education' of ladies." For more on the Conference Seminary, see Runnels, *History of Sanbornton*, 1:125–29, and "New Hampshire Conference," 443–45. During the mid-nineteenth century most "female colleges" differed little, if at all, from the secondary instruction available at academies or seminaries. See Thomas Woody, *A History of Women's Education in the United States* (New York: Octagon Books, 1980), 1:395, 2:230–31.

3. E. S., "The Last of His Tribe," in *The Token and Atlantic Souvenir: A Christmas and New Year's Present* (Boston: American Stationers' Company, 1838), 226–29. I am extremely grateful to Randall Holton for identifying the print source for the drawing and for commenting on an early draft of this entry. He and his wife, Tanya, are co-authors of a forthcoming book on sandpaper paintings and have written several articles on the subject, including "Sandpaper Paintings of American Scenes," *The Magazine Antiques* 150 (September 1996), 356–65, and "Excavating the Past: Prints and Sandpaper Paintings of the Ancient World," *Imprint* (American Historical Print Collectors Society, New York), spring 2000, 2–14.

4. In academic settings, several girls often worked from the same original design. Randall Holton, who

has examined thousands of sandpaper or "marble dust" drawings, has not encountered other drawings based on this particular print.

11, 12. Burton, *Profile Portrait of a Man, Profile Portrait of a Woman*

1. David Jaffee, " 'A Correct Likeness': Culture and Commerce in Nineteenth-Century Rural America," in Marianne Doezema and Elizabeth Milroy (eds.), *Reading American Art* (New Haven: Yale University Press, 1998), 109–10.

2. Ibid., 113.

3. Ibid., 115. The most common device of the period was known as a "physiognotrace." Invented in the 1780s by a French cellist named Gilles-Louis Chrétien, the mechanism had two prominent forms, one of which traced the sitter's features by physically touching them, while the other used an eyepiece for the artist that permitted him to follow the sitter's features precisely. Both were basically permutations of a copying device known as a "pantograph" that permitted the exact duplication of a drawing or writing by affixing the writer's pen or stylus to an armature that attached to a second writing implement on a separate sheet of paper. Drawings could also be scaled up or down by employing a more elaborate armature. For more extensive explanations of these technologies and their histories, see Ellen G. Miles, *Saint-Mémin and the Neoclassical Profile Portrait in America* (Washington, D.C.: National Portrait Gallery and Smithsonian Institution Press, 1994), 39–45, and Peter Benes, "Machine-Assisted Portrait and Profile Imaging in New England after 1803," in *Painting and Portrait Making in the American Northeast* (Boston: Boston University, 1994), 138–50.

4. Only J. M. Crowley (active 1830s) and Augustus Day (active c. 1804–c. 1840s) are known to have produced similar portraits entirely in graphite. Day, at least, was primarily a miniaturist, however. Charlotte Emans Moore, "Augustus Day," *Record of the Art Museum, Princeton University* 57, nos. 1–2 (1998), 38–39.

5. For the most extensive discussion of these two candidates, see George C. Groce and David H. Wallace, *The New-York Historical Society's Dictionary of Artists in America, 1564–1860* (New Haven: Yale University Press, 1957), 98–99.

6. Throughout the 1840s, the dominant photographic medium in the United States was daguerreotypy. Photographs made using this technology were unique photo-positive impressions, did not use a negative, and were priced according to the size of the plate on which they were produced. More relevant to their public display, daguerreotypes were highly reflective and could only be clearly viewed from limited angles. On a small, intimate scale, the experience of a daguerreotype was congenial, but it did not translate well to larger formats. Large-scale paper-print photography was not widely popularized in America until the 1850s.

13. Hill, *High Bridge*

1. From 1836 to 1841 Hill served as topographic artist for the New York State Geographical Society and, beginning in 1842, provided illustrations for

John De Kay's *Zoology of New-York*, completed in 1844.

2. Two iron pipes, each three feet in diameter, originally carried the water across High Bridge. These were soon found to be inadequate, and between 1860 and 1864 a larger pipe was added and the side walls of the bridge were raised and roofed over. High Bridge was the only means of carrying water across the Harlem River until 1890, when the water was supplied through a siphon under the Harlem River near Washington Bridge. For more on the aqueduct, see Gerard T. Koeppel, *Water for Gotham: A History* (Princeton: Princeton University Press, 2000); Laura Vookles Hardin, "Celebrating the Aqueduct: Pastoral and Urban Ideals," in *The Old Croton Aqueduct: Rural Resources Meet Urban Needs* (Yonkers, N.Y.: Hudson River Museum of Westchester, 1992); Richard J. Koke (comp.), *American Landscape and Genre Paintings in the New-York Historical Society* (New York: New-York Historical Society, in association with G. K. Hall, Boston, 1982), 3:319–20; and Jan Seidler Ramirez (ed.), *Painting the Town: Cityscapes of New York: Paintings from the Museum of the City of New York* (New Haven: Museum of the City of New York, in association with Yale University Press, 2000), 110–11.

3. Hill made the plates after Tower's designs titled *Croton Aqueduct at Jewel's Brook* and *Croton Aqueduct at Hastings.* Tower opened his book with a detailed discussion of ancient prototypes for New World aqueducts, particularly those built by the Romans. Fayette B. Tower, *Illustrations of the Croton Aqueduct, by F. B. Tower of the Engineer Department* (New York: Wiley and Putnam, 1843).

4. The city's outlying regions, including Westchester to the north, held by far the greatest number of slaves and presumably a large free black population in the decades following the enactment of gradual manumission bills in 1799 and 1804. For more on this issue, see Shane White, *Somewhat More Independent: The End of Slavery in New York City, 1770–1810* (Athens: University of Georgia Press, 1991), esp. 14–23, 46–55.

5. *The Knickerbocker*, November 1848, quoted in Carol Troyen, "Retreat to Arcadia: American Landscape and the American Art-Union," *The American Art Journal* 23, no. 1 (1991), 26. In 1849, one year after Hill's watercolor was shown, the organization's membership reached its high point at 18,960 — a remarkably large potential audience for an aspiring artist. The Hill watercolor was one of 454 works distributed from the 1848 exhibition, which was the second annual exhibition to include watercolors.

14. Huntington, *William Cullen Bryant, Daniel Webster, and Washington Irving*

1. The original identifying titles below the figures appear to have been removed by scraping. An inscription at the lower right, apparently added at a later date, mistakes Irving for Bryant, and vice versa.

2. A few references to the event, including the date on this drawing, give the day instead as February 24.

3. *Memorial of James Fenimore Cooper* (New York: G. P. Putnam, 1852), 69. In addition to paying tribute to Cooper through words, the event's speakers and organizers attempted to elicit interest and funds for

"a colossal statue of our great novelist, to be set up in one of the public squares in the city of New York," a project that was never realized. Ibid., 105–6.

4. Brief notices of the drawing's exhibition and impending publication appear in "The Last Artists Reception for the Season," *New-York Tribune*, March 2, 1860, sec. 5, 6; *New-York Tribune*, March 6, 1860, sec. 6, 6; "Art Items," *New-York Tribune*, March 10, 1860, sec. 6, 5–6. The newspaper accounts announce the drawing's impending publication in engraved form, but the 1860 reproduction is a photograph of the drawing laid on a mount bearing a printed caption. I am grateful to Wendy Greenhouse for bringing these newspaper articles to my attention.

5. One of Huntington's sketchbooks at the National Academy Museum of Fine Arts (1986.15.14, pp. 30–31) includes two very preliminary sketches taken during the occasion, one inscribed "at the Cooper festival — Bryant oration," but they depict figures different from those shown here. Again, I extend thanks to Wendy Greenhouse for identifying the relevant sketchbooks.

6. The affair was later described as the largest assembly, for any purpose, of the "most intellectual and socially eminent classes of the city" (*Memorial*, 22). It was held at Metropolitan Hall.

7. Cooper was a particularly close friend of Samuel F. B. Morse, in whose studio Huntington worked in 1835. Huntington likely met Irving through Morse as well. By the date of this work, Huntington would have known all of the sitters through the Century Association. Bryant was among the men who proposed Huntington's one-man exhibition at the Art-Union Buildings in New York in 1850. For more on Huntington's biography and work, see the extensive writings on this subject by Wendy Greenhouse, such as "Daniel Huntington and the Ideal of Christian Art," *Winterthur Portfolio* 31 (1996), 103–40.

8. For more on the Sketch Club, see James T. Callow, *Kindred Spirits: Knickerbocker Writers and the American Artists, 1807–1855* (Chapel Hill: University of North Carolina Press, 1967), 12–29.

9. Huntington served two terms as president of the academy, from 1862 to 1870 and 1877 to 1890, and was vice president of the Metropolitan from 1871 to 1903.

15. Bard, *The Steamer, Menemon Sanford*

1. John Bard, by contrast, became inexplicably destitute within a matter of years and died in 1856. James's painting commissions began to dwindle in the 1880s and dried up completely by 1890, by which time photography had triumphed as a cheaper and more expedient alternative to painted ship portraits, and railroads had superseded inland boat travel.

2. Bard made several subtle changes in the painted portrayal of the *Menemon Sanford* steamer. For instance, he reversed the angle of the drive mechanism's rocker arm, eliminated the rooster from atop the pilot house, added several passengers to the decks, and moved a reduced and slightly altered version of the ornate inscription to the lower corners of the canvas. He also introduced the hint of a landscape in the far right distance.

3. The uncannily precise handling of his works has generated suspicion that they may be based on actual blueprints of the vessels. Anthony Peluso Jr., the primary authority on Bard, argues that a mere artist never would have had access to such valuable plans, and that only the very rare full-scale rendering would have represented the vessel in complete profile. Moreover, Bard is known to have visited shipyards to measure ships and work up sketches before undertaking his paintings and presentation drawings and watercolors. See the Mariners' Museum, in collaboration with Anthony J. Peluso Jr., *The Bard Brothers: Painting America under Steam and Sail* (New York: Harry N. Abrams, Inc., 1977), 106.

4. Erik Heyl, *Early American Steamers* (Buffalo, N.Y.: Erik Heyl, 1953), 247.

16. Richards, *Palms*

1. George W. Sheldon, in *American Painters* (New York: D. Appleton and Co., 1879), quoted by Linda Ferber in "The Trained and Honest Pencil of Mr. Richards," in Beacon Hill Fine Art (in association with Jill Newhouse), *William Trost Richards: Rediscovered / Oils, Watercolors, and Drawings from the Artist's Family* (New York: Beacon Hill Fine Art, 1997), 7.

2. From an undated essay by Richards entitled "Lansdowne," quoted by Linda Ferber in *William Trost Richards: American Landscape and Marine Painter, 1833–1905* (Brooklyn, N.Y.: The Brooklyn Museum, 1973), 13. The preeminent Richards scholar, Ferber has written extensively on the artist and is currently preparing a monograph devoted to his work.

3. Richards to A. T. Matlack, Florence, January 31, 1856, quoted by Linda Ferber in *"Never at Fault": The Drawings of William Trost Richards* (Yonkers, N.Y.: Hudson River Museum, 1986), 10.

4. Like several of Richards's drawings from this period, *Along the River* (fig. 57) may have functioned as a full-scale study for a painting. The artist darkened the back of the paper with graphite and red chalk and appears to have traced some of the major contours of the composition onto another support, using a very hard, fine-pointed pencil or possibly a stylus. Under most circumstances, this drawing's modest scale would argue against its serving as a study for a painting of identical size, but Richards, like many of the American Pre-Raphaelites, painted several small, jewel-like compositions around this time. See, for example, *The Conservatory*, 1860, oil on panel, 10⅞ × 8⁹⁄₁₆ in. (private collection, reproduced in Ferber and Gerdts [below], 219), which he based on his nearly identical drawing now in the collection of the Brooklyn Museum of Art. The darkened verso and incised lines on the drawing for *The Conservatory* suggest that Richards transferred parts of the design directly to the panel. Linda S. Ferber and William H. Gerdts, *The New Path: Ruskin and the American Pre-Raphaelites* (Brooklyn, N.Y.: The Brooklyn Museum, 1985), 217, 218–19, 221.

5. As noted by Ferber, the early members already knew one another and had likely been meeting informally for some time. Linda S. Ferber, "'Determined Realists': The American Pre-Raphaelites and the Association for the Advancement of Truth in Art," in ibid., 19. By 1864 James Jackson Jarves described the American Pre-Raphaelites as "Mr.

Richards and his followers" (James J. Jarves, *The Art Idea*, 1864, quoted in Kathleen A. Foster, "Makers of the American Watercolor Movement: 1860–1890" [Ph.D. diss., Yale University, 1982], 110).

17. Johnson, *The Album*

1. The 1855 drawing's apparent ownership by no less a patron than the queen of Holland may have heightened demand for the image (according to Christie's, the work's provenance begins with the "Queen of Holland Sale"). Johnson was invited to serve as court painter toward the end of his stay in Holland but declined, owing to his wish to study in Paris. (William Walton, "Eastman Johnson, Painter," *Scribner's Magazine* 40, no. 3 [September 1906], cited by Patricia Hills, *The Genre Painting of Eastman Johnson: The Sources and Development of His Style and Themes* [New York: Garland Publishing, 1977], 43). Johnson is known to have made replicas of his earlier portrait drawings of Mrs. Alexander Hamilton and Dolley Madison. According to John I. H. Baur, "the resultant drawings . . . were so popular . . . that Johnson was forced to make replicas of both as he refused to part with the originals." John I. H. Baur, *An American Genre Painter: Eastman Johnson, 1824–1906* (Brooklyn, N.Y.: Institute of Arts and Sciences, 1940), 6. For more on the painting related to this drawing, see David B. Dearinger, catalogue entry on *The Art Lover* in Abigail Booth Gerdts, *An American Collection: Painting and Sculpture from the National Academy of Design* (New York: National Academy of Design, 1989), 34. For further discussion regarding the possible origins of this drawing, see note 5 below.

2. In the nineteenth century, the term "crayon" could refer to a variety of drawing media in stick form, including charcoal, chalk, and crayon. Teresa A. Carbone, "From Crayon to Brush: The Education of Eastman Johnson, 1840–1858," in Carbone and Patricia Hills, *Eastman Johnson Painting America* (Brooklyn, N.Y.: Brooklyn Museum of Art, in association with Rizzoli International Publications, 2002), 44n.9.

3. Cited by Carbone, "From Crayon to Brush," 12. I am indebted to Carbone's thoroughly researched essay, which has cast new light on the importance of Johnson's stay in The Hague.

4. Johnson to his patron Andrew Warner, July 19, 1851, cited by Carbone, "From Crayon to Brush," 19.

5. Various scenarios might explain the origins and purpose of this drawing. Johnson authority Patricia Hills noted: "Johnson frequently made detailed drawings of his favorite paintings before those paintings left his studio. In a letter that Johnson's widow wrote on October 27, 1909, to Mrs. E. W. Blatchford of Chicago, she stated: 'After he had painted a big genre painting & it had met with the usual success of all his pictures then he would make a crayon of it.' I have no reason to believe that Mrs. Johnson was incorrect." Letter from Patricia Hills to Debra Force, September 25, 2000. However, because this drawing is virtually identical in composition to the 1855 drawing and differs in several details from the 1859 painting, one suspects that Johnson must have had a visual record or some access to his previous drawing, which by 1859 was presumably in the queen of Holland's collection. It is also possible that this work is, in fact, an earlier replica he

brought back with him to the United States and that the 1859 date in the inscription—which is in French and by another hand—is in error. Although no lithograph of this composition is known, the drawing's high degree of finish and the inscription's reference to its being framed by the lithographic firm of Goupil (which then had an office in New York) raise the question of whether this drawing might have been intended for lithographic reproduction. Johnson is known to have made just five lithographs: four done in The Hague about 1853 that depict members of the George Folsom family of New York (Folsom was chargé d'affaires at the Court of the Netherlands), and the better-known *Marguerite*, 1860, published by George Ward Nichols, New York. See Joan Mary Kaskell, "Eastman Johnson, Lithographer," *Imprint* 22, no. 1 (spring 1997), 11–15. Other prints after Johnson's works exist. L. Prang and Company, for instance, made reproductive engravings from Johnson's highly finished drawing after his painting *The Field Hospital*, 1867. See Patricia Hills, "Eastman Johnson's *The Field Hospital:* The U.S. Sanitary Commission and Women in the Civil War," *Minneapolis Institute of Arts Bulletin* 65 (1981–82), 66–81.

6. For a discussion of the romantic child, especially in British art, see Anne Higonnet, *Pictures of Innocence: The History and Crisis of Ideal Childhood* (London: Thames and Hudson, 1998), esp. chaps. 1 and 2.

7. See, for example, *The Boy Lincoln*, 1868 (University of Michigan Museum of Art) and *The Little Convalescent*, c. 1872–80 (Museum of Fine Arts, Boston).

8. As H. Nichols B. Clark has pointed out, "both societies developed mercantile middle classes that sought definition, in part, in literal artistic representations of their world." Clark, abstract for "The Impact of Seventeenth-Century Dutch and Flemish Genre Painting on American Genre Painting, 1800–1865" (Ph.D. diss., University of Delaware, 1982). See also Annette Stott, *Holland Mania: The Unknown Dutch Period in American Art and Culture* (Woodstock, N.Y.: Overlook Press, in association with Ambo/Anthos, 1998).

9. Elizabeth Johns, *American Genre Painting: The Politics of Everyday Life* (New Haven: Yale University Press, 1991), 161.

18. Heade, *Two Studies of Islands*

1. Heade to John Russell Bartlett, July 23, 1860, cited in Theodore E. Stebbins Jr., *The Life and Work of Martin Johnson Heade: A Critical Analysis and Catalogue Raisonné* (New Haven: Yale University Press, 2000), 39.

2. For the significance of that viewpoint, see Albert Boime, *The Magisterial Gaze: Manifest Destiny and American Landscape Painting, c. 1830–1865* (Washington, D.C.: Smithsonian Institution Press, 1991).

3. Heade to Bartlett, [probably July or August 1860], cited in Stebbins, *Life and Work*, 40.

4. Only one oil, entitled *A View among the Thousand Islands* (exhibited 1861), is known to have resulted from this trip, and its whereabouts are unknown. Characterizing any precise relationship to a finished work is consequently impossible at this time. Ibid., 40.

5. Stebbins (ibid., 290) gave this work its present title, *Two Studies of Islands*. Although this drawing can be viewed as a single, integrated landscape, both the upper and lower islands show a surprising degree of flatness and lack of spatial recession relative to one another. The notation "very near" within the top right (ostensibly more distant) island also seems to counter a reading of the drawing as one scene, as does the fact that the two registers do not overlap.

6. Ibid., 24.

7. Rebecca Bedell has written that some artists, including the influential landscapist Asher B. Durand, found such intimate landscapes therapeutic in the increasingly impersonal, urban industrial nation. Rebecca Bedell, *The Anatomy of Nature: Geology and American Landscape Painting, 1825–1875* (Princeton: Princeton University Press, 2001), 55–58.

19. Nast, *Illustration for Edgar Allan Poe's "The Raven"*

1. Albert Bigelow Paine, *Thomas Nast: His Period and His Pictures* (New York: MacMillan, 1904), 82.

2. Ibid., 84.

3. The other three illustrations (see pp. 241–42) depict the fifth (D.944.31.4), fourteenth (D.944.31.1), and eighteenth (D.944.31.3) stanzas. Each of Nast's images has been mounted, presumably by the artist, above the stanza that it illustrates. The texts were clipped from a published version of the poem.

4. *New Year's Day* is reproduced in Morton Keller, *The Art and Politics of Thomas Nast* (New York: Oxford University Press, 1968), fig. 5. By at least 1864, other illustrators, including Frank Bellew in the pages of *Harper's Weekly*, seized on "The Raven" as a metaphor for Southern slavery. See Sarah Burns, *Painting the Dark Side: Art and the Gothic Imagination in Nineteenth-Century America* (Berkeley: University of California Press, 2004), 146–48.

5. *Emancipation* is reproduced in Keller, *The Art and Politics of Thomas Nast*, fig. 3.

6. Albert Boime, "Thomas Nast and French Art," *American Art Journal* 4, no. 1 (spring 1972), 46.

7. Bryan Jay Wolf, *Romantic Re-Vision: Culture and Consciousness in Nineteenth-Century American Painting and Literature* (Chicago: University of Chicago Press, 1982), 130.

8. Ibid., 119. Wolf was referring to the work of John Quidor, but his words apply equally well to Nast's "Raven" illustrations and Goya's *Sleep of Reason*.

9. Albert Boime has built the case for the French influence on Nast. Boime, "Thomas Nast," 49.

10. Art Young, *Art Young: His Life and Times*, cited in Puran Singh Khalsa, "Thomas Nast and 'Harper's Weekly': 1862–1886" (Ph.D. diss., University of California, Santa Barbara, 1983), 21n.22.

20. Hill, *Lake Scenery (Lake Winnepesaukee, New Hampshire)*

1. He also exhibited quite regularly at the Brooklyn Art Association from 1865 to 1885 (biography by Annette Blaugrund in Linda S. Ferber and William H. Gerdts, *The New Path: Ruskin and the American Pre-Raphaelites* [Brooklyn, N.Y.: The Brooklyn Museum, 1985], 166).

2. I am grateful to John J. Henderson and Dartmouth Professor Emeritus Robert L. McGrath, who are both well acquainted with White Mountains landmarks, for their opinions regarding the likely (or unlikely) terrain depicted in this watercolor.

3. For a listing of known White Mountain subjects by Hill, see Catherine H. Campbell, *New Hampshire Scenery: A Dictionary of Nineteenth-Century Artists of New Hampshire Mountain Landscapes* (Canaan, N.H.: Phoenix Publishing for the New Hampshire Historical Society, 1985), 84–85. In 1866, the year he executed this watercolor, Hill produced a series of etchings of various subjects that he published the following year as *Sketches from Nature*. An 1866 etching from the group, titled *Moonlight on the Androscoggin*, suggests a visit to New Hampshire or Maine that year.

4. See *Evening on Lake George*, 1869 (collection of Mr. and Mrs. Wilbur L. Ross Jr., illustrated in Ferber and Gerdts, *The New Path*, 177), and *The Island Pines, Lake George*, 1871 (illustrated in Patricia C. F. Mandel, *Fair Wilderness: American Paintings in the Collection of the Adirondack Museum* [Blue Mountain Lake, N.Y.: Adirondack Museum, 1990], 66). In 1871 Hill also created an etching of the latter work, which he titled *The Island Pines*. Hill was so taken with Lake George that he built a cabin on an island in the Narrows near Bolton's Landing, where he spent most of his time from 1870 to 1874 (his diary from this period is in the collection of the Adirondack Museum). Hill's temperamental character and reclusive habits led locals to dub him "the Hermit of Phantom Island." See Nancy Finlay, "The Hermit of Phantom Island: John Henry Hill's Etchings of Lake George," in Caroline Mastin Welsh (ed.), *Adirondack Prints and Printmakers: The Call of the Wild* (Syracuse, N.Y.: Adirondack Museum and Syracuse University Press, 1998), 105–124.

5. The exception to this tendency are Hill's watercolors of Yosemite Valley and Shoshone Falls, results of his trip to the American West with geologist Clarence King in 1868.

6. "The Academy Exhibition — No. 1," *The Crayon*, March 28, 1855, 203, quoted in William H. Gerdts, "Through a Glass Brightly: The American Pre-Raphaelites and Their Still Lifes and Nature Studies," in Ferber and Gerdts, *The New Path*, 41.

21. Richards, *Beach Scene*

1. As is any account touching on the work and life of Richards, this entry is indebted to the numerous excellent publications on the artist written by Linda S. Ferber, especially "William T. Richards (1833–1905): Watercolor Painter," in *Watercolors by William Trost Richards* (New York: Berry-Hill Galleries, Inc., 1989); *William Trost Richards: American Landscape and Marine Painter, 1833–1905* (Brooklyn, N.Y.: The Brooklyn Museum, 1973); and the publications cited in the entry for cat. 16. The critic's assessment originally appeared in "Art: The Exhibition of Water Colors," *Aldine* 6 (April 1873), 87, and is quoted in Kathleen Adair Foster, "Makers of the American Watercolor Movement: 1860–1890" (Ph.D. diss., Yale University, 1982), 128.

2. Quoted in Foster, "Makers of the American Watercolor Movement," 120.

3. Clarence Cook, *New York Tribune*, July 3, 1867, quoted in ibid., 117.

4. "International Water-Color Exhibition," *Nation* 16 (February 20, 1873), 138, quoted in ibid., 122.

22. Colman, *Fishing Boats, Étretat*

1. Kathleen Adair Foster, "Makers of the American Watercolor Movement, 1860–1890" (Ph.D. diss., Yale University, 1982), 356.

2. Ibid., 346–47.

3. "Notes," *The Art Journal* 2, no. 1 (1876), 32.

4. Charles C. Cunningham, *Jongkind and the Pre-Impressionists: Painters of the École Saint-Siméon* (Williamstown, Mass.: Sterling and Francine Clark Art Institute, 1977), 89.

5. Robert L. Herbert, *Barbizon Revisited* (Boston: Museum of Fine Arts, 1962), 64–65.

23. Murphy, *Pride of the Meadow (Flower Studies, New Jersey)*

1. Francis Murphy, *J. Francis Murphy: The Landscape Within, 1853–1921* (Yonkers, N.Y.: The Hudson River Museum, 1982), 9. The author drew much of his biographical information from the Murphy papers, which were carefully preserved by Dr. Emerson Crosby Kelly. Kelly also drafted an unpublished biography of the artist and a list of his works. The collective papers, known as the "Emerson Crosby Kelly research materials relating to J. Francis Murphy, 1761–1973," are now housed at the Archives of American Art, Smithsonian Institution, Washington, D.C. (hereafter cited as Kelly/Murphy papers).

2. For more on artists in Keene Valley, see Robin Pell, *Keene Valley: The Landscape and Its Artists* (New York: Gerald Peters Gallery, 1994). According to David Tatham, "Among the several other artists [in addition to Winslow Homer] who resided in or passed through Keene Valley in the summer of 1874 were J. Francis Murphy, Roswell Shurtleff, Calvin Rae Smith, and Kruseman van Elten." David Tatham, "Winslow Homer's Adirondack Prints," in Caroline Mastin Welsh (ed.), *Adirondack Prints and Printmakers: The Call of the Wild* (Syracuse, N.Y.: Adirondack Museum and Syracuse University Press, 1998), 125–26.

3. Murphy, *J. Francis Murphy*, 8–10. The author describes Roorbach as a "Sunday painter." Murphy's journal records his November 10, 1875, arrival in New York and his departure for Denmark, New Jersey, on January 7 and again on January 25, 1876 (Kelly/Murphy papers, reel 4853, frame 1255).

4. Murphy was one of a thousand mourners at Emerson's funeral in Concord, Massachusetts, in 1882 and, while in the area, made a pilgrimage to the site of Thoreau's cabin on Walden Pond. There he gathered pine seedlings to transplant to his studio in Arkville, New York (Murphy, *J. Francis Murphy*, 10).

5. A detailed pen-and-ink drawing in the Hood Museum of Art collection may have been intended as an illustration for a calendar project. Titled *Eupatorium* (p. 241) and dated 1877, it depicts the roadside perennial more commonly known as joe-pye weed. It is inscribed, lower left, in ornate letters illumi-

nated with flowers, "August" (the plant's conventional month of bloom). Wildflowers seemed to be a particular interest for Murphy during the summer of 1877, judging from his many botanical sketches in the Kelly/Murphy papers, reel 4360, frames 1018–40, passim. Among the published volumes for which Murphy contributed illustrations are Mary D. Brine, *Grandma's Attic Treasures: A Story of Old-Time Memories* (New York: E. P. Dutton and Company, 1881); Lida Brooks Miller (ed.), *Child's History of Birds: Being a Complete Natural History of the Feathered Kingdom: With Interesting Descriptions of Their Habits, Modes of Life, and Means of Defense. . . .* (Philadelphia: World Bible House, 1896); and an edition of Longfellow's *John Endicott* (Murphy, *J. Francis Murphy*, 9).

6. John Burroughs to Murphy, February 26, 1880, cited in Kelly/Murphy papers, reel 4341, frame 151.

7. The Hood Museum of Art owns two Catskill-area drawings by Murphy dated 1878. Wyant purchased a home in Arkville two years after the Murphys moved there. In 1899 the Murphys built Weedwild, a new house and studio on their property, which remained their summer residence for the rest of their lives. The artists who gathered in Arkville were known as the Pakatakan Colony, named after Pakatakan Lodge, a large summer boardinghouse that formed the nucleus of the colony and had been named for an earlier Indian settlement in the region. "History and Stories of Margaretville and Surrounding Area," Delaware County, New York, Genealogy and History Site, www.rootsweb.com/~nydelawa/gary/marghst3.htm.

8. Unidentified clipping, quoted by Murphy in *J. Francis Murphy*, 10.

24. Sargent, *The West Portals of the Cathedral of Saint Gilles du Gard (Venetian Facade)*

1. Annette Blaugrund, " 'Sunshine Captured': The Development and Dispersement of Sargent's Watercolors," in Patricia Hills (ed.), *John Singer Sargent* (New York: Whitney Museum of American Art, 1986), 210.

2. See Kathleen L. Butler, "Tradition and Discovery: The Watercolors of John Singer Sargent" (Ph.D. diss., University of California, Berkeley, 1994), 13–16.

3. That work, a portrait entitled *Fanny Watts* (1877), is now in the permanent collection of the Philadelphia Museum of Art. A watercolor of the sitter also exists, although this is thought to have been done several years later. On Sargent's early reputation at the Paris Salon, see Marc Simpson, *Uncanny Spectacle: The Public Career of the Young John Singer Sargent* (New Haven: Yale University Press, 1997), esp. 33–39.

4. Sargent's first show of works exclusively in this medium took place in 1904 at the Royal Society of Painters in Watercolours in London. He showed watercolors with the late Winslow Homer in 1917 at the Carnegie Institute in Pittsburgh. Today, these two artists are treated as mainstays of the American watercolor tradition. See Sue Welsh Reed and Carol Troyen, *Awash in Color: Homer, Sargent, and the Great American Watercolor* (Boston: Museum of Fine Arts, 1993), xlix–li; Linda S. Ferber and Barbara

Dayer Gallati, *Masters of Color and Light: Homer, Sargent, and the American Watercolor Movement* (Brooklyn, N.Y.: Brooklyn Museum of Art, 1998), 117–41.

5. According to Richard Ormond, Sargent spent early August 1879 in Aix-les-Bains with his mother and sister Emily and took the better part of a month to travel to Spain, where he remained for the rest of the year before traveling to North Africa. It is also possible, but less likely, that he went to Saint Gilles the previous winter, around the time that he visited his family in Nice. That year, Sargent also painted in Naples and Capri. Several figurative watercolors survive from each of these expeditions. See the "Chronology" in Richard Ormond and Elaine Kilmurray, *John Singer Sargent: The Early Portraits* (New Haven: Yale University Press, 1998), xiii–xiv.

6. Sargent's exact itinerary for these weeks remains vague. Sargent's first biographer notes that the young painter was accompanied in Spain with two French artist-colleagues—Messrs. Bac and Daux—although whether they traveled with him or joined him there subsequently is unknown. See Evan Charteris, *John Sargent* (New York: Charles Scribner's Sons, 1927), 49–51. The most thorough, though still incomplete, narrative treatment of Sargent's travel to Spain in 1879 can be found in Mary C. Volk, *John Singer Sargent's "El Jaleo"* (Washington, D.C.: National Gallery of Art, 1992), 22–24.

7. See Eugène-Emmanuel Viollet-le-Duc, *Dictionnaire raisonné de la architecture française du XIe au XVIe siècle* (Paris: E. Gründ, [n.d.]), 7:417. The portal was also noted by Americans. Andrew Carnegie, for example, paid for a plaster cast of the west portal to be produced for his Carnegie Institute Museum of Art in Pittsburgh in 1907. Architects in the United States also wanted to know more about this aspect of the building. See "The Doorways of the Abbey Church at Saint Gilles (Gard) France," *American Architect and Building News* 40 (April 15, 1893). Later historians of medieval art have continued to ponder the monument. For example, see Meyer Schapiro, "New Documents on Saint Gilles I and II," in his *Romanesque Art: Selected Papers* (New York: George Braziller, 1977), 328–46; Whitney S. Stoddard, *The Façade of Saint-Gilles-du-Gard* (Middletown, Conn.: Wesleyan University Press, 1973).

8. Perhaps most closely related is the small group of architectural studies he produced in Morocco, shortly after he visited Saint Gilles in 1879 (see, for example, *A Moorish Patio* [c. 1880], British Museum, London, and *Courtyard, Morocco* [1880], The Metropolitan Museum of Art, New York). Also relevant are the watercolors that he painted in Venice slightly later on (see, for example, *Campo dei Frari, Venice* [1880], Corcoran Gallery of Art, Washington, D.C., and *Venice* [1880–82], The Metropolitan Museum of Art, New York, both of which bear strong comparison to the Hood watercolor in terms of their size, technique, and compositional organization). The present watercolor was once mistakenly called *Venetian Facade* for this reason.

9. Paper conservators have proposed various theories regarding the composition of these touches of gray pigment. Judith Walsh proposed in 1989 that they might be "badly discolored white lead applications. Sargent did use whites in this manner, but I've never seen whites so badly discolored." In 2000 Leslie Paisley disagreed, feeling more comfortable

with "metallic gray paint" as a description. Both conservators based their assessments on visual inspection, not technical analysis. HMA object files. Sargent authority Richard Ormond has confirmed that he has not seen this effect on other works, further suggesting its rarity. Richard Ormond to Mark Mitchell, February 10, 2003, HMA object files.

25. Cassatt, *Drawing for "Evening"*

1. Much has been written on the relationship between Cassatt and Degas, including their collaboration on the planned journal. See, for example, George T. M. Shackelford, "*Pas de deux:* Mary Cassatt and Edgar Degas," in Judith A. Barter et al., *Mary Cassatt: Modern Woman* (Chicago: The Art Institute of Chicago, in association with Harry N. Abrams, Inc., 1998), 109–43. Cassatt's mother blamed Degas for the journal project not going forward: "As usual when the time arrived to appear, he [Degas] wasn't ready." Quoted in ibid., 125.

2. The literature on Cassatt is extensive, with many of the seminal works authored by Adelyn Breeskin and Nancy Mowll Mathews. I am especially indebted to Judith Barter's contextualization of themes in Cassatt's works—many of them relevant to this image—in her essay "Mary Cassatt: Themes, Sources, and the Modern Woman," in Barter et al., *Mary Cassatt*, 45–68. She addresses the print *Evening* on 54–55.

3. Cassatt returned to this depiction of her mother's fingers pressed against her head in this fashion in other works as well, such as *Mrs. R. S. Cassatt*, c. 1889 (oil on canvas, Fine Arts Museums of San Francisco), and the related etching (no. 122 in Adelyn Dohme Breeskin, *Mary Cassatt: A Catalogue Raisonné of the Graphic Work* [Washington, D.C.: Smithsonian Institution, 1979], 126). She was no doubt aware of Degas's *Portrait of Duranty* of 1879 (Burrell Collection, Glasgow Art Gallery), which employs the same gesture.

4. If Lydia is indeed sewing—as the image is generally described and as the spool of thread and scissors would indicate—she may be threading a needle and holding a large, stiff piece of fabric in her lap. The implied motion of her hands and what may be an indication of knitting needles, however, suggest some form of needlework. The artist routinely depicted her sister sewing, crocheting, or embroidering—activities she was able to pursue in spite of her failing health.

5. Drawings made for transfer to a soft-ground plate usually have soft-ground residue on the reverse of the paper, indicating where the sheet was pressed against the prepared plate. However, the sheet has been lined (conceivably to cover such residue), making it difficult to confirm the means of transfer. The National Gallery of Art has several examples of transfer drawings by Cassatt, including *In the Opera Box (No. 3)*, 1880, *The Loge*, 1882, and *In the Omnibus*, 1891.

6. *Union League Club, Exhibition Catalogue of the Work of the Women Etchers of America, with an Introduction by Mrs. Schuyler van Rensselaer* (New York: The Union League Club, 1888). Works by Cassatt were included in the New York version of this exhibition, which was based primarily on Sylvester Koelher's exhibition of the same subject held at the Museum of Fine Arts, Boston, in late 1887. Cassatt's

etchings are listed in the New York catalogue as "twenty-four unfinished studies." An annotated copy of the catalogue in the collection of the New York Public Library is inscribed alongside the listing: "two women at lamp—." Phyllis Peet, *American Women of the Etching Revivial* (Atlanta: High Museum of Art, 1988), 39n.29. I am grateful to Elizabeth Wyckoff, Print Specialist at the New York Public Library, for confirming the annotation.

26. Julian Scott Ledger Artist A, *Osage Dance*

1. The Plains warrior-artists acquired these new media by trade as well as by force from explorers, traders, military men, and Indian agents.

2. Scott reproduced and published a modified version of this drawing in his *Report on Indians Taxed and Indians Not Taxed in the United States (Except Alaska) at the Eleventh Census: 1890*. A notation written by an unknown hand and dated November 28, 1880, on 91 in the ledger firmly establishes its location at the Kiowa, Comanche, and Wichita Agency, Indian Territory, and its creation that same year, which predates Scott's possession of the book by about ten years. See Ronald McCoy, *Kiowa Memories: Images from Indian Territory, 1880* (Santa Fe, N.Mex.: Morning Star Gallery, 1987), 4 and pl. 45. The ledger remained with Scott's descendants until 1986, when Morning Star Gallery of Santa Fe, New Mexico, acquired the book, which was documented and published before it was dismantled so that the individual drawings could be sold.

3. Janet Catherine Berlo (ed.), *Plains Indian Drawings, 1865–1935* (New York: Harry N. Abrams, Inc., 1996), 150.

4. Ibid. As was the case in traditional Plains drawings, artists often collaborated in the creation of a work. Consequently, ledger books such as the Julian Scott Ledger could include drawings by various artists with distinctive styles.

5. Other Kiowa drawings of war dances by pre-reservation and reservation artists similarly depict performers of the war dance with a careful detailing of costume, posing, and accoutrements.

6. In pre-reservation times, hostilities among these tribes would have prevented cohabitation.

7. In 1875, at the end of the Southern Plains Indian War, seventy-two warriors who were considered the most dangerous Kiowas, Cheyennes, and Arapahoes were captured and imprisoned at Fort Marion in St. Augustine, Florida. During their captivity, Captain Richard Pratt encouraged his prisoners in their Native drawing arts, providing them with pencils, crayons, pens, ledger books, and a steady stream of local clientele who purchased the ledger drawings from the captives.

8. Herman J. Viola notes that among the performers were some of the best-known ledger artists, including White Horse, Little Medicine, Chief Killer, Bear's Heart, White Bear, Wohaw, and Zotom, some of whom created ledger drawings after the performance. Viola, *Warrior Artists: Historic Cheyenne and Kiowa Indian Ledger Art Drawn by Making Medicine and Zotom* (Washington, D.C.: National Geographic Society, 1998), 98.

9. Asah, Auchiah, Hokeah, and Mopope received art training at St. Patrick's Mission School in Anadarko, Oklahoma, in 1914. In addition, all of the members of the Kiowa Five were given art lessons by Indian Service Field Matron Susan Ryan Peters about 1918; she also arranged for them to attend special classes at the University of Oklahoma beginning in 1926. See W. Jackson Rushing, "The Legacy of Ledger Book Drawings in Twentieth-Century Native America Art," in Berlo, *Plains Indian Drawings*, 56–57.

27. Homer, *Boys Bathing*

1. The number "32" in its lozenge-shaped surround corresponds in its format to numbers that staff members of Doll and Richards Gallery in Boston assigned to Homer's watercolors as they were received for exhibition in December 1880. The reverse also bears pencil notations for framing and matting: 13 × 5½ mat- 18 × 10⅝ f / /023655-3. When acquired by the museum in 1996, the frame backing encased a separate piece of paper with Homer's signature. According to notes by Lloyd Goodrich, who examined the work in 1939, Mrs. Charles S. Homer Jr. clipped the signature from a document and put it with the watercolor; it had nothing to do with the piece originally. At the time that Goodrich examined the work, the backing bore a Doll and Richards label with a 71 Newbury St. address (where they were situated after 1908). It is possible that the work passed through the gallery merely for framing. We are deeply grateful to Abigail Booth Gerdts, director of the Lloyd Goodrich and Edith Havens Goodrich Whitney Museum of American Art Record of Works by Winslow Homer, for providing this information.

2. Margaret C. Conrads, *Winslow Homer and the Critics: Forging a National Art in the 1870s* (Princeton: Princeton University Press, in association with the Nelson-Atkins Museum of Art, 2001), 178–95.

3. Theodore E. Stebbins Jr., *American Master Drawings and Watercolors: A History of Works on Paper from Colonial Times to the Present* (New York: Harper and Row, 1976), 160–62.

4. Franklin Kelly, "A Process of Change," in Nicolai Cikovsky Jr. and Franklin Kelly, *Winslow Homer* (Washington, D.C.: National Gallery of Art; New Haven: Yale University Press, 1995), 171–72.

5. Helen A. Cooper observed a similar dynamic in another depiction of boys bathing of 1880 (Williams College Museum of Art, Williamstown, Mass.), writing that this "somewhat disquieting work" may "disclose an ambivalent attitude to the nude body." Cooper, *Winslow Homer Watercolors* (Washington, D.C.: National Gallery of Art; New Haven: Yale University Press, 1986), 69.

6. For a more extended discussion of Homer's transformation of his watercolor technique during the summer of 1880, see ibid., 70–77.

7. Whereas in oil, the artist simply overpainted unwanted elements, transparent watercolor required more direct intervention. Nicolai Cikovsky Jr., "Reconstruction," in Cikovsky and Kelly, *Winslow Homer*, 143–44.

28. Homer, *Beaching a Boat (Figures in the Water, Prout's Neck)*

1. The most prominent figure is located at the bow of the center dory, leaning in to the viewer's left. The knee of a second figure is visible below the keel of the same boat, bent to indicate his motion from right to left as well. The directions of the other figures are less determinate, but those pushing the second boat, located in the water at the right, are clearly pushing for shore and reinforce the slighter indications among the central figures.

2. Also related is *Men Beaching a Boat*, 1881–82, charcoal on paper (Fogg Art Museum, Harvard University).

3. Abigail Booth Gerdts, "Catalogue of the Exhibition," in Lloyd Goodrich, *Winslow Homer in Monochrome* (New York: M. Knoedler and Co., 1986), 45. Several of Homer's watercolors of this period were extremely finished, as were his few oils, but the majority of the watercolors, like the drawings, were more expressive and essentialized.

4. Goodrich, cited by Abigail Booth Gerdts to Barbara J. MacAdam, September 2, 1997, HMA object file.

5. Paul Raymond Provost, "Winslow Homer's Drawings in 'Black-and-White,' c. 1875–1885" (Ph.D. diss., Princeton University, 1994), 1:184.

29. Whistler, *Maud Reading in Bed*

1. Most famously, Whistler brought suit against John Ruskin for libel in 1877 after the art critic rudely disparaged a work by the artist— *Nocturne in Black and Gold* (c. 1875, The Detroit Institute of Arts) —that had been exhibited in July of that year at London's Grosvenor Gallery. For an account of the trial and its various implications, see Linda Merrill, *A Pot of Paint: Aesthetics on Trial in Whistler v. Ruskin* (Washington, D.C.: Smithsonian Institution Press, 1992). Whistler also sparred regularly with his major patrons, quarreling bitterly with Frederick R. Leyland and testing the patience of Charles Lang Freer.

2. James McNeill Whistler, *The Gentle Art of Making Enemies* (New York: William Heinemann, 1890).

3. As an adult, Whistler ardently disavowed his American roots, stating that he chose not to be from Lowell, Massachusetts, and preferring to mislead would-be biographers by insisting that his origins could be traced to more glamorous roots in Russia. His father, George Washington Whistler, served as an engineer to the czar's railroad-building enterprise. James, two older siblings, William and Deborah, and his mother, Anna Mathilda McNeill, joined Major Whistler in St. Petersburg in 1843, and the family remained abroad until his death in April 1849. For details of Whistler's biography given throughout this entry, I have relied on the following sources: E[lizabeth] R[obins] Pennell and J[oseph] Pennell, *The Life of James McNeill Whistler* (Philadelphia: J. B. Lippincott Company, 1908); Richard Dorment and Margaret F. MacDonald, *James McNeill Whistler* (London: Tate Gallery Publications, 1994); Robin Spencer, *Whistler: A Retrospective* (New York: H. Lanter Levin, 1989); and David Park Curry, *James McNeill Whistler at the Freer Gallery of Art* (Washington, D.C.: Freer Gallery of Art, Smithsonian Institution; New York: W. W. Norton, 1984).

4. *Whistler's Mother*, as the work is more popularly known, was originally purchased for the Palais du Luxembourg. See Geneviève Lacamabre's entry on the painting in Dorment and Macdonald, *James McNeill Whistler*, 141–43.

5. On the construction of Whistler's appeal for many of these men and women, see Sarah Burns, "Performing the Self," in her *Inventing the Modern Artist: Art and Culture in Gilded Age America* (New Haven: Yale University Press, 1996), 221–46.

6. Courbet's Pavilion du Réalisme was on view when Whistler first arrived in Paris, and his own *White Girl: Symphony in White* took center stage at the secessionist enterprise the Salon des Refusés (1863), in which Manet played a leading role. Courbet alone, perhaps, might be said to compete with Whistler in terms of an at-times overbearing artistic self-confidence, a professed disdain for conventional mores and aesthetics, and the cultivation of an obstreperous public reputation in this period. The two men shared notoriety among critics, patrons, and even shared models/mistresses, in the case of Jo Hiffernan.

7. The essential expression of this stance is Baudelaire's 1863 text, "The Painter of Modern Life," in *The Painter of Modern Life and Other Essays* (London: Phaidon Press, Ltd., 1995), 1–41.

8. Whistler's relationship to Wilde was problematic despite the fact that both men shared similar attitudes about the role of the creative artist. The Irish author repeatedly disparaged Whistler's art and writing in print and, in turn, Whistler snubbed Wilde during his own legal troubles. On the French variant of aestheticism, see Edgar Munhall, *Whistler and Montesquiou* (New York: The Frick Collection, 1995).

9. For an explanation of the spiritual needs subtending these efforts, see Kathleen Pyne, "Whistler and the Religion of Art," in her *Art and the Higher Life: Painting and Evolutionary Thought in Late-Nineteenth Century America* (Austin: University of Texas Press, 1996), 84–134.

10. That show took place at Dowdeswell's Gallery and included twenty-six watercolors, thirty-eight oils, and three pastels. Two of the watercolors that are closely related to the Hood's image were included in that presentation—*Convalescent* and *Pink Note—The Novelette*—which leads scholars to assume the rough date of 1884 for the work under discussion. Slightly larger shows of watercolors took place at Dowdeswell's in 1886 and at Wunderlich Gallery in New York City in 1889. For a thorough scholarly examination of the works in the first London display, see Kenneth J. Myers, *Whistler's Gallery: Pictures at an 1884 Exhibition* (Washington, D.C.: Smithsonian Institution in association with Scala Publishers, 2004).

11. Maud (Mary) Clifton Franklin was born in England in 1857 and died about 1941 in southern France. Scholars believe that the couple produced two illegitimate children—Ióne and Maud—during this period, but Whistler did not acknowledge these offspring publicly. Early biographical studies of the artist assign her a vague, rather marginal place in the artist's life. Recently, however, a number of art historical studies have reconsidered her role within Whistler's oeuvre. See, for example, Margaret F. MacDonald, "Maud Franklin," in Ruth E. Fine (ed.),

James McNeill Whistler: A Reexamination, Studies in the History of Art 19 (Washington, D.C.: National Gallery of Art, 1987), 13–26; Martha Tedeschi and Britt Salvesen, "Early Experiments: Images of Maud Franklin," *Songs on Stone: James McNeill Whistler and the Art of Lithography*, (The Art Institute of Chicago) *Museum Studies* 24, no. 1 (1998), 22–31; Margaret F. MacDonald, "Maud Franklin and the 'Charming Little Swaggers,'" in Margaret F. MacDonald et al., *Whistler, Women, and Fashion* (New York: The Frick Collection, in association with Yale University Press, 2003), 132–55; "Maud," in Dorment and MacDonald, *James McNeill Whistler*, 213.

12. It has been suggested, for instance, that Franklin assumed the role of Frances Leyland in both the painted and etched portraits that Whistler made of this sitter. See Katherine A. Lochnan, *The Etchings of James McNeill Whistler* (New Haven: Yale University Press, in association with the Art Gallery of Ontario, 1984), 162–67, and Susan G. Galassi, "Whistler and Aesthetic Dress: Mrs. Frances Leyland," in MacDonald et al., *Whistler, Women, and Fashion*, 102.

13. For background on the evolution of titles for these works and more on the suggestion that Franklin was either ill or pregnant at the time they were painted, see Margaret F. MacDonald, *James McNeill Whistler: Drawings, Pastels, and Watercolours; A Catalogue Raisonné* (New Haven: Yale University Press, 1995), 340–43.

14. Whistler's earliest forays into the print medium feature individual women whose attention is not directed at the spectator; for example, see the two etchings *Reading by Lamplight* (1858) and *Weary* (1863). Still more analogous would be his magisterial oil of Jo Hiffernan studying Japanese woodblock prints, *Caprice in Purple and Gold: The Golden Screen* (1864, Freer Gallery of Art), or the modest oil sketch *Note in Red: The Siesta* (1883–84, Terra Foundation for the Arts), which also depicts Franklin. Drawings featuring Maud Franklin reading date from the earlier 1880s, for example, *Girl Reading in Bed* (c. 1882, The Art Institute of Chicago), and an undated watercolor at the Fogg Art Museum entitled *Maud Reading, in a Hammock* shows the figure turned slightly farther away from the spectator. Closest of all are a chalk drawing, *Study of a Seated Girl* (c. 1878, Lady Lever Art Gallery, Port Sunlight, England), and an associated lithotint, *Study: Maud Franklin, Seated* (1878), in which the seated model in profile assumes the same posture and attitude of absorption as in the Hood watercolor. When Whistler married, in 1888, he continued to demonstrate a preference for this image type. A good example is the late lithograph *By the Balcony* (1896). For a compelling analysis of the fundamentally modern strategy that informs this staging of the absorbed subject, see Michael Fried, *Manet's Modernism, or the Face of Painting in the 1860s* (Chicago: University of Chicago Press, 1996), and Fried, *Courbet's Realism* (Chicago: University of Chicago Press, 1990); Whistler is discussed in the former text.

15. For a discussion of the *grisette* and her attendant significations, see T. J. Clark, *The Painting of Modern Life: Paris in the Art of Manet and His Followers* (New York: Knopf, 1985); Hollis Clayson, *Painted Love: Prostitution in French Art of the Impressionist Era* (New Haven: Yale University Press, 1991); and Charles Bernheimer, *Figures of Ill-Repute: Represent-*

ing Prostitution in Nineteenth-Century France (Cambridge, Mass.: Harvard University Press, 1989).

16. Still affixed to this board is the following transcription of the manufacturer's label: "SCHILLING SKETCHING BLOCK / MADE OF FINE CARTRIDGE DRAWING PAPER, / MANUFACTURED BY / G. ROWNEY & CO., / 52, Rathbone Place, & 29, Oxford Street, London. / This block consists of 32 Sheets of Paper, compressed so as to form a Solid / Substance to all appearance, containing a number of Sheets of Drawing Paper, / each of which, when drawn upon, can be separated by the introduction of a / penknife at the space left in front of the Block, and passing the knife round the edge of the paper, care being taken to cut only one at a time." Barbara J. MacAdam to Hope Davis, August 21, 1984, HMA object files.

30. Murphy, *Standing Male Nude*

1. Carl Goldstein, *Teaching Art: Academies and Schools from Vasari to Albers* (Cambridge: Cambridge University Press, 1996), 180.

2. Albert Boime, "Curriculum Vitae: The Course of Life in the Nineteenth Century," in his *Strictly Academic: Life Drawing in the Nineteenth Century* (Binghamton, N.Y.: University Art Gallery, State University of New York at Binghamton, 1974), 5.

3. Abigail Solomon-Godeau, *Male Trouble: A Crisis in Representation* (London: Thames and Hudson, 1997), 193.

4. Boime, "Curriculum Vitae," 10.

5. William A. Coles, "Hermann Dudley Murphy: An Introduction," in Graham Gallery, New York, *Hermann Dudley Murphy (1867–1945): "Realism Married to Idealism Most Exquisitely"* (New York: Graham Gallery, 1982), 34. Coles has written that Murphy's French instructors had "very little apparent influence" on his art, citing instead James McNeill Whistler as his primary influence; ibid., 9–11. While it is true that Murphy's more tonal paintings differ from French academic convention, no study of his drawing technique has yet been undertaken. Moreover, the strong underlying design of his later work, particularly in still life, points to an enduring interest in the complexity and nuance of natural forms.

6. Catherine Fehrer, *The Julian Academy, Paris, 1868–1939* (New York: Shepherd Gallery, 1989), 2.

7. Ibid., 1. H. Barbara Weinberg has observed that the potential for disagreement also increased with multiple instructors, as was the case in one recorded incident between Murphy's two masters, Jean-Joseph Benjamin-Constant and Jean-Paul Laurens. H. Barbara Weinberg, *The Lure of Paris: Nineteenth-Century American Painters and Their French Teachers* (New York: Abbeville Press, 1991), 223.

8. Robert Kashey and Elizabeth Kashey, introduction to Fehrer, *The Julian Academy*, v. William Coles has also speculated the Murphy's six-foot-six-inch height may also have contributed to his election, since it would have better enabled him to maintain order. Coles, "Hermann Dudley Murphy," 7–8.

9. Ibid., 7.

10. Susan Waller, "Professional Poseurs: The Male Model in the Ecole des Beaux-Arts and the Popular

Imagination," *Oxford Art Journal* 25, no. 2 (2002), 45.

31. Prendergast, *Woman with a Parasol (Reading in the Garden)*

1. The watercolor's early title, *Reading in the Garden,* is problematic, as no reading material is in clear evidence. Also, the figure's upright posture and outward glance do not suggest that activity.

2. Carol Clark, "Modern Women in Maurice Prendergast's Boston of the 1890s," in Carol Clark, Nancy Mowll Mathews, and Gwendolyn Owens, *Maurice Brazil Prendergast, Charles Prendergast: A Catalogue Raisonné* (Williamstown, Mass.: Williams College Museum of Art; Munich: Prestel, 1990), 24.

3. Margaret Breuning has written persuasively on the influence of Prendergast's attendance at the academy on his later work. "This life class work gave him, not only the necessary fundamentals of structure, the ABC of anatomy, but, as it were, afforded access for him to the whole compendium of bodily gesture, to which he turned again and again with almost uncanny surety in striking out those little figures so casually placed on his canvases. Each one is but a few shorthand notes in the brilliant calligraphy of his fluent arabesque, yet each reveals the essential of bodily gesture, vividly conveyed in a sharp characterization, often with delightful accents of witty notation." Breuning, *Maurice Prendergast* (New York: Whitney Museum of American Art, 1931), 9.

4. For more discussion of the early stylistic transformation in Prendergast's watercolor technique, see Charles Parkhurst, "Color and Coloring in Maurice Prendergast's Sketchbooks," in Clark, Mathews, and Owens, *Maurice Brazil Prendergast,* 76–77.

5. Eleanor Green has argued that in Prendergast's "world of color" he "systematically suppressed his draftsmanship." Green, *Maurice Prendergast: A New Art of Impulse and Color* (College Park: University of Maryland Art Gallery, 1976), 18. *Woman with a Parasol,* however, demonstrates an exceptional awareness of human proportion, anatomy, and composition that all mandate careful draftsmanship. Line and contour may not be privileged in Prendergast's composition, but mass and volume are suggested with remarkable acuity.

6. Bailey van Hook, *Angels of Art: Women and Art in American Society, 1876–1914* (University Park: Pennsylvania State University Press, 1996), 105.

7. Robert L. Herbert, *Impressionism: Art, Leisure, and Parisian Society* (New Haven: Yale University Press, 1988), 304, 305.

32. Prendergast, *The Harbor from City Point*

1. Trevor Fairbrother, *The Bostonians: Painters of an Elegant Age, 1870–1930* (Boston: Museum of Fine Arts, 1986), 60. Richard J. Wattenmaker has asserted that Fairbrother and others have misconstrued Prendergast as a critically neglected artist, when in fact he received frequent and positive reviews throughout his career. Wattenmaker does not, however, distinguish between superficial applause and serious critical review, as Fairbrother does. Richard J. Wattenmaker, *Maurice Prendergast* (New York: Harry N. Abrams, Inc., 1994), 33, 41.

2. The repetition of the artist's initials and signature in several places along the bottom edge of the sheet (below the cropped image reproduced in the entry) suggests that he was also experimenting with his professional signature.

3. Prendergast's palette and evolving use of color is explored in Charles Parkhurst, "Color and Coloring in Maurice Prendergast's Sketchbooks," in Carol Clark, Nancy Mowll Mathews, and Gwendolyn Owens, *Maurice Brazil Prendergast, Charles Prendergast, a Catalogue Raisonné* (Williamstown, Mass.: Williams College Museum of Art; Munich: Prestel, 1990), 74–77.

4. William J. Reid, President Emeritus, South Boston Historical Society, to Mark Mitchell, July 21, 2003, HMA object files.

5. Fairbrother, *The Bostonians,* 59.

6. On his father's side, Prendergast's family was a "two-boater," meaning that they immigrated to the United States from Ireland in two steps, living first in Newfoundland, where Prendergast was born, and finally journeying to Boston's heavily Irish South End. I am grateful to Thomas O'Grady, Professor of English and Director of Irish Studies at the University of Massachusetts, Boston, for his assistance in understanding the significance of Prendergast's heritage to his art. Prendergast's mother was of French Huguenot descent. Hedley Howell Rhys, *Maurice Prendergast, 1859–1924* (Boston: Museum of Fine Arts; Cambridge, Mass.: Harvard University Press, 1960), 20. Milton Brown has more recently asserted that the Prendergast family was Welsh, citing only a twelfth-century historical figure who shared the family name and failing to establish a direct connection to the artist. Milton W. Brown, "Maurice B. Prendergast," in Clark, Mathews, and Owens, *Maurice Brazil Prendergast,* 18.

7. Sinclair Hitchings, "The Prendergasts' Boston," in W. Anthony Gengarelly and Carol Derby, *The Prendergasts and the Arts and Crafts Movement: The Art of American Decoration and Design, 1890–1920* (Williamstown, Mass.: Williams College Museum of Art, 1989), 45. Carol Clark, "Modern Women in Maurice Prendergast's Boston of the 1890s," in Clark, Mathews, and Owens, *Maurice Brazil Prendergast, Charles Prendergast,* 32. Nancy Mowll Mathews, *The Art of Leisure: Maurice Prendergast in the Williams College Museum of Art* (Williamstown, Mass.: Williams College Museum of Art, 1999), 16, 22. Thomas H. O'Connor, *South Boston, My Home Town: The History of an Ethnic Neighborhood* (Boston: Quinlan Press, 1988), 111–13.

8. Cynthia Zaitzevsky, *Frederick Law Olmsted and the Boston Park System* (Cambridge, Mass.: Belknap Press, 1982), 92. C. Bancroft Gillespie (comp.), *Illustrated History of South Boston* (South Boston: Inquirer Publishing Company, 1900), 42. By 1912 one anecdotal account held that "as many as 70,000" people visited the island on a weekend day. Leo P. Dauwer, *I Remember Southie* (Boston: Christopher Publishing House, 1975), 45.

9. O'Connor, *South Boston,* 143.

10. Moses King, *King's How to See Boston, a Trustworthy Guide Book* (Boston: Maculler, Parker, and Company, 1895), 223. The virtues of the view in the opposite direction, as depicted in many of Prender-

gast's watercolors, are also enumerated in Gillespie, *Illustrated History of South Boston,* 42.

11. Margaretta M. Lovell, *A Visitable Past: Views of Venice by American Artists, 1860–1915* (Chicago: University of Chicago Press, 1989), 40. Lovell borrows the term "low mimetic mode" from Northrop Frye's influential text *The Anatomy of Criticism.*

12. Nigel Blake and Francis Frascina, "Modern Practices of Art and Modernity," in Frascina et al., *Modernity and Modernism* (New Haven: Yale University Press, 1993), 127.

13. Prendergast's continuing interest in this type of juxtaposition in reflection is attested by *The East River* of 1901 (cat. rais. no. 780, The Museum of Modern Art, New York), in which the artist portrays a group of children in a playground while showing tugboats and factories on the river beyond.

33. Shinn, *Trafalgar Square, London*

1. Quoted in Bennard B. Perlman, *The Immortal Eight: American Painting from Eakins to the Armory Show, 1870–1913* (Westport, Conn.: North Light Publishers, 1979), 81.

2. Contemporary critics, however, were well aware of Shinn's influences, including two other French artists whose works related to the style of Degas, Jean-Louis Forain (1852–1931) and Jean–François Raffaëlli (1850–1924). A. E. Gallatin began a 1907 essay on Shinn by remarking that "Degas is an artist whose influence on the art of today is incalculable." Albert Eugene Gallatin, "The Art of Everett Shinn," in *Whistler, Notes and Footnotes and Other Memoranda* (New York: The Collector and Art Critic Co.; London: Elkin Mathews, 1907), 79.

3. Richard Kendall, "Influence in Low Places: Degas and the Ashcan Generation," in Ann Dumas and David A. Brenneman (eds.), *Degas and America: The Early Collectors* (Atlanta: High Museum of Art; Minneapolis: The Minneapolis Institute of Arts, 2000), 66. Notably, however, the exhibition's title, *Exhibition of Pastels: Paris Types by Everett Shinn,* derives from the title of a book illustrated by Jean-François Raffaëlli, not Degas.

4. Everett Shinn Collection, Archives of American Art, Smithsonian Institution, Washington, D.C., microfilm reel 952, frame 1350. The art historian Janay Wong has referred to two depictions of Trafalgar Square, but in his record book (Archives of American Art) Shinn appears to have used the titles *Trafalgar Square* and *Trafalgar Square, London* interchangeably to refer to a single drawing. No record of a second drawing has been found in the course of this research. Wong may have been referring to a pastel entitled *Near the Strand London.* Janay Wong, *Everett Shinn: The Spectacle of Life* (New York: Berry-Hill Galleries, Inc., 2000), 41. Also Janay Jadine Wong, "The Early Work of Everett Shinn (1897–1911): Art at the Crossroads of a New Century" (Ph.D. diss., City University of New York, 2002), 129.

5. Kendall, "Influence in Low Places," 64. Shinn, quoted in Barbara C. Rand, "The Art of Everett Shinn" (Ph.D. diss., University of California, Santa Barbara, 1992), 1:76. Degas's works were being exhibited in the United States as early as 1878. Phaedra Siebert (comp.), "Appendix: Selected Degas

Exhibitions in America, 1878–1936," in Dumas and Brenneman, *Degas and America*, 248. Degas's work was also reproduced in several mainstream art publications, including the London-based *Art Journal* in 1894.

6. Not unusually, however, Shinn initially submitted the drawing to *Harper's Weekly*, though it was not published. Nevertheless, he showed it the following year alongside more fully conceived compositions in a series of five successive exhibitions, signaling his continuing confidence in the work. Everett Shinn Collection, Archives of American Art, microfilm reel 952, frame 30. Shinn sent the drawing to *Harper's* in October 1900, according to his record book, but no date of publication is given, as was Shinn's custom when a work was accepted by a journal.

7. Rand, "The Art of Everett Shinn," 78.

8. The author is grateful to Margaret Spicer for her kind assistance in identifying the male figure's costume.

9. Gallatin, "The Art of Everett Shinn," 80.

10. Perlman, *The Immortal Eight*, 82.

34. Hassam, *Weir's Garden*

1. I am deeply indebted to Kathleen Burnside of the Childe Hassam catalogue raisonné project, Hirschl and Adler Galleries, Inc., for her insights and background information on this work, particularly its early exhibition history and provenance.

2. Two exhibitions of his watercolors were held at Williams and Everett Gallery in Boston. The gallery advertised the first, held in 1882, as "quaint studies at Nantucket—bits of beach, with boats and figures; old cottages, with glimpses of sea and sky." The second, held in 1884, offered views from an 1883 trip to Europe. Hassam Papers, unidentified clipping under "Boston Journals," quoted in Ulrich W. Hiesinger, *Childe Hassam: American Impressionist* (New York: Jordan-Volpe Gallery; Munich: Prestel, 1994), 14.

3. For a detailed study of Hassam's association with Celia Thaxter and the Isles of Shoals, see David Park Curry, *Childe Hassam: An Island Garden Revisited* (Denver: Denver Art Museum, in association with W. W. Norton, 1990).

4. Seven years after meeting through the American Watercolor Society in 1890, Hassam and Weir worked together to found the Ten, a highly influential exhibition group of ten painters, most of them impressionists. As Hassam later reminisced, "I saw a great deal of Weir in town and country." Childe Hassam, "Reminiscences of Weir," in Phillips Memorial Gallery, *Julian Alden Weir: An Appreciation of His Life and Works* (New York: E. P. Dutton, 1922), 69. Weir is said to have purchased his eighteenth-century farm in 1882 from an art collector, Erwin Davis, for ten dollars and a painting. Over the years he made considerable improvements to the buildings and landscape and purchased adjoining land to create an estate of 238 acres. For more on the property, see Cynthia Zaitzevsky and Child Associates, Inc., *Cultural Landscape Report from Weir Farm National Historic Site*, Olmsted Center for Landscape Preservation, Cultural Landscape Publication no. 6 (Washington, D.C.: National Park Service, U.S. De-

partment of the Interior, 1996), 11. Other sources on Weir and his Branchville farm include Doreen Bolger Burke, *J. Alden Weir: An American Impressionist* (Newark: University of Delaware Press, 1983); Hildegard Cummings, Helen K. Fusscas, and Susan G. Larkin, *J. Alden Weir: A Place of His Own* (Storrs: William Benton Museum of Art, University of Connecticut, 1991); and Nicolai Cikovsky Jr., Elizabeth Milroy, Harold Spencer, and Hildegard Cummings, *A Connecticut Place: Weir Farm, an American Painter's Rural Retreat* (Wilton, Conn.: Weir Farm Trust, in collaboration with the National Park Service, Weir Farm National Historic Site, 2000).

5. According to Kathleen Burnside, Hassam also painted a watercolor entitled *Weir's Barns* (unlocated) and the oil *Road in the Land of Nod*, 1910 (Wadsworth Atheneum), in Branchville.

6. The precise origins and location of this garden remain unknown. Weir's wife planted a flower garden—apparently mostly annuals—as early as 1886, but it proved not to be a success. A more formal, enclosed garden seems to have supplanted it by 1915. See Zaitzevsky, *Cultural Landscape Report*, 18, 20, 75, 89, 94.

7. Beginning in the late 1890s Hassam frequently introduced other media, including opaque watercolor and pen and ink, to his watercolors. For example, Hassam employed pen and ink to strengthen the outline of two ships in another 1903 watercolor, *Fourmaster Schooner* (reproduced in Curry, *Childe Hassam: An Island Garden Revisited*, 25), and incorporated opaque watercolor, pastel, and Chinese white in several of his urban watercolors published in *Three Cities by Childe Hassam*, 1899.

35. Walkowitz, *New York (New York Impressions)*

1. The largest series by far, reportedly including more than five thousand works, was that of Isadora Duncan dancing. William Innes Homer, *Abraham Walkowitz (1878–1965): Watercolors from 1905 through 1920 and Other Works on Paper* (New York: Zabriskie Gallery, 1994), 12.

2. Carl Van Vechten, "Comments," in Abraham Walkowitz, *Improvisations of New York: A Symphony in Lines* (Girard, Kans.: Haldeman-Julius Publications, 1948), n.p.

3. Homer, *Abraham Walkowitz*, 9.

4. See, for example, Robin Jaffee Frank, *Charles Demuth Poster Portraits, 1923–1929* (New Haven: Yale University Press, 1994).

5. Jerome Mellquist, "The Plastic Alphabet of Abraham Walkowitz," in Abraham Walkowitz, *A Demonstration of Objective, Abstract, and Non-Objective Art* (Girard, Kans.: Haldeman-Julius Publications, 1948), 5.

6. Henry McBride, "Walkowitz and the Workers," in Walkowitz, *A Demonstration*, 7.

7. Sheldon Reich, "Abraham Walkowitz: Pioneer of American Modernism," *American Art Journal* 3, no. 1 (spring 1971), 72.

8. Martica Sawin, who has made perhaps the most extensive and rigorous study of Walkowitz's career and who had access to the artist's intact studio after his death in 1965, has suggested that the series "oc-

cupied his attention continually in the years between 1912 and 1920." Reich has suggested 1917 as the starting point. Reich, "Abraham Walkowitz," 80. Reva Wolf has suggested that the series was created between 1915 and 1925. Wolf, *Record of an Experience: Works on Paper by Abraham Walkowitz from the Collection of the Rose Art Museum* (Waltham, Mass.: Rose Art Museum, Brandeis University, 1978), 6. Priscilla Siegel has written that Walkowitz may have begun the city series in response to an exhibition of John Marin's work in 1913. Siegel, "Abraham Walkowitz: The Early Years of an Immigrant Artist" (M.A. thesis, University of Delaware, Newark, 1976), 117–18. Theodore W. Eversole is one of the very few authors to take Walkowitz's dates at face value, but he failed to explain his reasoning for doing so. Eversole, "Abraham Walkowitz and the Struggle for an American Modernism" (Ph.D. diss., University of Cincinnati, 1976), 145.

9. Kent Smith, *Abraham Walkowitz Figuration, 1895–1945* (Long Beach, Calif.: Long Beach Museum of Art, 1982), 39.

36. Sargent, *Preliminary Figure Study for "Hell," Boston Public Library Mural Project*

1. Sargent's first experience as a public mural painter came while he was still a pupil of Carolus-Duran in Paris. He, along with fellow Americans J. Carroll Beckwith and Frank Fowler, assisted Carolus on a large ceiling decoration for the Palais du Luxembourg, *The Triumph of Marie de' Medici* (1878), now preserved at the Musée du Louvre. Sargent's first independent mural was for the Boston Public Library (1895–1919), followed by mythologically based decorations for the stairwell and rotunda of the Museum of Fine Arts, Boston (1916–25), and a pair of commemorative panels—*Entering the War* and *Death and Victory*—for Harvard's Widener Library (1920–22). Sargent also painted a mural-scaled work for the British War Memorials Committee of the Ministry of Information in 1919. That twenty-foot-long painting, entitled *Gassed*, is now displayed at the Royal Imperial War Museum, London. With the exception of the Widener and British War Memorial commissions, these works also included monumental sculpture in relief by Sargent.

2. Sargent signed an initial contract with the library on January 18, 1893, for the sum of $15,000. A second contract for an equal amount was signed on December 5, 1895. See "Contract between John Singer Sargent and the Trustees of the Boston Public Library," Boston Public Library (BPL), Manuscript Division. For a thorough narrative account of Sargent's involvement at the BPL, see Trevor Fairbrother, *John Singer Sargent and America* (New York: Garland Press, 1986), 217, 267–68. McKim, Mead, and White pursued a number of artists then working in Europe. The architects approached Augustus Saint-Gaudens as early as 1887 to produce sculptural embellishments for the building. See Walter Muir Whitehill, *Boston Public Library: A Centennial History* (Cambridge, Mass.: Harvard University Press, 1956), 148–49. In addition to Sargent, Puvis de Chavannes, Edwin Austin Abbey, and John Elliott all painted murals in Boston's library. The architects also tried, unsuccessfully, to engage these other artists to decorate discrete spaces in the building: Elihu Vedder, John La Farge, James McNeill Whistler. Charles

Moore, in *Life and Times of Charles Follen McKim* (Boston: Houghton Mifflin, 1929), also recounts these failed efforts. For more on the sequence and implications of these individual commissions, see Derrick R. Cartwright, "Reading Rooms: Interpreting the American Public Library Mural" (Ph.D. diss., University of Michigan, 1994), 101–79.

3. See Martha Kingsbury, "Sargent's Mural's in the Boston Public Library," *Winterthur Portfolio* 11 (1976), 153–76, for a solid account of the commission and its development.

4. Initial published responses celebrated the works in unrestrained terms. One writer, for example, commented on seeing both of the large lunettes in place: "There is at last a mural painting in America worth a journey across the continent to see. . . . [Sargent's Boston murals are] a permanent example of the way to treat the human figure in painted decoration." Russell Sturgis, "Boston Public Library: The South End of Sargent Hall," *Architectural Record* 15 (May 1904), 423, 430. By the mid–twentieth century, however, prevailing critical opinion had shifted 180 degrees. Bernard Berenson was among the many authoritative voices who cruelly dismissed Sargent's effort. He wrote in 1963: "As 'murals' I know of nothing less appropriate to their walls than his in the Boston Public Library." Quoted by Mary C. Volk in "Sargent in Public: On the Boston Murals," in Elaine Kilmurray and Richard Ormond (eds.), *John Singer Sargent* (Washington, D.C.: National Gallery of Art, 1999), 45.

5. See Sally M. Promey, *Painting Religion in Public: John Singer Sargent's Triumph of Religion at the Boston Public Library* (Princeton: Princeton University Press, 1999), for a complex account of the content and controversies surrounding this commission and its subsequent reception by groups in Boston.

6. The sections of the mural were installed in four distinct phases: 1895, 1903, 1916, and 1919.

7. The first of these publications was issued at the opening of the library. Herbert Small, *Handbook of the New Boston Public Library* (Boston: Curtis and Company, 1895). Free descriptive brochures are still circulated by the library today.

8. The multiple inscriptions on the drawing considered here might have been written by Fox, who was devoted to this work and followed a careful registrarial system in his annotations. The key to that system is recounted in a typescript—seemingly related to an exhibition at the Museum of Fine Arts—entitled "John Singer Sargent: Studies and Preliminary Work for Decorations in the Boston Public Library and the Museum of Fine Arts, Boston: June–October 1927." The Hood drawings (see below and note 10), like others in the Corcoran collection and elsewhere, do not strictly follow the rationale of this document. The typescript is in the Thomas Fox Papers, Boston Athenaeum Library. Also see Melinda Linderer, "An Inventory of Works by Sargent Compiled by Thomas Fox" and "Sargent's Legacy: An American Inheritance," *Harvard University Art Museums Bulletin* 7 (fall–winter 2000), 7–15.

9. The Museum of Fine Arts, Boston, The Metropolitan Museum of Art, Philadelphia Museum of Art, and the Corcoran Gallery of Art received the majority of works from this distribution of what may have either been considered "study objects" or else "un-

saleable" studio contents. In addition to Dartmouth College, the following academic institutions also received gifts of drawings: Addison Gallery of American Art, Bowdoin College Museum of Art, Fogg Art Museum at Harvard, Mead Art Museum at Amherst, Mount Holyoke, Rhode Island School of Design, Smith College Museum of Art, Yale University Art Gallery, and Williams College Museum of Art.

10. The Dartmouth drawings are divided between Boston Public Library and Museum of Fine Arts subjects. A letter from Thomas A. Fox to Professor Arthur Fairbanks dated October 15, 1929, records the offer of ten or twelve drawings to which the institution was "entitled." HMA object files. Fairbanks was previously director of the Museum of Fine Arts, Boston, from 1907 to 1925, and he would certainly have been involved with Sargent's commission there before returning to his alma mater to teach for two years. See "Dr. Arthur Fairbanks," *Museum of Fine Arts Bulletin* 13 (February 1925).

11. *Handbook of the Boston Public Library* (Boston: Association Publications, 1918), 86–89. For a similarly worded appraisal, see Frank W. Coburn, "The Sargent Decorations in the Boston Public Library," *American Magazine of Art* 8 (February 1917), 134.

12. The related drawing that provides the most information about the intended use of this particular sketch is at Smith College (fig. 76), in which the head of the male figure is transformed into the devouring form of a monster. The Corcoran Gallery of Art possesses a slightly more developed drawing titled *Study for a Figure for "Hell"* (49.95) that is unquestionably related to the Hood's, and a third sheet, *Two Reclining Figures in Perspective*, at the Philadelphia Museum of Art (29.182.8) includes still another study of this pose. These drawings are on identically sized sheets of paper and bear the Michallet watermark.

13. Trevor Fairbrother points out, for example, that the artist employed a sketch for a screaming male on at least two panels at Boston. See Trevor Fairbrother, "Personal Selection: *Man Screaming* by John Singer Sargent," *American Art* 15 (spring 2001), 84–89. Mark Mitchell has also pointed out that the reclining figure at the bottom of Sargent's late mural depiction of Perseus on *Pegasus Slaying Medusa* (1925) at the Museum of Fine Arts, Boston, bears a strong resemblance to the figure in this sketch, but there it is reproduced in reverse.

14. Edwin Austin Abbey, a close friend, remarked in an 1890 letter to Charles Follen McKim that he was struck during a recent visit to Sargent's studio by the "stacks" of nude drawings he encountered, about which he commented dryly, "from my cursory observations of them, they seemed a bit earthy." Quoted in E[dward] V[erall] Lucas, *The Life and Works of Edwin Austin Abbey, R.A.*, 2 vols. (New York: Scribner's, 1921), 1:231.

15. Speculation about Sargent's sexuality has become a mainstay of art historical scholarship dealing with the artist over the past twenty-five years, largely as a result of the intense focus on the male nude body that characterizes so many of these mural studies. See, especially, Trevor Fairbrother, "A Private Album: John Singer Sargent's Drawings of Nude Male Models," *Arts Magazine* 56 (December 1981), 70–79; John Esten, *John Singer Sargent: The Male Nudes* (New York: Universe Publishing, 1999); Trevor Fair-

brother, *John Singer Sargent: The Sensualist* (Seattle: Seattle Art Museum, 2000); Ilene S. Fort, "Dressing Up: Subterfuge and Sublimation in the Alpine Paintings," in Bruce Robertson (ed.), *Sargent in Italy* (Los Angeles: Los Angeles County Museum of Art, 2003), 141–61.

37. Sloan, *Ludlow, Colorado (Class War in Colorado)*

1. George S. McGovern and Leonard F. Guttridge, *The Great Coalfield War* (Boston: Houghton Mifflin Co., 1972), vii.

2. David Bjelajac, *American Art: A Cultural History* (New York: Harry N. Abrams, Inc., 2001), 293. Sloan firmly held, at least later in life, that art and propaganda were separate entities. The fact that he reused *Ludlow, Colorado* as a cover for another journal, *The Masses*, points out several inconsistencies in his categorical statements about the differing natures of his work for those publications. As Joseph Kwiat has observed, *Ludlow, Colorado* "was nothing less than social protest with propagandistic intent." That Sloan published it in both journals contradicts his conviction that he created only "political cartoons" for the *Call*, "social satire" for *The Masses*, and propaganda for neither. Joseph J. Kwiat, "John Sloan: An American Artist as Social Critic, 1900–1917," *Arizona Quarterly* 10, no. 1 (spring 1954), 60–61. Also see Sloan, quoted directly in Helen Farr Sloan, "Unpublished Verbatim Notes, 1944–1950, of John Sloan's Conversation, Interviews and Lectures" (typescript, Richard Fitzgerald Papers, Archives of American Art, Smithsonian Institution, Washington, D.C.), 9. For more on Sloan's work in *The Masses*, see Rebecca Zurier, *Art for "The Masses": A Radical Magazine and Its Graphics, 1911–1917* (Philadelphia: Temple University Press, 1988).

3. Sloan was an active member of the Socialist Party from 1910 through 1914, running for state assembly twice, in 1910 and 1912. Philip Beam has asserted a minority opinion that Sloan's break with *The Masses* was the result of the magazine's "distorting the meaning of his and other illustrations." Beam, "The Gist of Sloan's Art," in *The Art of John Sloan, 1871–1951* (Brunswick, Me.: Bowdoin College, in association with the Walker Art Museum, 1962), 27. *The Masses* editor Max Eastman's recollection of Sloan's departure from the staff of the magazine appears to be the more widely accepted. Sloan had little to do with the publication after 1914, though he attended a staff meeting in 1916 hoping to depose the editors Max Eastman and Floyd Dell and give greater control to the artists, whose authority had diminished as the magazine's editorial policy became increasingly doctrinaire. When that effort failed, he withdrew from his symbolic position as art editor entirely. Max Eastman, *Enjoyment of Living* (New York: Harper and Brothers, 1948), 552–55. Lloyd Goodrich, *John Sloan* (New York: MacMillan Co., 1952), 47.

4. Sloan formally left the Socialist Party in 1916, the same year that he resigned as art editor for *The Masses*. Elizabeth H. Hawkes, *John Sloan's Illustrations in Magazines and Books* (Wilmington: Delaware Art Museum, 1993), 26. Guy Pène du Bois was perhaps the most strident in his denial of the artist's politics: "Sloan has often been accused of being a Socialist by people who have heard him talk or have remembered that he was once associated with that radical magazine *The Masses*. Nothing could be more

unfair to the painter. . . ." Pène du Bois, *John Sloan* (New York: Whitney Museum of American Art, 1931), 10. Lloyd Goodrich expressed the view, now widely held, that "although no longer active politically [after the onset of World War I], in his [Sloan's] thinking and his emotional reactions he remained a socialist to the end of his life, and both in private and public he often expressed himself on that side of issues." Goodrich, *John Sloan*, 47.

5. Sloan, quoted in *John Sloan/Robert Henri: Their Philadelphia Years (1886–1904)* (Philadelphia: Moore College of Art Gallery, 1976), 33.

6. Both artists are frequently cited in Sloan's autobiographical and pedagogical treatise *Gist of Art* (New York: American Artists Group, Inc., 1939), beginning with his early introduction to their works by his mentor, Robert Henri, on 1.

7. David Scott, *John Sloan* (New York: Watson-Guptill Publications, 1975), 112. No source has been found that relates an incident similar to this depiction, at least not in the *Call*, which Sloan reportedly "read every day." Van Wyck Brooks, *John Sloan: A Painter's Life* (New York: E. P. Dutton, 1955), 86. The drawing may be interpreted as a conflation of the initial massacre and the miners' outraged retaliation over the ensuing days.

8. That degree of intense emotional response may have in part led Sloan to withdraw from active contribution to socialist periodicals after the onset of World War I. His friend John Butler Yeats reportedly told Sloan at this time "with kindly frankness that his Socialist involvement and hatred of the World War had embittered him and cost him his sense of humor." Beam, "The Gist of Sloan's Art," 23.

9. Patricia Hills was the first to discover that the Hood's drawing was made for the *Call*, rather than for *The Masses*. She did not, however, remark that the two drawings were different versions of the same scene. Patricia Hills, "John Sloan's Images of Working-Class Women: A Case Study of the Roles and Interrelationships of Politics, Personality, and Patrons in the Development of Sloan's Art, 1905–16," *Prospects* 5 (1980), 192n.30.

10. McGovern and Guttridge, *The Great Coalfield War*, 51–52, 211. The workers' negotiator and de facto leader at Ludlow was Louis Tikas, whom the guardsmen called "Louis the Greek." For more on Tikas, see *Buried Unsung: Louis Tikas and the Ludlow Massacre* (Salt Lake City: University of Utah Press, 1982). Sloan's miner, with his prominent nose, high cheekbones, and extended chin, may be interpreted as an ethnic Greek himself, though the artist's technique is too broad to be conclusive.

11. Sloan may have written the caption himself. Helen Farr Sloan wrote in response to an inquiry in later years that Sloan sometimes differed with the editors of the *Call* when they altered the captions that he proposed for his drawings. Implicit, of course, is that Sloan wrote them in the first place. Helen Farr Sloan to Richard Fitzgerald, September 20, 1966, Richard Fitzgerald Papers, Archives of American Art, Smithsonian Institution, Washington, D.C. Halleck's original poem reads, "Strike— for your altars and your fires; / . . . / God—and your native land!" John Hollander (ed.), *American Poetry: The Nineteenth Century* (New York: Library of America, 1993), 1:102.

12. Bruce St. John, among a few others, has proposed that Sloan was basically naïve in his relationships with both the *Call* and *The Masses* and that their editors manipulated the artist's drawings to fit their political ends. St. John, *John Sloan* (New York: Praeger Publishers, 1971), 37. In several cases, *Ludlow, Colorado* prominent among them, that characterization appears inaccurate. St. John does not allow for the evolution of Sloan's attitude toward socialism over time. No such manipulation was necessary in the years leading up to World War I, judging by a number of Sloan's drawings from 1911 to 1915, including *The Triangle Fire* (1911), *Shall We Have a State Constabulary in New York* (1914), *Caught Red-Handed* (1914), *The Protected Sex* (1915), and *The Constabulary; Policing the Rural Districts in Philadelphia* (1915). More recent scholarship, including that by Rowland Elzea and Elizabeth Hawkes, has argued that Sloan's more humorous illustrations "could not be an adequate outlet for the growing strength of his Socialist feelings," even in 1909. Elzea and Hawkes, *John Sloan: Spectator of Life* (Wilmington: Delaware Art Museum, 1988), 18. See also Scott, *John Sloan*, 111–14.

13. Hills, "John Sloan's Images of Working-Class Women," 168.

14. Another likely precedent for Sloan's drawing is Goya's *Disasters of War* series of aquatints, especially no. 18 from the series, *Bury Them and Keep Quiet* (c. 1808–14).

15. The common error of relating *Ludlow, Colorado* to the later version in *The Masses* rather than to the *Call* may be attributed to the fact that the former had a far more prestigious art department, including Art Young, George Bellows, and Stuart Davis, whereas the *Call* included very little art and is consequently rarely studied by art historians.

16. "He loved youth, and particularly young women and girls; after seeing two girls roughhousing he wrote: 'A fine youthful vigor and beauty in their play. I enjoyed watching it. I get a joy from these healthy girls (one of them on the verge of womanhood) that I can't describe—it's as big as life itself.' " Quoted in Goodrich, *John Sloan*, 22. Sloan's treatments of working-class women have been the basis of several recent studies: Hills, "John Sloan's Images of Working-Class Women"; Janice Marie Coco, "John Sloan and the Female Subject" (Ph.D. diss., Cornell University, 1993); and Laurel Weintraub, "Women as Urban Spectators in John Sloan's Early Work," *American Art* 15, no. 2 (summer 2001), 72–83.

17. I am grateful to Ellen Wiley Todd for drawing my attention to these works. Two examples are illustrated in Elzea and Hawkes: *The Triangle Fire* (1911), 109, no. 296, and *The Protected Sex* (1915), 160, no. 524.

38. Gilmore, *In the Garden*

1. For a history of the art colony, see Ronald A. Kuchta (ed.), *Provincetown Painters, 1890's–1970's* (Syracuse, N.Y.: Everson Museum of Art, 1977). Several publications have surveyed the development of the Provincetown print, most notably Janet Flint, *Provincetown Printers: A Woodcut Tradition* (Washington, D.C.: Smithsonian Institution Press for the National Museum of American Art, 1983), and Barbara Stern Shapiro, *Blanche Lazzell and the Color Woodcut* (Boston: Museum of Fine Arts, 2002). For further information on Ada Gilmore, see Barbara Parker, "Ada Gilmore," in *Ada Gilmore: Woodcuts and Watercolors* (New York: Mary Ryan Gallery, 1988), and the catalogue and biographical entries for Ada Gilmore Chaffee in David Acton, *A Spectrum of Innovation: Color in American Printmaking, 1890–1960* (Worcester, Mass.: Worcester Art Museum; New York: W. W. Norton, 1990).

2. Gilmore participated in the New York landmark *Exhibition of Independent Artists* that Robert Henri helped to organize in 1910. The titles of her drawings, such as *Along Riverside Drive* and *In the Park*, indicate urban themes. Maurice Prendergast (see cats. 31, 32) also participated in this exhibition. His cheerful palette and mosaic-like technique may have provided an important example for Gilmore.

3. For more on Ethel Mars, see Catherine Ryan, *Très Complémentaires: The Art and Lives of Ethel Mars and Maud Hunt Squire* (New York: Mary Ryan Gallery and Susan Sheehan Gallery), 2000.

4. In 1915 Gilmore exhibited at the Panama-Pacific International Exposition in San Francisco; the first exhibition of the Provincetown Art Association; the New York Watercolor Club (at which she exhibited annually); and the Berlin Photographic Company in New York. She continued to exhibit regularly in Provincetown, New York, and Boston. Acton, *A Spectrum of Innovation*, 120. According to a reminiscence by Provincetown printmaker Blanche Lazzell, she and Gilmore both exhibited at the 1923 Salon d'Automne, Paris: "a print of Ada Chaffee was hung on each side of a painting by Henri Matisse. . . . I was there and saw this exhibition." Quoted in Shapiro, *Blanche Lazzell*, 19. Both artists continued to participate in these French exhibitions into the 1930s.

5. She also at times hand-applied additional watercolor to the printed images. Acton, *Spectrum of Innovation*, 70.

39. Bellows, *The Boardwalk (The Merry-Go-Round)*

1. "The Big Idea: George Bellows Talks about Patriotism for Beauty," *Touchstone* 1 (July 1917), 270–75, quoted in *Addison Gallery of American Art: 65 Years* (Andover, Mass.: Addison Gallery of American Art, 1996), 323.

2. I am grateful to Glenn Peck for originally suggesting that I investigate amusement parks in Maine for the subject of this work. I am also indebted to Eileen McNally of the Edith Belle Libby Memorial Library in Old Orchard Beach for her assistance in confirming the site depicted in our drawing. Bellows painted largely figures and portraits in Ogunquit, including *Nude with Parrot* (Collection Audrey Love, 2002) and likenesses of Gypsy women (among the works later destroyed by his widow).

3. The theme of two women drawing male attention as they stroll arm in arm appears in such lithographs as *The Street*, 1917 (Lauris Mason, assisted by Joan Ludman, *The Lithographs of George Bellows: A Catalogue Raisonné* [Millwood, N.Y.: KTO Press, 1997], no. 47, based on a 1914 drawing), and *Spring, Central Park*, 1921 (ibid., no. 90).

4. Unless it was created later than is presently believed, it is unlikely that this drawing served as a

study for a lithograph, as he did not work in the medium until 1916.

40. Lazzell, *Fox Glove (Foxgloves)*

1. Blanche Lazzell's notes, cited by John Clarkson, *Blanche Lazzell* (Provincetown, Mass.: Cape Cod Pilgrim Memorial Association, 1969), 10. Other important sources on the artist include Barbara Stern Shapiro, *From Paris to Provincetown: Blanche Lazzell and the Color Woodcut* (Boston: MFA Publications, a division of the Museum of Fine Arts, Boston, 2002), 11–23, 91–95; David Acton, *A Spectrum of Innovation: Color in American Printmaking, 1890–1960* (Worcester, Mass.: Worcester Art Museum; New York: W. W. Norton, 1990), 82–83, 270–71; and Michael Rosenfeld Gallery, *Blanche Lazzell: American Modernist* (New York: Michael Rosenfeld Gallery, 2000). Robert Bridges, curator of the West Virginia University Art Collections, is editor of a multi-author retrospective exhibition catalogue on Lazzell to be published by West Virginia University Press late in 2004.

2. Lazzell learned the method in 1916 from Oliver N. Chaffee (later the husband of Ada Gilmore). Lazzell had also studied earlier with Charles W. Hawthorne, patriarch of the early Provincetown art colony, at the Cape Cod School of Art.

3. She studied painting with Boss in New York City over the winter of 1916–17 and color analysis with Schumacher in Woodstock, New York, that next summer. Her other instructor, Andrew Dasberg, was dubbed the "Woodstock cubist" for his leading advocacy of modernism in the 1910s. From 1923 to 1926 Lazzell studied cubism with Albert Gleizes, Fernand Léger, and André Lhote in Paris, and in the late 1930s and 1940s she took classes in Provincetown from nonobjective American painter Hans Hofmann.

4. A 1951 article in the *Standard Times* of New Bedford described Lazzell's unusual container garden: "Flanking the sides of the studio stand rows of nail kegs and boxes, . . . forming a perfect background for the plants, vines and flowers that fill them, grow up to the roof on fish nets or strands of twine, or spill overboard and downward in the most engaging fashion. Here grow sunflowers, larkspur, petunias, morning glories, some of which are an unusual rosy red or deep royal purple, marigolds and geraniums. Some of these are more than four feet in height." Quoted in Clarkson, *Blanche Lazzell*, 13. Lazzell's verdant seaside garden, hospitality to visitors, and work in a range of media recall the eclectic artistic and horticultural pursuits of Celia Thaxter, whose home on Appledore, in the Isles of Shoals, was a center of an art colony in the late nineteenth century.

5. This drawing on a gray laid sheet differs from most of Lazzell's preparatory drawings for woodblock prints, which are done on tracing paper. A pinhole at the upper left corner may suggest it was attached to a block for transfer purposes. The sheet and drawn lines show no clear evidence of tracing, however.

6. The stylized ornamentation of Lazzell's 1907 handpainted ceramic plates reveals her clear grounding in Arts and Crafts design principles. The plates are reproduced in Shapiro, *From Paris to Provincetown*, 58.

7. Clarkson, *Blanche Lazzell*, 10.

8. Lazzell pulled the four prints in 1920, 1921, 1925, and 1926, and she exhibited each at venues large and small. She included the fourth impression of *Fox Glove* in 1926 in an exhibition of her work at the Howe Library in Hanover, New Hampshire. Blanche Lazzell Papers, Archives of American Art, Smithsonian Institution, Washington, D.C., reel 2991, frame 102.

9. This print is reproduced in Charles T. Lazzell and Dorothy P. Lazzell (comps.), *Blanche Lazzell: A Compilation of Her Art Work* (West Virginia: the compilers, 1998), woodblock no. 34 (color illus.).

10. Lazzell owned a large palette, dated 1907, that she is said to have shared with O'Keeffe at the Art Students League. Shapiro, *From Paris to Provincetown*, 22n.2.

11. Quoted in Clarkson, *Blanche Lazzell*, 10.

41. Luks, *Sketch of Two Men*

1. Study was further derailed when Luks's executors decided to destroy works in the artist's estate that they deemed inferior. "Luks Heirs to Sell His Best—Destroy the Rest," *The Art Digest* 24, no. 12 (March 15, 1950), 24.

2. John Loughery, "The Mysterious George Luks," *Arts Magazine* 62, no. 4 (December 1987), 34.

3. "Luks Speaks Up," *The Art Digest* 7, no. 7 (January 1, 1933), 12, 29.

4. Ira Glackens, "Little Old George Luks," in *George Luks, 1866–1933* (Utica, N.Y.: Museum of Art, Munson-Williams-Proctor Institute, 1973), 9.

5. Theodore E. Stebbins Jr., *American Master Drawings and Watercolors: A History of Works on Paper from Colonial Times to the Present* (New York: Harper and Row, 1976), 288.

6. Guy Pène Du Bois, "George Luks and Flamboyance," *The Arts* 3, no. 2 (February 1923), 118.

7. Elizabeth Luther Cary, "George Luks," *The American Magazine of Art* 14, no. 2 (February 1923), 77.

8. Benjamin de Cassères, cited in Newark Museum, Newark, N.J., *Catalogue of an Exhibition of the Work of George Benjamin Luks* (Newark, N.J.: Newark Museum, 1934), 12.

9. Michael Mosher, "Sketch of Two Men," in Franklin W. Robinson (ed.), *Works on Paper: Nineteenth and Twentieth Century Drawings and Watercolors from the Dartmouth College Collection* (Hanover, N.H.: Dartmouth College Collections, 1975), 34–35.

10. Mary Fanton Roberts, "'Painting Real People' Is the Purpose of George Luks' Art," *The Touchstone* 8, no. 1 (October 1920), 32, 35.

42. Sloan, *Family on Fire Escape (Ella Was a Washtub Woman)*

1. Oddly, social historians including Patricia Hills have celebrated Sloan's works specifically for *not* romanticizing their working-class subjects. Hills, "John Sloan's Images of Working-Class Women: A Case Study of the Roles and Interrelationships of Politics, Personality, and Patrons in the Development of Sloan's Art, 1905–16," *Prospects* 5 (1980), 160–61.

2. Clifford Raymond, "Brothers under the Sod," *Hearst's International* 42 (August 1922), 66.

3. The story's title, "Brothers under the Sod," derives from the fact that the lead character and his killer both end up dead.

4. E. John Bullard, "John Sloan: His Graphics," in National Gallery of Art, Washington, D.C., *John Sloan, 1871–1951* (Boston: Boston Book and Art, Publisher; Washington, D.C.: National Gallery of Art, 1971), 31.

5. John Baker, "Voyeurism in the Art of John Sloan: The Psychodynamics of a 'Naturalistic' Motif," *Art Quarterly* 1, no. 4 (1978), 380.

6. Ibid., 394–95. Janice M. Coco has advanced this argument even further, finding that the "optimistic tenor" of Sloan's depictions "masks the reality that the artist generally feared women, despite the fact that he married twice." Coco, "Re-viewing John Sloan's Images of Women," *Oxford Art Journal* 21, no. 2 (1998), 81.

7. Laural Weintraub, "Woman as Urban Spectators in John Sloan's Early Work," *American Art* 15, no. 2 (summer 2001), 72. She has asserted that Sloan's interest in self-conscious reflections on the subject of voyeurism endured in its most overt form only until 1908.

8. "It misses the point to interpret Sloan's women-watching, as some have, as voyeurism arising out of a blocked sexuality. It seems clear to me that Sloan's delight in women stems from his belief, perhaps even envy, that they represent pure, simple, innocent spontaneity. . . ." Hills, "John Sloan's Images of Working-Class Women," 176.

43. Feininger, *Seascape with Cloudy Sky (Marine mit bewölktem Himmel)*

1. Feininger to Julia Feininger, September 2, 1922, quoted in June L. Ness (ed.), *Lyonel Feininger* (New York: Praeger Publishers, 1974), 116.

2. Different scholars have different opinions on the matter of Feininger's artistic nationality. Legally, he was an American. He was raised in the United States until he was sixteen and lived out his life here after leaving Germany in 1937. Aesthetically, however, the issue is more ambiguous. Hans Hess has written that "Feininger neither knew, influenced, nor was influenced by any artist working in America." Hess, *Lyonel Feininger* (New York: Harry N. Abrams, Inc., 1961), 92. In different terms, Alfred Barr, former director of the Museum of Modern Art, New York, claimed the contrary: "During his whole long career in Germany Feininger always thought of himself as American, and was so considered by his German friends." Barr, "Lyonel Feininger—American Artist," in Museum of Modern Art, New York, *Lyonel Feininger Marsden Hartley* (New York: Museum of Modern Art, 1944), 10.

3. Hess, *Lyonel Feininger*, 100. *Seascape with Cloudy Sky*, dated to June 4, 1922, was painted before his departure for the coast. According to Ulrich Luckhardt, chief curator at the Hamburger Kunsthalle,

Feininger did not depart for the Baltic until August. A drawing dated June 8, 1922, depicting Ramsla, a town near Weimar, also places the artist inland. Ulrich Luckhardt to the author, e-mail correspondence, July 22, 2003, HMA object files.

4. Gropius, "My Friendship with Feininger," reprinted in Ness, *Lyonel Feininger*, 256.

5. Hess, *Lyonel Feininger*, 88.

6. Quoted in ibid., 105.

7. Feininger to Julia Feininger, February 11, 1922, quoted in Ness, *Lyonel Feininger*, 114.

8. Feininger, quoted in Hess, *Lyonel Feininger*, 98.

44. Zorach, *Sixth Avenue "L"*

1. Marguerite Zorach also frequented Gertrude Stein's artistic salon in Paris. At La Palette, where she first met William Zorach, she studied under John Duncan Fergusson, an enthusiastic exponent of post-impressionism. See Roberta K. Tarbell, "Early Paintings by Marguerite Zorach," *American Art Review* 1, no. 3 (March–April 1974), 43–57.

2. Zorach wrote from New York to her British friend Jessie Dismorr in April 1922: "As for myself, I probably will feel equally cheerful when we get out in the country somewhere. The world takes on a totally different aspect at once." Quoted in Roberta Tarbell, "Life and Work: Marguerite and William Zorach in New York and Maine, 1922–1968," in *Marguerite and William Zorach: Harmonies and Contrasts* (Portland, Me.: Portland Museum of Art, 2002), 64. To bring nature into their Greenwich Village apartment during the confining winter months, the Zorachs, according to one account, painted colorful murals of figures, flora, and fauna "invoking Gauguin. [They] created quarters like a breath of lush Tahiti opposite the noisome Jefferson Market Court. Every piece of furniture in the Zorachs' apartment was painted a crude color: yellow, vermillion, red, bright orange, purple. A huge flat group depicting Adam and Eve, the evil serpent, and the Tree of Life, all in flaming hues, covered one wall, while on the others were painted tropical foliage and flowers, orange leopards, birds, and other creatures." Allen Churchill, *The Improper Bohemians: Greenwich Village in Its Heyday* (London: Cassell, 1959), 60, quoted in Hazel Clark, "The Textile Art of Marguerite Zorach," *Woman's Art Journal* 16, no. 1 (spring–summer 1995), 18–19. Aside from her discontent with city living, Marguerite struggled with melancholy during the late 1910s and the 1920s as she confronted the common challenges facing women artists. She resented the lack of professional recognition afforded her as a female artist and the limitations on her time imposed by domestic responsibilities. Zorach voiced many of these frustrations when interviewed by Rebecca Hourwich for the article "Art Has No Sex," in *Equal Rights* (Washington, D.C.: National Woman's Party, December 12, 1925).

3. William Zorach, *Art Is My Life*, 31, quoted in Jessica Nicoll, "To Be Modern," in *Marguerite and William Zorach: Harmonies and Contrasts*, 34.

4. Other urban works include her lithographs *Cat in Our Backyard (Cat and Bird)*, 1923, and *Grapefruit*, c. 1924 (with urban buildings prominently visible through a window); and an untitled watercolor that depicts an abstracted embracing couple surrounded by a fractured cityscape. I am grateful to Katherine Degn of Kraushaar Galleries for providing me with images of these three works.

5. Of fourteen works in the exhibition, just two seem certain to have been painted in New York, *Our Corner* and *Snow and Steam*, the latter described by one reviewer as an excavation scene that "shows all that is left of the ancient Jefferson Market" (Edward Alden Jewell, "Variety Incarnation, As Lancelot Gobbo Would Say, If He Were Here to Tramp about among Galleries," *New York Times*, February 23, 1930, 120).

6. Beginning in 1926, for instance, Zorach served as the first president of the New York Society of Women Artists, "the left wing of the feminine artistic movement." Ella Honig Fine, *Women and Art* (Montclair, N.J., 1978), 145, quoted in Amy J. Wolf, *New York Society of Women Artists 1925* (New York: ACA Galleries, 1987), 6. Zorach also served as vice president of the Society of Independent Artists in 1922 and as a director from 1922 to 1924.

7. *New York Times*, July 10, 1927, review of Provincetown Art Association exhibition, quoted in Margaret MacDougal, "Annotated Chronology," in *Marguerite and William Zorach: Harmonies and Contrasts*, 95.

45. Burchfield, *Early Morning*

1. Burchfield moved to Buffalo to take a job designing wallpaper for M. H. Birge and Sons. He worked there until 1929, when he began to paint full time.

2. John I. H. Baur, for instance, referred to Burchfield's late style as the "Triumph of Expressionism" in his title for a chapter covering the period 1950–61 in his monograph on the artist, *The Inlander: Life and Work of Charles Burchfield, 1893–1967* (Newark: University of Delaware Press, An American Art Journal Book, 1982). Burchfield also minimized, in retrospect, the value of his work from his second period. I am indebted to Michael D. Hall's reevaluation of Burchfield's work from the 1920s and 1930s in "Burchfield's Regionalism: The Middle Border and the Great Divide," in Nannette V. Maciejunes and Michael D. Hall, *The Paintings of Charles Burchfield: North by Midwest* (New York: Harry N. Abrams, Inc., in association with the Columbus Museum of Art, 1997), 73–88.

3. Despite his clear affinities with the regionalists, Burchfield's comments on the movement ranged from lukewarm to hostile, culminating in his exclamation in 1938: "Regionalism—it makes me sick!" Burchfield to Frank K. M. Rehn, October 11, 1938, quoted in Baur, *The Inlander*, 169.

4. Gordon Washburn, "An Artists Society Sponsors a Regional Show," in *The Great Lakes Exhibition 1938–39: Paintings by Artists of the Great Lakes Region* (Buffalo, N.Y.: Albright Art Gallery, 1938), n.p., quoted in Hall, "Burchfield's Regionalism," 73. Washburn continued: "In fact we sometimes feel, glancing at old houses in his neighborhood, that he must have built them himself, so much more clear to us is his vision of them, transmitted through his pictures, than are the original objects of his affection."

5. Charles E. Burchfield's journals, Burchfield-Penney Art Center, Buffalo State College, Buffalo, N.Y., vol. 36, p. 48. I am deeply grateful to Nancy Weekly, Head of Collections and the Charles Cary Rumsey Curator of the Burchfield-Penney Art Center, for providing this citation and confirming that the view of *Early Morning* was taken from the artist's Franklin Street apartment (see below). Letter from Nancy Weekly to Mark Mitchell, July 25, 2003, HMA object files.

6. Photographs of the apartment building taken in 2003 (courtesy of Mark Mitchell, Hood Museum of Art; HMA object files) reveal that Burchfield narrowed the building's proportions, as he often did when depicting architecture. See, for example, the comparison between a photograph of about 1944 of a building at Clinton and Lord Streets, Buffalo, and Burchfield's watercolor of the same scene, *Ice Glare*, 1931–33 (Whitney Museum of American Art), reproduced in "Burchfield's Buffalo: A Comparison Between the Artist's and the Camera's Eye," *Art News* 43, no. 6 (May 1–14, 1944), 13.

7. Quoted in John I. H. Baur (ed.), "Burchfield's Intimate Diaries," *Art News* 54, no. 9 (January 1956), 66 (quotation is undated but falls under the heading "On his return to intimate interpretation of nature, 1942–54"). Burchfield also wrote: "What intoxication. The February sun has started roofs to dripping glittering water. The streets are full of water and muddy slush. The crude hideous buildings glow with brilliant color, and I feel as if I would like to embrace them." Ibid., 66 (under Baur's heading "The Mid-Western Scene, 1918–42").

8. Beginning about 1941, he often expanded and revised earlier drawings and watercolors, especially his work from about 1917. For more on this method, see Ruth Osgood Trovoto, *Extending the Golden Year* (Clinton, N.Y.: Emerson Gallery, Hamilton College, 1993), 28–31.

9. Charles Burchfield, *The Drawings of Charles Burchfield*, 1968, quoted in Hall, "Burchfield's Regionalism," 87.

46. Ault, *Back of Patchin Place*

1. John Ruggles, "The Art of George Ault," in *George Ault Memorial Exhibition* (Woodstock, N.Y.: Woodstock Art Gallery, 1949), n.p.

2. Ault's favorite brother, Harold, committed suicide in 1915, and five years later his mother died in a mental institution. His father died of cancer in 1929, and two other brothers committed suicide that same year. Although George Ault's widow and close friends argued otherwise, he likely died by suicide as well. Susan Lubowsky, *George Ault* (New York: Whitney Museum of American Art, 1988), 7–8. Lubowsky's exhibition catalogue is the single most useful source on Ault's career.

3. Quoted in Louise Ault, "Questions and Answers," George Ault Papers, Archives of American Art, Smithsonian Institution, Washington, D.C., reel D247, frame 17.

4. Ault continued to visit New York and paint the city after his move to Woodstock but also developed a quasi-regionalist style influenced in part by the folk art he collected, which he applied to his rural surroundings.

5. Patchin Place and the adjacent Milligan Place were developed in the mid–nineteenth century as a series of boardinghouses for workers at the old

Brevoort House on Fifth Avenue. By the early twentieth century, Patchin Place had become a fashionable neighborhood for the literary set. See Elliot Willensky and Norval White, *AIA Guide to New York City: Third Edition* (New York: Harcourt Brace Jovanovich, 1988), 120, and Bill Morgan, *Literary Landmarks of New York: The Book Lover's Guide to the Homes and Haunts of World Famous Writers* (New York: Universe, 2003), 54–57.

6. Elizabeth McCausland, in catalogue entry for lot 45 in *Berenice Abbott's New York: Photographs from The Museum of the City of New York* (New York: Sotheby's, October 23, 2002), 60.

7. Henry McBride, for instance, wrote, "Now [Ault's] world appears less like building blocks skillfully fitted together for he begins to turn to more representative work with decided development of three-dimensional design." McBride, "Attractions in Local Galleries," *New York Sun Herald*, November 17, 1928, 7. A reviewer for the *Art News* felt "his [Ault's] work has gained in plasticity and warmth, has less of theory and more of imagination." "George Ault: Downtown Gallery," December 1, 1928. Another critic reviewing the exhibition noted that Ault's "drawings . . . exhibit a sensitiveness of tone and quality not unlike the effects produced in silver point." *New York Herald Tribune*, November 25, 1928, sec. 7, 10. Ault eventually chafed at Edith Halpert's aggressive marketing strategies and broke with her Downtown Gallery in 1934, to the detriment of his commercial success. As his paintings had begun to sell to collectors and museums, Ault came under great pressure: "the gallery got excited; they began phoning me to get a picture ready for this and a picture ready for that—I can't work that way." Ault, quoted in Louise Ault, *Artist in Woodstock: George Ault: The Independent Years* (Philadelphia: Dorrance and Company, 1978), 70.

8. William B. McCormick, "Ault and Others Return to Local Art Galleries," *New York American*, November 25, 1928, quoted in George Ault Papers, reel 3935, frame 1202.

47. Herrera (Ma-Pe-Wi), *Rain Dance—Annual Fiesta—Zia Pueblo*

1. Janet Catherine Berlo and Ruth B. Phillips, *Native North American Art* (Oxford: Oxford University Press, 1998), 217.

2. Leslie A. White, *The Pueblo at Sia, New Mexico* (Washington, D.C.: Smithsonian Institution Bureau of American Ethnology, 1962), 65.

3. The artist reportedly "backslid" on his religious conversion, which may have diminished the tribe's animosity. White, *The Pueblo at Sia*, 70–71. In a 1944 interview, Herrera reported that the Zia elders had softened their criticism. However, since the tribe had confiscated his land and expelled him from the tribe, we can only speculate as to what form any reconciliation may have taken. Herrera, quoted in "Well-Known Indian Painter Thanks Dr. Edgar Hewitt," *Santa Fe New Mexican*, December 19, 1944.

4. J. J. Brody, *Pueblo Indian Painting: Tradition and Modernism in New Mexico, 1900–1930* (Santa Fe, N.Mex.: School of American Research Press, 1997), 160.

5. Herrera began to sign his works "Ma-Pe-Wi" at

this time as well, presumably to appear more overtly Indian to European American audiences. Brody, *Pueblo Indian Painting*, 160.

6. Brody has expressed the opinion that this scene more likely represents a Christmas dance than the annual fiesta in summertime. Brody, letter to the author, February 11, 2003, HMA object files. His assertion is substantiated by a watercolor virtually identical to *Rain Dance—Annual Fiesta—Zia Pueblo* that is titled *Christmas Dance* (unlocated). The difference of titles may be explained by the artist's or dealer's belief as to what might appeal to a particular collector.

7. Alternatively, as Brody has proposed, the changes may constitute a form of false code intended to satisfy tribal concerns about the portrayal of rituals by inaccurately recording them. Brody, *Pueblo Indian Painting*, 164–65. Of the general form of the men's costumes, however, there can be little doubt as to their accuracy, as they are corroborated by eyewitness accounts. Leslie White recorded the costumes of this dance as follows: "Male dancers wear a white kilt, sash and moccasins; a foxskin hanging from the belt in the rear, a bunch of parrot feathers on top of the head, armbands at the biceps, a bandoleer of small hoofs slung from one shoulder, sleigh bells below the knees; they carry a gourd rattle in the right hand, a sprig of evergreen in the left. Female dancers wear the old style sleeveless dress, leaving the left shoulder bare, the wooden headpiece, or tablita, and are barefoot." White, *The Pueblo at Sia*, 272. There also remains the possibility that there was a unique performance of the ritual that Herrera re-creates in *Rain Dance*, in which these costume changes were made. There is not, however, any evidence to support that theory, and Herrera's other depictions render it further unlikely.

8. C. Norris Millington, "American Indian Water Colors," *The Magazine of Art* 25, no. 2 (August 1932), 92.

9. Quoted in Vassar College Art Gallery, Poughkeepsie, N.Y., *Exhibition of American Indian Painting and Crafts of the Southwest, 1915–1940* (Poughkeepsie, N.Y.: Vassar College Art Gallery, 1941), n.p. Brody, letter to the author, February 11, 2003, HMA object files.

10. If anything, this conclusion points to the ironic success of Herrera's early schooling, where acculturating education was promulgated in an effort to integrate Native Americans into American culture. The government's unwitting instruments of indoctrination were idealistic teachers and administrators like Elizabeth DeHuff, Herrera's mentor at the Santa Fe Indian School, who brought the students into line with European American modernism even as they strove to "preserve" Native American culture. David W. Penney and Lisa Roberts, "America's Pueblo Artists, Encounters at the Borderlands," in W. Jackson Rushing III (ed.), *Native American Art in the Twentieth Century: Makers, Meanings, Histories* (London: Routledge, 1999), 22–23.

48. Davis, *Statue, Paris*

1. Davis, in *Art News*, February 1, 1943, quoted in Diane Kelder (ed.), *Stuart Davis* (New York: Praeger Publishers, 1971), 129.

2. There have been brief mentions of possible surre-

alist moments in Davis's work. Lewis Kachur saw a reflection of Giorgio de Chirico's arcades in Davis's drawing *Café Table ("Bottin")*, and E. C. Goossen felt that Davis had "taken a hint from Miro and the Surrealists" in his *Still Life with Saw*. Kachur, *Stuart Davis: An American in Paris* (New York: Whitney Museum of American Art at Philip Morris, 1987), 5. Goossen, *Stuart Davis* (New York: George Braziller, Inc., 1959), 24.

3. James Johnson Sweeney wrote, referring to the cubist artists Pablo Picasso, Georges Braque, and Fernand Léger, that "For Davis the art of contemporary Paris was the main life stream." Sweeney, *Stuart Davis* (New York: Museum of Modern Art, 1945), 22. By 1925, however, Picasso himself was exhibiting with the surrealists and exploring surrealist themes in his art. By 1928 cubism was no longer the prevailing Parisian aesthetic, having given way to surrealism.

4. Kachur, *Stuart Davis*, 2.

5. Davis, "The Place of Abstract Painting in America," *Creative Art* 6 (February 1930), quoted in Kelder, *Stuart Davis*, 109.

6. For a color reproduction of de Chirico's *The Departure of the Poet*, see Paolo Baldacci, *De Chirico: The Metaphysical Period, 1888–1919* (Boston: Little, Brown and Co., 1997), 227, fig. 53. Davis offered little help in establishing any influence from surrealism, insisting that he depicted Paris "just as it was" despite all evidence to the contrary. Davis, quoted in Sweeney, *Stuart Davis*, 20. There was some ambiguity even at the time, however, as to de Chirico's stylistic persuasion. Jacques Mauny wondered whether de Chirico "should be called a cubist or a *surréaliste* (as it has been claimed lately). . . ." Mauny, "Paris Letter," *The Arts* 12, no. 2 (August 1927), 106.

7. Reading de Chirico's words about his own art, we find the elements of Davis's, but emptied of the speaker's intent: "Yet our minds are haunted by visions; they are anchored to everlasting foundations. In public squares shadows lengthen their mathematical enigmas. Over the walls rise nonsensical towers decked with little multicolored flags; infinitude is everywhere, and everywhere is mystery." De Chirico, "Second Part: The Feeling of Prehistory," reprinted in James Thrall Soby, *Giorgio de Chirico* (New York: Museum of Modern Art, 1966), 247.

8. James Johnson Sweeney remarked on that "increment of humor" in the Paris series as well, writing that "Davis' humor is a muscular humor, not a drawing-room wit." Sweeney, *Stuart Davis*, 26.

9. Henry McBride, "Stuart Davis Comes to Town," *New York Sun*, April 4, 1931, quoted in Kelder, *Stuart Davis*, 192.

10. Kachur, *Stuart Davis*, 6. The abstracted element along the lower edge of the composition has been seen as a depiction of the island's embankment.

11. Agee, in ibid.

49. Stella, *Dying Lotus*

1. Stella attributed this quote, which he cited frequently, to the early Italian Renaissance master Giotto. Joann Moser, *Visual Poetry: The Drawings of Joseph Stella* (Washington, D.C.: Published for the

National Museum of American Art by the Smithsonian Institution Press, 1990), 19.

2. Whitman's romantic, optimistic embrace of both modern life and spirituality especially influenced Stella's energetic, symbolic views of New York City. Stella also admired the transcendentalist works of Henry David Thoreau and the symbolist tendencies of Edgar Allan Poe. See ibid., esp. 64–67.

3. Barbara Haskell, *Joseph Stella* (New York: Whitney Museum of American Art, 1994), 109.

4. The flowers of most water lilies close at night and open at sunrise, a characteristic that came to symbolize in ancient Egypt both resurrection and the sun itself. The lotus's association with enlightenment, purity, and creation made it a particularly important sacred symbol in Buddhist India. See William E. Ward, "The Lotus Symbol: Its Meaning in Buddhist Art and Philosophy," *The Journal of Aesthetics and Art Criticism* 11, issue 2, Special Issue on Oriental Art and Aesthetics (December 1952), 135–46.

5. In discussing Stella's oil-on-glass painting *Lotus Flower* (collection of Dr. and Mrs. Martin Weissman, 1984), Ella Foshay observed that he painted the outside and inside of the flower simultaneously, with the stamen visible despite the closed petals. She likened this approach to "a creative X-ray of the plant." Foshay, *Reflections of Nature: Flowers in American Art* (New York: Alfred A. Knopf, 1984), 71. In this womblike presentation of the flower, Stella emphasizes the stamen's centrality to the lotus's identity.

6. Quoted in Barbara Rose, "Flora: The Flower Paintings of Joseph Stella," in *Joseph Stella Flora: A Survey* (West Palm Beach, Fla.: Eaton Fine Art, Inc., 1997), 16.

7. Joseph Stella, "Discovery of America: Autobiographical Notes," *Art News* 59, no. 7 (November 1960), 65.

50. Calder, *The Exits (Les Sorties)*

1. A two-week press pass with Ringling Bros. and Barnum and Bailey Circus inspired his earliest circus illustrations, which the *National Police Gazette* published as a half-page spread in May 1925.

2. Calder, interviewed by Cleve Gray, "Calder's Circus," in *Art in America* 52, no. 5 (October 1964), 30.

3. The following year Jean Arp, having seen the mechanical work, dubbed his static sculpture "stabiles." Marlo Prather, *Alexander Calder: 1898–1976* (Washington, D.C.: National Gallery of Art, 1998), 61.

4. Thomas M. Messer, introduction to *Alexander Calder: A Retrospective Exhibition* (New York: Solomon R. Guggenheim Museum, 1964), 13.

5. "The circus marks progress by circular movement, never in a straight line; as each self-contained, individual act comes to a climax and a successful close, life is affirmed, control is maintained, and art triumphs." Donna Gustafson, *Images from the World Between* (Cambridge, Mass.: MIT Press and American Federation of Arts, 2001), 9.

6. Quoted in Gray, "Calder's Circus," 23.

7. Quoted in ibid., 25.

51. Cadmus, *Deposition (Bewailing of Christ)*

1. Cadmus's identity as a "magic realist" stems from his inclusion in the 1943 exhibition *American Realists and Magic Realists* at the Museum of Modern Art, New York. As Cadmus later described his own development, "that interest in line, and awareness of its descriptive abilities—that really came from looking at Signorelli." Quoted in Justin Spring, *Paul Cadmus: The Male Nude* (New York: Universe Publishing, 2002), 171. As Spring has noted, Signorelli's exuberant delight in portraying the male nude was key to the formation of Cadmus's identity, as both an artist and a homosexual.

2. The locations of the works cited follow: *Juan* (Hood Museum of Art); *Mallorcan Fisherman* (collection of Mr. and Mrs. Lincoln Kirstein, in 1984); *Y.M.C.A. Locker Room* (collection of John P. Axelrod, Boston, in 1992) and *Shore Leave* (Whitney Museum of American Art); *The Fleet's In!* (Naval Historical Center, Washington, D.C.). For more on the controversy surrounding *The Fleet's In!* see Harry Salpeter, "Paul Cadmus: *Enfant Terrible*," *Esquire*, July 1937, 105–7, 112, and Jonathan Weinberg, "Cruising with Paul Cadmus," *Art in America*, November 1992, 102–9.

3. According to Justin Spring, "French appears nude as the deposed Christ." Spring, *Paul Cadmus: The Male Nude*, 17. Lincoln Kirstein, however, claimed that "all the bodies, including the nude Jesus, were studied from Jared French." Kirstein, *Paul Cadmus* (New York: Imago Imprint, 1984; rev. ed., New York: Chameleon Books, 1992), 12.

4. Cadmus attributed this quote to "a person who wrote a very good book on drawing named Nicolaides." Kirstein, *Paul Cadmus*, 109. He is likely referring to Kimon Nicolaïdes, *Kimon Nicolaïdes: Instructor, Life Drawing, Painting, Composition* (New York: Art Students League, 1940–49[?]).

5. *To the Lynching* is in the Whitney Museum of American Art. Other works relevant to the theme of violence are *Pocahontas Saving the Life of Captain John Smith*, 1938 (mural [since removed] in the Parcel Post Building, Richmond, Va.), and *Venus and Adonis*, 1936 (collection of Forbes Magazine, in 1992). I am grateful to my colleague, Mark Mitchell, for pointing out the formal and thematic relationship of *Deposition* to these later works.

52. Cadmus, *Factory Worker: Francisco (Francisco Femenias)*

1. The backing for this work includes a Midtown Gallery label with the title "FACTORY WORKER: FRANCISCO" as well as an inscription (not in artist's hand): FACTORY WORKER: FRANCISCO / 1933 (MALLORCA) 12⅝ × 9⅛ / PENCIL (THIS DRAWING HAS BEEN / TREATED by A. J. Yow. Conservator at / The MORGAN LIBRARY for 25 years) / CADMUS

2. "I did a great many drawings of him while living in Mallorca in 1932 and 33." Letter to author, August 23, 1996, HMA object files. No other life drawings of Francisco are known.

3. This later drawing is also reproduced in Guy Davenport, *The Drawings of Paul Cadmus* (New York: Rizzoli, 1989), 28, and listed as "*Francisco*, black and white watercolor on gray paper, size and whereabouts unknown."

4. In 1941 Cadmus was ranked with Edward Hopper, Thomas Hart Benton, John Steuart Curry, and Grant Wood in the *Encyclopedia Britannica* as one of the nation's five leading artists.

5. Paul Cadmus to author, August 23, 1996, HMA object files.

6. See note 1 for the inscription on the backing. A 1933 graphite drawing of Francisco's brother is also rendered broadly and bears a title that similarly reveals his profession (*Miguel, the Cobbler Asleep*, 21.22 × 28.89 cm [8⅜ × 11⅜ in.], reproduced without location in Lincoln Kirstein, *Paul Cadmus* [New York: Imago Imprint, Inc., 1933], 115).

7. "I often do a preparatory drawing for a finished drawing. I do a preliminary sketch just to make sure I've got everything as I like it. Then I transfer the outline [which is often on tracing paper] to a prepared paper." Quoted in Justin Spring, "Drawing from the Heart," in *Paul Cadmus: 90 Years of Drawing* (New York: DC Moore Gallery, 1998), 12. Unfortunately, without examining the later drawing of Francisco, the size of which is unpublished, it is impossible to know whether it, too, was based on a tracing of the face's outline taken from this work. The painting *Francisco* reverses aspects of the drawn portrayals: the eyes, for instance, look to the left instead of the right, and the hair sweeps back primarily to the left as well. Certain tracing methods would help to explain such a reversal, but Cadmus wrote: "I think I started the oil from life in Mallorca—not from the drawing # 1 [*Factory Worker*]—and finished it in New York in 1940—using several sketches and memory. It was not traced from a drawing." Cadmus to author, August 23, 1996, HMA object files.

53. Bacon, *Morris Ernst*

1. *New York Evening Post*, March 3, 1934, 1.

2. One sympathetic writer found her caricatures humanistic: "With a deft touch, she bares human weakness, and lends charm to the ridiculous. . . . She may state the worst features of her characters, but these bad points arouse only a kindred recognition of another's faults and peculiarities." "Peggy Bacon, Kindly Humorist, Has a Show," *Art Digest*, March 1, 1934, 8. Others called the drawings "vitriolic" and the accompanying prose "tasteless and cruel." Edward Alden Jewell, "Peggy Bacon Gives Caricature Show," *New York Times*, November 21, 1934, 17, Downtown Gallery Records, Archives of American Art, Smithsonian Institution, Washington, D.C. (hereafter AAA), reel 5566, frame 527. She abandoned her caricatured portraits not long after completing the 1934 book. She explained to a reporter in 1943, "I couldn't stand getting under people's skins. . . . The caricatures made them smart so." Quoted in Roberta K. Tarbell, *Peggy Bacon: Personalities and Places* (Washington, D.C.: National Collection of Fine Arts, 1975), 37.

3. She wrote of herself: "Pin-head, parsimoniously covered with thin dark hair, on a short, dumpy body. Small features, prominent nose, chipmunk teeth and no chin, conveying the sharp, weak look of a little rodent. Absent-minded eyes with a half-glimmer of observation. Prim, critical mouth and faint coloring. Personality lifeless, retiring, snippy, quietly egotistical. Lacks vigor and sparkle." Peggy Bacon, *Off*

With Their Heads! (New York: Robert M. McBride and Co., 1934), n.p.

4. The son of a Czech immigrant, Ernst started his career in manufacturing and began practicing law full time in 1915. He won several other censorship cases, participated in cases aiming to protect reproductive rights, and advocated for racial equality. Having held appointments under both La Guardia and Roosevelt, he moved in the liberal political sphere to which Bacon apparently gravitated. In the 1950s he lost much of his liberal backing when he became a supporter of the House Un-American Activities Committee. For more on Ernst, see John A. Garraty and Mark C. Carnes (eds.), *American National Biography* (New York: Oxford University Press, 1999), 7:564–66, and the finding aid for the "Ernst (Morris L.) Banned Books Collection," University of California, Santa Barbara Library, Dept. of Special Collections <http://dynaweb.oac.cdlib.org/dynaweb/ead/ucsb/ernst99/>. Like most of her subjects, Bacon knew Ernst socially, having met him at a party in December 1930 at the home of a friend. Tarbell, *Peggy Bacon*, 33.

5. "Morris Ernst," in Bacon, *Off With Their Heads!* n.p.

6. L. Cabot Hearn, "Superb Decapitations: 'Off With Their Heads,' by Peggy Bacon," *The Saturday Review of Literature*, December 1, 1934, 325. Also see *Art Digest* 8, no. 11 (March 1, 1934), 8. The Hood Museum possesses Bacon's preliminary sketches of Ernst. With the exception of one compositional study for this work, they are straightforward on-site sketches taken from different vantage points, without caricaturization (see p. 226).

7. Halpert exhibited Bacon's pastel caricatures in 1931 and a broader sampling of her work in February 1934. Later that year, concurrent with the publication of *Off With Their Heads!* she exhibited the drawings for the book. Along with the pastel of Ernst, Halpert sent to the Municipal exhibition Bacon's caricatured lithograph of La Guardia and a ruthless pastel portrait of progressive journalist Heywood Broun. Broun was a passionate defender of Sacco and Vanzetti and ran for Congress in 1930 as a socialist. Garraty and Carnes, *American National Biography* 3:639–40.

8. Responding to the Great Depression, the exhibition organizers aimed to "create a bigger market for the work of living artists." Quoted from a sample letter sent to one hundred clients from Edith Gregor Halpert, February 23, 1934. Downtown Gallery Records, reel 5600, frame 767, AAA.

9. The four thousand visitors to the opening celebrations were reminded of this act by "radical" artists who picketed the exhibition's entrance, brandishing such slogans as "Hitler Burns Books." "4,000 Applaud As Mile of Art Is Put on View" *New York Herald Tribune*, February 28, 1934, n.p. Downtown Gallery Records, reel 5600, frame 800, AAA. For more on the Rivera mural controversy, see Irene Herner de Larrea et al., *Diego Rivera: Paradise Lost at Rockefeller Center* (Mexico City: Ediciples, 1987). Peggy Bacon, her former teacher John Sloan, and her husband, Alexander Brook, had all signed a letter to John D. Rockefeller Jr. protesting his dismissal of Rivera. "A Plea for Rivera Sent to Rockefeller," *New York Times*, May 28, 1933, 55. Cited in Larrea, 124.

10. Abby Aldrich Rockefeller's taste in modern art mystified her husband, who instead favored porcelains and medieval tapestries. She also pursued more progressive social causes, likely in an attempt to soften his harsh, conservative image. As a major stockholder in the Colorado Fuel and Iron Company, John D. Rockefeller had been implicated in the infamous 1914 Ludlow Massacre (see cat. 37), in which thirteen members of miners' families were killed during a bitter strike against the firm. In the aftermath, Abby Aldrich Rockefeller played a key role in encouraging her husband's pursuit of more progressive industrial relations and took on several initiatives on her own. For example, in 1919 she sought to improve housing and amenities for employees of a Standard Oil refinery, creating a community center for workers and bearing most of the costs personally. Bernice Kert, "Abby Aldrich Rockefeller," in Garraty and Carnes, *American National Biography*, 18:692. For more on Abby Aldrich Rockefeller's role as a donor to Dartmouth College, see the author's introductory essay, "American Drawings and Watercolors at Dartmouth: A History," pp. 27–46.

54. Demuth, *Beach Study No. 3, Provincetown*

1. On Demuth's enduring French sympathies, see Wanda Corn's chapter "And the Home of the Brave," in *The Great American Thing: Modern Art and National Identity, 1915–1935* (Berkeley: University of California Press, 1999), 193–237. More on the influence of his four French sojourns can be found in Sophie Lévy (ed.), *A Transatlantic Avant-Garde: American Artists in Paris, 1918–1939* (Berkeley: University of California Press, in association with the Musée d'Art Américain Giverny, 2003), 15–21.

2. See Emily Farnham, "Charles Demuth's Bermuda Landscapes," *Art Journal*, winter 1965–66, 130–37.

3. See Barbara J. Bloemink, *The Life and Art of Florine Stettheimer* (New Haven: Yale University Press, 1995), 150, 212, and Cécile Whiting, "Decorating with Stettheimer and the Boys," *American Art* 14 (spring 2001), 25–49. Dandified portraits of Demuth appear in no fewer than three independent paintings by Florine Stettheimer: *Love Flight of the Pink Candy Heart* (1930, The Detroit Institute of Arts), *Cathedrals of Fifth Avenue* (1931, The Metropolitan Museum of Art), and *Portrait of Alfred Stieglitz* (1928, Fisk University, Nashville, Tenn.).

4. Demuth and Hartley are the sources for one of the key characters — Charlie Marsden — in O'Neill's 1928 play *Strange Interlude*.

5. Williams and Demuth became lifelong friends. Williams wrote at least two poems about works by Demuth and dedicated his 1928 text *Spring and All* to the artist. See James E. Breslin, "William Carlos Williams and Charles Demuth: Cross Fertilization in the Arts," *Journal of Modern Literature* 6 (April 1977), 248–63.

6. For a concise account of Demuth's overall literary and artistic connections, see Robin Jaffee Frank, *Charles Demuth: Poster Portraits, 1923–1929* (New Haven: Yale University Art Gallery, 1994), and Barbara Haskell, *Charles Demuth* (New York: Whitney Museum of American Art, in association with Harry N. Abrams, Inc., 1987).

7. See Charles Brock, "Charles Demuth: A Sympa-

thetic Order," in Sarah Greenough, *Modern Art and America: Alfred Stieglitz and His New York Galleries* (Washington, D.C.: National Gallery of Art; Boston: Little, Brown and Company, 2000), 363–73.

8. Many scholars have championed Demuth's watercolors because of their technical mastery. See, for example, Theodore E. Stebbins Jr., *American Master Drawings and Watercolors: A History of Works on Paper from Colonial Times to the Present* (New York: Harper and Row, 1976), 314–17. These works were also the artist's primary source of income throughout the 1920s. See Betsy Fahlman, *Pennsylvania Modern: Charles Demuth of Lancaster* (Philadelphia: Philadelphia Museum of Art, 1973), 62.

9. In addition to performers and nightclub denizens, Demuth included recognizable portraits in some of these watercolors. Duchamp is recognizable in *At the Golden Swan*, 1919 (collection of Irwin Goldstein, M.D., in 1993, reproduced in Haskell, *Charles Demuth*, 80), and Charles Duncan appears in a related watercolor, *Café Scene #1, The Purple Pup*, 1918 (Museum of Fine Arts, Boston, reproduced as *The Purple Pup* in ibid.). A nattily dressed, bowler-hatted double for Demuth himself recurs throughout these works, most notoriously in *Distinguished Air*, 1930 (Whitney Museum of American Art, New York, reproduced in ibid., 205).

10. The most revealing discussion of Demuth's erotic watercolors can be found in Jonathan Weinberg, *Speaking for Vice: Homosexuality in the Art of Charles Demuth, Marsden Hartley, and the First American Avant-Garde* (New Haven: Yale University Press, 1993), esp. 89–113, 195–219. See also Kermit Champa, "Charlie Was Like That," *Artforum*, March 1974, 54–59; G. Koskovich "A Gay American Modernist: Homosexuality in the Life and Art of Charles Demuth," *The Advocate* (Los Angeles), June 25, 1985, 50–52; and Nayland Blake et al., *In a Different Light: Visual Culture, Sexual Identity, Queer Practice* (San Francisco: City Lights Books, in association with University Art Museum and Pacific Film Archive, 1995), 145, fig. 110.

11. See Bruce Robertson, "Yankee Modernism," in William E. Treuttner and Roger B. Stein, *Picturing Old New England: Image and Memory* (New Haven: Yale University Press, in association with the National Museum of American Art, 1999), 179–80.

12. According to his hosts, Frank and Elsie Everts, the artist sketched every day despite his disease while in Provincetown. See Emily Farnham, *Charles Demuth: Behind a Laughing Mask* (Norman: University of Oklahoma Press, 1971), 170–72. His health deteriorated shortly after leaving the resort and within a year's time Demuth stopped painting completely. He died in his sleep in October 1935. Haskell, *Charles Demuth*, 207.

13. This work is carefully described in Henry Adams, "The Beal Collection of Watercolors by Charles Demuth," *Carnegie Magazine* 56 (November–December 1983), 28.

14. About a dozen of the Provincetown sketches and watercolors from 1934 survive. The majority of these works show groups of women and children by the water, although a few isolated figures exist. The sketchbook is annotated in Emily Farnham, "Charles Demuth: His Life, Psychology, and Works" (Ph.D. diss., Ohio State University, 1959), 2:639–64, and a

large group of these images is discussed by Alvord L. Eiseman, "A Study of the Development of an Artist: Charles Demuth" (Ph.D. diss., New York University, 1979), 2:550–56.

15. On the uniqueness of this approach to the later Provincetown sketches, see Sherman E. Lee, "The Illustrative and Landscape Watercolors of Charles Demuth," *The Art Quarterly* 5 (spring 1942), 173.

55. Dove, *Boat Houses*

1. Ann Lee Morgan, *Arthur Dove: Life and Work, with a Catalogue Raisonné* (Newark: University of Delaware Press; London: Associated University Presses, 1984), 40–43.

2. Wassily Kandinsky, *Concerning the Spiritual in Art*, trans. M. T. H. Sadler (New York: Dover Publications, 1977), 56–57.

3. Martha Davidson, "Arthur Dove: The Fulfillment of a Long Career," *Art News* 36 (May 7, 1938), 16.

4. Barbara Haskell, *Arthur Dove* (San Francisco: San Francisco Museum of Art, 1974), 110.

5. In her catalogue raisonné of Dove's work, Ann Lee Morgan has observed that the period 1938–39 was one of his least productive, even in the less strenuous media. Morgan, *Arthur Dove*, 60.

6. Dove, quoted in William C. Agee, "Arthur Dove: A Place to Find Things," in Sarah Greenough, *Modern Art and America: Alfred Stieglitz and His New York Galleries* (Washington, D.C.: National Gallery of Art; Boston: Little, Brown and Company, 2000), 429.

7. The view from their new home became what Melanie Kirschner has characterized as Dove's "window on the world for the rest of his career." Kirschner, *Arthur Dove: Watercolors and Pastels* (New York: George Braziller, 1998), 19.

8. Deanne S. Rathke, director of the Greenlawn-Centerport Historical Association, has researched the likely vantage of the watercolor. The Methodist Episcopal church was the only church on the pond in 1938, and its steeple today does loosely resemble the one in *Boat Houses*. Deanne S. Rathke to Mark Mitchell, August 28, 2003, HMA object files.

9. Sherrye Cohn, *Arthur Dove: Nature as Symbol* (Ann Arbor, Mich.: UMI Research Press, 1985), 46–47. Cohn has found particular resonance between Dove's spiritual leanings and the contemporary theosophical movement, in which scientific understanding of the natural world and religious faith are inextricably interwoven.

10. Likewise, the iconic *Fog Horns* (1929, Colorado Springs Fine Arts Center, Colo.) are represented by concentric circles of ever lighter color emanating from a darkened center, signifying sound in visual terms.

56, 57. Wood, *Fruit, Vegetables*

1. Hans Memling was his favorite Netherlandish artist. Wood's early training was with an exponent of the Arts and Crafts movement, Ernest Batchelder, with whom he studied at the Minneapolis School of Design and Handicraft. In terms of contemporary art, Wood was especially drawn to the austere, classicizing tendencies of the German *Neue Sachlichkeit*

(new objectivity). Brady M. Roberts, "The European Roots of Regionalism: Grant Wood's Stylistic Synthesis," in *Grant Wood: An American Master Revealed* (Davenport, Iowa: Davenport Museum of Art, 1995), 19–34.

2. Wood wrote, "I am so thoroughly convinced of the value of the five dollar original lithograph as the most effective means of producing an art-minded public for the future, that I would be delighted to sign a long-time exclusive contract with AAA tomorrow. A contract based upon the five dollar print—depression or no depression." Wood to Archie F. Winter (with a copy to Reeves Lewenthal), December 27, 1938. Quoted in Sylvan Cole Jr., *Grant Wood: The Lithographs, A Catalogue Raisonné* (New York: Associated American Artists, 1984), 6.

3. Nan Wood Graham and her husband tinted the lithographs according to meticulous instructions from her brother, who also colored one set of the prints as models (now at the Davenport Museum of Art). George Miller printed the lithographs in editions of 250 images each. Because of the extra hand work involved, AAA sold the prints for $10 rather than $5 each.

4. These lithographs also provided an example in terms of their fruit and flower subjects, which Currier and Ives often marketed in pairs or series, including *Fruit Piece: Autumn Gift* and *Fruit Piece: Summer Gift* (undated). The catalogue raisonné for Currier and Ives prints lists approximately 170 fruit and flower subjects. Gale Research Company (comp.), *Currier and Ives: A Catalogue Raisonné* (Detroit: Gale Research Company, 1983), 951–52.

5. These were in a private collection as of 1984. Wanda Corn to author, January 13, 1984.

6. Nan Wood Graham recalled that there was also a painted version of *Vegetables*, but the painting is not with the group today and no other references confirm her statement. Nan Wood Graham, with John Zug and Julie Jensen McDonald, *My Brother, Grant Wood* (Iowa City: State Historical Society of Iowa, 1993), 153. A reminiscence of an Iowa hotel keeper suggests a possible inspiration for the image: "Probably the most famous visitor we had was Mr. Grant Wood, the wonderful artist. On chilly spring evenings I often found him in front of the stone fireplace deep in thought. While sitting there one evening he noticed a wicker basket filled with fruit . . . and commented on what a nice subject for a picture it would be. After he had gone, he sent me a lithograph print of a wicker basket filled with fruit." Violet Schroeder, owner of the McGregor Heights Hotel, to United States Senator and Mrs. John Culver of Iowa about the 1935 visit of Grant Wood. *This Is Grant Wood Country* (Davenport, Iowa: Davenport Municipal Art Gallery, 1977), 33.

7. "All the murals were painted in the artist's studio, cut from the canvas and applied to the walls of the coffee shop" ("The Fruits of Iowa, Cedar Rapids," *American Magazine of Art* 26 [March 1933], 151). According to the artist's sister, Grant Wood tried unsuccessfully to purchase the works for the fee he was originally paid when the hotel changed its decor. When the hotel later was sold, the local citizenry fought to keep the paintings in the area. They are now displayed at Coe College. Graham, *My Brother, Grant Wood*, 59. Wanda Corn discusses *The Fruits of Iowa* in her important monograph, *Grant Wood: The*

Regionalist Vision (New Haven: Yale University Press, 1983), 94–97.

8. Corn, *Grant Wood*, 118–19.

58. Traylor, *House with Figures and Animals*

1. Charles Shannon described how "on summer evenings [Traylor] would be sitting there at nine or ten o'clock smoking his pipe and drawing." Frank Maresca and Roger Ricco, "Remembering Bill Traylor: An Interview with Charles Shannon," in Frank Maresca and Roger Ricco, *Bill Traylor: His Art — His Life* (New York: Alfred A. Knopf, 1991), 4.

2. The first exhibition, *Bill Traylor — People's Artist*, was held at the local cooperative art space in Montgomery, called New South. The second was held in 1942 at the gallery of the Ethical Culture Fieldston School in Riverdale, New York, and was organized by gallery director Victor E. D'Amico. Shannon met D'Amico the previous year when he was in New York showing the work of Traylor to friends. Later that year D'Amico showed Traylor's work to Alfred Barr, then director of the Museum of Modern Art, New York. Barr selected sixteen drawings to add to the museum's collection, but Shannon, who owned the works, had not been consulted on the price. When the check arrived and was insufficient in the eyes of Shannon (they paid $1 and $2 apiece), he recalled the drawings. Roman Kurzmeyer, "The Life and Times of Bill Traylor," in Josef Helfenstein and Roman Kurzmeyer (eds.), *Bill Traylor, 1854–1949: Deep Blues* (New Haven: Yale University Press, 1999), 174–75.

3. When Traylor returned to Montgomery after staying with various children, he was not allowed back at his old post on the street and had to live with a sister. His recurring renditions of figures with amputated legs have sometimes been read as self-portraits, but these images predate his own amputation. According to Shannon, Traylor required the use of canes for walking. Maresca and Ricco, *Bill Traylor: His Art — His Life*, 19. Shannon also recalled that a legless man frequented the part of town where Traylor worked, as well as "two or three" other men with just one leg. Ibid., 14. According to current scholarship, Traylor died on October 23, 1949, in St. Jude Hospital in Montgomery. His death date has often been cited previously as 1947. The most complete chronology of Traylor's life is Kurzmeyer, "The Life and Times of Bill Traylor," 169–77. Traylor's work finally began to receive wider recognition when it was included in the 1982 exhibition at the Corcoran Gallery of Art, *Black Folk Art in America, 1930–1980*.

4. Morrin continued, "A background in one or more crafts may also be surmised from the care he took in execution, and Traylor indeed claimed to have been a basket maker." Peter Morrin, "Bill Traylor," in Phyllis Stigliano (comp.), *Bill Traylor: Exhibition History, Public Collections, Selected Bibliography* (New York: Luise Ross Gallery, 1990), 2.

5. Kuyk speculates that Traylor's mother was Igbo and his father Kongo, although no confirmation of these assertions is possible. Betty Kuyk, *African Voices in the African American Heritage* (Bloomington: Indiana University Press, 2003), 134–35. Kuyk provides provocative and imaginative analyses of Traylor's works based on a deeper probing of his biography and her sense of his possible African links.

Kuyk heard an anecdote about Traylor having killed a man early in his life for sleeping with his woman. She believes that some of the threats of violence in his work relate to that incident. Ibid., 167–75.

6. Maude Southwell Wahlman links the top-hatted man with Haitian images of Baron Samedi, lord of the cemeteries, and the patterned clothing to ideographic references to secret societies. She also notes that snakes serve as a Vadou symbol of the rainbow god in Haiti and the Republic of Benin. "The Art of Bill Traylor," in *Bill Traylor (1854–1947)* (Little Rock: Arkansas Arts Center; New York: Luise Ross Fine Art, 1982), n.p.

7. I am grateful to architectural historian Marlene E. Heck, Senior Lecturer in History and Art History at Dartmouth College, for her assistance in identifying the building type and explaining Traylor's imaginative reconstruction.

8. Osayin is often represented as having just one leg and one arm, "the stigmata of a quondam selfish life." Robert Farris Thompson, *Flash of the Spirit: African and Afro-American Art and Philosophy* (New York: Random House, 1983), 42. I am grateful to my Hood Museum of Art colleague, Barbara Thompson, Curator of African, Oceanic, and Native American Art, for her insights on Traylor's possible African sources.

9. Pamela Wye, *Visionary Artists: Bill Traylor and Minnie Evans* (Wichita, Kans.: Wichita Art Museum, 1992), n.p.

59. Pollock, Untitled (*Number 37*)

1. Kirk Varnedoe, "Comet: Jackson Pollock's Life and Work," in Varnedoe, with Pepe Karmel, *Jackson Pollock* (New York: Museum of Modern Art, 1998), 27.

2. The precise date on which Pollock began this series is unknown, but his analyst later recalled that Pollock was already drawing these works when he entered therapy in early 1939. Claude Cernuschi, *Jackson Pollock: "Psychoanalytic Drawings"* (Durham, N.C.: Duke University Press, 1992), 7–8.

3. Pollock appears to have been a witting collaborator in his own therapy. See Cernuschi, *Jackson Pollock*, 20. Dr. Joseph Henderson, his analyst, referred on several occasions to discussions with Pollock about the psychoanalytic symbolism of the drawings, which the artist later gave to Henderson at the conclusion of their sessions in 1940. The aggressive, tortured tone witnessed in this drawing bears at least passing resemblance to Carl Jung's theory of the Shadow, the primary negative aspect (or "archetype") of the self that is often projected onto others. For more on Jung, see cat. 68.

4. William Rubin has most effectively voiced the skeptics' position. Rubin, "Pollock as Jungian Illustrator: The Limits of Psychological Criticism," reprinted in Pepe Karmel (ed.), *Jackson Pollock: Interviews, Articles, and Reviews* (New York: The Museum of Modern Art, 1999), 220–28. He wrote, "While a few of the drawings might conceivably have been experiments done specifically for his analytic sessions, it is evident that Pollock simply brought [Dr. Joseph] Henderson [his analyst] examples of the work he was doing." Ibid., 224. In the most recent monographic reassessment of the drawings in 1992, art historian Claude Cernuschi concluded that "the at-tempt to integrate psychoanalysis and iconography, as Pollock's Jungian critics—and even Henderson—have attempted, misfires *specifically* because it confuses the conscious elements of Pollock's work for the unconscious elements. . . . Indeed, to retrospectively attribute psychoanalytic relevance to stylistic traits in works of art, or to diagnose a patient on the basis of such traits in absence of therapeutic results, blatantly violates both psychoanalytic theory and practice." Cernuschi, *Jackson Pollock*, 29.

5. Michael Leja, *Reframing Abstract Expressionism: Subjectivity and Painting in the 1940s* (New Haven: Yale University Press, 1993), 128.

6. Donald Kuspit, *Signs of the Psyche in Modern and Postmodern Art* (Cambridge: Cambridge University Press, 1993), 121.

7. In a 1987 biography of Pollock, Deborah Solomon asserted, "No other artist played as pivotal a role in Pollock's development as Picasso, and no painting was as pivotal as *Guernica*." Solomon, *Jackson Pollock, A Biography* (New York: Simon and Schuster, 1987), 96.

8. William Rubin, "Pollock as Jungian Illustrator: The Limits of Psychological Criticism" (1979), reprinted in Karmel, *Jackson Pollock*, 228.

9. Ibid., 257.

10. Alfred H. Barr Jr. (ed.), *Picasso: Forty Years of His Art* (New York: Museum of Modern Art, in association with the Art Institute of Chicago, 1939), 149, no. 233. Hilliard Goldfarb has also observed that Pollock's drawing includes a loose cross or crucifixion at the composition's lower left. Goldfarb, "Recent Accessions at the Hood," *Dartmouth Alumni Magazine* 78, no. 7 (April 1986), 45.

11. Henderson, Pollock's analyst, actually drew a distinction between the drawings that show psychological development on the artist's part and those that demonstrated his contention with Picasso and José Clemente Orozco. In 1968 he wrote of the first group, "They seemed to demonstrate phases of his sickness and they were followed by others showing a gradual development during therapy into a healthier condition. . . . In contrast to these there were a number of sketches which reflected the influence of Picasso in his 'Guernica' period, or of Orozco, and would have to be classified as experimental works." The Hood drawing would, presumably, fall into the latter category. Henderson, quoted in B. H. Friedman, *Jackson Pollock, Energy Made Visible* (New York: McGraw-Hill Book Company, 1972), 41.

12. Pollock reportedly traveled to Dartmouth to see the murals. Stephen Polcari, "Orozco and Pollock: Epic Transfigurations," *American Art* 6, no. 3 (summer 1992), 42. Though evidence of the trip is scarce, the strong relationship between Pollock's *Untitled (Woman with Skeleton)* (c. 1938–41, Washburn Gallery, New York, in 2002) and the Baker mural makes it clear that even if he did not visit Dartmouth, he was at least familiar with Orozco's work in reproduction.

13. Jacquelynn Baas, "*The Epic of American Civilization*: The Mural at Dartmouth College (1932–34)," in Renato González Mello and Diane Miliotes (eds.), *José Clemente Orozco in the United States, 1927–1934* (Hanover, N.H.: Hood Museum of Art, 2002), 178.

60. Benton, *"Routining" the Fish*

1. As Henry La Farge has written, "Overwhelmed by the turmoil of events and feeling the inadequacy of his plastic means to give expression to them, [in his nonmilitary works of the mid-1940s] Benton began turning his attention to the ordinary, intimate aspects of the everyday world, the play of tone and texture, the rhythm of line in foliage, flowers, land formations, figures—a renewal of nature in terms of plastic form." Henry A. La Farge, *Thomas Hart Benton* (New York: Graham Gallery, 1968), n.p.

2. The series was commissioned by Abbott Laboratories, a pharmaceutical company based in Chicago. Abbott sponsored a number of these series for exhibition and republication in support of the war effort. For more on the Abbott commissions, see Brian Lanker and Nicole Newnham, *They Drew Fire: Combat Artists of World War II* (New York: TV Books, 2000), 151–56, and Jean Williams-Sherrill (org.), *World War II through the Eyes of Thomas Hart Benton* (San Antonio, Tex.: Marion Koogler McNay Art Museum, 1991).

3. In his autobiography, Benton recalled, "Two days after we left this vessel she was sunk and all on board were killed." Thomas Hart Benton, *An Artist in America*, 4th rev. ed. (Columbia: University of Missouri Press, 1983), 300. When the submarine did not arrive in Panama as expected on October 14, a search was undertaken, but the *Dorado* and her crew were never found. When Benton's and Schreiber's depictions of the *Dorado* were reproduced the following year both in *Collier's* magazine and in a privately printed publication entitled *The Silent Service*, they were dedicated to the memory of the crew. Quentin Reynolds, "Take 'er Down," *Collier's*, November 4, 1944, 16–19, 42, 44, and Thomas Hart Benton and Georges Schreiber, *The Silent Service* (North Chicago, Ill.: Abbott Laboratories, 1944). The rest of the works in the series were given to the Navy Art Collection, Washington, D.C., by Abbott in 1948–49.

4. Interview in *Demcourier* 13 (February 1943), reprinted in Matthew Baigell (ed.), *A Thomas Hart Benton Miscellany: Selections from His Published Opinions* (Lawrence: University Press of Kansas, 1971), 95–96. Two years later, Benton added, "I have not yet fully conquered my craft. But I have a good grip on it, and it will never get away from me." Thomas Hart Benton, foreword to *Thomas Hart Benton* (New York: American Artists Group, Inc., 1945), reprinted in ibid., 103.

5. Matthew Baigell, *Thomas Hart Benton* (New York: Harry N. Abrams, Inc., 1974), 167.

6. Karal Ann Marling, *Tom Benton and His Drawings: A Biographical Essay and a Collection of His Sketches, Studies, and Mural Cartoons* (Columbia: University of Missouri Press, 1985), 16.

61. Dickinson, *The Bee: Lothrup Weld's House*

1. Donald Kuspit, "Report from New York: Cursed by Life, Saved by Nature, Edwin Dickinson's Paintings at the National Academy of Design," *Art New England*, April–May 2003, 9. For the most complete examination of Dickinson's work to date, see Douglas Dreishpoon et al., *Edwin Dickinson: Dreams and Realities* (New York: Hudson Hills Press, in association with the Albright-Knox Art Gallery, Buffalo, 2002).

2. Dickinson's father built a summer cottage in Sheldrake, on Lake Cayuga. According to the artist's daughter, Dickinson "collected fossils there not only in his childhood but all his life." Helen Dickinson to author, May 27, 2003, HMA object files. I am very much indebted to Ms. Dickinson for sharing her insights and information regarding her father's career.

3. Elaine de Kooning, "Edwin Dickinson Paints a Picture," *Art News*, September 1949, 28.

4. He completed the drawing on October 2. According to the artist's daughter, his return was delayed because "We had no car and the Weld house was some distance away." She also noted: "The Welds had embarked on the business of raising chickens, but it was not successful and before long they left Wellfleet. By that time we ourselves had a small flock of chickens and they gave us one of their chicken houses." The younger Weld daughter, born in 1943 in New York City, is the movie actress Tuesday Weld. Helen Dickinson to Mark Mitchell, April 8 and 29, 2003, HMA object files. According to a biography on Weld, her father, Lothrup Motley Weld, Harvard Class of 1920, "became a gentleman farmer on Cape Cod where he raised up to 3,000 chickens on his farm. Eventually, he gave up farming and moved to New York where he became an investment broker. . . . Before Tuesday was born, her father developed a serious heart condition which prevented him from working. She was only three when her father died of a coronary at the age of 49." Floyd Conner, *Pretty Poison: The Tuesday Weld Story* (New York: Barricade Books, 1995), 11.

5. The artist's daughter observed: "That inscription is so characteristic of my father. . . . Closets, in his scheme of things, held a very low order of priority." Helen Dickinson to author, December 11, 1992, HMA object files. In later correspondence, she said the inscription expressed his "*outrage*" at the alterations, which would have also required the destruction of the house's original brick ovens (emphasis in original). Helen Dickinson to author, May 27, 2003, HMA object files.

6. De Kooning, "Edwin Dickinson Paints a Picture," 50.

7. For the influence of film on Dickinson, see Douglas Dreishpoon, "Striking Memory," in Dreishpoon et al., *Edwin Dickinson*, 28.

62. Sample, *Will Bond*

1. In 1928 Sample married Sylvia Howland, whom he had met about 1923, when both were recuperating from tuberculosis at a sanatorium at Saranac Lake, New York (he was there from 1921 until 1925). Her family owned property on Lake Willoughby, near Barton, Vermont, where Sample would frequently paint over the years. The primary source for biographical information on Sample is Paula Glick, "Paul Sample, 1896–1974: An Extended Chronology," in *Paul Sample: Painter of the American Scene* (Hanover, N.H.: Hood Museum of Art, 1988), 14, 17. Paula Glick wrote her master's thesis, "The Murals of Paul Sample," for George Washington University in 1981, and she is presently writing her dissertation on the artist for Columbia University. She has been tremendously generous with her research over the years, and I am particularly grateful for her assistance with this entry and that of cat. 63. I would also

like to thank Don Hawthorne, the sitter's grandson, for providing background on Will Bond.

2. Diary entry, August 3, 1926, quoted in Glick, "Paul Sample," 15. Sample drew incessantly throughout his career. The Hood Museum of Art has an extensive collection of Sample's drawings and sketchbooks, as well as his paintings and watercolors.

3. His best-known social realist work is his animated street scene *Unemployment*, 1931 (National Academy of Design), which won the Isador Gold Medal at the National Academy in 1932. For an overview of his stylistic development, see Robert L. McGrath, "Paul Sample, Painter of the American Scene," in *Paul Sample: Painter of the American Scene*, 27–46.

4. This large canvas, depicting several elderly men looking out on youthful, springtime activities from a Victorian-era porch, is titled *Remember Now the Days of Thy Youth* (1950, Hood Museum of Art). The unlocated watercolor dates to 1947 and was listed in a 1948 exhibition catalogue, *Paul Sample: Retrospective Exhibition* (Manchester, N.H.: Currier Gallery of Art, 1948), cat. 84; it may be the same watercolor of Bond listed with no date in a 1960 exhibition brochure, *An Exhibition of Paintings by Paul Sample* (Manchester, Vt.: The Southern Vermont Art Center, 1960), no. 16, n.p. The two charcoals are in a private collection. There also exists a photograph of Bond seated in a similar pose in an armchair in front of his woodshed (Paul Sample Papers, Archives of American Art, Smithsonian Institution, Washington, D.C.; photocopy courtesy of Paula Glick).

5. The drawing bears a particular stylistic resemblance to Sample's highly detailed studies documenting the invasion of the island of Leyte in the Philippines in 1944 (see, for example, his study for *"Field Hospital in a Church [Delirium Is Our Best Deceiver],"* p. 243.

6. Sample's own horse serves as Bond's chief attribute in the oil, alluding to the farmer's role as a boarder of horses.

63. Sample, *Approach to White River*

1. In 1934 Sample was quoted as saying, "I have no particular theories about painting. . . . I detest imitative painting, but at the same time, complete abstractions leave me without a quiver. Peter Breughel the elder is my favorite painter of all time." "Paul Sample, Who Worships Peter Brueghel," *Art Digest* 8 (May 1934), 8. A writer in 1949 claimed of Sample, "Marin he thinks is the greatest living watercolor painter." Herbert F. West, "Paul Sample: Dartmouth's Artist-in-Residence, Steadily Growing in Stature as American Painter, Is Stimulus to an Expanding Art Colony in Both College and Community," *Dartmouth Alumni Magazine*, May 1949, 15.

2. Alfred Frankenstein, "Paul Sample," *Magazine of Art* 31 (July 1938), 387.

3. A lesser-known painter, Molly Luce, was called the "American Brueghel" as early as 1925. For more on the Brueghel revival in American art, see Robert L. McGrath, "Paul Sample, Painter of the American Scene," in McGrath and Paula F. Glick, *Paul Sample: Painter of the American Scene* (Hanover, N.H.: Hood Museum of Art, Dartmouth College, 1988), 35–41.

4. In this painting, one of his most pared-down

compositions, Sample silhouetted rhythmic groupings of hunters and dogs against a barren, snow-covered hillside. While Sample modified his style in later years, he addressed the hunting theme often, particularly in watercolors sketched during hunting and fishing excursions.

5. Many of the California watercolorists were students or faculty at the Chouinard Art Institute, where Sample taught night classes in 1929. He was exhibiting his watercolors both locally and nationally by the mid-1930s. A *Los Angeles Times* review in 1939 observed: "Sample's water colors are among the best being done in this country. They are transparent, luminous, the color is sensitive and the artist avoids entirely the pretentious size and over-noisy effects as well as the merely clever technical stunts which abound in current practice." Quoted in Martin Petersen, "Paul Sample," in Ruth Lilly Westphal and Janet Blake Dominik (eds.), *American Scene Painting: California, 1930s and 1940s* (Irvine, Calif.: Westphal Publishing, 1991), 144.

64. Marin, *Sea Piece in Red*

1. In a memorial tribute to Marin, Duncan Phillips declared that "whatever he did was independent of all isms and his impetuosity was that of a poet-painter. . . ." The Art Galleries, University of California, Los Angeles, *John Marin Memorial Exhibition* (Los Angeles: University of California, 1955), n.p.

2. Sheldon Reich has called it "one of the most impressive records of recognition ever achieved by a living American artist." Reich, *John Marin: A Stylistic Analysis and Catalogue Raisonné* (Tucson: University of Arizona Press, 1970), 1:225.

3. In the summer of 1951 Marin traveled to New Brunswick, Canada, hoping to reconnect with extended family whom he had met as a child. He was not recognized and returned home frustrated by his efforts to reestablish a sense of family and community. Dorothy Norman, "John Marin's Sketchbook—Summer 1951," *Art in America* 55, no. 5 (September–October 1967), 51. In his old age, however, Marin was fortunate to have a frequent companion and advocate in his son, John Marin Jr. Ruth E. Fine, *John Marin* (Washington, D.C.: National Gallery of Art; New York: Abbeville Press, 1990), 250.

4. In his later years, Marin reportedly signed many of his letters "The Ancient Mariner," including one to Dorothy Norman that closed, "Yer ancient Mariner / who was named / John." Reprinted in Dorothy Norman (ed.), *The Selected Writings of John Marin* (New York: Pellegrini and Cudahy, 1949), 229. MacKinley Helm, *John Marin* (New York: Pellegrini and Cudahy, 1948), 103. Several writers, including Helm, Duncan Phillips, and Cleve Gray, adopted that term when referring to Marin in old age.

5. Samuel Taylor Coleridge's "The Rime of the Ancient Mariner" was first published in 1798. The comparison between Marin and Coleridge's mariner is clearly loose, but apt if taken only in a general sense. Coleridge's mariner has returned from a terrible sea voyage during which he shot an innocent albatross and endured terrible consequences: all of his shipmates were killed and his only solace on reaching home derived from recounting his moralizing tale to strangers such as the wedding guest he

has waylaid in the poem. Marin certainly felt the losses of his family and friends, though not an affliction for any known sin in his life that we are aware of, and derived satisfaction from sharing his wisdom with the young. For the poem, see Ernest Hartley Coleridge (ed.), *The Complete Poetical Works of Samuel Taylor Coleridge* (Oxford: Clarendon Press, 1912), 1:186–209.

6. Helm, *John Marin*, Herbert J. Seligmann (ed.), *Letters of John Marin* (New York: An American Place, 1931), and Norman, *The Selected Writings of John Marin*.

7. Elizabeth Johns, citing the work of sociologists Erik Erikson and Daniel Levinson, has attached new significance to the interpretation of an artist's work in light of his or her stage of life in her recent study *Winslow Homer: The Nature of Observation* (Berkeley: University of California Press, 2002). Homer, like Marin, painted stormy seascapes along the coast of Maine in later life. Paraphrasing Erikson, Johns has written, "During our lifetime we develop, test, confirm, and reconfirm—or perhaps cannot—important psychic strengths: trust, in infancy; autonomy, in childhood; . . . concern for the development of the next generation, in mature adulthood; and wisdom in old age." Ibid., 2.

8. Helm, *John Marin*, 95.

9. Ibid. Also quoted in Cleve Gray, "Marin and Music," *Art in America* 58, no. 4 (July–August 1970), 72.

10. Reich, *John Marin*, 1:233. Several art historians have remarked on the fulfillment of Marin's "calligraphic" tendency in his later art. Cleve Gray (ed.), *John Marin by John Marin* (New York: Holt, Rinehart and Winston, 1977), 12. Fine, *John Marin*, 255, 259–63. Marin viewed his paintings and drawings as parts of the same project and wrote, "Know that I personally make no separating distinction—to me—they are all drawings." Quoted in Norman, "John Marin's Sketchbook," 52.

11. When *Sea Piece in Red* was exhibited at the Downtown Gallery in 1952, the critic for *Art News*, Henry McBride, called it "almost hurricane force," a phrase that captures the motion and drama at work in the watercolor. McBride, "John Marin 1951," *Art News* 50, no. 9 (January 2, 1952), 47.

12. "'The sea that I paint may not be *the* sea, but it is *a* sea, not an abstraction," Marin insisted to his biographer, MacKinley Helm. Helm, *John Marin*, 103. Although Helm believed that this statement rendered Marin a realist, it would certainly be more appropriate to conclude that Marin's art was figurative, but not necessarily realistic. Duncan Phillips felt similarly, writing that "Marin regarded himself as a lyrical realist, which of course he was, although an expressionist rather than an impressionist by temperament. . . . Mere illusion was seldom, if ever, his aim even in the representative landscapes of Maine, New Hampshire and New Mexico. . . . He experimented at the frontiers of visual consciousness. . . ." *John Marin Memorial Exhibition*, n.p. Cleve Gray agreed, writing, "With all his objections to abstract art, Marin often came very near to abstraction." Gray, *John Marin by John Marin*, 14.

13. Early in Pollock's career, Clement Greenberg wrote that he might someday rival Marin. Greenberg, cited in Reich, *John Marin*, 1:236. Duncan

Phillips concurred, "We are witnessing a period in art of private symbols and unconscious calligraphy. . . . It may be claimed that John Marin, especially in his latest canvases, . . . anticipated such improvisations. . . ." *John Marin Memorial Exhibition*, n.p. John I. H. Baur added of Marin's work about 1950 that it "is the purest, most forceful abstract expressionism we have yet produced" in this country. Baur, *Revolution and Tradition in Modern American Art* (New York: Praeger Publishers, 1951), 73.

65. Crawford, *Box Car & New Orleans*

1. Inspired by the shifting perspectives of Paul Cézanne and the flat areas of color in the paintings of Henri Matisse, Crawford rooted his art in the European stylistic developments of the early twentieth century. His subject matter was uniquely modern as well; because of his industrial themes—such as oil tanks, bridges, and silos—he was initially identified with the American precisionist artists of the 1930s, such as Charles Sheeler and Charles Demuth. As he matured as an artist, his movement toward stark abstractions marked him as uniquely different, not only from this older generation of the 1930s but also from the abstract expressionist painters of his own age, who firmly rejected the cubist and European-derived abstraction to which his work was so clearly related.

2. Barbara Haskell, *Ralston Crawford* (New York: Whitney Museum of American Art, 1985), 96. Haskell also comments on Crawford's disinterest in the "poignancy of the site." The harshness of the shadows cast by intense light in Crawford's New Orleans cemetery drawings and paintings recalls the artist's descriptions of the "blinding light of the blast" of the atomic tests at the Bikini Atoll. He had been sent to witness these tests in order to record them for illustration in *Fortune* magazine. See William C. Agee, *Ralston Crawford* (Pasadena, Calif.: Twelve Trees Press, 1983), 10–11.

3. Reproduced as no. 38 in Agee, *Ralston Crawford*.

4. Letter to Richard Freeman, October 1972, quoted in Freeman, *Graphics 73—Ralston Crawford* (Lexington: University of Kentucky Art Gallery, 1973), n.p.

5. Freeman, *Graphics 73*, n.p.

66. Smith, *3/20/52*

1. Clement Greenberg, "David Smith," *Art in America*, winter 1956–57, 30.

2. Handwritten text for a speech given at the Portland Museum of Art, Oregon, on March 23, 1952. The artist's papers indicate that the lecture was given in 1953, but both Cleve Gray and Rosalind Krauss agree that it was actually 1952. David Smith Papers, owned by Rebecca and Candida Smith, microfilmed by the Archives of American Art, Smithsonian Institution, Washington, D.C., reel ND Smith 4, frames 387–88. Also cited in Cleve Gray (ed.), *David Smith by David Smith, Sculpture and Writings* (New York: Thames and Hudson, 1968), 104. Mentioned in Rosalind Krauss, *The Sculpture of David Smith: A Catalogue Raisonné* (New York: Garland Publishing, 1977), 154. The text also closely follows a similar description of his drawing that Smith wrote in a letter of the same date as the lecture.

Smith to Wells Bennett, March 23, 1952, David Smith Papers, reel ND Smith 1, frame 1095.

3. Typescript of an interview with Thomas Hess, June 1964, David Smith Papers, reel ND Smith 4, frame 294.

4. David Smith Papers, reel ND Smith 4, frame 388. Also quoted in Trinkett Clark, *The Drawings of David Smith* (Washington, D.C.: International Exhibitions Foundation, 1985), 29.

5. E. A. Carmean Jr., *David Smith* (Washington, D.C.: National Gallery of Art, 1982), 69.

6. David Smith Papers, reel ND Smith 1, frame 954. We can only speculate that his motive for downplaying drawing in his fellowship application was to justify his need for the foundation's financial support for costly sculpture materials, not paper and ink.

7. Krauss, *The Sculpture of David Smith*, 59–60.

8. Paul Cummings, *David Smith: The Drawings* (New York: Whitney Museum of American Art, 1979), 21.

9. He also wrote that he sometimes used casein as a thickening agent instead of egg yolk. David Smith to Wells Bennett, March 23, 1952, David Smith Papers, reel ND Smith 1, frame 1095.

10. Cummings, *David Smith*, 35.

11. Smith wrote, "I don't differentiate between writing and drawing, not since I read . . . Joyce," referring to an unlocated passage in *Finnegans Wake*. David Smith Papers, reel ND Smith reel 4, frame 302. Also see David Anfam, *Abstract Expressionism* (New York: Thames and Hudson, 1990), 99.

12. David Smith Papers, reel ND Smith 4, frame 301.

67. Wyeth, *Winter Light*

1. "Above the Battle," *Time*, November 2, 1962, 70–71.

2. Wanda M. Corn, "Andrew Wyeth: The Man, His Art, and His Audience" (Ph.D. diss., New York University, 1974), passim and esp. chap. 2, "Wyeth as a Twentieth-Century Artist."

3. Ailene B. Louchheim wrote in 1953, the year Wyeth painted this watercolor, "but [Wyeth's] closest affinity—in his recognition of the timelessness of the countryside and the passing of human life, his expressions of loneliness and solitude and his loving yet objective respect for the dignity and austerity of the human being—is not to a painter at all, but to the poet Robert Frost." Louchheim, "Wyeth—Conservative Avant-Gardist," *New York Times Magazine*, October 25, 1953, 33.

4. Charles W. Cole, president of Amherst College, to Hyde Cox (a friend and scholar of Frost), February 4, 1954. Dartmouth College Library. In Cox's presentation of the watercolor during a commemorative dinner held at Amherst College, March 26, 1954, he said, "We also know that you share our high opinion of the work of Andrew Wyeth—one of the truest and deepest of American painters. Moreover, the world Mr. Wyeth has created in his art seems to many people to have underlying affinities with the world of Robert Frost. I am not alone in feeling that a sympathy exists between these two unique and different worlds. . . . We hope you will have much

pleasure from his beautiful water-color of a scene that is 'North of Boston,' we feel, in spirit." Transcript of Cox's remarks in Dartmouth College Library. Wyeth had planned to go to the dinner but was waylaid at the last minute. Frost attended Dartmouth briefly in 1892 and returned to Dartmouth as Ticknor Fellow in the Humanities, a position he held from 1943 to 1949. Frost had held various faculty appointments over the years at Amherst and in 1949 was given a life appointment as Simpson Lecturer in Literature.

5. Wyeth explained, "I still feel if you really love an object and you want to use it to say something you really feel, you're not content with just an impression of it." Quoted in Louchheim, n.p. Frost believed that "if you don't know something specifically, you don't know it." Quoted in Jay Parini, *Robert Frost: A Life* (London: William Heinemann, 1998), 388.

6. Wyeth exhibited at the Art Alliance of Philadelphia in 1936 and received a one-man exhibition at MacBeth Gallery, New York, in 1937. His early watercolors owed a particular debt to the example of Winslow Homer, whose late watercolors he saw about 1933. "Wyeth, Andrew (Newell)," in Jane Turner (ed.), *The Dictionary of Art* (New York: Grove's Dictionaries, 1996), 33:451.

7. Agnes Mongan, "The Drawings of Andrew Wyeth," *American Artist*, September 1963, 74.

8. According to Karen Baumgartner, assistant curator of the Wyeth Collection, this work depicts the John McVey barn in Chadds Ford. The same structure appears in *McVey's Barn*, 1948 (New Britain Museum of American Art) and *March Storm*, 1960 (Collection of Delaware Art Museum). Fax and letter from Karen Baumgartner, February 25 and March 12, 2003, respectively.

9. Letter of January 1957 to his friend and neighbor, Mr. Phelps, cited in Mongan, "The Drawings of Andrew Wyeth," 30. Wyeth's famous tempera *Winter* (1946), painted the year after his father's death in a railway accident, clearly links this season with his personal loss and conveys the artist's sense of confusion after the tragedy.

68. Gottlieb, *Male and Female*

1. Irving Sandler, *The Triumph of American Painting: A History of Abstract Expressionism* (New York: Praeger Publishers, 1970), 193.

2. According to Nancy Litwin of the Adolphe and Esther Gottlieb Foundation, the artist often made drawings after his paintings in ongoing reassessment of his work, as is the case here. Litwin to author, February 11, 2003, HMA object files.

3. David Anfam, *Abstract Expressionism* (London: Thames and Hudson, 1990), 101. Jung's work was available in English translation by 1939. Lawrence Alloway and Mary Davis MacNaughton, *Adolph Gottlieb: A Retrospective* (New York: The Arts Publisher, Inc., in association with the Adolph and Esther Gottlieb Foundation, Inc., 1981), 31.

4. Alloway and MacNaughton, *Adolph Gottlieb*, 31, 50n.20.

5. Robert F. Creegan, "Jung, Carl G.," in Philip Lawrence Harriman (ed.), *Encyclopedia of Psychology* (New York: Philosophical Library, 1946), 317.

6. These depictions include *The Couple* (1946, Fred Jones Jr. Museum of Art, University of Oklahoma), *Male and Female* (1950, collection of the artist, in 1968), *Man and Woman* (1951, Manny Silverman Gallery, Los Angeles, in 1995), and *The Couple* (1955, Adolph and Esther Gottlieb Foundation, New York, in 1977), as well as the present drawing.

7. Adolph Gottlieb and Mark Rothko (with the assistance of Barnett Newman) to Edward Alden Jewell, June 7, 1943, published in the *New York Times* and reprinted in Alloway and MacNaughton, *Adolph Gottlieb*, 169.

8. Sandler, interviews by Jeffrey Wechsler, 1987–88, published in Wechsler, *Abstract Expressionism, Other Dimensions: An Introduction to Small Scale Painterly Abstraction in America, 1940–1965* (New Brunswick, N.J.: Jane Voorhees Zimmerli Art Museum, Rutgers, The State University of New Jersey, 1989), 76.

69. Bischoff, *Still Life: Fungus*

1. *Ilse Bischoff: A Retrospective*, with an introduction by Paul Cadmus (Hanover, N.H.: Hopkins Center Galleries, Dartmouth College, 1966), n.p. The College's art galleries mounted small exhibitions of Bischoff's works in 1947, 1949, 1958, 1965, 1976, and 1986. In 1954 the College hosted an exhibition of her drawings, along with drawings by Cadmus and Jared French (no checklist). Today the Hood Museum of Art has extensive holdings of her paintings, drawings, and illustrations (see, for example, p. 227). For more on Bischoff, see the following illustrated catalogues: *The Intimate Realism of Ilse Bischoff: Paintings and Drawings, 1964–1976* (Hanover, N.H.: Carpenter Galleries, Dartmouth College, 1976); and *Ilse Bischoff: The Pleasure of Drawing* (Hanover, N.H.: Hood Museum of Art, Dartmouth College, 1986). For a listing of Bischoff's further exhibitions and her writings and illustrations, see Peter Hastings Falk (ed.), *Who Was Who in American Art, 1564–1975* (Madison, Conn.: Sound View Press, 2001). She formed a distinguished collection of Meissen and Nymphenburg porcelain. She gave sixteen pieces to the Busch-Reisinger Museum in 1958 (supplemented by smaller additional gifts) and sold much of the remaining collection at Parke-Bernet in 1977.

2. Bischoff transferred to Parsons in Paris in February 1922 and returned to Parsons in New York on November 15, 1922, to complete her third year of Costume. She also studied for more than a year in Munich in the 1920s but resumed courses at the league on her return. Bischoff mentioned studying privately in Munich with Buchner (probably Gustav-Johannes Buchner). Taped interview conducted January 27, 1982, by Robert Brown for the Archives of American Art, Smithsonian Institution, Washington, D.C. Her friend Claire Nix reported that she studied at the Academy of Fine Arts in Munich (conversation with author, September 6, 1991).

3. Bischoff's most widely exhibited painting in this style was her large canvas of African American theatergoers entitled *Harlem Loge* (c. 1934, Hood Museum of Art), which she exhibited several times nationally and for which she received a $500 award from the 1945 *Second Annual "Portrait of America" Exhibition*, sponsored by the Pepsi-Cola Company under the auspices of Artists for Victory, Inc. The exhibition opened in New York and traveled to eight U.S. museums.

4. Bischoff originally went to Hartland because she had friends in nearby Woodstock. She furnished her Hartland home with extreme elegance so as to have her "New York comfort in Hartland." Brown interview.

5. Biographical Materials and Diaries, Papers of Ilse Martha Bischoff, Archives of American Art, Smithsonian Institution, Washington, D.C.

6. Cadmus was spending extended periods in Bischoff's cottage on her Hartland property at that time. Brown interview. Bischoff also adopted Cadmus's method of toning her papers with casein using an atomizer. The color provided a middle value for her paintings and drawings.

7. Brown interview.

70. Mitchell, Untitled

1. In 1957 she painted *To the Harbormaster* in response to O'Hara's poem. She also at some point discussed with Beckett the possibility of illustrating his radio play *Embers*, which he wrote and published in 1959. The pairing seemed natural since Mitchell, like Beckett, concerned herself with such themes as the sea, light, memory, the passage of time, and death. There is a remote chance that this work bears a relationship to the *Embers* project, but conflicting information about the nature and date of Mitchell's illustrations makes such a possibility tenuous. According to Klaus Kertess (*Joan Mitchell* [New York: Harry N. Abrams, Inc., 1997], 27), Mitchell began a series of watercolors for this project about 1959 (said to have been "lost"), but ultimately she decided that Beckett's work was so visual on its own, it required no accompaniment. Judith Bernstock, by contrast, states that Mitchell planned a series of gouaches to illustrate the play in the mid-1980s (Bernstock, *Joan Mitchell* [New York: Hudson Hills Press, in association with the Herbert F. Johnson Museum of Art, Cornell University, 1988], 107–8). Jane Livingston wrote that Beckett and Mitchell had planned to publish a small edition of *Embers*, illustrated by some of Mitchell's etchings (Livingston, with essays by Linda Nochlin, Yvette Y. Lee, and Livingston, *The Paintings of Joan Mitchell* [New York: Whitney Museum of American Art; Berkeley: University of California Press, 2002], 43). It is therefore not known if or how this work, which dates stylistically to about 1959 and had been called a watercolor by previous owners, relates to this initiative. In any case, Beckett's writings certainly resonated with Mitchell during this period and for the remainder of her life. Few other works on paper by Mitchell appear to survive from this period, with the exception of two "colored oil stick and chalks and graphite on paper" studies that are the same size as this work and likely came from the same sketchbook. See *Contemporary Art* (New York: Christie's, November 21, 1996), lots 122, 123.

2. Founded in 1949, the Club held meetings in a rented loft at 39 East Eighth Street. Kline, de Kooning, and Ad Reinhardt were among the initial members. Female members included Mitchell, Elaine de Kooning, Helen Frankenthaler, and Lee Krasner. The Club also featured presentations by such poets as O'Hara, John Ashbery, and James Schuyler. For more on the social milieu of the abstract expressionists, see Carolyn Kinder Carr, "Rebel Painters of the 1950s," www.npg.si.edu/exh/rebels/painters.htm.

3. Kertess, *Joan Mitchell*, 27.

4. Quoted in ibid., 25.

5. Ibid., 28.

71. Rivers, *Double Money Drawing*

1. Rivers's status as a pop artist has been the subject of some discussion. Irving Sandler has placed the artist as a second-generation New York School artist, working in a mode that Sandler called "gestural realism." Sandler, *The New York School: The Painters and Sculptors of the Fifties* (New York: Harper and Row, 1978), 103, 110. Rivers's use of popular motifs and subjects, his humor, his play with the concept of repetition, and his antiestablishment bias in his mature work all place him squarely in the pop tradition. Art historian Sam Hunter has written, "The abstract expressionist cult of painting as unique and unrepeatable experience was first, and grossly[,] compromised by Rivers' twin image variations of his mother-in-law, in the *Double Portrait of Birdie*" in the mid-1950s. His work thereafter only increased that interest, as *Double Money Drawing* attests. Hunter, *Larry Rivers* (New York: October House Inc., 1965), 20.

2. Rivers recalled, "I think that if one analyzes a lot of these drawings from the early sixties one can see certain roots in some of the charcoal drawings by de Kooning which interested me at the time." He quickly added, "On the other hand, I think his sense of naturalism is different from mine." Rivers with Carol Brightman, *Drawings and Digressions* (New York: Clarkson N. Potter, Inc., 1979), 156–57.

3. Barbara Rose has summed up Rivers's legacy: "His lasting contribution would be to art history as the originator of the imagery of pop art and as a painter who held fast to Jean-Dominique Ingres's idea that drawing is the probity of art." Rose, "Larry Rivers: Painter of Modern Life," in Corcoran Gallery of Art, Washington, D.C., *Larry Rivers: Art and the Artist* (Boston: Little, Brown and Company, in association with the Corcoran Gallery of Art, 2002), 20.

4. Rose, "Larry Rivers," 35.

5. Rivers, quoted in Jacquelyn Days Serwer, "Larry Rivers and His 'Smorgasbord of the Recognizable,'" in Corcoran Gallery of Art, *Larry Rivers*, 64.

6. The artist's choice of a 1960 bill, one of the first produced after the creation of the new currency, also points to his awareness of the revaluation.

7. Suzanne Ferguson has written on the role of such hero figures in Rivers's work, particularly in *Washington Crossing the Delaware*. "We end up with a 'new' Washington — or two, or more. Demythologized but nonetheless a creature of myth, he is a Washington reinterpreted for our time, still conventional but also, in his post-modern representation(s), still compelling." Ferguson, "Crossing the Delaware with Larry Rivers and Frank O'Hara: The Post-Modern Hero at the Battle of Signifiers," *Word and Image* 2, no. 1 (January–March 1986), 32.

8. Rose has remarked that Rivers's "criticism is not of consumerism but of orthodoxy and convention, whether in art or in life." Rose, "Larry Rivers," 20.

9. Both Rose and Jean Lipman have remarked on the relationship between Rivers's and Warhol's 1962 money series. Rose has further speculated that Warhol's work may have inspired Rivers, though she offers no evidence to support that theory. Rose, "Larry Rivers," 42. Lipman, "Money for Money's Sake," *Art in America* 58, no. 1 (January–February 1970), 76.

10. Quoted in Lipman, "Money for Money's Sake," 82.

11. Vivien Raynor, "Larry Rivers," *Arts Magazine* 37, no. 5 (February 1963), 47.

72. Murch, *Study #18*

1. During the last years of Murch's life, pop art held center stage, and although this movement was more sympathetic to object-oriented subjects, the artist's quiet paintings really had little in common with Warhol's Campbell's Soup cans or Jasper Johns's less ironic work on similar themes. Although Murch was a maverick in his art making, he was not an outsider in the social sense. Born and raised in Toronto, he received his initial training at the Ontario College of Art. Moving to New York in 1927 at the age of twenty, he studied at the Art Students League but soon abandoned his courses there, opting instead for independent sessions with the painter Arshile Gorky. The older artist taught Murch that the handling of the medium — be it paint, charcoal, or graphite — was as important as the subject itself. He soon became friends with the surrealist dealer Julian Levy as well as the abstract painter Barnett Newman, who hung Murch's first solo show at Betty Parsons's new Fifty-seventh Street space in 1947 and included him in the gatherings on Eighth Street, where members of the abstract expressionist group discussed the meaning and purpose of art. Joseph Cornell, a reclusive maker of boxes and colleges, also befriended the shy and quiet Murch. Both men worked as commercial artists to support themselves and had an interest in objects found on the street, which they incorporated into their art. Cornell sometimes gave Murch objects that he had picked up in his searches for material for his own work, such as old photographs and a pen case, which Murch put into his still lifes. For a more thorough discussion of his artistic training and friendships, see Daniel Robbins, *Walter Murch* (Providence: Museum of Art, Rhode Island School of Design, 1966), n.p.

2. Writing about an experience that had happened fifteen years earlier, Murch told about visiting a dilapidated and deserted inn during a trip to New Hampshire in the early 1950s. Exploring its interior, he became fascinated by the peeling wallpaper. He stated that suddenly he knew he could draw. "What moved me was the texture of the paper itself, the color, the fact that someone had done something to it already." His visceral reaction to the texture of the paper, with the bits of plaster adhering to its reverse side, led him later to distress paper he left in his studio by walking across it, thereby altering the surface. Eventually he would pick it off the floor and use it for a drawing. See Dorothy Adlow, "The Artist on His Work — 7: Taking on the Task," *Christian Science Monitor*, October 26, 1965, 8.

3. Judy Kay Collischan van Wagner, "Walter Murch" (Ph.D. diss., University of Iowa, 1972), 1:261.

73. Lawrence, *Soldiers and Students*

1. Jacob Lawrence, quoted in Romare Bearden (moderator), "The Black Artist in America: A Symposium," *Metropolitan Museum of Art Bulletin* 27, no. 5 (January 1969), 259.

2. Milton W. Brown, *Jacob Lawrence* (New York: Whitney Museum of American Art, 1974), 11.

3. In retrospect, Lawrence denied that his works were "protest pictures" or visual propaganda. In 1980 he reportedly said, "I never use the term 'protest' in connection with my paintings. They just deal with the social scene. . . . They're how I feel about things." In spite of that semantic distinction, Lawrence clearly had strong feelings about racism and segregation in America. Lawrence, quoted in Patricia Hills, "Jacob Lawrence's Paintings during the Protest Years of the 1960s," in Peter T. Nesbett and Michelle DuBois (eds.), *Over the Line: The Art and Life of Jacob Lawrence* (Seattle: University of Washington Press, in association with Jacob Lawrence Catalogue Raisonné Project, 2000), 189.

4. Richard J. Powell, *Jacob Lawrence* (New York: Rizzoli, 1992), n.p.

5. Pablo Picasso himself recognized the emotive and political potentials of cubism, as his iconic *Guernica*, depicting the Nazi destruction of a Spanish town of that name during the Spanish Civil War in 1937, clearly demonstrates. *Guernica* was exhibited at the Museum of Modern Art from 1939 until 1981, and Lawrence undoubtedly knew it.

6. Hills, "Jacob Lawrence's Paintings," 177.

7. Superficially, there are many similarities between the plight of the students in *Soldiers and Students* and that of the Arkansas teenagers known as the Little Rock Nine, who endured violent harassment to integrate Little Rock High School in September 1957. The presence of ten students in Lawrence's composition, as well as their apparent youth and confrontation with the soldiers, quickly undermines that interpretation, however. The intensely well-documented national media event that was the Little Rock Crisis of 1957 would nevertheless have mediated viewers' experience of *Soldiers and Students* even in 1963, when it was first exhibited.

8. Another related work is Lawrence's *Ordeal of Alice*, 1963, cat. rais. no. P63–04, private collection, New York.

9. Aline B. Saarinen, *Jacob Lawrence* (New York: American Federation of Arts, 1960), 4.

74. Bontecou, Untitled

1. Bontecou was annexed by feminists themselves as well as grouped with them in the popular press. Feminist critic Lucy Lippard cited Bontecou as an example of one of the "few women who dared to make such subject matter [as the vagina] visible and to accept the potential scorn of a society unfamiliar with it." Lippard railed against the fact that when Bontecou was accepted by the art establishment, it was on the basis of her art's aesthetic merits rather than for the revolutionary subject matter that Lippard championed. Lippard, "Fragments," in *From the Center: Feminist Essays on Women's Art* (New York: E. P. Dutton, 1976), 79.

2. "I just wasn't there. I had no community spirit. I haven't that many friends in the art world. And I'm not really involved with the Women's Movement: it's nothing new to me." Bontecou, quoted in Eleanor Munro, *Originals: American Women Artists* (New York: Simon and Schuster, 1979), 378. Elizabeth A. T. Smith, "Abstract Sinister," *Art in America* 81, no. 9 (September 1993), 87. Mona Hadler, "Lee Bontecou's 'Warnings,'" *Art Journal* 53, no. 4 (winter 1994), 61n.3.

3. The 2003 retrospective of the artist's career has done much to return Bontecou's work to the spotlight and survey the full range of her artistic practice over the decades. Elizabeth A. T. Smith, *Lee Bontecou: A Retrospective* (Chicago: Museum of Contemporary Art; Los Angeles: UCLA Hammer Museum, in association with Harry N. Abrams, Inc., New York, 2003).

4. Quoted in Munro, *Originals*, 384. Also quoted elsewhere, including Mona Hadler, "Lee Bontecou—Heart of a Conquering Darkness," *Source* 12, no. 1 (fall 1992), 42.

5. Quoted in Munro, *Originals*, 384.

6. Smith, "Abstract Sinister," 84–86. Smith interprets Bontecou's open work as a later phase, predominantly of the 1960s, whereas Bontecou herself recalled the two styles as contemporaries. See Munro, *Originals*, 384.

7. Munro, *Originals*, 379.

8. Donna De Salvo, "Inner and Outer Space: Bontecou's Sculpture through Drawing," in Smith, *Lee Bontecou*, 217.

9. Those elements of the drawing that resemble Bontecou's commission include schematic dimensions of a sculpture at the drawing's lower right that closely approximate those of the New York State Theater sculpture, a flight of stairs leading up to one sketch in the lower right center, the framing elements that surround each of the sketches above and below (calling to mind ceiling and floor, respectively), and what could be interpreted as the interior of the New York State Theater itself in a sketch at the center of the drawing's lower edge.

10. Letter to the author, December 17, 2002, HMA object files.

11. Philip Johnson, "Young Artists at the Fair and at Lincoln Center," *Art in America* 52, no. 4 (August 1964), 123.

75. Hesse, Untitled

1. The identity of the only prior owner of this drawing is, by agreement, kept confidential in the curatorial files of the Hood Museum of Art.

2. Hesse (1970), quoted in Cindy Nesmer, "A Conversation with Eva Hesse," in Mignon Nixon (ed.), *Eva Hesse* (Cambridge, Mass.: MIT Press, 2002), 6. Doyle and Hesse were invited to Kettwig by F. Arnhard Scheidt, a German industrialist who admired Doyle's sculpture and proposed an exchange of lodging, supplies, and other support for works of art.

3. Scholars have typically attributed the trauma associated with Hesse's first months in Germany with her own anxiety about returning to the place where she was born and that her parents fled, in 1938, as a

result of the rising Nazi threat. For a more complex reading of Hesse's biography, see Anne M. Wagner, "Another Hesse," in her *Three Artists (Three Women): Modernism and the Art of Hesse, Krasner, and O'Keeffe* (Berkeley: University of California Press, 1996).

4. Entry from May 11, 1965, quoted in Renate Petzinger, "Thoughts on Eva Hesse's Early Work," in Elizabeth Sussman (ed.), *Eva Hesse* (San Francisco: San Francisco Museum of Modern Art, 2002), 53.

5. Entry from August 4, 1965, quoted in Helen Cooper, "Eva Hesse: Diaries and Notebooks," in her *Eva Hesse: A Retrospective* (New Haven: Yale University Art Gallery, 1992), 35.

6. Hesse also showed four drawings at the *Winterausstellung* at the Kunstverein für die Rheinlande und Westfalen, Kunsthalle, in Düsseldorf in November 1964, and she and Doyle also had a small exhibition at Scheidt's home in May 1965. The solo exhibition was open from August through October and was entitled *Eva Hesse: Materialbilder und Zeichnungen*. A small brochure with a photograph of the artist on its cover was produced at the time. See Robert Pincus-Witten, "Eva Hesse: More Light on the Transition from Post-Minimalism to the Sublime," in Linda Shearer, *Eva Hesse: A Memorial Exhibition* (New York: Solomon R. Guggenheim Foundation, 1972), n.p.

7. See Lucy Lippard, *Eva Hesse* (New York: New York University Press, 1976), 28–30.

8. Robert Pincus-Witten has argued persuasively that Hesse and her cohorts—for example, Robert Smithson, Mel Bochner, and Richard Tuttle—are best understood as responding strongly to the minimalist orthodoxy of their immediate predecessors in this period. Biomorphism and an attitude of play replace the more severe geometry and seriousness of the canonical minimalists. See Pincus-Witten, *Postminimalism* (New York: Out of London Press, 1977). For another strong appraisal of this contribution and its difference from contemporary artists, see Arthur C. Danto, "Growing Up Absurd," *Art News* 88 (November 1989), 118–21.

9. Eva Hesse to Sol LeWitt, transcribed into her diary, March 1965. Original text in the Eva Hesse Archives, Allen Memorial Art Museum, Oberlin College, quoted in Cooper, "Eva Hesse," 33.

10. A 1968 photograph (Estate of the Artist) shows a surface in Hesse's studio with a hand-drawn periodic table made by Carl Andre. It is not known, however, when the artist received this gift from Andre. Hesse made a number of drawings for the children of her German patron, which she presented as Christmas gifts in 1964. These works bear an unmistakable formal resemblance to the Hood drawing. For color reproductions, see Brigitte Reinhardt et al., *Eva Hesse: Drawing in Space—Bilder und Reliefs* (Ostfildern, Germany: Cantz Verlag, 1994), 146.

11. For a good overview of the variety of work done in these media, see Ellen H. Johnson, *Eva Hesse: A Retrospective of Drawings* (Oberlin, Ohio: Allen Memorial Art Museum, 1982).

76. White, *Exploding Star (Awake)*

1. Lucinda Heyel Gedeon, "Introduction to the Work of Charles W. White with a *Catalogue Raisonné*"

(master's thesis, University of California, Los Angeles, 1981), 41.

2. Janice Lovoos, "The Remarkable Draughtsmanship of Charles White," *American Artist* 26, no. 6 (June–July–August 1962), 101.

3. White, quoted in ibid., 118.

4. The figure's gender is arguably indeterminate, but the artist himself remarked in answer to a question about why women were his most frequent subjects: "Women are the source of life. It's very easy for me to use them as a symbol of anything that I talk about in nature, and that's basically what I am doing with all of my work. . . . If I had to give a gender to things, then I see everything as female." White, quoted in Sharon G. Fitzgerald, "Charles White in Person," *Freedomways* 20, no. 3 (1980), 161.

5. Andrews, " 'Charles White Was a Drawer,' " *Freedomways* 20, no. 3 (1980), 146.

77. Martin, Untitled

1. For a brief chronology of Martin's life until 1992, see Barbara Haskell, *Agnes Martin* (New York: Whitney Museum of American Art and Harry N. Abrams, Inc., 1992), 167.

2. For a compilation of Martin's writings, see Dieter Schwartz, *Agnes Martin: Writings/Schriften* (Winterthur, Switzerland: Kunstmuseum Winterthur, 1992).

3. She took up painting again in 1974, after a 1973 retrospective exhibition of her work at the Institute of Contemporary Art at the University of Pennsylvania in Philadelphia. By this time she had built a log and adobe house on her leased property in New Mexico and had begun constructing a studio.

4. See Barbara Haskell's chapter entitled, "Agnes Martin: The Awareness of Perception," in her *Agnes Martin*, 93–95.

5. Agnes Martin, "Notes," in *Agnes Martin* (Munich: Kunstraum Munich, 1973), 63. This exhibition catalogue reproduces the notes that Martin gave to the Institute of Contemporary Art at the time of her retrospective in 1973, along with other texts by the artist. She writes: "I hope I have made it clear that the work is *about* perfection as we are aware of it in our minds but that the paintings are very far from being perfect—completely removed in fact—even as we ourselves are."

6. Quoted in Lawrence Alloway, "Agnes Martin," in *Agnes Martin* (Philadelphia: Institute of Contemporary Art, University of Pennsylvania, 1973), 9. Alloway took Martin's quotation from an article by Lucy Lippard, "Homage to the Square," *Art in America*, July–August 1967, 54. In the early twentieth century, nonobjective art was first attempted by figures such as Kasimir Malevich and Wassily Kandinsky. No doubt Martin was aware of Malevich's painting *Black Square* and his use of the square as a metaphor for "feeling" and the white void within which it sits as the "void beyond this feeling." Malevich's association of geometric forms recalls the associations that Martin ascribes to nonobjective imagery in her writings. For a discussion of the square and its implications in twentieth-century art and Martin's art, see Anna C. Chave, "Humility, the

Beautiful Daughter . . . All Her Ways Are Empty," in Haskell, *Agnes Martin*, 142.

7. See Hermann Kern, "Some Notes on the Drawings of Agnes Martin," in Martin, *Agnes Martin*, 5.

78. Lawrence, *Flight II*

1. Only seventeen of Lawrence's twenty paintings for the commission were reproduced in the final book, and some controversy surrounded the exclusion of a depiction of Tubman with a gun. Peter T. Nesbett and Michelle DuBois with Stephanie Ellis-Smith, *Jacob Lawrence: Paintings, Drawings, and Murals (1935–1999): A Catalogue Raisonné* (Seattle: University of Washington Press, in association with Jacob Lawrence Catalogue Raisonné Project, 2000), 163.

2. Jacob Lawrence, *Harriet and the Promised Land* (New York: Windmill Books, Simon and Schuster, 1968; reprint, New York: Simon and Schuster, 1993), n.p. Lawrence's first series of paintings on the life of Tubman consisted of thirty-one panels and is now in the collection of the Hampton University Museum, Hampton, Virginia.

3. Patricia Hills, "Jacob Lawrence as Pictorial Griot: The Harriet Tubman Series," *American Art* 7, no. 1 (winter 1993), 45–46.

4. Sarah Bradford, *Harriet Tubman: The Moses of Her People* (reprint, Gloucester, Mass.: Peter Smith, 1981), 34–35.

5. Lawrence, *Harriet and the Promised Land*, n.p.

6. Patricia Hills has interpreted Lawrence's appropriation of his various sources as a visual analogue of African American oral tradition, in which improvisation and delivery complement historical content to make each retelling unique to the speaker and to the context in which it is delivered. Hills, "Jacob Lawrence as Pictorial Griot," 42–43, 58.

7. Critic Aline Saarinen noted the significance of masking in Lawrence's art in 1960, and her observations resonate particularly well with *Flight II*. Saarinen, *Jacob Lawrence* (New York: American Federation of Arts, 1960), 7. Masks are an important part of visual traditions in Africa and the Diaspora and make frequent appearances in Lawrence's art throughout his career. In *Flight II*, Tubman's concealment is also a means to ultravisibility, allying her expansive form with the North Star at the upper right. Lawrence's language of masks here offers an eloquent visual metaphor for Tubman's uniquely ironic form of renown; she became famous precisely because she was invisible and therefore uncatchable.

8. Some viewers found Tubman ugly in Lawrence's depiction and criticized the artist for not making her appear more beautiful. The artist replied with considerable indignation, "If you had walked in the fields, stopping for short periods to be replenished by underground stations; if you couldn't feel secure until you reached the Canadian border, you, too, madam, would look grotesque and ugly. Isn't it sad that the oppressed often find themselves grotesque and ugly and find the oppressor refined and beautiful?" Lawrence, quoted in Ellen Harkins Wheat, *Jacob Lawrence: The "Frederick Douglass" and "Harriet Tubman" Series of 1938–40* (Hampton, Va.: Hampton University Museum, 1991), 41.

9. The discrepancy between the painted and published versions of Lawrence's *Flight II* is difficult to explain. Although a change was clearly made, there is no record of how or why the decision came about to alter the image.

79. Albright, *Persepolis, Iran*

1. Susan S. Weininger has gone so far as to propose that "Albright's entire oeuvre can be viewed as a twentieth-century exploration of the *vanitas* in which he pondered the connection between the physical and spiritual and the relationship of growth and decay, time and space, the finite and the infinite." Weininger, "Ivan Albright in Context," in Courtney Graham Donnell, *Ivan Albright* (Chicago: Art Institute of Chicago, 1997), 61.

2. Albright's work continues to elude designation, but his more famous works, such as *The Picture of Dorian Gray*, have been associated convincingly with psychoanalyst Jacques Lacan's theory of the abject. Bernard Olive, "Figuration et défiguration: Oscar Wilde, Ivan Albright et *The Picture of Dorian Gray* d'Albert Lewin," in *L'Art dans l'art: Littérature, musique et arts visuels* (Paris: Presses de la Sorbonne Nouvelle, 2000), 266. Weininger has noted that "over the years, [Albright] has been variously designated a surrealist, a mystic realist, a magic realist, a romantic realist, a subjective realist, and a realist-expressionist." Weininger, "Ivan Albright in Context," 67. The artist himself disliked any classification: "I know I've been called one but I do not consider myself a realist. I don't consider myself anything. . . . No, I'm not a realist. All I'm trying to do is to achieve my end, and that certainly is not realism. The reason I use an extremely minute technique is to tie down, to fuse, to crystallize various discordant elements so that my painting has a composite feeling." Albright, quoted in Michael Croydon, *Ivan Albright* (New York: Abbeville Press, 1978), 273.

3. Of his subjects, Albright once said, "I wanted to pick things that looked as if they had lived their lives." Albright, quoted in Croydon, *Ivan Albright*, 85.

4. Jean Dubuffet, "A Foreword by Jean Dubuffet," in Croydon, *Ivan Albright*, 8.

5. Quoted in Marilyn Robb, "Ivan Le Lorraine Albright Paints a Picture," *Art News* 49, no. 4 (summer 1950), 45.

6. Albright scholar Robert Cozzolino has suggested that the artist's wife, Josephine, was probably a great influence on the couple's extensive travels after their marriage in 1946. Albright also traveled extensively around the United States with his family as a child, which may have sown the seeds of his later wanderlust. Cozzolino to Mark Mitchell, September 12, 2003, HMA object files.

7. Albright reportedly painted in oil at a rate "averaging one half of a square inch each five-hour working day . . . using hundreds of Winsor and Newton brushes, sizes 1 to triple 0, cut down to a single hair. . . ." Jan van der Marck, "Ivan Albright: More Than Meets the Eye," *Art in America* 65 (November–December 1977), 96–97.

8. Courtney Graham Donnell, "A Painter Am I: Ivan Albright," in Donnell, *Ivan Albright*, 23, 27. Joshua Kind, "Albright: Humanist of Decay," *Art News* 63, no. 7 (November 1964), 70.

9. Robert Cozzolino has speculated that Albright's travels offered him great latitude for exploration of the formal aspects of painting, including color, touch, texture, time, and others, without worry about a negative impact on one of his long-term projects. Cozzolino to Mark Mitchell, September 12, 2003, HMA object files.

10. As cultural historian Edward Said has written of French writer François-René de Chateaubriand, "the Orient was a decrepit canvas awaiting his restorative efforts." The same may be said of Albright's orientalist mode. Edward W. Said, *Orientalism* (New York: Vintage Books, 1979), 171.

11. Official excavations of the site began in the early 1930s, sponsored by Reza Shah and conducted by the University of Chicago. After the onset of World War II, the Iranian Antiquity Service took over the expedition, only to delegate the project to the Italian Institute of the Middle and Far East in 1964. Donald N. Wilber, *Persepolis: The Archaeology of Parsa, Seat of the Persian Kings* (New York: Thomas Y. Crowell Company, 1969), 108–9.

12. Mehran Kamrava, *The Political History of Modern Iran, from Tribalism to Theocracy* (Westport, Conn.: Praeger, 1992), 46. The Pahlavi shahs' quest for legitimacy ultimately failed and ended in the Islamic revolution of 1978–79.

13. Robert Cozzolino has recently helped to determine the watercolor's date as 1967. The bull's head was reattached in May of that year. The story of its reconstruction is told in detail in both words and images in Ann Britt Tilia, *Studies and Restorations at Persepolis and Other Sites of the Fars* (Rome: Istituto Italiano per il Medeo ed Estremo Oriente, 1972), 49, figs. 93–103.

14. Ilya Gershevitch (ed.), *The Cambridge History of Iran* (Cambridge: Cambridge University Press, 1985), 2:657–58.

15. Competing theories have arisen among archaeologists as to the original use of the hall, and it has various names in different archaeological treatises according to the theory to which the author subscribes. Alternatives are the Throne Hall and Hall of Honor or Reunion. For a discussion, see Wilber, *Persepolis*, 63–65.

80. Bearden, *Two Figures*

1. Bearden first began working professionally as an artist while he was attending New York University (he graduated in 1935, having majored in mathematics); he was a cartoonist for the school newspaper, *The Medley*, and later submitted cartoons weekly to the *Baltimore Afro-American* (see Myron Schwartzman, *Romare Bearden: His Life and Art* [New York: Harry N. Abrams, Inc., 1990], 73). After graduation, Bearden studied at the Art Students League with George Grosz and then Stuart Davis, whose brightly colored abstractions made a profound impression on the young artist. In the late 1930s he became associated with a close-knit group of black artists that met regularly in Harlem and encountered such figures there as writer Ralph Ellison and painter Norman Lewis. He also deeply immersed himself during the ensuing years in not only European modernism and African art but also Byzantine art, medieval stained glass, the old masters, and Chinese

painting. While learning his craft as a painter, Bearden made his living as a caseworker for New York's Department of Welfare. For details on Bearden's life and career, see Ruth Fine, *The Art of Romare Bearden* (Washington, D.C.: National Gallery of Art, in association with Harry N. Abrams, Inc., 2003), and also Schwartzman, *Romare Bearden*.

2. His art of these years had a social bent, similar to but less overtly political than his early work as a newspaper cartoonist. In the late 1940s he experimented with a type of cubist vocabulary in paintings of the Passion and bullfighters that are as reminiscent of the work of André Masson and Giorgio de Chirico as they are of Pablo Picasso.

3. In 1961 Bearden was publicly exhibiting only painted abstractions. With their veils of color, these meditative canvases were a far cry from the expressive photomontages that a short time later would bring him recognition and success as an artist. However, it was in the course of doing this abstract work that he began pasting painted rice paper to canvas and then tearing it to create broad areas of color. See Romare Bearden, "Rectangular Structure in My Montage Paintings," *Leonardo* 30 (1969), 11. Bearden is thought to have created his first signed figurative collage, *Circus*, in 1961, inspired in part by the colorful cut-paper works of Henri Matisse. See Schwartzman, *Romare Bearden*, 208.

4. Bearden was also working on other projects at this time that tackled the issue of poverty and its impact on the urban poor. In January 1968 Bearden created a collage for the cover of *Fortune* magazine, a special issue on "business and the urban crisis." He also did a photomontage for a fall 1968 cover of *Time* that showed New York City mayor John Lindsay surrounded by images of people, police, and buildings. See Fine, *The Art of Romare Bearden*, chronology section for the year 1968, 225.

Index